ARTISTS AS ILLUSTRATORS:

An International Directory With Signatures and Monograms, 1800–Present

by
John Castagno

THE SCARECROW PRESS, INC.
Metuchen, N.J. & London 1989

British Library Cataloguing-in-Publication data available.

Library of Congress Cataloging-in-Publication Data

Castagno, John, 1930–
 Artists as illustrators.

 Bibliography: p.
 1. Illustrators—Directories. 2. Illustrators—Autographs—
Facsimiles. 3. Artists' marks. I. Title.
NC961.63.C37 1989 741.6'092'2 88-34832
ISBN 0-8108-2168-0

I dedicate this book to my mother, Maria Grazia Leone Castagno, who sacrificed her life bringing up eleven children, of whom I was the youngest, and who died when I was thirteen.

I dedicate this book also to my father, Joseph Castagno, who loved and cared for me into my adult years and who was my best friend and continues to be in my memory each day of my life.

CONTENTS

FOREWORD

It has been an uphill struggle for the illustrator to achieve a respected position of recognition in the world of art. As the illustrator sometimes crossed that thin line into "fine art," so did the fine art painter cross that same line into illustration. In the twentieth century we have witnessed many fine art painters producing story illustrations, magazine covers, and posters. Today, colorful and beautiful illustrations adorn the walls of art lovers and collectors, and can also be seen hanging in art galleries and museums. Auction galleries around the world hold specialized auctions of illustrations and the prices range from hundreds to hundreds of thousands of dollars.

This book is the first definitive book encompassing the international world of illustration of the last two centuries. It is long overdue and is sorely needed as a research tool.

As a collector and dealer in illustrations, I commend John Castagno for his successful endeavor in gathering and compiling such a large and diversified volume of valuable information.

JUDY GOFFMAN
Fine Arts
New York City

ACKNOWLEDGMENTS

Christofer Macatsoris, Philadelphia
Caroline Murdoch Khella, New York City
Marianne Wells, West Chester, Pa.
John and Marie Carey, Philadelphia
Judith Lovat, Glasgow, Scotland
Paula Serrano, Philadelphia
Shirley Ann Weekly, Philadelphia
Daniel Smith, Philadelphia
Edward Bernstein, Philadelphia
David Morgan, Wilkes-Barre, Pa.
Jerry Cohen, New York City

Marianne Promos, Joseph Perry, Mary Elizabeth VandenBerge, and Jill McConkey of the Art Division of the Free Library of Philadelphia.

Betty Krulik, formerly of Christie's East, New York City

Wendy Foulkes, Sotheby's of Philadelphia

THE FOLLOWING AUCTION GALLERIES AND THEIR PAINTING DEPARTMENTS:

CHRISTIE'S EAST, New York City
CHRISTIE'S, New York City
CHRISTIE'S, London
CHRISTIE'S, Amsterdam
CHRISTIE'S, Monaco
SOTHEBY, New York City
PHILLIPS, New York City
WILLIAM DOYLE, New York City
SAMUEL T. FREEMAN, Philadelphia
FINE ARTS, Philadelphia
BARRY S. SLOSBERG, Philadelphia
BUTTERFIELD & BUTTERFIELD, San Francisco
SELKIRK, St. Louis, Missouri
RICHARD BOURNE, Massachusetts
WESCHLERS, Washington, D.C.
WOLFGANG KETTERER, Munich, West Germany
GEORGES BLACHE, Versailles, France

ALSO:

NEWMAN ART GALLERIES, Philadelphia

INTRODUCTION

With more than 14,000 entries of nineteenth- and twentieth-century artists, this book is the most comprehensive international listing of artists as illustrators to have been compiled to date. No single art reference source can supply even one percent of the content of this volume. The entries include illustrators, sculptors, and fine art artists who have done illustrations in the following categories: Book and Magazine Illustrations, Booklet Illustrations, Cover Illustrations for Books, Magazines and Records, and, finally, Posters. Bibliographical reference keys are provided with each entry. Approximately 4,000 of the listed artists will be shown with a signature facsimile.

In compiling this book, I have included the following material, which has often been omitted in previously published artist indexes:

1. Nearly 1,000 dual-nationality entries. Previous artist indexes often list only one nationality in cases where the artist is claimed by more than one country.

2. When possible, full names, initials, nicknames, and pseudonyms.

3. Notation of questionable birth and death dates when they vary in different sources.

4. Listing many nineteenth- and twentieth-century artists as illustrators when previous indexes have listed them only as artists. Each entry has at least one bibliographical reference that shows the artist as an illustrator.

The signature facsimiles provided herein are accurate and quite reliable as a guide for identifying similar signatures of a given artist. However, it is quite common for artists to vary their signature styles and a difference in style does not necessarily mean that the work in question is not authentic.

Many of the cited works also provide photographic reproductions of the artist's work. This abundant bibliographical material will save hours, even weeks, of research time.

For clarity in the alphabetical use of this book, the user should note the following: Mac and Mc names are not intermixed, e.g., Mac follows MAB and Mc follows MAZ. All names spelled with an umlaut are placed alphabetically regardless of the umlaut. For researching artists who have a DE, VAN, or VON with their last name, one should check the two possible ways the name may be listed.

No matter how voluminous this book is, no work of this kind is ever complete. Consequently, in the next four and eight years, two additional volumes will follow.

This has been and will continue to be a labor of love for me, and my greatest satisfaction is in knowing that I have been successful in my attempt to fill this obvious void in the field of art research.

AVANT-PROPOS

Ce livre, qui contient plus de 14 000 noms d'artistes des XIX et XXe siècles, représente le répertoire le plus complet d'artiste du monde entier ayant travaillé comme illustrateurs, mis à jour jusqu'à présent. Il n'existe pas un seul livre de l'art offrant ne serait-ce qu'un pour cent de ce que contient ce volume. Ce livre de l'art comprend les noms d'illustrateurs, de sculpteurs, d'artistes des beaux-arts qui ont collaboré comme illustrateurs sous les formes suivantes: illustrations de livres et de revues, de plaquettes, de couvertures de revues et de disques et enfin illustrations de posters. Chaque nom est pourvu d'une figure de renvoi aux références bibliographiques. Une signature télécopie accompagne le nom d'environ 4000 artistes mentionnés.

Dans le travail de préparation de ce livre, j'ai ajouté les données suivantes, bien souvent omises dans les indexes d'artistes publiés dans le passé:

1. Jusqu'à 1000 noms indiquant la double nationalité. Les indexes d'artistes publiés jusqu'à présent n'indiquent souvent qu'une nationalité quand bien même plus d'un pays revendique le nom de l'artiste.

2. Selon le cas, nom et prénom, initiales, surnoms et pseudonymes.

3. Notation des dates de naissance et de décès incertaines quand celles-ci diffèrent dans plusieurs sources d'informations.

4. La liste des noms de nombreux artistes des XIX et XXe siècles ayant travaillé comme illustrateurs alors que dans le passé les indexes publiés ne les mentionnaient que comme artistes. Chaque nom comprend au moins une référence bibliographique introduisant l'artiste comme illustrateur.

Les signatures télécopies reportées dans le présent volume sont fidèles et représentent une source fiable pour l'identification des mêmes signatures pour un artiste donné.

Néanmoins, les artistes changent souvent le style de leur signature; cela dit une différence dans le style n'implique pas automatiquement que l'oeuvre concernée n'est pas authentique.

Parmi les oeuvres citées, un certain nombre fournissent une reproduction photographique de l'oeuvre de l'artiste. Cette abondance de données bibliographiques fera gagner des heures, voire des semaines de travail consacrées à la recherche.

Ce livre a beau être volumineux, un tel ouvrage ne sera jamais complet. Deux volumes supplémentaires sont donc prévus dans les quatre et huit années à venir.

Ce travail représente et continuera à représenter un travail que je chéris et la plus grande satisfaction que j'en dérive est de savoir que ma tentative de combler ce vide évident dans le domaine de recherche de l'art a été couronnées de succès.

VORWORT

Mit mehr als vierzehntausend Eintragungen von Künstlern des neuzehnten und zwanzigsten Jahrhunderts, ist dieses Buch die umfassendste internationale Aufzählung von Künstlern als Illustratoren, die bis dato zusammengestellt wurde. Kein anderes Nachschlagwerk für Kunst kann auch nur ein Prozent des Inhalts dieses Buches aufweisen. Die Eintragungen inkludieren Illustratoren, Bildhauer und Künstler, die die folgenden Kategorien illustriert haben: Bücher und Magazine, Illustrationen, illustrierte Broschüren, illustrierte Einbände für Bücher, Magazine und Schallplatten und zuguterletzt Plakate. Jede Eintragung ist mit einem bibliografischen Referenzschlüssel versehen, ungefähr viertausend der aufgezählten Künstler werden mit einem Unterschriftenfaksimile gezeigt.

In der Zusammenstellung dieses Buches habe ich folgendes Material angeführt, das in vorangehenden Kunstindexen oft ausgelassen wurde.

1. Beinahe tausend Eintragungen von Doppelstaatsangehörigen. Vorangegangene Kunstindexe haben oft nur eine Nationalität angeführt in Fällen in denen mehr als ein Land Anspruch auf den Künstler erhoben hat.

2. Wenn möglich, die kompletten Namen, Initialen, Spitznamen und Pseudonyme.

3. Bezeichnungen von fraglichen Geburts und Sterbedaten, wenn sie in verschiedenen Quellen variieren.

4. Aufzählung vieler Künstler des neuzehnten und zwanzigsten Jahrhunderts als Illustratoren, wenn vorangehende Indexe diese nur als Künstler anführte. Jede Eintragung hat zumindest eine bibliografische Referenz, die den Künstler als Illustratoren zeigt.

Die Unterschriftenfaksimiles, die hier bereitgestellt sind, sind genau und ziemlich verlässlich als Anleitung zur Identifizierung ähnlicher Unterschriften eines gegebenen Künstlers. Wie auch immer, es ist nicht ungewöhnlich für einen Künstler, den Stil seiner Unterschrift zu variieren und eine Differenz im Stil heisst nicht unbedingt, dass das fragliche Werk nicht authentisch ist.

Viele der angeführten Werke liefern auch fotografische Reproduktionen des Werkes des Künstlers. Dieses umfassende bibliografische Material wird Stunden, sogar wochen der Nachforschungsarbeit ersparen.

Wie umfassend dieses Buch auch sein mag, kein Werk dieser Art wird jemals vollständig sein. Deshalb werden in den nächsten vier bis acht Jahren zwei weitere Bände erscheinen.

Das war und wird auch weiterhin Arbeit für mich sein, die ich liebe, und meine grösste Genugtuung liegt darin, dass ich weiss, ich war erfolgreich in meinem Versuch diese offensichtliche Lücke im Gebiet der Kunstforschung zu füllen.

INTRODUZIONE

Questo libro contiene oltre 14.000 nominativi di artisti del XIX e XX secolo attivi anche quali illustratori, ed è il più esauriente catalogo internazionale compilato fino ad oggi. Nemmeno 1% di quanto è contenuto in quest'opera è reperibile da altra fonte singola. La lista comprende pittori, scultori e professionisti delle Belle Arti i quali hanno eseguito illustrazioni nelle seguenti categorie: Illustrazioni per Libri e Periodici, per Opuscoli, Copertine per Libri, Riviste e Dischi, e, infine, Manifesti. Ogni nome è correlato dai dati bibliografici. Esemplari delle firme di circa 4.000 artisti sono riprodotti.

Nell'organizzare il contenuto ho voluto includere materiale che è stato totalmente trascurato negli elenchi di artisti finora pubblicati.

1—Quasi 1.000 nominativi dalla duplice nazionalità. Spesso un artista è rivendicato da più di un paese. I vecchi cataloghi gliené attribuiscono solo una di nazionalità.

2—Completano le generalità, quando possibile, monogrammi, soprannomi, e pseudonomi.

3—Annotazioni su date imprecise di nascita e di morte ove queste varino in altre fonti.

4—Si definiscono illustratori numerosi artisti del XIX e XX precedentemente classificati in altri cataloghi solo quali artisti. Ogni nominativo comprende almeno un dato bibliografico che lo qualifica "illustratore."

Gli esemplari delle firme qui riprodotte sono fedeli, e ben valide per la verifica delle firme del rispettivo artista. Spesso capita che gli artisti varino lo stile della loro firma: tali variazioni, tuttavia, non comportano necessariamente che l'opera in esame non sia autentica.

Inoltre molti dei testi indicati contengono riproduzioni fotografiche delle opere di numerosi artisti. Questo abbondante materiale farà risparmiare ore di ricerche, persino settimane.

Per quanto voluminoso possa essere questo libro, nessuna fatica del genere potrà mai dirsi completa. È perciò che, con scadenze rispettive di quattro e otto anni, saranno pubblicati altri due volumi.

Questa è stata e continuerà ad essere la fatica della mia passione, ed il sapere d'aver raggiunto il successo nel tentativo di colmare quest'ovvia lacuna nel campo delle ricerche sulle arti è la mia massima soddisfazione.

INTRODUCCION

Este libro, con más de 14.000 entradas de pintores de los siglos diecinueve y veinte, es el más abarcador listado de pintores como ilustradores compilado hasta este momento. Ninguna otra fuente de referencia pudiera proveer siquiera un centésimo del contenido de este volumen. Las entradas incluyen ilustradores, escultores y pintores, que han hecho ilustraciones en las siguientes categorías: Ilustración de libros y revistas, Ilustración de folletos, Ilustración de cubiertas de libros, revistas y discos fonográficos y finalmente Carteles. Indices de referencias bibliográficas van incluídos junto a cada entrada. En adición, van incluídos facsímiles de las firmas de aproximadamente 4.000 de los pintores listados.

Al compilar esta obra, he incluído el material que sigue, el cual ha sido frecuentemente omitido en índices de pintores de publicación previa:

1. Cerca de mil entradas de nacionalidad dual. Los índices previos frecuentemente mencionan solamente una nacionalidad en casos donde el pintor es reclamado como propio por más de una nación.

2. Tanto como posible, nombres completos, iniciales, apodos y seudónimos.

3. Anotaciones en fechas de nacimiento y deceso cuando estas varían de fuente en fuente.

4. Listado de muchos pintores como ilustradores aun cuando índices previos los incluían solamente como pintores. Cada entrada tiene por lo menos una referencia bibliográfica que muestra al pintor como ilustrador.

Los facsímiles de firmas incluídos son fieles y confiables como guía para la identificación de firmas similares de algún pintor. Sin embargo, es bastante común entre los pintores el variar el estilo de la firma, por lo cual una diferencia en el estilo no significa necesariamente que la obra en cuestión no sea auténtica.

Varias de las obras citadas proveen además reproducciones fotográficas de obras de los pintores. Este abundante material bibliográfico ahorrará horas y tal vez semanas de trabajo de investigación.

No obstante cuan voluminoso sea este libro, ninguna obra de esta índole es exhaustiva. Por consiguiente, en cuatro y luego ocho años en el futuro, seguirán volúmenes adicionales.

Esta labor ha sido y seguirá siendo para mí obra de amor, siendo fuente de honda satisfacción el saber que he logrado una gran medida de éxito en mis intentos por llenar este evidente vacío en el campo de la investigación del arte.

LIST OF ABBREVIATIONS AND SOURCES

AA *American Artists,* Les Krantz, Krantz Company Publishers, Chicago, 1985.

ABD *American Art Annual, Biographical Directory of American Painters and Sculptors,* American painters and sculptors born after 1860 and active in 1933, Anthony C. Schmidt, Fine Arts, Collingswood, N.J.

ABL *Appleton's Booklovers Magazine,* New York, 1905.

AD *Art Deco,* posters and graphics, Jean Delhaye, Academy Editions/St. Martin's, New York, 1984.

ADV *Advertising,* Bryan Holme, Viking Press, New York, 1982.

AM *Atlantic Monthly Magazine,* Boston, 1923 through 1926.

AMA *American Magazine of Art,* The American Federation of Arts, Washington, D.C., 1930, 1931, 1934.

AN *Art Nouveau,* prints, illustrations and posters, Hans H. Höfstatter, Germany: Holle Verlag GmbH, Baden-Baden, 1968; England: Omega Books Ltd., Ware; United States: Greenwich House, New York, 1984.

APP *American Prints and Printmakers,* 1900 to the present, Una E. Johnson, Doubleday, New York, 1980.

B *E. Bénézit,* Dictionnaire critique et documentaire des peintres, sculpteurs, dessinateurs et graveurs, E. Bénézit, 10 volumes, Librairie Gründ, Paris, 1976.

BA *British Art,* The Thames and Hudson Encyclopaedia of, David Bindman, Thames and Hudson, London, 1985.

BAA *Brooklyn Art Association,* History of, index of exhibitions 1859–1898, Clark S. Marlor, published by James F. Carr, New York, 1970.

BI *Bicycle Posters,* 100 years of, Jack Rennert, Harper and Row, 1973.

BK *Bibliography of British Book Illustrators 1860–1900,* Charles Baker, Birmingham Bookshop, 1978.

BKM *Bookman Magazine,* published by George H. Doran Company, Concord, N.H., 1926.

BL *Booklovers Magazine,* Library Publishing Company, Philadelphia, 1905.

BRP *The Century of Change, British Painting Since 1900,* Richard Shone, Phaidon Press, Oxford, England, 1977; E. P. Dutton, New York; Amilcare Pizzi, S.p.A., Milan, Italy.

BSA *Biographical Sketches of American Artists,* Helen L. Earle, originally published by the Michigan State Library 1924; fifth edition, revised and enlarged, Anthony C. Schmidt, Fine Arts, Collingswood, N.J.

C *First Connecticut Illustrators Exhibition Catalogue,* ADS, Inc., Rocky Hill, Conn., c. 1978.

CAV *Cartoon Cavalcade,* Thomas Craven, Simon and Schuster, New York, 1943.

CC *Image of America in Caricature and Cartoon,* Amon Carter Museum, Fort Worth, Texas, 1975.

CEN *Century Magazine,* The Century Co., New York/Macmillan & Co. Ltd., London, 1886–1913.

CG *Country Gentleman Magazine,* Curtis Publishing Co., Philadelphia, 1934.

CL *Current Literature Magazine,* The Current Literature Publishing Co., New York, 1910.

CO *Cosmopolitan Magazine,* Cosmopolitan Publishing Co., Irvington, New York, 1904–1905.

COL *Columbian Magazine,* The Columbian Magazine Publishing Co., New York, 1911.

CON *Contemporary Western Artists,* Peggy & Harold Samuels, Bonanza Books, 1985.

CP *Concise History of Posters,* John Barnicoat, Oxford University Press, New York & Toronto, 1979; printed in England by Jarrold & Sons Ltd., Norwich.

CWA *Civil War Art,* The American Heritage Century Collection of, Stephen W. Sears, American Heritage Publishing Co. Inc./Bonanza Books, New York, 1983.

D *Dictionary of Artists in America*—The New York Historical Society's, 1564–1860, George C. Groce & David H. Wallace, Yale University Press, New Haven & London, 1969.

DA *Dictionary of Art and Artists,* Peter & Linda Murray, Frederick A. Praeger, Publishers, New York/Washington, 1965; printed in England by Jarrold & Sons Ltd., Norwich.

DES *Dessins et Aquarelles du XXe Siècle,* Raymond Cogniat, Librairie Hachette, Paris, 1966.

DRA *20th Century Drawings—part I, 1900–1940,* Una E. Johnson, Shorewood Publishers Inc., Plainview, N.Y., 1964.

DRAW *20th Century Drawings—part II, 1940 to the present,* Una E. Johnson, Shorewood Publishers Inc., Plainview, N.Y., 1964; published in Canada by Little, Brown & Co.

EAM *Early American Modernist Painting, 1910–1935,* Abraham A. Davidson, Harper & Row, New York, 1981.

EC *World Encyclopedia of Cartoons,* Maurice Horn, Chelsea House Publishers, New York/London, 1980.

EI *European Illustration, 1979 thru 1984,* European Illustration, London; Polygon Publishing Ltd, Zurich.

EN *English Illustrated Magazine, 1884–1885,* Macmillan & Co., New York, 1885; Richard Clay & Sons, London, 1885.

F *Mantle Fielding's Dictionary of American Painters, Sculptors & Engravers,* Apollo Books, Poughkeepsie, N.Y., 1983.

FM *Forum Magazine,* The Forum Publishing Co., Concord, N.H., 1925–1926.

FO *French Opera Posters, 1868–1930,* Lucy Broido, Dover Publications, Inc., New York, 1976.

FOR *Forty Illustrators,* Ernest W. Watson, Watson-Guptill Pub., New York, 1946.

FS *French Satirical Drawings from "L'Assitte au Beurre,"* Stanley Appelbaum, Dover Publications, Inc., New York, 1978.

G *Deutsche Illustratoren der Gegenwart,* Eberhard Hölscher, F. Bruckmann KG, Munich, 1959.

GA *Golden Age of the Poster,* Hayward & Blanche Cirker, Dover Publications, New York, 1971; published in Canada by General Publishing Company, Ltd., Toronto, and in London by Constable and Company, Ltd.

GMC *Great Magazine Covers,* of the world, Patricia Frantz Kery, Abbeville Press, New York, 1982.

GR *Graphis Annual,* 1952 through 1969 & 1980 through 1985, Graphis Press Corp., Zurich; Distributed: USA, Hastings House, New York; in Canada, Hurtig Publishers, Edmonton; in France, Graphis Distribution, St.-Remy-lès-Chevreuse; in Italy, Inter-Orbis, Milan; in Spain, Comercial Atheneum, Barcelona; and in Latin America, Australia, Africa & Asia, Fleetbooks, c/o Feffer & Simons, New York.

GWA *German War Art, 1939–1945,* William P. Yenne, Crescent Books, New York, 1983.

H *Index to Artistic Biography,* volumes I & II—1973, supplement—1981, Patricia Pate Havlice, Scarecrow Press, Metuchen, N.J.
HA *Harper's Monthly Magazine,* Harper & Brothers, New York and London, 1901–1909.

I *Biographical Index of American Artists,* Ralph Clifton Smith, Garnier & Company, Charleston, S.C., 1967.
IL *The Illustrator in America, 1900–1960's,* Walt Reed, Reinhold Publishing Corp., New York, 1966.

J *Block Printing and Book Illustration in Japan,* Louise Norton Brown, G. Routledge & Sons Ltd., London; and E. P. Dutton & Co., New York, 1924.

L *French Illustrators in Five Parts,* Louis Morin, Charles Scribner's Sons, New York, 1893.
LATV *Latviešu Padomju Grafika,* Latvian States Publisher, Riga, Latvia, 1960.
LEX *Monogramm Lexikon,* Von Franz Goldstein, Verlag Walter & Co., Berlin, 1964.
LHJ *Ladies Home Journal Magazine,* Curtis Publishing Co., Philadelphia, 1894, 1905 & 1906.
LIL *L'Illustration Magazine,* Journal Hebdomadaire universel, Paris, 1932 & 1934.

M *Mallett's Index of Artists,* International-Biographical, Daniel Trowbridge Mallett, R.R. Bowker Company, with supplement; both reprinted 1948.
MCC *McClure's Magazine,* S.S. McClure Co., New York, 1904.
ME *Mentor Magazine,* Crowell Publishing Company, Springfield, Ohio, 1923–1924.
MM *Marks and Monograms of the Modern Movement 1875–1930,* Malcolm Haslam, Cameron & Tayleur (Books) Ltd., London, 1977; Charles Scribner's Sons, New York.
MP *Modern Priscilla Magazine,* Priscilla Publishing Co., Boston, Mass., 1918.
MUN *Munsey's Magazine,* Frank A. Munsey—Publisher, New York, 1897, 1902 & 1903.

NH *National Geographic Magazine,* National Geographic Society, Washington, D.C., 1915–1925.
NV *New Visions,* science fiction art, Doubleday & Co., New York, 1982.

P *The Art of Playboy,* Ray Bradbury, Alfred van der Marck Editions, New York, 1985.
PAP *Paperbacks, U.S.A., graphic history 1939–1959,* Piet Schreuders, Baart, Borsbeek—Belgium, 1980; Loeb, Amsterdam, 1981; Virgin Books, Great Britain (published as *The Book of Paperbacks),* 1981; Blue Dolphin, San Diego, 1981.
PC *Prints and Their Creators,* world history, Carl Zigrosser, Crown Publishers, New York, 1937; revised editions 1948, 1956 & 1974.
PE *Treasury of American Pen and Ink Illustration, 1881–1938,* Fridolf Johnson, Dover Publications, Inc., New York, 1982; in Canada, General Publishing Co., Toronto; in England, Constable & Co., London.
PET *Peterson Magazine,* The Peterson Company, New York, 1896 & 1897.
PG *Political Graphics,* Robert Philippe, Abbeville Press, New York; first published in Italian in Milan, "Il Linguaggio della Grafica Politica" by Arnoldo Mondadori Editore S.p.A., 1980.

PLC *Playboy Cartoon Album,* Hugh M. Hefner, Crown Publishers, New York, 1959.

POS *The Poster,* worldwide survey and history, Alain Weill, published in Canada and the U.S.A. by G.K. Hall & Co., Boston, 1985; published in Paris as "L'Affiche dans le monde" by Editions Aimery Somogy, 1984.

POST *The Poster,* illustrated history from 1860, Harold F. Hutchinson, Viking Press, New York, 1968 & 1969; published in London by Studio Vista Limited, 1968.

PUN *Punch (or, The London Charivari),* London, 1937.

R *American Poster Renaissance,* Victor Margolin, Watson/Guptill Publications, New York, and Canada 1975.

RC *Red Cross Magazine,* The Red Cross Magazine, Garden City, N.Y., 1917.

RS *Russian and Soviet Painting,* The Metropolitan Museum of Art, 1977; distributed by Rizzoli International Publications.

S *500 Years of Art and Illustration,* Howard Simon, World Publishing Co., Cleveland and New York, 1942.

SC *Scandinavian Art,* Carl Laurin/Emil Hannover/Jens Thiis, American-Scandinavian Foundation, New York, 1922; Oxford University Press, London, 1922.

SCR *Scribner's Magazine,* Charles Scribner's Sons, New York; Sampson Low Marston & Co., Ltd., London, 1888 to 1912.

SH *Shadowland Magazine,* Brewster Publications, Inc., Jamaica, N.Y., 1923.

SI *Simplicissimus,* Stanley Appelbaum, Dover Publications, New York, 1975.

SN *St. Nicholas Magazine,* The Century Co., New York, 1886 and 1894.

SO *Society of Independent Artists,* exhibition record 1917–1944, Clark S. Marlor, Noyes Press, Park Ridge, N.J., 1985.

ST *Golden Age of Style,* Julian Robinson, Gallery Books, New York; Orbis Publishing Ltd., London, 1976.

STU *Studio Magazine,* Studio International Journal, Ltd., London, 1898–1930.

TB Thieme, U. and Becker, F., *Allgemeines Lexikon der bildenden Künstler von der Antike bis zur Gegenwart,* vol. 1–37, 1907–1950.

VC *Vogue Covers 1909–1940,* the art of, William Packer, Octopus Books, Ltd., London, 1980; Bonanza Books, distributed by Crown Publishers, New York, 1985.

VO H. Vollmer, *Allgemeines Lexikon der Bilden Künstler des XX Jahrhunderts,* E. A. Seeman, Leipzig, 1953–62.

WS *Winnipeg School of Art,* Marilyn Baker, University of Manitoba Press, Canada, 1984.

WW *Woman's World Magazine,* Woman's World Publishing Co., Mount Morris, Ill., 1934.

WWK *World's Work Magazine,* Doubleday, Page & Co., Garden City, N.Y., 1910–1914.

Y *200 Years of American Illustration,* Henry C. Pitz/Norman Rockwell, Random House, Inc., New York, 1977.

* An asterisk (*) indicates that the artist is not listed as an illustrator in any of the reference sources which I have cited; and when this is the case, I often note a particular illustrated source.

A M
see
CASSANDRE, A. M.

ABA, Leo
Italian mid 20c
GR54

ABBE
see
ANDERSSON, Albert

ABBE, Elfried Martha
American 1919–
F,H,M

ABBETT, Robert K.
American 1926–
AA,CON,H,IL,PAP

[signature: bob abbett]

ABBEY, Edwin Austin
Anglo/American 1852–1911
B,BAA,BK,EC,F,H,HA6/07 & 4/09,M,PE,R,Y

[signature: EA Abbey 1903]

ABBEY, Henry
English 1817–83
B,BK,F,H,M,Y

ABBOTT, Samuel Nelson
American 1874–1953
F,H,IL,Y

[signature: S.N. ABBOTT]

ABBOTT, Elenore Plaisted
American 1875–1935
B,F,H,HA8/01,I,M

[signature: Elenore Plaisted Abbott]

ABBOTT, Jacob Bates
American 20c.
M

ABDY, Rowena Meeks
American 1887–1945
F,H,M,SO

ABEKING, Hermann
German 1882–
AN,B,LEX,VO

ABEL-TRUCHET
see
TRUCHET, Abel

ĀBELĪTE, Ol̆gerts Mintauta
Latvian 1909–
LATV

A

ABEYTA, Narciso Platero
American 1918–
H

1

ABRAHAMS, Joseph B.
 Polish/American 1884–
 H,M

ABRAHAMSEN, Christian
 American 1887–
 B,F,H,I,M

ABREU, Lázaro
 Cuban mid 20c.
 PG

ABREU, Luis Filipe de
 Portuguese 1935–
 H

ABSOLON, John
 English 1815–95
 B,BAA,H,M

ACCURSO, Anthony Salvatore
 American 1940–
 H

ACCURTSONE, Giovanni
 Italian 1897–1944
 POS

Accurtsone '64

ACHESON, Alice Stanley
 American 1895–
 B,F,H,M

ACKLEY, Telka
 American 1918–
 H,M

ACOSTA, Manuel Gregorio
 Mexican/American 1921–
 H

ACRUMAN, Paul
 American 1910–
 H

ADAM, Wilbur G.
 American 1898–
 F,H,M

ADAM, Yvon
 Belgian late 20c.
 GR67–82

YVON ADAM

ADAMO, Max
 German 1837–1901
 B,H

ADAMOVIČS, Sergejs Fadeja
 Latvian 1922–
 LATV

A57

ADAMS, A. C. E.
 English late 20c.
 GR52

ADAMS, Bruce
 American 20c.
 M

ADAMS, Cassily
 American 1843–1921
 H

ADAMS, Frank
 Anglo/American 19/20c.
 B,H,M

ADAMS, Harvey
 English 1903–
 LEX,VO

ADAMS, John Wolcott
 American 1874–1925
 B,F,HA10/03,I,IL,M,PE,Y

John Wolcott Adams

ADAMS, Julius
 German 1852–1913
 BAA,LEX,TB

ADAMS, Laurence
 American 1905–
 H,M

ADAMS, Mary Crosjean
 American 20c.
 M

ADAMS, Moulton Lee
 American 1922–
 H

ADAMS, Norman
 Anglo/American 1927–
 F,H,Y

Norman Adams

ADAMS, Walter Burt
American 1903–
H,M

ADAMSON, Penryhn Stanley
Scots/American 1877–
B,H,I,M,Y

[signature: Penryhn Stanlaws]

ADAMSON, Sydney
American early 20c.
CEN8/04 & 6/05,HA7/07

[signature: Sydney Adamson]

ADARAMAKARO
Japanese 19/20c.
GMC

ADDAMS, Charles Samuel
American 1912–
CC,EC,GMC,GR55,H

[signature: chas Addams]

ADDISON, Chauncy
see
DAY, Chon

ADDISON, Wilfred John
Canadian/American 1890–
H,M

ADELSBERGER, Lizia
Austrian 20c.
LEX

ADES, Harold (Hal)
Anglo/American 1888–
H

ADLER, Alan Nils
English late 20c.
EI84

[signature: ADLER]

ADLER, Jules
French 1865–1952
B,LEX

ADLER, Leo
Austrian early 20c.
LEX,VO

ADLER, Randolph
American 20c.
M

ADMIE-WETTER, W.
English mid 20c.
LEX

ADNEY, Edwin Tappan
American/Canadian 1868–1950
B,F,H,I,M,SN9/94

[signature: TAPPAN ADNEY]

AEBI, Ernst Walter
American 1938–
H

AFFLERBACH, Ferdi
Swiss mid 20c.
GR52-53-57-59-61-62-63-66-67

[signature: FERDI AFFLERBACH]

AFFLERBACH-HEFTI, Beatrice
Swiss mid 20c.
GR52-53-54

[signature: Beatrice Afflerbach]

AFFOLTER, Charles H.
Swiss mid 20c.
GR64

AGATE, Alfred T.
American 1812–46
B,D,F,H,I,M

AGHA, (Dr.) Mehemed Fehmy
Russian/American 1896–1950
GMC,H

AGHIAN, Janine
French early 20c.
B,ST

AGIN, Alex Alexejewitsch
Russian 1818–70
B

AGNEW, Clark M.
American 20c.
H,M

AGOSTINI, Sergio
 Italian mid 20c.
 GR59

AGOTHA, E.
 Hungarian 19/20c.
 LEX

AGUIRRE, Carlos Llerena
 American late 20c.
 GR82

AHLERS, Fritz
 German early 20c.
 B?,POS

AHRENDTS, Conrad (Konrad)
 German 1855–1901
 B

AHRENS, Ellen Wetherald
 American 1859–
 B,F,H,I,M

AHRENS, Hermann
 German 20c.
 LEX

AHTIALA, Heikki
 Finnish mid 20c.
 GR52

AICHER, Otl
 German 1922–
 GR52–53–54–56–57,H

AICHER, Teja
 Austrian mid 20c.
 LEX

AID, George Charles
 American 1872–1938
 B,F,H,I,M

AIGNER, Marie Thérèsa
 French 20c.
 B

AINSWORTH, Edgar
 English early 20c.
 POS

AITKEN, Robert
 Scots/American 1734–1802
 B,D,F,I,M,TB

AKIMOV, Nikolai Pavlovich
 Russian 1901–68
 MM,POS

AKINO, Fuku
 Japanese 1908–
 B,H

AKIYAMA
 Japanese mid 20c.
 GR56

AKIZUKI, Shigeru
 Japanese late 20c.
 GR65–85

ALAIN, D. A.
 Franco/American 1904–
 H,M

ALAIN, Marie Barrett
 American 20c.
 H,M

ALAJALOV, Constantin
 Russian/American 1900–
 ADV,EC,F,FOR,GMC,H,IL,M,Y

ALARY, Pierre
 French 1924–
 B,H

ALBAN, Tom
Australian 20c.
H

ALBIEZ, Alfred
German mid 20c.
GR57

ALBITZ, Ruth
German 20c.
GR55-56

ALBRECHT, Frederick E.
American 20c.
H

ALBRECHT, Henry
German 1857-1910
B,LEX,TB

H.a.

ALBRECHT, Robert A.
American 1925-
H

ALBRIGHT, Gertrude Partington
American 1883-
A,F,H,M

ALBUQUERQUE, José Manuel Campos
Portuguese 1941-
H

ALCANTARILLA, Susan
English late 20c.
EI79

ALCORN, Bob
American late 20c.
GR82

Bob Alcorn

ALCORN, John
American 1935-
AA,GR57-59-60-66-82,H,POS

ALCORN, Rowena Lung
American 1905-
H

ALCOTT, Abigail May
American 1840-79
B,D,F,H,M

ALDIN, Cecil Charles Windsor
English 1870-1935
ADV,H,H,LEX,POS,TB,VO

Cecil Aldin 1900

ALDRICH, Frank Handy
American 1866-
F

ALDRICH, John G., Jr.
American 20c.
M

ALDRIDGE, Alan
Anglo/American late 20c.
CP,EI79,GR65-67

ALDWIN(C)KEL, Eric
Anglo/Canadian 1909-
GR55,H,LEX

ALECHINSKY, Pierre
Belgian 1927-
B,H,POS

Alechinsky

ALEŠ, Nikolaus (Mikulas)
Czechoslovakian 1852-1913
B,H

M.A.

ALEXANDER
American mid 20c.
PAP

Alexander

ALEXANDER, Clifford Grear
American 1870-
B,F,H,I,M,SO

ALEXANDER, Guy
American 20c.
M

ALEXANDER, John White
American 1856–1915
B,BAA,F,H,I,M

J.W.A.

ALEXANDER, Jon H.
American 1905–
H

ALEXANDER, Martha
American 1863–1937?
H

ALEXANDER, Nina
American early 20c.
F,H

ALEXANDER, William H. S.
American 1883–
I,M

ALEXEÏEFF, Alexander A.
Russian/American 1901–82
ADV,B,EC,GR56,H,POS

alexeïeff.

ALHO, Asmo
Finnish 1903–75
EC

ALISON
American mid 20c.
GR52

ALIVERTI, Cesare
Italian mid 20c.
GR54–57

ALIX, Yves
French 1890–1969
B,H,M

Yves ALIX

ALIZADEH, Javad
Iranian late 20c.
GR82

ALKE, Stephen
American 1874–1941
B,F,H,M

ALKEMA, Chester Jay
American 1932–
H

ALLCHIN, Harry
American late 19c.
SN8/94 & 9/94

Harry Allchin.
.93

ALLEN, Charles Edward
American 1921–
H

ALLEN, Clara Marie
American 1913–
H

ALLEN, Clarence Canning
American 1897–
H

ALLEN, Courtney
American 1896–1969
CG10/34,F,H,IL,M

COURTNEY
ALLEN

ALLEN, Erma Paul
American 1877–1942
H,M,SO

ALLEN, George
English 1832–1907
M

ALLEN, George J.
English
LEX

ALLEN, Grace Weston
American 1905–
M

ALLEN, Harry Epworth
English 1894–
M

ALLEN, James Edward
American 1894–1964
F,H,M,IL

J.E.
ALLEN

ALLEN, Julian
American late 20c.
EI79

ALLEN, Marion Campbell
American 1896–
H

ALLEN, Mary Gertrude
American 1869–
F,H,M

ALLEN, Olive
English 19/20c.
STU1900

O.A.

ALLEN, Paul
English late 20c.
EI79

ALLEN, Ray
American 20c.
M

ALLEN, Terry
American late 20c.
GR82

ALLEN, Thomas B.
American 1928–
F,GR58,IL,Y

ALLEN, W. S. Vanderbilt
American early 20c.
B,R

W.S. ALLEN.

ALLIER, Paul
French early 20c.
B,ST

ALLIGO, Santo
Italian late 20c.
GR85

ALLINGHAM, Helen Patterson
French/English 1848–1926
B,H,M

ALLIS, Marguerite
American 20c.
M

ALLISON, William Merle
American 1880–1934
F,H,M

ALLNER, Walter H.
German/American 1909–
GR56–60–63–66–68,H,POS

ALSTON, L. R.
English mid 20c.
GR52

ALMEIDA, Alvaro Figuieredo Duarte de
Portuguese 1909–72
H

ALMEIDA, Henry
Venezuelan/Canadian
H

ALMOND, William Douglas
English 1868–1916
B,H,M

ALMQUIST, Don
American 20c.
C,H

ALOISE, Frank
American
H

ALONSO, Felix
Spanish mid 20c.
GR52

ALONSO, Joaquin Guilherme Santos Silva
Portuguese 1871–1948
H

ALSTON, Charles H.
American 1907–77
H,LEX

ALSTON, Frederick Cornelius
American 1895–
H,M

ALTENDORF, George
American 20c.
M

ALTON, (pseudonym for TULLIO-ALTON,
Francesco)
Italian 1942/43–
EC,PG

ALTHAUS, René
Swiss mid 20c.
GR57–58

althaus

ALTMAN, Natan Isaevich
Russian 1889–1970
B,RS

ALTSCHULE, Hilda
Russian/American 20c.
H,M,SO

ALTSCHULER, Franz
German/American 1923–
F,GR55–60,H,Y

ALVAREZ, Edvardo
Argentinean early 20c.
GMC

EDVARDO ALVAREZ

ALVES, João Rodriques
Portuguese 1910–60
H

AMALDI
Italian early 20c.
POS

AMAN-JEAN, Edmond François
French 1860–1935/36
AN,B,CP,GMC,H

Aman·Jean

AMARAL, Maria da Silva Pires Keil do
Portuguese 1914–
H

AMARELHE, Américo da Silva
Portuguese 1892–1946
H

AMATO, Fortunato
American 20c.
M

AMATO, Giuseppe
American 20c.
M

AMBERGER, Fritz Ludwig
American 1899–
M

AMEIJIDE, Raymond
American 1924–
F,GR66–67–68,Y

AMES, Lee Judah
American 1921–
H

AMESEDER, Blas
Spanish 1768–1841
B

AMESEDER, Eduard
Austrian 1856–1938
B,LEX,TB

E.a.

AMFT, Bob (Robert E.)
American 1916–
GR59–62,H

BOB AMFT

AMICK, Robert Wesley
American 1879–1969
B,CEN10/09,F,H,M,Y

RWAmick

AMIET, Cuno
German 1868–1961
B,H,POS

CA

AMIGUES, Georges
French ac. late 19c.
LEX

AMLING, Franz
 German 1853-94
 B,LEX,TB

FA

AMOSS, Berthe
 American 1920-
 H

AMREIN, Walter
 French mid 20c.
 GR61-62

AMSTUTZ, André
 English mid 20c.
 GR57-65 thru 68

Amstutz

AMTHOR, Marianne
 German early 19c.
 LEX

AMUCHASTEGUI, Axel
 Argentinean 1921-
 CON

AXEL AMUCHÁSTEGUI

AMUNDSEN, Richard
 American 1928-
 CON

Richard Amundsen

ANCONA, Victor
 American 20c.
 PG

ANCONA

ANCOURT, Edward
 French late 19c.
 FO

Edw. Ancourt

ANDEREGG, Elfridge
 Swiss mid 20c.
 GR60-61

ANDERMATT, P.
 Swiss mid 20c.
 GR60

ANDERSCH, Martin
 German mid 20c.
 GR52-59-62

ANDERSEN, Arne
 Danish 1907-
 GR60-61-64

ANDERSEN, Ib
 Danish early 20c.
 POS

ANDERSEN, Martinus
 American 1818-
 B,F,H,I,M,SO

ANDERSEN, Norman
 American 1894-
 H,M

ANDERSEN, Poul
 Danish mid 20c.
 GR60-62

ANDERSEN, Roy H.
 American 1930-
 F,H,Y

ANDERSON
 English early 20c.
 AD

ANDERSON 35

ANDERSON, Alexander
 American 1775-1870
 APP,CC,D,F,H,I,M,PC,Y

ANDERSON, Carl Thomas
 American 1865-1948
 F,H,M

ANDERSON, Clarence William
 American 1891-1972
 H,M,SO,Y

ANDERSON, Doug
 American 1919-
 H

ANDERSON, Ellen G.
 American 19/20c.
 B,F,H

ANDERSON, Freddie
American 1932–
H

ANDERSON, Frederic A.
American 19/20c.
F,I,M

ANDERSON, Gunnar Donald
American 1927–
H

ANDERSON, Harold Edgerly
American 1899–
H,M

ANDERSON, Harold N.
American 1894–
H,M,IL

HAROLD ANDERSON

ANDERSON, Harry
American 1906–
IL

Harry Anderson

ANDERSON, (Miss) Heath
American 1903–
F,H,M

ANDERSON, J. B.
Canadian ac. 1877
H

ANDERSON, Karl
American 1874–1956
B,F,H,I,M,SO

ANDERSON, Kjell Ivan
Swedish late 20c.
EI79,GR64–66–67–68

KIA

ANDERSON, Lyman Matthew
American 1907–
F,H,IL

LYMAN
ANDERSON

ANDERSON, Margaret
American mid 20c.
GR54

ANDERSON, Martinus
American 1878–
F

ANDERSON, Mary
American early 20c.
GMC

ANDERSON, Milo Elvyn
American 1905–
H,M

ANDERSON, Percy E.
Anglo/American 1881–1934
B,F,M

ANDERSON, Ronald Lynn
American 1886–1926
B,F,I,M

ANDERSON, Victor Coleman
American 1882–1937
SCR2/12,H,M

VICTOR C. ANDERSON

ANDERSON, Wayne
English late 20c.
EI79,GR68–85

ANDERSSON, Albert
Swedish mid 20c.
GR54

ANDRADE, Mary Fratz
American 19/20c.
F

ANDRAUD, Norma
American 1941–
CON

ANDRÉ, Irmelin
German mid 20c.
GR53

ANDRE, Rudolf
Hungarian 1873–
B,LEX,VO

FR.

ANDREA, Pat
Dutch 20c.
GR82

PAT ANDREA

ANDREA, V.
Italian late 19c.
LEX

ANDRES, Charles John
American 1913–
H,PAP

CHARLES. ANDRES

ANDRESEN, Adrian Emerich
German 1869–
LEX

ANDRÉU, Mariano
Spanish 1888–
B,H,M

ANDREWS, Benny
American 1930–
H

ANDREWS, Douglass Sharpus
English 1885–
M,STU1925,VO

D.S.A.

ANDREWS, George Henry
Anglo/Canadian 1816–98
B,H,M

ANDREWS, Gordon
English mid 20c.
GR52–55

ANDREWS

ANDREWS, Iris
American 1907/08–
B

ANDREWS, Marietta Minnigerode
American 1869–
B,F,H,I,M

ANDREWS, Virginia
American 20c.
M

ANDRI, Ferdinand
Austrian 1871–1956
B,H,POS

ANDRIAN, Dieter von
German mid 20c.
GR53–56–58

andrian

ANDRIEUX, Clement Auguste
French 1829–
B,LEX,TB

A.

ANDRIOLI, Elviro Michele
Polish/Italian? 1836–93
B,H

ANELAY, Henry
English 1817–83
B,H

ANGAS, George French
Australian/English 1822–86
B,H,M

ANGEL, Debi
English lae 20c.
EI82

*debi angel.
1981*

ANGELI, Marguerite de
American 1889–
H,M

M. de A.

ANGELO, Valenti
American 1897–
H,M,S

ANGOLETTA, Bruno
Italian 1889-1954
EC,H

ANG

ANGRAVE, Bruce
English mid 20c.
GR52-54-61

BRUCE ANGRAVE

ANGULO, Chappie
American 1928-
F,H

ANKER, Hans
German 1873-
B,LEX,TB

·H·A·

ANNAND, Douglas
Australian 1903-
GR52 thru 55,H

DOUGLAS ANNAND

ANNAUD, George
American early 20c.
M,SO

ANNEN, Helen Wann
American 1901-
H,M

ANNENKOFF, Georges
Russian/American 1890/94-1971
B,H,M

ANNETTE, Ida
American 1901-
H,M

ANNIN, Phineas F.
American ac. 1852-58
D

ANQUETIN, Louis
French 1861-1932
AN,CP,GA,H,POS

Anquetin

ANSALDI, Giorgio
Italian 1844-1922
H

ANSELIN, Jean Louis
French 1754-1823
B,H,M

ANSIEAU, Roland
French early 20c.
POS

ROLAND
ANSIEAU

ANSON, L. W.
English early 20c.
LEX

ANSTED, William Alexander
English 19/20c.
B,BK

AˣA

ANTHONY, Carol
American 1943-
F,Y

ANTHONY, Elizabeth Mary
American 1904-
H,M

ANTHONY, Ernest Edwin
American 1894-
H,M

ANTHONY, Rosemary
American 1918-
M

ANTIKAINEN, Kosti Aukusti
Finnish 1930-
H

ANTINORI, Vittorio
Italian mid 20c.
GR65

Antinori

ANTIS, Harry E.
 American 1942–
 CON

ANTLERS, Max H.
 German/American 1873–
 B,M

ANTON
 see
 YOEMAN, Antonia

ANTON, O.
 Belgian mid 20c.
 POS

ANTON, Prudencia
 Spanish 20c.
 LEX

ANTONI, Ib
 Danish mid 20c.
 GR60-62-65-67

ANTONUCCI, Emil
 American mid 20c.
 GR53-61

ANTRAL, Louis Robert
 French 1895-1940
 B,H,M

ANTREASIAN, Garo Zarek
 American 1922–
 APP,H

AOKI, Kiyoshi
 Japanese mid 20c.
 GR55

APERGHI-SCHINAS, E.
 Greek mid 20c.
 GR64

APINIS, Arturs Petera
 Latvian 1904–
 LATV

APOLLONI, Livio
 Italian 1904–
 H

APOSTLE, James
 American 1917–
 H,M

APPEL, Karl
 Dutch 1921–
 APP,DA,DRAW,H,PC,POS

APPELHANS, Albrecht
 German 1900–
 G

APPLEBY, Ellen
 American 20c.
 C

APPLETON, Bob
 American late 20c.
 GR85

APPLETON, Le Roy
 American 20c.
 M

AR, Giuseppe
 Italian 1898–
 H

ARACA
 Italian early 20c.
 POS

ARAGON, J. M. de
 American 20c.
 M

ARBUCKLE, Franklin
 Canadian 1909–
 H,M

ARCHBOLD, Geoffrey Charles
American 1902-38
H,M

ARCHER, Dorothy Rush
American 1904-
M,SO

ARCHIPENKO, Alexander
American 1887-1964
APP,B,DA,EAM,F,H,M,SO,PC

Archipenko (signature)

ARCHIPOW, Efimowitsch Abraham
Russian 1862-1930
B,LEX,TB

AA (signature)

ARDIZZONE, Edward
French/English 1900-79
GR52-53-57,H,M,TB,VO

DIZ (signature)

AREND, Pejo
German 20c.
LEX

ARGNANI, Antonio
Italian 1870-
H

ARGYRAKIS, Minos
Greek 1920-
H

ARIKHA, Avigdor
Rumanian/Israeli 1929-
B,H

ARIMOTO, Isao
Japanese mid 20c.
GR61

ARISMAN, Marshall
American 20c.
GR82-85,P,PG

M. Arisman (signature)

ARISS, Herbert Joshua
Canadian 1918-
H

ARISSINOS, Mario
Greek/French 1916-
H

ARLEN, Philipp
Danish 20c.
LEX

ARMBRUSTER, Otto Herman
American 1865-1908
B,F,I,M

ARMENGOL, H.
French ac. early 20c.
LEX

ARMER, Laura Adams
American 1874-
M

ARMER, Sidney
American 1871-
M

ARMETTI, Adriano
Italian 1907-
H

ARMFIELD, Maxwell Ringwood
Anglo/American 1881/82-1972
BRP,F,H,I,M

ARMIN, Emil
Rumanian/American 1883-
H,M

ARMITAGE, Frank
American 1924-
H

ARMOUR, George Denholm
Scots 1864-1930
B,H,M

ARMSTRONG, Francis Abel William Taylor
English 1849-1920
B,H,M

ARMSTRONG, M. K.
American ac. 1865
H

ARMSTRONG, Rolf
 American 1881–1960
 AM12/23,GMC,Y

ARMSTRONG, Samuel John
 American 1893–
 B,F,H,I,M,SO

ARMSTRONG, Voyle Neville
 American 1891–
 B,F,H,I,M

ARNAUD, Victor
 German early 20c.
 POS

ARNDT, (W.) Leo
 German 1857–
 B,TB

W. L. A.

ARNDT, Ursula
 German/American
 H

ARNHOLD
 Swiss early 20c.
 POS

A
R
N
HOLD

ARNO, Enrico
 German/American 1913–
 H

ARNO, Peter
 American 1904–68
 ADV,CC,EC,F,GMC,H,M,Y

PETER
ARNO

ARNOLD, A. F.
 American 1901?–
 Gr54–55,H

A. F. ARNOLD

ARNOLD, Charles A.
 American 20c.
 M

ARNOLD, Harold Weston
 American 1904–
 H

ARNOLD, Harry
 English 1884–
 B,F,SO

ARNOLD, James Irza
 American 1887–
 H,M

ARNOLD, Karl
 German 1883–1953
 EC,GMC,PG,SI,VO

ARNOLD, T. MacIntosh
 American 19/20c.
 B

ARNOSKY, James Edward
 American 1946–
 H

ARNOULD, Reynold
 French 1919–
 B

ARNOUX, Guy
 French –1951
 AD,B,POS,VO

Guy ARNOUX

ARNSTAN, Cyril
 French late 20c.
 GR85

Cyril ARNSTAN

AROLDI, Tommaso
Italian 1879–1928
H

AROSIO, Antonio
Italian 1911–
H

ARP, Jean (Hans)
French 1887–1966
APP,B,GMC,H,PC,POS

ARPA Y PEREA, Jose
Spanish/American 1868–
B,H,M,SO

ARPKE, Otto
German
LEX

ARRIGHINI, Nicola
Italian 1905–
H

ARROWS, Russell
American 20c.
M

ARTHUR, Revington
American 1908–
H,M,SO

ARTHURS, Stanley Massey
American 1877–1950
B,F,H,HA9/07,M,IL,SCR3/12,SO

ARTIGAS, Miro
Spanish mid 20c.
GR55–64

ARTIOLI, Alfonso
Italian 1913–
GR53–54–57–58–59–65,H

ARTIS, William Ellsworth
American 1914–77
F,H,M

ARTUR, J.
see
BEVILACQUA, José Artur

ARTZYBASHEFF, Boris
Russian/American 1899–1965
ADV,F,FOR,H,IL,M,S,Y

ASAEDA, Takanori
Japanese late 20c.
GR82

ASAL, Paul
Swiss mid 20c.
GR52–53

ASCARI, Peppino
Italian 1911–
H

ASCHER, H. S. G.
Canadian ac. 1876
H

ASCHI, Amor
Tunisian mid 20c.
GR65

ASCHIERI, Pietro
Italian 1889–
H

ASHBROOK, Paul
American 1867–
F,H,M,P

ASHE, Edmund M.
American 1867–1941
B,F,HA10/01,IL,LEX,M,SN1/94

ASHE, Edmund M., Jr.
American 1908–
B,H

ASHFORD, Pearl J.
American 20c.
F,H

ASHITATE, Yushi
Japanese mid 20c.
GR60

ASHLEY
see
HAVIDEN, Ashley

ASHLEY, Clifford Warren
American 1881-1947
B,F,H,I,IL,M,SCR5/08

C·W·Ashley

ASHTON, George Rossi
Australian/English 1857-
B,H

ASMUSSEN, Andreas (Des)
Danish 1913-
GR52-54-56-63,H

DEJ

ASPELL, (Miss) S. B.
American 19c.
B

ASPIT
Russian early 20c.
POS

ASSANGER, J.
American early 20c.
POS

ASSELIN, Paul Maurice
French 1882-1947
B,H,M

M.ASSELIN

ASSELIN, Roberta
American 20c.
M

ASSIRE, Gustave
French 1870-
B

ASSMUS, Robert
German 1837/42-
B,H,M,TB

Robert ASSMUS

ASSUNCÃO, Acácio
Portuguese/Canadian 1935-
H

ASTROP, (ASTROP brothers)
English mid 20c.
GR61-67

A T C
Spanish 20c.
GMC

ATAMIAN, Charles Garabed
Turkish/French 19/20c.
B,M,VO

ChA

ATCHÉ, Jean
French 19/20c.
B,MM

Atché

ATELIER YVA
German early 20c.
CP

Yva

ATHERTON, John C.
American 1900-52
ADV,B,C,F,FOR,H,IL,M,VO,Y

Atherton

ATHEY, Ruth C. (VIVASH, Ruth Athey)
American 1892-
B,F,H,M

ATKINS, Alan
American 1892–
H

ATKINS, Alan
American 1910–
H,M

ATKINS, Florence Elizabeth
American –1946
F,H

ATKINSON, Anthony
English mid 20c.
GR 57

Anthony Atkinson.

ATKINSON, James
English 1780–1852
B,H

ATKINSON, Leslie
English ac. mid 20c.
LEX

ATKINSON, Robert
Australian/English 1863–96
B,H

ATKINSON, Spencer R.
American 20c.
M

ATKINSON, Thomas C.
Canadian ac. 1871
H

ATKINSON, W.
English early 20c.
LEX

ATKYNS, Willie Lee, Jr.
American 1913–
H

ATTENDU, Antoine Ferdinand
French late 19c.
B,LEX,TB

F.A.

ATTIE, David
American mid 20c.
PAP

ATTWELL, Mabel Lucie
English 1879–1964
ADV,EC,M

MABEL LUCIE ATTWELL

ATTWOOD, Francis Gilbert
American 1856–1900
EC,PE

F.F.attwood

ATWELL, Thomas B.
American 20c.
H

ATWOOD, Mary Hall
American 1894–
H,M

AUCHENTALLER, Josef Maria
Austrian 1865–1949
AN,B,POS

JMA.

AUCHLI, Herbert
Swiss mid 20c.
GR53–54–56–58

AUDIBERT, Louis
French 1881–
B,M

AUDUBON, John James
American 1788–1851
BAA,D,F,GMC,H,I,M,PC,Y

AUER, Robert
Yugoslavian 19/20c.
LEX,VO

AR

AUERBACH-LEVY, William
Russian/American 1889–1964
B,EC,F,H,M,SO

AUGER, Raoul
French 20c.
LEX

AUGSBERGER, Pierre
Swiss 1933–
GR57-60-61,POS

PIERRE AUGSBURGER

AULD, James Muir
Australian 1879-1942
B,H

AULT, Charles H.
Canadian ac. 1870-81
B,H

AULT, Norman
English 1880-1950
M

AURELE, Marc
French late 19c.
B,LEX,TB

AURES, Victor
American 1894–
H,M

AURIAC, Jacques
Ivory Coast mid 20c.
GR62-65-66

AURIOL, Georges
French 1863-1938
B,L,MM

AUSCHER, Jean
French early 20c.
B

AUSTEN, John
English 1886-1948
M,S

AUSTIN, Charles Percy
American 1883-1948
F,H,M

AUSTIN, Dorothy Elease
American 1926–
H

AUTHERIED, Josef
Austrian 1904–
GR52-55

AUVO, Lea
Finnish mid 20c.
GR56-61-63

AUZOLLE
French ac. late 19c.
POS

AVATI, James S.
American 1912–
PAP

AVELOT, Henri
French -1935
B,LEX,VO

AVERBEKE, Emil van
Belgian 19/20c.
LEX,TB

AVERIL(L), (John) Johann
American 20c.
GR52 thru 55-57-59

AVERY, Claire
American/French -1929
B,M

AVERY, Harold
American 1858-1927
B,I,M

AVERY, Keith W.
American 1921-
CON

[signature: Keith W. Avery]

AVERY, Ralph Hillyer
American 1906-76
H,M

AVINOFF, Andrey N.
Russian/American 1884-1948
F,H,M

AVIROM, Joel
American mid 20c.
GR60

AVISON, George
American 1885-
F,H,M

AVRIL, Paul
Algerian/French 1849-1928
B,LEX,TB

[signature: PA]

AVY, Marius Joseph
French 1871-
B,H,M

AWAZU, Kiyoshi
Japanese 1929-
GR58-59-60-64-67-68-85,H,POS

[signature: awazu]

AXELSON, Axel
Swedish/American 1871-
H,M

AXENTOWICZ, Teodor
Polish 1859-
AN,B,CP

AXTER-HEUDLASS von
German 20c.
LEX

AYALA, Javier Gaytan de
American 20c.
M

AYAO
see
YAMANA, Ayao

AYER, Margaret Mary Lewis
American 1878-
H,M,TB

[signature: M.A.]

AYERS, Eric
English mid 20c.
GR53

AYKROYD, Woodruff K.
Canadian 20c.
M

AYLMER, George B.
English early 20c.
B,LEX

AYLWARD, William James
American 1875-1956
B,F,H,I,IL,M,SCR5/08,SO,TB

[signature: W. J. Aylward.]

AYLWOOD, Ida
American 20c.
F,H,M

AYRES, Thomas A.
American 1820-58
D,H,Artists of the American West by Doris
Dawdy-Swallow Press 1974

AYRTON, Michael
English 1921-75
GR54-55-58,H

AZEVEDO, Fernandeo Jose Neves de
Portuguese 1923-
B,H

AZIMZADE, Azim Aslan Ogly
Russian 1880-1943
EC

- B -

BAARING, Maggi
Danish mid 20c.
GR53 thru 56

Maggi

BABA, Noboru
Japanese 1927–
EC

BABCOCK, Dean
American 1888–1969
F,H,I,M

BABCOCK, Elizabeth Jones
American 1887–
F,H,I,M,SO

BABCOCK, Richard
American 1887–1954
B,F,H,I,M

BABIĆ, Ljuba
Yugoslavian early 20c.
LEX, STU1924

BAC, Ferdinand Sigmund
German/French 1859–1952
B,EC,LEX

BACARISAS, Gustave
Spanish ac. late 19c.
B,LEX,TB,VO

GB

BACH, Ferdinand Sigismund
see
BAC, Ferdinand Sigmund

BACHARACH, Herman I.
American 1899–
H,M

BACHELET, Gilles
French late 20c.
EI79

BACHELOR, C. D.
American early 20c.
M

BACHEM, Bele (Renate Gabrielle)
German 1916–
EC,G,GR68,H

Bele Bachem

BACHER, Henri
French 1936–
B,LEX,TB,VO

BACHER, Otto Henry
American 1856–1909
B,CEN5/99 & 1/05,CWA,F,H,I,M,PC,SCR2/02

*Otto H. Bacher.
—1901.*

BACHMANN, Hans
Swiss 1852–
B,LEX,TB

HB

BACHMANN, Johann B.
German 1888–
G

J.B.Bachmann

BACHMANN, O.
Swiss 20c.
LEX

BACHMEIER, J.
German late 19c.
LEX

BACHRACH-BARÉE, Emmanuel
Austrian 1863–
B,TB

E.B.

BACKALENICK, William
American mid 20c.
GR60

BACKUS, Standish, Jr.
American 1910–
H,M

BACLY
French early 20c.
ST

BACON, Cecil Walter
English 1905–
LEX

BACON, Francis
English 1909–
APP,B,DA,GMC,H

BACON, Frank
English 1803–87
B,H

BACON, Henry
American 1839–1912
B,BAA,D,F,H,I

BACON, Henry Lynch
English 19c.
B

BACON, Irving R.
American 1875–1962
B,F,H,I,M

BACON, John Henry Frederick
English 1865–1917
B,H,M

BACON, Paul
American mid 20c.
PAP

BACON, Peggy Brook
American 1895–
APP,F,H,M,S,SO,VO,Y

BADIA-VILATO, E.
Brazilian mid 20c.
GR55

BADIALI, Giulio Ernesto
American 1875–
M

BADITZ, Otto
Hungarian 1849–
B,LEX,TB

BADMIN, Stanley Roy
English 1906–
GR52,H

BAECHER [BÄCHER], Hans
Swiss mid 20c.
GR60–62–63

BAER, Howard
American 1906–
B,H,M

BAER, William Jacob
American 1860–1941
BAA,F,H,I,M

BAES, Emile
Belgian 1879–
B,H,M

BAGDASCHWILLI, Wasyl
West German late 20c.
EI79,GR85

BAGDATOPOULAS, William Spencer
Greek/American 1888–
B,H,M

BAGSHAW, Sydney
American 20c.
M

BAHNER, Willi
Austrian mid 20c.
GR53–55–59

BAHR, Florence Riefle
American 1909–
H,M

BAHR, Johann
 German 1859–
 B

B̶

BAILAY, Albert
 English early 20c.
 LEX

BAILEY, Albert P., Jr.
 American 1902–
 H

BAILEY, Dennis
 English 1931–
 GR56-60-63,H

BAILEY, Harry Lewis
 American 1879–
 F,M

BAILEY, Henry Turner
 American 1865–1931
 B,F,I,M

BAILEY, John
 English 1750–1819
 B,H

BAILEY, Malcolm C. W.
 American 1947–
 H

BAILEY, Minnie M.
 American 1890–
 F,H

BAILEY, Richard Emerson
 American 1897–
 B,H

BAILEY, Robert
 American 1920–
 B,CP

BAILEY, Vernon Howe
 American 1874–1953
 B,F,H,I,M,SCR5/08,Y

Vernon Howe Bailey

BAILEY, Walter A.
 American 1894–
 B,F,H,I,M

BAILEY, Whitman
 American 1883–
 B,I

BAILEY, William J.
 American 1902–
 H

BAILEY, Worth
 American 1908–
 H

BAILLE, Herve
 French 1896–
 B,M

←H̶

BAINBRIDGE, F. Edith
 American early 20c.
 B

BAINBRIDGE, John
 English mid 20c.
 ADV,GR54-56-57

BAINBRIDGE.

BAIN(E)S, Ethel Franklin Betts
 American 20c.
 F,H,M

BAIRD, Evelyn
 American 20c.
 M

BAIREI, Kono (also known as: CHOKUHO or
 SHIJUN)
 Japanese 1843–95
 B,H,J

BAIRNSFATHER, (Capt) Bruce
 English 1888–1959
 EC,GMC,POS

B.B.

BAIRNSFATHER, Thomas
 English 20c.
 POS

BAISCH, Hermann
German 1864-94
B,LEX,TB

HB

BAIZE, Wayne
American 1943-
CON

WAYNE BAIZE ©

BAKER, Bernard
English mid 20c.
GR61

BAKER, Ernest Hamlin
American 1889-
FOR,H,IL

Ernest Hamlin Baker

BAKER, George Augustus, Jr.
American 1821-80
BAA,D,F,H,I,M

BAKER, George O.
American 1882-
B,F,H,I,M

BAKER, Henrik
Norwegian early 20c.
POS

BAKER, Jill Withrow
American 1942-
H

BAKER, Joseph E.
American 19c.
BAA,F,I

BAKER, Mary Baker
English 1897-
CEN2/99,M

BAKER, William Henry
American 1899-
F,H,M

BAKERVILLE, Charles, Jr.
American 1869-
F

BAKST, Leon
Russian/French 1866-1924
ADV,AN,GMC,H,POS,RS,ST,VC

Bakst

BALANO, Paula Himmelsbach
German/American 1878-
F,H,I,M,SO

BALCOM, Lowell Leroy
American 1887-1938
B,F,H,I,IL,M,Y

BALCOM

BALDINGER, Arnold Karl
Austrian 1850-
B,LEX

BALDRICH
French early 20c.
ST

BALDRICH.

BALDRIDGE, Cyrus Leroy
American 1889-
B,F,H,I,M,SO

B

BALDWIN, Albertus H.
American 1865-
BAA,M

BALDWIN, Burton Clarke
American 1891-
F,M

BALDWIN, Clifford Park
American 1889-
H,M

BALDWIN, John Tomlinson
American early 20c.
B,M

BALDWIN, (Mr. & Mrs.) R. Roberts
American 20c.
H

BALDWIN, Robert Wood
 American 1920–
 H

BALDWIN-FORD, Pamela
 American 20c.
 H

BALES, George Carson
 American 1920–
 H

BALET, James
 American mid 20c.
 GR55

BALET, Jan (Jean?)
 American mid 20c.
 ADV,GR52–53–54–56–57–59

Balet

BALFOUR, Helen
 American 1857–
 B,F,H

BALICKI, Karl
 Polish 1820–54
 B

BALL, L. Clarence
 American 1858–1915
 B,F,I,M

BALL, Linn B.
 American 1891–
 F

BALL, Lyle V.
 American 1909–
 H

BALL, Robert
 American 1890–
 B,F,H,M

BALL, Seymour Alling
 American 1902–
 H,M

BALLANTYNE, Kenneth M.
 American 1886–
 F,H,M

BALLERIO, Osvaldo
 Italian 1870–
 BI,H,POS

BALLESTA, Juan
 Spanish/Italian? late 20c.
 EI79,GR68

BALLESTER, Anselmo
 Italian 1897–1974
 EC

BALLIN, Hugo
 American 1879–1956
 F,H,I,M,SO

BALLINGER, Harry Russell
 American 1892–
 B,F,H,M

BALLINGER, Reymond
 American 20c.
 M

BALLMER, Theo
 Swiss early 20c.
 POS

BALLOCCO(S), Mario
 Italian 1913–
 GR58,H

BALLURIAU, Paul
 French 1860–1917
 B,POS

BALOGH, Istvan
 Hungarian mid 20c.
 GR61

BALUSCHEK, Hans
 German 1870–1935
 AN,B

HB

BAMA, James Elliott
 American 1926–
 CON,F,H,PAP,Y

Bama

BANBERY, Frederick E.
Anglo/American mid 20c.
PAP

BANCROFT, Milton Herbert
American 1865-67/1947
F,H,I,M,SO

BANK, Heinrich
Austrian 1834-
B,LEX,TB

JHB

BANKER, William Edwin
American 1908-
H

BANNISTER, Pati
Anglo/American 1929-
CON

BANNISTER

BANNWART, Rudi
Swiss mid 20c.
GR61

BANTING, John
English 1902-72
BRP

J BANTING

BAR, P. A.
French early 20c.
B

BARALDI, Severino
Italian mid 20c.
LEX

BARANCEANU, Belle
American 1905-
F,H,M

BARBASAN Y LAGUERUELA, Mariano
Spanish/Brazilian 1864-1924
B,H,LEX,TB,VO

MB

BARBER, A.
American late 19c.
HA,LEX

BARBER, Della J.
American 20c.
M

BARBER, H. Waddell
American 1907-
H

BARBER, William Harold
American 1940-
CON

BILL BARBER

BARBERIS, Franco
Swiss mid 20c.
GR54

BARBERO, Michael
American mid 20c.
GR60

BARBIER, Albert M.
American 20c.
M

BARBIER, Georges
French 1882-1932
AD,B,GMC,LEX,M,POS,ST,VO

G. BARBIER

BARBIZET, A.
French late 19c.
FO

BARBIZET.

BARBOSA
English? mid 20c.
ADV

BARBOUR, Arthur J.
American 1926-
H

BARBOUR, John
American early 20c.
PAP

BARBOUR, Karen
American late 20c.
GR85

BARBOUR

BARCLAY, McClelland
American 1891–1943
AM10/26,B,F,GMC,H,I,IL,M,Y

McClelland Barclay

BARDIN, Jesse Redwin
American 1923–
H

BARDWELL, (George W.?)
American 19/20c.
M?,SN5/86

Bardwell

BARE, Arnold Edwin
American 1920–
H

BARENSFELD, Mark
American 1947–
F,Y

BARER, Miriam Anne
American 1923–
H

BARFORD, George
American 20c.
H,M

BARILE, Xavier J.
American 1891–
B,F,H,I,M,SO

BARJANSKY
French? early 20c.
ADV

Barjansky

BARK, Stig
Swedish mid 20c.
GR65

Bark

BARKAN, Bebe
American 1943–
H

BARKER, Albert Winslow
American 1874–1947
B,F,H,M,PC

BARKER, Carol Minturn
English 1938–
GR67,H

BARKER, Cecily Mary
English 1895–
B,LEX,VO

CMB

BARKER, David
American 1888–
H

BARKER, John R.
English mid 20c.
ADV,GR52-54-55-56-58-59

John Barker

BARKLEY, Bruce E.
American 1950–
F,Y

BARLACH, Ernst
German 1870–1938
AN,B,DA,DRA,H

BARLÖSIUS, Georg
German 1864–1908
B,M

BL

BARLOW, Anne
Anglo?/American mid 20c.
GR52,H

BARLOW, Peter
American 20c.
GMC

P Barlow

BARLUING
German 20c. (ac. 1930s)
GMC

BARNA, Elek
Hungarian early 20c.
LEX

BARNARD, Frederick (Fred)
English 1836/46-96
B,H,M,TB

BARNARD, George
English -1890
B,H

BARNARD, William S.
American 1809?-
D,F,I

BARNES, Ayax
Uruguayan mid 20c.
GR59

BARNES, Burt
American 1879-
B,F

BARNES, Catherine J.
American 1918-
H

BARNES, Ernie E., Jr.
American 20c.
H,P

BARNES, Hiram Putnam
American 1857-
B,F,I,M

BARNES, Robert
English 1840-95
H

BARNETT, Eugene A.
American 1894-
F,H,M

BARNETT, Isa
American 1924-
IL

BARNEY, Maginel Wright
American 1881-1966
H,IL,M

BARNS, Cornelia
American 1888-
F,M

BARNUM, Jay Hyde
American 20c.
F,M

BARON, Henri Charles Antoine
French 1816-85
B,BAA,H,LEX,TB

BARON, William
American mid 20c.
GR61

BARR, Diane
American 20c.
P

BARR, Howard
American 20c.
H,M

BARR, John
Canadian ac. 1879
H

BARR, Ken
Scots/American 20c.
NV

BARR, William
Scots/American 1867-1933
B,F,H,I

BARRADAS, Jorge Nicholson Moore
Portuguese 1894-1971
H,M

BARRALET, John James
 Irish/American 1747-1815
 D,F,H,I,M

BARRATT, Louise Bascom
 American 20c.
 F,H,M

BARRATT, Reginald
 English 1861-1917
 B,H,M

BARRATT, Watson
 American 1884-
 B,F,H,I,M,SO

BARRAUD, Alfred Thomas
 Canadian 1849-1925
 B,H

BARRAUD, Maurice
 Swiss 1889-1955
 B,GR54,H,POS

BARREAUX, Adolphe
 American 1900-
 H,M

BARREIROS, Pedro Manuel Pacheco Jorge
 Portuguese 1943-
 H

BARRÈRE, Adrien
 French 1877-1931
 B,POS

BARRET, Gaston
 French 20c.
 LEX

BARRETT, C. R. B.
 English 19/20c.
 BK

BARRETT, Lawrence Louis
 American 1897-1973
 APP,H,M

BARRETT, Oliver O'Connor
 Anglo/American 1908-
 H,M

BARRETT, Peter
 English late 20c.
 EI79

BARRICK, Kenneth Roberts
 American 1913-
 H

BARROS, José Ricardo Judice de Samora
 Portuguese 1887-1972
 H

BARRY, Ethelred Breeze
 American 1870-
 B

BARRY, James E.
 American 20c.
 H

BARSOTTI, John Joseph
 American 1914-
 H,M

BARTA, Ernö (Erwin)
 Hungarian 1878-
 LEX,VO

BARTÉ, Eleanor
 American 20c.
 M

BARTH, Eugene Field
 American 1904-
 F,H,M

BARTH, Otto
 Austrian 1876-1916
 LEX,TB

BARTH, Ruddi
 Swiss mid 20c.
 GR52-53

BARTH, Wolf
 Swiss 1926-
 B,GR64 thru 68-82-85

BARTHA, Laszlo
 Hungarian 1908–
 B

BARTHÉLÈMY, Henri
 French 20c.
 B,S

BARTLE, Annette
 Polish/American 20c.
 H

BARTLETT, Christopher E.
 English 1944–
 H

BARTLETT, Dana
 American 1878–1957
 B,F,H,I,M

BARTLETT, William Henry
 Anglo/American 1809–54
 D,H,M,Y

BARTO, Emily Newton
 Anglo/American 1886–
 H,M,SO

BARTOLINI, Luigi
 Italian 1892–1963
 B,H,LEX,TB,VO

 ℒℨ

BARTOMIEJCZYK, Edmund L.
 Polish early 20c.
 POS

BARTON, Bernard
 American mid 20c.
 PAP

BARTON, Harry
 American mid 20c.
 PAP

BARTON, Kent
 American late 20c.
 GR82–85

BARTON, Loren Roberts
 American 1893–
 B,F,H,I

BARTON, Ralph
 American 1891–1931
 CC,EC,F,I,M,Y

 F.ALT'A
 H.AFTN

BARTRAM, Harold
 English mid 20c.
 GR60–61

BARTSCHAL, H. J.
 American early 20c.
 POS

BARUFFI, Alfredo
 Italian 1876–1948
 B,H

BARUFFI, Andrea
 American late 20c.
 GR82

 ANDREN 3ARUffi

BAVELINK, Hans
 Dutch mid 20c.
 GR53–55

BARYE
 see
 PHILLIPS, Barye

BAS, Marti
 Spanish early 20c.
 POS

 marti

BAS, Martin
 French 20c.
 B

BASALDUA, Héctor
 Argentinean 1895–
 B,H,M

BASCH, Árpád
 Hungarian 1873–
 B,CP,POS

BaschArpad₉₉

BASCHANT, Karl
 Austrian 1879–
 LEX

BASCOVE, Barbara
 American late 20c.
 GR82

B , B

BASEILHAC, Jacques
 French 1874–1903
 B,FS

J.Baseilhac

BASILE, Carlo
 American late 20c.
 GR82

C.Basile

BASILEVSKY, Helen
 Belgian/American 1939–
 H

BASKERVILLE, Charles, Jr.
 American 1896–
 GMC,H

BASKERVILLE

BASKIN, Leonard
 American 1922–
 APP,DRAW,F,GR61,H,PC,Y

BASS, Anna
 German 1876–1961
 B,LEX

BASS, Rudi
 American mid 20c.
 GR52-53-54

Rudi Bass

BASS, Saul
 American 1921–
 ADV,CP,GR52 thru 56-58 thru 64-66-68,H,POS

Saul Bass

BASSETT, H. Ellsworth
 American 1875–
 B,M

BASSETT, N. H.
 American 19c.
 B

BASSETTE, Beatrice
 American 20c.
 H

BASSFORD, Wallace
 American 1900–
 B,F,H,M

BASSI, Franco
 Italian mid 20c.
 GR59-60-63

BASTARD, Marc Auguste
 French 1863–
 B,LEX

BASTÉ, J.
 French 19/20c.
 LEX

BASTIEN, Gabriel
 Canadian 1923–
 H

BASTIEN, M.
 Canadian ac. 1876–77
 H

BASTRUP, Leonard Hollis
 American 1907–
 H

BASYROV, Garif Sh.
Russian late 20c.
E184

BASYROV.

BATAILLARD, Pierre
Swiss mid 20c.
GR60-61-63-67-68

BATCHELOR, Clarence Daniel
American 1888-1978
EC,F,H,M,SO

C P Batchelor

BATE, Norman Arthur
American 1916-
H

BATEMAN, Henry Mayo
Australian 1887-1970
ADV,B,STU1915,VO

H.M BATEMAN.

BATES, Bertha Carsan Day
American 1875-
B,F,H,I,M

BATES, Betsy
American 1924-
H

BATES, Gladys (Bergh)
American 1898-1944
F,H,M

BATES, Lorin
American -1970
M,SO

BATH, Olive
English ac. early 19c.
LEX

BATHASAR
see
HAUG (HAUS)

BATLEUX, V.
French early 20c.
LEX

BATTEN, John Dickson
English 1860-1932
BK,M,STU1898,TB

JDB

BATTERSBY, David M.
Canadian 20c.
M

BATTHYÁNY, Gyula Graf
Hungarian 1888-
LEX,VO

B.G.

BATTLER, Ugo
Swiss 20c.
LEX

B.

BATTY (BATTY & Co.s)
English early 20c.
AD

Batty

BAUDIEZ, E.
French 19/20c.
LEX

BAUDIN, Georges
French 20c.
B,M

BAUER, C. F.
Austrian early 20c.
LEX

BAUER, Fred
Swiss mid 20c.
GR60-61-62-64-65-67

Fred Bauer

BAUER, Heiner
Swiss mid 20c.
GR55-59-62

H.BAUER

BAUER, Hilde
German 20c.
LEX

BAUER, Karl Konrad Friedrich
German 1868–1942
B,M,LEX,TB,VO

K.B.

BAUER, John
Swedish 1882–1918
LEX,TB

B.

BAUER, Mari (Marius Alexander Jacques)
Dutch 1864–1932
B,CP,M,PC,TB,VO

MB

BAUER, William
American 1888–
B,F,H,I,M

BAUER-RADNAY, Elizabeth de
Hungarian 1897–1972
B

BAUERLE, Amelia
English late 19c.
BK

BAUERNFEIND, Gustav
Austrian/German? 1848–1904
B,LEX,TB

G.B.

BAUERNFEIND, M.
German 19/20c.
LEX

BAUGNIET, Marcel Louis
Belgian 1896–
B,POS

BAUHOF, Otto Karl
American 20c.
M

BAULE, E. Werner
German 1870–
LEX,VO

BAUM, Don
American 20c.
P

BAUM, Walter Emerson
American 1884–1956
B,F,H,I,M

WEBAUM

BAUMANN, Charles Hart
American 1892–
H,M

BAUMANN, Gustave
German/American 1881–1971
APP,B,F,H,I,M,STU1930

BAUMANN, Ludwig
Silesian 1854–1939
LEX,TB

BAUMBERGER, Otto
Swiss 1889–1961
CP,H,M,POS,VO

B

BAUMEISTER, Willi
German 1889–1955
B,DA,H,LEX,TB,VO

BAUMER, Lewis
English 1870–1963
ADV,BK,POS,PUN6/2/37

LEWIS
BAVITER

BAUMGARD, George
American 19/20c.
B,SO

BAUMGARTEN, F.
German 19c.
B

BAUMGARTEN, O.
Swiss ac. early 20c.
LEX

BAUMGARTNER, Fritz
German late 19c.
LEX

BAUMGARTNER, Theodor
Austrian 19/20c.
LEX

BAUMGARTNER, Warren W.
American 1894–1963
GMC,H,IL,M,PAP

Baumgartner

BAUMHOFER, Walter M.
American 1904–
H,IL,M

Walter M Baumhofer

BAUR, Albert
German 1835–1906
B,H,LEX,TB

AB

BAUR, Gilles Marie
French late 20c.
EI84

BAUR

BAURIEDL, Otto
German 1879–
B

BAURNFEIND, Moritz
Austrian 1870–
B

BAUS, Saxon
German early 20c.
POS(pg.176)

BAWDEN, Edward
Anglo/American 1903–
ADV,GR53 thru 61–63,H

EB

BAWOROWSKI, Anton Karl (Carl)
Austrian 1853–
B

a.c.B

BAYARD, Emile Antoine
French 1837–91
B,H,L

Emile Bayard

BAYER, Herbert
Austrian/American 1900–
B,GMC,GR52–53–55–56–57–63–65,H,PAP,POS

bayer 64

BAYERLEIN, Hans
German 1897–
LEX,TB,VO

HB

BAYHA, Edwin F.
American 20c.
F,M

BAYLE, Luc Marie
French mid 20c.
B,GR55–60

LUC MARIE BAYLE

BAYLEY, Dorothy
American 20c.
M

BAYNES, Pauline
English 1922–
ADV

BAYRLE, Thomas
American late 20c.
GR82

Bayrle

BAZ, Ben Hur
Mexican/American 1906–
H,M

BEACH, Lou
American late 20c.
GR82

BEALE, Joseph Boggs
American 1841-1926
M

BEALES, Joan
English mid 20c.
GR55-57

JB

BEALL, Cecil Calvert
American 1892-
H,IL,M,PAP

-C.C.Beall-

BEALL, Leah
American 1910-
H,M

BEALL, Lester Thomas
American 1903-69
CP,GR52 thru 56-58 thru 63-65-66-67,H,M,
POS,VO

Lester Beall

BEALS, Victor
American 1895-
H,M

BEARD, Adelia Belle
American -1920
B,F,H,I,M,SN5/86

BEARD, Alice
American early 20c.
B,H,M,SO

BEARD, (Dan) Daniel Carter
American 1850-1941
B,BAA,EC,F,H,I,M,PE,SN5/86 & 2/94

BEARD, Frank (Thomas Francis)
American 1842-1905
B,EC,F,H,I,LEX,M,TB

F.Beard.

BEARD, Freda
English early 20c.
ADV,LEX

FB

BEARD, James Carter
American 1837-1913
B,BAA,D,H,I,M,SN8/86 & 2/94,TB

Carter Beard

BEARD, Lina
American 20c. (ac. 1933)
B,F,I,M

BEARD, Mary Caroline
American 1852-1933
M

BEARD, Thomas Francis
see
BEARD, Frank

BEARDSLEY, Aubrey Vincent
English 1872-98
ADV,AN,B,CP,DA,EAM,GA,GMC,H,M,MM,PC,
POS,R,S

AVBREY
BEARDSLEY

BEARDSLEY, Jefferson
American ac. 1859
D,H

BEARDSLEY, Rudolph
American 1875-1921
B,I,M

BEARMAN, Jane Ruth
American 20c.
H

BEATIEN YAZZ, (Jimmy Toddy)
American 1928-
H

BEATON, Cecil
 English 1904–80
 ADV

BEATTY, Frank W. Moore
 Canadian/American 1900–
 PG,WS

BEATTY, Kenneth E.
 American 1930–
 H

BEAUCÉ, Vivant
 French 1818–76
 B,POS

BEAUCLERK, (Lady) Diana
 English 1734–1808
 B,H,M

BEAUDIN, André
 French 1895–
 B,H

BEAUDOUIN, Frank
 American 1885–
 H

BEAULAURIER, Leo James
 American 1912–
 H,M

BEAUME, Serge
 French ac. 1933
 M

BEAUMONT, Arthur
 American 1879–1956
 B,F,H

BEAUMONT, Arthur Edwaine
 Anglo/American 1890–
 H,I,M

BEAUREGARD, Donald
 American 1884–1914
 H,I,M

BEAUREPAIRE, André
 French 1927–
 B

BEBE
 see
 GERSHENZON, Bebe

BECAN, Bernard
 French 1890–1943
 B,CP

BECHER, Arthur E.
 German/American 1877–1960
 ABL8/05,B,CEN6/05,F,H,M

·ARTHUR·E·
·BECHER·

BECHSTEIN, Ludwig
 German 1843–
 B,TB

BECK, Bruce
 American mid 20c.
 GR52–53–54

BECK, Dunbar Dyson
 American 1902–
 H,M

BECK, Ellen
 German 1900–
 LEX,VO

EB

BECK, Gloria
 German late 20c.
 GR82

BECK, Jack Wolfgang
 American mid 20c.
 GR59–60–61

BECK, Jay
 American 1916–
 H

BECK, Ner
 American late 20c.
 GR82

BECK, Raphael
 American 20c.
 B,F,M

BECK, Richard
 English early 20c.
 POS

BECKER, Carl
 German 1862–
 B,TB

C.B.

BECKER, Charlotte
 American 1907–
 H,M

BECKER, Ferdinand
 German 1846–77
 B,H

BECKER, Hans B.
 German 20c.
 LEX

BECKER, Joseph
 Canadian 1841–1910
 B,H,I,M

BECKER, Ludwig Hugo
 German 1833–68
 LEX,TB

BECKER, Walter
 German/French 1893–
 B,G,GWA,VO

W.B

BECKER-BERKE, Helmar
 German 1906–
 LEX

BECKER-GUNDAHL, Carl Johann
 German 1856–
 B

BECKETT, Sheila
 American mid 20c.
 PAP

BECKMAN, Per
 Swedish mid 20c.
 GR52–67

BECKMAN(N), Anders
 Swedish 1907–
 GR54,H

AB

BECKMANN, Max
 German/American 1884–1950
 APP,B,DA,DRA,DRAW,GMC,H,PC

BECKOFF, Harry
 American 1901–79
 F,H,IL,M,Y

HARRY BECKHOFF

BEDFORD, Cornelia E.
 American 1867–1935
 F,H,M

BEDFORD, Francis Donkin
 Anglo/American 1864–1954
 AN,B,BK,H,M

F.D.B.

BEDFORD, (Admiral (Sir)) Frederick George
 Denham
 English 1838–1913
 H

BEDNÁR, Štefan
 Czechoslovakian 1909–
 LEX,TB,VO

SB

BEDNO, Edward
 American 1925–
 GR57–59–65–66–67,H

BEE, Lon(n)ie
 American 1902–
 H,IL

Lonie Bee

BEE, Louis
 American 20c.
 M

BEEBE, Robb
 American 20c.
 M,PG,WW2/34

BEEKE, Anthon
 Dutch late 20c.
 GR85

BEELE, Tobie
 South African late 20c.
 GR85

BEER, Paul
 Swiss mid 20c.
 GR57

BEGAY, Harrison
 American 1917–
 H

BEGG, John Alfred
 American 1903–74
 GR53,H

BEGG, Samuel
 Australian 1854–
 B,H

BEGGARSTAFFS, (double pseudonym for Sir
 William Nicholson & James Pryde)
 ADV,CP,GA,MM,POS

BEHAR, Ely Maxim
 American 1890–
 F

BEHAR, F.
 French 20c.
 B

BEHMER, Marcus Michael Douglas
 German 1879–1958
 AN,LEX,TB,VO

BEHRENDT, Erich
 German 1889–
 LEX

BEHRENS, Peter
 German 1868–1940
 B,CP,H,MM,POS

BEHRMANN
 Swiss 20c.
 BI

BEISTLE, Mary Alice
 American 20c.
 M

BEITZ, Lester U.
 American 1916–
 H,M

BELARSKI, Rudolph
 American 1900–
 PAP

BELCHER, Hilda
 American 1881–1963
 B,F,H,I,M

BELEW, Ruth
 American mid 20c.
 PAP

BELINA, Renate
 English late 20c.
 EI83,GR84

BELL, Blanche Browne
American 1881–
H,M

BELL, Charles E.
American 1874–1935
H,M

BELL, Clara Louise
American 1886–
B,F,H,I,M

BELL, Joan
English early 20c.
LEX,STU1924,TB,VO

BELL, Robert Anning
English 1863–1933
B,BK,H,M,POS

R.A.B.

BELL, William Abraham
English 1841–1921
H

BELLAIGUE, J. C.
French 20c.
B

BELLAIR, Henriette
French 1904–
B

BELLANGE, F.
French ac. early 20c.
LEX

BELLECROIX, Ernest
French 19c.
B

BELLERY DESFONTAINES, Henri Jules Ferdinand
French 1867–1910
B,LEX

BELLEW, Frank Henry Temple (Chip)
American 1828–88
D,EC,F,H,I,M

BELLIN, Milton Rockwell
American 1913–
H,M

BELLOGUET, Léon
French? early 20c.
POS

BELLOWS, George W.
American 1882–1925
APP,B,CC,DA,EAM,F,H,I,M,PC

BELSER, Burkey
American late 20c.
GR85

BELSON, Robert
American mid 20c.
GR54

BELTON, Louis
Australian ac. 1880
H

BELTRAM, Achille
Italian 1871–1945
B,EC,H

BELTRAMI, Giovanni
Italian 1860–1926
B,H,POS

BELTRAN, Alberto
Mexican 1923–
H

BELTRAN, Felix
American mid 20c.
GR61-66-67-68

BELTRAN

BELVILLE, E.
French 19/20c.
B,GMC

E. Belville

BEMAN, (Mrs.) Jean
American 1865–
B,F,I

BEMELMANS, Ludwig
American 1898–1962
ADV,F,GR57,H,M,Y

Bemelmans

BEMIS, Waldo Edmund
American 1891–1951
H

BENAIS, Christian
French mid 20c.
GR65

Christian Benais

BENARON, Don
American 1925–
H

BENASITT, Louis Emile
French 1833–1902
B,LEX

BENCKE, Werner
German early 20c.
POS

BENCZUR, Gyula
Hungarian 1844–1920
B,CP,H

B. Gy.

BENDA, Wladislaw Theodore
American 1873–1948
B,F,GMC,H,I,M,PE

W. T. Benda

BENDER, Don
American mid 20c.
ADV

Bender

BENDER, Karl
German late 19c.
LEX

BENDER, Russell Thurston
American 1873–1948
F

BENDINER, Alfred
American 1899–
H,M

Bender

BENEDEK, Karl
Austrian early 20c.
LEX

BENEKER, Gerrit(t) Albertus
American 1882–1934
B,F,H,I,M,SO

Gerrit A. Beneker 1918

BENETT, Léon
French 19c.
B

BENGOUGH, William
Canadian/American 1863–1932
B,F,H,M,SCR1/04

Wm Bengough

BENIGNI, Léon
French early 20c.
B,M,ST

L bénigni 1926

BENITO, Éduardo Garcia
Spanish/French/American 20c.
B,GMC,M,ST,VC

BE NI TO

BENJAMIN, Marguerite
American 1897–1936
M

BENJAMIN, Nora
American 1899–
H,M

BENJAMIN, Samuel Green Wheeler
Greek/American 1837-1914
B,BAA,D,F,H,I,M

BENKA, Martin
Yugoslavian 1888-1971
B,H,M

BENLLIURE Y MORALES, Emilio
Spanish 1866-
B,LEX

BENNETT, Charles Henry
English 1830-67
H,M,S

C.K.B.

BENNETT, Elizabeth
American 20c.
P

BENNETT, Emma Sutton (Carter)
American 1902-
F,H,M,SO

BENNETT, F. F.
American early 20c.
B

BENNETT, Harry R.
American 1925-
F,PAP,Y

Harry Bennett

BENNETT, Henry H.
American 19/20c.
B

BENNETT, John
American 1865-
B,H,M

BENNETT, Richard
Irish/American 1899-
F,H,M

RB

BENNETT, Ruth H.
American 20c.
M

BENNETT, Susan
American 20c.
H

BENNETT, William James
Anglo/American 1787-1844
B,D,F,H,I,M,PC,Y

BENNETTS, Beatrice
American 20c.
M

BENNEY, Robert L.
American 1904-
F,H,IL,M,Y

ROBERT BENNEY

BENOIS, Alexandre Nikolaevich
Russian 1870-1960
AN,B,RS

BENOIT, Jacques
French late 20c.
GR85

BENRIMO, Thomas Duncan
American 1887-1958
H,M

BENSING, Frank C.
American 1893-1983
H,IL,M,NG4/25,PC

FRANK BENSING

BENSLEY BRUERE, Martha
American 20c.
LEX

BENSON, Ben Albert
Swedish/American 1901-
H,M

BENSON, Leslie Langille
American 1885-
F,H,M

BENTELE, H.
German mid 20c.
GR53

BENTHAM, George
American 1850–1914
B,I,M

BENTO, Fernando Trindade Carvalho
Portuguese 1911–
H

BENTON, Elizabeth Eaton
American 20c.
M

BENTON, Harry Stacy
American 1877–
B,F,I,M

BENTON, Thomas Hart
American 1889–1975
APP,B,EAM,F,H,M,PC

Benton

BENTSEN, Arne
Danish mid 20c.
GR60–61

BENYOVSZKI, Rudolf
Hungarian 1924–
LEX

BÉQUINON, Y.
French 20c.
B

BERAN, Alex
Czechoslovakian mid 20c.
GR65

BÉRARD, Christian
French 1902–49
ADV,B,GMC,H,M,VC

Bérard

BÉRAUD, Jean
French 1849–1936
B,BAA,H,L,TB

J.B.

BERBANK, A. E.
English 20c.
M

BERCHMANS, Émile
Belgian 1867–1947
AN,B,CP,GA,H,MM,POS

·C·ERCHMANS

BERDANIER, Paul Frederick
American 1879–1961
B,F,H,I,M,SO

BERDON, Maurice
French early 20c.
B

BERÉNY, Robert
Hungarian 1884/87–1953
B,CP,M,POS

Berény

BERG, August
Norwegian 1858–
B

BERG, Camille
French 1904–
B,M

BERG, John
American mid 20c.
GR57

BERG, (Dr.) Werner
Austrian?/German 1904–
G,H

BERG, Yngve
Swedish 1887–
LEX,TB

BERGEN, Claus
German 1885–
GWA,LEX,VO

C.B.

BERGEN, Fritz
German 1857–
B,LEX,TB

F.B.

BERGEN, William Merritt
American 1872–
CEN 9/12,F,H,M

Burgen

BERGER, E.
Swiss mid 20c.
GR53

BERGER, Fred
American 20c.
P

BERGER, Fritz
Austrian 1916–
LEX,TB,VO

BERGER, Heinz
German late 20c.
GR85

BERGER, Klaus
Swiss mid 20c.
GR64

BERGER, Roberts
Spanish mid 20c.
GR52

BERGERAT, (Mme) Emile
French 19c.
B

BERGERE, Richard
American 20c.
H

BERGEVIN, Raymond
French early 20c.
B

BERGEY, Earle K.
American mid 20c.
PAP

EARLE BERGEY

BERGHAUS, Albert (Alfred)
American ac. 1869–80
H

BERGMAN(N), Frank (Franz) W.
American 1898–
F,H,M

BERGMANN, Walther
German 1904–
GR52–53–56–60–67–68,LEX,TB

W Bergmann

BERGNER, Heinrich
German 19/20c.
LEX

BERINGER, Max
German 1886–
LEX,VO

M.B

BERJEAU, C.
French late 10c.
LEX

BERKE, Berenice Yvette
American 1920–
H

BERKE, Ernest
American 1921–
CON,H

ERNEST BERKE

BERKE, Hubert
German 1908–
B,G,H

BERKEY, John Conrad
American 1932–
F,NV,Y

BERKMAN, Bernice
American 1911–
M

BERKOFF, Blanche
American 1911–
H

BERKOWITZ, Rosalie
American 1906–
M

BERLAGE, Hendrik Petrus
Dutch 1856–1934
POS

BERLANDINA, Jane Clara
Franco/American 1898–
B,H,LEX

BERLE, Reidar
Norwegian 1917–
H

BERLEPSCH-VALENDAS, Hans Eduard von
Swiss 1849–
B,LEX,TB

BERLIAT, J. A.
Italian mid 20c.
GR60

BERMAN, Eugene
Russian/French 1899–1972
ADV,APP,B,F,GMC,GR53-54-56,H

BERMAN, Felix
Swiss mid 20c.
GR64-66

BERMAN, Steven M.
American 1947–
H,P

BERMINGHAM, Dave
American 1939–
CON

BERNARBIRSKY, Olga
Russian/French early 20c.
M

BERNARD, (Captain)
English 20c.
GMC

BERNARD, C. C. B. (C.C.B.B.G.)
American 20c.?
LEX

BERNARD, Edouard
French early 20c.
FS

BERNARD, Emile
French 1868–1941
AN,B,DA,H

BERNARD, Francis
French 1900–
B,GR52 thru 57-64-67-68,H,POS

BERNARD, Joseph Antoine
French 1866–1931
B,M

BERNARD, T.
Anglo/American 1867–
F

BERNARD, Victor
Anglo/American 1867–
F

BERNARDES, Antonio Teixeira
Portuguese 1918–
H

BERNARDINI, Pietro
Italian 1891-1974
B,EC,H

BERNER, Otto
German ac. early 20c.
LEX

BERNEY, Theresa
American 1904-
F,H,M

BERNHARD, Fritz
Austrian early 20c.
LEX

BERNHARD, Lucian
German 1883-1972
AD,CP,H,MM,POS

BERN HARD

BERNHARDT, Glenn R.
American 1920-
H

BERNIQUET, Jean
French 20c.
LEX

BERNINGHAUS, Oscar Edmund
American 1874-1952
F,H,I,M

O.E. BERNINGHAUS

BERNT, Rudolf
Austrian 1844-
B,LEX,TB

RB

BERNUTH, Max
German 1872-
B,LEX,TB,VO

M.B.

BERQUE, Jean
French 1869-
B,VO

JB

BERROCAL, Miguel Ortiz
Spanish 1933-
B,GR62-64,H

BERRY, Camelia
American 1918-
H

BERRY, Eric
American 20c.
M

BERRY, K. W.
American 20c.
M

BERRY, Phil
American 20c.
H,M

BERRY, William David
American 1926-79
H

BERRY, Wilson Reed
American 1851-
F,H?

BERRYMAN, Clifford Kennedy
American 1869-1949
B,CC,EC,F,H,I,M

Berryman

BERRYMAN, James Thomas
American 1902-
CC,EC,H,M

Jim Berryman

BERTALL, Charles Albert
French 1820-83
B,LEX,POS,TB

B.

BERTHAUER, Wim
Dutch mid 20c.
GR57

BERTHAULT, Lucien
French 1854-1921
B,LEX,PC

BERTHON, Paul Emile
French 1872-1909
B,GA,GMC,MM,POS

Paul Berthon

BERTI, Guglielmo
Italian ac. late 19c.
LEX

BERTIN, Émile
French 1878-1957
B,M

BERTIN, Henry
French 20c.
B

BERTIN, Louis
French 19/20c.
GMC

BERTIN, Roger
French 1915-
B

BERTINI, Ganni
Italian 1922-
B,H

BERTLE, Franz
Austrian 1828-83
B,LEX,TB,VO

F. B.

BERTONI, Dante H.
American 1926-
H

BERTRAM
see
WEIHS, Bertram A. Th.

BERTRAND, Emile
French 19/20c.
B,FO

BERTRAND, Harald
Norwegian 1856-90
B,LEX,TB

B

BERTZ, Ted
American 1939-
C

BERWALD, Ludwig
German 1865-
LEX

BESKOW, Elsa
Swedish 1874-
B,M

B

BESNARD, Paul Alexis
French 19c.
L,POS

BESNIARD
French mid 20c.
B,POS(pg.291)

BESSEMER, Auriel
American 1909-
H,M

BESSER, Leonard
American 1919-
H

BEST, W. R.
Canadian ac. 1858
H

BESTETTI, Pietro
Italian late 20c.
GR82

BESTETTI

BETHERS, Ray
American 1902-
H,M

BETHGE, Rudolf
German early 20c.
LEX

BERTOURNÉ, Jacques
French 20c.
LEX

BETTELI, G.
Italian mid 20c.
GR57

BETTIS, Charles Hunter
American 1891–
F

BETTS, Anna Whelan
American early 20c.
B,CEN8/04,F,H,I,M,Y

BETTS, Edith F.
American 20c.
M

BETTS, Edwin Daniel, Jr.
American 1879–
B,M

BETTS, Edwin David (Daniel), Sr.
American 1847–1915
B,BAA,F,I

BETTS, Harold Harington
American 1881–
B,H,M

BETTS, Jack
American 20c.
H

BEUTHIEN, Reinhard
German 20c.
LEX

BEVANS, Margaret Van Doren
American 20c.
M

BEVANS, Tom Torre
American early 20c.
GMC

BÉVERY, Henri May
French 1915–
B

BEVILACQUA, Jose Artur
Brazilian 1880–1915
EC

BEWICK, Robert Elliot
English 1778–1849
B,H,M

BEWICK, Thomas
English 1753–1828
APP,B,BA,DA,GMC,H,M,PC

B

BEYER, Albin
Russian 1891–
LEX

BEYER, George Albert
American 1900–
F,H,M

BEYRER, Eduard Maximilian
German 1866–1934
B,LEX,TB

BEYRER, Michael Emanuel
German early 20c.
LEX

BEZOMBES, Roger
French 1913–
B,GR53-56-57,H

BIA
see
VÖGLEIN, István (Bia)

BIAIS, Maurice
French 19/20c.
CP

BIANCHI, Alberto
Italian 1882–
H

BIANCONI, Fulvio
Italian 1915–
GR57–58–59–61–64,H

FB

BIASSONI, Marco
Italian mid 20c.
GR57–58–59–62–63–66

BICKEL, Karl
Swiss 1886–
LEX,VO

KB

BIDDLE, George
American 1885–1973
APP,B,C,F,H,I,M,SO

George Biddle

BIEDERMANN, Edward
German 1864–
B

BIEL, Egon Vitalis
Austrian/American 1902–
H,LEX,VO

E

BIELER, Ernest
Swiss 1863–1948
B,LEX,TB

BIEMANN, Emil O.
American mid 20c.
GR61

BIERACH, S. E.
American 1872–
B,SO

BIERBACH, S. E.
see
BIERACH, S. E.

BIERHAIS, Otto
see
BIERHALS, Otto

BIERHALS, Otto
German/American 1879–1944
B,H,M,SO

BIERS, Clarence
American 20c.
M

BIESEL, H. Fred
American 1893–1954
F,H,M,SO

BIESELE-VAN OYEN, Igildo
Swiss mid 20c.
GR60

BIESELE-VAN OYEN, Renate
Swiss mid 20c.
GR60

BIGELOW, Charles Bowen
American 19/20c.
B

BIGELOW, Charles C.
American 1891–
H

BIGELOW, Daniel Folger
American 1823–1910
B,D,F,I,M

BIGGS, D. Guy
Canadian 20c.
M

BIGGS, Geoffrey
American 1908–
H,IL,PAP

GEOFFREY BIGGS

BIGGS, Walter
American 1886–1968
F,FOR,H,I,IL,M,Y

W Biggs

BILECK, Marvin
American 1920–
H

BILEK, Franziska
German 1915?–
EC

BILIBIN(E), Ivan (Iwan Jakowlewitsch)
 Russian 1876-1942
 AN,B,EC,GMC,TB

ИБ

BILKOVA, Zdenka
 Polish mid 20c.
 GR56

BILL, Carroll M.
 American 1877-
 F,H,M

BILL, Max
 Swiss 1908-
 B,CP,DA,H,POS

bill

BILLINGS, Hammatt
 American 1816/18-74
 B,D,I,M

BILLINGS, Henry
 American 1901-
 H,M

BILLINGSHURST, Percy J.
 English 19/20c., ac. 1898-1906
 BK

P.J.B.

BILLING(S)TON, John Jules
 American 1900-
 H,M

BILLMYER, Charlotte Post
 American 1901-
 H,M

BILLMYER, James Irwin
 American 1897-
 H,M

BILLON, Daniel
 French 1927-
 EC

BILLOUT, Guy R.
 American 1941-
 EI79,F,GR82-85,Y

GUY BILLOUT

BILLUPS, Elizabeth Jean
 American 1948-
 CON

Billups

BINDER, Hannes
 Swiss late 20c.
 GR82

HANNES BINDER

BINDER, Josef (Joseph)
 Austrian/American 1898-1972
 ADV,GMC,GR52-55 thru 58,H,POS,VO

b i n d e r

BINDER, Ludwig
 German 20c.
 LEX

BINDER, Zilla
 Israeli mid 20c.
 GR56

BINDEWALD, Erwin
 German 1897-
 LEX,TB,VO

BINDRUM, Elsie Spaney
 American 1906-
 H,M

BINET, Adolphe Gustave
 French 1854-97
 B,H,LEX

BINGER, Charles
 Anglo/American? mid 20c.
 PAP

BINGHAM, A. Y.
 English 19c.
 B,LEX

BINGHAM, James R.
 American 1917-
 H,IL

BINKERT, G. A.
 Canadian ac. 1863
 H

BINKS, Robert
Canadian mid 20c.
GR63-64

BINNER (BINNER COMPANY)
American 19/20c.
GMC

⊕INNER

BINYON, Helen Francesca Mary
English 1904-79
B,M

BIOUX, G.
French late 19c.
LEX

GB

BIRCH, Ranice (Davis)
Canadian/American 1915-
H

BIRCH, Reginald Bathurst
Anglo/American 1856-1943
B,EC,F,H,I,IL,M,PE,Y

BIRCH, William Henry
English 1895-
B,LEX,STU1919

W.H.B.

BIRCHANSKY, Leo
Russian/American 1887-1949
EC,H

BIRCHMAN, Willis
American 20c.
H,M

BIRD, Alice
American 20c.
H

BIRD, Cyril Kenneth
see
FOUGASSE

BIRD, Elisha Brown
American 1867-1943
B,H,I,M,MM,POS,R

◦BIRD◦

BIRDSALL, Derek
English mid 20c.
GR60-64

BIRDSALL, Jack (John?)
Canadian mid 20c.
GR59-61-62

BIRKHÄUSER, Peter
Swiss 1911-
POS

BIRMINGHAM, Lloyd Paul
American 1924-
H

BIRNBAUER, Hans
Austrian 20c.
LEX

BIRNBAUM, Abe
American 1899-
GMC,H

WBirnbaum

BIRNBAUM, Meg
American 1952-
F,Y

BIRO, Balint Stephen
English 1921-
GR52-53

BIRO, Michael
Hungarian early 20c.
CP,POS

Biró

BIRREN, Joseph Pierre
American 1864-1933
B,F,H,M,SO,TB

J.P.B

BISBING, Henry Singlewood
 American 1849-1933
 B,F,H,I,M

BISCARRA, Carlo Felice
 Italian 1823/25-94
 B,H,LEX,TB

BISCHOF, Anton
 German 1877-
 LEX

BISCHOFF, Helmut
 German mid 20c.
 GR60-61-62

BISCHOFF, Herman E.
 American 20c.
 H,PAP

BISCHOFF, Ilse Martha
 American 1903-
 F,M,S

BISCHOFF, Wilhelm
 German 1858-
 LEX

BISEO, Cesare
 Italian 1843-1909
 B,H,LEX,TB

BISHOP, A. Thornton
 American 20c.
 M

BISHOP, Raymond
 American 20c.
 M

BISONE, Edward George
 American 1928-
 F,H

BISSELL, Charles Philip
 American 1926-
 EC,H

BISSIERE, Roger
 French 1886-1964
 APP,B,H,M

BISTI, Dimitri
 Russian 1925-
 B

BISTOLFI, Leonardo
 Italian 1859-1933
 AN,B,CP,H,MM,POS

BITTERLICH-BRINK, Roswitha
 Austrian 1920-
 LEX,VO

BITTINGER, Pauline Hatfield
 American 1899-
 H

BITTMANN
 Swiss mid 20c.
 GR57

BITTNER, Frank
 American 1879-
 B

BITTNER, Hans Oscar
 German/American 1905-
 H

BITTNER, Helmut
 German 1908-
 LEX

BITTROF, Marx
 German early 20c.
 POS

BIXBEE, William Johnson
 American 1850-1921
 B,F,I,M,SO

BJAREBY, Alfred Gunnar
 Swedish/American 20c.
 B,H

BJERVA, Bruce
 American late 20c.
 GR85

Bjerva

BJORKLUND, Lorence F.
 American 1915?-
 H

BJORVAND, Helen H.
 American 1902-
 H

BLAAW, C. J.
 Dutch early 20c.
 GMC

BLACK, Laverne Nelson
 American 1887-1938/39
 H,M

BLACK, Norman Irving
 American 1883-
 B,CEN12/09,F,H,I,M

Norman Irving Black

BLACK, Oswald Ragan (Oz)
 American 1898-
 H,M

BLACK, W. S.
 English 19/20c.
 LEX

BLACKALL, Jasper
 English mid 20c.
 GR53-54-57-60-66

BLACKSHEAR, Annie Lauro Eve
 American 1875-
 B,F,H,I,M

BLACKWELL, Garie
 American 1939-
 F,Y

BLACKWOOD, Gladys Rourke
 American 1904-
 H

BLAHZ, Richard
 Czechoslovakian mid 20c.
 GR57

BLAINE, Mahlon
 American early 20c.
 M,S,SO

MB

BLAIR, E. R.
 American 20c.
 F

BLAIR, Helen (Crobie)
 American 1910-
 H,M

BLAIR, Lawrence Edson
 American 1892-
 H

BLAIR, Mary Robinson
 American 1911-
 GR54,H,M

BLAIR, Preston Erwin
 American 1910-
 H

BLAIR, Robert Noel
 American 1912-
 CG10/34,H,M

Bo Blair

BLAISDALE, Elinore
 American early 20c.
 H,M,S,SO

Elinore Blaisdell

BLAISDELL, Elinore
 see
 BLAISDALE, Elinore

BLAKE, Donald
 American 1889-
 F,H,M

BLAKE, James Henry
 American 1845-
 B,F,H,I,M

BLAKE, Leo B.
American 1887-1976
H,M

BLAKE, Peter
American 1932-
B,BRP,CP,EI79,F,H,Y

Peter Blake. 1978.

BLAKE, Quentin
English 1932-
GR58-60,H

BLAKE, William
English 1757-1827
B,DA,H

W. Blake.

BLAKE, William Phipps
American 1825-1910
D,H,PC

BLAKELY, Dudley Moore
American 1902-
H,M

BLAKEMAN, Thomas Greenleaf
American 1887-
H,M

BLANCH, Arnold
American 1896-1968
B,C,H,M,SO

BLANCHARD, Bob
American mid 20c.
PAP

BLANCHARD, Carol
American 1918-
GR53,H

Carol Blanchard

BLANCHFIELD, Howard James
American 1896-1957
H,M

BLANCHOT, Gustave
see
BOFA, Gus

BLANCHOT, Léon Alexandre
French 1868-1947
B

BLANCO, Santa
American 20c.
M

BLAND, Garnet William
American 1903-
H

BLANEY, Henry Robertson
American 1885-
B,I,M

BLANK, B.
Ukrainian early 20c.
LEX

BLASE, Karl Oscar
German 1925-
GR60 thru 66,H

BLASER, Hermann
Swiss early 20c.
POS

BLASHFIELD, Albert Dodd
Anglo/American 1860-1920
B,EC

A D Blashfield .06

BLASHFIELD, Edwin Howland
American 1848-1936
B,BAA,F,H,I,M,PE,Y

EHBlashfield

BLATCH, Bernard
Norwegian/English? late 20c.
EI79,GR63

BERN^D· BLATCH '77

BLATCH, F. K.
Canadian ac. 1872
H

BLATCHLEY, William Daniel
Canadian 1838–1903
B,H

BLATTNER, Robert Henry
American 1906–
H

BLAZKOVA, Stasa
Czechoslovakian mid 20c.
GR52–53–54–56–57

BLAZ

BLECHMAN, Robert O. (Bob)
American 1930–
AA,CC,EC,GR58 thru 61–63–65–68–82–85,POS

Blechman

BLEGVAD, Eric
Danish 1923–
H

BLEIFELD, Stanley
American 1924–
B,C,H

BLENCOWE, Carlyne
Australian 1907–
H

BLESER, August, Jr.
American 20c.
M

BLICKENSTAFF, Wayne
American mid 20c.
PAP

BLOCH, Alexander
French late 19c.
B,H,LEX

BLOCH, Julia
American 1903–
H,M

BLOCH, Lucienne
Swiss/American 1909–
B,F,H,M

BLOCH, Marcel
French 1882/84–
B,LEX

BLOCK, Andreas
Norwegian early 20c.
POS

BLOCK, Henry
Lithuanian/American 1875–1938
F,H,M

BLOCK, Julian
American 1923–
H

BLOCK, Lou
American 1895–
H,HA

L.B.

BLOCK, V. Jeanne
American 20c.
M

BLONDELA, Ozame
Canadian ac. 1788
H

BLONDHEIM, Adolphe W.
American 1888–
B,F,H,I,M

BLOODGOOD, Robert Fanshawe
American 1848–1930
B,BAA,F,I,M

BLOOMFIELD, Arthur Merrick
see
BOYD, Arthur

BLOS, Mary Elizabeth
American 1906–
H

BLOSSOM, David J.
American 1927–
F,IL,Y

DBlossom

BLOSSOM, Earl
American 1891–1970
F,H,IL,M,Y

Earl
Blossom—

BLOUET, Guillaume Abel
Canadian ac. 1795-1853
B,H,M

BLUHM, Oskar
German 1867-
LEX

BLUM, A. Aladar (also, possibly BLUM, Alex A.)
American 19/20c.
B,F,H?

BLUM, Robert Frederick
American 1857-1903
B,F,H,I,IL,M,PC,PE,Y

BLUM, Tom
American late 20c.
GR85

BLUM, Zevi
American 1833-
F,Y

BLUMENFELD, Erwin
American mid 20c.
GR55

BLUMENSCHEIN, Ernest Léonard
American 1874-1960
B,BAA,CEN7/07 & 2/12,F,H,I,IL,M,SO

BLUMENSCHEIN, Mary Shepard Greene
American 1868/69-1958
B,F,H,I,M

BLUMENSTIEL, Helen Alpiner
American 1899-
H,M,SO

BLUMENTHAL, Moses Lawrence
American 1879-
B,F,H,I,M

BLUMERT, Johanna Marie
American 1901-
H,M

BLUMHART, Arthur
Canadian 20c.
M

BLUMRICH, Christoph
American late 20c.
GR85

BLUST, Earl R.
American 20c.
H

BLYTHE, David Gilmour
Canadian/American 1815-65
B,D,H,M,PC

BO, Lars
Danish 1924-
B

BOAK, Milvia W.
American 1897-
H,M

BOBBETT, Walter
American late 10c.
BAA,SN5/86

BOBBITT, Vernon L.
American 1911-
H,M

BOBERTZ, Carl
American 20c.
H,PAP

BOBRI, V. (BOBRITSKY, Vladimir)
American 1898-
ADV,FOR,GMC,GR52-53-57,H,IL,M,POS

BOBRITSKY, Vladimir
see
BOBRI, Vladimir

BOCASILI, Gino
see
BOCCASILE, Gino

BOCCALATTE, Pietro Anacleto
Italian 1885–
H

BOCCASILE, Gino
Italian 1901–52
B,H,PG,POS

BOCCHINO, V.
French 19/20c.
LEX

BOCIANOWSKI
Polish early 20c.
POS

BÖCK, Rudolf
Austrian late 19c.
LEX

BOCK, Theophile Emile Achille de
Dutch 1851–1904
B,LEX,TB

BOCK, Vera
Russian/American 20c.
H,M

VB

BOCK, William Sauts-Netamux'we
American 1939–
H,M

BÖCKLI, Carl
Swiss early 20c.
POS

BÖCKLIN, Carlo
Swiss 1870–1934
LEX,TB,VO

BOCOCK, John Paul
Canadian ac. 1890
H

BOCOLA, Sandro
Italian/Swiss? 1931–
B,GR60–62–63

BOCZ, Istvan
Polish?/Hungarian mid 20c.
GR52–56–58

BODECKER, Nils Mogen
Danish/American 1922–
H,HA

BODFISH, William P.
American ac. 1865–94
H

BODIN, Gunnar
Swedish mid 20c.
GR55

BODMER, Karl
Swiss/American 1809–93
B,D,F,H,M,PC,TB

KB

BOEBINGER, Charles William
American 1876–
B,F,H,I

BOEDECKER, Arnold E.
American 1893–
H

BOEHM, Henry Richard
American 1870–1914
B,I,M

BOEHMER, B. G.
German early 20c.
GMC

BÖES, F. G.
German mid 20c.
GR61–64–65

BOESCH, Ferdinand
American mid 20c.
GR61

BOFA, Gus
 French 1885–1968
 B,EC,H,VO

G B

BOFARULLI
 Spanish early 20c.
 POS

BOGATKIN, W.
 Russian mid 20c.
 LEX

BOGELUND-JENSEN, Thor
 Danish 1890–
 GR53,POS

Bj.

BOGER, Fred
 American 1857–
 B,F,H,I,M

BOGNI
 Italian mid 20c.
 GR60

BOGORAD, Alan Dale
 American 1915–
 H

BOGUSTAW, Gorecki
 Polish mid 20c.
 GR54

BOHLMAN, Edgar Lemoine
 American 1902–
 H,M

BÖHM, Adolf Michael
 Austrian 1861–1907
 AN,H,TB

·AB·

BÖHMER, Gunter
 German 1911–
 G,H,VO

GB

BOHNERT, Henry
 American 1890–
 H

BOHNERT, Herbert
 American 1888–
 F,M

BOHROD, Aaron
 American 1907–
 B,F,GR56,H

BOHT, Hans
 German
 LEX

BOILVIN, Emile
 French 1845–99
 B,H,L

E. Boilven

BOK, Hannes Vajn
 American 20c.
 H

BOKUNIEWICZ, Carol
 American late 20c.
 GR82

BOLASNI, Saul
 American mid 20c.
 ADV,GR52

Bolasni

BOLD (GUTENSOHN, Bruno)
 German 1895–
 LEX

BÖLD, Alfred
 German early 20c.
 LEX

BOLDEN, Joseph
 American 20c.
 H,M

BOLEGARD, Joseph
 American 20c.
 B,H

BOLES, Terry
 American late 20c.
 GR82

T.BoLes

BŌLIN, George
American? early 20c.
ADV,GMC,VC

Bolin

BOLLER, Harri
American late 20c.
GR85

BOLLES, Francisca
American 20c.
M

BOLLIGER-SAVELLI, Antonella
Swiss late 20c.
GR82

BOLLINGER, Roger
French early 20c.
POS

BOLLMAN, Carl Pierce
American 1874–
F,H,M

BOLLWAGE, Max
German 1927–
LEX

BOLMAR, Carl Pierce
see
BOLLMAN, Carl Pierce

BOLOGNESE, Donald Alan
American 1934–
H

BOLONACHI, Carlo
Italian late 19c.
LEX

BOLTON, Richard Frederick
American 1901–
F,H,M

BOLTON, Shirley L.
American 1945–
H

BOMBACH, Willy Julius
German 1880–
LEX,VO

BCH.

BOMBERGER, Bruce
American 1918–
IL

Bruce Bomberger

BOMBLED, Louis Charles
French 1862–1927
B,LEX

BOMBOVÁ, Viera
Yugoslavian 1932–
H

BOMPARD, Luigi
Italian 1879–
H,MM,POS

LB

BON, Olivié
French 1863–
LEX,TB

OB

BOND, Oriel Edmund
American 1911–
F,H

ORIEL BOND

BONESTELL, Chesley
American 20c.
H

Chesley Bonestell

BONFANTE, Egidio
Italian 1922–
B,GR53–54

BONFILS, Robert
French 1886–1971
AD,B,POS,ST

Robert bonfils

BONGARD, Hermann
Norwegian 1921–
H

BONHOMME, François Ignace
French 1809–81
B,LEX,TB

BONINI, Ezio
Italian mid 20c.
GR52-53-54-57-63-64-65-67-68

BONISCONTRI, Adriana
Italian 1921–
H

BONNAR, George Wilmot
English 1796–1836
H,I

BONNARD, Pierre
French 1867–1947
AN,B,CP,DAR,DES,EAM,GA,GMC,H,PC,POS

BONNER, Mary Anita
American 1885–1935
B,H,M

BONNER, Thomas
English 1740–1807/12
B,H,M,TB

BONOMI, José Lucio
Argentinean 1903–
GR59,H

BONS, Jan
Dutch 1918–
GR52-53-57-58-60-66,H

BONSALL, Crosby Barbara (Newell)
American 1921–
H

BONSALL, Elizabeth Fearne (Stearns)
American 1861–
B,F,H,HA10/03,M,I,LEX

BONSALL, Mary Waterman
American 19/20c.
B,F,H,I,M

BONTÉ, George Willard
American 1873–
CEN4/04 & 5/04,M

BONVICINI, Bruno
Italian mid 20c.
GR65

BONWILL, C. E. H.
Canadian ac. 1865–82
H

BONZAGNI, Aroldo
Italian 1887–1918
PG

BOOG, Carle Michel
Swiss/American 1877–
B,F,H,M

BOOKER, Nell Battle
American 1918–
H

BOONSHAFT, Rochelle Margolis
American 1919–
H

BOOST, Ch.
Dutch mid 20c.
GR61

BOOTH, Franklin
American 1874–1948
B,EC,F,I,IL,M,PE,Y

BOOTH, Hanson
American 1886–1944
B,F,H,I,M

BOOTHROYD, Arthur Sharland
Australian 1910–
H

BORACK, Stanley
American 1927–
CON,PAP

BORBOTTONI, Fabio
Italian 1820–
B,H

BORCHARDT, Norman
American 1891–
F,H,M

BORDAL(L)O PINHEIRO, Rafael
Portuguese 1846–1905
B,EC,H

BORDEWISCH, Ferdinand F.
American 1889–
F,M

BOREIN, (John) Edward
American 1872–1945
B,F,H,I,M

Edward Borein

BOREL, Marina
Argentinean 1915–
H

BOREN, Jodie
American 1926–
CON

Jodie Boren

BORG, Carl Oscar
American 1879–1947
B,F,H,I,M

Carl Oscar Borg

BORGHINI, Frederico Santiago Jorge Carlos
Italian/Argentinean 1925–
H

BORIS
see
VALLEJO, Boris W.

BORISOV, Grigori Ilych
Russian early 20c.
MM

BORISOV, Grigori Ilych and PRUSAKOV, Boris
Russians, 1899–
MM

БОРИС ПРУСАК DB

BORJA, Corinne
American 20c.
H

BORJA, Robert
American 20c.
H

BORLIN, Jean
Swedish early 20c.
POS

BORN, Adolf
Czechoslovakian 1930–
B,GR64–85

BORN, Wolfgang
German/American 1893–
H

BORNESCHLEGEL, Ruth
American 20c.
H

BORNSTEIN, Marguerita
Polish/Australian 1950–
EC

BOROBIO, Luis
Spanish 20c.
LEX

BORSSUM, Van (BORSSUM van?)
Dutch mid 20c.
GR58

BORTEN, Helen
American mid 20c.
GR53

BORTHWICK, John David
Scots/American 1825–1900?
B,D,H

BORTNYK, Alexandre
Hungarian 1893–
B,POS

BOSC, Jean Maurice
French 1921-73
EC,H

BOSC

BOSCH, Ernst
German 1834-
B,H,LEX,TB

EB

BOSCHIROLI, Tonino
Italian mid 20c.
GR52-53-55

BOSCOVITS, Friedrich
Hungarian 1845-
B

BOSCOVITS, Fritz, Jr.
Swiss 1871-
B,POS,TB,VO

F Bj.

BOSE, Neal
American 1894-
F

BOSIN, Francis Blackbear
American 1921-
H

BOSSAERT, A. M.
French 20c.
LEX

BOSSARD, Johann
Swiss 1874-
B

BOSSCHÉRE, Jean de
French/Belgian 1881-1953
B,M

BOSSHARDT, Walter
Swiss mid 20c.
BI,GR52-56 thru 61-64

BOSTELMANN, Elsie W. von Roeder
German/American 20c.
H,M

BOSTICK, William Allison
American 1913-
H

BOSWELL, Hazel
American 20c.
M

BOSWELL, James
English 1906-71
B,GR52-53

BOSWORTH, Sala
American 1805-90
D,H

BOTELHO, Carlos Antonio Teixeira Bartos Nunes
Portuguese 1899-
H

BOTH, Armand
American 1881-1922
B,F,I,M,SCR5/08

ARMAND BOTH

BOTH, William C.
American 1880-
F,M

BOTKE, (Mrs.) Jessie Arms
American 1883-1971
B,F,H,I,M

BOTTINI, Georges Alfred
French 1873-1906
B,BI,POS

George Bottini 97

BOTTLIK, Josef
Hungarian early 20c.
LEX

BOUCHARD, Lorne Holland
Canadian 1913-78
H

BOUCHAUD, Michel
French early 20c.
ADV,GR56-59

Bouchaud

BOUCHE, René Robert
American 1906–63
F,GMC,GR52,VC,Y

BOUCHER, Lucien
French 1889–1971
B,GR56–57,M

BOUCHOT, Frédéric
French 1798–
B,LEX

BOUCHOUCHA, Mustapha
Tunisian mid 20c.
GR65

BOUDA, Cyril
Czechoslovakian 1901–
LEX,TB,VO

BOUDIER, Edouard Louis
French –1903
B,LEX,TB

BOUDREAU, James Clayton
American 1891–
H,M

BOUGHTON, George Henry
Anglo/American 1833–1905
B,BAA,F,H,I,M

BOUILLON, Henri
French 1864–1934
B,POS

BOUISSET, Firmin
French 1859–
LEX,POS,TB

BOULANGER, Henri
see
GRAY, Henry

BOURDIN, Frederic
French 19/20c.
B

BOURET, Alfredo G.
French 20c.
GR58–59,LEX

BOURGEOIS, Albert
Canadian 1888–
H

BOURGOIS, Djo
French early 20c.
POS

BOURNE, George
Canadian 1780–1845
H

BOUSSINGAULT, Jean Louis
French 1883–1943
B,CP,H,M

BOUTET de MONVEL, Bernard
French 1884–1949
B,CEN9/12,ST

BOUTET de MONVEL, Louis Maurice
French 1851–1913
B,GA,H,POS

BOUTWELL, George
American 1943–
CON

BOUVIER, Stanislas
French late 20c.
GR85

BOVARINI, Maurizio
 Italian 1934–
 EC

BOVIS, Marcel
 French 1904–
 B

BOWDEN, Beulah Beatrice
 American 1875–
 H,M

BOWDISH, Edward Romaine
 American 1856–
 B,F,I,M

BOWDOIN, Harriette
 American 19/20c.
 B,F,H,M

BOWEN, Thomas Alfred
 English 1904–
 LEX

BOWER, John
 American early 19c., ac. 1809–19
 B,D,M

BOWER, Maurice L.
 American 1889–
 F,H,M,Y

BOWLER, Joseph R., Jr.
 American 1928–
 AA,F,H,IL,Y

BOWLER, Thomas William
 English –1869
 B,H

BOWLING, (Lt.) Jack Frank
 American 1903–79
 H,M

BOWMAN, Donald
 American 20c.
 M

BOWMAN, F. B.
 Canadian 20c.
 M

BOWMAN, Jean (MacKay-Smith)
 American 1917–
 H

BOWMAN, Jean (Magruder)
 American 1917–
 H

BOWRING, Walter Armiger
 Australian 1874–1931
 H

BOXER, Mark
 English mid 20c.
 GR57

BOXSIUS, Sylvan G.
 English 1878–
 B

BOYCE, Richard Audley
 American 1902–
 B,C,F,H,M,SO

BOYD, Alexander Stuart
 Scots 1854–1930
 B,BK,H

BOYD, Arthur
 Australian 1920–
 B,H

BOYD, Brian
 American late 20c.
 GR82

BOYD, Frank
 Canadian/American 1893–
 M

BOYD, Marguerite
 American 20c.
 M

BOYD, Rutherford
 American 1884–1951
 F,H,M

BOYD-HARTE, Glynn
 English late 20c.
 EI82–83

BOYER, Hubert
 Canadian 1914–
 H

BOYER, Ralph Ludwig
 American 1879–1952
 B,F,H,M

BOYLE, Beatrice A.
 American 1906–
 H

BOYLE, James Neil
American 1931–
IL

Boyle

BOYNTON, Ray Scepter
American 1883–1951
F,H,M,SO

BOZZO, Frank Edward
American 1937–
F,GR65–67,Y

FRANK BOZZO

BOZZOLINI, Silvano
Italian 1911–
B,H

BRAAKENSIEK, Johan
Dutch 1858/59–1940
B,EC,M,POS

BRAATZ, Joachim
German 1925–
G

BRACKEN, Charles W.
American 1909–
H

BRACKER, Charles E.
American 1895–
H,M

BRACKER, M. Leone
American 1885–1937
F,HA6/09,LEX,M,Y

-M·LEONE BRACKER-

BRACKETT, Ward
American 1914–
IL

Ward Brackett

BRACQUEMOND, Emile Louis
French 20c.
B,LEX,PC

BRADBURY, Charles Earl
American 1888–
F,H,I,M

BRADER, Betty
American mid 20c.
GR60

BRADFIELD, Margaret Jewell
American 1898–
H

BRADLEY, Carolyn Gertrude
American 20c.
F,H,M

BRADLEY, E. R.
American 20c.
M

BRADLEY, (Rev.) Edward (Cuthbert Bede)
English 1827–89
B,H

BRADLEY, Gertrude M.
English 19/20c.
BK,STU1906

GMB

BRADLEY, Luther Daniels
American 1853–1927
CC,EC

BRADLEY

BRADLEY, Susan H.
American 1851–1929
B,F,H,I,M

BRADLEY, (Will) William H.
American 1868–1962
AN,B,BI,CP,F,GA,GMC,H,I,M,MM,R

WILL H
BRADLEY

BRADSHAW, George A.
American 1880–
F,H,M

BRADSHAW, Percy Vanner
English 1878–1965
EC,M

BRAGDON, Claude Fayette
 American 1866–1946
 B,I,MM,POS,R,TB

C.F Bragdon

BRAGG, Charles
 American 20c.
 P

CHARLEY BRAGG

BRAGIN, Ernest
 American 20c.
 H

BRAGUIN, Simeon
 Russian/American 1907–
 H,M

BRAIDEN, Rose Margaret J.
 American 1923–
 H

BRALDS, Braldt
 Dutch/American 1951–
 AA,EI79,GR82–85

braldtbralds.

BRAMBERG, Lars
 Swedish 1920–
 GR52–53–54–56–57–61,H

BRAMBERG

BRAMHALL, Winifred
 American 20c.
 M

BRAMLETT, James E.
 American 1932–
 H

BRANBERG, Fred
 American 20c.
 HA,LEX

FB

BRAND, Werner
 German early 20c.
 LEX

BRAND-OKSEN
 German 20c.
 LEX

BRANDÃO, Alfredo Marcal
 Portuguese 1852–1918
 H

BRANDEGEE, Robert Bolling
 American 1848–1922
 B,F,I,M

BRANDENBERG, Aliki
 Swiss mid 20c.
 GR60–62–66–67

BRANDENBURG-POLSTER, Dora
 German 1884–
 LEX,VO

D.B.P.

BRANDT, Henry George
 American ac. early 20c.
 GMC

H·GEO·BRANDT

BRANDT, Robfalax A.
 English 1906–
 LEX

BRANGWYN, Frank William
 English 1867–1956
 ADV,AN,APP,B,BK,EAM,GMC,H,MM,POS,S,
 TB,VO

FrBryon

BRANN, Esther (Schorr)
 American 20c.
 H,M

BRANSOM, (John) Paul
 American 1885–1979
 B,EC,F,H,I,IL,M,VO,Y

PAUL BRANSOM

BRANSTON, Allen Robert
 English 1778–1827
 B,H,M

BRAQUE, Georges
　　French 1882-1963
　　APP,B,DA,DES,DRA,GMC,GR59,H,M,PC,
　　POS,SO

BRARI, Carlo
　　Italian early 20c.
　　POS

BRASCH, Sven
　　Danish 1886-
　　GMC,POS

BRASTOFF, Sascha
　　American 1918-
　　H,M

BRASZ, Arnold Franz
　　American 1888-
　　B,F,I,M

BRATE, Charlotte
　　American 20c.
　　M

BRATEAU, Jules Paul
　　French late 10c.
　　B,LEX

BRATTINGA, Pieter
　　Dutch 1931-
　　CP,GR59-66-67,POS

BRAUMÜLLER, George
　　German early 20c.
　　CP

BRAUN, August
　　German 1876-
　　B,LEX,TB

BRAUN, Esther
　　American 20c.
　　M

BRAUN, Heinrich
　　German 1852-92
　　B,LEX,TB

BRAUNE, Anna Parker
　　American 20c.
　　M

BRAUNE, Hugo L.
　　German 1872-
　　AN,B,LEX,TB,VO

BRAUNHOLD, Louis
　　American 19/20c.
　　F,GMC

BRAVERMAN, Sylvia
　　American 20c.
　　GMC

BRAXTON, William Ernest
　　American 1878-1932
　　B,F,H,I,M,SO

BRAYMER, L. E.
　　American 1901-
　　F,M

BRAZELTON, Julian
　　American 20c.
　　M

BRAZELTON, William Calvin
　　American 1909-
　　H,M

BREAKEY, John
　　American late 20c.
　　GR82-85

BREAUTÉ, Albert
 French 1853–
 B,LEX,TB

BRECK, G. William
 American 1883–1936
 M

BRECK, Joseph
 American early 20c.
 F

BRECKENRIDGE, Walter A.
 American 20c.
 M

BRED, Marold Matthew
 American early 20c.
 HA,LEX

BREDIN, Christine S.
 American 19/20c.
 B,CEN4/04 & 1/05 & 12/06,F,M

Christine S. Bredin

BREEZE, Beatrice
 American 20c.
 M

BREEZE, Kenneth W.
 American 20c.
 M

BREHM, George
 American 1878–1966
 B,F,H,IL,M,POS,Y

G.BREHM

BREHM, Worth
 American 1883–1928
 B,F,HA,IL,M,VO

WORTH-BREHM.

BREHME, Claire Eichbaum
 American 1886–
 H,M

BREIDVIK, Mons
 Norwegian/American 1881–
 F,H,M,SO,TB,VO

BREITHUT, Peter
 Austrian 1869–1930
 LEX

BREITKREUZ, Horst
 German 1925–
 GR59-65-68,H

BREKER, Walter
 German mid 20c.
 GR53-54-56-58-61-63-65 thru 68

Breker

BRENDERS, Carl
 Belgian late 20c.
 EI79

BRENEISER, John Day
 American 1905–
 H,M

BRENER, A.
 American? mid 20c.
 ADV

ABrener

BRENNAN, Alfred Laurens
 American 1853–1921
 B,F,I,M,P.SN5/86

A.Brennan
1886

BRENNE(R)MAN, George W.
 American 1856–1906
 B,BAA,F,I,M

BRENOT, Pierre Laurent
 French 1913–
 B,POS

Brenot

BRENSON, Theodore
 Latvian/American 1892–1959
 B,H

BRESSLER, Harry S.
 American 1893–1962
 H,SO

BRESSLERN-ROTH, Norbertine von
Austrian 1891–
B,LEX,VO

B.-Roth

BRÉTÉCHER, Claire
French 1940–
EC,EI82

BRETECHER

BRETSCHNEIDER, Gusti
Austrian 20c.
LEX

BRETT, Harold Matthews
American 1880?–
B,F,GMC,H,HA6/07 & 7/07,I,M,Y

Harold Matthews Brett

BRETT, Newton
Canadian 1890–
WS

N.B

BREUER, Henry Joseph
American 1860–1932
B,F,H,I,M

BREUL, Harold Guenther
American 1889–
B,F,H,I,M

BREVAL, (Alfred) Roger
French early 20c.
B,LEX

BRÉVIÈRE, Louis Henri
French 1797–1869
B,H,LEX,TB

Br.

BREWER, Bessie Marsh
Canadian/American 1883–1952
F,H,M

BREWER, Edward Vincent
American 1883–
ADV,H,M

EDW. V. BREWER

BREWER, Henry Charles
English 1866–1943
B,H,LEX,TB,VO

H.C.B.

BREWER, Henry Joseph
American 1860–
B,I

BREWSTER, Anna Richards
American 1870–1953
B,F,H,I,M

BREZIK, Hilarion
American 1910–
H

BRICKNER, Alice
American late 20c.
GR85

Alice Brickner 1984

BRIDG(E)MAN, Frederick Arthur
American 1847–1928
B,BAA,F,H,I,M

FABridgman

BRIDGMAN, Lewis (Louis) Jesse
American 1857–
B,CEN8/96,I

Bridgman '96.

BRIGGS, Austin
American 1908/09–73
F,H,IL,Y

Austin Briggs

BRIGGS, Bud
American 20c.
M

BRIGGS, Clare Austin
American 1875–1930
LEX

BRIGGS, Richard Delano
American 1914–
H,M

BRIGHAM, Barbara
American 1929–
CON

B. Brigham

BRIGHAM, William Edgar
American 1885–
F,H,M

BRIGHT, Henry
English ac. 1870–77
H,M

BRIGHTY, G. M.
English ac. 1809–27
B,H

BRILL, George Reiter
American 1867–1918
B,CL11/10,I,M,POS

BRILL

BRINDLE, (E.) Melbourne
Australian/American 1904–
H,IL

Melbourne Brindle

BRINKERHOFF, Robert Moore
American 1879–
B,CL7/10,F,H,I

Brinkerhoff

BRINKLEY, Nell
American –1944
H,M

BRINKMANN, Gerhard
German 20c.
LEX

BRINLEY, Daniel Putnam
American 1879–1963
B,F,H,M,SO

BRINNER, Manuel
Spanish early 20c.
GMC

BRINTON, Sarah W.
American 20c.
H,M

BRISLEY, Joyce Lankester
English 1896–1978
M

BRISLEY, Nina Kennard
English –1978
M

BRISSAUD, Pierre
French 1885–
B,GMC,ST,VC

Pierre Brissaud

BRITO E CUNHA, José Carlos de
Brazilian 1884–1950
EC,H

BRITTAIN, Miller Gore
Canadian 1912–68
H,M

BRITTEN, William E. F.
English 19/20c.
B,BK,H

W E F Britten

BRITTON, James
American 1878–
B,F,I,M

BRITTON, James II
American 1915–
H

BROADHEAD, W. Smithson
American 20c.
M

BROCHANT
French 20c.
POS

BROCK, Charles Edmond
English 1870–1938
B,BK,H,M

C E Brock (signature)

BROCK, Emma L.
American 1886–
F,H,M

BROCK, Henry Matthew
English 1875–1960
B,BK,M

Hm Brock (signature)

BROCKMANN, K. W.
German? ac. early 20c.
LEX

BROCKMULLER, Paul
German 1864–
B

PB (signature)

BROCKS, C. E.
English early 20c.
LEX

C.E.B. (signature)

BRODERS, Roger
French 1883–1953
ADV,POS

ROGER BRODERS (signature)

BRODEUR, Albert Samuel
Canadian 1862–1904
H

BRODIE, Howard Joseph
American 1916–
F,H,M,Y

BRODIE, M.
American 19/20c.
ADV

BRODOVICH, Alexis
Russian/French 1900–71
GR52–63,POS

A.B (signature)

BRODSKY, Harry
American 1908–
H,M

BRODY, Judy
American mid 20c.
GR54

BRODZKY, Horace
American 1885–1969
B,F,I,SO

BROEDEL, Max
American 1870–1941
B,F,H,I,M

BROEK, Ten
Dutch early 20c.
POS

BROEMEL, Carl William
American 1891–
F,H,M

BROHMER, A. F.
American 20c.
M

BROMBERGER, Otto
German 1862–
B

BROMFIELD, Kenneth
Irish?/English mid 20c.
GR55–67

BROMLEY, Clough W.
English late 19c.
B,LEX,TB

C.B (signature)

BROMLEY, Valentine Walter
English 1848–77
B,H,M

BRONSCH, Alice
German early 20c.
ADV

BRONSON, Wilfrid Swancourt
American 20c.
M

BRONSTERT, Franz
German early 20c.
LEX

BROOKE, Iris
English 1908–
M

BROOKE, Leonard Leslie
English 1862–1940
B,BK,H,M,TB

L·L·B·

BROOKE, William Henry
English 1772–1860
B,H

BROOKES, (Major) Allan
Canadian early 20c.
M

BROOKES, Peter
German/English late 20c.
EI79,GR82

Peter Brookes

BROOKS, Amy
American early 20c.
F

BROOKS, Bernard W.
American 20c.
H

BROOKS, Erica May
American 1894–
F,H,M,SO

BROOKS, Lou
American 1944–
F,Y

BROOKS, Walter
Scots/American 1921–
PAP

BROOM, Robert
American 20c.
LEX

BROOME, B. C.
American ac. 1900
H

BROOMFIELD, (Adolphus) George
Canadian 20c.
H,M

BROOMFIELD, Isabel Clark
Canadian 20c.
M

BROSIER, H.
see
BROSIUS, H.

BROSIUS, H.
Canadian ac. 1875
H

BROTHERS, Barry
American 1955–
AA

BROUET, Auguste
French 1872–1941
B,M

BROUGH, Richard Burrell
American 1920–
H

BROUGHTON, Charles
Canadian/American 1861–1912
GMC,H,PE

C BROUGHTON

BROUN, Aaron
American 1895–
F

B

BROUOT, J.
French late 19c.
LEX

BROUTIN, Christian
French late 20c.
EI79,GR82

C. broutin.

BROWDY, Dorothy R.
 American 1909–
 H,M

BROWN, Arthur William
 Canadian/American 1881–1966
 B,F,H,IL,M,PE,Y

ARTHUR WILLIAM BROWN

BROWN, Brian
 American 1911–58
 H

BROWN, Charles E.
 American early 20c.
 ADV,H

BROWN, Charles Harding
 English early 20c.
 LEX

BROWN, Charlotte Harding
 American 1873–
 B,F,H,I,M

BROWN, Daniel
 American 1949–
 C

BROWN, Daniel Quilter
 American 1911–
 H

BROWN, Don Paul
 American 1899–
 H,M

BROWN, Elmer William
 American 1909–
 H,M

BROWN, Elmor J.
 American 1899–
 H,IL,M

Elmor Brown/64

BROWN, Ethel Pennewill
 American 19/20c.
 F,H,SO

BROWN, Ford Madox
 English 1821–73
 B,H,LEX,TB

FMB

BROWN, George E.
 Canadian 20c.
 M

BROWN, George Massiot
 see
 MASSIOT, George

G.Massiot

BROWN, Glenn Madison
 American 1876–1932
 B,F,H,I,M

BROWN, Grace Evelyn
 American 1873–
 F,H,M

BROWN, Gregory
 English 1887–
 B,CP

BROWN, H. L.
 American 19/20c.
 SCR5/01

H·L·Brown.

BROWN, Harold Haven
 American 1869–1932
 B,F,I,M

BROWN, Harriet Gurney
 see
 BROWN, Rhett Delford

BROWN, Howard V.
 American 1878–
 F,GMC,M

Howard Brown

BROWN, Jeanette Perkins
 American 1887–
 M

BROWN, Joseph Randolph
 American 1861–
 B,H,I,M,SO

BROWN, Judith Gwyn
American 1933–
H

BROWN, Lucille Rosemary
American 1905–
H,M

BROWN, M.
English late 10c.
LEX

BROWN, Marcia Joan
American 1918–
H

BROWN, Michael David
American late 20c.
GR82–85

BROWN, Ozni C.
American 20c.
H,M

BROWN, Paul
American 1893–1958
AM11/25,H,IL,M

Paul Brown

BROWN, Ray
American 1865–
B,I,M

BROWN, Reynold
American 1917–
CON,H

Reynold Brown

BROWN, Rhett Delford
American 1924–
H

BROWN, Robert
Canadian ac. 1877
H

BROWN, Roger
American 1941–
H,P

BROWN, Roy Henry
American 1879–1956
B,F,H,I,M

BROWN, Walter Francis
American 1853–1929
B,F,I,M

BROWN, William Ferdinand II
American 1928–
H

BROWN, William Fulton
Scots 1873–1905
B,H,M

BROWNE, Belmore
American 1880–1954
F,H,M

BROWNE, Gordon Frederick
English 1858–1932
B,BK,H,STU1907

BROWNE, Hablot Knight
English 1815–82
B,H,M,S,TB

BROWNE, John Ross
Irish/American 1821–75
H

BROWNE, Lewis
American 1897–
F,H,M

BROWNE, Margaret Fitzhugh
American 1884–
F,H,M,MP6/16

MARGARET FITZHUGH BROWNE

BROWNE, Mathilde
American 1869–
B,F,H,I

BROWNE, Stewart
English 19/20c.
GMC,POS

BROWNE, Tom (Thomas) Arthur
 English 1872–1910
 ADV,B,H,M,POS,TB,VO

Tom BROWNE

BROWNE, Walter East (Bud)
 American 1912–
 H,M

BROWNFIELD, Mick
 German late 20c.
 GR82

BROWNFIELD

BROWNHILL, Harold
 Canadian 1887–
 H

BROWNING, Amzie Dee
 American 1892–
 F,H,M

BROWNING, G. Wesley
 American 1868–1951
 B,F,H,M

BROWNJOHN, Robert
 American mid 20c.
 GR59–62

BROWNLOW, William Jackson
 American 1890–
 F

BRU, Salvador
 American late 20c.
 EI79

BRUBAKER, Jon O.
 American 1875–
 F,M

BRUBAKER, Lee
 American 1933–
 CON

Brubaker

BRUCE, John A.
 American 1931–
 CON

BRUCE, Margaret
 English 20c.
 M

BRUCE, Robert (Bob)
 Canadian 1911–81
 H,WS

Bob
Bruce
29

BRUCHNALSKI, Janusz
 Polish mid 20c.
 GR63–65

BRUDI, Walter
 German 1907–
 G,GR52–64,H

BRUEHL, Anton
 American mid 20c.
 GR52

BRUEHLER, Lenor Belterley
 American 1903–
 H,M

BRUESTLE, Bertram G.
 American 1902–
 F,H,M

BRUGGMANN, Werner
 Swiss mid 20c.
 GR61

BRULÉ, Al.
 American mid 20c.
 PAP

BRULE, Elmo A.
 American 1917–
 H

BRUMMER
 see
 ZIG

BRUMSTEEDE, Emile (Miles)
 Dutch mid 20c.
 GR52

BRUN, Donald
 Swiss 1909–
 CP,GR52 thru 63-66-67-68,H,POS

Donald Brun

BRÜN, Theodor
 German 1885–
 B,LEX

BRUNA, Dick
 Dutch mid 20c.
 GR57-59 thru 63-66-68

dick

BRUNCK-FREUNDECKE, Richard de
 French 20c.
 B

BRUNDAGE, William Tyson
 American 1849–1923
 B,BAA,F,I,M

BRUNELLESCHI, Umberto
 Italian 1879–
 B,H,POS,ST

BRUNELLESCHI

BRUNELLI
 Italian early 20c.
 AN

BRUNELLI

BRUNET, Adele Laure
 American 1879–
 H,M

BRUNETTA
 see
 MATELDI, Brunetta

BRUNHOFF, Jean de
 French 1899–1950
 B,M

BRUNHOFF, Laurent de
 French late 20c.
 EI82

LB

BRUNNER, Frederick Sands
 American 1886–
 F,H,M

BRUNNER, Sigismond Léopold
 French 19/20c.
 B

BRUNNER, Vratislav H.
 Czechoslovakian 1886–1928
 LEX,VO

VHB

BRUNNER, Zyg
 see
 ZYG

BRUNNER-STRO(E)SSER, Ruth
 American 1944–
 F,GR82,Y

Ruth Brunner-Strosser

BRUNOVSKY, Albín
 Czechoslovakian 1935–
 B,H

BRÜSCH, Béat
 Swiss late 20c.
 EI79

BRUSILOVSKY, A.
 Russian? late 20c.
 EI79

BRUSSE, Wim
 Dutch mid 20c.
 GR55-57-59

brusse

BRUTON, Margaret
 American 1894–
 H,M

BRUUN, Rolf Erik
 Finnish 1926–
 GR53-55-57-59-60-66,H

Bruun

BRYAN, Alfred
English 1852-99
B,H

BRYAN, Marguerite
American 20c.
M

BRYAN, William Edward
American 1876-
H,M

BRYANT, Harold Edward
American 1894-1950
H

BRYANT, Will
American 20c.
H

BRYCHCY, Bernhard
Prussian 20c.
LEX

BRYERS, Duane
American 1911-
CON

BRYGIDER, Edward
American 1916-
H

BRYLKA, Andreas
German 1931-
H

BRYSON, Bernard A.
American 1903-
GR65,H,M

BRYSON, Charles A.
American 20c.
H

BUBA, Joy Flinsch
American 1904-
H

BUBA, Margaret Flinsch
American 1914-
H,M

BUCEK, M.
Austrian early 20c.
LEX

BUCHEGGER, Erich
Austrian 1924-
B,H,LEX

BUCHER, Hans
Swiss mid 20c.
GR57

BUCHER, Otmar
Swiss mid 20c.
GR60-61-62

BUCHER-CROMIERES, Etienne
French mid 20c.
GR53-54-55-57-58-61-62-67

BÜCHLER, Robert
Swiss mid 20c.
GR61

BUCHNER, Georg
German 1858-1914
B,LEX,TB

BUCHOLZ, Emmaline Hardy
American 20c.
H,M

BUCHOLZ (BUCHHOLZ), Fritz
German 1871-
B,CP,LEX,TB,VO

BUCHSBAUM, Elizabeth Mabel
American 1909-
B,H,M

BUCHTERKIRCH, Armin
American 1859-
B,M

BUCHTGER, Robert
Russian 1862-
B

BUCKLAND, Arthur Herbert
English 1870–
B,M

BUDAY, György (Georg)
Hungarian 1907–
LEX,VO

BUDD, Charles Jay
American 1859–1926
B,EC,F,HA6/04,I,M

BUDD, Denison M.
American 1893–1944
F,H,M

BUDD, Katherine Cotheal
American early 20c.
F,H

BUDELL, Ada
American 1873–
F,H,M

BUECHLER, Katharina
Swiss late 20c.
GR82

BUEHR, Walter
American 20c.
GMC

BUELOW, John
American mid 20c.
GR57

BUFF, Conrad
Swiss/American 1886–1975
F,H,M

BUFFA, Giovanni
Italian 1871–
B,H,LEX,TB,VO

BUFFET, Bernard
French 1928–
B,DA,DES,GR59-60-61-64,H

BUFFINGTON, Eliza
American 1883–
H,M

BUFFONI, M.
Italian late 10c.
LEX

BUFFUM, Katharine G.
American 1884–1922
B,F,I,M

BUGBEE, Harold Dow
American 1900-63?
H,M

BUGBEE, Henry
American 20c.
M

BUHE, Walter
German 1882–
B,LEX,TB,VO

BUHLER, Augustus
American –1921
B,I,M

BÜHLER, Fritz
Swiss 1909–
GR52 thru 57-59-62-64,H,POS

BÜHLMANN, Paul
Swiss mid 20c.
GR54-61-62

BUHOT, Felix
 French 1847-98
 B,L,PC

F. Lix Buhot.

BÜHRER, Karl
 Swiss early 20c.
 POS

BUK
 see
 ULREICH, Eduard Buk

BUKOVAC, Vlacho
 Yugoslavian 1855-1923
 B,LEX

BUKOWSKI, Jan
 Polish 1873-1943
 AN,B

JAN BUKOWSKI

BULAS, J.
 Polish ac. early 20c.
 LEX

BULCOCK, Percy
 English 1877-1914
 BK

BULL, Charles Livingston
 American 1874-1932
 B,CEN12/06,EC,F,H,I,IL,M,Y

CHARLES LIVINGSTON BULL.

BULL, Johan
 American 1893-
 FM3/25 & 9/26,H,M

JOHAN BULL.

BULL-TEIMAN, (Mrs.) Gunvor
 American 1900-
 H,M,SO

BULLARD, Marion R.
 American 20c.
 F,H,M

BUMMERSTEDT, J. C.
 German
 LEX

BUNCE, Bill
 American mid 20c.
 GR54

BUNCHO, Ippitsusai
 Japanese ac. 1764-1801
 B,H,PC

BUNDT, Paul
 German 1864-
 B

BUNDY, Gilbert
 American 1911-55
 F,H,IL,M,Y

Gilbert Bundy

BUNGERT, Benno
 German ac. early 20c.
 LEX

Bgt.

BUNGERT, Gyula von
 Hungarian 1844-
 LEX

BUNJES, Emil
 American 20c.
 M

BUNKYO
 Japanese 1767-1830
 H

BUNN, William Edward Lewis
 American 1910-
 F,H,M

BUNNER, Rudolph F.
 American 19/20c.
 B,BAA,F,I,M,SN2/94

Rudolph F. Bunner

BUNNY, Rupert Charles Wulsten
 English?/Australian 1864-1947
 B,H,LEX

BURATINI, Angelo
 Italian early 20c.
 POS

BURBANK, Addison Buswell
 American 1895–
 F,H,M

BURBANK, James W.
 American 1900–
 H,M,poster:'Join The Navy'

JBURBANK

BURCH, Claire
 American 1925–
 H

BURCHARD, Peter Duncan
 American 1921–
 H

BURCHARTZ, Max
 German 1887–1961
 B,POS

BURCK, Jacob
 American 1904/07–
 CC,EC,H,M

BuRck

BURD, Clara Miller
 American 19/20c.
 B,F,H,M

BURDEN, Nancy Doris
 Canadian 1923–
 H

BURDICK, Doris
 American 1898–
 H,M

BÜRGEL, Bruno H.
 German 1875–1948
 LEX

BURGER, Carl
 American 1888–
 M

BURGER, Franz
 Austrian 1857–1940
 B,LEX,TB,VO

Fz B M

BURGER, HOTZEL and SCHLEMMER
 German/Austrian early 20c.
 POS

BURGER SCHLEMMER HOTZEL

BURGER, Ludwig
 Polish 1825–84
 B,H

L.B.

BÜRGER, (Prof.) Werner
 German 1908–
 G,GR52

W. Bürger

BURGESS, Ethel Kate
 English 19/20c.
 LEX,STU1900

BURGESS, Frank Gelett
 American 1866–
 B,F,H,M

BURGESS, Joseph E.
 American 1890–1961
 H

BURGHART, Toni
 German mid 20c.
 GR52

BÜRGY, Emmanuel
 Swiss 1863–
 B

BURIAN, F.
 Austrian ac early 20c.
 LEX

BURIKO
 Italian? early 20c.
 POS

BURKE, (Dr.) Edgar
 American 20c.
 M

BURKE, May Cornella
 American 1903–
 F,H,M

BURKERT, Nancy Ekholm
American 1933–
F,H

BURKH-MONGOLD
Swiss early 20c.
CP

BURKHARDT, A.
Swiss mid 20c.
GR65

BURKIEWICZ, Franciszek
Polish 20c.
LEX,VO

FB.

BÜRKNER, Hugo
German 1818–97
LEX

BURLEIGH, Averil M.
English –1949
B,M

AMB

BURLEIGH, Sidney Richmond
American 1853–1931
B,BAA,F,I,M,SO

BURLINGAME, Charles Albert
American 1860–1931
B,F,I,M,SO

BURLINGAME, Will
American 1942–
CON

WILL BURLINGAME

BURNAND, Gaston
Swiss mid 20c.
GR60

BURNE, Harry
American 20c.
M

BURNETT, Calvin W.
American 1921–
H

BURNEY, Edward Francis
English 1760–1848
B,H,M

BURNINGHAM, John Mackintosh
English 1936–
GR63–66,H

BURNLEY, John Edwin
American 1896–
H

BURNS, Irene
American 20c.
H

BURNS, Michael J.
American 19/20c.
B,BAA,CEN2/99 & 5/99,I,M,SCR11/02

Burns -98-

BURNS, Mike
American 1943–
CON,H

M BURNS ANS

BURR, A.
Canadian ac. 1884
H

BURR, George Elbert
American 1859–1939
B,F,H,I,M

GB

BURRA, Edward J.
English 1905–76
B,BRP,H,LEX,TB,VO

E J Burra

BURRIS, Burmah
American 20c.
H

BURROUGHS, John Coleman
American 1913–
H

BURROWS, Gordon
 English mid 20c.
 GR56

BURRUS, James H.
 American 1894–
 H

BURT, Marie Haines
 see
 HAINES, Marie Brunner

BURTIN, Will
 American 1908–
 GR52 thru 57–59–66–67,H

BURTON, Jack Munson
 American 1917–
 H,M

BURTON, Samuel Chatwood
 American 1881–
 B,F,H,I,M

BURTON, Virginia Lee
 American 1909–68
 F,H,M

BUSCH, Arnold
 German 1876–
 B,GWA

BUSCH, Kurt
 German 1902–
 LEX,TB,VO

BUSCH, Wilhelm
 German 1832–1908
 B,H,M,PC

BUSCH, Wilhelm M.
 German 1908–
 G,GWA

BUSCH-SCHUHMANN, Ruth
 German 20c.
 LEX

BUSH, Charles Green
 American 1842–1909
 EC

BUSH, Jack Hamilton
 Canadian 1909–77
 B,H,M

BUSH, William Broughton
 American 1911–61?
 H

BUSHMILLER, Ernest Paul
 American 1905–
 H,M

BUSONI, Rafaello
 Italian/American 1900–
 H,PAP

BUSS, Robert William
 English 1804–75
 B,H,M

BUSSE, Fritz
 Austrian/German 1903–
 G,H

BUSSET, Maurice
 French 1880–1936
 B,CP,M

BUSSIÉRE, Gaston
 French 1862–1929
 B,LEX,TB,VO

BUSSON DU MAURIER, Georges Louis Palmella
 French 1834–96
 B,LEX,TB

BUTCHER, Bill
 English late 20c.
 EI79

BUTCHER, Enid
English early 20c.
LEX,VO

E.B.

BUTCHKES, Sydney
American 1922–
GR53,H

BUTLER, Alban B., Jr.
American 20c.
M

BUTLER, Bernice
New Zealander 1902–
B

BUTLER, Edith F.
English early 20c.
ADV

BUTLER, Frances
American late 20c.
GR82

BUTLER, Herbert E.
English 19/20c.
B,LEX,TB

H.E.B.

BUTLER, Howard
American 20c.
H

BUTLER, (Sir) William Francis
Canadian ac. 1838–1910
H

BUTTE, Bruce
American mid 20c.
GR52-62-65-66-67

BUTTERA, Frank J.
American 20c.
M

BUTTER(S)WORTH, Roderick
American 1901–
H,M

BUTTON, Albert Prentice
American 1872–
B,F,M

BUTZ, Fritz
Swiss 20c.
GR52 thru 55-60

BUVAL, E.
French late 10c.
FO

E. BUVAL

BUZBY, Rosella T.
American 1867–
F

BUZEK, Elisabeth
Austrian 20c.
LEX

BYARD, Carole Marie
American 1941–
H

BYERS, Ruth Felt
American 1888–
H,M

BYLES, William Hounsom
English 1872–
B

BYLINA, Michal
Polish 1904–
B,H,M

BYRAM, Ralph Shaw
American 1881–
B,F,H,M

BYRD, David Edward
American 20c.
ADV

BYRD

BYRD, Robert John
American 1942–
H

BYRNE, John
Australian late 20c.
GR82

BYRNES, Eugene
American 1889–1974
H,M

BYSZEWSKA, Teresa
 Polish mid 20c.
 GR61

BYWATERS, Jerry
 American 1906-
 H,M

- C -

C. S.
 Kenyon early 20c.
 GMC

CABALLERO, José
 Spanish early 20c.
 GMC

CABRAL, António Teixeira
 Portuguese 1910-
 H

CAÇOILA, Aurora Severo
 Portuguese 1908-
 H

CADDEL, Foster
 American 1921-
 H

CADMUS, Egbert (Paul?)
 American 1868-1939
 ADV,B,F,H,I,M

CADORET, Michel de L'Epinequen
 Franco/American 1912-
 B,H

CADY, Walter Harrison
 American 1877-1970
 B,CEN7/07,EC,F,FOR,H,I,M,PE

CAGLI, Corrado
 Italian/American 1910-
 B,GR65-68(pg.641),H,M

CAHAN, Samuel George
 American 1886-1974
 F,M,SO

CAHARD, André
 French 20c.
 B

CAHÉN, Oscar
 Danish/Canadian 1915-56
 H

CAHILL, Arthur James
 American 1878-
 B,F,H,I,M

CAHILL, William Vincent
 American -1924
 B,F,H,HA6/09,I,M

CAIMITE, Lynn Ruskin
 American 1922-
 H

CAINE, Georges
 French 1856-1919
 B,M,L,TB

CALABRESE, Andrés
 Argentinean 1914-
 H

CALABRESI, Aldo
 Italian 1930-
 GR59 thru 63-65-67-68,H

CALAME, Georges
 Swiss mid 20c.
 GR59

CALAME, Jean Baptiste Arthur
 Swiss 1843-
 B,H,LEX,TB

CALAME, Juliette
 Swiss 1864-
 B

CALADIN
Spanish 19c.
POS

CALBET, Antoine
French 1860–1944
B,GMC

A. Calbet

CALDAS, António Pedro Barros Cruz
Portuguese 1898–
H

CALDAS, José Fernandes
Portuguese 20c.
H

CALDECOTT, Randolph
English 1846–86
B,BK,GMC,H,M,MM,S,STU1906,TB

RC.

CALDER, Alexander
American 1898–1976
ADV,APP,B,DA,DRA,DRAW,F,GMC,H,POS,SO

calder

CALDERWOOD, Kathy
American 20c.
P

CALFO, Jason
American late 20c.
GR52

CALI, François
French mid 20c.
GR54

CALKINS, Frank W.
American ac. 1896
H

CALKINS, Lorin Gary
American 1870–1960
F,H,M

CALLAN, Mary Catherine
American 1871–
B

CALLE, Paul
American 1928–
F,H,Y

CALLET-CARCANO, (Mme) Marguerite
Belgian/Italian 1878–
B,H

CALLIGAN, Edwin
English? early 20c.
ADV

CALMA, Monica C.
American 1907–
H,M

CALNEK, Louis Hermann
American 1922–
H,PLC

CALNEK

CALOGERO, Eugene D.
American 1932–
F,Y

CALURI, Bruno
Italian 1903–
H

CALVER, Dave
American late 20c.
GR85

Ⓒ

CALVERT, Edith
English 19/20c.
BK

E.C.

CALYO, Nicolini Vicomte
Italiam/American 1799–1884
D,F,H,I,M,Y

CAMARA, Leal da
Portuguese 1877–1948
B,LEX

CAMBELLOTTI, Duilio
Italian 1876–1960
B,H,M

CAMBIASO, Sefania
Italian 1887–
H

CAMELLI, Don Illemo
Italian 1876–1939
H

CAMERINI, Augusto
Italian 1894–
H

CAMERON, (Sir) David Young
English 1865–1945
APP,B,BK,H,M

CAMERON, William Ross
American 1893–
F,H,M

CAMIELEWSKI, Henryk
Polish mid 20c.
GR57

CAMILLE, Al
American mid 20c.
ADV

CAMILLE, Sister
American 1901–
H,M

CAMMEROTA, Dominic
American early 20c.
M

CAMOIN, Charles
French 1879–1965
B,H,LEX,TB,VO

CAMPANELLI, Daniel
American 1949–
H

CAMPBELL, Albert H.
American 1826–99
D,H

CAMPBELL, Blendon Reed
American 1872–
B,CEN2/05,CO2/05,F,H,I,M,SCR2/05,SO

CAMPBELL, E. Elmus
American 20c.
H,M

CAMPBELL, Elmer Simms
American 1906–71
EC,H

CAMPBELL, Ethel
American 20c.
H,M

CAMPBELL, Floy
American 1875–
F,H,M

CAMPBELL, Helen Eastman Ogden
American 1879–
B,F,H,M,SO

CAMPBELL, Heyworth
American 1886–
F,M

CAMPBELL, John Carden
American 1914–
H,M

CAMPBELL, John Patrick
English ac. 1900–19
B

CAMPBELL, Orson D.
American 1876–1933
D,H

CAMPBELL, Patrick
English ac. 1790s
D

CAMPBELL, Rosamond Sheila
Canadian 1919–
H

CAMPBELL, Sara Wendell
American 1886–1960
F,H,M

CAMPBELL, Stuart
American 20c.
M

CAMPBELL, V. Floyd
American –1906
B,BL1/05,I,M

[signature: Floyd Campbell]

CAMPBELL, Virginia
American 1914–
H

CAMPBELLOTTI, Duilio
Italain 1876–
AN,LEX,TB,VO

[monogram: CD]

CAMPEL, Jan
American 20c.
LEX

CAMPIGLI, Massimo
Italian 1895–1971
B,GR58–63,H

[signature: CAMPIGLI 55]

CAMPION, Emily C.
American early 20c.
M

CAMPOS, Emilio de Paula
Portuguese 1884–1943
H

CANALS, Ricard
Spanish 19c.
POS

CANCIAN, Sante
Italian 1902–47
H

CANDELL, Victor G.
American 1903–77
H,M

CANEVARI, Angelo
Italian 1901–
H

CANIFF, Milton A.
American 1907–
H,M

CANNING, P. W.
Canadian ac. 1874
H

CANNON, Marian
American 1912–
H,M

CANOVAS, Eduardo A.
Argentinean late 20c.
GR85

CANTÉRE, Jozef
Dutch early 20c.
GMC

CANTON, Shelly
American 20c.
P

CANTRÉ, Josef
Belgian 1890–1957
B,H,LEX

CANZI, Reszö Odön
Hungarian 1854–1906
B

CANZIANI, Estella L. M.
English 1887–1964
B,H,M

[monogram]

CAPERS, Harold Harper
American 1899–
F

CAPOBIANCO, Louis
American 20c.
M

CAPOGROSSI, Giuseppe
Italian 1900–
B,GMC,GR68

CAPOUILLARD
Belgian early 20c.
POS

CAPPA LEGORA, Cesare
Italian 1895–
H

CAPPADONIA, Giuseppe
Italian 1888–
H

CAPPIELLO, Leonetto
Italian/French 1875–1942
AD,ADV,B,BI,CP,FS,H,MM,POS

CARAN d'ACHE, (pseudonym for KANDACH,
Emmanuel Poire)
French 1858/59–1909
FS,GA,H,PG,POS

CARAWAY, James
American mid 20c.
GR53-54-55

CARBEN, Josef
German 1862–
B

CARBEN, Julius
German 1862–
LEX

CARBONI, Erberto
Italian 1899–
GR52-53-54-56-57-60,H,POS

CARDAIRE, Yvonne Madeleine
Swiss 20c.
B

CARDER, Malcolm M.
English mid 20c.
GR65

CARDIFF
American mid 20c.
PAP

CARDINAUX, Emile
Swiss 1877–1936
ADV,B,M,POS

CARDONA, J.
French 19/20c.
BI

CARDOZO, Francis
American ac. 1950s
H

CAREY, Alice G.
Canadian 1920–
H

CARI, G. DE
French ac. 1820
B,M

CARIGIET, Alois
Swiss 1902–
ADV,GR53-56-57-63,H

CARINI, Edward
American mid 20c.
GR53

CARL, Craig
American late 20c.
GR82

CARL, Katherine Augusta
American –1938
B,CEN10/05,F,H,I,M

CARLE, Eric
German 20c.
GR53-56-58 thru 61-63-65-66

CARLÈGLE, Charles Emile
French 1877-1936/40
B,FS

Carlègle

CARLETON, Clifford
American 1867-1946
B,F,H,I,IL,M,PE

C.Carleton. 90

CARLIN, Leon
American 20c.
GMC

CARLING, Ake
Swedish mid 20c.
GR52

CARLISLE, D. T.
American 20c.
M

CARLO, Giancarlo de
Italian mid 20c.
GR58

CARLONI, Giancarlo
Italian 20c.
H

CARLOS, J.
see
BRITO e CUNHA, José Carlos

CARLOS, Rui da Palma
Portuguese 20c.
H

CARLOTTI, Jean Albert
French 20c.
H

CARLSON, Charles X.
American 1902-
H

CARLSON, George L.
American 20c.
M

CARLSON, Jean
American 1952-
F,Y

CARLSON, Ken
American 1940?-
CON

Ken Carlson

CARLSON, Margaret Mitchell
American 1892-
F,H

CARLU, Jean Georges
French 1900-
AD,ADV,B,BI,CP,GR52-53-54-58,H,PG,POS

JEAN CARLU

CARLYLE, Robert
English 1773-1825
H

CARMER, Elizabeth Black
American 1904-
H

CARMI, Eugenio
Italian 1920-
CP,GR53-54-57-58-59-61-66,H

Carmi

CARNEIRO, Carlos
Portuguese 1900-72
B,H

CARNEIRO, Celso Herminio Freitas
Portuguese 1871-1904
H

CARNELL, Athea J.
American 20c.
F

CARNICERO
Spanish 19c.
B

CAROLIS, Adolfo de
see
KAROLIS, Adolfo de

CARON, Philippe
French late 20c.
EI82

CARON

CARPENTER, Dudley Saltonstall
American 1870–
B,I,M

CARPENTER, Earl L.
American 1931–
AA,H

CARPENTER, Helen K.
American 1881–
F,H

CARPENTER, Kate Holston
English 1866–
B

CARPENTER, Mia
American 1933–
GR62–65,IL

Mia Carpenter

CARPENTER, Mildred Bailey
American 1894–
F,H,M

CARPENTER, Orpha Klinker
American 20c.
M

CARQUEVILLE, William (Will)
American 1871–
B,CP,GA,MM,POS,R,TB

WILL CARQUEVILLE

CARR, Gene
American 1881–
B,F,H,I,M

CARR, Lyell
American 1857–1912
B,BAA,I,M

Lyell Carr

CARR, M. Emily
Canadian 1871–1945
H,M

M.E.CARR

CARR, Pauline
English late 20c.
EI79

CARR, Robert Burns
American 1906–
H,M

CARRÉ, Jean (Léon Georges Jean Baptiste)
French 19/20c.
M,R

CARRENO, Mario
American 1913–
B,H

Carreno

CARRICK, Valery
Russian/Norwegian 1869–
M

CARRIÉRE, Edmond
French 19/20c.
LEX

CARRIÈRE, Eugène
French 1849–1906
B,GMC,H

CARROLL, L. V.
American 20c.
AM12/25

L. V. CARROLL

CARROLL, Robert Joseph
American 1904–
H,M

CARROLL, Ruth
American 1899–
H

CARRUTHERS, Roy
South African/Anglo/American 1938–
F,GR65–67,P,Y

CARSON, James
American 1942–
CON

© Carson

CARTE, Antoine
Flemish 1886–1954
B,H,M

CARTER, A. Helene
American 1887–1960
F,H,M

CARTER, Albert Ross
American 1909–
H,M

CARTER, Bessie
Canadian 20c.
M

CARTER, Charles Henry
American 20c.
H

CARTER, Ellen Vavseur
English 1762–1815
B,H,M

CARTER, Frederick Timmins
American 1925–
H

CARTER, Gary
American 1939–
CON

Gary CARTER ₥

CARTER, Helene
see
CARTER, A. Helene

CARTER, Pruett A.
American 1891–1955
F,H,IL,M,POS,Y

PRUETT CARTER

CARTER, William Sylvester
American 1909–
H

CARTWRIGHT, Reg
English late 20c.
EI84

Reg Cartwright

CARTY, Leo
American 20c.
H

CARUCHET, Henri
French 19c.
B

CARUGATI, Eraldo
Italian/American 1921–
F,GR82–85,P,Y

CARUSO, Bruno
Italian 1927–
GR57–60–61–62–65,H

Bruno Caruso

CARVALHAIS, Jose Herculano Stunt Torres de
Almeida
Portuguese 1887–1961
B

CARVALHO, Cristiano de
Portuguese 1874–1940
H

CARVER, Steve
American late 20c.
GR85

CARY
American 20c.
H

CARY, (Miss) Page (Coffman)
American 1904–
H,M,SO

CARY, William de la Montagne
American 1840–1922
BAA,D,H,M,Y

W. MCary

CASADO, John
American late 20c.
GR85

CASALINI, Max
Italian late 20c.
GR85

CASANOVAS, Enrique
Spanish? 19c.
B

CASAROLI, Luciano
Italian 1934–
H

CASAS Y CARBO, Ramón
Spanish 1866–1932
CP,GMC,H,POS

R. Casas

CASAVANT, F., Jr.
American early 20c.
COL1/11

F. Casavant. Jr. 10

CASE, Elizabeth
American 1867–
F

CASEAU, Charles Henry
American 1880–
F,H,M

CASEY, F. De Sales
American –1934
F,M

CASEY, Jacqueline S.
American 20c.
ADV,GR68

CASEY, John J.
American 1878–1930
F,M

CASH, William Edmund, Jr.
American 1907–
H,M

CASIMACKER, A. de
French 19/20c.
B

CASON, Merrill
American 1929–
F,Y

CASPARI, Claus
German 1911–
LEX

CASPARI, Gertrude
German 1873–
LEX,TB,VO

G.C.

CASPARI, Walther
German 1869–
B,TB

W.C.

CASSADAY, Chase
American 20c.
M

CASSANDRE, A. M.
Russian/French 1901–68
AD,ADV,GMC,GR58–85,MM,POS

A.M.CASSANDRE

CASSEL, John Harmon
American 1873/75–1960
CEN8/04 & 6/05,EC,F,H,M

*Jno Cassel
1906*

CASSERES, Joe de
American mid 20c.
GR53

CASSIDY, Ira Diamond Jerald
American 1879–1934
B,F,H,I,M,SO

CASSIERS, Henri (Henrik)
Flemish 1858–1915
B,CP,GMC,H,M,MM,POS,TB

HCassiers

CASON, Hugh
English mid 20c.
GR54

CASTAGNO, John Edward
American 1930–
American Heritage 6/76, Philadelphia Public
Library, posters:'Rigoletto'–Pennsylvania
Opera Co.–1972, 'Philadelphia'–United Van
Lines–1976,*

Castagno

CASTAGNOLA, Salvatore
Italian/American 20c.
M

CASTAIGNE, J. Andre
French 1860–1930
CEN11/98–2/99–8/04–2/05,H,HA9/07,M,Y

d. Castaigne

CASTEL, Eric
French early 20c.
POS

CASTELLANO, Mimmo
Italian mid 20c.
GR57–59 thru 62–68

CASTELLI, Horace
French 1825–89
B,LEX,TB

h.C.

CASTELLON, Federico
Spanish/American 1914–71
APP,F,H,M,PC

FEDERICO CASTELLÓN

CASTIGLIONI, Romolo
Italian mid 20c.
GR60

CASTILEDEN, George Frederick
Anglo/American 1861–
F,H,I,M

CASWELL, Edward C.
American 1879–
F,H,M

CATAN-ROSE, Richard
American 1905–
H,M,SO

CATEL, Franz Ludwig
German 1778–1856
B,H,LEX,TB

C.

CATENACCI, (Ercole) Hercule
French 1816–84
B,H

CATHER, Carolyn
American 20c.
H

CATHERWOOD, Frederick
English 1799–1854
B,H,Y

CATO, Robert
American mid 20c.
GR52–63–65–66

Cato

CATTERMOLE, George
English 1800–68
B,H,M,TB

GC

CAUSÉ, Emile
French 1867–
B,LEX,TB

E. C.

CAVAILLÉS, Jules
French 1901–
GR57–58,H

J. CAVAILLES

CAVALCOLI, Gianni
Italian 1941–
H

CAVALIERE, R. J.
American 20c.
M

CAVANNA, Elise
American 20c.
H

CAVE, James
English early 19c., ac. 1801-17
B,H

CAY, A. M.
German early 20c.
POS

CAZALET, (Captain) Charles Henry
English 1818-60
H

CAZALS, Frédéric Auguste
French 1865-1941
GA,H,POS,TB

CAZENOVE, G.
French ac. early 20c.
LEX

CAZORELLI, Frank
American mid 20c.
PAP

CEBRIAN
Spanish 19c.
POS

CECELIN, Frank
American 20c.
H

CECI, Carlo
Italian 1917-
H

CEELY, Lincoln
English 19/20c.
LEX

CEFISCHER
see
FISCHER, Carl E.

CELLE, Edmond Carl de
see
de CELLE, Edmond Carl

CELLINI, Eva
Hungarian 20c.
H

CELLINI, Joseph
Hungarian/American 1924-
H

CÉLOS, E.
Canadian 19/20c.
BI

CENNI, Quinto
Italian 1845-1917
B,H

CERACCHINI, Gisberto
Italian 1899-
B,H,LEX,VO

CERF, Iwan
Belgian 1883-
B,POS

CERRUTTI, Henri
French early 20c.
POS

CÉS
see
KEISER, César

CESARE, Oscar Edward
Swedish/American 1885-1948
EC,M,SO

CESC
see
VILLA, Francisco

CESNAK, Jozef
Yugoslavian 1936-
H

CHABAS, Paul Emile
French 1869–1934
B,GMC,H

Paul Chabas

CHABOT, Lucille Gloria
American 1908–
H,M

CHABRIER, Nathalie
French 1932–
B

CHAGALL, Marc
Russian/French 1887–
ADV,APP,B,DA,DES,DRA,GMC,GR56-63-68,
H,PC,POS,TB,VO

Marc chagall

CHALIAPIN, Boris
American 1904–
B,H,M,SO

CHALK, John R., Jr.
American 1930–
CON

John Chalk

CHALMERS, Audrey McEvers
Canadian/American 20c.
H

CHALMERS, Mary Eileen
American 1927–
H

CHALON, Alfred Edward
English 1780–1860
B,H,M

Œ halon.

CHALON, Louis
French 1866–
B,M,TB

CHAM
see
d'AMEDEE, Comte de Noé

CHAMALIAN, Lillian
American 20c.
H

CHAMBERLAIN, Emily Hall
American –1916
B,H,I,M

CHAMBERLAIN, Jack B.
New Zealander/American 1881–1907
B,I,M

CHAMBERLAIN, Kenneth
American 19/20c.
CC,M

CHAMBERLAIN, Samuel V.
American 1895–1975
B,F,H,PE,TB,VO

SC

CHAMBERLIN, Helen
American 20c.
F,H,M

CHAMBERS, C. Bosseron
American 1883–
F,H,M

CHAMBERS, Charles Edward
American 1883–1941
F,H,IL,M,POS

C. E. Chambers

CHAMBERS, Fanny Munsell
American –1920
B,I

CHAMBERS, Frank
American 1859–1939
M

CHAMBERS, Robert William
American 1865–1933
B,F,H,I,M,R

RW Chambers

CHAMBERS, William
American 1932/40–
F,H,Y

CHAMBRY, Paul
French early 20c.
AD

Paul Chambry

CHAMPNEY, James Wells
American 1843–1903
B,BAA,F,H,I,M

J.W.Champney.

CHAMPNEY, W. L.
American ac. mid 19c.
D

CHAMPON, Edmond Charles Constantin
French 1879–
B

CHAMPSEIX, E. Paul
French early 20c.
POS

CHANCE, Frederick
American 20c.
ADV,GR64,M

FRED CHANCE

CHANDLER, George Walter
American ac. 1926
F,H,I,M

CHANDLER, Helen Clark
American 1881–
F,H,M

CHAPELLIER
French 19/20c.
CP

CHAPERON, Eugene
French 1857–
B,H

CHAPIN, Archibald B.
American 1875–
F

CHAPIN, John R.
American 1823–1904
B,D,H,I,M

CHAPMAN, Abel
English 1851–1929
H

CHAPMAN, Carlton Theodore
American 1860–1926
B,BAA,F,I,M

CARLTON. T. CHAPMAN

CHAPMAN, Charles Shepard
American 1879–1962
B,CEN10/09,F,H,I,IL,M,SCR2/05,SO,Y

Charles S. Chapman.

CHAPMAN, Cyrus Durand
American 1856–1918
B,BAA,F,H,I,M

CHAPMAN, Frederic A.
American 1818–91?
BAA,D,H

CHAPMAN, Frederick F.
American 1887–
H

CHAPMAN, Frederick Trench
American 1887–
H,IL,Y

CHAPMAN, Gaynor
English 1935–
GR63–64–65–67

Gaynor Chapman

CHAPMAN, George
English mid 20c.
GR56–59

CHAPMAN, Hester W.
English mid 20c.
GR58

HESTER W. CHAPMAN

CHAPMAN, Howard Eugene
American 1913–77
H,M

CHAPMAN, John Gadsby
American 1808–90
B,BAA,D,F,H,I,M,PC

CHAPMAN, Kenneth Milton
American 1875–1968?
B,F,H,I,M

CHAPMAN, Paul
American 20c.
H,M

CHAPMAN, Walter Howard
American 1912–
H,M

CHAPPEL, Alonzo
American 1828–87
BAA,D,H,M

CHAPPEL, Warren
American 1904–
H,M

CHAPRONT, Henry
French 1876–1865
B

CHAPUIS, Hippolyte
French 1843–
B,TB

H.C

CHARBONNIER, J.
French 20c.
GMC

CHARBONNIER, Pierre
French 1897–
B,LEX,VO

CHARDIN, Paul Louis Léger
French 1833–
B

CHARLEMAGNE, Adolf Jossifowitsch
Russian 1826–1901
B,TB

A.CH.

CHARLEMAGNE, Joseph Adolfowitsch
Russian 19/20c.
B

CHARLEMONT, Hugo
Austrian 1850–1939
B,BAA,H,LEX,TB,VO

H.Ch.

CHARLES, Geraldine
American 20c.
H

CHARLES, Milton
American mid 20c.
PAP

CHARLES, William
American 1776–1820
B,CC,D,EC,F,H,I

Charles

CHARLOT, Jean
French/Mexican/American 1898–1979
APP,B,F,H,M,PC,SO

Jean Charlot 36

CHARLOT, Martin Day
American 1944–
AA,H

CHARLTON, Georges
English 1899–
B,M

CHARLTON, John
English 1849–1910/17
B,H,M

CHARMATZ, William (Bill)
American 1925–
F,GR52-60-62-63-65-67,Y

charmatz

CHARMOT, Jacqueline
French 1907–
B

CHARMOZ, Jacques
American/French 1856–1909
GR65-66,M

jacques charmoz

CHARPENTIER, Alexandre
French 1856–1909
B,LEX

CHARRIER, Michel
Swiss late 20c.
GR85

CHARUSHIN, Evgeny Ivanovich
Russian 1901–
H,S,PC

CHASE, Edward Leigh
American 1884–1965
F,H,M

CHASE, Elsie Rowland
American 1863–1937
F,H,M,SO

CHASE, Rhoda
American 20c.
M

CHASE, Sidney March
American 1877–1957
F,H,HA6/09

S·M·Chase

CHASEMORE, Archibald
English late 19c.
B

CHASMAN, David
American mid 20c.
GR60

CHATINIÈRE, Antonin Marie
French 1828–
B,FO

CHAVAL
see
LE LOUARN, Yvan

CHAVANNE, Rose
American 1907–
M

CHAVES, Lawrence
American 20c.
M,S

CHAVIGNAUD, Léon
French early 20c.
LEX

CHEESE, Bernard
English mid 20c.
GR54

CHEESE, Chloë
English late 20c.
EI79

Chloe Cheese

CHEESMAN, Roy M.
American 20c.
M

CHEFFER, Henry Lucien
French 1880–
B,LIL7/7/28

CH

CHEFFETZ, Asa
American 1896/97–1965
APP,F,H,M

CHEN, Tony (Anthony)
West Indian/American 1929–
H,Y

CHENEY, Philip
American 1897–
H,M,SO

CHENNEY, Stanley James
American 1910–
H

CHEREMNYKH, Mikhail
Russian 1890–1962
CP,EC,POS

CHÉRET, Jules
French 1836–1932
ADV,AN,B,BI,CP,FO,GA,GMC,GR59,H,L,M,
MM,PC,POS,R,SI,TB

CHERMAYEFF, Ivan
Anglo/American 1932–
ADV,F,GR61-62-63-66-67-68,H,POS,Y

CHERRY, Burton
American mid 20c.
GR53

CHERRY, Lynne
American 20c.
C

CHERRY, S.
American mid 20c.
PAP

CHESNEY, Paul
English early 20c.
ADV

CHESTERMAN, Adrian
English late 20c.
EI79

CHESTNEY, Lillian
American 20c.
H

CHESWORTH, Frank
English 19/20c.
BI

CHEVALIER, Nicolas
Swiss/Russian 1830–1902
B,H,LEX,TB

CHEVALIER, Paul Maurice
French 1898–
B

CHEVALIER, Paul Sulpice Guillaume (GAVARNI
pseudonym)
French 1804–66
B,CP,EC,H,PC,PG,POS

CHIAPPELLI, Aldo
Italian 1907–
H

CHIATTONE
Italian early 20c.
POS

CHICHESTER, Cecil
American 1891–
F,H,M

CHICKERING, Charles R.
American 20c.
M

CHIESA, Alfred
American mid 20c.
GR60

CHILCOT, Thomas Charles
English 1883–
B

CHILD, Charles Jesse
American 1902–
B,H,M

CHILD, Edwin Burrage
American 1868-1937
B,CO1/05,F,H,I,M,TB

-Edwin-B-Child-

CHILDS, Joseph
American -1909
B,I,M

CHIMOT, Edouard
French 20c.
AD,B

Chimot

CHIOSTRI, Sofia
Italian 1898-
H

CHIP
see
BELLEW, Frank Henry Temple (Chip)

CHIRIACKA, Ernest
American 1920-
CON,H

E. chiriacka

CHLAD, Boldan
Czechoslovakian 1881-
LEX

CHŌ
see
TAIZAN

CHOATE, Florence
American 20c.
M

CHOBSOR
French early 20c.
CP

CHODOWIECKA, Suzanne
Polish 1763/64-1819
B

CHODOWIECKI, Daniel Nicholas
German 1726-1801
EC,H,M,PC

CHODOWIECKI (cont'd)

D Chodowiecki

CHOMPRÉ, S.
French early 20c.
ST

S. Chompré

CHOMTON, Werner
German 1895-
LEX,TB,VO

C.H.

CHOPPING, Richard
English mid 20c.
GR61-62-63-65

CHORIS, Louis (Login) Andrevitch
Russian 1795-1828
B,H,M

CHOTĚNOVSKÝ, Zdeněk
Czechoslovakian 1929-
GR58-60 thru 65-68,H

CHOUBRAC, Alfred
French 1853-1902
B,CP,FO,POS

Houbrac

CHOUBRAC, Léon
French 1847-85
B,CP,POS

CHOUKHAIEFF, Vassili Ivanovitch
Russian 1887-
B

CHOWDHURY, Dilip
Indian mid 20c.
GR61

CHRISTENSEN, Gardell Dano
American 1907-
H

CHRISTENSEN, Ralph A.
American 1886?-1961
F,H

CHRISTENSEN, Ronald Julius
American 1923–
GR58,H

CHRISTIAN, Erica
Austrian 20c.
LEX

CHRISTIANSEN, Hans
German 1866–1945
AN,MM,POS

HANS CHRISTIANSEN

CHRISTMAS, (Rev.) Henry
Canadian 1811–68
H

CHRISTODOULOU (CHRISTO-DOULOU), Paul
English 20c.
B,CPP

Christodoulou

CHRISTOPHE, Franz
Austrian 1875–
AN,B,LEX,TB

CHR

CHRISTY, (F.) Earl
American 1883–
M,VC

F. EARL CHRISTY

CHRISTY, Howard Chandler
American 1873–1952
ADV,B,CEN8/96,F,GMC,H,I,IL,M,POS,SO,Y

Howard Chandler Christy 1909

CHRYSTIE, Edward
American 20c.
M

CHTERENBERG, David
Russian 1881–1942
B

CHUN, David P.
American 20c.
H,M

CHURBUCK, Leander M.
American 1861–
B,F,H,I,M

CHURCH, Frederick Stuart
American 1842–1924
B,BAA,CEN3/04,F,H,HA,I,M,SN2/94,TB,Y

F.S.CHURCH.

CHURCHILL, Francis G.
American 1876–
F,SO

CHWAST, Jacqueline
American 1932–
H

CHWAST, Seymour
American 1931–
CP,F,GR55 thru 59–61 thru 68–82–85,H,P,PG,
POS,Y

chwast

CID, Jorge
Portuguese 20c.
H

CIESLEWICZ, Roman
Polish 1930–
B,CP,GR57 thru 68,H,POS

R. Cieslewicz

CIHANKOVÁ, Jamila
Yugoslavian 1925–
H

CILITIS, Gunārs Augusta
Latvian 1927–
LATV

9.C
57

CIMA, Luigi
Italian 1860–
B,H,LEX,TB

CL

CIMINO, Harry
 American 1898–
 F,H,M

CINAMON, Gerald
 American mid 20c.
 GR60

CINATH, Ludwig John
 American 1914–
 H,M

CINGOLI, Giulio
 Italian 20c.
 H

CIOLKOWSKI, H. S.
 French ac. early 20c.
 B,LEX,STU1912,VO

CIPÁR, Miroslav
 Yugoslavian 1935–
 H

CIRLIN, Edgard
 Canadian/American 1913–
 PAP

Cirlin

CIRULIS, Kārlis Pētera
 Latvian 1925–
 LATV

ČA

CISNEROS, José
 Mexican 1910–
 H

CISSARZ, Johann Vincente
 Swedish/German 1873–1942
 AN,B,CP,MM,POS,TB

J. V. Cissarz 94

CITO, M.
 French early 20c.
 ST

ano. cito

CLACK, Clyde Clifton
 American 1896–1955
 H

CLAIRIN, Georges (Jules Victor)
 French 1843–1919
 B,BAA,FO,H,POS,TB

J. Clairin

CLARKE, Edward
 Canadian ac. 1879
 H

CLARK, Alson Skinner
 American 1876–1949
 B,BAA,F,H,I

CLARK, Benton Henderson
 American 1895–1964
 H,IL,M

Benton Clark

CLARK, Christophor
 English 1875–1942
 B,H,M

CLARK, Emery
 American 20c.
 M

CLARK, Emma E.
 American 1883–1930
 M

CLARK, (Prof.) Harry
 American 20c.
 M

CLARK, Herbert Francis
 American 1876–
 B,F,SO

CLARK, James
 English 1858–1943
 B,H,M

CLARK

CLARK, James Alfred
American 1886–
EC

CLARK, James E.
American 20c.
GR52

CLARK, Joseph Benwell
English 1857–
B,H,LEX,STU1907

CLARK, Matt
American 1903–
F,H,IL,M,Y

*MATT
CLARK*

CLARK, Ralph Samuel
American 1895–
H,M

CLARK, Sarah L.
American 1869–1936
F,H,M

CLARK, Virginia Keep
American 1878–
B,F,H,I,M

CLARK, Walter Appleton
American 1876–1906
B,H,HA8/04,I,IL,M,TB,Y

Walter Appleton Clark

CLARKE, Carl Dame
American 1904–
H,M

CLARKE, Edgar
American late 20c.
GR82,H

CLARKE, (Rev.) Edward Daniel
English 1769–1822
H

CLARKE, Frederic Colburn
American? 19/20c.
HA10/03

FREDERIC COLBURN CLARKE

CLARKE, George Row
English ac. 1858–88
B,H

CLARKE, Harry
Irish 1888/90–1931
AN,B,S,VO

C

CLARKE, Harry
Irish 1840–
LEX

CLARKE, René
American 1886–
ADV,F,H,IL,M,POS,STU1926,Y

R.C.

CLARKE, Robert James
American 1926–
EC

CLARKE, Thomas
American ac. early 20c.
PE

J. Clarke

CLARKIN, Lucille Marie
American 1907–
H

CLARKSON, John D.
American 1916–
H,M

CLARO, Rodolfo
Argentinean 1902–
H

CLARRY, Siriol
English mid 20c.
GR60

CLASTER, Ab
Dutch mid 20c.
GR57

CLAUDIUS, Wilhelm Ludwig Heinrich
German 1854–1942
LEX,TB,VO

W. C.

CLAVÉ, Antoni
Spanish/French 1913–
B,GR52-53-54-57,H,MM,POS

clavé

CLAVERICE, Jean
French late 20c.
GR82

CLAXTON, Adelaide (Turner)
English 1842–
B,H

CLASTON, William Rockliff
American 1903–
GR59-60,H

CLAY, John Cecil
American 1875–1930
EC,M

CLAYTON, Eleanor (Ellen) Creathrone
Irish 1846–
H

CLAYTON, Frances
American 20c., ac. 1932
M

CLEARY, Joseph S.
American 1926–
IL

clea

CLEAVER, Elizabeth
Canadian 1939–
H

CLEAVES, Muriel Mattocks
American –1947
F,H,M

CLELAND, Thomas Maitland
American 1880–1964
ADV,AM11/25,B,F,H,I,IL,M

McCleland

CLEMENT, Joseph Massy
Anglo/American 1894–1956
H,M,PAP

– JM CLEMENT –

CLEMENT, Joseph Maxime
French 20c.
M

CLERE, Hazel
American 20c.
H,M

CLERICE (brothers)
French early 20c.
FO

CLERICI, Fabrizio
Italian 1913–
B,GR53,H

CLERICI, Renzo
Italian mid 20c.
GR60

CLIFFORD, Edward Charles
English 1858–1910
B,H

CLIFFORD, Harry P.
English ac. early 20c.
B,LEX,STU1908,TB

H.P.C.

CLIFFORD, Judy Dean
American 1946–
AA,F,Y

CLIFT, John Russell
American 1925–
GR56-57,H

CLIFTON, Adele Rollins
American 1875–
F,M

CLINEDINST, Benjamin West
American 1859–1931
B,CEN11/98 & 2/99,F,I,IL,M

CLINKER, Leroy C.
American 20c.
M

L.C.Clinker

CLISBEE (KLIZ), George
American 20c.
M

CLOETINGH, James H.
American 1894–
H,M

CLOUET
French 19/20c.
CP

CLOUSTER, K. Warren
English 19/20c.
LEX

CLOUZOT, Marianne
French 1908–
B,M

CLOWES, Paul
American 20c.
M

CLUTE, Bealah Mitchell
American 1873–
B,F,H,I

CLUTE, Walter Marshall
American 1870–1915
B,F,I,M

CLYMER, John F.
Canadian/American 1907–
CON,F,H,IL,M,Y

COALE, Griffith Bailey
American 1890–1950
F,H,I,M,Y

COAN, Frances C. Challenor
American 20c., ac. 1932
F,M,SO

COAN, Helen E.
American 19/20c.
B,F,H,M

COATES, Palgrave Holmes
American 1911–
H,M

COATS, Alice M.
American 20c.
M

COATS, Amelia
American 20c.
M

COBB, Ron
American 1937–
PG

COBER, Alan E.
American 1935–
AA,F,GR82–85,H,IL,P,PG,Y

COBHAM, Ethel Rundquist
American 20c.
H,M

COBURN, Frederick Simpson
Canadian 1871–1960
H,M

COBURN, Frederick William
American 1870-1953
F,H,M

COCHRAN, George McKee
American 1908-
H

COCHRANE, Constance
American 20c.
F,H,M

COCKBURN, (Maj.-Gen.) James Pattison
Anglo/Canadian 1778-1847
B,H

COCKCROFT, Dave
English late 20c.
EI82

DC.

COCKING, Thomas
Irish ac. 1783-91
H,M

COCKS, H. S.
English mid 20c.
GR52

CoCONIS, Constantinos (Ted)
American 1937-
F,IL,Y

T Co Conis

COCTEAU, Jean
French 1892-1963
ADV,B,GMC,GR52-55-56,H,M,POS

Jean Cocteau

CODOGNATO, Plinio
Italian 1879-1940
AD,BI,H

COE, Ethel Louise
American 1880-1938
F,H,I,M

COE, Lloyd
American 1899-1977
H,M

COE, Sue
American late 20c.
EI79-82-84

Sue Coe

COELHO, Crisóstomo Alberto Mendes Ferreira
Portuguese 1938-
H

COELHO, Eduardo Teixeira
Portuguese 1919-
EC

COES, Kent Day
American early 20c.
H,M

COFFIN
English mid 20c.
GR53

COFFIN, Frederick M.
American ac. 1856
D,M

COFFIN, George Albert
American 1856-1922
B,F,LEX

COFFIN, Haskell
American early 20c.
B,GMC

Haskell Coffin

COFFIN, Robert P. Tristram
American 1892-
F,H,M

COG(H)ILL, Bobs
see
HAWORTH, Zema Barbar Coghill

COGSWELL, Ruth McIntosh
American 1885-
F,H,M

COHELEACH, Guy Joseph
American 1933?-
CON,H

Guy Coheleach

COHEN, Serge
late 20c.
GR85

COHEN, Stephen Donald
American 1940–
H

COINER, Charles Tousey
American 1898–
F,H,M

COLBY, George Wilbur
American 19/20c.
F,H,M

COLBY, Homer Wayland
American 1874–1950
F,H,M

COLE, Fred
American early 20c.
AM7/23

Fred Cole

COLE, (Sir) Henry
English 1808–82
B,H

COLE, Herbert
English 1867–1930
B,BK

H·C

COLE, Tom A.
American 20c.
H

Tom A. Cole

COLEMAN, Ralph Pallen
American 1892–1968
F,H,IL,M

RALPH
PALLEN
COLEMAN

COLEMAN, William Stephen
English 1829–1904
B,H,M

COLGROVE, Ronald B.
American 1930–
H

COLIN, Jean
French 1912–
GR52 thru 61–63,H

JEAN COLIN

COLIN, Paul
French 1892–
AD,B,CP,H,MM,POS

PAUL
COLIN

COLKETT, Gordon
American 20c.
M

COLL, Joseph Clement
American 1881–1921
B,F,I,IL,PE,Y

Coll

COLLADO, M. Fernandez
Spanish 19?/20c.
LEX

COLLER, Henry
English 20c.
M

COLLETTE
French early 20c.
ST

COLLIER, Alan Caswell
Canadian 1911–
H,M

COLLIER, Carroll Lloyd
American 1923–
CON

Carroll Collier

COLLIER, John
American 1948–
F,Y

COLLIER, Nate (Nathan Leo)
American 1883-1961
CG10/34,F,H,M

Nate Colliers

COLLIN, Hedvig
American 20c.
M

COLLINS, David
English mid 20c.
GR56-58

David Collins

COLLINS, Fred L.
American 1876-
F

COLLINS, George Edward
English 1880-1968
B,H

COLLINS, Harold Dean
American 1898-
H

COLLINS, John Walter
American 1897-
H,M

COLLINS, Kreigh
American 1908-74
H

COLLINS, Marjorie S.
American mid 20c.
F,GR57

COLLINS, Roy Huse
American 1883-1949
AM11/15,H,IL,SO

R.H.Collins

COLLINS, Sewell
American 1876-
B,I

COLLINS, Walter
American 1870-1933
F,H?,M

COLLISON, Marjory (Schulhoff)
American 1902-
H

COLSON, Frank V.
American 1894-
F

COLVILLE, Alex (Alexander)
Canadian 1920-
B,GR85,H

COLWELL, Elizabeth
American 1881-
F,H,M,SO

COLWELL, Worth
American 20c.
H,M

COMBAZ, Gisbert
Belgian 1869-1941
B,MM,POS

COMBES, Lenora Fees
American 1919-
H

CÔME, Raymond
Belgian mid 20c.
GR65-66-68

Côme

COMFORT, Charles Fraser
Scots/Canadian 1900-
B,H,M,WS

COMFORT '48

COMITO, Nicholas U.
American 1906-
H,M

COMMARMOND, Pierre
French early 20c.
B,POS

P. Commarmond

COMPTE, Pierre M.
French mid 20c.
GR53 thru 57-60-61-66

COMPTON, Carl Benton
American 1905-
H,M

COMPTON, Edward Th.
English 1849-
B,H,LEX,TB

ETC

COMSTOCK, Anna Botsford
American 1854-1930
B,F,I,M

COMSTOCK, Enos Benjamin
American 1879-1945
B,F,H,I,M

COMSTOCK, Frances Christine Bassett
American 1881-
B,F,H,I,M

CONACHER, D.
American 19/20c.
LEX

CONACHER, John
American 1948-
Y

CONACHER, John C.
American 1876-1947
EC,F,HA8/01,M,PE

J. CONACHER.

CONADAM, Adolf
German 1857-
B

CONANT, Homer
American early 20c.
GMC(67)

**HOMER
·CONANT·**

CONANT, Mina
American 20c.
M

CONDAK, Clifford Ara
American 1930-
F,GR60-61-68,P,Y

CONDON, Grattan
American 1887-1966
F,H,IL,M

GRATTAN CONDON

CONFALONIERI, Giulio
Italian 1926-
GR60-61-63-65 thru 68,H

Giulio Confalonieri

CONLEY, Sara Ward
American 1861-
F,H,M

CONLON, James H.P.
American 1894-
H,M

CONNARD, Philip
English 1875-1958
B,BK,M,TB,VO

CONNELLY, Darrill
American mid 20c.
GR52-53

*darrill
connelly*

CONNELLY, George L.
American 1908-
H

CONNELLY, Marc
American 20c.
F

CONNER, Bruce
American 1933/38-
H

CONNER, McCauley
American 1913–
IL

Conner

CONNOLLY, Jerome
American 1931–
H

CONNOLLY, Patrick
American 1931–
H

CONOVER, Alida
American 1904–
H,M,SO

CONRAD, Freddy
Belgian mid 20c.
GR53

CONRAD, Rupert
American 1904–
H,LEX

CONRAD, Timothy A.
American early 19c.
D

CONRAN, Terence
English mid 20c.
GR53

CONREY, Lee F.
American 1883–
F

CONSTANT, George J. Zachery
American 1892–1978
APP,F,H,M,SO

CONSUELO-FOULD
German 1862–1927
LEX

CONTENT, Daniel
American 1902–
F,H,IL,M,Y

DAN CONTENT

CONTENT, Ira
American mid 20c.
GR54

CONTI, Oscar
Chilean 1914–
H

CONTI, Tito
Italian 1842–1924
B,H,LEX,TB

J.C.

CONTRERAS, José Melendez
Puerto Rican mid 20c.
GR54

CONWAY, Gordon
American early 20c.
GMC

COOK, Frances Kerr
see
COOKE, Frances Kerr

COOK, Gladys Emerson
American 1899–
H

COOK, Howard Norton
American 1901–
APP,F,FM3/25,H,M,PC

HOWARD N COOK

COOK, John
American 1904–
ADV,H

COOK, Lauren W.
American 20c.
H,M

COOK, Richard
English 1784–1857
B,H,M

COOK, (Mrs.) S. E.
see
BEMAN, Jean

COOK-SMITH, J. B.
See
BEMAN, Jean

COOKE, Cromwell
English mid 20c.
GR53

COOKE, Donald Ewin
American 1916–
H,M

COOKE, Dorothea
American 1908–
H

COOKE, Edna
American 1890–
F,GMC,H

Edna Cooke

COOKE, Frances Kerr
American 1909–
F,H,M

COOKE, Hereward Lester, Jr.
American 1916–
H

COOKE, Jessie Day
American 1872–
F,H,M

COOKE, Roger
American 1941–
CON

Roger Cooke

COOKINS, James
American 1835?–1904
B,D,F,I

COOLEY, Gary
American 1947–
F,Y

COOLEY, Lydia
American 1907–
H,M,SO

COOLIDGE, C. M.
American 19/20c.
BI

COOLIDGE, John (Earle) Templeman, Jr.
American 1882–
F,H,I

COONEY, Barbara
American 1917–
H,M

COOPER, Alfred Heaton
English 1864–1929
B,H,M

COOPER, Austin
English 1890–1964
ADV,MM,POS

AUSTIN COOPER

COOPER, Barbara Ritchie
American 1899–
H,M

COOPER, Colin Campbell
American 1856–1937
B,F,H,LEX

Wiy Campbell Cooper

COOPER, Fred (Frederic) G.
American 1883–1962
ADV,F,FOR,H,POS

fgc

COOPER, George Victor
American 1810–78
D,H,M

COOPER, Heather
Canadian late 20c.
GR82

COOPER, James Graham
American 1830–1902
BAA,D,F,H

COOPER, Leone
American 1902–
H

COOPER, Mario Ruben
Mexican/American 1905–
F,FOR,H,IL,M,Y

MARIO
COOPER

COOPER, Royston
English mid 20c.
GR60-61

COOTES, Frank Graham
American 1879-1960
F,H,M

COPE, Charles West D. J.
English 1811-90
B,H,LEX,TB

COPELAND, Charles G.
American 1858-
B,F,I,M

COPELAND, Patrick Forbes
Canadian 1860-1933
H

COPI
French mid 20c.
GR65

COPLANS, Peta
English late 20c.
EI79

COPPING, Harold
English 1863-1932
ADV,B

CORBEN, Richard
American 20c.
NV

CORBOULD, Edward Henry
English 1815-1905
B,H,M

CORBOULD, Henry
English 1787-1844
B,H,M

CORBOULD, Richard
English 1757-1831
B,H,M

CORCOS, Lucille
American 1908-73
F,H,M,SO,Y

CORCOS, Vittorio Matteo
Italian 1859-1933
B,H,M

CORDEIRO, Calisto
Brazilian 1877-1957
EC

CORDESSE, Louis
French 1938-
B

CORDIER, Eugene Maria
German/French 1903-74
CP,POS,VO

CORDREY, Earl Somers
American 1902-
H,M

CORETTE, Alphonse
French 19/20c.
LEX

COREY, Robert
American mid 20c.
GR59-60,H

CORINTH, Lovis
German 1858-1925
AN,B,DA,DES,DRA,H,LEX,TB,VO

CORNARO, Hans
Austrian 1899-
LEX

CORNELIUS, Marty
American 1913-79
F,H

CORNELIUS, Ray Mel
American late 20c.
GR85

CORNELIUS, Siegfried (Cosper)
Danish 1911–
EC

COSPER

CORNELL, Jeff
American 20c.
C

J. Cornell

CORNET I PALAU, Gaietá
Spanish 1878–1945
EC,POS

CORNIC, Alain
French mid 20c.
GR57

CORNIN, Jon Corka
American 1905–
H,M

CORNWELL, Dean
American 1892–1960
B,F,FOR,H,I,IL,M,PAP,Y

DEAN
CORN
WELL

CORR, Christopher
English late 20c.
EI79

CORRADO, L. A.
American mid 20c.
PAP

CORREIA DIAS DE ARAÚJO, Fernando
Portuguese/Brazilian 1893–1935
EC

CORRELL, Richard
American 1904–
H,M

CORRIGAN, Barnara
American mid 20c.
GR52

CORRODI, Wilhelm August
Swiss 1826–85
B

CORSON, Grace
American 20c.
M

CORSON, Katherine Langdon
Anglo/American ac. 1895–1937
B,F,H,I,M

CORTESE, Edward Fortunato
American 1922–
H

CORTI, C.
Italian early 20c.
LEX

CORUTNEY, Leo
American 20c.
M

CORY, Fanny Young Cooney
American 1877–
B,H,HA11/02,I,M,SCR11/02

F.Y.CORY — CORY 1902

CORY, Gustav
Austrian 19/20c.
LEX

CORY, Sarah Morris
American –1915
B,BAA,I

COSGRAVE, John O'Hara II
American 1908–68
B,H,M,SO

COSIMINI, Roland Frances
American 1898–
F,H,M

COSL-FREY
Austrian early 20c.
POS

COSL-FREY

COSPER
see
CORNELIUS, Siegfried

COSTA, Francisco Pereira da
Portuguese 1893–
H

COSTA, Nuno Santos
Portuguese 1921–
GR53,H

COSTANTINI, Flavio
Italian 1926–
GR58-59-63-66-67-68-82,H,PG

F. Costantini

COTÉ, Harvey
American mid 20c.
GR60

COTSWORTH, Staats
American 1908-79
H,M

STAATS COTSWORTH

COTTA, J. A.
Argentinean mid 20c.
GR52

COTTON, John Wesley
Canadian 1868-1931
B,F,H,I,M

COTTON, William Henry
American 1880-1958
F,GMC,H,M

COUALLIER, R. Ph.
French 20c.
B

COUCH, Greg
American late 20c.
GR85

COUCH, R. William
American 1929–
CON

R. Wᵐ Couch

COUGHLIN Mildred Marion
American 1895–
F,H,M,SO

COUGHTRY, (John) Graham
Canadian 1931–
GR58-59,H

COUGHTRY

COURATIN, Patrick
French late 20c.
EI79

COURBOIN, Eugène
French 19/20c.
B,FS,L,TB

Èᵘᵍ- COURBOIN

COURBOIN, François
French early 20c.
B,LEX,STU1907

COURIER
American 19c.
POS

COURTOIS, Gustave
French 1852/53-1923/24
B,BAA,GMC,H

GUSTAVE COURTOIS

COURTOS, Tom
American mid 20c.
GR60

COURVOISIER, Jules
Swiss 1884–
LEX,VO

J.C.

COUSE, William Percy
American 1898–
H,M

COUTHOUY, J. P.
American ac. mid 19c.
D,H

COUTINHO, Manuel Gouveia
Portuguese 1907–
H

COUTINHO, Manuel de Vasques da Cunha
 Portuguese 1846-1915
 H

COUTTS, Gordon
 American 1880-1937
 F,H,M

COUTURIER
 French ac. early 20c.
 POS

COVARRUBIAS, Miguel
 Mexican/American 1904-57
 B,CC,EC,GMC,H,M,PC,S

COVARRUBIAS

COVRIAS, Raoul de Chareum (pseudonym)
 see
 SINOPICO, Primo

COWANT
 English late 19c.
 LEX

COWELL, Oreon
 American early 20c.
 LHJ7/06

**OREON
COWELL**

COWHEY, Kenneth
 American 20c.
 H

COWLES, Clement
 English mid 20c.
 GR52

COWLES, Edith V.
 American 1874-
 B,F,H,I,M

COWLES, Genevieve Almeda
 American 1871-
 B,F,H,I,M

COWLES, Maud Alice
 American 1871-1905
 B,H,I,M

COWPER, Max
 English 19/20c.
 B

COX, Albert Scott
 American 1863-
 B,F

COX, Allyn
 American 1896-
 F,H,World War II poster for France: 'Invaded
 But Not Conquered',*

Allyn Cox

COX, Charles Hudson
 American 1829-1901
 B,D,H,I,M,R

Charles A Cox

COX, E. A.
 English early 20c.
 POS

COX, Kenyon
 American 1856-1919
 B,BAA,EAM,F,H,I,M,SCR9/88,TB,Y

**KENYON COX.
1888**

COX, Louise Howland King
 American 1865-1945
 B,F,H,I,M

LOUISE COX-1897

COX, Merle
 American 20c.
 M

COX, Palmer
 Canadian 1840-1924
 ADV,B,EC,F,H,I,M,SN5/86 & 7/94,Y

Palmer Cox

COX, Patrick
 English late 20c.
 EI79

COYE, Lee Brown
American 1907–
GMC,H

LEE BROWN COYE

COYNE, Dean G.
American 20c.
M

COYNE, Douglas
English mid 20c.
GR53

COYNE, William Valentine
American 1895–
F,H,M,SO

COZE (COZE-DABIJA), Paul Jean
Libyan/French/American 1903–
B,H,M

COZZENS, Frederic Schiller
American 1846/56–1928
B,BAA,F,H,HA2/19/81

Fred. S. Cozzens

CRABTREE, J. G.
Canadian 20c.
M

CRACKNELL, Alan
English late 20c.
EI79,GR66–67

Alan Cracknell.

CRAFT, Kinuko Yamabe
Japanese/American 1940–
F,GR82,P,Y

raft

CRAIG, Anna Belle
American 1878–
F,H,M

CRAIG, Charles
American 1846–1931
F,H,I,M

CRAIG, Edward Gordon
English 1872–1966
B,LEX,VO

G.C.

CRAIG, Frank
English 1874–1918
B,H,HA4/09,M,McC11/04,VO,Y

FRANK CRAIG 1904

CRAIG, Gordon
English early 20c.
PC,POS

CRAIG, John
American 20c.
P

CRAIG, Tom
American 1908–
H,M

CRAIG, William Marshall
English 1765?–1834?, ac. 1788–1827
B,H,M

CRAIR, Mel
American mid 20c.
PAP

CRAM, Allan Gilbert
American 1886–1947
B,F,H,I,M

CRAM, L. D.
American 20c.
M

CRAMER, Rie
Dutch 1887–
B,VO

R.C.

CRAMER, S. Mahrea
American 1896–
H

CRAMPEL, Paule
French 19/20c.
B,TB

CRAMPTON, Rollin McNeill
American 1886–1970
B,F,H,M

CRANDALL, Doris
American mid 20c.
GR55–56–57

CRANDELL, Bradshaw
American 1896–1966
F,GMC,H,IL,Y

Brcdgho.Xrondil

CRANE, Alan Horton
American 1901–
H

CRANE, (Robert) Bruce
Canadian/American 1857–1934
B,F,H,SO

BRUCE CRANE

CRANE, Frank
American 1857–1917
B,EC,I,M

CRANE, Lancelot
English 19/20c.
B,LEX,TB

L|C

CRANE, Stanley William
American 1905–73
H,SO

CRANE, Walter T.
English 1845–1915
AN,APP,B,BK,CP,GMC,H,M,MM,PC,POS,TB

CRANE, W. (William?) T.
American ac. mid 19c.
D

CRANK, James H.
American 20c.
F

CRAPS, A.
Belgian 19/20c.
LEX

CRAWFORD, Brenetta Hermann
American 1875–1956
F,H,M,SO

CRAWFORD, Earl Stetson
American 1877–
B,F,GMC,H,I,M,SO

CRAWFORD, Mel
American 1925–
H

CRAWFORD, Robert
American late 20c.
GR85

CRAWFORD, Will
American 1869–1944
EC,F,H,IL,M,Y

WILL (CRAWFORD)

CRAWFORD, William Galbraith
American 1894–
H,IL,M

galbraith

CRAWFORD, William H.
American 1913–
EC,H

CRAWFORD

CRAWHALL, Joseph
English 1821–96
H

CRAWHALL (CRAWHILL), Joseph
Scots 1860–1913
B,H,M

CRAYON, J.
 French 19/20c.
 LEX

CREDLE, (Miss) Ellis
 American 1902–
 M

E.C.

CREMONESI, Carmelo
 Italian mid 20c.
 GR 52–54–55–57–59–65

C.Crpmonesi

CREPON, L.
 French 1890–
 LEX

CRESPI, Pachita
 American 1900–
 H,M

CRESPIN, Adolphe Louis Charles
 Belgian 1859–1944
 AN,B,CP,GA,H,MM,POS,TB

A CRESPIN

CRESWICK, Thomas
 English 1811–69
 B,H,M

CRETEN, Victor C. J.
 Belgian 1878–1966
 B,MM,POS

VICTOR CRETEN

CREUX, René
 Swiss mid 20c.
 GR 58–60–61–64

R. CREUX

CREUZ, Serge
 Belgian mid 20c.
 GR 52–55–56–58

jerge creuz

CREW, Mayo
 American 1903–
 F,M

CREWS, Monte
 American 1888–1946
 H,M

CRIBB, Preston
 English 1876–
 M

CRICHLOW, Ernest T.
 American 1914–
 H

CRITCHETT, Naomi Azalia
 American 20c.
 H

CROCKWELL, Spencer Douglass
 American 1904–68
 ADV,H

COMIÈRE(S)
 see
 BOUCHER-CROMIÈRE, Etienne

CROMIÈRES, Huguette
 French mid 20c.
 GR 53

Cromières

CROMMIE, Michael James
 American 1889–
 H,M

CROMPTON, James Shaw
 English 1853–1916
 B,H,M

CROMWELL, Joane Christian
 American 20c.
 F,H,M

CRONAU, Rudolf Daniel Ludwig
 German/American 1855–1939
 B,M,TB

·RG·

CRONBERGER, Theodor
 German 19/20c.
 LEX

CRONIN, David Edward
American 1839-1925
D

CROOKS, Forrest C.
American 1893-
F,H,M

CROOME, William
American 1790-1860
D,F,I,M

Croome

CROSBY, Frederick Gordon
English 1885-
M

CROSBY, John A.
Canadian 1925-
H

CROSBY, Percy Leo
American 1891-1964
F,H,M,PE,Y

P.L.Crosby

CROSBY, Ranice
Canadian/American 1915-
H

CROSBY, Raymond Moreau
American 1875/77-1945
B,H,I,M,PE

Rm.Crosby

CROSMAN, John Henry
American 1897-
IL,M

J.H.Crosman—

CROSS, Adelyne Schaefer
American 1905-
H,M

CROSS, James
American mid 20c.
GR60

CROSS, Peter
English late 20c.
EI83

CROT, Madeleine
Swiss mid 20c.
GR64

CROUCH, Mary Crete
American -1931
M

CROUS-VIDAL
French mid 20c.
GR54

CROUSE, Danny
American 1938-
CON

CROUSE

CROUWELL, Wim
Dutch 20c.
GR59-61-63,H?,POS

CROWE, Jocelyn
English 20c.
M

CROWELL, Magaret
American 20c.
F,H

CROWLEY, Donald V.
American 1926-
CON

Donald V. Crowley

CROWN, Keith Allan, Jr.
American 1918-
H

CROWNINSHIELD, Frederic
American 1845-1918
B,F,H,I

CROWTHER, Robert W.
American 1902–
H,IL,M

Robt. W. Crowther

CRUGER, William F.
American 20c.
M

CRUIKSHANK, George
Scots 1792–1878
B,EC,H,M,PG,S,TB

George Cruikshank

CRUIKSHANK, Isaac
Scots 1756/57–1810/11
B,H,M,PC

CRUIKSHANK, Isaac Robert
English 1789–1856
B,H

CRUMB, R.
American 1945–
F,Y

CRUMP, Iris
American 20c.
H

CRUMP, Leslie
American 1894–1962
F,H,M

CRUTCHFIELD, William Richard
American 1932–
H

CRUZ, Cristiano
Portuguese 1892–1938
H

CRUZ, Raymond
American 1933–
F,Y

CRUZ-DIEZ, Carlos
Venezuelan 1923–
B,H

CRZELLITZER, Fritz
German early 20c.
LEX

CSAKANY, Gabriel S.
Hungarian/Canadian 1938–
F,Y

CSEMICKY, Tilhamer
Hungarian early 20c.
POS

CSERNA, Karoly
Hungarian late 19c.
LEX

CSIKOS-SESIA, Béla
Austrian 1864–
B,LEX,TB

CSOSZ, John
Hungarian/American 1897–
F,H,M

CUADRADO, Heriberto
French? late 20c.
EI79

CUBAS, Manuel
Spanish 19c.
B

CUCHI y ARNAU, José
Spanish 1859–
B

CUCUEL, Edward
American 1879–
B,F,H,I

Cuecel

CUE, Harold James
American 1887–1961
H

CUENDET, Bernard
Swiss mid 20c.
GR59

CUETA, Lola
Mexican 20c.
LEX

CUEVAS, José
Spanish 19c.
B

CUEVAS, José Luis
Mexican 1933/34–
B,DRAW,GR65,H,P

Cuevas

CUFFARI, Richard J.
American 1925–
H

CULBERTSON, Queenie
American 20c.
F,H

CULLEN, Thomas Gordon
English 1914–
H

CULLIS, Auguste
English ac. early 20c.
LEX,Art-Journal-1910

CULTER, Richard
American 1903–
F,M

CUMMINGS, Jerry
American mid 20c.
PAP

CUNEO, Cyrus Cincinnati
American/English 1878–1916
B,CO6/04 & 7/04,H,I

CYRUS CUNEO

CUNEO, (Mrs.) Nill Marion
English 20c.
B

CUNNINGHAM, Cornelia
American 1903–
H

CUNNINGHAM, Frances
American 1931–
H

CUNNINGHAM, Joan
American 1916–
H,M

CUNNINGHAM, Mary Phillips
American 1903–
H,M

CUN(N)INGHAM, Oswald Hamilton
English 1883–
ADV(pg.29),B

CUNNINGHAM, Robert Morris
American 1924–
F,GR85,Y

CUNNINGHAM, William Phelps
American 1903–
H,M

CUNRADI, Marcelle
French 20c.
B

CURLESS, Allan
English late 20c.
EI79

Allan Curless

CURRIER, Cyrus Bates
American 1878–1951?
F,H,M

CURRIER, Walter Baron
American 1879–1934
B,F,H,I

CURRY, Bill
American mid 20c.
GR59

CURTIS, Charles M.
English 1795–1839
B,H

CURTIS, William Fuller
American 1873–
B,F,GMC,H,I,SN8/94

william fuller Curtis

CURTISS (CURTISS-TRUETSCH), George Curt
American 1911–
H

CURUCHET, J. M.
French 20c.
LEX

CURZON, F. W.
Canadian ac. 1885
H

CUSACK, Marie Louise
Canadian late 20c.
GR85

CUSAK (CUSACK), Margaret
American 1945–
AA,H

CUSDEN, Leonard C.
English mid 20c.
GR52

CUSHING, Otho
American 1871–1942
CC,CO7/04,EC,PE

Otho Cushing

CUSIN, Federico
Italian 1875–
H,S

CUSTIS, Eleanor Parke
American 1897–
F,H

CUTLER, Merritt
American 20c.
H,LEX,M

M.C.

CUZIN
French 20c.
CP

CWIK, Jefim
Russiam 20c.
CP

CYLIAX, Walter
Swiss?/German early 20c.
POS

CYL

CYRAN, Eberhard
Austrian 20c.
LEX

CZABRAN, Fedor
Austrian 1867–
LEX,TB

F.G.

CZECH, Erich
Austrian 20c.
LEX

CZEGKA, Bertha
Austrian 1880–
B,LEX,TB

CZEREFKOW, Serge
Russian 20c.
B

CZERMANSKI, Zolzislaw
Polish 1900–70
F,Y

CZERNIAWSKI, Jerzy
Polish 1947–
POS

J. Czerniawski

CZERNY, Rudolf
German 1879–
LEX

CZESCHKA, Carl Otto
Austrian 1878–1960
AN,H,LEX,VO

CC

– D –

DABAT, Alfred
French 1869–
B,LEX,TB

d'ACHE, Caran
see
CARAN d'ACHE

DACOSTA, Antonio
 Portuguese 1914–
 B,H

DADD, Dolly
 English early 20c.
 LEX

DADD, Frank
 English 1851–1929
 B,H,TB

FD

DAEFFKE, W. H.
 German early 20c.
 LEX

DAENERT, R.
 German ac. early 20c.
 LEX

DAERR, Joachim
 German 1909–
 GWA,LEX

D.

DÄGE, Eduard
 German 1805–83
 B,H,LEX,TB

DAGGY, Richard
 American 1892–
 B,F,H

DAGLEY, Richard
 English 1765?–1841
 B,H

DAGNAN-BOUVERET, Pascal Adolphe Jean
 French 1852–1929
 B,H,LEX,TB

DAGOUSSIA-MOUAT
 English 20c.
 B

DAGRADA, Mario
 Italian 1934–
 GR65–66–67,H

DAGRADA

DAGUET, Alfred
 French 19/20c.
 LEX

DAHL, Constance
 English early 20c.
 M

DAHL, Francis
 American 1907–
 H

DAHLBERG, Edwin Lennart
 American 1901–
 H,M,WW2/34

Dahlberg

DAHLEM, Joseph
 German 1872–
 B

DAHLEN, Paul
 German 1881–
 B,LEX,TB,VO

P.D

DAHLGREN, Marius
 American 1844–1920
 H

DÄHNKE, Johann
 German 20c.
 LEX

DAINGERFIELD, Elliot
 American 1859–1932
 B,BAA,F,H,I

DAIR, Carl
 Canadian mid 20c.
 GR52–61

DALAIN, Yvan
 Swiss mid 20c.
 GR65

DALAND, Katherine M.
 American 1883–
 F,H

DALE, Benjamin Moran
 American 1889–1951
 F,GMC,H,M

DALE, John B.
 American –1848
 D,H

DALENOORD, Jenny
 Dutch mid 20c.
 GR57-58

d'ALESI, Hugo
 French ac. late 19c.
 POS

D'ALESSIO, Gregory
 American 1904-
 EC,FOR,H

[signature: Gregory d'Alessio]

DALEY, Joann
 American 1904?-
 GR82,H

DALI, Salvador
 Spanish 1904-1989
 ADV,APP,B,CP,DA,DRA,GMC,GR52-57-58,
 H,PC,POS

[signature: Dali]

DALLAIRE, Jean
 Canadian 1916-65
 B,H

DALLAS, A. G.
 Canadian ac. 1873
 H

DALLAS, Jacob A.
 American 1815-57
 D,H

DALLAS, Paul
 Canadian late 20c.
 GR82

DALLA ZORZA, Carlo
 Italian 1903-
 H,LEX,TB

[monogram: CDZ]

DALLISON, Ken
 Anglo/Canadian 1933-
 Y

DALTON, P.
 English 20c.
 PG

DALY, Tom
 American 1938-
 AA,GR64-65,H

[monogram: TOM DALY]

DALZIEL, John Sanderson
 Scots/American 1839-1937
 M

DALZIEL, Thomas Bolto Gilchrist
 English 1823-1906
 B,M

D'AMATO, Janet Potter
 American 20c.
 H

d'AMEDEE, Comte de Noe (Cham)
 French 1819-79
 H,POS

DAMESTETH, Harold
 Norwegian 20c.
 LEX

DaMILANO, Giulio
 Italian 1897-
 H

DAMMY, (H.) Robert
 French early 20c.
 ST

[signature: H Robert Dammy 14.]

DAMOURETTE, Abel
 French 20c.
 B,LEX,TB

DAMPIER, Guy M.
 American 1932-
 H

[signature: GUY DAMPIER]

DAMRON, John Clarence
American 20c.
H

DANA, Mary Pepperell
American 1914–
B,H,M

DANA, Newton T.
American 20c.
M

D'ANDREA, Bernard L.
American 1923–
H,IL,Y

D'Andrea

DANGON, François Emile
French 20c.
LEX

DANIEL, Jacques
French 20c.
GR58–59–62–63,PG

44
DANIEL

DANIEL, Lewis C.
American 1901–52
B,F,H,M

DANIELSEN, Max
German
LEX

DANILO
Swiss mid 20c.
GR52

DANILOWATZ, Josef
Austrian 1877–
B,LEX,TB,VO

J.D.

DANK, Leonard Dewey
American 1929–
H

DANNENBERG, Fritz
German early 20c.
POS

FD

DANNENBERG, Otto
Prussian 1867–
B,LEX,TB

O·D.

DANNHEISER, Paul
American 20c.
H

DANSKA, Herbert
American early 20c.
HA,LEX

d.

DANVERS, V. L.
English early 20c.
CP

DANZIGER, Louis
American mid 20c.
GR53–55 thru 61–63–66–68,H,POS

DARAGNES, Jean Gabriel
French 1886–1950
B,H,LEX,S,VO

DARAGNES

DARCE, Virginia Chism
American 1910–
H

DARCHE, Jacques
French mid 20c.
GR58

DARCY
American mid 20c.
PAP

Darcy

DARDENNE, Léon
Belgian 1865–1912
B,POS

DARGENT, Edouard Yan
 French 1824-99
 B,H,LEX,TB

Y.D.

DARGNÈS, Jean Gabriel
 see
 DARAGNES, Jean Gabriel

DARIGO, Pierre Paul
 French late 20c.
 GR62-65

DARIGO

DARJOU, Henri Alfred
 French 1832-74
 B,H,LEX,TB

aD

DARLEY, Felix Octavius Carr
 American 1822-88
 B,BAA,D,F,H,I,PC,Y

F.O.C.Darley

DARLING, Gilbert
 New Zealander/American mid 20c.
 H,PAP

DARLING, Jay Norwood
 American 1876-1962
 CC,EC,F,H

inDing

DAROWSKI, Andrejz
 Polish mid 20c.
 GR65

DAROWSKI, Zofia
 Polish mid 20c.
 GR65-66-67

DARROW, Whitney, Jr.
 American 1909-
 ADV,EC,H

whitney Darrow

DART, Harry Grant
 American 1869-1938
 EC,PE

*HARRY
GRANT
DART*

DARVAS, Anna
 American 20c.
 M

DARVAS, Árpád
 Hungarian 1927-
 GR59-65

DAR.

DARWIN, Beatrice
 American 20c.
 H

DARWIN, Leonard
 American 20c.
 H

DAS, Elsie Jensen
 American 1903-
 M

D'ATTILIO, Anthony
 American 20c.
 H

DAUGHERTY, H. R.
 American 20c.
 M

DAUGHERTY, James Henry
 American 1889-1974
 B,EAM,F,H,I,M,SO

JAMES H DAUGHERTY

DAUGHERTY, Nancy Lauriene
 American 1890-
 B,H

d'AULAIRE, Edgar Parin
 Swiss/American 1898-
 H

d'AULAIRE, Edgar Parin, Jr.
 Norwegian/American 1905–
 H,M

d'AULAIRE, Ingri Mortneson Parin
 Norwegian/American 1904/05–80
 H,M

DAUMIER, Honoré
 French 1808–79
 AN,B,DA,EAM,EC,GMC,H,PC,PG,TB

[signature: h. Daumier]

DAURA, Pierre
 American 20c.
 M

d'AURIAN, Jean Emmanuel
 French 19/20c.
 LEX

DAVEY, Gordon
 English 20c.
 LEX

DAVID, Hermine
 French 1886–1971
 B,H

DAVID, Jean
 Israeli 1908–
 GR53–56–61–64–65–66,H

[signature: J. d.]

DAVIDSON, Clara D.
 American 1874–
 F,H

DAVIDSON, George Dutch
 Scots 1879–1901
 B,H

DAVIDSON, Herbert Laurence
 American 1930–
 H,P

DAVIDSON, Julian O.
 American late 20c.
 BAA,SN7/94,Y

[signature: JO DAVIDSON]

DAVIDSON, Victoria
 English mid 20c.
 GR61

DAVIE, Howard
 English early 20c.
 LEX

DAVIES, Arthur B.
 American 1862–1928
 APP,B,CWA,F,H,PC,PE

[signature: Arthur B. Davies]

DAVIES, George O.
 American 20c.
 M

DAVIS, Bette
 American 20c.
 H

DAVIS, Charles Percy
 American 19/20c.
 B,F

DAVIS, Emma Earlenbaurgh
 American 1891–
 B,F,H

DAVIS, Floyd Macmillian
 American 1896–1966
 F,FOR,H,IL,M,Y

[signature: FM·DAVIS]

DAVIS, George
 American 1914–
 H

DAVIS, Georgina A.
 American 1850–
 H

DAVIS, Gladys Rockmore
 American 1901–67
 B,F,GR52,H,VO

[signature: G.R.D.]

DAVIS, Hubert
 American 1902–
 B,H

DAVIS, Jack C.
 American 1924–
 F,H,PLC,Y

DAVIS, John Harold
 American 1923–
 H

DAVIS, John Steeple
 American 1844–1917
 BAA,I

DAVIS, Leonard Moore
 American 1864–1938
 F,H

DAVIS, Louis
 English ac. 1885–1920
 B,MM,TB

DAVIS, Lucien
 English ac. 1860–93
 B,EN,H

LUCIEN DAVIS

DAVIS, Margurite
 American 1889–
 H,M

DAVIS, Marshall
 American 20c.
 H

DAVIS, Natalie Harlan
 American 1898–
 H,M

DAVIS, Paul
 American 1938–
 F,GR61 thru 64–66–67–68,P,POS,Y

Paul Davis

DAVIS, Robert Allen
 American 1912–
 H

DAVIS, Ronald Fremont
 American 1887–1917
 I

DAVIS, Stanley
 English 20c.
 M

DAVIS, Stuart
 American 1894–1964
 APP,B,DRAW,EAM,F,H,PC,SO,VO

STUART DAVIS

DAVIS, Theodore Russell
 American 1840–94
 H,Y

DAVIS, W. Triplett
 American early 20c.
 F

DAVIS, Warren
 American early 20c.
 GMC,M

DAVIS, Wayne Lambert
 American 1904–
 B,H

DAVISON, Austin L.
 American 1909–
 H

DAVOL, Ralph
 American 1874–
 M

DAWLER, E. Guy
 English 19/20c.
 LEX,M,TB

E.G.D.

DAWSON, Alfred
 English 19c.
 B,H,LEX,TB

DAWSON, Charles Clarence
American 1889–
H

DAWSON, Charles E.
English late 19c.
LEX

DAWSON, Diane
American 1952–
Y

DAWSON, Eugenie Wireman
American 20c.
H

DAWSON, (M.) Anne
American 1946–
H

DAWSON

DAY, B. C.
American 19/20c.
HA,LEX

B·C·D·

DAY, Benjamin Henry
American 1838–1916
D,H

DAY, Chauncey Addison (Chon)
American 1907–
EC,H

Chon Day

DAY, Clarence
American 1874–
M

DAY, Doris
American 20c.
M

DAY, Francis
American 1863–
CEN2/99 & 5/99,F,H,I,M,SN7/94

FRANCIS DAY

DAY, Lewis Foreman
English 1845–1910
LEX,TB

L.F.D.

DAY, Maurice
American 1885–
M

DAY, Robert James
American 1900–
ADV,EC,H

Robt. Day

DAYTON, F. E.
American 20c.
F,M

DAYTON, Helen Smith
American 20c.
F,M

DEAN, Abner (Abner Epstein)
American 1910–
EC,H

DEAN, Christopher
English 19/20c.
B,TB

C†D

DEAN, Ethel
American 20c.
M

DEAN, Eva Ellen
American 1871–
H

DEAN, Mallette
American 1907–
B,H

DeANGELI, Marguerite
American 1889–
H

Marguerite de Angeli

DEARDOFF, Kenneth
American mid 20c.
GR59

DEAS, Michael
 American late 20c.
 GR82

DEBASSIGE, Blake R.
 Canadian 1956–
 H

de BEAUMONT
 French 19c.
 BAA,POS

De BEERS
 French 19/20c.
 CP

De BELLE, Charles Ernest
 Hungarian/Canadian 1873–1939
 H

de BERNARDINIS, Olivia
 American 20c.
 P

DEBICKI, Stanislaw
 Polish 1866–1924
 AN,B

S.1901

DEBORD, Guy
 French 20c.
 POS

De BOYNES, Louis
 French mid 20c.
 GR65

LOUIS DE BOYNES

De BRA, Mabel Mason
 American 1899–
 F,H

DEBRECZENI, Laszlo (Ladislaus)
 Hungarian 20c.
 LEX

de BRUNHOFF, Jean
 French/Swiss 1900–37
 M

DECAM
 French 19/20c.
 BI

DECAM 1897

De CAMP, Ralph Earll
 American 1859–1936
 H

DECARIS, Albert
 French 1901–
 B,M

Decaris

de CARO, Anita
 American/French 1909–
 H,M

de CELLE, Edmond Carl
 American 1889–
 B,H

de CHAVANNES, Puvis
 see
 PUVIS de CHAVANNES, Pierre Paul

DECHEVOI, Ivan
 Russian 19c.
 B

de CIDON, Francesco
 Spanish? early 20c.
 POS

DECKER, (Mrs.) E. Bennet
 American 1869–
 B,H

DECKER, Richard
 American 1907–
 EC,F,H,Y

RD

de COSSEY, Edwin
 American 20c.
 M

de COULON, Eric
 French early 20c.
 POS

De DIEGO, Julio
Spanish/American 1900–79
B,GR53,H

DEED-BASZEL, Franz
Hungarian/Austrian 1902–
LEX

DEEL, Guy
American 1933–
GR64,IL

DEERING, Roger L.
American 1904–
B,H,M

De FEO, Charles
American 20c.
H,M

de FEURE, Georges
French 1868–1928
B,CP,GMC,H,POS

DEFFKE
German early 20c.
POS(pg.176)

De FORREST, Grace Emily Banker
American 1897–
F,H

De FOUW, J.
Irish mid 20c.
GR60

DEFRADAT, Serge
French mid 20c.
GR65–66

De FRANCISCO, Manuel Silva
Portuguese 1936–
H

De FRANCISCO, Pietro
Italian 1873–
H

DEGEN, Paul
Swiss/American 1941–
GR68,H

DEGKWITZ, Hermann
West German late 20c.
EI79

de GOGORZA, Maitland
American 20c.
LEX,VO

DEGOUY, Nelly
Belgian 1910–
LEX,VO

De GRAZIA, Ettore Ted
American 1909–
H

DEGROAT, Diane L.
American 1947–
H

de HARAK, Rudolph
American 20c.
GR65,POS

DEHN, Adolf Arthur
American 1895–1968
APP,B,F,H,PC

DEIBEL, John
Irish mid 20c.
GR58

DEIGAN, James Thomas
American 1934–
F,GR64–65–67

DEIGHTON, Len
English mid 20c.
GR58

DEINES, Ernest Hubert
American 1894–1967
H

DEITERS, Heinrich
German 1840–
B,H,LEX,TB

HD

De IVANOWSKY, Sigismund
American 1874–
B,F,H,HA10/03,SCR12/06,VO

S. de Ivanowski 1905

DEKK, Dorritt
English mid 20c.
GR54–56–62–63–65–66

De KLERK (probably KLERK, Michael de)
Dutch ac. early 20c.
GMC,H

DELAMARE, Francis
Belgian early 20c.
POS

De LAND, Clyde Osmar
American 1872–1947
F,H,I

DELANEY, A. J.
Canadian ac. 1876
H

DELANEY, E.
Canadian ac. 1850
H

DELANO, Gerard Curtis
American 1890–1972
H,M

DELANO, Irene
Puerto Rican mid 20c.
GR53

DELANO, Jack
Russian/American 1914–
H

de LAPPE, Phyllis
American 20c.
H,M

DELARIS, Marcel
French mid 20c.
GR59

Delaris

DELARUE-NOUVELLIÈRE
French 20c.
B

DELASPRE, H.
French 19/20c.
B,LEX

De La TORRE, William
Mexican/American 1914–55
H

DELAUNAY, Claude
French 1915–
B

DELAUNAY, Robert
French 1885–1941
AD,B,DA,EAM,H,PC

r. delaunay

DELAUNAY, Sonia Terk
French 1885–1979
AD,B,EAM,H

S.D.

DELAVANTE, S.
American 20c.
M

DELAVILLA
Austrian? early 20c.
POS

DELAW, Georges
French 1874–1929
B,M,VO

G.D.

DELCOURT, Maurice
French 1877–1917
B

DEL DRAGO, Francesco
Italian 1920–
B,H

De LEEUW, Cateau
American 1903–
H

De LEMOS, Pedro J.
American 1882–
H

De LESLIE, Alexander P.
Russian/American 1893–
F,H

DELESSERT, Etienne
Swiss late 20c.
EI79,GR64–66–67–82–85

Etienne Delessert.

DELESSERT, Philippe
Swiss mid 20c.
GR60

DELEVANTE, S.
see
DELAVANTE, S.

DELF, Brian
English late 20c.
EI79

DELGADO, Teodoro
Spanish 20c.
GMC

TEODORO DELGADO

D'ELIA, Teresa Ilda
American 1918–
H

DELL ACQUA, Amadeo
Argentinean 1905–
H

DELLARIPA, Filomena Joan
American 1922–
H

DELLENBAUGH, Frederick Samuel
American 1853–1935
B,BAA,H,I,TB

FSD

DELLESERT, Etienne
see
DELESSERT, Etienne

DELONEY, Jack Clouse
American 1940–
H

DELORT, Charles Edward (Edmond?)
French 1841–95
B,BAA,H,L

C. DELORT

de LOSQUES, Daniel
Spanish? –1915
POS

DELPECH, Daisy
French early 20c.
B

DELPIRE, Robert
French mid 20c.
GR63–65

DELPPINO, José Moya
Spanish/American 1891–
B,H

DELSON, Robert
American 1909–
B,H

DELUERMOZ, Henri
French 1876–1943
AD,B

DEMARIA (de MARIA), Pierre Jean
French 1896–
B

De MARIS, Walter
American 1877–
F

De MARTELLY, John Stockton
American 1903–
APP,H

DEMARTIN, E. G.
American mid 20c.
GR61

De MAURO, Don
American 1936–
GR67,IL

Don De Mauro

De MERS, Joseph
American 1910–
F,IL,M,Y

Joe Kle Mers

DEMEURE de BEAUMONT
Belgian 19/20c.
LEX

DEMING, Edwin Willard
American 1860–1942
B,CEN4/04,F,H,HA,I,LEX,TB

EWDEMING

DEMIREL, Selçuk
French late 20c.
GR85

De MOLL, Mary Hitchner
American 1884–
F,H

De MUTH, Flora Nash
American 20c.
M

De MYROSH, Michael
American 1898–
H

De NATALE, Richard
American mid 20c.
GR65–67

DENEIKA
Russian early 20c.
POS

DENGHAUSEN, Alfred L. F.
American 1906–
H,M

DENGROVE, Ida Leibovitz
American 1918–
H

DENHOF, Miki
American mid 20c.
GR56

DENI
Russian early 20c.
POS

DENIS, Maurice
French 1870–1943
AN,B,DA,EAM,H,POS

DENISON, Harold Thomas
American 1887–1940
F,H,IL,PE

HAROLD DENISON/28

DENISOV, Viktor Nikolayevich
Russian 1893–1946
EC

DENNEY, Irene
American 20c.
H

DENNING, A.
American early 20c.
AM7/93

(A)DENNING

DENNIS, (Burt) James Morgan
American 1892–1960
H,M

Morgan Dennis

DENNIS, Charles Warren
American 1898–
F,H

DENNIS, Don W.
American 1923–
AA,H

DENNYS, Joyce
English early 20c.
POS

Joyce Dennys

DENSLOW, William Wallace
American 1856–
B,R

WILL. W. DENSLOW.

DENT, Dorothy
American 20c.
H,M

de PAOLI, Iris
Italian late 20c.
EI79

IRIS DE PAOLI

DEPAQUIT, Jules
French 1872–1924
B

De PAULA, Nilo
Brazilian late 20c.
GR82

De PAUW, Victor
American 1902–
H,M

DEPERO (De PERS), Fortunato
Italian 1892–1960
B,H,POS

Depero

DEPEW, Viola
Canadian 1894–
H,M

DEPIÈRE, Guy
Belgian 20c.
LEX

DEPILLARS, Murry N.
American 1938–
H

De POL, John
American 1913–
H

DEPUY, Hal
American 20c.
PG

HAL DEPVY

DERAIN, André
French 1880–1954
B,DA,DES,DRA,EAM,GR53,H,PC,POS

aderain

DERAS, Frank
American late 20c.
GR85

DERBEKEN, Lewis van
American mid 20c.
GR61

DERBY, Alfred Thomas
English 1821–73
B,H

De REGOYOS Y VALDES, Dario
Spanish 1857–1913
B,LEX,TB

DÉRÉMEAUX, Irma
 American ac. early 20c.
 CEN10/09

- DEPÉMEAUX·

De RIQU(I)ER, Alejandro
 Spanish 19/20c.
 MM?POS

A de Riquer

DERNONAIN, Germaine
 American early 20c.
 LEX

de ROECK, Lucien
 Belgian 1915–
 GR55,POS

DEROECK

DEROLEZ, M.
 Belgian early 20c.
 POS

DEROUET, Edgar
 French early 20c.
 POS

DERRICK, Paul E.
 American early 20c.
 ADV

Paul E. Derrick

DERYKE, Emma
 American 19c.
 H

DES
 see
 ASMUSSEN, Andreas

de SAINT PHALLE, Niki
 French 20c.
 POS

DESALEUX, Jean
 French mid 20c.
 GR61

JEAN DESALEUX

DESANDRE, Jules Marie
 French 19c.
 B,LEX

DESETA, Enrico
 Italian 1908–
 EC

DESEVE, Peter
 American mid 20c.
 GR85

DES GACHONS, André Stanislas Albert
 French 1871–
 B,POS

DESOTO, Rafael M.
 Puerto Rican 1904–
 H,PAP

DESPIAU, Charles
 French 1874–1946
 B,DES,DRA,H,LEX,PC,TB,VO

C Despiau

DESPRÉS, V.
 French ac. late 10c.
 LEX

DESSIRIER, Rene
 French mid 20c.
 GR60–61

DESTEZ, Paul Louis Constant
 French 19/20c.
 B,LEX,TB

Paul DZ.

DESWARTE, F. Jean
 French mid 20c.
 GR53–54

DETAILLE, Jean Baptiste Edouard
 French 1848–1912
 B,BAA,H,L

Edouard Detaille

De TESSIER, Isabelle Emilie
 English 1851–
 H

DETHOMAS, Maxime
 French 1867–1929
 B,M,POS,TB,VO

De THULSTRUP, Thure
 Swedish/American 1848–1930
 BAA,H,I

de TIRTOFF, Romain
 see
 ERTÉ

DETMOLD, Charles Maurice
 English 1883–1908
 B,H

DETMOLD, Edward Julius
 English 1883–1957
 B,H,M

DETOUCHE, Henry Julien
 French 1854–1913
 B,POS,TB

DETTI, Cesare
 Italian 1874–1914
 B,H,LEX,TB

DETTMANN, Ludwig J. Christian
 German 1865–1944
 B,LEX,TB,VO

De TULLIO, Luigi
 Italian 1920–
 H

DETWILLER, Frederick Knecht
 American 1882–
 H

DEUTSCH, Ernst
 Austrian 1883–1938
 B,MM,POS

DEUZ, M.
 French 19c.
 L

De VALERIO, Raymond
 French early 20c.
 POS

DEVAMBEZ, Andre Victor Edouard
 French 1867–1943
 B,GMC,LEX,M,TB,VO

DEVER, Jeffrey
 American mid 20c.
 GR85

DEVILLE
 French 19/20c.
 BI

DEVLIN, Harry Arthur
 American 1918–
 H

De VRIES, Dora
 American 1909–
 H

DEWEY, Julia H.
 American early 20c.
 F,H

DEWEY, Kenneth Francis
American 1940–
F,H,Y

DEWHURST, Wynford
English 1864–
B,LEX,TB

W. D

DEWIDE, G. R.
Canadian ac. 1875–76
H

DEWING, Marie Oakey
American 1857–
B,H,I

De WITT, Cornelius Hugh
American 1905–
H

De WITT, Jerome Pennington
American 1885–1940
F,H

DEXEL, Walter
German 1890–1973
B,H,POS

Dex

DEXTER, Walter
English 1876–
B,LEX,TB,VO

DEXTER, Wilson C.
American 1881–1921
I

DEYROLLES, H.
French ac. late 19c.
LEX

De ZAYAS, George
Mexican/American 1895–
F,H

D'HARANCOURT, René
American 20c.
LEX

DIAMOND, Harry O.
American 1913–
F,GR52 thru 57,Y

H. diamond

DIAMONSTEIN, David
Russian/American 1883–
F,H

DIAS, Júlio Martins da Silva
Portuguese 1917–
H

DIAZ, Cesáreo Federico
Argentinean 1894–
H

DIAZ, Juan
Puerto Rican mid 20c.
GR53

DICK
see
BRUNA, Dick

DICKEL, Conrad
American 20c.
CG10/34,M

DICKEY, Robert Livingston(e)
American 1861–1944
F,H,M,PE,SCR2/12 & 5/12

Robert L. Dickey

DICKEY, W. Terrell
American mid 20c.
GR54

DICKINSON, Charles
American mid 20c.
GR57

DICKINSON, Edgar A.
Canadian ac. 1871–1900
H

DICKREITER, Heinrich
German 20c.
LEX

DICKSEE, (Sir) Francis Bernard
English 1853–1928
B,H,TB

F.D

DICKSON, Frank
English 1862–
B,LEX,TB

F.P.

DICKSON, June
American mid 20c.
GR54

DIEDRICKSEN, Theodore
American 1884–
F,H

DIEHL, Cal G.
American mid 20c.
PAP

CAL DIEHL

DIELMAN, Frederick
American 1847–1935
B,BAA,F,H,TB

(7.D.

DIENST, Vera
German 19?/20c.
LEX

DIER, Erhard Amadeus
Austrian 1893–
LEX,VO

E.D.

DIESTAL, George Charles
American 1898–
H

DIETERICH, Waldemar Franklin
American 1876–1953?
H,I

DIETHELM, Walter J.
Swiss mid 20c.
GR52-60-62-66

DIETRICH, Carl
Austrian 1821–88
B,LEX

DIETRICH, George Adams
American 1905–
H

DIETRICH, Paul
German 1907–
GR55,LEX,VO

PD

DIETRICHS, Hermann
German 1852–
B,LEX,TB

HH

DIETZ, Jakob
German 1889–
LEX,TB,VO

DIETZ, Wilhelm
German? 1839–1907
LEX,TB

DIEZ, Julius
German 1870–1957
AN,B,LEX,TB

·I· ·1899·

DIEZ, Wilhelm von
German 1837–1907
B,H

Wilh v. Diez

Di FIORI, Lawrence
American 20c.
Y

DIGGELMANN, Alex W.
Swiss 20c.
BI,POS

di GIOIA, Frank
Italian/American 1900–
H,M

DIGNIMONT, André
French 1891-1965
B,DES,H

Dignimont

DIL, S. M.
French early 20c.
POS

DILL, Ludwig
German 1848-1940
AN,B,LEX,TB,VO

DILLAYE, Blanche
American 20c.
B,F,H,M

DILLON, Corinne Boyd
American 20c.
H,M

DILLON, Diane
American 1933-
F

DILLON, Henri Patrice
American/French 1851/1909
B,LEX,TB

HD

DILLON, Leo
American 1933-
F,GR66-67,Y

Di MARCO, Jan
American 1905-
H

Di MASSA, Romano
Italian 1889-
H

DIMONDSTEIN, Morton
American 1920-
GR58,H

DIMSON, Theo
Canadian 1930-
GR55-59-62,H

THEO DIMSON

DINET, Alphonse Etienne
French 1861-1929
B,H

E DINET

DING, J. N.
see
DARLING, Jay Norwood

DINGER, Otto
German 1860-
B

DINGLE, Adrian
Welsh/Canadian 1911-
H

DINI, Mario Victorio
American 1916-
H

DINNERSTEIN, Harvey
American 1928-
F,H,Y

DINSMORE, E. J.
Canadian 20c.
M

DIONYSIUS, Dooley
American 1907-
H

Di OSIMO, (F. J. Busters)
American 20c.
M

DIOSY, Antal
Hungarian 20c.
LEX,VO

D.A.

DIRKS, Gustavus
American 1897?-1903
EC,I

GUS-DIRKS

DIRX, Willi
German 1917-
G

Willi Dirx

DISERTORI, Andrea
Italian 1927–
H

DISMORR, Jessica
English 1885–1939
B,BRP

DISNEY, Walter Elias
American 1901–66
ADV,B,EAM,EC,GMC,H,VO

DISNEY, Walter (Studios)
American 20c.
ADV,EC,GMC,VO

DISTÉFANO, Juan Carlos
Argentinean 1933–
GR61-62-64-66-68,H

DISTELI, Martin
Swiss 1802–44
B,EC,H

DISTLER, Kenneth
American 20c.
NV

DITTMANN, E.
German mid 20c.
B,LEX

DITZLER, Ch. Weber
American early 20c.
LHJ4/05

DIVÉKY, Josef von
Austrian 1887–1951
AN,LEX

Di VITA, Frank
Italian/American 1949–
CON

DIX, (Capt.)
Canadian ac. 1872
H

DIX, Otto
German 1891–1969
APP,B,DRA,GMC,H,PC,PG

DIXON, Lafayette Maynard
American 1875–1946
F,H,R,SO

DIXON, Rachel Taft
American 20c.
M

DIZ
see
ARDIZZONE, Edward

DIZAMBOURG, J.
French mid 20c.
GR52

DLAWSSO
see
OSSWALD, Eugen

DMITRI, Ivan
American 20c.
APP,M

DMITRIEFF–ORENBURGSKY, Nikolai Dmitrievitch
Russian 1838–98
B

DOANE, Lucy
American 20c.
M

DOARES, Bob
American mid 20c.
PAP

DOBIAS, Frank
American 20c.
M

DOBKIN, Alexander
American 1908–
H

DOBRIN, Arnold Jack
American 1928–
H

DOBSON, Ralph
English? 20c.
ADV

DOBUZHINSKII, Mstislav Valerianovich
Russian 1875–1957
B,EC

DOCKER
Austrian 19/20c.
POS

DODACKI
Polish early 20c.
POS

DODD, Albert W.
Anglo/American? early 20c.
LEX

DODD, Daniel
English ac. 1752–80
B,H

DODGE, Chester L.
American 1880–
H

DODGE, Frank E.
American 20c.
M

DODGE, Richard
American 1918–
H,M

DODGE, William De Leftwich
American 1867–1935
B,F,GMC,H

W. DE LEFTWICH-DODGE-98

DODGSON, Catherine
English 20c.
M

DODSON, Alan
South African mid 20c.
GR52

DODSON, Richard W.
American 1812–57
B,D,F

DOEBELE, H. P.
Dutch mid 20c.
GR61–62

DOEPLER (DÖPLER or DÖPPLER), Carl Emil
Polish/German/American 1824–1905
B,D,I,M

DOEPLER, Emil
German 1855–
B,POS

E.D.

DOERN, Virginia Linise
American 1913–
H,M

DOERRE, Tivadar (Theodor)
Hungarian 1858–
B,TB

DOHANAS, Stevan
American 1907–
F,FOR,GMC,H,IL,PAP,POS,Y

Stevan Dohanos.

DÖHRER, Klaus
Swiss mid 20c.
GR60

DOKI, Mitsuo
Japanese mid 20c.
GR 63–65

DOLA, Georges (pseudonym: VERNIER, Edmond)
French 1872–1950
B, FO

DOLAN, Elizabeth Honor
American 1884/87–1948
F, H

DOLAS, Michael
American 20c.
M

DOLBIN, B. F.
Austrian/American 1883–
H

DOLEZAL, Carroll
American 20c.
H

DOLLIERS
German early 20c.
CP

DOLOBOWSKY, Robert
American mid 20c.
GR 53–54

DOLWICK, William Adelbert
American 1909–
H

DOMANSKA, Janina
Polish/American 20c.
H

DOMBROWSKI, Carl Ritter von
German 1872–
LEX

DOMBROWSKI, Katharina (K.O.S.)
Austrian/American 1881–
M

DOMBROWSKY, Raoul Ritter von
Czechoslovakian/Austrian 1883–
LEX

DOMERGUE, Jean Gabriel
French 1889–1964
AD, B, POS, VC

DOMINICUS, Josef
German 1885–
LEX, VO

DON, Jean
French early 20c.
B, POS

DONAHEY, James Harrison
American 1875–1949
CO1/05, EC, F, I, M

DONAHEY, William
American 1883–
F, I, M

DONAHUE, Vic
American 1917–
H

DONALD, Douglas
American early 20c.
ADV

DONALDSON, Alice Willits
American 1885–
F, H

DONGEN, Kees van, (Cornelius T. M.)
Dutch/French 1877–1968
AD, B, DA, DES, FS, H, PC, POS

DONIPHAN, Dorsey
 American 1897–
 F,H

DONLEVY, Alice H.
 Anbglo/American 1846–
 BAA,F,H

DONNAY, Auguste
 Flemish 1862–1921
 B,CP,H,MM,POS

DONSHEA, Clement
 American 20c., ac. 1924
 H

DOOD, W.
 English ac. early 20c.
 LEX,STU1905

DOOLEY, Thomas M.
 American 1899–
 H

DORA, (MATHIEU, Dora)
 American 1909–
 H

DORAN, Thomas
 Canadian ac. 1880
 H

DORÉ, Gustave
 French 1832–83
 B,EC,GMC,H,PC,PG,TB

DOREMUS, Robert
 American 20c.
 H

DORF(S)MAN, Louis
 American 1918–
 GR52-53-54-56 thru 62-66-67,H,POS

DÖRIG, Hansreudi
 Swiss mid 20c.
 GR63-65

DÖRING, Lia
 German 20c.
 LEX

DORIVAL, Géo
 French 1879–
 B,POS

DORMAN, Margaret
 American 1910–
 H

DORMONT, Philip
 American 20c.
 H

DORNE, Albert
 American 1904-65
 F,FOR,H,IL,M,Y

ALBERT
DORNE

DORR-STEELE, Fred
 see
 STEELE, Frederic Dorr

DÖRSCHUG, Alfons
 German 1926–
 LEX,TB,VO

FONS

DORSEY, Thomas
 American 1920–
 H

DORY
 French early 20c.
 ST

DOSKOW, Israel
 Russian/American 1881–
 F

DOTTERWEICH, (Gedo) George
 German 1914–
 LEX

DOTTKE, Daniel
 German mid 20c.
 GR52

DOTY, Roy
 American 1922–
 EC,F,GR52-53,Y

DOUBA, Josef
German 1866-1928
B,LEX,VO

DOUBBLE, Dorothy Eve
American 20c.
M

DOUBEK, Franz Bohumil
Czechoslovakian/German? 1865/85-
B,LEX,VO

DOUBRAVA, Fr.
Czechoslovakian 1902-
LEX

DOUDELET, Charles
Belgian/French? 1861-
B,LEX,TB

DOUGHERTY, Ida
American 19/20c.
CEN10/06

DOUGLAS, Aaron
American 1898/99-1979
H,M

DOUGLAS, Emory
American 20c.
CP

DOUGLAS, Lucille Sinclair
American early 20c.
F

DOUGLASS
see
CROCKWELL, Spencer Douglass

DOUGLASS, Ralph Waddell
American 1895-
H

DOUGLASS, Robert W.
American 1918-
H

DOURGNON, Marcel Lazare
French 1858-
B,LEX,TB

DOUWE, Gerard
Dutch mid 20c.
GR52-53

DOVA, Gianni
Italian 1925-
B,GR59,H

DOVE, Arthur Garfield
American 1880-1946
APP,B,DRA,EAM,F,H

DOVE, Bill
American 20c.
LEX

DOVE, Leonard
American -1964
F,M,Y

DOW, Arthur Wesley
American 1857-1922
APP,B,F,H,I,M,R

DOWD, Victor
American 20c.
H

DOWDEN, Anne Orphelia Todd
American 1907-
H

DOWLING, Colista
American 20c.
H

DOWLING, Henry G.
English 20c.
LEX

DOWLING, Victor J.
American 20c.
M

DOWNER, Marion
American 20c.
M

DOWNES, J. F.
Canadian ac. 1830-47
H

DOWNING, Marguerite
English early 20c.
LEX,HA7/07

Marguerite Downing

DOWNS, B. F.
American 20c.
M

DOYLE, Charles Altimont
English 1832-93
B,H

DOYLE, Edward A.
American 1914-
H

DOYLE, James William Edmund
English 1822-92
B,H

DOYLE, Richard
English 1824-83
B,EC,GMC,H

DRAEGER, FRÈRES (brothers)
French mid 20c.
GR60 thru 63

DRAINS, Geo. A.
French 20c.
B

DRAKE, Frank Cornelius
American 1868-1922
I

DRAKE, William Henry
American 1856-1926
B,BAA,F,HA,I,PE,SN1/94 & 2/94

W.H. Drake 93

DRALLE, Elizabeth M.
American 1910-
H

DRANSY
French early 20c.
CP,POS

DRANSY.

DRAPER, David
English late 20c.
EI79

DRAVNEEK, Henry
American 20c.
H

DRAWSON, Blair
Canadian late 20c.
EI79,GR82-85

Drawson

DRAYTON, Grace Gebbie
American 1877-
ADV,B,F,H,I

DRAYTON, John
American 1766-1822
D

DREAMER, Mabel
English early 20c.
LEX

DREPPE, Joseph
Flemish 1737-1810
B,H

DRESCHER, Henrik
American late 20c.
GR82

HENRIK DRESCHER

DRESEL, H. B.
Canadian ac. 1883
H

DRESSEL, August
German 1862-
B,LEX,TB,VO

A.D.

DRESSLER, Pat
American mid 20c.
GR52

DREVET, Jules
French 1889–
B

DREW, E.
American early 20c.
GMC

E DREW

DREW, John
American 20c.
M

DREWATOLITSCH, Josef
Austrian/American mid 20c.
BI,LEX

JD

DREYER, Georg Léonhard
German/Swedish 1793–1879
B,M

DRIAN, Etienne
French 1885–
H,ST

Drian

DROIT, Jean
French early 20c.
B,PG

DROPPA, Vladimir
Czechoslovakian?/Yugoslavian 1907–
H,LEX

DROWER, Sara Ruth
American 1938–
H

DROWN, Jerry
American mid 20c.
GR57

DRUCE, Melville
English ac. 1893
H

DRUCKER, Mort
American 1929–
EC

DRUILLET, Philippe
French 1944–
B

DRUMMOND, Arthur A.
Canadian 1891–
F,H,M

DRYDEN
French early 20c.
LEX

DRYDEN, Ernst
see
DEUTSCH, Ernst

DRYDEN, Helen
American 1887–
F,GMC,H,M,POS,VC

Helen Dryden

DRYSDALE, Alexander John
American 1870–1934
F,H,I

DUBINSKY, David Alexandrovitch
Russian 1920–
H

Du BOIS, Jacques
French 1912–
GR52-53-55-61-63-64,H

Dubois

du BOIS, William Péne
American 1916–
M

DUBOUT, Albert
French 1905–76
B,EC

DUBOUT, Jean
French early 20c.
POS

Du BRAU, Gertrud Margarete
German/American 1889–
F,H

DUBUFE, Edouard Marie Guillaume
 French 1853-1909
 B,LEX,TB

DUBUFFET, Jean
 French 1904-
 APP,B,DA,DES,DRAW,EAM,GMC,H,POS,VO

DUCHAMP, Marcel
 French 1887-1968
 APP,B,DA,DRA,DRAW,EAM,GMC,GR66,H,
 PC,POS

DUCHAMP-VILLON, Raymond
 French 1876-1918
 B,GMC,H

DUDA, Stanislav
 Czechoslovakian 1921-
 GR52-53-60-62-64-65,H

DUDOVICH, Marcello
 Italian 1878-1962
 AD,B,CP,MM,POS,VO

DUDZINSKI, Andrezej
 American late 20c.
 EI79,GR82-85

DUER, Douglas
 American 1887-1964
 F,H

DUFAU, Clémentine Hélène
 French 1869-1937
 B,LEX,TB,VO

DUFAULT, William James
 see
 JAMES, Will

DUFAULT, Joseph Ernest Nepthali
 see
 JAMES, Will

DUFF, Leo
 English late 20c.
 EI79-82-83-84

DUFFY, Edmund
 American 1899-1962
 EC,F,H

DUFOUR, E.
 French 20c.
 LEX

DUFOUR, Jean Jules
 French 1889-
 B,LEX,VO

DUFRÈNE, Maurice
 French 1876-
 B,FO

DUFY, Raoul
 French 1887-1953
 AD,ADV,B,DES,DRA,EAM,GR53,H,PC,POS

DUGO, Andre
 American 20c.
 LEX

DUHOUSSET, E.
 French late 19c.
 LEX

DUILLO, John
American 1928–
CON

[signature: John Duillo]

DUJARDIN, Louis
French 1808–59
B,H

DUKE, Chris
American 1951–
AA

DULAC, Edmund
French/English 1882–1953
AD,AN,B,GMC,H,M,S

[signature: ED.]

DULAC, (Jean) Guillaume
French 20c.
B,M

DUMAIS, P. H.
Canadian ac. 1876
H

DUMAS, Antoine
Canadian 1932–
B

DUMAS, Jack
American 1916–
H,IL

[signature: Jack Dumas]

DUMAS, Jean
Romanian/American 1890–
H,M

Du MAURIER, George Louis Palmella Buson
French/English 1854?–96
EC,B,H

[signature: Du Maurier]

DUMM, Edwina
American 20c.
H

[signature: EDWINA]

DUMMER, H. Boylston
American 1878–1945
F,H

Du MOND, Frank Vincent
American 1865–1951
B,CEN6/05,F,H,I,VO

[signature: Frank Vincent DuMond.]

DUMONT, M.
French 19/20c.
LEX,STU1907

DUMONT-VOLIGUET
French 19/20c.
LEX

DUNBAR, Harold C. Brockton
American 1882–
B,F,H,I

[signature: Harold Dunbar]

DUNCAN, Frederick Alexander
American 1881–
F

DUNCAN, Gregory
American 20c.
CC,M

DUNCAN, James
Canadian 1805–81
B,H

DUNCAN, John A.
English 1866–1945
AN,B,LEX,TB

[signature: (ID)]

DUNCAN, Perry M.
American 20c.
M

DUNCAN, Walter Jack
American 1881–1941
CEN4/04,F,H,I,IL,PE

[signature: WALTER JACK DUNCAN]

DUNIN-BRZEZINSKI, Jerzy (Karo)
English mid 20c.
GR59

KARO

DUNKELBERGER, Ralph D.
American 1894–
H

DUNLAP, Hope
American 20c.
M

DUNLOP, Marion Wallace
English 19/20c.
BK

DUNN, Alan Cantwell
American 1900–74
EC,F,H,M

DUNN, Calvin E.
American 1915–
CON,H,M

DUNN, Edwina
American 20c.
M

DUNN, George Carroll
American 1913–
H

DUNN, Harvey Hopkins
American 1879–
F,H

DUNN, Harvey T.
American 1884–1952
F,FOR,GMC,GR57,H,IL,Y

DUNN, Robert
American 1932–
H

DUNNE, Lawrence Francis
Australian 1898–1937
EC

DUNNELL, William N.
American ac. mid 19c.
D,B,F

DUNNINGTON, Tom (Thomas)
American 20c.
GR55,H

DUNOYER de SEGONZAC, André Albert Marie
French 1884–1974
B,DES,EAM,H,PC,S

DU(N)PHINEY, Wilfred Israel
American 1884–
F,H

DUNPHY, Nicholas
American 1891–1955
H

DUNTON, William Herbert (Buck)
American 1878–1936
B,F,H,HA,I,IL,SCR2/12

DUPAS, Jean Théodore
French 1882–1964
AD,ADV,B,CP,F,M,POS,Y

Du PASSAGE, Arthur Marie Gabriel
French 1838–1900
B

Du PASSAGE, Charles Marie, Vicomte
French 1848–1926
B

DUPEREX, L.
French early 20c.
LEX

DUPHINEY, Wilfred Israel
see
DU(N)PHINEY, Wilfred Israel

DUPLAIX, Georges
French/American 1898–
B,M

DUPONT, Alfred
American 1906–
H

DUPONT, Robert
French 1874–1949
B,FO

DUPUIS, Georges (Geo)
French 1875–
B,FS,POS,STU1902

DUPUY, R. L.
French early 20c.
LEX

DURAN, Nina
American mid 20c.
GR85

DURAND, Lucille Murphy
American 20c.
H

DURAND-ROY, René Emile
French 1894–
B

DUREN, Terence Romaine
American 1907–
H

DURIE, Alex
Canadian ac. 1863
H

DURKIN, John
American 1868–1903
H,I,M

DURM, Josef
German 1837–
LEX,TB

DURMAN, Alan
English mid 20c.
GR57

ALAN DURMAN

DURY, J.
French 20c.
LEX

DUSA, Ferdinand (Ferdys)
Czechoslovakian 1888–
LEX,VO

FD

DUSEL, Karl
German 20c.
LEX

DUSS, Carlos
Swiss mid 20c.
GR65

DUSSEK, Ede Adorjan
Hungarian 1871–
B,LEX,TB

DUTRIAC, Georges Pierre
French 20c.
B,LEX,TB,VO

DUVERT, Renée
French mid 20c.
GR57

DUVOISIN, Roger
Swiss/American 1904–
GMC,GR52–67–68,H,M

Roger Duvoisin

DUX, Alexander
American 20c.
M

DUYCK, Edouard
　　Belgian 1856-97
　　B,CP,POS

EJDuyck

DVOŘAČEK, Jaroslav
　　Czechoslovakian 20c.
　　LEX

DWIGGINS, William Addison
　　American 1880-1956
　　GMC,H,M,TB

WAD

DWIGHT, Mabel
　　American 1876-1955
　　APP,H

DWYER, M. J.
　　American early 20c., poster:'Don't Waste
　　Food While Others Starve'--U.S. Food
　　Administration (with Leroy C. Clinker)*

M.J.Dwyer

DYE, Charlie
　　American 1906-72/73
　　H

DYER, C. J.
　　Canadian ac. 1875-97
　　H

DYER, Harry W.
　　American 1871-
　　F,H

DYER, Nancy A.
　　American 1903-
　　F,M

D'YLEN, Jean
　　see
　　YLEN, Jean D'

DYSON, Will (William Harry)
　　Australian/English 1880-1938
　　CP,EC,M

Will. Dyson

DZENIS, Edward A.
　　Canadian 1907-
　　H

DZIERSKI, Vincent
　　American 1930-
　　AA

Dzierski

DZUBAS, Willy
　　German 1877-
　　LEX

- E -

EADIE, Eleanor
　　American 20c.
　　M

EAGAN, Joseph B.
　　American 1906-
　　H,M

EAGLE, Mike
　　American 1942-
　　C

Mike Eagle 72

EAMES, Charles
　　American 1907-
　　GMC,GR59-65,H

EARLE, Eyvind
　　American 1916-
　　H

EARLEY, James W.
　　American 20c.
　　M

EARLY, Walter
　　American 20c.
　　H

EASTMAN, Harrison
　　American 1823-86?
　　H

EASTMAN, Ruth
American 20c.
B,F,GMC

Ruth Eastman (signature)

EATON, Charles Harry
American 1850–1901
B,BAA,CWA,F,H,I

EATON, Gerald
Welsh/American 1880–1951
GA

G.EATON (signature)

EATON, H. M.
Canadian ac. 1889
H

EATON, Hugh McDougal
American 1865–1924
B,F,I

EATON, John
Canadian 1942–
H

EATON, Malcolm
American 20c.
M

EATON, Margaret Fernie
Anglo/American 1871–
B,F,H

EATON, Thomas Newton
American 1940–
H

EBEL, Alex
American late 20c.
GR82,P

ALEX EBEL (signature)

EBEL, Heinrich
German 1849–1931
B,LEX,VO

Eb (signature)

EBER, Elk (Wilhelm Emil)
German 1892–1944?
GWA,H

EBERS, Hermann
German 1881–
B,LEX,TB,VO

H (signature)

EBERSBERGER, Max
German 1852–
B,LEX,TB

EBERT, Charles H.
American 1873–
B,F,H,LEX

EBERT, Dietrich
German late 20c.
GR82–85

EBY, Kerr
Canadian/American 1889/90–1946
APP,B,F,H,I,PE,Y

Eby 24 (signature)

ECHOHAWK, Brummett
American 1920–
H

ECKENBRECHER, Karl Paul Themistokles von
German/Greek 1842–1921
B,H,LEX,TB

T.v.E (signature)

ECKERSLEY, Thomas
English 1914–
ADV,CP,GR52 thru 59–62 thru 68,H,MM,POS

Eckersley.43 (signature)

ECKLE, Carl
German 20c.
LEX

ECKMANN, Helmuth
German 1904–
B,LEX,TB

HE (signature)

ECKMANN, Otto
German 1865-1902
AN,B,CP,MM

ECONOMOS, Gérard
French 1935-
B

EDDELBUTTEL, Richard
German (Prussian) 1856-
B,TB

EDDY, Henry Brevoort
American 1872-1935
F,H,M,R

H.B.Eddy.

EDEL, Alfredo
Italian/French 1856/59-1912
B,FO,H

EDEL, Edmund
German 1863-1933
B,CP,MM,POS

EDELMANN, Anna
German mid 20c.
GR61-62

EDELMANN, Charles Auguste
French 1879-
B

EDELMANN, Heinz
German mid 20c.
CP,GR61-62-64 thru 68-85,POS

EDELS, J.
German 19c.
LEX

EDENS, Annette
American 1889-
H,M

EDER, Alfons E.
Finnish mid 20c.
GR59-60-61-65

EDGERLY, Beatrice E.
American 20c.
F,H

EDHOLM, Charlton Lawrence
American 1879-
B,F,H

EDLER, Richard
German 1869-
LEX,VO

EDMINSTON, Henry
American 1897-
H

EDMOND, Rodolphe
see
CANZI, Reszö Odön

EDMUNDSON, Carolyn Moorhead
American 1906-
F,H

EDROP, Arthur Norman
Anglo/American 1884-
B,F,H

EDWARDS, Allan W.
American 1915-
H

EDWARDS, Edward B.
American 1873-
B,F,I,SCR2/05

EDWARDS, Esmond
American mid 20c.
GR58

EDWARDS, George Wharton
American 1859/69–1950
B,BAA,CO7/04,F,H,HA,I,LEX,PE,R

George Wharton Edwards.

EDWARDS, Harry C.
American 1868–1922
CWA,F,H,I,SCR9/88

H C Edwards

EDWARDS, John Kelt
English 19/20c.
B

EDWARDS, Lionel
English 20c.
B,LEX

EDWARDS, Mary Ellen
English 1839–1908?
B,H,TB

M.E.E.

EDWARDS, Peter
English 1934–
H

EDWARDS, Robert
American 1879–1948
B,F,H

EDWARDS, Stanley Dean
American 1941–
H

EDWARDS, Sydenham Teak
English 1768–1819
B,H

EDWARDS, William Alexander
American 1924–
F,PAP,Y

EDWINA
see
DUMM, Edwina

EDY-LEGRAND, Edouard Léon Louis
French 1892–1970
B,VO

EL

EDZARD, Dietz
German/French 1893–1963
B,H

EFFEL, Jean
see
LEJEUNE, Francois

EFIMOV, Boris Efimovich
Russian 1900–
EC

EFTIMIADES, E.
Austrian 20c.
LEX

EGAN, Beresford
English 20c.
AD

BERESFORD EGAN 29

EGAN, Joseph Byron
American 1906–
H

EGBERT, Henry
American 1826–1900
B,M

EGEDIUS, Halfdan Johnsen
Norwegian 1877–99
B,H,SC,TB

HAE

EGELI, Bjorn P.
Norwegian/American 1900–
B,H

EGELI, Peter Even
American 1934–
H

EGERSDÖRFER, Konrad
German 1868–
B,LEX,TB

K.E.

EGERTON, H. E.
 American mid 20c.
 GR54

EGGENHOFER, Nick
 American 1897–
 H,IL

N.EGGENHOFER

EGGER LIENZ, Alnin
 Austrian 1868–1926
 B,GMC,H

EGGER LIENZ

EGGERT, Benno
 German 1885–
 LEX,VO

E

EGGERT, Sigmund
 German 1839–96
 B

EGGERT, Werner
 German 1909–
 LEX

EGGLESTON, Edward M.
 American 1887–
 B,F,M

EGGLESTON, George T.
 American 20c.
 H

EGGMANN, Hermann
 Swiss mid 20c.
 GR59–63

EGLEY, William Maw
 English 1826/27–1916
 B,H

EGNER, Thorbjorn
 Norwegian 1912–
 H

EGRON, L.
 see
 LUNDGREN, EGRON

EHLERS, Henry
 German 1897–
 POS

H·EHLERS

EHM(C)KE, Fritz Hellmuth
 German 1878–1965
 AN,CP,MM,POS

·F·H·EHMCKE·

EHMSEN, Heinrich
 German 1886–
 LEX,VO

EHNINGER, John Whetten
 American 1827–89
 B,BAA,D,F,H

EHRENBERGER, Ludwig (Lutz)
 German ac. early 20c.
 POS,VO

EHRHARDT, Adolf
 German 1813–99
 LEX,TB

ÆE

EHRMANN, François Emile
 French 1833–1910
 B,H,LEX

EIBAKKE, A.
 see
 EIEBAKKE, August

EICHBAUM-BREHME, Clare
 American 1886–
 H

EICHENBERG, Fritz
 German/American 1901–
 APP,H,M,PC,VO

EICHENBERGER, H.
Swiss mid 20c.
GR58

EICHHORN, André
Swiss mid 20c.
GR53

EICHLER, Reinhold Max
German 1872–1947
B,SI,TB,VO

R. Max Eichler

EICHRODT, Helmut
German 1872–
B,POS,TB

H.E.

EICHSTÄDT, Rudolf
German 1857–
B,LEX,TB

RE

EIDENBENZ, Hermann
German/Swiss 1902–
GR53–54–55–58,H,POS

EIDLITZ, Frank
Australian 20c.
LEX

EIDRIGEVICIUS, Stasys
Polish late 20c.
EI82

Stasys

EIEBAKKE, August
Norwegian 1867–1938
H,LEX

EIGENMANN, Hermann
German mid 20c.
GR64

Eigenmann

EILSHEMIUS (EILSHIMIUS or ELSHEMUS), Louis Michael
American 1864–1941
B,EAM,F,H,SO

Eilshimius-, Elshemus

Eilshemius

EINSEL, Naiad
American 1927–
F,GR55–56–57–59,Y

EINSEL, Walter
American 1926–
F,GR52 thru 57–59,Y

EINZIG, Susan
English mid 20c.
GR52–53

EIRI
Japanese early 19c.
H

EIRICHK, Edward C.
American 1878–1929
M

EISEN
Japanese 1790–1848
B,H

EISENMAN, Stanley
American mid 20c.
GR63–65–67–68

EISENSTAT, Benjamin
American 1915–
H

B. Eisenstat

EISGRUBER, Elsa
German 20c.
M

EISNER, Phyllis
American 1915–
M

EISSEL, W.
German 19/20c.
LEX

EITAKU KANO
Japanese 1843-90
B,CP,H

EITGEN, Allan
American 20c.
H

EIWECK, Franz E.
Austrian early 20c.
LEX

EKE, Rob
American mid 20c.
GR57

EKES, Louis Csabai
Hungarian early 20c.
POS

EKSELL, Olle
Swedish 1918-
GR52 thru 55-57-58-85,H

EKWALL, Knut
Swedish 1843-1912
B,H,LEX,TB

ELAND, John Shenton
Anglo/American 1872-1933
B,F

ELCHLEB, Karl
German 20c.
LEX

ELDH, Hjalmar
Swedish 1884-
LEX,VO

ELDRIDGE, Harold L.
American 20c.
H

ELFER, Arpad
English 20c.
ADV,GR52-53-56-57-59,POS

ELFFERS, Dick
Dutch 1910-
GR52-57-58 thru 63-66,H,POS

ELGIE, Colin
English late 20c.
EI79

ELIA, Albert
Lebanese/American 1941-
F,Y

ELIAS, Lee (Leopold)
Anglo/American 1920-
H

ELIASOPH, Paula
American 1895-
B,H

ELIOT, Frances
American 20c.
M

ELIOT, Harry
English 20c.
B

ELISE (ELISE ROSEN)
Austrian/American 20c.
H

ELKUS, Bruce
American mid 20c.
GR57

ELLEDER, Karl
Austrian 1860-
LEX

ELLERTSON, Homer F.
American 1892-1935
B,F,H

ELLIOT, Freeman
American mid 20c.
PAP

ELLIOT, Henry Wood
see
ELLIOTT, Henry Wood

ELLIOTT, Elisabeth Shippen Green
American 20c.
B,F,H,I

ELLIOTT, George
American mid 20c.
GR53

ELLIOTT, Hannah
American 1876-
B,F,H

ELLIOTT, Henry Wood
American 1846-1930
H

ELLIOTT, John
Anglo/American 1858-1925
F,H,I

ELLIOTT, John Theodore
American 1929-
H

John Elliott 75

ELLIOTT, Lee
English early 20c.
POS

ELLIOTT, Lilian Elwyn
English 19?/20c.
I

ELLIS, Clifford
English early 20c.
GR55,POS

ELLIS, Clifford and Rosemary
English early 20c.
GR55,POS

C & R E

ELLIS, Dean
American mid 20c.
GR57,H

ELLIS, Edwin John
English 1841-95
B,H

ELLIS, Harvey
American 1852-1904
B,I,M,R

ELLIS, M. B.
Canadian ac. 1890-91
H

ELLIS, Maude Martin
American 1892-
F

ELLIS, Richard
American 1938-
H

ELLIS, Rosemary
English early 20c.
GR55,POS

ELLIS, Tristram James
English 1844-1922
B,H

ELLMANN, Siegfried
Austrian mid 20c.
LEX

ELLMS, Charles
American ac. mid 19c.
D

ELLSWORTH, Clarence Arthur
American 1855-1961
H,M

ELLSWORTH, Roy
English late 20c.
EI79

ELMES, Willard Frederic
American 20c.
PG

ELOG-VINCENT, A.
French late 19c.
LEX

ELSHIN, Jacob Alexandrovitch
Russian/American 1891-
B,H

ELWELL, D. Jerome
American 1847-1912
B,I

ELWELL, John H.
American 1878-
B,F,H,I

ELWELL, R. Farrington
American 1874-1962
H,M

R. Farrington Elwell—

ELT, Richard
American 1928-
H,Y

EMANUEL, Frank Lewis
English 1865-1948
B,H

EMBERLEY, Ed
American 1931-
H

EMCKE, Fritz Helmut
German 1878-
H

EMERSON, Arthur Webster
American 1885-
B,F,H

EMERSON, Charles Chase
American -1922
F,I

Chase Emerson

EMERSON, Edith
Anglo/American 20c.
B,F,H

EMERSON, J.
American ac. 1840s
D

EMERSON, R. L.
American 19?/20c.
R

EMERTON, James H.
American 1847-1930
B,F,M

EMERY, Margaret Rose
American 1907-
H

EMERY, Marion B.
Canadian 20c.
M

EMETT, R.
see
EMMETT, Rowland

EMMERIK, Louis
Dutch mid 20c.
GR52

EMMET, Rosina
American 1854-
B,F,H,I

EMMET(T), Lydia Field
American 1866-1952
B,H,I

EM(M)ETT, Rowland
English 1906-
EC,GR56-57-59-63,H

E^ME^T^T

EMMONS, Dorothy Stanley
American 1891-
B,F,H

EMORY, Hopper
American 1881-
B,F,M

EMPIE, Hal H.
American 1909-
H

EMSHWILLER, Edmund A.
American mid 20c.
PAP

EMY, Henry
French 19c.
B,LEX,TB

HE

EN EL
Uruguayan 20c.
GMC

En El

ENDERTON, S. B.
American ac. 1866
H

ENDEWELT, Jack
American 1935–
F,Y

ENDICOTT, James
American late 20c.
GR82

ENDICOTT

ENG, Peter
Austrian early 20c.
LEX

ENGEL, Erika
German 20c.
LEX

ENGEL, Johann Friedrich
American 1844–
B,LEX,TB

JFE

ENGEL, José
French 1873–
B,LEX,TB

H

ENGEL, Michael Martin, Sr.
Hungarian/American 1894/96–
H

ENGEL, Michael Martin, Jr.
American 1919–
H

ENGELHARD, Elizabeth
American 20c.
H,M

ENGELHARD, Julius Ussy
German early 20c.
AD,CP,POS

F. U. Engelhard. 28.

ENGELHARD, Paul Otto
German 1872–
LEX,VO

P.O.E.

ENGELHARDT, F. N.
German early 20c.
GMC(p1.226)

ENGELHARDT, Willy
German 1900–
LEX

ENGELHART, Michael
Austrian early 20c.
LEX

ENGELMANN, Karen
Swiss 20c.
BI,GR82

ENGELMANN, Martin
Dutch/French? 1924–
B,GR53–57,H

M.E.

ENGELS, Robert
German 1866–1926
B,TB,VO

RE

ENGELSE, Dick
Dutch mid 20c.
GR54

ENGERTH, Max
German 1859–
LEX

ENGL, Hugo
Austrian 1852–
B

HE

ENGLE, Nita
American 1925–
F,Y

ENGLISH, Bill
American mid 20c.
GR52,PAP

Bill English

ENGLISH, Mark F.
American 1933–
F,IL,Y

Mark English

ENGLISH, Michael
English 1939–
CP,EI79,POS

ENGSTRÖM, Albert
Swedish 1869–1940
B,EC,POS

Albert Engström

ENGSTRÖMER
Danish early 20c.
POS

ENOCK, David
American mid 20c.
GR60–63–65–68

ENOS, Randall
American 1936–
C,F,GR68–82–85,Y

E N O S

ENRIGHT, Elizabeth
American 20c.
M

ENRIGHT, Walter J.
American 1879–
B,F,H

ENSER, John F.
American 1898–
H

ENSOR, Arthur John
Canadian 1905–
H

ENSOR, James
Belgian 1860–1949
AN,B,EC,GMC,H,PC,POS

ENSOR

ENTART, C.
French ac. late 19c.
LEX

ENTERS, Angna
American 1907–
H

ENTWISTLE, Ralph Edmund
American 20c.
M

EPIFANOV, Gennadi Dmitrievich
Russian 1900–
H

EPPENSTEINER, John Joseph
American 1893–
B,H

EPSTEIN, Abner
see
DEAN, Abner

EPSTEIN, Ernest
American 20c.
H

ERDMANN, H.
Swiss mid 20c.
GR52

ERDMANN, Harry
German early 20c.
LEX

ERDOES, Richard
American 1912–
GR52 thru 56–58–59,H

ERDOES

ERDT, Hans Rudi
German 1883–1918
AD,ADV,CP,MM,POS

ERESCH, Josie
American 1894–
H,M

ERHARDT, Anton
Czechoslovakian 20c.
LEX

ERIC
see
ERICKSON, Carl Oscar August

ERIC
see
NITSCHE, Erik

ERICHSEN, Nellie
English 19/20c.
B,BK

N. ERICHSEN

ERICKSON, Carl Oscar August
American 1891–1958
ADV,F,FOR,GMC,H,IL,VC,Y

Eric

ERICKSON, George T.
American 1924–
PAP

Erickson

ERICKSON, John M.
Danish/American 1884–1918
I

ERICSON, David
Swedish/American 1870–
B,F,H,I,SN7/94

DAVID ERICSON

ERICSON, Dick
American 1916–
H

ERICSON, Ernest
American 20c.
H

ERIKSSON, Leif
Swedish late 20c.
GR82

ERIKSSON, Willy
Swedish mid 20c.
GR65

Willy

ERK, Emil
German 1871–
LEX,VO

E

ERLER, Fritz
German 1868–1940
AN,B,GMC,GWA,POS

Erler

ERLER, Georg Oskar
German 1871–
B,LEX,TB

GE

ERMOYAN, Seran
American mid 20c.
GR61

ERNI, Hans
Swiss 1909–
B,GR52 thru 58–60 thru 63–65–66–67,H,PG,POS

Erni

ERNST, James A.
American 1916–
H,LEX

JAE

ERNST, Jupp
German mid 20c.
GR54

ERNST, Max
German/French 1891–1976
APP,B,DES,DRAW,EAM,GMC,H,PC,POS

max ernst

ERNST, Paul
Swiss mid 20c.
GR53

ERNYEI, Sándor
Hungarian 1924–
GR59,H

ERRO (pseudonym)
see
GUNDMUSSON, Gundmunder

ERTÉ (de TIRTOFF, Romain)
Russian early 20c.
ADV,B,GMC,ST

ERTZ, Edward Frederick
American 1862–
B,F,H,I

ERTZ, Gordon
American early 20c.
GMC

ESCHER, Maurits Cornellis
Dutch 1898–1972
B,H,LEX,PC

ESCHLE, Max
German early 20c.
POS,VO

ESCOTT, D.
English mid 20c.
GR54

ESHRAW, Ra
American 1926–
H

ESKRIDGE, Robert Lee
American 1891–
B,F,H

ESLEY, Joan
American 20c.
M

ESMOND, (Mrs.) Clement
see
PAXSON, Ethel

ESNER, Arthur L.
Russian/American 1902–
H,M

ESPINHO, José
Portuguese mid 20c.
GR57

ESSENTHER, Walter
Austrian early 20c.
LEX

ESSERS, Bernard
French early 20c.
B,GMC

ESSIG, George Emerick
American 1838–
B,F

ESTACHY, Francoise
French mid 20c.
GR52-54-55

ESTEBAN
Spanish 19c.
BAA,POS

ESTERLE, Max Ritter von
Austrian 1870–1947
B,LEX,TB,VO

ESTIN, Peter Georg
Czechoslovakian/American 1927–
H,PLC

ETBAUER, Theodor Paul
German 1892–
POS,VO

ETCHELLS, Frederick
English 1886–1973
B,BRP

ETS, Marie Hall
American 1895–
H,M

ETTING, Emlen
American 1905–
H

ETTINGER, Trudy
English mid 20c.
GR52–54

EUTEMEY, Loring
American 20c.
POS

EUWER, Anthony Henderson
American 1877–
F,H,HA12/07,I,M

ANTHONY H.
EUWER

EVANS, Edgar Samuel
American 1852–1919
H,I

EVANS, Elizabeth E.
American 1908–
H,M

EVANS, G. E.
English mid 20c.
GR52

EVANS, George
American 20c.
H

EVANS, Grace
American 1877–
B,H

EVANS, Harry
American 20c.
M

EVANS, John William
American 1855–
F,H,I

EVANS, Raymond Oscar
American 1887–1954
EC,F,I,M

EVANS, Scott
American 20c.
M

EVATT, Harriet Torey
American 1895–
H

EVEN
French mid 20c.
GR55

EVEN

EVENEPOEL, Henri Jacques Edouard
Belgian 1872–99
AN,B,CP,GA,H,MM

h.evenepoel.

EVENHUIS, Frans
American late 20c.
EI79

EVERETT, Elizabeth Rinehart
American early 20c.
B,F,H

EVERETT, Fred
American 20c.
M

EVERETT, Joseph Alma Freestone
American 1884–1945
B,F,H

EVERETT, Walter H.
American 20c.
IL,M,Y

W.H.Everett

EVERHART, Adélaide
American 1905–
B,H

EVERS, Alf
 American 20c.
 M

EVERS, Charles
 Swedish 20c.
 LEX

EVERS, Helen
 American 20c.
 M

EVERTON, Macduff
 American 20c.
 P

EWERBECK, Ernst
 German 1872–
 B,TB

EWERBECK, Franz Klemens
 German? 1839–98
 LEX,TB

EWING, Elizabeth
 American 20c.
 M

EX
 French early 20c.
 AD

EXCOFFON, Roger
 French 1910–
 CP,GR54–58–65,H,POS

EXINGER, Otto
 Austrian 20c.
 LEX

EYAL, Ephraim
 Israeli late 20c.
 GR82

EYTH, Karl
 German 1856–
 B,LEX,TB

EYTH, Louis
 American 1838–9?
 H

EYTINGE, Solomon, Jr.
 American 1833–1905
 B,D,H

– F –

F. R.
 English early 20c.
 ADV

F. W. K.
 German early 20c.
 POS

FABER, Erwin F.
 American –1939
 M

FABER, Will
 German 20c.
 LEX

FABIAN, Erwin
 English mid 20c.
 GR53–55–56–58–59

FABIAN, Max
 German 1873–1926
 B,LEX,TB,VO

FABIANO, F.
 American ac. 1920s
 PE

FABIANO, Giuseppe (Bepi)
 Italian 1883–
 H,POS

FABIGAN, Hans
Austrian 1901–
GR52–53–54–57–60–62–63,H,POS

FABRÈS, Oscar
American mid 20c.
GR55

fabrès

FABRES Y COSTA, Antonio Maria
Spanish 1854–
B

Fabres

FABRICIUS, Johan
Dutch 20c.
M

FABRY, Jaro
American mid 20c.
PAP

FABRYEN
Belgian? ac. late 19c.
POS

FÄCKE, Rudi (Rufa)
German 1909–
LEX

RUFA

FACKERT, Oscar William
American 1891–
B,F,H

FACTOR, Yale
American 1951–
AA

FAGG, Kenneth Stanley
American 1901–
B,F,H

FAHRBAUER, J. G.
Austrian 1841–
B,LEX

FAHRENBACH, Wilhelm
German 1892–
LEX

FAINI, U.
Italian mid 20c.
GR60

FAIOLA, Susan
American late 20c.
New Yorker magazine 5/86

FAIRBANKS, J. Leo
American 1878–1946
B,F,H

FAIRCHILD, Charles Willard
American 1886–
B,F,H,M

FAIRCHILD, Hurlstone
American 1893–1966
H

FAIVRE, Jules Abel
French 1867–1945
B,CP,EC,FS,GMC,M,POS

AbelFaivre

FALCONER, Pearl
English mid 20c.
ADV

FALK, Hans
Swiss 1918–
CP,GR52 thru 60,H,POS,VO

Falk 55

FALKÉ, Pierre
French 1884–1947
B,FS

PiERRE FALKÉ

FALKENSTEIN, Claire
American 1908/09–
B,H

FALKNER, Harold
English early 20c.
B,LEX,TB

HF

FALLS, Charles Buckles
American 1874–1960
ADV,B,EC,F,H,I,IL,M,VO

Falls

FALLS, Clinton DeWitt
American 1864–
B,F,I

FALTER, John Philip
American 1910–
CON,F,GR60,H,IL,M,Y

JOHN FALTER

FALUS, Elek Endre
Hungarian 1883–
B,LEX,TB,VO

FE

FALVARD, Maurice Gabriel
French 1889–
B

FANCHER, Louis (Luis?)
American 1884–
B,POS

FANGEL, Maud(e) Tousey
American 20c.
GMC,H,IL,M,Y

*Maud
Tousey
Fangel*

FANGOR, Wojiech (Voy)
Polish 1922–
GR55,H

FANIEL
Belgian early 20c.
POS

FANKHAUSER, G.
Swiss mid 20c.
GR65

FANNAIS, George
Canadian 1922–
H

FANNING, Nettie B.
American 19/20c.
B

FANNING, William Sanders
American 1887–
B,F,H

FANTINI, Luisa
Italian 1907–
H

FANTIN-LATOUR, Ignace Henri Jean Théodore
French 1836–1904
B,GMC,H,PC

FAORZI, Giovanni
Italian 1919–
H

FARAFONTOFF, Fedor Timofeievitch
Russian 1770–
B

FARAGASSO, Jack
American 1929–
H,PAP

FARAGO(Y), Géza
Hungarian 1877–
B,POS,TB,VO

G

FARBER, Hy
American mid 20c.
GR57

FARBER, Rose
American mid 20c.
GR57

FARIA, José
Portuguese 1940–
H

FARKAS, André
Romanian 1915–
EC,POS

André Farkas

FARLEIGH, John
 English 20c.
 B,M,S

FARM, Gerald E.
 American 1935–
 CON,H

[signature: G. Farm]

FARMER, Mabel McKibbin
 American 1903–57?
 H,M

FARNY, Henry Francois
 Franco/American 1847–1916
 B,F,H,HA,PE

[signature: H.F.FARNY]

FARR, Helen
 American 1911–
 H

FARRAR, Midred R. H.
 English 1860–
 M

FARRELL, A. T.
 American early 20c.
 F

FARRELL, Richard
 American late 20c.
 GR82

[signature: farell]

FASCIANO, Nicolas
 American mid 20c.
 GR65

FASOLINO, Teresa
 American 1946–
 F,GR82–85,Y

[signature: Teresa Fasolino]

FASSBENDER, Joseph
 German 1903–
 B,GR52,H

FASSL, Ernest
 Austrian 1926–
 GR59

[signature: .FASSL]

FASSL, Irmgard
 Germand mid 20c.
 GR60

FASSL, Rolf
 German mid 20c.
 GR60

FASSONI, Piero
 Dutch late 20c.
 GR82

FASTOVE (FASTAVSKY), Aaron
 Russian?American 1898–
 H

FAU, Ferdinand
 French 19/20c.
 LEX

FAUCHEUX, Pierre
 French mid 20c.
 GR55–65–67

FAULCONER, Mary (Fullerton)
 American mid 20c.
 GR53,H

FAULKNER, Herbert Waldron
 American 1860–
 B,F,H

[signature: H.W.Faulkner]

FAULKNER, John
 American 20c.
 H

FAURE, Gabrielle
 French 20c.
 B

FAUST, Victoria
 American mid 20c.
 GR85

FAUSTINA, James
 American 1876–
 B

FAUSTINO
Cuban 20c.
POS

FAUTRIER, Jean
French 1898–1964
H,PC

FAVORSKY, Vladimir Andreyevich
Russian 1886–1964
B,H,M,MM,PC,POS,S

FAVRE, Henri
French 20c.
POS

FAVRE, Louis
Swiss 1822–1904
B

FAWCETT, George
Anglo/Canadian/American 1877–
B,F,H,WS

FAWCETT, Robert
Canadian/American 1903–67
F,H,IL,M,VO,WS

FAWKES, Wally (Walter Ernest (Trog))
Canadian/English 1924–
CC,GMC

Trog

FAX, Elton Clay
American 1909–
H

FAY, Augustus
American 1824?–
D

FAY, Clark
American 20c.
IL,M

CLARK FAY

FAY, Dezső
Hungarian early 20c.
LEX,STU1926

FAY, Fred
Swiss 1901–
B

FAY, Georges
French ac. 1890s
MM

georges fay

FAY, Jean Bradford
American 1904–
H

FAYASH, Julius F.
Hungarian/American 1904–
H

FEASER, Daniel David
American 1920–
H

FEASLER, Gustav
Austrian ac. early 20c.
LEX

FEDERICO, Gene
American mid 20c.
GR52-54-60

FEDERICO, Helen
American mid 20c.
GR55-60

FEELINGS, Tom
American 1933–
H

tom feelings

FEGIZ, Rita Fava
American 1932–
H

FEIFFER, Jules
American 1929–
GR61,H

FEIN, Stanley
 American 1919–
 H

FEIND, Anna Nordstrom
 American early 20c.
 Y

FEINSTEIN, Samuel Lawrence
 American 1915–
 H

FEIO, J.
 Portuguese mid 20c.
 GR52

FEITLER, Beatriz
 Brazilian 1938–
 H

FELDE, Zum
 Argentinean 20c.
 LEX

FELDMAN, Eugene
 American 20c., (deceased)
 GR57-58-60

FELDMAN, Jean?
 French 20c.
 GR61,POS

FELDMAN, Lester
 American 20c.
 ADV

FELDMAN, Max Marek
 Austrian/American 1909–
 H,M

FELDWISCH, Albert
 German 19c.
 LEX

FELINI, G. W.
 Italian 20c.
 GMC

FELIX, Franz
 Austrian/American 1892–
 H

FÉLIX, Monique
 Swiss late 20c.
 GR85

FELKER, Ruth Kate
 American 1889–
 B,F,H

FELL, Herbert Granville
 English 1872–1951
 B,BK,TB

HGF

FELLER, Frank
 Swiss 1848–1908
 B,TB

FF

FELLOWS, Lawrence
 American 1885–1964
 F,IL,PE,Y

L•FELLOWS•21

FELLOWS, Muriel H.
 American 20c.
 M

FELSTEAD, Cathie
 English late 20c.
 EI79

FELTEN, Major
 American 20c.
 GMC,H,M

MAJOR FELTEN

FENDERSON, Mark
 American 1873–1944
 B,CEN7/09,EC,F

Mark Fenderson

FENDT, Max
 see
 XAM

FENICAL, Marlin Edward
 American 1907–
 H

FENN, Harry (Henry)
 English 1838–1911
 B,BAA,CEN2/99,CWA,H,HA5/05,LEX,TB

FENNE(C)KER, Joseph
German 1895-1956
AD,GMC,POS

J.Fenneker
20

FENNELL, John Greville
English 1807-85
B,H,M

FENTON, Carroll Lane
American 20c.
M

FENWICK, Roland
Canadian 1932-
H

FENWICK, T.
Canadian ac. 1873-80
H

FERAGUTTI (Visconti), Adolfo
Italian 1850/58-1924
H,LEX,TB,VO

A

FERAT, Pierre
French ac. late 19c.
LEX

FERCH, Rudolf
Austrian mid 20c.
GR54-57

FERGUSON, Bernard La Marr
American 1911-
H,M

FERGUSON, Elizabeth F.
American 1884-
F,H

FERGUSON, J.
English ac. 1850-65
H

FERGUSON, Walter W.
American 1930-
H

FERN, Dan
English late 20c.
EI82-83,GR82-85

FERNALD, George Porter
American 19/20c.
CO7/04,SCR2/06

GEORGE PORTER FERNALD

FERNANDES, Millôr
Brazilian 1924-
EC,H

FERNANDES, Stanislaw
American 20c.
GR85

FERNANDO, Berto
Portuguese 1910-
H

FERNANDUS, A.
French late 19c.
LEX

FERNE
French ac. late 19c.
POS

FERNS, Ronald
English mid 20c.
GR52-55-56

Ronald Ferns

FERRARA, Joe
American 1931-
CON

JOE FERRARA

FERRARA, Lidia
American mid 20c.
GR85

FERREIRA, Manuel
Portuguese 1940-
H

FERREIRA, Paolo
Portuguese 1911–
GR56,H

paolo

FERRERO, Roger
Swiss 1915–
B

FERRI, Liana
Italian 1906–
H

FERRINI, Luis
Argentinean 1898–
H

FERRIS, Bernice Branson
American 20c.
B,F,H,M

FERRIS, Carlisle Keith
Americ an 1929–
H

FERRIS, Edythe
American 1897–
B,F,H

Edythe Ferris

FERRIS, Warren Wesley
American 1890–
B,H

FERRISS, Hugh
American 1889–
B,F,H,I,M,VO

FERRIS(S), Jean Leon Gerome
American 1863–1930
B,F,H,I

JLGFerris

FERRITER, Clare
American 1913–
H,M

FERRY, Dave
American 20c.
C

Ferry

FERSTADT, Louis Goodman
American 1900–54
H

FEUILLATE, Raymond
French 1901–71
B

FEURE, Georges de
French 1868–1943
AN,B,GA

de Feure

FIALA, Vaclav
Czechoslovakian 1896–
B,LEX

FIAMMENGHI, Gioia
American 1929–
H

FICALORA, Toni
American mid 20c.
GR60

FICHET, (Pierre?)
French 20c., (Pierre 1927–)
B,H?,POS

FIDUS
see
HOEPPNER, Hugo

FIEBIGER, A(l)bert
German 1869–
LEX

FIEDLER
American 20c.
PAP

Fiedler

FIEDLER, G.
English ac. late 19c.
LEX

FIELD, Charlotte E.
American 1838-1920
H,M

FIELD, Phyllis M.
Canadian early 20c.
WS

FIELD, William
American 20c.
GR65-67

FIELDS, Earl Thomas
Finnish/American 1900-
H,M

FIERBOUGH, Margaret
American 20c.
H

FILDES, (Sir) Luke
English 1844-1927
B,BA,H,TB

L.F.

FILMER, John
American
F

FILO, Julián
Yugoslavian 1921-
H

FILONOV, Pavel Nikolaevich
Russian 1833-1941
RS

FILSAK, Josef
Polish 20c.
LEX

FINETTI, Gino Ritter von
Italian/German 1877-
B,LEX,VO

FINGER, Helen
American 1912-
H,M

FINI, Léonor
Argentinean/French 1908-
B,GMC,GR53,H

Leonor Fini

FINK, Denman
American 1880-
B,F,H,I

FINK, Robert Richard
American 1909-
H,PAP

FINK, Sam (Samuel)
American 1916-
F,H,Y

FINKELSTEIN, Clara S.
American 1885-
H

FINLEY, Frederick James
Canadian 1894-
H

FINLEY, Halleck
American mid 20c.
PAP

FINNEMORE, Joseph
English 1860-1939
B,H,LEX,TB

J.F.

FINNIE, John
English 1829-1907
B,H

FINOPIENS
French early 20c.
GMC

FINSON, Hildred A.
American 1910–
H

FINSTERER, Alfred
German 1908–
M,LEX,VO

FINTA, Alexander
Hungarian/American 1881–1958?
B,F,H

FIRESTONE, Isadore Louis
Austrian/Hungarian/American 1894–
B,F

FIRFIRES, Nicholas Samuel
American 1917–
CON,H

Nicholas S. Firfires

FIS, H.
see
FISCHER, Hans

FISCHER, Adolf
Austrian 1856–1908
B

A.F.

FISCHER, Anton Otto
German/American 1882–1962
B,EC,F,H,I,IL,M,Y

ANTON OTTO FISCHER

FISCHER, Béla
Brazilian/German 1898–
LEX

FISCHER, Carl E.
German early 20c.
LEX

FISCHER, Ernest Albert
German 1853–
B

FISCHER, Fritz
German 1911–
G,GR68,VO

Ff

FISCHER, Hans
Swiss mid 20c.
GR53–54–55–58–61,PC

Dr Fis

FISCHER, Heinrich
Swiss mid 20c.
GR53

FISCHER, Ludwig Hans
Austrian 1848–1915
B,LEX,TB

LfH

FISCHER, Mary Ellen Sigsbee
American 1876–
B,F,H,I,M

FISCHER, Otto
German 1870–1947
B,GA,POS,TB,VO

OTTO FISCHER

FISCHER, Paul
Danish 1860–
POS,TB

Paul Fischer

FISCHER, Peter
West German late 20c.
EI79,GR62

FISCHER, Sidney
American mid 20c.
GR85

FISCHER-CÖRLIN, Ernst Albert
German 1853–
B,LEX

FISCHER-KÖYSTRAND, Carl
Austrian 1861–
B,LEX

FISCHER-NOSBISCH, D.
Germand mid 20c.
GR57-60-63

FISCHER-NOSBISCH, Fritz
German mid 20c.
GR59-60-63-65

FISER, Jaroslav
Czechoslovakian mid 20c.
GR52-61-67-68

FISH
see
SEFTON, Anne Harriet

FISHER, Ann A.
American 20c.
H

FISHER, Harrison
American 1875–1934
ADV,B,EC,F,GMC,H,I,IL,M,Y

FISHER, Jeffrey
English late 20c.
EI84

FISHER, (Mrs.) Jessie Shaw
American 1887–
M

FISHER, Leonard Everett
American 1924–
F,H,Y

FISHER, Nicholas
American 20c.
H

FISHER, Orville N.
Canadian 1911–
H,M

FISHER, Philip D.
American ac. 1867
H

FISHER, T. H.
English 20c.
H

FISHER, William Edgar
American 1872–
B,F,H

FISHER-WRIGHT, Blanche
American ac. early 20c.
LEX

FISK, Harry T.
American ac. 1921–48
H

FISK, W.
American ac. 1857–67
H

FISKE, W.
American ac. mid 19c.
D,H

FITCH, Walter
English ac. 1835
H

FITCHER, E. H.
English ac. late 19c.
LEX

FITHIAN, Frank Livingston
American 1866–1935
H,LEX,LHJ4/05,M

·F.L·FITHIAN·

FITTON, Hedley
English 1859–1929
B,BK,H

FITTS, Clara Atwood
American 1874–
B,F,H,M

FITZCOOK, Henry
English 1824–
B

FITZER, Karl H.
American 1896–
B

FITZGERALD, Edmond James
American 1912–
M

FITZGERALD, (Edmond?) James
American mid 20c.
GR60-61-63-66

FITZGERALD, Pitt Loofbourrow
American 1893–1971
B,H

FITZPATRICK, John C.
American 1876–
B,F,H

FIUME, Salvatore
Italian 1915–
B,H

FIX-MASSEAU, Pierre Felix
French 1869–1937
AD,B,CP,GR52-57-63,POS

Pierre MASSEAU 32

FIYALKO, Tony
American 20c.
NV

Tony Fiyalko

FLACCUC, Violetta
American 20c.
M

FLACK, Marjorie
American 20c.
M

FLAGG, James Montgomery
American 1877–1960
ADV,B,CC,EC,F,GMC,H,I,IL,M,PE,PG,
SCR12/06,SO,WWK2/12,Y

JAMES MONTGOMERY FLAGG

FLAMENG, François
French 1856–1923
B,FO,H,L,TB

FRANÇOIS·FLAMENG

FLANAGAN, John Richard
Australian/American 1895–1964
F,IL,M,PE,Y

FLANDERKA, Jaroslav
Czechoslovakian 1877–1913
LEX

FLASHAR, Max
German 1855–1915
B,TB

FLATO
American early 20c.
ADV

FLATO

FLAXMAN, John
English 1755–1826
B,DA,H

FLECHTENMACHER, Otto
Rumanian 20c.
LEX,VO

FLEISCHMAN, Seymour
American 1918–
H

FLEISCHMANN, Glen
American 1909–
H

FLEISCHNER, Jzidor
Hungarian 19/20c.
LEX

FLEISSIG, Viktor
Austrian early 20c.
LEX

FLEJSAR, Josef
Czechoslovakian 1922–
GR54-56-60 thru 68,H

FLEJSAR

FLEMING, Henry Stuart
American 1863–
B,F,I

FLESHER, Vivienne
American late 20c.
GR82

FLESSEL, Creig
American 1912–
H

FLETCHER, Alan
English 1931–
GR55-60-61-62-64,H

FLETCHER, Gilbert
American 1882–
F

FLETCHER, Sydney E.
American ac. 1924–39
H

FLINT, (Sir) William Russell
English 1880–1969
B,H,TB

WRF

FLINZER, Feodor
German 1832–1911
B,LEX

FLISAK, Jerzy
Polish mid 20c.
GR62 thru 68

Flisak

FLOETHE, Richard
American 1901–
H,M

FLOHERTY, John J., Jr.
American 1907–
H,IL,M,PAP

FLOHERTY JR

FLORA, James Royer
American 1914–
GR54-56,H

Flora

FLORA, Paul
Austrian 1922–
B,EC,GR62-63-64-66-67,H

FLORA

FLORANE
French early 20c.
FS

Florane

FLORENTINO-VALLE, Maude Richmond
American early 20c.
F,H

FLORSHEIM, Carl
American mid 20c.
GR53

FLORY, Arthur L.
American 1914–
H

FLOWER, Charles Edwin
English 1871–
H

FLOWER, Lynda
English late 20c.
EI79

FLOYD, Gareth
English 20c.
H

FLÜCKIGER, Adolf
Swiss 1917–
GR52 thru 56-59-60-64-66,H

FLÜGEL, Th.
German 19/20c.
LEX

FOGARTY, Frank Joseph
American 1887–
H

FOGARTY, Mae
American 20c.
M

FOGARTY, Thomas
American 1873–1938
B,CO6/05 & 8/05,F,H,I,IL,M,PE,Y

THOMAS FOGARTY

FOGARTY, Thomas J., Jr.
American 20c.
H

FOLKUS, Dan (Daniel Alan Frederickson)
American 1946–
H

FOLLOT, Paul
French 1877–1941
B,LEX,VO

FOLON, Jean Michel
Belgian 1934–
B,EC,GMC,GR66-68-82-85,P,POS

FOLON

FOLSOM, George
American 1859–1919
I,M

FOMINA, Iraïda
Russian 1906–
H

FONESCA, Joao Thomaz da
Spanish 1754–1835
B,H

FONESCA, Martinho Gomes da
Portuguese 1890–1972
H

FONTANAROSA, Lucien Joseph
French 1912–75
B

L·F

FONTANEZ, Jules
Swiss 1875–
B

FONTANINI, Clare
American 1908–
H

FONTS, Noemí
Portuguese
H

FOO, Mei Lou
American mid 20c.
GR60

FOOTE, Mary Anna Hallock
American 1847–1938
B,BAA,F,H,I

FORAIN, Jean Louis
French 1852–1931
B,BI,CP,DA,EC,FS,H,L,PC,POS,VO

forain

FORBELL, Charles
American early 20c.
B,F

FORBELL, F. A.
American ac. early 20c.
LEX

FORBES, Bart John
American 1939–
F,Y,American Way Magazine 12/15/86

B. John

FORBES, Colin
English mid 20c.
GR60-61-64

FORBES, Edwin
American 1839–95
B,BAA,F,H,PC,POS,Y

FORCHEY, A.
　French early 20c.
　BI

FORD, Brian
　Australian mid 20c.
　GR57

FORD, Edwin Joseph
　American 1914-
　H,M

FORD, H. J.
　American 20c.
　M

FORD, Henry Chapman
　American 1828-94
　H

FORD, Henry Justice
　English 1861-1941
　B,BK,TB

HJF

FORD, Lauren
　American 1891-
　B,F,H

FORD, Pamela Baldwin
　American 20c.
　C

FORD, Richard
　English 1796-1838
　B,H

FOREGGER, L.
　Austrian 20c.
　LEX

FOREMAN, Mark
　English late 20c.
　EI84

MF

FOREMAN, Michael
　English late 20c.
　EI79,GR68-82-85

FORESTIER, (Sir) Amèdèe
　French/English 20c.
　M

FORESTIER, Henri Claudius
　Swiss 1875-1922
　B,POS,VO

H.C.F.

FORG, Liège
　Belgian mid 20c.
　GR56

FORG.

FORGEOIS, Michele
　French 1929-
　B

FORGY, John D.
　American 19?/20c.
　I

FORINGER, Alonzo Earl
　American 1878-
　B,F,H,I

FORISSIER, Roger
　French 1924-
　B

FORJOHN, Horatio
　American 1911-
　M

FORMAN, Kerr Smith
　American 1889-
　H

FORMAN, Vera Smith
　American 1889-
　B

FORMIGÉ, Jean Camille
French 1845–1926
B,LEX,TB

FORMSTECHER
see
MOSES, (called Formstecher)

FORNASETTI, Piero
Italian 1913–
GR60,H

FORREST
English early 20c.
POS

FORRESTALL, Thomas De Vany
Canadian 1936–
B,H

FORSETH
Swedish early 20c.
POS

FÖRSTER, Christian
German 1846–1902
B,TB

FORSTER, John Wycliffe Lowes
Canadian 1850–1938
B,H,M

FORSTER, William
English 1852–
LEX,TB

FORSTMOSER, Alois
Austrian 1866–1905
B

FORSTNER, Leopold
Austrian 1878–
B,POS

FORSYTH, Constance
American 1903–
B,F,H

FORSYTH, (Mary) Bryan
American 1910–
CON

FORSYTHE, Renée
American mid 20c.
GR54

FORSYTHE, Victor Clyde
American 1885–1962
B,H

FORTESCUE-BIREKDALE, Eleanor
English –1945
B,LEX,STU1898

FORTIER, Bob
Canadian late 20c.
GR82

FORTIN, Jean
French mid 20c.
GR53–59–60–62–64–65–68

FORTUNA, Ben M.
American 1916–
H,M

FOSBERY, Ernest George
Canadian 1874–1960
B,H

FOSDICK, James William
American 1858–1937
F,H,I,M,SN7/94

FOSSOMBRONE, Andrea
Italian 1887–
H,LEX,VO

FOSSUM, Sydney Glenn
American 1909–
H

FOSTER, Alan Stephens
American 1892-
B,F,H

FOSTER, Anna
American 1905-
H

FOSTER, Genevieve
American 20c.
M

FOSTER, Harold (Hal) R.
Canadian/American 1892-1982
H,WS

FOSTER, Miles Birket
English 1825-99
B,H

FOSTER, Ralph Leete
American 1887-
B,F,M

FOSTER, Robert
American 1895-
H,M

FOSTER, Robert G.
Canadian 20c.
M

FOSTER, Susan
American mid 20c.
GR57

FOSTER, William
English 1853-99
B,H,LEXsic

FOSTER, William Friedrich
American 1882-
B,H,HA6/07 & 9/07 & 6/09

FOTHERGILL, George Algernon
English 1868-
H

FOUGASSE, (BIRD, Cyril Kenneth)
English 1887-1965
ADV,CP,EC,GR52

FOUJITA, Tsugouharu
Japanese/French 1886-1968
B,DES,H,POS

FOULQUIER, Jean Antoine Valentin
French 1822-96
B,LEX,TB

FOUQUERAY, Dominique Charles
French 1869-1956
B,LEX,POS

FOURNERY, Felix
French 19c.
B

FOURNIER, Alain
French early 20c.
POS

FOURNIER, Alexis Jean
American 1865-1948
B,F,H,I

FOUSSIER, Jean
French 1886-1950
B

FOWLER, Eric
American 1954-
AA

FOWLER, Frank
 American 1852–1910
 B,F,H,I

FOWLER, Gene
 American 20c.
 M

FOWLER, Mel Walter
 American 1922–
 AA,H

FOX, Charles
 English 1794–1849
 B,H

FOX, Daniel G.
 American 20c.
 M

FOX, Fontaine Talbot
 American 1884–
 H

FOX, G. B.
 American late 19c.
 SN2/94

G. B. Fox.
1892

FOX, J. Chester
 American early 20c.
 CO10/04

J. CHESTER FOX

FOX, Lorraine D'Andrea
 American 1922–76
 F,H,IL,Y

lorraine fox

FOX, Margaret M. Taylor
 American 1857–
 B,F,H,I,M

FOX, R. Atkinson
 Canadian 1860–
 H

R Atkinson Fox

FOX, Winifred Grace
 Canadian 1909–
 H

FOXLEY, Griffith
 American 20c.
 H,PAP

FOY, Francis M.
 American 1890–
 B,F,H

FRACE, Charles Lewis
 American 1926–
 H

FRADKIN, M.
 Russian early 20c.
 LEX

FRAIN, Nellie M.
 American 1887–
 F,H,M

FRAIPONT, Georges
 French 1873–1912
 B,FO

FRAIPONT, Gustave
 Belgian/French 1849–
 B,CP,FO,L,POS,TB

FRAIPONT

FRAIPONT, Gustave & Georges
 FO

G. & Geo. FRAIPONT

FRAME, Paul
 American 1913–
 H

FRANCE, Eurilda Loomis
 American 1865–1931
 B,F,H

FRANCE, Jesse Leach
 American 1862–
 B,F,H,I

FRANCESCHI
 Brazilian mid 20c.
 GR61

Franceschy

FRANCHE, Don
 Canadian
 H

FRANCIS, Harold Carleton
 Canadian 1919–
 H

FRANCIS, J. G.
 Anglo/American? ac. late 19c.
 LEX,SN5/86

JGFrancis—

FRANCIS, John Jesse
 American 1889–
 H

FRANCIS, Vida Hunt
 American 1892–
 F

FRANCIS-BERNARD, M.
 French 1900–
 B,M

FRANCK, Frederick S.
 Dutch/American 1909–
 GR60,H

FRANCK, Hermann
 German early 20c.
 LEX

FRANÇOIS, André
 French 1915–
 B,CC,GMC,GR52 thru 68-82-85,H,POS,Y

André François

FRANÇOISE, (Mlle. Françoise Seignobosc)
 French 20c.
 M

FRANK, Gustav
 Austrian 1859–
 B,LEX,TB

G.F.

FRANK, Helen
 American 1911–
 H

FRANKE, Franz
 German 1918–
 LEX

FRANKE, Joseph
 American 1894–1933
 AM12/23,M

FRANKE

FRANKEN, Jan
 Dutch 1878–
 LEX,VO

JF

FRANKENBERG, Robert Clinton
 American 1911–
 H

FRANKENBURG, Arthur
 American early 20c.
 F

FRANKLE, Philip
 American 1913-68
 H

FRANKLIN, Dwight
 American 1888–
 B,F,H,M,ME4/23 & 5/23

Dwight Franklin

FRANTZ, Alice Maurine
 American 1892–
 H,M

FRANTZ, (Samuel) Marshall
 Russian/American 1890–
 B,F,H,M

FRANZ, Gottfried
German 1846-1905
B,TB

G.F.

FRASCHINI, Felice
Italian mid 20c.
GR53

FRASCINO, Edward
American 20c.
H

FRASCONI, Antonio R.
Uruguayan/American 1919-
APP,F,GR56-57-59 thru 64,H,PC,Y

Frasconi

FRASER, Alex
English ac. early 20c.
LEX

FRASER, Claud Lovat
English 1890-1921
B,H,M

FRASER, Eric
English 20c.
ADV,B?,GR52 thru 56,M

ericfraser

FRASER, Gillian
English late 20c.
EI82

Gillian Fraser

FRASER, Juliette May
American 1887-
H

FRASER, Malcolm
Canadian/American 1858/69-1949
B,CE12/97 & 1/99 & 2/99,CWA,F,H,I,M,Y

MALCOLM FRASER

FRASER, William Lewis
Anglo/American 1841-1905
B,H,I,M

FRATZ, Mary
American early 20c.
B,LHJ7/06

Mary Fratz

FRAYDAS, Stan
American mid 20c.
GR52

FRAYE, André
French 1887-1963
B

André Fraye

FRAZEE, Hallie Clarkson
American 20c.
M

FRAZER, Harland
American 20c.
B,F,H,IL

Harland Frazer

FRAZER, William Durham
American 1909-
H,M

FRAZETTA, Frank
American 20c.
NV,P

frazetta

FRECH, Howard
American 20c.
M

FRECSKAY, László
Hungarian 1844-
B,TB

Laci

FREDENTHAL, David
American 1914-58
F,GR58,H

FREDERIC, (Baron) Léon Henri Marie
Belgian 1856-1940
B,GMC,H

FREDERICK, Alfred
Canadian ac. 1853-81
BAA,H

FREDERICK, Edmund
American 1870-
B,F,I,M

FREDERICKS, Alfred
American 19/20c.
D,F,H

FREDERIKSEN, George A.
American mid 20c.
PAP

FREDMAN, Harry Homer
American 1923-
H

FREED, Louise
American 1915-
H

FREEDMAN, Barnett
see
FREEDMAN(N), Barnett

FREEDMAN, Cal
American mid 20c.
GR60-61-63-65-67-68

FREEDMAN, Louise
American 1915-
H

FREEDMAN(N), Barnett
English 1901-58
ADV,B,LEX,POS

FREEMAN, Don (Donald)
American 1908-78
APP,H,PAP,VO

FREEMAN, Fred
American 1906-
H,IL,M

FREEMAN, Margaret Lial
American 1893-
F,H,M

FREEMAN, Paul K.
American 1929-
H

FREEMAN, W. E. (Bill)
American 1927-
H

FREHM, Paul
American 20c.
H

FREIDA, Raphael
French 1877-
B,VO

FREIMANIS, Kārlis Indriķa
Latvian 1909-
LATV

FREIRE, Segundo Jose
Argentinean mid 20c.
GR57-61

FREISAGER, Hans Michael
Swiss mid 20c.
GR57-59-60-63-65-67

FREITAS, José Maria Lima de
Portuguese 1927-
H

FREITAS, Rogério de
Portuguese 1910-
H

FREMEZ
Cuban 20c.
POS

FRENCH, Alice Helm
American 1864–
B,F,H

FRENCH, Annie
Scots 19/20c.
B,LEX,TB

A.F.

FRENCH, Frank
Anglo/American 1850–1933
B,BAA,F,I

F.F.

FRENCH, Howard Barclay
American 1906–
B,H

FRENCH, John T.
American ac. mid 19c.
D

FRENCK, Hal
American 20c.
B

FRENZENY, Paul
French 1840?–1902?
H

FRÈRES, Clerice (Clerice brothers)
see
CLERICE

FRESHMAN, Shelley A.
American 1950–
F,Y

FREUND, Franz
German 20c.
LEX

FREUND, Harry Louis
American 1905–
B,F,H

FREUND, Rudolf
American 1915–
GR68,H

FREW, Jim
American mid 20c.
GR60

FREY, Jeanne Wade
American 20c.
H

FREY, Max Adolf Peter
German 1874–
B,LEX,TB

MF

FREYBORN, Eva
German 20c.
LEX

FREYHOLD, Karl von
Swiss 1878–1944
B,VO

.Kv.F.

FREYMAN, Gertrude
American 20c.
H,M

FRIADO, Joseph
Spanish early 20c.
POS

FRIBERG, Arnold
American 1913–
CON,H

Arnold Friberg

FRIDRIHSONS, Kurts Jāna
Latvian 1911–
LATV

KF

FRIEDEBERGER, Klaus
English mid 20c.
GR52–54–55–56–59–61–65–66

FRIEDINSON, T.
English early 20c.
LEX

FRIEDL, J.
Austrian 20c.
LEX

FRIEDLAENDER, Johnny
German 1912–
B,H,PC

FRIEDLANDER, Maurice
 American 1899–
 H

FRIEDMAN, Marvin
 American 1930–
 F,H,IL,Y

F RIEDMAN (signature)

FRIEDMAN, S. I.
 American mid 20c.
 GR 57

FRIEDRICH, Edith
 Austrian 20c.
 LEX

FRIEDRICH, Josef
 Czechoslovakian 1875–
 LEX

FRIEDRICH, Karl
 German 1898–
 LEX,VO

FRIEDRICH, Leo
 Austrian 20c.
 LEX

FRIEDRICH, Otto
 Hungarian/Austrian 1862–
 B,LEX,TB

O.F (signature)

FRIEDRICH, Waldemar
 German 1846–1910
 B,LEX,TB

FRIES, Charles Arthur
 American 1854–1940
 B,F,H,I

FRIESE, Richard Bernhard Ludwig
 German 1854–
 B,LEX,TB

PF (signature)

FRIESZ, Emile Othon
 French 1879–1949
 B,DES,EAM,H,PC,POS

Eothon Fuesz (signature)

FRIMBERGER, Marianne
 Austrian 1877–
 B,LEX,TB,VO

(monogram signature)

FRINTA, Dagmar
 American late 20c.
 GR 82–85

FRIPP, Charles Edwin
 Canadian 1854–1906
 B,H

FRITZ, Joachim
 German late 20c.
 GR 82

FRIZZEL, Ralph Linwood
 American 1909–
 H

FRODERSTROM, Alma Wentzel
 American 20c.
 M

FROER, Veit
 German 1828–
 B,LEX,TB

VF (signature)

FRÖHLICH, Bernhard
 German 1823–85
 B,LEX,TB

FRÖHLICH, Ernst
 German 1808–69
 B

FRÖLICH (FROLICH), Lorens
 Danish 1820–1908
 B,H,SC

FRÖLICH, Max
 German ac. early 20c.
 LEX

FROMENT-MEURICE, Emile
French late 19c.
LEX

FRONIUS, Hans
Austrian 1903-
B,H,VO

H.J.

FRONTINO, Domenic J.
American 1948-
posters: 'Phillies'-Philadelphia-1983,
'Philadelphia Zoo'-1985,*

Frontino

FRONZONI, Angelo
Italian mid 20c.
GR58-60-61-66

FRÖSCHL, Carl (Karl)
Austrian 1848-
B,H,LEX,TB

FROST, Arthur Burdett
American 1852-1928
B,EAM,EC,F,GMC,H,I,IL,PE,SO,Y

A.B.FROST.1887.

FROST, George
English mid 20c.
GR53

FROST, George Albert
American 1843-
B,H,I

FROST, Honor Elizabeth
English 1917-
M

FROST, John (Jack)
American 1890-1937
B,F,H

FROST, M.
English mid 20c.
GR60

FRUCHTER, Lou
American mid 20c.
GR60

FRUEH, Alfred J.
American 1880-1968
EAM,EC,F,PC

Frueh

FRY, Finley
American 1908-
H

FRY, Guy Edgar
American 1903-
H,M

FRY, Loren G.
American 1924-
CON

Loren G. Fry

FRYCZ, Karol Joszef
Polish 1877-
B,LEX,VO

KFr.

FRYE
American mid 20c.
PAP

Frye

FRYER, C.
English mid 20c.
GR52

FRYSZTAK-WITOWSKA, Eva
Polish mid 20c.
GR65-66-68

FUCHS, Bernard
American 1932-
F,IL,Y

B. Fuchs.

FUCHS, Ernst
 Austrian 1930-
 B,GR82,H

[signature: Ernst Fuchs]

FUCHS, Heinz
 German 1886-1961
 POS

FUCHS, Willi F.
 German mid 20c.
 GR57

FUERTES, Louis Agassiz
 American 1874-1927
 M,NG3/19 & 12/20

[signature: Louis Agassiz Fuertes.]

FUGLER, Grace
 Canadian 20c.
 M

FUHR, Ernest
 American 1874-1933
 F,COL1/11,IL,M

[signature: E Fuhr]

FÜHRICH, Josef von
 Austrian 1800-76
 B,H,LEX,TB

[signature: .F.]

FUJII, Masahiko
 Japanese late 20c.
 GR85

FUJITA, S. Neil
 American mid 20c.
 GR64-65

FUJITA, Shinja
 Japanese mid 20c.
 GR56-61

FUKA, Vladimir
 Czechoslovakian 1926-
 H

FUKUDA, Sachiko
 Japanese mid 20c.
 GR65

FUKUDA, Shigeo
 Japanese 1932-
 GR61-63-65-68-85,POS

FULE, Otto
 German early 20c.
 POS

FULGHUM, Caroline Mercer
 American 1875-
 B

FULLER, Arthur D.
 American 1889-
 H,IL

[signature: Arthur D. Fuller]

FULLER, Harvey Kenneth
 American 1918-
 H

FULLER, Margaret
 American 20c.
 M

FULLER, Meta Vaux Warrick
 American 1877-1968
 F,H,I

FULLER, Ralph Briggs
 American 1890-
 B,H,M

[signature: RB.F.]

FULLEYLOVE, John
 English 1845-1908
 B,BK,H

[signature: J. Fulleylove]

FULLINGTON, Gilbert
 American mid 20c.
 PAP

FULTON, John Russell
 American 20c.
 IL

[signature: John Fulton]

FUMAGALLI, Barbara Merrill
 American 1926-
 H

FUMAGALLI, Giovanni (daBrescia)
 Italian 1899-
 H

FUNCIUS, Gil
 German late 20c.
 GR82

FUNG-DSE-KAI
 Chinese mid 20c.
 LEX

FUNK, Clotilde Embree
 American 20c.
 M

FUNK, John A.
 American 20c.
 M

FUNK, Wilfred J.
 American 20c.
 M

FUNSCH, Edyth Henrietta
 American 1905-
 H,M

FURLONG, Charles Wellington
 American 1874-
 B,H,HA6/07 & 6/09,I

[signature: Charles W Furlong]

FURLONG, Thomas
 American 19c.
 B,F,H

FURMAN, E. A.
 American 20c.
 M

FURNISS, Harry
 Irish 1854-1925
 B,BK,EC,EN,TB

[signature: Harry Furniss]

FÜRST, Edmund
 German 1874-
 B

FÜRST, Julius
 Danish 1861-
 B

FUSELI, Henry
 Swiss 1741-1925
 B,DA,H

FUSS
 German early 20c.
 POS

FUX, Josef
 Austrian 1842-1904
 B,H,LEX,TB

[monogram: ḞF]

FYPE (FYFE), John Hamilton
 American 1896-
 H,M

- G -

GAAB, Hannes
 German
 LEX

GAADT, Georges S.
 American 1941-
 F

GABA, A. Lester
 American 1907-
 H

GABAIN, Ethel Léontine
 French/English 1883-1950
 B,H,LEX,VO

[monogram: EG]

GABORIAUD, Josué
 French -1955
 B

GACHET, Pascal
 Swiss late 20c.
 GR 82

GACS, Gabor
 Hungarian 1930-
 B

GADAU, Carl Otto
 German 1885-
 LEX

GADBURY, Harry Lee
 American 1890-
 B,F,H

GADE, John
 American 1870-
 F,M

GAEMMERLER, Theodor
 German early 20c.
 LEX,VO

GAENSSLEN, Hans
 German 1900-
 LEX

GAERTNER, Carl Frederick
 American 1898-1952
 B,F,H

GAERTNER, Lillian V.
 American 1906-
 F

GAETANO, Nicholas
 American mid 20c.
 F

GAFFRON, Horace
 American early 20c.
 H

GAG, Wanda
 see
 GAG, Wanda Hazel

WANDA GAG

GAG, Wanda Hazel
 American 1893-1946
 APP,F,H,M,PC,S

GAGARIN, Sonia
 American 20c.
 M

GAGE, George William
 American 1887-1957
 F,H

GAGNON, Clarence Alphonse
 Canadian 1881-1942
 B,H

GAIGG, Lois
 Austrian early 20c.
 LEX

GAILLARD, Arthur
 French 1890-
 B,LEX

GAILLARD, E.
 Dutch 20c.
 LEX

GAILLIARD, Frans (François)
 Flemish 1861-1932
 B,H

FRANÇOIS GAILLIARD

GAKKO
 see
 TESSAI, Tomioka

GALAKTIONOV, Stepan Filippovich
 Russian 1779-1854
 B,EC

GALANDA, Mikuláš
 Yugoslavian?/Czechoslovakian 1895-1938
 B,H,LEX,VO

G

GALANIN, Igor Ivanovich
 Russian/American 1937-
 H

GALANIS, Dimitrios Emanuel D.
　　Greek/French 1880-1966
　　B,H,M,TB,VO

W. Galanis (signature)

GALBRAITH
　　see
　　CRAWFORD, William Galbraith

GALBRAITH, Victor
　　English mid 20c.
　　GR61-62-68

Galbraith (signature)

GALCHUTT, Ron
　　American mid 20c.
　　GR61

GALDONE, Paul
　　American 20c.
　　M,PAP

GALE, Bob
　　American late 20c.
　　GR82

Gale (signature)

GALE, George Albert
　　American 1893-
　　B,F,H

GALE, Walter Rasin
　　American 1878-1959
　　B,F,H

GALIZZI, Giovan Battista
　　Italian 1882-
　　H,LEX

GALLAGHER, Michael, Jr.
　　American 1898-
　　H,M,VO

MG (signature)

GALLAND, André
　　French 20c.
　　LEX

GALLAND, Pierre Victor
　　French 1822-92
　　B,H,LEX,TB

P.V.G (signature)

GALLANTE, Francesco
　　Italian 1884-
　　H

GALLARDO, Gervasio
　　Spanish late 20c.
　　EI83,GR64 thru 67-82

Gallardo (signature)

GALLAY, Michel
　　Swiss mid 20c.
　　GR59-63

GALLÉN-KALLELA, Axel (Akseli Valdemar)
　　Finnish 1865-1931
　　AN,B,H

Gallen (signature)

GALLEY, G. P.
　　French ac. early 20c.
　　LEX

GALLI, Stanley Walter
　　American 1912-
　　CON,F,H,IL

Stan Galli (signature)

GALLIEN, P. A.
　　French ac. early 20c.
　　LEX

GALLIGAN, E.
　　English mid 20c.
　　GR52

GALLO, Bernardo (called)
　　see
　　SALOMON, Bernard

GALLO, William (Bill) Victor
　　American 1922-
　　EC,H

GALLONI, Adelchi
Italian late 20c.
GR82

GALLUS, Bernardus (called)
see
SALOMON, Bernard

GALOS, Ben
Russian/American 1889–1963
H

GALPIN, Cromwell
American ac. 1895–
H

GALSTER, Robert
American 1928–
H

GAMASHIRO, Ryuichi
Japanese mid 20c.
GR58

GAMBARD, J. Hector Henri
French 1854–91
LEX, TB

GAMBARTES, Leonidas
Argentinean 1909–
B

GAMBEE, Martin
American 1905–
H

GAMBLE, William Sylvester
American 1912–
H

GAMBORG, Knud Frederik
Danish 1828–1900
B

GAMEIRO, Alfredo Roque
Portuguese 1864–1935
B, H

GAMES, Abram
English 1914–
CP, GR52 thru 56–58–59–61 thru 64, H, PG, POS

GAMPP, Josua Leander
German 1889–
LEX, VO

GAN, Lena
Austrian late 20c.
GR85

GANDELA
Spanish 19c.
POS

GANDON, Pierre
French 1889–
B, S

GANDON, Yves
French 20c.
B

GANDY, Peter
English 1787–1850
B

GANEAU, F.
French mid 20c.
GR54

GANGLOFF, Dominique
French late 20c.
EI79

GAN HOSOYA
Japanese 20c.
CP

GANNAM, John
American 1907–65
FOR, H, IL, M

GANNETT, Ruth Chrisman
American 1896–
H, M

GANTENBEIN, Heini
Swiss mid 20c.
GR52

GANTENBEIN, Leo
Swiss mid 20c.
GR52

GANTNER, Bernard
French 1928–
B

GANZIGER, C.
Austrian 20c.
LEX

GAONA, Gabriel Vincente
Mexican 1828–99
B

GARBAYO, Fermin Hernandez
Spanish 1929–
GR64,H

GARBER, Don
American mid 20c.
GR54

GARCIA, Antonio
Portuguese 1925–
H

GARDINER, Frederick
see
GARDNER, Frederick

GARDNER, Charles Reed
American 1901–
B,F,H

GARDNER, Donald
Anglo/American 20c.
F,GR52,M,NG3/25

DONALD
GARDNER

GARDNER, Frederick
Canadian 19/20c.
CEN2/12,H

F. Gardner

GARDNER, James
English early 20c.
POS

GARDNER-SOPER, James Hamlin
American 1877–
B,F

GARDOSH, Kariel
Israeli 1921–
EC

GAREIS, Fritz, Jr.
Austrian 19/20c.
LEX

GAREL, Leo
American 1917–
EC,H,PLC

LEO
GAREL

GARELLI, Titti
Italian late 20c.
GR85

GARGIULO, Antonio
Argentinean 1894–
H

GARIN, Louis
French 1888–1959
B

GARLAND, C. George
American 20c.
H,M

GARMES, Lee
American 20c.
ADV

GARNEAU, St. Denys
Canadian 1912–43
H

GARNER, Charles S.
American 1890–1933
F,M

GARNER, Elvira
American 20c.
M

GARNET, Porter
American ac. early 20c.
MM

G

GARNETT, Eve
American 20c.
M

GARNIER, Victor Alexandre Humbert
French ac. late 19c.
B,LEX

GARRAD, Sidney Arthur
English mid 20c.
GR52

GARRETSON, Albert M.
American 1877–
F,I

GARRETT, Anna Shapleigh
American 1924–
F,H,M

GARRETT, Edmund Henri
American 1853–1929
B,F,H,R,TB

GARRETTO, Paulo Frederico
Italian 1903–
GMC,GR55,H

GARRIOTT, Gene
American 1930–
CON

GARRIS, Philip
American 1951–
F

GARRISON, John Louis
American 1867–
F,I

GARRY, Charles
French early 20c.
B,POS

GARUTI, Giuseppe (Pepein Gamba)
Italian 1868–1954
H

GAS
English early 20c.
GMC

GASCARD, G.
Canadian ac. 1873–74
H

GASKIN, Arthur Joseph
English 1862–1928
AN,B,BK,EI79(pg.196)

GASKIN, Georgina E. (Cave)
English 19/20c.
BK,TB

GASSNER, Mordi
American 1899–
H

GAST, Carolyn Bartlett (Lutz)
American 1929–
H

GASTON, Marianne Brody Lane
American 1918–
H

GATCHELL, Charles
American 1883–1933
M

GATENBY, John William
American 1903–
B,H

GATES, Richard F.
American 1915–
H,M

GATTER, Otto Jules
American 1892–
F,I

GAUCHAT, Pierre
Swiss 1902–
GR52 thru 56,POS,VO

GAUD-ROZA-BONNARDEL
French 1903–
B

G(A)UDIN, Louis
see
ZIG

GAUDIN, Marguerite
American 1909–
H,M

GAUDION, Georges
French 20c.
B

GAUDY, Adolf
Swiss early 20c.
LEX,VO

GAUDY, Georges
French 1872–
B,BI,POS

GAUG, Margaret Ann
American 1909–
H

GAUGUIN, Paul
French 1848–1903
AN,APP,B,DA,GMC,H,PC

GAUL, (William) Gilbert
American 1855–1919
B,BAA,F,H,I,IL

GAUNTLETT, Frances A.
American/Japanese 1900–
M

GAUSE, Wilhelm
German 1854–1916
B,LEX,TB

GAUSS, Charlotte W.
American 20c.
M

GAVARNI (pseudonym)
see
CHEVALIER, Guillaume

GAVLER, Martin
Swedish mid 20c.
GR52-53-54-61-63

GAY, Romney (Phyllis Britcher)
American 20c.
M

GAY, Susan Elizabeth
English early 20c.
H

GAY, Zhenya
American 20c.
H,M

GAZAN, Henry
French 1887–
B,M

GEARY, Clifford N.
American 1916–
H

GEBHARDT, C. Keith
American/Canadian 1899–1978
H,WS

GEBHARDT, Hermann
German 1889–
LEX,VO

GEBHARDT, Otto
 German 1874–
 LEX,VO

GEDO, Leopold
 American 20c.
 M

GEE, John
 American 20c.
 H

GEE, Yun
 Chinese/American 1906–63
 H

GEER, Charles
 American 1922–
 H,HA

C.G.

GEETERE, Frans de
 Belgian? 20c.
 B

GEH, Peter
 German 1865–
 B

GEHRING, Louis H.
 American 1900–
 H

GEHRKE, Fritz
 German 1855–1916
 B,TB

G

GEHRKE, Otto
 German 1867–
 LEX

GEHRTS, Carl
 German 1853–95
 B,H,LEX,TB

CG

GEHRTS, Johannes
 German 1855–
 B,LEX,TB

GEIGENBERGER, August
 German? 1875–1909
 B,LEX

GEIGER, Carl Joseph
 Austrian 1822–1905
 B,H

GEIGER, Peter Johann Nepomuk
 Austrian 1805–80
 B,H,LEX,TB

GEIGER, Willi
 German 1878–
 LEX

G

GEIGER-THURING, August
 German 1861–96
 B,LEX,TB

GEIKIE, Walter
 English 1795–1837
 B,H

GEISEL, Theodor Seuss (Dr. Seuss)
 American 1904–
 EC,F,H

GEISERT, Arthur Frederick
 American 1941–
 H

GEISMEHN
 German early 20c.
 GMC

GEISSBÜHLER, Karl
 Swiss 1932–
 GR60–61–63–68?

Ge

GEISSER, Robert
 Swiss mid 20c.
 GR61–66

GEISSLER, Barbara
 German late 20c.
 GR62–63–66–68–82

Ge Bln.

GEISSLER, Hannes
German late 20c.
GR 62-63-66-68

GEISSLER, Heinrich
German 1782-1839
B

GEISSLER, Robert Paul
German 1874-1954
LEX, VO

GEISSLER, Wilhelm
German 1848-
B, LEX, VO

GEISSMAN, Robert Glenn
American 1909-76
F, GR52, H, Y

GEISZEL, John H.
American 1892-
H

GEISZEL, Marjorie Margaret Malpass
American 1901-
H, M

GEKEIRE, Madelaine
Swiss/American 1919-
H

GELB, Philip
American 20c.
M

GELBHAAR, Klaus
German 20c.
LEX

GELBKE ROMMEL, Li
see
ROMMEL, Li

GÉLIBERT, Jules Bertrand
French 1834-1919
H, LEX, TB, VO

GELL, (Sir) William
Enbglish 1774-1836
B, H

GELLER, Barry
American mid 20c.
GR59-60-64

GELLER, Johann Nepomuk
Austrian 1860-
B, LEX, TB

GELLER, Todros
Russian/American 1889-
H

GELLERT, Hugo
Hungarian/American 1892-
B, F, H, M

GELLERT, Robert
American 20c.
M

GELLETLY, May Florence
American 1886-1955?
H

GENCHY, Clara
American mid 20c.
GR60

GENTHE, Arnold
German/American 1869-1942
CP, F, H

GENTILE, John O.
American 20c.
GR82, H

GENTILINI, Franco
Italian 1909-81
B, GR58-61-62-66, H

GENTLE, Edward
American 1890-
F, M

GENTLEMAN, David William
 English 1930–
 GR54-57,H

[signature: David gentleman]

GENTLEMAN, Tom
 English 1930–
 GMC,POS,STU1924

[signature: π]

GENTZ, Karl Wilhelm

[signature: W.G.]

GEOFFROY, Jean

[signature]

GEOGHEGAN, Walter B.
 American 1904–
 H

GEORG, Edouard Joseph
 French 1893–
 H

GEORGE, Adrian
 English late 20c.
 EI79

[signature: Adrian George]

GEORGE, Rence
 American 20c.
 LEX

GEORGE, Sylvia James
 American 20c.
 H

GEORGES-PICARD
 see
 PICARD, Georges

GEORGET, Guy
 French 20c.
 GR52-53-55 thru 63,POS

[signature: Guy Georget]

GEORGI, Edwin A.
 American 1896–1964
 F,H,IL,M,Y

[signature: Georgi]

GEORGI, (Dr.) Hanns
 German 1901–
 G

[signature: 50]

GEORGI, Walter
 German 1871–1924
 AN,B

[signature: Georgi]

GEORGY, Wilhelm
 German 1819–87
 B,LEX,TB

[signature: WG]

GÉRARD, Jean I. I.
 see
 GRANDVILLE, J. I. I. G.

GERARDI, Andrea
 German late 20c.
 GR82

GÉRARDIN, Auguste
 French 1849–
 B,LEX

GERASIMOV
 Russian early 20c.
 POS

GERASSIMOFF, Alexander
 Russian 1884–
 LEX

GERASSIMOFF, Sergej
 Russian 1885–
 LEX

GERBAULT, Henri
 French 1863–1930
 B,FS,GA,L,POS,TB,VO

H. Gerbault

GERBER, Carl
 German 1839–
 B

GERE, Charles March
 English 1869–(1934?)1957
 B,BK,H,MM,STU1905,TB,VO

GERE, Nellie Huntington
 American 1859?–
 B,F,H

GERGALOVA, Viera
 Yugoslavian 1930–
 H

GERGELY, Tibor
 Hungarian 1900–
 LEX,VO

Gerg

GERHARDT, Paul Wilhelm
 German –1851
 B

GERING, Joseph
 American mid 20c.
 GR54

GERITZ, Franz
 Hungarian/American 1895–1945
 B,F,H,M

GERLACH, Otto
 German 1862–1908
 B,TB

O.G.

GERMELA, Raimund
 Hungarian 1868–
 B

GERNEZ, Paul Elie
 French 1888–1948
 B,H,VO

Gernez

GERRARD, J.
 English 20c.
 M

GERRING, Joseph
 American 20c.
 M

GERSH, Louis
 American 1901–
 H,M

GERSHENZON, Bebe
 American mid 20c.
 GR59–60–63

Bebe

GERSON, Adalbert de Woicieck
 see
 GUERSON, Adalbert de Woicieck

GERSTEN, Gerry N.
 American 1927–
 F,GR53 thru 64–68,Y

Gersten

GERSTENBRANDT, Alfred
 Austrian 1887–
 LEX

GERSTER, Károly
 Hungarian 1859–
 B,LEX,TB

G.K.

GERSTLE, Miriam Alice
 American 1868–
 F,H

GERSTNER, Karl
 Swiss 1930–
 CP,GR56-58-59-82,H,POS

Gerstner

GERVIS, Ruth
 English 20c.
 M

GERY-BICHARD, Adolphe Alphonse
 French 1841–
 B

GESCHEIDT, Alfred
 American mid 20c.
 GR57-60

GESLIN, Jean Charles
 French 1814-85
 B,LEX,TB

GESMAR, Charles
 French 1900-28
 AD,MM,POS

C.Gesmar

GESSNER, Robert
 Swiss mid 20c.
 GR52 thru 57-60

GESTEL, Leo (Leendert)
 Dutch 1881-1941
 GMC,H

GETTIER, C. R.
 American 20c.
 F

GETZ, Arthur
 American 1913–
 F,H,PAP

Getz

GEYER, Fritz
 German 1875–
 B

GEYGAN, George
 American mid 20c.
 PAP

Geyggn

GEYLER, Ida L.
 American 1905–
 H

GEYSER, Gottlieb Wilhelm
 German 1789-1865
 B

GIACHETTI, Maria Gracia
 Italian 20c.
 LEX

GIACOMELLI, Hector
 Italian/French 1822-1904
 B,H,L,TB

GIACOMETTI, Alberto
 Swiss 1901-66
 B,GR59,H

Alberto Giacometti

GIACOMETTI, Augusto
 Swiss 1877-1947
 B,H,TB

a.g.

GIAD
 see
 JUDD, David

GIANI
 Italian early 20c.
 POS

GIANI, Felice
 Italian 1760-1823
 B,H

GIANNINI, O.
American 19/20c.
GMC,R

GIANNINI

GIBB, William
English 1839–1929
H

GIBBINGS, Robert
Irish 1889–
LEX,VO

R.G.

GIBBO, Pearl
American 1900–
H

GIBBS, George
American 1870–1942
ADV,B,CO7/04 & 7/05,F,H,I,M

GIBLAN, Naiad
American mid 20c.
GR53–54

GIBSON, Charles Dana
American 1867–1944
ADV,B,EC,F,GMC,H,I,IL,M,PE,POS,R,ST,Y

GIBSON, George
Scots/American 1904–
H

GIBSON, Lydia
American 1891–
F

GIBSON, William Hamilton
American 1850–96
BAA,F,I

GID, Raymond
French mid 20c.
B,GR55–56,POS

GIERTH, Patrick W.
English 20c.
LEX

GIESBERT, Edmund W.
German/American 1893–
F,H

GIESEL, Hermann
Hungarian 1847–1906
B,LEX,TB

GIFFORD, Robert Gregory
American 1895–
B,F,H

GIFFORD, Robert Swain
American 1840–1905
B,BAA,H

GIFUKU
see
SHOTEI, Wanatabe

GIGOUX, Jean François
French 1806–94
B,H

GIGUÈRE, George E.
American 20c.
M

GIGUERE, Ralph
American late 20c.
GR85

GIKOW, Ruth
Russian/American 1913–
H,M,PC

GIL Y GAVILONDO, Isidoro
Spanish 19c.
B

GILBERT, Albert Earl
 American 1939–
 H

GILBERT, Anne Yvonne
 English late 20c.
 EI79

GILBERT, Anthony
 English mid 20c.
 GR52,LEX

GILBERT, Charles Allan
 American 1873–1929
 B,F,I,R

C. Allan Gilbert

GILBERT, Ellen
 English ac. 1863–1903
 H

GILBERT, (Sir) John
 English 1817–97
 B,H,M,TB

GILBERT, Michael G.
 Franco/American 1914–
 B,H

GILES, F. Kenwood
 American mid 20c.
 PAP

GILES, Howard Everett
 American 1876–1955
 B,F,GMC,H,I,MCC11/04

HOWARD
GILES

GILKISON, Grace
 American 20c.
 M

GILL (GILL brothers)
 English ac. early 20c.
 POS

GILL, André
 see
 GOSSETT de GUINES, Louis

GILL, Arthur Eric Rowton
 English 1882–1940
 H

GILL, Bob (Robert)
 American 1931–
 GR57 thru 60-62-63-64-68,IL

gill

GILL, Leslie (S. Leslie)
 American mid 20c.
 ADV,F,GR52

GILL, Margery Jean
 English 1925–
 H

GILL, Paul Ludwig
 American 1894–1938
 B,F,H

GILL, Ruth
 English mid 20c.
 GR57-62

GILLAM, Frederick Victor
 Anglo/American 1867–1920
 CO6/04,EC,F

GILLAM

GILLEN, Denver Caredo
 Canadian/American 1914–
 H

GILLEN, Denver L.
 Canadian/American 1914–
 H,IL,PAP

Denver Gillen

GILLES, Nicolas
 German 1870–
 B

GILLESPIE, Jessie (Willing)
 American 20c.
 F,H,M

GILLET, Edward Frank
English 1874-1927
M

GILLETT, Violet Amy
Canadian 1898-
H

GILLI, Guido
Swiss mid 20c.
GR59

GILLIES, Bill
American mid 20c.
PAP

GILLMOR, Robert Allen Fitzwilliam
English 1936-
EI79,GMC,H

GILMAN, Esther Morganstern
American 1922-
H

GILMAN, Helen Ethel
American 1913-
H,M

GILMARTIN, Gary M.
American 1949-
C,H

GILMORE, A.
Canadian ac. 1871
H

GILMORE, H. H.
American 20c.
M

GILMORE, Marion
American 1909-
H,M

GILOTT, A.
French late 19c.
LEX

GILROY, John
English 1898-
ADV,CP,M,POS

GILSPEAR, Adrian
Anglo/American? early 20c.
POS

GINCANO, John
American 20c.
M

GINSBURG, Max
American 1931-
AA,H

GINZEL, Roland
American 1921-
APP,H,P

GIOIA, Maria Luisa
Italian mid 20c.
GR64

GIORDANO, Edward Carl
American 1909-
H

GIORDANO, Joseph
American 1935-
CON

GIOVANETTI, Raimondo
Italian 1898-
H

GIOVANOPOULOS, Paul A.
Greek/American 1939-
F,H,Y

GIPKENS (BIPKENS), Julius
German 1883-
AD,CP,POS,VO

GIPS, Phil
American mid 20c.
GR60

GIR, Charles Felix
French 1883–
B

GIRALDON, Adolphe Paul
French 1855–1933
B,TB,VO

AⅮGIR

GIRALT MIRACLE, Ricardo
Spanish 1911–
H

GIRARD, Daniel
French 1890–
B

GIRARDET, Jules
French 1856–
B,H,LEX,TB

J.G.

GIRBAL, Gaston (Arton sic)
French early 20c.
AD,POS

Irton Girbal 24

GIRESSE, Monique
French 1926–
B

GIRONELLA, Alberto
Mexican 1929–
B,H

GIROUX, André
French 1895–
B

A.G.

GISCH, William S.
American 1906–
H

GISCHIA, Léon
French 1903–
B,H,POS

GISPEN
American? ac. early 20c.
CP

GIULIANI, Vin
American 1930–76
F,GR71(annual reports),Y

vin giuliani

GIURGOLA, Aldo (Ronaldo)
American mid 20c.
GR55-57-58

GIUSTI, George
American mid 20c.
ADV,FOR,GR52 thru 56-58-59-61-63-66-68,H

Giusti

GIUSTI, Robert G.
Swiss/American 1937–
ADV,F,GR82,P,Y

R·GIUSTI

GIVEN, Eben
American 20c.
M

GJÖGREN
Swedish early 20c.
POS

GLACKENS, William J.
American 1870–1938
B,EAM,F,H,I,IL,M,MCC9/04,PE,R,CR9/02

W. Glackens

GLADBACH, Ernst Georg
German 1812–96
B,LEX,TB

EG

GLADKY, Serge
French early 20c.
POS

GLANCKOFF, Samuel
American 1894–
M

GLANZMAN, Louis S.
American 1922–
APP,H,IL

GLASER, Corinne L.
American 1898–
M

GLASER, David
American 1919–
H

GLASER, Milton
American 1929–
AA,ADV,CP,F,GMC,GR53-55 thru 64-66-
67-68-82,H,IL,P,PG,POS

GLASER, Otto
Swiss mid 20c.
GR52-53-56-59-63

GLASGOW, Everett W.
American 1892–
H,M

GLASHAN, John
English late 20c.
EI82

GLASS, Franz Paul
German 1886-1964
POS

GLASS, Irwin
American 20c.
M

GLASS, Zoltan
English mid 20c.
GR52

GLATZ, Oszkár
Hungarian 1872-1958
B,LEX,TB,VO

GLATZER, Simon
Russian 1890–
B

GLAZEBROOK, Hugh J.
Canadian ac. 1878-88
H

GLEESON, Joseph Michael
American 1861–
B,F,M,MUN8/97

GLEESON, Tony
American 20c.
NV

GLEIZES, Albert
French 1881-1953
B,DA,DES,EAM,H,PC

GLENNY, Alice Russel
American 1858–
B,F,H,M,R

GLEVIEW, Dale Nichols
American 20c.
LEX

GLINTENKAMP, Hendrik (Glint)
American 1887-1946
B,F,H,M,S,VO

GLOAG, Isobel Lillian
Scots 1865-1917
B,H

GLOVER, Lyle
 Canadian 1921–
 H

GLÜCKERT, Günther
 German mid 20c.
 GR59–61–63–67

GLUECKSELIG, Leo
 American mid 20c.
 GR57

GNAM, Hugo, Jr.
 Swiss/American 1899–
 H

GNIDZIEJKO, Alex
 American late 20c.
 GR82–85

GNOLI, Domenico
 Italian/American 1932–70
 B,F,H,P,Y

GOAMAN, Michael
 English mid 20c.
 GR52–54–58

Joaman

GOATER, John H.
 American ac. mid 19c.
 BAA,D,F

GOBBATO, Imero
 Italian/American 1923–
 H

GOBLE, Warwick
 English 19c.
 B

GOBO, Georges
 American/French 1876–
 B,VO

GODDÉ, Jules
 French 1812–76
 B

GODEFROID, Alain
 Belgian late 20c.
 EI79

a Godefroid

GODFREY, Neil
 English mid 20c.
 GR61

GODQUIN, S.
 French mid 20c.
 LEX

GODWIN, Frank
 American 1889–
 F,H,M,Y

GODWIN, James
 English –1876
 B,H

GODWIN, Karl
 American 1893–
 B,F,H,M

GOEDECKER, Georg
 Austrian 20c.
 LEX

GOENNEL, Heidi
 American late 20c.
 New Yorker magazine cover 5/12/86,*

heidi

GOETZELL, Amandus
 German 1889–
 B

GOFF, Carleton
 American 20c.
 M

GOFF, Harry Sharp, Jr.
 American 1905–
 H,M

GOFF, Lloyd Lozes
 American 1919–
 H

GOGIN, Charles
 English 1844–1931
 B,H

GOGORZA, Maitland de
 see
 de GOGORZA, Maitland

GOINES, David Lance
 American 1905–
 BI,POS

david lance goines:1970

GOLBIN, Andrée
 German/American 1923–
 F,H

GOLD, Albert
 American 1916–
 F,H,IL,Y

albert gold

GOLD, Jeff
 American 20c.
 P

JEFF GOLD

GOLDBERG, Fred
 German early 20c.
 LEX,TB

F.G.

GOLDBERG, Reuben Lucius
 American 1883–1970
 CC,F,H,VO

RLG.

GOLDBERG, Richard A.
 American late 20c.
 GR85

GOLDBERG, Virginia Eagan
 American 1914–
 H

GOLDBLATT, Burt
 American mid 20c.
 GR57–59–60

BURT GOLDBLATT

GOLDEN, B.
 American 20c.
 LEX

BG.

GOLDEN, Charles O.
 American 1899–
 H

GOLDEN, Jack
 American mid 20c.
 GR61

GOLDEN, William
 American 1911–
 GR52–57–60,H

GOLDENBERG, Esther
 Canadian 20c.
 H

GOLDMAN, Robert Douglas
 American 1908–
 H

GOLDONE, Paul
 American 20c.
 M

GOLDSHOLL, Morton
 American mid 20c.
 GR52–53–54–57–59–61–66–67

GOLDSTEIN, Leo
 American mid 20c.
 GR60

GOLINKIN, Joseph Webster
 American 1896–
 B,F,H

GOLLIN, Norman
 American mid 20c.
 GR54–57–60

GOLLINGS, William (Bill) Elling
 American 1878–1932
 H,M

Gollings '04

GOLOWANOW, L.
 Russian mid 20c.
 LEX

GOLUB, J.
Mid 20c.
LEX

GOMBERG, Ab
American mid 20c.
GR52

GOMEZ-JAROMILLO, Ignacio
Colombian 1900–
H,P

GOMEZ

GONCHAROV, Andrei Dmitrievich
Russian 1903–
RS

A.G. / 27

GONSE, René
French late 19c.
B,LEX

GONSKE, Walter
American 1942–
AA,CON,H

Watt Gonske

GONTCHAROVA, Natalia Sergeevna
Russian 1881–1962
B,EAM,GMC,H,PC,POS,RS

N. Gontcharowa.

GONZALEZ, Amado
American mid 20c.
GR52

GOOCH, Donald Burnette
American 1907–
AA,H

GOOCH, Thelma
American 20c.
M

GOOD, Bernard Stafford
American 1893–
B,F,H

GOOD, Peter
American 20c.
C

GOODALL, Edward Angelo (Alfred?)
English 1819–1908
B,H,LEX,TB

E.A.G.

GOODELMAN, Aaron J.
American 1890–1978
B,F,H

GOODEN, Stephen
English 1892–
M

GOODENOW, Girard
American 1912–
H

GOODHUE, Bertram Grosvenor
American 1869–1924
CEN7/04 & 10/09,H,MM,PE,R

B·G·Goodhue 1902

GOODLOE, Burton E.
American 20c.
M

GOODMAN, Art
American mid 20c.
GR58 thru 64–66–68

GOODMAN, Marshall
American 20c.
LEX

GOODMAN, Percival
American 20c.
M

GOODMAN, Walter
English 1838–
B,F,TB

GW

GOODWIN, Arthur Clifton
American 1866–1929
B,F,I,M,SO

A.C. Goodwin
1910

GOODWIN, Ernest
English 20c.
B

GOODWIN, Philip Russell
American 1882–1935
F,H,IL,M,Y

Philip R. Goodwin–

GOOKINS, James Farrington
see
COOKINS, James

GOOLD, Paul
American 1875–1925
EC

GOPI
see
PILZ, Gottfried

GOPO
see
POPESCU-GOPO, Ion

GORANSON, Gunnar
Swedish mid 20c.
GR54

GORANSON, Paul Alexander
Canadian 1911–
H,M

GORBATY, Norman
American mid 20c.
GR59-60-61-64-67

GORDER, Luther Emerson van
American 1861–
B

GORDON, Frederick Charles S.
Canadian/American 1856–1924
B,CEN10/05,F,H,I,M,TB

F·C·GORDON

GORDON, Harry
American 20c.
GR58

GORDON, John Sloan
Canadian 1868–1940
H

GORDON, Maurice
American 1914–
H,M

GORDON, Morris
American 1911–
H

GORDON, Violet
American 1907–
H

GORDON, Witold
American 20c.
H

GORE, Chester
American mid 20c.
ADV

GORELEIGH, Rex
American 1902–
H

GOREY, Edward St. John
American 1925/29–
H,Y

GORGUET, Auguste François Marie
French 1862–1927
B,L

GORIAEV, Vitaly Nikolayevich
Russian 1910–
EC

GÖRING, Anton
German 1836–1905
B,LEX,TB

A.G

GÓRKA, Wiktor
Polish 1922–
GR56-58 thru 64-67,POS

W.GÓRKA 58

GORMAN, Chris
English early 20c.
PG

GORMAN, William D.
American 1925-
H

GORO von AGYAGFALVA, Lajos II
Hungarian 1865-1904
B,TB

GÖRÖG, Lajos
Hungarian mid 20c.
GR61

GORRA, Giulio
Italian 1832-84
B,H

GORSKI, Konstanty
Russian 19c.
B

GORSLINE, Douglas Warner
American 1913-
H

Gorsline

GORWAY, W.
English 19c.
B

GOSE, Francisco Javier
Spanish 1876-1915
B,FS

Sosé

GOSEI
Japanese ac. 1804-44
H

GOSLIN, Charles
American mid 20c.
GR58-59-60-62-64-66

GOSS, John
American 1886-1963?
B,F,H,I,M

GOSSET de GUINES, Louis (Andre Gill)
French 1840-85
EC,H

GOTHELF, Louis
American 1901-
B,F

GOTLIEB, Jules
American 1897-
IL,M

GOTLIEB

GOTLINGER, Walther
Austrian late 20c.
GR85

GOTO, Byron
American 20c.
GR60

GÖTTLER, Heinrich
German 1890-
LEX,VO

H.G.

GÖTTLICHER, Erhard
German late 20c.
GR82

GOTTLIEB, Dale
American late 20c.
GR82

DALE GOTTLIEB

GOTTLOB, Frenand Louis
French 1873-1935
B,FO,FS,GA,VO

F. Gottlob

GOTTSCHLING, Werner
German mid 20c.
GR60-61

GOTTWALD, Alfred
German 1893–
LEX,VO

GÖTZE, Wolfgang
German early 20c.
LEX

GÖTZ-RACKNITZ, Paul
German 1873–
B

GOTZSCHE, Kai G.
Danish/American 1886–
B,H,M

GOUDY, Frederic W.
American 1865–1947
F,GMC,H

GOULD, Chester
American 20c.
H

GOULD, (Sir) Francis Carruthers
English 1844–1925
B,EC,H,LEX,TB

GOULD, J. J.
American early 20c.
M,POS,R,SCR1/04,Y

GOULD, Jerome
American mid 20c.
GR52–53–54–61

GOULD, John F.
American 1906–
H,IL

GOULDEN, Jean
French 20c.
M

GOURCY, (Count) Henri Antoine Gaston
French 19c.
B,LEX,TB

GOUREAU, Hélène
Russian 1877–1913
B

GOURMELIN, Jean
French late 20c.
EI82

GOURO, Ilena Genrikhovna
see
GOUREAU, Hélène

GOURSAT, Georges
see
SEM

GOUTZWILLER, Charles
French 1810–1900
B,LEX,TB

GOUVEIA, Francisco Pereira da Silva
Portuguese 1872–1951
B,H

GOWDY, Carolyn
English late 20c.
EI82–84,GR85

GRABIANSKI, Janusz
Polish 1929–
GR59,H

GRABOFF, Abner
American 1919–
GR52 thru 55–67,H

GRACE, Alexa
American mid 20c.
GR85

GRACE, James Edward
English 1851–1908
B,H

GRADO, Angelo John
American 1922–
H

GRAE, Robert A.
see
GRAEF, Robert A.

GRAEF, Robert A.
American early 20c.
M,SCR1/04 & 4/06

[signature: Robt A. Graef]

GRAELLS, Francisco (Pancho)
Venezuelan late 20c.
GR82–85

PANCHO

GRAEME, Malcolm
American 20c.
M

GRAESE, Judith Ann
American 1940–
H

GRAF, Carl B.
Swiss mid 20c.
GR52–57–58–59–63–64

GRAF, Georg
German 1869–
B

GRAFSTROM, Ruth Sigrid
American 1905–
F,H,IL,M,VC,Y

[signature: grafstrom]

GRAHAM, Arthur J.
Canadian ac. 1881–84
H

GRAHAM, Charles
American 1852–1911
H

[signature: C Graham]

GRAHAM, J.
American mid 20c.
GR53–54–57

GRAHAM, Madge
English 20c.
M

GRAHAM, Margaret Bloy
Canadian/American 1920–
H

GRAHAM, Payson
American early 20c.
F,H

GRAHAM, Walter
American 1903–
CON,H

[signature: Walter Graham]

GRAMATKY, Hardie
American 1907–79
B,EC,F,H,IL,Y

[signature: HARDIE GRAMATKY]

GRAMMAT, George
Canadian 1931?–
H

GRANAHAN, David Milton
American 1909–
H

GRANATH, N. G.
Danish? early 20c.
POS

[signature: N G GRANATH]

GRANDEE, Joe Ruiz
 American 1929–
 AA,F,H

Joe Grandee

GRANDJOUAN, Jules Félix
 French 1875–1968
 B,EC,FS

grandjouan.

GRANDMAISON, Nicholas
 Russian/Canadian 1895–1978
 H,WS

GRANDMAISON, P.
 American 20c.
 M

GRANDPRE, Mary
 American mid 20c.
 GR85

GRANDPRE'

GRANDSTAFF, Harriet Phillips
 American 1895–
 H

GRANDVILLE, Jean Ignace Isadore Gerard
 French 1803–47
 B,CP,EC,H,PC,PG

J.J. Grandville

GRANE, Knut
 Danish mid 20c.
 GR52

Grane

GRANGER, Marie
 French 20c.
 LEX

GRANGER, Michel
 French late 20c.
 GR52

GRANGER 79

GRANOWITTER, Jules
 American 1930–
 H

GRANSTAFF, William Boyd
 American 1925–
 H

GRANT, Alistair
 English mid 20c.
 GR53

GRANT, Blanche Chloe
 American 1874–1948
 F,H

GRANT, Douglas M.
 American 1894–
 H

GRANT, Duncan James Corrowr
 Scots 1885–
 H,LEX

GRANT, Edward Lyman
 American 1907–
 H,M,PAP

GRANT, Frederic M.
 American 1886–
 B,F,H,I

FREDERIC M. GRANT

GRANT, Gordon Hope
 American 1875–1962
 B,CO1/05,EC,F,H,IL,M,LEX,PE,TB,VO

Gordon H. Grant

GRANT, John E.
 English mid 20c.
 GR52–67

GRANT, L. F.
American 20c.
M

GRANT, Vernon
American 1902–
EC,H,M

GRANVILLE BAKER, B.
English early 20c.
LEX

GRANVILLE-SMITH, Walter
see
SMITH, Walter Granville

GRAPUS
(artists' collective--founded France 1970)
GR85,POS

Grapus

GRASHOW, James
American late 20c.
GR82

GRASIS, Tenis Davida
Latvian 1925–
LATV

Tenis Grasis

GRASS, Günter
American 20c.
P

GRASSET, Eugène Samuel
Swiss 1841–1917
AN,B,BI,CEN11/98,CP,FO,GA,GMC,LEX,
M,MM,POS,R,S,TB

Grasset

GRASSO, Doris Elsie
American 1914–
H

GRASSO, Ric
American mid 20c.
PAP

GRAU-SALA, Emile
Spanish 1911–75
B,H

grau sala

GRAUER, William C.
American 1896–
H

GRAUX, Louis William
French 1889–
B,LEX,VO

LWG

GRAVES, Elizabeth Evans
American 1895–
F,H

GRAVES, Etta Merrick
American 1882–
H,M

GRAVES, H. Tempest
American 1884–
M

GRAVES, Mary De Berniere
American early 20c.
F,H

GRAVES, Stuart
American 20c.
M

GRAY, Eric
English early 20c.
ADV

GRAY, Félix de
French 1889–
B

GRAY, Henri (pseudonym) (Boulanger)
French 1858–1924
AN,B,BI,FO,POS

H. GRAY.

GRAY, Lynda
 English late 20c.
 EI83-84

Lynda Gray

GRAY, Milner
 English 1899-
 GR54-60-62,H

GRAY, Paul Mary
 Irish 1842-66
 B,H

GREATOREX, Eliza Pratt
 Irish 1820-97
 B,H

GREATOREX, (Elizabeth) Eleanor
 American 1854-
 B,BAA,F,H,I

GREATOREX, Kathleen Honora
 American 1851-
 B,BAA,F,H,I

GREAVES, Harry E.
 American 1854-
 B

GREBEL, Alphonse
 French 1885-
 B,LEX,VO

GRECO, Emilio
 Italian 1913-
 B,DA,GR53,H

GRECO, Simon
 American mid 20c.
 PAP

GREEN, Benjamin R.
 American 1808-76
 B,H

GREEN, Bernard I.
 American 1887-1951
 B,H,M

GREEN, Charles
 English 1840-98
 B,H,TB

GREEN, Elizabeth Shippen (Mrs. Huger Elliott)
 American 1871-1954
 B,F,H,HA12/07,IL,LEX,M,PE,TB,Y

ELIZABETH SHIPPEN GREEN

GREEN, H.
 American mid 20c.
 GR52

GREEN, Hiram Harold
 American 1865-1930
 F,H

GREEN, Mildred C.
 American 1874-
 F,H

GREEN, Ruzzie
 American 20c.
 CP

GREEN, Winifred
 English 19/20c.
 BK

WG

GREENAWAY, Kate (Catherine)
 English 1846-1901
 B,BK,GMC,H,M,MM,TB

KG

GREENBERG, Maurice
 American 1893-
 F,I

GREENBERG, Morris
 American -1949
 F,M

GREENE, Albert van Nesse
 American 1887-
 B,F,H,I

GREENE, Fred Stewart
 American 1876-1946
 B,F,H

GREENE, Hamilton
 American 1904–
 H,IL

HAMILTON GREENE

GREENE, Stephen
 American 1917/18–
 B,H

GREENHALGH, Robert
 American 20c.
 HA,LEX

R.G.

GREENING, Harry Cornell
 American 1876–1930
 B,EC,F,TB

H·C·GREENING

GREENLEAF, Ray
 American –1950
 F,H,M

Ray Greenleaf

GREENLEAF, Viola M.
 American 20c.
 F,M

GREENWELL, Robert
 American 20c.
 GR64,M

GREENWOOD, Irwin
 American 20c.
 M

GREER, Blanche
 American 1884–
 B,F,H

GREER, Harvey
 American 20c.
 HA,LEX

h.g.

GREER, Terence
 English mid 20c.
 GR61-63

GREFÉ, Will
 American 19/20c.
 CO7/04,HA 11/02

WILL GREFE·'04'

GREGG, Gerald
 American 1907–
 PAP

Gregg

GREGG, (Mme.) Kenneth
 see
 WORDEN, Laicita Warburton

GREGG, Kenneth Roger
 American 1913–
 H,M

GREGORI, Leon
 American mid 20c.
 ADV,PAP

Gregori

GREGORY, Dorothy Lake (Moffet)
 American 1893–
 F,H,M

GREGORY, Edward John
 English 1850–1909
 B,H,M

GREGORY, Frank
 American 20c.
 M

GREGORY, Frank M.
 American 1848–
 BAA,F,I

GREGORY, Jack
 American mid 20c.
 GR61

GREGUSS, Imre
Hungarian 1856-1910
B,LEX,TB

G I

GREIFFENHAGEN, Maurice
Scots 1862-1931
AN,B,CEN12/06,CP,GA,M,POS

MAVRICE
GREIFFENHAGEN
1906

GREIL, Alois
Austrian 1841-1902
B,H,LEX,TB

a.G

GREINER, Wilhelm
German 1854-1916
LEX,TB

GRELL, Louis Frederick
American 1887-
H

GRELLET, G.
French 19/20c.
LEX

GREMINGER, Walter
Swiss mid 20c.
GR60

GREMKE, Henry Dietrich
American 1860/69-1933/39
H

GRENET, Edward Louis
American/French 1856/59-1922
B,BAA,H

GRENET, Málaga
American/French 20c.
M

GRES, Serge
French 20c.
B,M

GRESHAM, Arthur
Canadian 20c.
M

GRESSLEY
American mid 20c.
PAP

GRESsLEY-

GRETTA, J. Clemens
see
GRETTER, J. Clemens

GRETTER, J. Clemens
American 20c.
M

GRÉVIN, Alfred
French 1827-92
B,LEX

GREY-PARKER, C.
American late 19c.
LEX

GRIBAYEDOFF, Valerian
Russian/American -1908
CWA

GRIBBLE, Harry Wagstaff
American early 20c.
F

GRIEDER, Walter
Swiss late 20c.
GR53 thru 64-66-67-68-82

GRIER, Stella Evelyn (Gould)
Canadian 1898-
H

GRIESBACH, Cheryl
American mid 20c.
GR85

GRIESS, Rudolf
 German 1863–
 B,TB

R.G.

GRIEVE, Walter Graham
 English 20c.
 B

GRIFALCONI, Ann
 American 20c.
 H

GRIFFIN, Burr
 American? early 20c.
 FOS

GRIFFIN, Rick
 American 20c.
 POS

RICK GRIFFIN

GRIFFITHS, (Lieut.)
 Canadian ac. 1862
 H

GRIFFITHS, E. H.
 Canadian ac. 1871–72
 H

GRIFFITS, Cecil
 English early 20c.
 LEX,STU1923

GRIGGS, Frederick Landseer Maur
 English 1876–1938
 B,BA,BK,H

GRIGNANI, Franco
 Italian 1908–
 GR52–54 thru 57–59–60–61–63–64–66–67–68,
 H,POS

grignani

GRIGNANI, Jeanne
 Italian mid 20c.
 GR56–60

Grignani

GRIGNY, J.
 French 19/20c.
 LEX

GRIGORIEV, Boris
 Russian 1886–1939
 B,GMC

GRIGWARE, Edward T.
 American 1889–1960
 B,F,H

GRILLER, Anna
 American 20c.
 M

GRILLO, Oscar
 English late 20c.
 EI79–83–84

Oscar Grillo

GRILO, Ruben Campos
 Brazilian late 20c.
 GR82–85

GRILO 1981

GRIMAULT, Paul
 French 1905–
 EC,GR56

GRIMM (GRIMM-SACHSENBERG), Richard
 German 1873–
 B,MM

Gl

GRIMME-SAGAI, Emmi
 Austrian 20c.
 LEX

GRIMWOOD, Brian
 English late 20c.
 EI79

Grimwood

GRINEVSKY, A. (Mme. Alexeieff)
 French 20c.
 B

GRIS, Juan (José Victoriano Gonzales)
Spanish 1887-1927
B,DA,DES,DRA,EC,FS,GMC,H,M,PC

Juan Gris 1919

GRISET, Ernest Henry
French/English 1844-1907
B,H

EG

GRISHINA, (Madame) N.
Russian/American 20c.
M

GRIVAZ, Eugene
French 1852-1915
B,M,MUN8/97

E. Grivaz

GRODTCZINSKI, Justin
German early 20c.
LEX

GROEBLI, René
Swiss mid 20c.
GR59-60

GROENKE, Sherman Austin
American 1914-
H

GROFE, Lloyd Nelson
American 1900-
CG10/34,H,M

NELSON GROFE

GROGAN, Nathaniel
Irish 1740?-1807
B,D,H

GROGLER, Wilhelm
German 1830-97
B,LEX,TB

GROHE, Glenn
American 1912-56
CP,FOR,H,IL

grohe

GROHS, Hans
German 20c.
LEX

GROLLIER, Paul
French -1902
B

GROM-ROTTMAYER, Hermann
Austrian 1877-
B,LEX,VO

R

GRONOWSKI, Tadeusz
Polish 1894-
POS,VO

gronowski 30

GROPPER, William
American 1897-
ADV,APP,B,CC,EAM,EC,F,GMC,H,M,PC,SO

GROPPER-

GROSBECK, Dan Sayre
American early 20c.
F

GROSCH, Sophie
German 1874-
LEX

GROSE, Helen Mason
American 1880-
H,M

GROSJEAN, Claude Michel
French 1931-
B

GROSS, Anthony
 English 1905–
 APP,B,H,PC

GROSS, August Ignaz
 Austrian 1847–1917
 B,LEX,TB

GROSS, Chaim
 American 1904–
 B,H

GROSS, E. M.
 Canadian ac. 1879
 H

GROSS, George
 American mid 20c.
 PAP

GROSS, Milt
 American 1895–
 H,M

GROSS, Sidney
 American 1897–
 F,H,M

GROSS, Valentine
 French early 20c.
 ADV,ST

GROSSE, Daniel Charles
 Irish –1938
 M

GROSSE, Margarete R.
 German 20c.
 LEX

GROSSE, Theodor
 German 1829–91
 B,LEX,TB

GROSSMAN, David
 American late 20c.
 GR82

GROSSMAN, Elias Mandel
 American 1898–
 F,H,M

GROSSMAN, Robert
 American late 20c.
 GR82,PG

GROSSMANN, Gerhard
 German 20c.
 LEX

GROSSMANN, Rudolf
 German 1882–1941
 B,LEX,TB,VO

GROSSMANN, Wunibald
 German early 20c.
 LEX

GROSSPIETSCH, Catherine
 American 1917–
 H,M

GROSVENOR, Thelma Cudlipp
 American 1891–
 F,H,M

GROSZ, August Ignaz
 see
 GROSS, August Ignaz

GROSZ, George (EHRENFRIED, Georg)
German/American 1893–1959
B,DA,DRA,DRAW,EAM,EC,GMC,H,M,PC,
PG,SI

GROT, Johann Philipp
German 1841–
B

GROT-JOHANN, Philipp
see
GROT, Johann Philipp

GROTEMEYER, Fritz
German 1864–
B,LEX,TB,VO

GROTH, John August
American 1908–
F,H,IL,M,PAP,Y

GROTJOHANN, Philipp
see
GROT, Johann Philipp

GROTZ, William
American ac. 1920s
H

GROULT, André
French early 20c.
LEX

GROUT, Stephen
American 20c.
M

GROVE, David
American 1940–
F,GR82,Y

GROVES-RAINES, Antony
English mid 20c.
GR53-54

GRUAU, Rene
French 1910–
ADV,B,GR52 thru 60-63-66-82-85,H,LEX,POS,
TB,VO

GRUBER, Louis
German early 20c.
LEX

GRUBER, Veronika
German mid 20c.
GR58

GRUBSTEIN, Saul
American mid 20c.
GR53-55-56

GRUEN, Chuck
American mid 20c.
GR54

GRUGER, Frederic Rodrigo
American 1871–1953
F,I,IL,LEX,M,Y

GRUMIEAU (GRUMIEZUX), Emile Jacques
Belgian/American 1897–
F,H

GRÜN, Jules Alexandre
French 1868–1945
B,CP,FS,GA,GMC,H,M,POS

GRÜNBÖCK, Fritz
Austrian 1891–
LEX

GRÜNDL, Hans
Austrian 20c.
LEX

GRUNDMAN, S.
Israeli mid 20c.
GR56

GRUNER, Erich
German 1881–
B,POS,TB

GRÜNINGER, Heiner
Swiss mid 20c.
GR54

GRUNWALD, C.
American 19/20c.
HA11/01

GRUPPO, Nelson
American 20c.
M

GRUSHKIN, Philip
American 1921–
PAP

GRUT, Anton
American early 20c.
ADV

GRYGORCEWICZ, Theresa
American mid 20c.
GR85

GSCHWENDT, Heiner
German? 1914–
LEX,VO

GSELL, Laurent Lucien
French 1860–1944
B

GUAL, Adria
Spanish early 20c.
POS

GUARINO, (Salvatore) Antonio (Anthony)
Italian/American 1882–
B,F,H

GUARNACCIA, Steve
American late 20c.
GR82-85

GUARNACCIA

GUELDRY, Ferdinand Joseph
French 1858–
B,H,LEX,TB

F. Gueldry

GUERARD, Henri Charles
French 1846-97
B,H,LEX,TB

GUERIN, Jules
American 1865/66–1946
B,CEN12/09 & 3/13,F,H,I,M,SCR5/01 & 2/02
& 2/05

Jules Guérin

GUERREIRO, Inês Amparo Maraceto
Portuguese 1915–
H

GUERRINI, Giancarlo
Italian mid 20c.
GR57-59-62-63-66-68

GUERSON, (Adalbert de) Wojciech
Polish 1831–1901
B,H

GUERTIK, Helène
American 20c.
M

GUGGENHEIM, L.
German mid 20c.
LEX

GUHEL, J.
German ac. late 19c.
LEX

GUIDI, Robert
American mid 20c.
GR53 thru 56-59

GUIGNON, Henri
English mid 20c.
ADV

GUILBERT, Nicholas
French late 20c.
EI79

GUILD, Frank S.
American -1929
F,GMC,M

GUILD, Laurell van Arsdale
American 1898-
F,H

GUILLAUME, Albert
French 1873-1942
B,EC,FS,GA,HA11/02,M,POS

Guillaume

GUILLONNET, Octave Denis Victor
French 1872-
B,LEX,M,TB

GUIMARD, Hector
French 1867-1942
B,CP,H

GUINZBURG, Ruth Lewy
American 1898-
H,M

GUIPON, Leon
Franco/American 1872-1910
B,CEN1/05 & 8/07,I

LEON GUIPON.

GUIRALDES, Alberto
American 20c.
M

GULBRANSEN, Segur
American 20c.
M

GULBRANSSON, Olaf
Norwegian 1873-1958
AN,B,CP,EC,GMC,H,M,MM,PG,POS,SI,VO

OLAF GULBRANSON

GUMBART, August Friedrich
Swedish mid 20c.
LEX,VO

GUMERY, Adolphe Ernest
French 1861-
B,LEX,TB

AG

GUNDELFINGER, John Andre
Franco/American 1937-
GR66,H,IL

J. gundelfinger

GUNDLOCH, Max E. H.
American 1863-
B

M.G.

GUNDMUDSSON, Gundmunder (Erro, pseudonym)
Icelandic 1932-
B,CP

GUNGHER, Floyd Theodore
Canadian 1907-
H

GUNN, Archie
Anglo/American 1863-1930
F,M

GÜNTHER-NAUMBURG, Otto
German 1856-1941
LEX,TB,VO

O.G.N.

GURDUS, Luba
Polish/American 1914-
F,H

GURNEY, J. Eric
Canadian 1920?-
EC,M

GURNEY, William
American -1929
I

GURSCHNER, Herbert
Austrian 1910-
LEX

GUSTAVSON, Lealand R.
American 1899-1966
IL

GUSTAVSON

GUSTIN, Paul Morgan
American 1886-
B,F,H

GUTENSOHN, Bruno
see
BOLD, (GUTENSOHN, Bruno)

GUTHRIE, James
Scots 1874-
B?,M,STU1898,TB,VO

GUTHRIE, (Sir) James J. (G.)
English 1859-1930
B,BK,H

GUTMANN, Ernst
German ac. early 20c.
LEX

GUTSCHMIDT, Richard
German 1861-
B,TB

R.G.

GUTSCHOW, Harald
German mid 20c.
GR60

GUTTUSO, Renato
Italian 1912-
B,DA,GR52,H

GUY, A.
English mid 20c.
GR60-61

GUY, Gladys M.
Canadian 20c.
M

GUYDO, Henri
French ac. 1930s
CP,M

Guydo

GUYS, Constantin Ernest Adolphe Hyacinthe
French 1802/05-92
B,DA,H,M

GUZMAN-FORBES, Robert
American 1929-
H

GYER, E. H., Jr.
American 1900-
F,M

GYOKUANSAI
Japanese ac. 1778
B

GYOKUSHO, Kawabata
Japanese 1842-1913/14
H,J

GYOKUZAN
Japanese 1737-1812
H

GYÖRGY, Károly
Hungarian ac. late 19c.
LEX

GYÖRGY, Miklos
Hungarian 20c.
LEX

GYOSIA
see
KYOSIA

GYP, Sibylle Gabrielle Marie Antoinette
French 1850-1932
B

GYRA, Francis Joseph, Jr.
American 1914–
H,M

GYSIN, Brian
Anglo/American 1916–
B,H

GYSIN, Georg
Swiss 1876–
B

GYSIS, Nikolaus
Greek 1842–1901
B,CP,H,M,POS

N.G.

GYSSLER, F.
Swiss mid 20c.
GR59

GYSSLER

GYULAY, Laszlo
Hungarian 1843–1911
B

– H –

HA-SO-DE, (Abeyta Narcisco)
American Indian 1918–
H,M

HAACKEN, Frans
German mid 20c.
GR52

haacken.

HAAG, Carl
German 1820–1915
B,H,M

HAAK, Kenneth
American mid 20c.
GR52–54

HAANEN, Fritz van
Dutch 19c.
B

HAAR, Leopold
Brazilian mid 20c.
GR52–53

HAAS, Irene
American 1929–
GR58,H

HAASE, C. Friedrich M. E. von
German 1844–
B,POS,TB

C.H.

HAASE, Erich
German 1911–
LEX

HABASHI, Yoshio
Japanese mid 20c.
GR54

Y

HABBEN, Joseph E.
American 1895–
F

HABDANK, Walter
German 1930–
G

Habdank 56

HABERER, Eugene
Canadian ac. 1872–91
H

HABERERNOVÁ, Mira
Yugoslavian 1939–
B,H

HABERFIELD, Bob
English late 20c.
GR85

HABERMANN, Hugo Frieherr (von)
German 1849–1929
AN,B,CP,H,M

HABERSTROH, Alex
American 20c.
M

HABERT-DYS, Jules Auguste
French 1850–
B,LEX

HACKETT, Grace Edith
American 1874-1955
B,F,H,M

HADANG
German early 20c.
POS

HADANK, O. Werner Hermann
German 1889-
GR53,H,LEX,VO

HDK

HADE, Berta
American 20c.
LEX

HADE, Elmer
American 20c.
LEX

HADEM, Heinz
German mid 20c.
GR53

HADEN, Eunice Barnard
American 1901-
H

HADEN, Francis S.
see
SEYMOUR-HADEN, Francis

HADER, Bertha Hoerner
American 20c.
H,M

HADER, Elmer Stanley
American 1889-1973
H,M

HADJCKRIAKOS-GHYKAS, Nicos
Greek 1906-
B

HADOL, Paul (White)
French 1835-75
B

VENTE HADOL

HAEBERLIN (HÄBERLIN), Carl (Karl) von
German 1832-1911
B,H,LEX,M

CH

HAEMER, Alan
American 20c.
M

HAENEL, William M.
American 1885-
B,F,H,M

HAENEN, Frederik de
French 19/20c.
B,LEX

F d H.

HAENIGSEN, Harry
American 1900-
H,M

HAENISCH, Gerhard Hellmuth
German 1871-
B,TB

HAERDTLE, Eugen Max
German 20c.
LEX

HAERLIN, Laura
German ac. early 20c.
LEX

HÄFELI, Walter
Swiss 20c.
LEX

HAGEL, Frank D.
American 193?-
CON

Hugel

HAGENHOFER, John Daniel
American 1913-
H,M

HAGER, Luther George
 American 1885–1945
 F,H,I,M

HAGIO, Kunio
 Japanese? 20c.
 P

HAGMAN, Rune
 Swedish 1914–
 LEX,VO

HAHMANN, Werner Franz
 German 1883–
 B,GMC,TB

HAHN, Albert
 Dutch 1877–1918
 B,EC,POS,TB

HAHN, Monika
 German late 20c.
 GR82

HAHN, Sylvia
 Canadian 1911–
 H,M

HAIDER, Max
 German 1807–73
 B,LEX,TB

HAIG, (Capt.) H. de H.
 Canadian ac. 1885
 H

HAINES, Bowen Aylesworth
 Canadian/American 1858–
 F,M

HAINES, Charles Richard
 American 1906–
 H,M

HAINES, Marie Brunner
 American 1885–
 B,F,H,M

HAITÉ, George Charles
 English 1855–1924
 B,GMC,H,M,STU1900

HAJNALL, Gabriella
 Hungarian mid 20c.
 GR61

HAKE, Otto Eugene
 American 1876–
 B,F,H,M

HAKEN-KUAHLMANN, P.
 German early 20c.
 LEX

HALBRITTER, Kurt
 German early 20c.?
 LEX

HALE, Walter
 American 1869–1917
 ABL8/05,B,HA6/04,M

HALEM, Francisco de Paula van
 Spanish late 19c.
 B

HALEY, Gail
 American 20c.
 H

HALICKA, Alice
 Polish 1895–1975
 B,H,M

HALKE, Paul
 German 1866–
 B,TB

HALL, Arnold
 American 1901–
 F,H,M

HALL, Edward S.
 Anglo/American 1840?–
 D,H?

HALL, Helge
 Danish 1907–
 EC

HALL, Isabel Hawxhurst
 American 20c.
 F,H,M

HALL, James
 American 1869–1917
 B,H,M

HALL, John Alexander
 Canadian 1914–
 H,M

HALL, Norman
 American 1885–
 F

HALL, Philip
 Canadian 20c.
 M

HALL, Sydney Prior
 Canadian 1842–81
 B,H,M,TB

S. P. H.

HALL, Thomas Victor
 American 1879–
 B,F,M

HALL, Tom
 Canadian 1885–
 ADV,H

Tom Hall

HALLADAY, Allan Wells
 American 1906–
 H,M

HALLADAY, Milton Rawson
 American 1874–
 F,H,M

HALLAM, Ben
 American mid 20c.
 PAP

HALLAM, Joseph Sydney
 Canadian 1899–1953
 H,M

HALLER, Alfred
 German mid 20c.
 GR54-57-58

HALLER, Gerta
 German mid 20c.
 GR57-59-62-68

HALLER, Oswald
 Austrian 1908–
 LEX,VO

HALLIDAY, Nancy Ruth
 American 1936–
 AA

HALLMAN, Adolf
 Swedish 1893–
 H,POS

Hallman
-33-

HALLMAN, Henry Theodore
 American 1904–
 B,F,H,M

HALLOCK, Ruth Mary
 American 1876–1945
 B,F,H,M

HAL(L)OWELL, George Hawley
 American 1872–1926
 B,F,H,I,M

HALLOWELL, Robert
 American 1886–1939
 B,F,H,I,M

HALLSTRÖM, Gunnar August
 Swedish 1875–
 B,M

HALLWARD, Cyril R.
 English late 19c.
 LEX

HALM, George Robert
American 1850-99
CWA,I,M

HALM, Peter
German 1854-
B,LEX,TB

[signature: PH monogram]

HALOUZE, Edouard
French early 20c.
N,ST

[signature: EDOUARD HALOUZE]

HALPERT, A.
American 20c.
H,M

HALPIN, Frederick W.
Anglo/American 1805-80
B,D,F,H,I,M

HALSWELLE, Keely
English 1832-91
B,H,M,TB

HALVERSON, Janet
American 20c.
GR57-59

HAM, Georg (Geo)
French early 20c.
LIL1932 & 1934

[signature: Geo Ham]

HAMBERGER, John F.
American 1934-
H

HAMBIDGE, Jay (Edward John)
American 1867-1924
B,CEN10/06,F,H,M,Y

[signature: JAY HAMBIDGE]

HAMBIGE, Jay (Edward John)
see
HAMBIDGE, Jay (Edward John)

HAMBLETT, Theora
American 1895-
B,H

HAMBLY, Bob
Canadian late 20c.
GR85

HAMBOURG, André
French 1909-
B,H,M

[signature: a. hambourg]

HAMBRIDGE, Jay (Edward John)
see
HAMBIDGE, Jay (Edward John)

HAMBUGER, Jürg
Swiss mid 20c.
GR59-61

HAMEL, Geo
see
HAM, Georg

HAMERTON, R. J.
Canadian ac. 1845
H

HAMERTON, Robert Jacob
Irish ac. 1831-58
B,H,M

HAMILTON, Garin
Scots mid 20c.
GR54

HAMILTON, Grant E.
American 1862-1920
B,CC,EC

[signature: HAMILTON]

HAMILTON, Hamilton
Anglo/American 1847-1928
B,BAA,F,H,I,M

[signature: Hamilton Hamilton]

HAMILTON, Ida Gertrude
Canadian 20c.
M

HAMILTON, James
Irish/American 1819-78
B,BAA,F,H,I,M,TB

HAMILTON, John McLure
American 1853–1936?
B,BAA,F,H,I,M

HAMILTON, Wilbur Dean
American 1864–
B,F,H,M

HAMILTON, William
English 1750/51–1801
B,BA,H

HAMILTON-CRAWFORD, T.
Scots 1860–
LEX,STU1907,TB

HAMMACHER, Arno
Italian mid 20c.
GR61-62

HAMMAN, Edouard Jean Conrad
Flemish 1819–88
B,BAA,H,M

Edouard Hamman

HAMMAN, Joé
French 20c.
B

HAMMARLUND, Gosta
Danish 19?/20?c.
LEX

HAMMELL, Elizabeth Lansdell
American 1889–
H,M

HAMMELL, Will
American 1888–
F,H,M

HAMMER, John
American 20c.
F,M

HAMMER, Julius Walter
American 1873–
B

HAMMER, Victor Karl
Austrian/American 1882–1967
B,H,LEX,M,TB

VH

HAMMON, Bill, Jr.
American 1922–
H

HAMMOND, Aubrey L.
English 1894–1940
ADV,CP,M

AUBREY HAMMOND

HAMMOND, Frank
Canadian late 20c.
GR85

HAMMOND, Gertrude E. Demain
English 1862–1953
B,H,LEX,M,TB

HAMON, Remie
American 20c.
PAP

HAMPE, Lisa
German 20c.
LEX

HAMPE, Theo
American 19?/20?c.
R

HAMPTON, Bill
American 1925–77
H

HAMPTON, Blake
American 1932–
F,GR66-68,Y

HAMPTON, H. G.
English 20c.
M

HAMPTON, John Wade
American 1918–
CON,H

[signature: Hampton]

HANCKE, Rudolf
Austrian ac. early 20c.
LEX

HANCOCK, R.
Canadian late 19c.
H

HANDFORTH, Thomas Schofield
American 1897–1948
APP,B,F,H,M,PC

[signature: Thomas Handforth]

HANDLEY, Hester Merwin
American 1902–
H,M

HANDLEY, Vincent F.
English 20c.
M

HANDS, Hargrave
English late 20c.
EI79

HANDSCHUH, Franz
Austrian 20c.
LEX

HANDVILLE, Robert Thompkins
American 1924–
F,H,IL,Y

[signature: RT Handville]

HANE, Roger
American 1940–75
F,GR62,P,Y

[signature: Roger Hane]

HANGEN, Heijo
German? 1927–
LEX

HÄNISCH, Martin
German 20c.
LEX

HAN LEN
Chinese mid 20c.
GR55

HANLON, Louis (Lou) Wilfred James
American 1882–1955?
F,H,M

HANN, Harry
Austrian mid 20c.
LEX

HANNA, Boyd Everett
American 1907–
H

HANNA, John
English mid 20c.
GR52–54 thru 57–59

[signature: HANNA]

HANNA, Thomas King, Jr.
American 1872–1951
B,F,H,HA,I,IL,SCR11/02,TB,Y

[signature: T.K. Hanna Jr.–1902]

HANNAH, Muriel
Anglo/American early 20c.
FM9/26,H

[signature: Hannah]

HANNAN, Tom
American mid 20c.
GR61

HANS, Hillmann
German 1925–
H

HANSEN
see
UNSHO, Ikeda

HANSEN, Ernest
Danish 1882–
B

HANSEN, Ernst
 Danish 1906–
 M

HANSEN, Gaylen Capener
 American 1921–
 H

HANSEN, Gylling
 Danish mid 20c.
 GR57

HANSEN, Hans Nikolai
 Danish 1853–1923/27
 B,H,M,POS,SC

HH. 98

HANSEN, Joseph Theodor
 Danish 1848–1912
 B

HANSEN, Knut
 Danish 1876–1926
 B,POS,TB

Khut Hansen

HANSEN, Sikker
 Danish 1897–
 B,GR57,POS

HANSI, (Jacques Waltz?)
 French 20c.
 POS

HANSON, Berta
 American 1876–
 B

HANSON, Henry T.
 American 1888–
 F

HANTMAN, Carl
 American 1935–
 CON

Carl Hantman

HANZABURÔ
 see
 JICHOSAI

HAPGOOD, Theodore Brown, Jr.
 American 1871–1938
 H,R,STU1899,VO

TBH

HARA, Hiromu
 Japanese mid 20c.
 GR57–63,POS

HARAK, Rudolf de
 American mid 20c.
 GR52–53–54–56–57–58–61–63–64

HARARI, Hananiah
 American 1912–
 F,H,M

HARBESON, Georgina Brown
 American 1894–
 B,F,H,M

HARBURGER, Edmund
 German 1846–1906
 BAA,EC,H,LEX,M,TB

E.H.

HARCOURT, George E.
 American 1897–
 F,M

HARDENBERGH, Gerard Rutgers
 American 1855–1915
 BAA,I,M

HARDIE, Charles Martin
 English 1858–1916/17
 B,H,LEX,M,TB

CMH

HARDIE, George
 English late 20c.
 EI79,GR85

George Hardie

HARDING, Charlotte
 Anglo?/American 1873–1951
 CEN8/04 & 12/06,F,HA10/03 & 6/04 & 8/04,
 IL,LEX

C. Harding.

HARDING, Emily J. (Andrews)
English ac. 1877–98
B,BK,H

EJH

HARDING, George
American 1882–1959
B,F,H,HA8/07 & 9/07,I,IL,M,Y

GEO. HARDING 08

HARDING, Lonal
English late 20c.
GR85

HARDING, W.
English ac. 1787–92
B,H

HARDMEYER, Robert
Swiss 1876–1919
B,POS

HARDY, Charles
Anglo/American 1888–1935
F,H,M

HARDY, Dorothy Sturgis
American 20c.
M

HARDY, Dudley
English 1866/67–1922
ADV,AN,B,CP,EC,GA,H,M,MM,POS

Dudley Hardy

HARDY, E. Stuart
English ac. early 20c.
LEX

HARDY, Horace W.
American –1955?
H

HARDY, Howard C.
American 20c.
H,M

HARDY, Walter Manly
American 1877–
B,F,M

HARE, H. de H.
Canadian 1885–
H

HARE, J. Knowles
American 1884–1947
F,H,M

HARGENS, Charles W.
American 1893–
F,H,LEX,M

HARGRAVE, John
English ac. early 20c.
LEX

HARLAN, Harold Coffman
American 1890–
F,H,M

HARMAN, Fred, Jr.
American 1902–
H

HARMER, Alan
American 20c.
M

HARMER, Alexander F.
American 1856–1925
H,M

ALEX F. HARMER

HARMON, Alan
American mid 20c.
PAP

HARMON, Barbara Sayre
American 1927–
H

Hungarian/Yugoslavian 1879-1955
B,H,LEX,TB,VO

HARNISCH, Friedrich
German 20c.
B,LEX,TB

HARNISCH, Guilo
American 20c.
M

HARPER, Charles George
English 1863-1943
BK,M,TB

HARPER, Frank Robert
American 1876-
AM12/23,H,M

HARPER, Frank Robert
American 1908-
H

HARPER, Henry Andrew
English 1835-1900
B,H

HARPER, Irving
American mid 20c.
GR52

HARPER, Roberta Blewett
American 1905-
M

HARPER, William St. John
American 1851-1910
B,F,I,M

HARR, Pamela C.
American 1944-
CON

HARRACH, Max
German 1874-
B,TB,VO

HARRER, Honore
American 20c.
GMC,GR82 (see Sharrer (sic))

HARRIES, Laurens S.
American ac. early 20c.
HA,LEX

HARRINGTON, Oliver Wendell
America 1913-
H,M

HARRIS, Ben Jorj
American 1904-57
H

HARRIS, Caroline Estelle
American 1908-
M

HARRIS, Derrick
English mid 20c.
GR52-53-54

HARRIS, Greg
American 1950-
C

HARRIS, H. H.
English early 20c.
ADV,GMC,POS

HARRIS, John
English 20c.
GR64

HARRIS, Lawren Stewart
 Canadian 1885–1970
 H,HA4/09,M

HARRIS, Margaret A.
 American mid 20c.
 GR53,M

HARRIS, Robert
 Canadian 1849–1919
 B,H,M

HARRIS, Robert George
 American 1911–
 F,H,IL,M,Y

HARRIS, Robin
 English late 20c.
 GR82

HARRIS, Teske
 see
 TESKE HARRIS, Diane

HARRISON, Birge (Lowel)
 American 1854–1929
 B,H,I,M

HARRISON, F. C.
 English mid 20c.
 ADV,GR60

HARRISON, George
 French? early 20c.
 ST

HARRISON, Richard E.
 American 20c.
 M

HARSDORF, Jobst von
 German 1924–
 GR59

HARTMAN

HAR(S)HBERGER, Florence E. Smith
 American 1863–
 B,H,M

HART, Ernest Huntley
 American 1910–
 H,M

HART, Frank
 American 20c.
 M

HART, Mary Theresa
 American 1872–1971
 B,BAA,M

HART, Solomon Alexander
 English 1806–81
 B,H,M

HARTE, Glynn Boyd
 see
 BOYD-HARTE, Glynn

HARTELL, John Anthony
 American 1902–
 H,M

HARTER, Tom John
 American 1905–
 H,M

HARTING, George W.
 American 1877–
 F,H,M

HARTLAND, Beryl
 English mid 20c.
 GR53

HARTLEY, Harrison Smith
 American 1888–
 H

HARTLEY, Paul
 American mid 20c.
 GR54,M

HARTLEY, Rachel
 American 1884–
 B,F,M

HARTMAN, Emil Alvin
 American 20c.
 M

HARTMAN, G. H. (probably Gertrude &/or Hazel)
 American early 20c.
 CEN7/07,H,M

HARTMAN, Sydney K.
German/American 1863-1929
F,M

HARTMANN, Grete
Austrian 20c.
LEX

HARTMANN, Hans
Swiss mid 20c.
GR54-60 thru 63-66-68

HARTMANN, Oluf
Danish 1879-1910
B,H,M

HART-NIBBRIG, F.
Dutch early 20c.
BI

HARTRICK, Archibald Standish
English 1864/65-1950
B,H,M,POS,TB,VO

A.S.H.

HARTSHORNE, Gordon
American mid 20c.
GR60

HARTWELL, George Kenneth
American 1891-1949
F,H,I,M

HARTWELL, Marjorie
American 20c.
M

HARTWERTH, Wilhelm
German 1894-
LEX

HARUMI
see
YAMAGUCHI, Harumi

HARVEY, Alice
American 1894-
EC,I,M

AH.

HARVEY, Harold Leroy
American 1899-
B,F,H,M

HARVEY, RICHARD DEAN
American 1940-
F,H,Y

HARVEY, William
English 1796-1866
B,H,LEX,M,TB

H

HÁRY, Gyula von
Hungarian 1864-1946
B,LEX,TB,VO

HC.

HASCHER, Hans
German early 20c.
LEX

HASE, Ernst
German 1889-
LEX

HASEGAWA, Eiichi
Japanese mid 20c.
GR61-67

HASELRIS, Else
Danish 20c.
M

HASEMANN, Wilhelm Gustav Friedrich
German 1850-1913
B,LEX,M,TB

W.H.

HASHIMOTO, (Mrs.) Michi
Japanese/American 1897-
B,F,M

HASKELL, Ernest
American 1876-1925
APP,B,F,H,HA6/07 & 7/07,LEX,M,R,TB

HASKINS, Samuils Mendela
Latvian 1909-
LATV

Ha-ha

HASLEHURST, Ernest William
English 1866-1949
B,H,M

HASS, Fritz
German 1864-1930
B,LEX,TB,VO

o

HASSAL, Joan
English 1906-
B,H

HASSAL(L), John
English 1868-1948
ADV,B,BI,CP,EC,GMC,M,POS,TB,VO

Hassall

HASSE, Sella
German 1878-
LEX,TB,VO

HS

HASSELRIIS, Malthe C. M.
Danish/American 1888-
F,H,M

HASTAIN, Eugene
American 20c.
M

HASTE, Laurence B.
American 20c.
M

HASTINGS, Howard L.
American 20c.
M

HATA, Taizo
Japanese mid 20c.
GR52

HATCHER, Clare
English late 20c.
EI79

HATHERELL, William
English 1855-1928
H,HA10/01 & 12/07 & 9/08

W. HATHERELL.

HATTS, Clifford
English mid 20c.
GR52

HAUG (HAUS), called BATHASAR
French 20c.
B

HAUG, Robert von
German 1857-1922
B,LEX,M,TB

Rh

HAUGSETH, Andrew John
American 1884-
H,M

HAUKE, Hans
Austrian 20c.
LEX

HAUMAN, Doris
American 20c.
M

HAUMAN, George
American 20c.
M

HAUN, Robert Charles
American 1903-
H,M

HAUNOLD, Karl Franz Emanuel
Austrian 1832-1911
B,LEX,TB

H.C.

HAUPT, Winifred Hope
American 1891-
H,M

HAUPTMANN, Feodor
German early 20c.
LEX

HAURI, Edi
Swiss mid 20c.
GR52-57-68

EDI HAURI

HAUS
see
HAUG (HAUS)

HAUSCHILD, Max
 German 1907–
 LEX,VO

HAUSER, Rudolf
 German mid 20c.
 GR54

HAUSMAN, Fred S.
 German/American 1921–
 GR52–61,H,M

HAUSMANN, Claus
 German 20c.
 LEX

HAUTH(-TRACHSLER), Dora
 Swiss 1874–
 B,LEX,TB,VO

HAVENS, James Dexter
 American 1900–60
 APP,H,M,SO

HAVERS, Alice Mary (Morgan)
 English 1850–90
 B,H,LEX,M,TB

HAVINDEN, Ashley
 English 1903–
 ADV,GR52–53–55–56–58–59–67,H,M,MM,POS

HAVLIČEK, Karel
 American late 20c.
 GR82

HAWES, Charles M.
 American 1909–
 H

HAWKINS, Arthur J., Jr.
 American 1903–
 GR52,H,M,PAP

HAWKINS, Basil G.
 American 1903–
 H,M

HAWKINS, Benjamin Waterhouse
 English 1850–
 B,LEX,TB

HAWKINS, Harold Frederick Weaver
 English 1893–
 LEX,VO

HAWKINS, Sheila
 English 20c.
 M

HAWLEY, Carl T.
 American 1885–
 B,F,H,M

HAWLEY, Peter
 American mid 20c.
 ADV

HAWORTH, James
 American? early 20c.
 ADV

HAWORTH, William G.
 American 20c.
 M

HAWORTH, Zema Barbar Coghill
 South African/Canadian 1904/10–
 H,M

HAY, Stuart
 American 1889–
 CG10/34,F,FOR,M

HAYAKAWA, Yoshio
Japanese 1917–
GR52–53–54–57–59–61–62–64–67,H,POS
(pg.333)

yoshio hayakawa

HAYAMI, Taisuke
Japanese mid 20c.
GR64

HAYASAKA, Osamu
Japanese mid 20c.
GR60–62–63

HAYASHI, Seichi
Japanese 1945–
EC

HAYASHI, Yoshio
Japanese mid 20c.
GR60–66

HAYDEN, Hayden
American 20c.
M

HAYDEN, Sara S.
American early 20c.
F,H,M

HAYDON, Harold Emerson
American 1909–
H

HAYES, Katherine Williams
American 1889–
F,H,M

HAYNEMAN, Ann
American 20c.
M

HAYNES, George Edward
American 1910–
H

HAYNES, Robert
American 20c.
H

HAYS, Philip Harrison
American 1932–
GR58–59–61–67,IL,Y

phil hays

HAYWARD, George
American 1874–1932
Y

HAYWOOD, Helen
American 20c.
M

HAYWOOD (Hayward sic), Mary Carolyn
American 1898–
F,H,M

CAROLYN HAYWOOD

HAZELL, Frank
Canadian 1883–1958?
B,F,H,M

HAZELTON, Isaac Brewster
American 1875–1943
F,H,M,RC8/17

I. B. HAZELTON.

HAZENPLUG, Frank
American 1873–
B,CP,GA,MM,POS,R,TB

H

HEAD, Bruce
Canadian 1931–
GR57–59,H

HEAGY, Ouidabon Henry
American 1907–
H

HEALEY, Dale
American mid 20c.
GR61

HEALY, Deborah Ann
American 20c.
H

HEANEY, Charles Edward
American 1817–87
H,M

HEARTFIELD, John (pseudonym for
HERZFELD, Helmut)
German 1891–1968
B,CP,H,PG,POS

HEASLIP, William John
Canadian/American 1898–
H,IL,M

HEASLIP

HEATH, Charles
English 1785–1848
B,H,M

HEATH, Edda Maxwell
American 1875–1972
B,F,H,M

HEATH, Howard P.
American 1879–
B,F,H,M,SO

HEATH, William
English 1795–1840
B,H

HEBBELYNCK, Jennie
Anglo/American 20c.
M

HEBERLING, Glen Austin
American 1915–
H

HECHENBLEIKNER, Louis
American 1893–
H,M

HECHTER, Charles
Romanian/American 1886–
H,M

HECKEL, Erich
German 1883–1970
AN,B,DRA,H,M,PC,POS

HEDIN, Donald Monroe
American 1920–
CON,H

HEDIN, Sven Anders
Swedish 1865–1952
M

HEERMANN, Erich
German 1880–
B,LEX,TB

HEESEN
Dutch 20c.
GMC

HEESOM, Robert
English late 20c.
EI83

HEFFETER, E.
Austrian ac. early 20c.
LEX

HEFFRON, Walter J.
American 20c.
M

HEGEDÜS, László
Hungarian 1870–1911
B,LEX,M,TB

HEGEDUSIC, Krsto
Yugoslavian 1901–
B,H

HEGENBARTH, (Prof.) Josef
German 1884–1962
B,G,H,TB,VO

H U

HEGER, Joseph
German/American 1835–97
H

HEHL, Vincenz
Czechoslovakian 1901–
LEX

HEIBAK, Erik
Danish mid 20c.
GR 52–54–57–59–63

HEIDE, Alfred
German 1855–
B

HEIDERICH, Arnold
German 1901–
LEX

HEIDERSBERGER, Heinrich
German mid 20c.
GR 57

HEIDI
see
GOENNEL, Heidi

HEIGENMOSER
German early 20c.
POS

HEIL, Charles Emile
American 1870–
B,F,H,M

HEIL, Gustav
German 1817–97
B

HEILBRONNER, Yvonne
French 1892–
B

HEILEMAN(N), Charles Otto
American 1918–
H

HEILIG, Karl
German 1863–1910
B,TB

K.h

HEILMANN, Gerhard
Danish early 20c.
POS

HEIN, Franz
German 1863–
B,LEX,M,TB

FH

HEIN GOOS
see
KRANNHALS, Hedda von

HEINDEL, Robert Anthony
American 1938–
C,F,GR85,Y

B.Heindel

HEINE, Friedrich Wilhelm
German 1845–1921
B,LEX,M,TB

F.W.H.

HEINE, Marc K.
German/American 1919–
H

HEINE, Thomas Theodor
German 1867–1948
AN,B,CP,EC,GA,GMC,H,M,MM,PG,POS,SI,
TB,VO

Thomas Theodor Heine

HEINIGKE, Otto
American 1851–1915
B,H,M

HEINL MAZAL, R.
Austrian 20c.
LEX

HEINRICH, Roy Frederic
American 1881-1943
H,IL,M

RFH

HEINS, John P.
American 1896-
M

HEINSDORF, Emil Ernst
German 1887-
LEX,VO

E.E.H.

HEINSDORF, Reinhart
German mid 20c.
GR60

HEINTZ, Jerzy
Polish 20c.
GMC

JERZY HEINTZE

HEINZEL, A.
German late 19c.
LEX

HEINZMANN, Samilla L. Jameson (JAMESON, Samilla L.)
American 1881-
F,H,I,M

HEISE, Hans
French 1871-1902
LEX

HEISLER, Gregory
American mid 20c.
GR85

HEISS, Jesse S. C.
American 1859-
B

HEISS, Max
German 20c.
LEX

HEITER, Guillermo
Czechoslovakian/Venetian 1915-
H

HEITER, Michael M.
American 1883-
F,M

HEITER, William P.
Venezuelan mid 20c.
GR57

HEITLAND, Ludwig
German late 19c.
LEX,TB

L.H.

HEITLAND, Wilmot Emerton
American 1893-
B,F,H,I,IL,Y

**W
EMERTON
HEITLAND**

HEKKING, William M.
American 1885-
B,F,H,M

HELBIG, Erwin E.
American 1919-
CON

*Bud Helbig*CA

HELCK, Clarence Peter
American 1893-
F,FOR,H,IL,M,NG4/25,Y

HELCK

HELD, John, Jr.
American 1889-1958
ADV,CC,F,GMC,H,IL,M,PE,VO,Y

*John
Held Jr*

HELD, Klaus
German 20c.
POS

HELGU(E)RA, Leon
 American 20c.
 H,M

HÉLION, Jean
 French 1904–
 B,GMC,H,M

HELLÉ, André
 French 1871–
 B,M

HELLER, Bert
 German 1912–
 H,LEX,VO

HELLER, Helen West
 American 1872–1955
 F,H,M

HELLEU, Paul César
 French 1859–1927
 B,H,M,POS

HELLGREWE, Rudolf
 German 1860–
 B,M,TB

HELLINGER, Fritz
 Swiss mid 20c.
 GR53–61–67

HELLMUTH, Leonhard
 German 1859–
 LEX,TB

HELLSTERN, Max
 Swiss mid 20c.
 GR57

HELMICK, Howard
 American 1845–1907
 B,F,H,M

HELNWEIN, Gottfried
 Austrian late 20c.
 EI79,GR82

HELOK, C. Peter
 American 1893–
 B,F,M

HELWIG, Albert Mettee
 American 1891–
 F,H,M

HEMAN, Erwit
 Swiss 1876–
 B

HEMARD, Joseph
 French 1880–1961
 B,M,VO

HEMBERGER, Andreas Karl
 Austrian early 20c.
 LEX,POS

HEMBERGER, Armin Bismarck
 American 1896–
 F,M

HEMELMAN
 Dutch early 20c.
 CP

HEMING, Arthur Henry Howard
 Canadian 1870–1940
 B,F,H,I,M

HEMJIC, M.
 French early 20c.
 ADV,B

HENCKE, Albert
 American 1865–1936
 M

HENCKEL, Carl (Charles)
German 1862–
B,H

HENDERSON, David
American 20c.
M

HENDERSON, Doria
American 20c.
M

HENDERSON, J. J.
Canadian ac. 1881
H

HENDERSON, Marion
American 20c.
M

HENDLER, Sandra
American 20c.
GR82,P

HENDRICH, Antal
Hungarian 1878–
LEX,TB

HENDRICK, Fred
Dutch early 20c.
LEX

HENDRICKSON, David
American 1896–
H,IL,M

HENDRICKX, L. Henri
Flemish 1817–94
B,H

HENETTE, L.
French late 19c.
LEX

HENKE, Burnard Albert
American 1888–
B,F,M

HENKE, Erich
German mid 20c.
GR54-55-57

HENKEL, August
American 1880–
H,SH6/23

HENKEL, Carl
German 1862–
LEX,TB

HENKORA, Leo Augusta
Austrian/American 1893–
B,F,H,M

HENNEBERGER, Obert G.
American 1921–
H

HENNEMAN, Jeroen
Dutch late 20c.
B,GR82

HENNESSEY, Frank Charles
Canadian 1894-1941
H,M

HENNIG, Erich
German 1875–
B

HENNING, Albin
American 1886-1943
F,H,IL,M,Y

HENNING, Archibald Samuel
English ac. 1825-35
B,H

HENNING, Henrietta Hunt
American 1898–
H,M

HENNINGER, Joseph Morgan
American 1906–
H,M

HENNINGER, M. (probably Joseph Morgan)
American mid 20c.
ADV

M. Henninger

HENRI, Paolo
French 19/20c.
BI

Paolo Henri

HENRIKSEN, Sven
Danish early 20c.
LEX

HENRION, Armand Francois Joseph
Belgian 1875–
B,M,POS

HENRION, Frederick Henri K.
English 1914–
ADV,CP,GR52–53–54–56 thru 63–66,H,POS

HENRION

HENRY, E. Everett
American 1893–1961
IL,M,SH6/23

Everett Henry

HENRY, Edward Lamson
American 1841–1919
B,D,F,H,I,M

E.L.HENRY

HENRY, Edwin
American 20c.
IL,M

Edwin Henry

HENRY, Edwin Bean
American 1900–
M

HENRY, H. Raymond
American 1882–
H,poster:'Grand Canyon'-Union Pacific Canyon
Lodge tourist poster-early 20c.,*

H.RAYMOND HENRY.

HENRY, John R.
American 1945–
H

HENS, Robert
Belgian early 20c.
POS

HENSLEE, Jack
American 1942–
H

HENSLER, Ernst
German 1812–
LEX,TB

E.H.

HENSTRA, Friso
Dutch late 20c.
GR85

HENTZE, Herman Peter Gudmund
Danish 1875–
B,LEX,TB,VO

HÉRAUT-DUMAS, Jean Marcel
French 1920–
B

HERBENER, Peter
Swiss 1933–
B,GR57

HERBERT, Henry William
Anglo/American 1807–58
D

HERBERT, Robert Gaston
American 20c.
M

HERBERT, Tom
American late 20c.
GR82

HERBERT, William Beverley
Canadian 1916–
H

HERBIN, Auguste
French 1882–1960
B,DES,H,M,POS

herbin

HERBST, Frank C.
American ac. 1920s
F,H

HERDEG, Walter
Swiss 1908–
GR53–54–57,POS

HERDTLE, Richard
German 1866–
B,LEX,TB

R.H.

HERFIELD, Phyllis Anne
American 20c.
H

HERFORD, Oliver
Anglo/American 1863–1935
EC,F,H,M,PE,R,SN8/94 & 9/94

O.Herford.

HERGER, Edmund
German 1860–1907
B,LEX,TB

E.H.

HERING, Émile
American 1872–1916
CEN8/07,CO1/05,I,M

E.HERING.

HERING, George Edwards (Dewards?)
English 1805/06–79
B,H,M

HERKOMER, Herbert
English early 20c.
POS

HERKOMER, Hubert von
Welsh 1849–1914
B,BA,H,M

H.H'81

HERMANN, Otto
German late 19c.
LEX

HERMANN, Reinhard
German 19?/20c.?
LEX

HERMANN, Wilhelm
Austrian mid 20c.
LEX

HERMANN-PAUL
see
PAUL, René Georges Hermann

HERMANSEN, Charles
American 20c.
M

HERMANSEN, Fred
American 20c.
M

HERMLIN, T.
Swedish 19?/20c.?
LEX

HERMUS, Milou
Dutch late 20c.
GR82

HERNLUND, Ferdinand Carl
Swedish 1837–1902
B,LEX,TB

FH

HEROLD, Don
American 1889–1966
EC,F,H,I,M

DON Herold

HEROLD, Jacques
Romanian/French 1910–
B,H

HEROURARD, Mathilde Angeline
French early 20c.
B,GMC

HÉROUX, Bruno
German 1868–1944
B,LEX,TB,VO

Hé

HERRERO, Abelardo
Spanish 1936–
H

HERRERO, Lowell
American mid 20c.
GR 53–54–57

HERRFURTH, Oskar
German 1862–
B,LEX,TB

O.H.

HERRICK, Frederick Charles
English 1887–1970
CP,POS

HERRICK

HERRICK, Henry William
American 1824–1906
BAA,H,M

HERRING, Lee
American 1940–
CON

HERSCHBERG, Carl
American –1923
I

HERSCHEL, S.
German ac. late 19c.
LEX

HERSCHFIELD, Harry
American early 20c.
F

HERSHFIELD, Leo
see
HIRSCHFELD, Leo

HERTEL, Albert
German 1843–1912
B,H,M

HERTENBERGER, Fernand
French 1882–1970
B,VO

HERTER, Albert
American 1871–1950
F,H,HA 8/01,M

![clover flower mark] ALBERT HERTER

HERTERICH, Ludwig Ritter von
German 1856–1932
B,LEX,M,TB,VO

L.H.

HERTWIG, Max
German 1881–
LEX

HERVEY, Robert Morris
American 1913–
H

HERVIEU, Auguste (probably HERVIEUE,
Augustine Jean, French/English 1794–
English early 19c.
B,D,F,H,M

HERWEGEN MANINI, Veronika Maria
German 1851–
B,LEX,TB

∅∂

HERZBERG, Robert A.
American 1886–
F,H,M

HERZEL, Paul
German/American 1876–
F,H,I,M

HERZFELD, Helmut
see
HEARTFIELD, John

HERZMANOVSKY-ORLANDO, Fritz von
Austrian 1877–1954
EC,LEX

F.H.O.

HES, Willy
German early 20c.
LEX

HESELER, W.
German 20c.
LEX

HESS, Emil John
American 1913–
AA,H

HESS, Lowell Francis
American 1921–
H

HESS, Mark
American 1954–
AA,ADV,GR82–85

M·HESS

HESS, Paul
German 20c.
LEX

HESS, Richard
American late 20c.
ADV,CC,GR68–82–85

Hess

HESSE, Isa
Swiss 20c.
LEX

HESSING, Gustav
Austrian 1909–
LEX,VO

GH

HESSING, Valjean McCarty
American 1934–
H

HETLAND, Audun
Norwegian 1920–
GR55,H

HETTNER, Otto (Hermann Otto)
German 1875–1931
B,LEX,TB,VO

Ø

HEUBACH, Walther
German 1865–
B,LEX,M,TB

W.Hch.

HEUBNER, Friedrich (Fritz)
German 1886–1974
B,POS,TB,VO

FH

HEUBNER, Hermann Ludwig
German 1843–1915
B,H,LEX,TB

LH

HEUERMANN, Magda
American 1868–1966?
B,F,H,I,M

HEUGH, James
American 20c.
H,M

HEUMANN, Augustin
German 1885–1919
B,LEX,TB

HEUSS, Eduard van
German 1808–80
B,H,LEX,TB

E.H.

HEUSTIS, Louise Lyons
American 19/20c.
B,CEN5/01,F,H,M

Louise L Heustis

HEWERDINE, Matthew Bede
English 1871?-1909
H

HEWES, Agnes Danforth
American 20c.
M

HEWET (HEWETT), H. W.
American ac. mid 19c.
D

HEWISON, William
English mid 20c.
GR59-66-67

Hewison

HEWITT, Donald C.
American 1904-
H

HEWLINGS, Drew Malgrave
American 1915-
H,M

HEY, Paul
German 1867-1952
B,M,TB,VO

P.H.

HEYDE, Helen
English ac. early 20c.
STU1914,*

HH

HEYDEL, Paul Alexander
German 1854-
B,LEX,M,TB

HEYDT, Edna
American 1903-
H,M

HEYER, Arthur
Hungarian 1872-1931
B,LEX,TB

A.F.

HEYER, Herman
American 19/20c.
CO8/05,VC

O-O
O-O

HEYER, William
American 20c.
M

HEYLER, Mary Pemberton Ginther
American early 20c.
F,H

HIBBEN, Thomas
American 1893-
F,M

HICK, Grace Floyd
American 20c.
M

HICKEY, Frances
American 20c.
M

HICKEY, Patrick
Irish 1927-
'Contemporary Irish Art'-R. Knowles--Wolfhound
Press--Ireland 1982

HICKLIN, Barbara Roe
Canadian 1918-
H

HICKS, Arnold L.
American 20c.
M

HICKS, Bernice
American 20c.
M

HICKS, Herbert
American 1894-
B,F,H,M

HICKS, (Mrs.) Leslie A.
American 20c.
M

HICKSON, Wilma
 American 20c.
 M

HIDA, Keiko
 Japanese 1913–
 H

HIDDEMANN, Friedrich Peter
 German 1829–92
 B,BAA,H,LEX,M,TB

F. H.

HIDEO, Yamashita
 Japanese late 20c.
 GR82

HIDER, A. H.
 Canadian ac. 1889–98
 H

HIGASHI, Sandra
 American late 20c.
 GR82-84-85

HIGBY
 American 19/20c.
 R

Higby

HIGDON, Hal
 American 1931–
 H

HIGGONS, Cardwell S.
 American 1902–
 H

HIGHAM, Sydney
 English ac. 1890–1905
 H

HIGHT, Francis
 American 20c.
 M

HILBERT, Robert
 American mid 20c.
 PAP

HILDEBRANDT, Greg J.
 American 1939–
 Y

HILDEBRANDT, Tim A.
 American 1939–
 F,Y

HILDEBRANDT, William Albert, Jr.
 American 1917–
 H,M

HILDER, Edith
 American mid 20c.
 ADV

HILDER, G. Howard
 American 1868–1965
 B,H

HILDER, Rowland
 American 1905–
 M

HILE, Warren
 American late 20c.
 GR82

HILL, A.
 American ac. 1850s
 D

HILL, Albert J.
 Canadian ac. 1869–77
 H

HILL, Alice Stewart
 American 1850?–1921?
 H

HILL, Anna Gilman
 American 20c.
 M

HILL, Homer
 American 1917–69?
 H

HILL, James
 American mid 20c.
 PAP

HILL, James Jerome II
 American 1905–
 F,H,M

HILL, James Thomas
 Canadian 1930–
 GR80,H

HILL, Joan (Chea-Se-Quah)
 American 1930–
 H

HILL, L. Raven
see
RAVEN-HILL, Leonar

HILL, Mabel Betsey
American 1877-
F,M

HILL, Pearl L.
American 1884-
F,H,M

Pearl L.Hill

HILL, Robert Jerome
American 1878-
F,H,HA7/07,M

R.JeromeHill

HILL, Robert John
American 1891-
H

HILL, Tom
American late 20c.
CON

Tom Hill

HILL, Vernon
English 1887-
M,STU1910 & 1911

HILL, William S.
American 20c.
GR71?,M

HILLE, R.
German early 20c.
LEX

HILLER, Anita
American 20c.
M

HILLER, Lejaren A.
American 1880-
F,H,M

HILLER, Nelson
American 20c.
M

HILLMAN(N), Hans
German 1925-
CP,G,GR58 thru 67-69-70-83-84,POS

HILLMANN

HILSCHER, Hubert
Polish 20c.
GR57-58-59-69-74-75

HILTON, John William
American 1904-
H

John W Hilton

HIM, George
English 1900-
ADV,CP,GR52-56 thru 66-69,H,POS

him

HIMLER, Mary Martha
American 1889/90-
H,M

HINCHMAN, Margaretta S.
American -1955
F,H,M

HINCHY, Theresa
American 20c.
H,M

HINCZ, Gyula
Hungarian 1904-
B

HIND, Henry Youle
English 1823-61?
H

HINE-NO-TAIZAN
see
TAIZAN

HINES, Bob
American 20c.
H

HINGE, Mike
American 20c.
NV

mike hinge

HINKLE, Catherine
American 1926–
H

HINOJOSA, Albino R.
American 1943–
F,Y

HINTERMEISTER, Henry
American 1897–
B,F,H,M

H. Hintermeister

HINTON, Charles Louis
American 1869–1950
B,F,H,I,M

HINTON, W. H.
American early 20c.
PE

W H HINTON

HIROKATSU HIJIKATA
Japanese/American? 20c.
CP

HIROMOTO, Katsuichi
Japanese mid 20c.
GR60

HIROSHI OHCHI
Japanese 1908–
BI

HIRSCH, Gustav
German 1867–
B

HIRSCH, Jules
American 1907–
H,M

HIRSCH-RADO, Nelly
Hungarian/Austrian 1872–1915
B,TB

RN

HIRSCHBERG, Carl
German/American 1854–1923
B,F,I,M

HIRSCHBERGER, Robert
German mid 20c.
GR57 thru 60-63-65 thru 71

HIRSCHFELD, Albert
American 1903–
APP,CC,EC,F,GR78-83?-84,H,M,Y

HIRSCHFELD

HIRSCHFELD (HERSHFIELD), Leo
American early 20c.
CC,LEX

Leo Hershfield.33

HIRSHFIELD, Morris
American 1872–1946
B,GMC,H

M.HIRSHFIELD·1945

HIS, Andreas
Swiss mid 20c.
GR57

HITCHCOCK, David Howard
American 1861–1943
B,F,H,M

HITCHCOCK, De Witt C.
American ac. 1845–79
D

HITCHCOCK, George
American 1850–1913
B,F,H,I,M

G HITCHCOCK

HITCHCOCK, Lucius Wolcott
American 1868–1942
B,F,H,HA,IL,LEX,M,TB,VO

LUCIUS WOLCOTT HITCHCOCK

HITCHCOCK, Orra White
American 1796–1851?
D,H

HITTLE, Margaret A.
American 1886–
B,F,H,M

HJÖRTZBERG
Swedish early 20c.
POS

HJULER, Marie
Swiss 20c.
LEX

HLADKI
Polish early 20c.
POS

HLAVSA, Oldrich
Czechoslovakian 1909–
GR55-59-60-61-69,H

HLOZNIK, Vincent
Czechoslovakian 1919–
B,H

HO, Tien
Chinese/American 1951–
F,Y

HOARE, Constance
Canadian ac. 1888
H

HOBAN, Russell
American 1925–
IL

HOBAN

HOBBIE, Holly
American 1944–
F,Y

HOBBIE, Lucille
American 1915–
AA,H

HOBSON, Cecil J.
English ac. 1896–1914
B,H

HŌBUN, Kikuchi
Japanese 1862–1918
B,H,J

HOCKNEY, David
English 1937–
AA,ADV,B,BRP,GR81,H

HODAPP, Otto
German 1894–
LEX

HODÉ, Pierre
French 1889–1942
B,M

HODGES, C. Walter
English 20c.
M

HODGES, David
American 20c.
H

HODGINS, Frances
New Zealander 1868–1947
BRP,M

HODGSON, Daphne
American 20c.
H

HODGSON, William J.
English ac. 1878
H

HODLER, Ferdinand
Swiss 1853–1918
AN,B,DA,DES,GMC,H,LEX,M,PC,POS

HOEBER, Arthur
American 1854–1915
B,I,M

HOECKER, Hazel
American early 20c.
GMC,M

HOEFIG, Nancy
American late 20c.
GR79 thru 83

HOEFLICH, Sherman Clark
American 1913–
H,M

HÖEFNER-POENICKE, Eva
German 1923–
GR55-58

Ep

HOEFS, Karl Friedrich
German early 20c.
LEX

HOEK, Ries
Irish mid 20c.
GR61

HOEKSEMA, Daan
Dutch 1879–
BI

*DAAN
HOEKSEMA*

HOEPPNER, Hugo (Fidus)
German 1868–1948
AN,B,TB,VO

HOEPPNER, Oskar
Grman 1871–
B

HOERSCHELMANN, Rolf von
German 1885–1947
B,LEX,TB,VO

RH

HOESSLIN, Holger von
German 1919–
LEX

HOF (HOFF), H. M.
English mid 20c.
ADV,GR52 thru 56

HOFBAUER, Arnošt
Czechoslovakian 1869–
B,POS

Hofbauer

HÖFEL, Blasius
Austrian 1792–1863
B,H,LEX,TB

HÖFER, Adolf
German 1869–
B,LEX,TB

HOFER, André
French 20c.
B,M?

HOFER, Josef
Austrian 20c.
GR71,LEX

HOFER, Toni
Austrian 20c.
LEX

HOFF, Guy
American 1889–
F,M

HOFF, H. M.
see
HOF, H. M.

HOFF, Johann
Austrian early 20c.
POS

HOFF, K.
Danish mid 20c.
GR58-59

HOFF, Max
Austrian/English 1905–
GR57,H

HOFFMAN, Belle
American 1889–
B,F,H,M

HOFFMAN, Frank B.
American 1888–1958
H,IL,M

Hoffman

HOFFMAN, H. Lawrence
American -1976
PAP

hoffman

HOFFMAN, Harry Zee
American 1908-
F,H,M

HOFFMAN, Malvina
American 1887-1966
B,F,H,poster:'Serbia Needs Your Help'--
circa 1916,*

MALVINA HOFFMAN
1917

HOFFMAN, Martin Joseph
American 1935-
GR76,H,P,Playboy Mag. 2/84

HOFFMAN, Spencer Augustus
American 1902-
H,M

HOFFMAN VAN VESTERHOF (HOFFMANN VAN
VESTERHOF), August
German 1849-
B,TB

HOFFMANN, Anny
German? 20c.
LEX

HOFFMANN, Arnold, Jr.
American 1915-
H

Arvald Hoffmann Jr.

HOFFMANN, Felix
Swiss mid 20c.
GR58

HOFFMANN 59

HOFFMANN, Josef Franz Maria
Austrian 1870-1956
AN,CP,H,POS,TB

HOFFMANN, Robert
Austrian mid 20c.
LEX

HOFFMANN, Walter
Austrian 1906-
LEX

HOFFMANN-LEDERER, Hans
German 1899-
LEX,VO

HOFFMANN-ZEITZ, Ludwig
German 1832-95
LEX,TB

Hz

HOFFMASTER, Maud Miller
American 1886-
H,M

HOFFMEISTER, Adolf
Czechoslovakian 1902-
B,EC,H

HOFFMULLER, Hans
German 1888-1916
B

HOFFNUNG, Gerard
German/English 1925-59
EC,H

Hoffnung

HOFFSTÄDTEROVÁ, Olga
Yugoslavian 1922-
H

HOFMAN, Hans O.
American 1893-
F

HOFMAN, P. Alt.
Dutch early 20c.
POS

HOFMANN, Anton
German 1863-
LEX,TB

HOFMANN, Armin
Swiss 1920-
GR52-57 thru 60-61-63-65-70,H

HOFMANN, Godi
 Swiss mid 20c.
 GR 59-60

HOFMANN, Gottfried
 German 1894-
 LEX

HOFMANN, Hans
 German 1880-1966
 B,H,LEX

HH.

HOFMANN, Ludwig von
 German 1861-1945
 AN,B,H,M

HOFMÜLLER, Hans
 German 1888-1916
 B,LEX,TB

H.H.

HOGAN, Inez
 American 20c.
 M

HOGAN, Jamie
 American late 20c.
 GR 82

HOGAN, Jean
 American 20c.
 H,M

HOGAN, Thomas
 Irish/American 1839-1900?
 CWA,H

Thos. Hogan

HOGARTH, Burne
 American 1911-
 B,H

HOGARTH, Paul
 English 1917-
 GR 53-64-65-68-70-82-85,H

Paul HOGARTH

HOGEBOOM, Amy
 American 20c.
 M

HOGL, F.
 German ac. early 20c.
 LEX

HÖGNER, Franz
 German early 20c.
 LEX

HOGNER, Nils
 American 1893-1962
 H,M

NILS HOGNER

HOGROGIAN, Nonny
 American 1932-
 H

HOHENBERGER, Franz
 Austrian 1867-1941
 B,LEX,TB

HOHENSTEIN, Adolfo
 German 1854-
 B,CP,GA,M,POS

Hohenstein 98

HOHLWEIN, Ludwig
 German 1874-1949
 AD,ADV,AN,BI,CP,GMC,LEX,MM,POS,POST,
 TB,VO

LUDWIG HOHLWEIN //

HOHMANN, Heinz
 German 1879-
 B

HOHNER, John F.
 American 20c.
 H,M

HOHNHORST, Harry
 American 20c.
 H

HOKE, Martha
American 1861–1939
CWA?,M

HOKE, Robert A.
American 1910–
H

HOKINSON, Helen Edna
American 1893–1949
ADV,CAV,EC,H,M

HOKUBA, Teisai
Japanese 1771–1844
B,H,M

HOKUGA
Japanese early 19c.
B,H

HOKUTAI (Probably HOKUSAI, Katsushika,
Japanese 1760–1849)
AN,H,M,POST

HOLBERG, Richard A.
American 1889–
B,F,H,M

HOLBROOK, Peter
American 20c.
P

HOLBROOK, Ruth
American 20c.
M

HOLDANOWICZ, Leszek
Polish mid 20c.
GR 67–74,POS

HOLDEN, Lansing C.
American 20c.
M

HOLDEN, (The Misses) M. & E.
English 19/20c.
BK

HOLDEN, Raymond James
American 1901–
H,M

HOLE, William Brassey
English 1846–1917
B,BK,H,M

HOLEYWELL, Arnold C.
American 20c.
LEX

HOLFRETER, Jürgen
Chilean? mid 20c.
PG

HOLGATE, Edwin Headley
Canadian 1892–1977
H,M

HOLGATE, Jeanne
American 1920–
H

HOLIDAY, Henry James
English 1839–1927
B,H,M

HOLL, Frank (Francis) Montague
English 1845–88
B,BA,H,M,TB

HOLLAND, Brad
American 1944–
CC,EC,F,GR72 thru 85,P,PG,Y

HOLLANDER, Frederick J.
American mid 20c.
ADV

HOLLENSTEIN, Albert
French mid 20c.
GR61–63–68–69

HOLLERBACH, Serge
American 1923–
H,HA

HOLLEY, Robert Maurice
American 1913–
H,M

HOLLING, Holling C.
American ac. 1935-48
H,M

HOLLING, Lucille Webster
American 1900-
H,M

HOLLINGSHEAD, H. B.
Canadian ac. 1879
H

HOLLINGSWORTH, Alice Claire
American 1907-
F

HOLLINGSWORTH, Will (William R., Jr.)
American -1944
H,M

HOLLÓSY, Sim(e)on
Hungarian 1857-1918
B,H,M

HOLLOWAY, Charles Edward
English 1838-97
B,H,LEX,M,*

C.HOLLOWAY 1893 , Charles Holloway

HOLLOWAY, Edward Stratton
American 1859-1939
F,H,I,M

H

HOLLOWAY, Ida Holterhoff
American 19/20c.
F,H,M

HOLLY, Anton
Czechoslovakian 1915-
LEX,VO

HOLLY, Robert
American mid 20c.
PAP

HOLM, Adolf
German 1858-
B,LEX,TB

HOLM, Per Daniel
Swedish 1835-1903
B,LEX,TB

P.H.

HOLMAN, Bill (William)
American 1903-
CAV,H,M

BILL
HOLMAN

HOLMAN, Louis Arthur
Canadian/American 1866-1939
F,I,M

HOLME, Geoffrey
English 19/20c.
B,TB

G

HOLME, John Francis
American 1868-1904
B,H,I

HOLMES, Calvin Joseph
American 1910-
M

HOLMES, G.
English ac. 1786-99
H

HOLMES, George
Irish ac. 1789-1843
B,H,M

HOLMES, Margaret D.
Irish, Canadian/American -1939
H,M

HOLMES, Ralph
American 1876-1963
B,F,H,M,SO

RALPU UOLMES

HOLMES, William Henry
American 1846-1933
B,BAA,F,H,M

WHH

HOLMGREN, R. John
American 1897-1963
F,H,IL,M,Y

HOLM
GREN

HOLNSHURT, W. H.
 English 19c.
 LEX

HOLSNYDER
 French mid 20c.
 GR65

HOLST, Richard Nicolaas Roland
 Dutch 1868/69-1938
 AN,B,M,POS,TB

R.H.

HOLT, Charlotte Sinclaire
 American 1914-
 H

HOLT, Margaret
 American 20c.
 H,M

HOLT, Nell Inez
 American 20c.
 M

HOLT, Walter A.
 American 20c.
 M

HOLTAN, Gene
 American mid 20c.
 GR55-57 thru 63-66-67

HOLTON, Leonard T.
 American 1900-
 F,H,M,Y

HOLY, Miloslav
 Czechoslovakian 1897-
 B,H,LEX,M,VO

HOLZER, Adalbert
 German 1881-
 B,LEX,TB,VO

HOMAR, Gelabert Lorenzo
 Puerto Rican 1913-
 GR53-68,H

HOMER, Winslow
 American 1836-1910
 B,BAA,D,DA,F,GMC,H,M,PC,Y

HOMER

HONEGGER, Gottfried
 Swiss 1917-
 B,GR54 thru 58,H

HONEGGER-LAVATER, Warja
 Swiss mid 20c.
 B,GR52 thru 58-63

Warja Honegger

HONG, Joe Allen
 American late 20c.
 GR59-82

HONORÉ, Paul
 American 1885-
 B,F,H,M

HOOD, Dorothy
 American 1919-
 ADV,H

Hood.

HOOD, George Percy Jacomb
 English 1857-1929
 B,H,TB,VO

G.P.J.H.

HOOD, George Washington
 American 1869-
 B,H,M

HOOK, Frances A.
 American 1912-
 H

HOOK, Sandy
 English? early 20c.
 POS

HOOKER, Margaret Huntingdon
 American 1869-
 F,H,M

HOOKS, Mitchell Hillary
 American 1923-
 F,IL,PAP,Y

Mitchell Hooks

HOOPER, Annie Blakeslee
 American early 20c.
 B,F,H,M

HOOPER, Edward
 Canadian ac. 1863
 H

HOOPER, Elizabeth
 American 1901-
 F,H,M

HOOPER, Will Philipp
 American 1855-1938
 B,F,H,M,R

Hooper

HOOPES, Florence
 American 20c.
 M

HOOPES, Margaret
 American 20c.
 M

HOOPLE, William Clifford
 American 1893-
 F,H,M

HOOT, V. Z.
 American mid 20c.
 GR59

Hoot v. Z.

HOOVER, Charles
 American 1897-
 F,M

HOOVER, Ellison
 American 1888/90-1955
 CAV,EC,H,M,VO

ELLISON HOOVER.

HOOVER, (Mrs.) Louise Rochon
 American early 20c.
 F,M

HOPE
 see
 CHOUBRAC, Léon

HOPFMULLER, A. M.
 American early 20c.
 SH6/23

AM Hopfmuller

HOPKINS, Arthur
 English 1848-1930
 B,H,LEX,M

Arthur Hopkins

HOPKINS, Charles Benjamin
 American 1882-
 F,H,M

HOPKINS, Everard
 English 19c.
 B,TB

EH

HOPKINS, John Henry
 American 1792-1868
 D

HOPKINSON, Harold I.
 American 1918-
 H

HOPPER, Frank J.
 American 1924-
 H

HOPPER, Justine
 American 20c.
 H,M

HOPPER, Pegge
 American 1935-
 GR63-64,H

HOPPIN, Augustus
 American 1828-96
 B,D,EC,F,H,I,M,TB

H

HOPWOOD, William
English 1784–1853
B,M

HORACIO, German
Spanish early 20c.
POS

HORDINSKIJ, Swatislaw
Polish? early 20c.
LEX

HORDYK, Gerard
American 1899–
B,H,M

HORMEYER, Freddy
German early 20c.
POS

H.

HORN, Carl (Karl)
German 20c.
GR74

Hr

HORNBY, Lester George
American 1882–
B,F,H,I,STU1919

L·G·H·

HORNER, Arthur
German 20c.
LEX

HORNER, Blanche A.
American 1915–
H,M

HORNSTEIN, Karl
Austrian ac. early 20c.
LEX

HORNYANSKI, Nicholaus
Hungarian/Canadian 1896–1965
H,M

HORRABIN, James Francis
English 1884–1962
EC

HORSFALL, Robert Bruce
American 1869–1948
B,CEN1/05,F,H,I,M

BRUCE HORSFALL

HORSFELD, Friedrich
German 1809–81
B

HORST, P. Horst
American 20c.
ADV

HORSTIG, Eugen
German 1843–1901
B,LEX

HORSTMEYER, Wilhelm
German 1880–1901
B,LEX,TB

HORT, Hans Peter
Swiss?/German mid 20c.
GR52–53–57–70–72

HoRT

HORTALA, Ginette
French 20c.
LEX

HORTENS, Walter Hans
Austrian/American 1924–
F,Y

HORTER, Earle
American 1881–1940
APP,F,H,I,M,PC

E Horter

HORTON, L.
English mid 20c.
GR61

HORTON, William Thomas
English 1864–1919
AN,LEX,STU1899

William T. Horton.

HORVATH, Ferdinand Huszti
Hungarian/American 1891–
H,M

HÖRWARTER, Josef Eugen
 Austrian 1854–1925
 B,LEX,TB

HOSEMANN, Théodor (Frederick Wilhelm
 Théodor)
 German 1807–75
 B,EC,H,LEX,M,TB

18 FH 42

HOSKINS, Gayle Porter
 American 1887–1962
 F,H,M,VC,Y

Gayle HOSKINS

HOSOKAWA, Tokisa
 Japanese 20c.
 POS

HOSOYA, Awazu
 Japanese mid 20c.
 GR59

HOSOYA, Gan
 Japanese mid 20c.
 GR59–60–61–62

HOSOYA, Iwao
 Japanese 20c.
 POS

HOSTETTLER, Rudolf
 Swiss mid 20c.
 GR52–56

HOTOP, Gerhard M.
 German mid 20c.
 GR55–58–62–64–66–67–68

Hotop

HOTTENROTH, Friedrich
 German 1840–
 B,LEX,TB

HOTTINGER, William A.
 American 1890–
 F,H,M

HOTZ, Eugen
 Swiss mid 20c.
 GR52–54–57

HÖTZEL
 see
 BURGER, HÖTZEL & SCHLEMMER

HOUGHTON, Arthur Boyd
 English 1836–75
 B,BA,H,M

ABH

HOULIHAN, Raymond F.
 American 1923–
 IL

Ray Houlihan

HOUSE, James Charles, Jr.
 American 1902–
 F,H,M

HOUSEMAN, Edith Giffard
 English 20c.
 M

HOUSER, Alan C.
 American 1914/15–
 H,M

HOUSER, Lowell
 American 20c.
 H,M

HOUSMAN, Laurence
 English 1867–1959
 B,BK,M,TB

LH

HOUSTON, James Archibald
 Canadian 1921–
 H

HOUSTOUN, Donald Mackay
 Canadian 1916–
 H

HOUTHUYSE, David
 Dutch mid 20c.
 GR57–68–69

HOWARD, Alfred Harold
 Canadian 1854–1916
 H

HOWARD, Francis Gilman
 Anglo?/American? late 10c.
 M?,MUN8/97

FRANCIS GILMAN HOWARD

HOWARD, John Rowland Escoit
English 20c.
M

HOWARD, Justin H.
American ac. 1856-76
D

HOWARD, Katharine Lane
American -1929
M

HOWARD, Lucille
American 1885-
H

HOWARD, Oscar F.
American -1942
M,PE

HOWARD, Rob (possibly Robert Boardman
Howard)
American 20c.
H,M?

HOWARD, W. A.
Canadian 20c.
M

HOWARTH, F. M.
American -1908
B,I

HOWE (originally HAUTHALER), George
American 1896-1941
IL,M,Y

HOWE, Gertrude Herrick
American 1902-
H

HOWE, Katharine L. Mallett
American -1957
H

HOWE, Oscar
American 1915-
H

HOWELL, Elizabeth Ann Mitch
American 1932-
H

HOWELLS, Mildred
American 1872-
HA,I,M

HOWES, Alfred Loomis
American 1906-
H,M

HOWITT, John Newton
American 1885-1958
ADV,B,F,H,M

HOWS, John Augustus
American 1832-74
B,BAA,D,F,H,I,M

HOYLE, Annie Elizabeth
American 1851-1931
B,F,M

HOYNCK VAN PAPENDRECHT, J.
Dutch 1858-1933
B,STU1911,TB

HOYRUP, Paul
Danish 1909-
GR52-53-56,H

HOYT, Hettie J.
American 20c.
H,M

HOYTEMA, Theodor van
Dutch 1863-1917
AN,B,LEX,M,TB

HOZAN
Japanese ac. 1822-37
H

HRASTNIK, Franz
Austrian 20c.
LEX

HRUSCHKA, Degenhard
Austrian 1930-
LEX

HRUSCHKA, Richard
Latvian 1912–
LATV

HRUSCHKA

HRYNIEWICZ
Polish early 20c.
POS

HUARD, Charles
French 1874–1965
B,EC,GMC

[signature]

HUBACHER, Manfred
Swiss mid 20c.
GR53-54-56

M. HUBACHER

HUBBARD, Charles Daniel
American 1876–1951
B,F,H,M

HUBBARD, Sydney
American 20c.
M

HUBBELL, Henry Salem
American 1870–1949
B,CEN12/97,F,H,I,M

H.S. Hubbell—

HUBBELL, Stephen J.
American 1933–
CON

S.HUBBELL

HUBENTHAL, Karl Samuel
American 1917–
EC,H

[signature]

HUBER, Ernst
Austrian 1895–
B,LEX,TB,VO

HUBER, Josef Franz
German 1889–
LEX,VO

HUBER, Max
Swiss 1903–
GR54-56-60,LEX,POS,POST

HUBER-SULZEMOOS, Hans
German 1873–
B

H.H.S.

HUBERT, Alfred
Flemish 1830–1902
B,H

AH.

HUBERT, Edouard
French 1834–1923
B

HUBRECHT, Amalda Bramine Louise
Dutch 1855–1913
B

HUDEČEK, Stanislav
Czechoslovakian 1872–
LEX

HUDEMANN, Hildegard
German 1914–
LEX

HUDON, Normand
French/Canadian 1929–
EC

HUDSON, Grace Carpenter
American 1865–1937
B,F,H

HUDSON, Henriette
American 1862–
F,M

HUDSON, Simone M.
Canadian 20c.
H,M

HUELSENBECK, Richard
German early 20c.
B,POS

HUENS, Jean Leon
 Belgian 1921–
 F,Y

HUF, Karl Philip
 American 1887–1937
 F,H,M

HUF, Paul
 Dutch mid 20c.
 GR57–58

HUFFAKER, Sandy
 American 1943–
 F

HUFFER, Cornelia Cunningham
 American 1903–
 H

HUFFMAN, Tom
 American 1935–
 AA

HUGENDUBEL, Alfred
 German 1903–
 LEX,VO

HUGENTOBLER, Iwan E.
 German 1886–
 LEX,VO

J.E.H.

HUGHES, Alan
 American 20c.
 H

HUGHES, Arthur
 English 1832–1915
 B,BA,H

A.H.

HUGHES, Edward John
 Canadian 1913–
 B,H,M

HUGHES, George (E.?)
 American 1907–
 F,H,IL,M?,Y

Hughes

HUGHES, Roy V.
 American 1879–
 F,M

HUGHES-MARTIN, Agnes
 Irish/American 1898–1930
 F,M

HUGHES-STANTON, Blair Rowlands
 English 1902–
 M,PC,S

Blair HS

HUGO, Jean
 French 1894–
 B,DES,H,L,M

Jean Hugo

HUGO, Valentine
 French 1890/1900–1968
 B,H,M

HUGON, Roland
 French 20c.
 GR53,POS

HUGUEMIN, Paul
 Swiss 1870–
 B

HUGUET, Georges
 French 19?/20c.
 LEX

HULETT, Ralph
 American 1915–
 H

HULINGS, Clark
 American 20c.
 H,PAP

Hulings

HULL, A. G.
 American early 20c.
 NG3/19

A·G
Hull

HULL, Cathy
 American 1946-
 AA,GR73 thru 85

Cathy Hull

HULME, James Sanford
 American 1900-
 H,M

HULSE, Marion Jordan Gilmore
 American 20c.
 H

HULT, Harry
 American 20c.
 H

HUMBEECK, Pierre van
 Flemish 1891-
 B,H

HUMBERT, Albert
 French 1835-86
 B,EC

HUMER, Wilhelm
 Austrian 1897-
 LEX,TB

HUMMER, Lisl
 American 20c.
 M

HUMMERSTONE, Philip
 American 1905-
 M

HUMPHREY, David W.
 American 1872-
 F,H,M

HUMPHREY, Elizabeth B.
 American 1850?-
 F,I

HUMPHREY, S. L.
 American 1941-
 H

HUMPHREY, Walter Beach
 American 1892-
 H,M

HUMPHREYS, Henry Noël
 English 1810-79
 B,H,M

HUMPHRYS (HUMPHREYS), William
 Irish/American 1794-1865
 B,D,F,H,M

HUNT, Helen Zerbe
 American 1905-
 H,M

HUNT, Lynn Bogue
 1878-1960
 F,H,IL,M

LYNN
BOGUE
HUNT

HUNT, Una Clarke
 American 1876-
 F,H,M

HUNTER, David (C.?)
 Anglo?/American early 20c. (1846-1927??)
 M?,MM

HUNTER, Frances Tipton
 American 1896-1957?
 F,H,M

HUNTER, James Graham
 American 1901-
 CG10/34,H,LEX,M

GRAHAM
HUNTER 34

HUNTER (HUNTER-YOUNG or YOUNG-HUNTER),
 John Young
 Scots/American 1874-1955
 B,F,H,LEX,M

HUNTER, Robert Douglas
 American 1928-
 F,H

HUNTER, Samuel
 Canadian 1858/59-1939
 H,M

HUNZIKER, Max
Swiss 20c.
GR57-58,LEX,PC,VO

M H

HUPP, Otto
German 1859-1949
LEX,TB,VO

HURD, Clement
American 20c.
M

HURD, Peter
American 1904-
B,F,H,LEX,M,VO

P.HURD 1941

HURD, Zorah
American 1940-
H

HURFORD, John
English 20c.
CP

HURFORD, Miriam Story
American 1894/95-
H,M,WW3/34

MIRIAM STORY HURFORD

HURLEY, Edward Timothy
American 1869-1950
B,F,H,M

HURST, Earl Oliver
American 1895-1958
F,FOR,H,IL,M,Y

hurst

HURTER, Hans
Swiss mid 20c.
GR60

HURTT, Arthur R.
American 1861-
F,H,I,M

HUSKOWSKA, Hanna
Polish mid 20c.
GR58-59

HUSKOWSKA

HUSS, Gerd
English late 20c.
GR85

HUSSA, Theodore J.
American 20c.
M

HUSSAR, Laci
American 20c.
M

HUSSL, Alexander
Austrian 1912-
LEX

HUSTED, Mary Irving
American early 20c.
H,M

HUSZAR, Vilmos
Dutch 1884-
B,POS

HUTAF, August William
American 1879-1942
F,H,M

HUTCHINSON, Mary Elizabeth
American 1906/07-
H,M

HUTCHINSON, Milburn Robert
American 1917-
H

HUTCHINSON, Paula A.
American 1905-
H

HUTCHINSON, William M.
American 1906-
H

HUTCHISON, D. C.
 Scots/American 1869-1954
 B,H,HA6/07,TB

D.C.Hvtchison

HUTER, Otto
 German 1901-
 LEX

HUTSCHENREUTHER, Louis
 German 1841-1915
 LEX,TB

LH

HUTSON, Ethel
 American 1872-
 F,H,M

HUTT, Henry
 American 1875-1950
 F,H,IL,LEX,M

- HENRY - HUTT -

HUTTON, Hugh McMillen
 American 1897-
 H,M

HUYOT, Jean Marie Joseph
 French 1841-
 B,LEX,TB

HUYSHE, (Capt.) G. L.
 Canadian ac. 1870-71
 H

HUYSSEN, Roger
 American 1946-
 F,GR81,Y

HYAKUNEN, Suzuki
 Japanese 1823-91
 H,J

HYAKUREN
 see
 TESSAI, Tomioka

HYDE
 Canadian ac. 1882
 H

HYDE, Bill
 American mid 20c.
 GR57-62-63-65-66

HYDE, Helen
 American 1868-1919
 APP,B,H,M

HYDE, William
 English 19/20c.
 BK

WH

HYDEMAN, Sidney
 American 20c.
 M

HYLAND, Fred
 English ac. 1890s
 AN,GA

FRED HYLAND

HYMAN, Trina Schant
 American 1939-
 H

HYNCKES, Raoul
 Belgian 1893-
 B,GR65,H,M

HYNDMAN, Robert Stewart
 Canadian 1915-
 H,M

HYRCHENUK, Mary
 Canadian
 H

- I -

IACOVLEFF, Alexandre
 French 1887-1938
 B,F,M

IBAÑEZ, Genaro
 Bolivian early 20c.?
 LEX,VO

IBÁÑEZ, V.
 Spanish ac. early 20c.
 GMC

IBELS, Henri Gabriel
 French 1867-1936
 AN,B,EC,FS,GA,M,POS,POST

HG.Ibels

IBELS, Louise Catherine
French 1891–
B

IBERINO, Santos
Portuguese
H

IBLING, Miriam
American 1895–
H,M

ICART, Louis
French 1889–1950
AD,B,GMC,M

ICKE, Norman
English mid 20c.
GR58-59

ICKES, Paul A.
American 1895–
F,H,M

IFERT, Gérard
Swiss mid 20c.
GR57

IGARASHI, Takenobu
Japanese 20c.
GR75-77 thru 82-85,POS

IHNATOWICZ, Maria
Polish mid 20c.
GR65-68 thru 71

IHRIG, Clara Louise
American 1893–
F,H,M

IHRIG, Robert
Canadian 19/20c.?
H

IIRASEK, Anton
Austrian 19/20c.
LEX

IKEDA, Hatsuyuki
Japanese mid 20c.
GR64

IKKESAI, Yoshiki
Japanese late 19c.
POS

IKKO, Tanaka
Japanese mid 20c.
GR58

IL-CHER
French early 20c.
GMC

ILECKO, Ludovit
Yugoslavian 1910–
H

ILIGAN, Ralph W.
American 1894–1960
H,M

ILJIN, Nicolai Wassiljewitsch
Russian 1894–
LEX,VO

ILLE, Eduard
German 1823–1900
B,EC,H,TB

ILLIAN, George John
American 1894–1932
B,F,M

ILLINGSWORTH, Leslie Gilbert
American 20c.
CC,EC,M

ILLION
French? ac. early 20c.
posters:'Cardinal Mercier' & 'Koscuiszko
Pulawski' ,*

ILSLEY, Velma Elizabeth
 Canadian/American 1918–
 H

ILSTED, Peter, Vilhelm
 Danish 1861–1933
 B,M

IMAGE, Selvyn
 English 1849–1930
 B,LEX,MM,STU1899,VO

SJ

IMAMURA, Akihide
 Japanese mid 20c.
 GR64–69

IMAO KEINEN
 Japanese 1845–1924
 B,H,J

IMATAKE, Shichiro
 Japanese 1905–
 POS

IMAZU, Mokuto
 Japanese/American 1914–
 GR64–66

IMAZU

IMAZU, Seitaro
 Japanese mid 20c.
 GR54–57

IMBACH, Manfred
 Swiss mid 20c.
 GR54

IMBRIE, H.
 American ac. early 20c.
 CAV,LEX

H ·IMBRIE

IM-HO (Sol IMMERMAN, H. Lawrence
 HOFFMAN & Robert HOLLY)
 Americans early 20c.
 PAP

IMMEL, Paul J.
 American 1896–
 H,M

IMMERMAN, Sol
 American mid 20c.
 PAP

IMREY, Ferenc
 American 1885–
 H,M

IMRICH, Irving
 American 20c.
 M

INDEN, Hugo
 German/American 1901–
 H,M

INDIVIGLIA, Salvatore Joseph
 American 1919–
 H

INGERSOLL, Wyleys King
 American 1909–
 H,M

INGHAM, Elizabeth H.
 American early 20c.
 F,H

INGHAM, Thomas
 American 1942–
 AA,GR81–83

INGLES, Ronald
 English mid 20c.
 GR54–61

INGLESLY, Esther Hepler
 American 20c.
 M

INGLIS, Antoinette Clark
 American 1880–
 H,M

INGLIS, John J.
 Irish 1867–1946
 B,F,H,M,PUN6/37

JACK INGLIS

INGRAM, Herbert
 Anglo/Canadian ac. 1860
 GMC,H

INMAN, Henry
 American 1801/02–45/46
 B,BAA,F,H,M

INMAN, Pauline Winchester
American 1904–
H

INNES (INNIS), John
Canadian 1863–1941
H

INNESS, George, Jr.
American 1853/54–1926
B,BAA,F,H,I,M

Inness Jr

INNOCENT, Ferenc
Hungarian 1859–
B

INOKUMA, Genichiro
Japanese/American 1902–
B,GR58,H

INOUE, Mokuda
Japanese arly 20c.
POS

INOUYE, Carol
American 1940–
F,Y

INSAM, Ernst
Austrian mid 20c.
GR59–65

INVERARITY, Robert Bruce
American/Canadian 1909–
H,M

INWOOD, G. B.
American ac. 1920–40
PE

G.B.INWOOD

IORIO, Adrian J.
American 1879–1957
H,M

IPCAR, Dahlov
American 1917–
H,M

IREDELL, Russell
American 1889–1959
H,M

IRELAND, Geoffrey
English mid 20c.
GR53–61

IRELAND, John
English late 20c.
GR82

JOHN IRELAND

IRELAND, Richard William
American 1925–
H

IRELAND, William Addison
American 1880–1935
EC,F,H,M

IRIBE, Paul
French 1883–1935
AD,B,FS,GMC,POS

IRISH, Margaret Holmes
Canadian 1878–
H,M

IRMLER, Monika
German mid 20c.
GR64

IRO, George
Hungarian/Canadian 20c.?
H

IRSAI, Stefan
Hungarian early 20c.
POST

irsai

IRVIN, Fred Maddox
American 1914–
H

IRVIN, Rea
American 1881–1972
CAV,CC,EC,F,GMC,H,M

REA IRVIN

IRVIN, Robert
American 1928–
B,GR56,H

IRVINE, Sadie A. E.
American 1886–
H,M

IRVING, Constance
English ac. early 20c.
LEX

IRVING, Laurence
English 1897–
LEX,VO

IRWIN, Grace
American 20c.
M

IRWIN, Rea
see
IRVIN, Rea

IRWIN, Robert
see
IRVIN, Robert

IRWIN, Stewart
English mid 20c.
GR57

ISAACS, Barbara Shivitz
American 1936–
H

ISAACS, Betty Lewis
Australian/American 1894–1971
H,M

ISHII TSURUZO
Japanese 1887–
B,H

ISHIKAWA, Mitsutomo
Japanese mid 20c.
GR59

mitu.

ISHIKAWA, Natsuo
Japanese mid 20c.
GR54-55-57-59-61

ISHIOKA, Eiko
Japanese 1938–
GR67-76,POS

ISRAI, Stefan
Hungarian early 20c.
POS

ISSEN, Urakawa
Japanese
B

ITABASHI, Yoshio
Japanese mid 20c.
GR60

ITOH, (Ken) Kenji
Japanese 1915–
GMC(p1.416),GR54 thru 60-62-63-67,H,LEX,
POS,POST

KEN.

ITSCHNER, Karl
Swiss 1868–
B,LEX,TB,VO

ITTEN, Joseph
German early 20c.
POS

IVANOFF, Nicolai
Russian 1885–
B

IVANOWSKI, Sigismund
see
de IVANOWSKI, Sigismund

IVEKOVIČ, Otto
Yugoslavian 1870–
B,LEX,TB

Φ:

IVERD, Eugène
American 1893–1938
F,H,M

IVES, Norman
American mid 20c.
GR60-61-66

IVES, Sara Noble
American 19/20c.
I,M

IVORY, P. V. E.
American early 20c.
B,CEN12/09,F,M

P. V. E. IVORY

IWAMOTO, I.
Japanese mid 20c.
GR54

IWAMOTO, Morihiko
Japanese mid 20c.
GR58

IWATA, Kentaro
japanese 20c.
GMC

KENTARO

IZCUE, Elena
Peruvian 20c.
M

– J –

J. G.
American early 20c.
VC

J.G.

JACKLEY, F. Dano
American 1900–
H,M

JACKMAN, Reva
American 1892–
H,M

JACKSON, Annie Hulbert
American 1877–1956
F,H,M

JACKSON, Elbert McGran
American 20c.
M

JACKSON, Everett Gee
American 1900–
F,H,M

JACKSON, Frederick Hamilton
English 1848–1923
B,H,M

JACKSON, John Edwin
American 1876–1950?
B,F,H,I,M

JACKSON, Lee
American 1909–
H,M

JACKSON, Mason
English 1819–1903
B,LEX,M,TB

JACKSON, Robert Fuller
American 1875–
F,H,M

JACKSON, Vaughn Lyle
American 1920–
H

JACKSON, Virgil Vernon
American 1909–
H,M

JACKSON, William Henry
American 1843–1942
H,M

JACNO, Marcel
French 1904–
B,GR52–56–59–61–64,H

JACNO

JACOBI, Eli
Russian/American 1898–
H,M

JACOBS, Murray
American 20c.
LEX

JACOBS, Raymond
American mid 20c.
GR59–60

JACOBS, William Leroy
American 1864–1917
B,BAA,CO7/04,HA,I,M

JACOBSEN, Mme.
see
PLUMMER, Ethel McClellan

JACOBSON, William George
American mid 20c.
PAP

JACOBY, Helen E.
American
H

JACOMB-HOOD, G. P.
see
HOOD, G. P. J.

JACQUELIN, J.
French mid 20c.
GR57-61-63-66

J. JACQUELIN

JACQUEMART, Jules Fer(di)nand
French 1837-80
B,H,LEX,M,TB

JACQUEMON, Pierre
Franco/American 1935-36-
B,H

JA(C)QUES, Faith
English mid 20c.
GR53-54,H

Faith Jaqves

JACQUES, Robin
English 1920-
GR57,H

JACQUOT, Michel
French mid 20c.
POS

MICHEL JACQUOT

JADZEWSKI, Ernst
German 20c.
LEX

JAECKEL, Willy
German 1888-1944
B,H,POS

WJ

JAEGER, Bert
German mid 20c.
GR54-58-59-60

JAEGHER, Luc de
Belgian 20c.
LEX,VO

Đ

JAEHN, Hannes
German mid 20c.
GR59-60-63-64-65-67-68-71

JAENSCH, Paul
German ac. early 20c.
LEX

JAFFE, Sarah
American 20c.
M

JÄGER, Heinrich
German early 20c.
LEX

JÄGER, Josef
Bohemian 1883-
POS

H

JAGUARIBE, Sergio
Brazilian 1932-
H

JAHNASS, Ilse
German 20c.
LEX

JAKAČ, Bodežar (Bozidar)
Yugoslavian 1899-
B,LEX,TB

JAKOB, Felix
German 1900-
LEX

JAMAS, Abel
French 1862-
B,LEX,M

JAMES, Alice Archer Sewall
American 1870-
B,H,I,M

JAMES, Bill
American 1943-
AA

JAMES, Evalyn Gertrude
American 1898–
F,H

JAMES, Frederic (E.? Frederic)
American 1915–
H,M

JAMES, Gilbert
English 20c.
M

JAMES, R. F.
American 20c.
M,WW3/34

RF JAMES [signature]

JAMES, Roy Harrison
American 1889–
F

JAMES, Will (William Roderick)
Canadian/American 1892–1942
F,H,IL,M

WILL JAMES '28 [signature]

JAMESON, Arthur Edward
American 1872–
M,SCR2/02

ARTHUR E. JAMESON [signature]

JAMESON, Helen D.
American 20c.
M

JAMESON, Lionel B.
Canadian 1908?–
H

JAMESON, Samilla Love
see
HEINZMANN, S. L. J.

JAMIESON, Mitchell
American 1915–
F,H,LEX,M,Y

M. Jamieson [signature]

JAMPEL, Judith
Anglo/American 1944–
F,GR77,Y

JANCU (JANCO), Marcel
Romanian/Israeli 1895–
LEX

JANEČEK, Ota
Czechoslovakian 1919–
B,GR54-61-64-72,H

OJ [monogram]

JANELSINS, Veronica
Latvian/American 1910–
H

JANES, Phyllis
Canadian 1905–
H

JANEWAY, Hestermary
American 20c.
M

JANK (JANCK), Angelo
German 1868–1940
B,GMC,LEX,M,POS

Jank [signature]

JANK, Anton
Austrian 20c.
LEX

JANKO, Marcel
Swiss early 20c.
POS

JANOWSKI, Witold
Polish mid 20c.
BI,GR61-65-66-69-71

W. JANOWSKI [signature]

JANSON
Swedish early 20c.
POS

JANSON, Andrew Raymond
American 1900–
B,H

JANSON, Dorothy Plymouth
American 20c.
H,M

JANSSON, Acke
 Swedish mid 20c.
 GR56

JANTHUR, Richard
 German 1883-1956
 B,LEX,TB,VO

JANTYIK, Mathias
 Hungarian 1864-1903
 B,LEX,TB

JANUSZEWSKI, Zenon
 Polish mid 20c.
 GR65

JARDON, L. E.
 French 19/20c.
 B,poster:Marque de Frabrique Le
 Clement'--Clement & Co.--Societe des
 Velocipedes Clement--Paris 1896,*

JARONĚK, Bohumir
 Czechoslovakian 1866-1922
 B,LEX,TB

JARRETT, Marcia Lane
 English 1897-
 M

JARUSKA, Wilhelm
 Austrian 20c.
 LEX

JARVIS, Antonio J.
 American 1901-
 H,M

JARVIS, Donald Alvin
 Canadian 1923-
 H

JARVIS, M.
 American ac. 1865
 H

JASINSKI, Felix (Stanislas)
 Polish 1862-1901
 B,LEX,M,TB

JASORKA, Erich
 German 1909-
 LEX

JASPAR, Emile
 Belgian 19/20c.
 POS

JASPER, Wiltraud
 German 20c.
 G

JASTRAU, Viggo
 Danish 1857-1946
 B

JAUCH, Gustav
 Austrian 20c.
 LEX

JAUMANN, Rudolf Alfred
 German 1859-1923
 B,LEX,TB

JAUSLIN, Karl
 Swiss 1842-1904
 B,LEX

JAUSS, Anne Marie
 German/American 1907-
 H,HA

JAYNE, DeWitt Whistler
 American 1911-
 H,M

JEAN-HAFFEN, Yvonne
French early 20c.
B

JEAN SAINT PAUL
French 1897–
B

JEANBIN, Imprimerie Vve
French mid 20c.
GR54

JEANNIOT, Pierre Georges
Swiss/French 1843–1937
B,GMC,H,L,LEX,M,S,TB,VO

JEBB, Kathleen Mary
English 1878–
M

JEFFERSON, Robert Louis
American 20c.
H

JEFFREY, Charlotte
American 20c.
M

JEFFREYS, Charles William
Anglo/Canadian 1869–1951/52
H,M

JEGERLEHNER, Hans
Swiss 1906–
B,M

JĒGERS, Arvīds Reinholda
Latvian 1922–
LATV

JELINEK, Hans
Austrian/American 1910–
H

JELINEK, Jeng
German ac. early 20c.
LEX

JEMNE, Elsa Laubach
American 1888–
F,H,I,M

JEMÜLLER, Hans
German early 20c.
LEX

JENEY, N. Lajos
Hungarian 20c.
LEX

JENKINS, Burris, Jr.
American 18971966
H,M

JENKINS, Clayton Evans
American 1898–
H,M

JENKINS, Leonard Seweryn
Polish/American 1905–
H,M

JENKINS, Mattie Maud
American 1867–
F,H,M

JENNETT, Norman Ethre
American 1877–
H

JENNINGS, Rixford Upham
American 1906–
H,M

JENNINGS, Wilmer Angier
American 1910–
M

JENSEN, Carl
Danish 1851–1933
B,LEX,VO

JENSEN, Gustav B.?
American 20c.
M

JENSEN, Harald C.
American 1900–
H,M

JENSEN, John (John Paul?)
 American ? mid 20c.
 ADV,M

Jensen:

JENSENIUS, Herluf
 Danish 20c.
 M

JENTSCH, H. S.
 German 19/20c.
 LEX

JENTSCH, Hans Gabriel
 Germa 1862-
 LEX,TB

H.G.J.

JERNDORFF, August Andreas
 Danish 1846-1906
 B,H,SC

JEROME, Irene Elizabeth
 American 1858-
 F,H,I

JERVIS, Margaret
 American 20c.
 M

JESCHEK, Anton
 Austrian early 20c.
 LEX

JESSEL, Manon
 French 20c.
 LEX

JETTER, Frances
 American 1951-
 F,GR76-77-79 thru 85,Y

JETTMAR, Rudolf
 Austrian 1869-1939
 AN,B

CRJ

JEWELL, K. Austin
 American 1902-
 H,M

JEWETT, Thomas O. S.
 see
 JEWITT, T. O. S.

JEWETT, William Samuel Lyon
 American 1834-76
 D

JEWITT (JEWETT), Thomas Orlando Sheldon
 English 1795/99-1869
 B,H,M

JEX, Garnet W.
 American 1895-
 B,F,H,M

JICHOSAI (NICHOSAI)
 Japanese -1802, ac. 1780s
 B,H

JIMA, N.
 see
 NISHIJIMA, Isao

JIRINCOVA, Ludmilla
 Czechoslovakian mid 20c.
 GR64

JO, Leo
 see
 JORIS, Leontine

JOANNES, Gérard
 French 20c.
 POS

JOB (Jacques de BRÉVILLE)
 French 1858-1931
 B,LEX,TB

JOBLING, Robert
 English 1841-1923/26
 B,EN,H,LEX,TB

RJobling 1884

JOCHHEIM, Konrad
 German 1895-
 LEX,VO

JODKOWSKI, Tadeusz
 Polish 1925-
 GR56-70,H

JOEL, Robert
 French 1894-
 B

R.J.

JOELO
German? early 20c.
POS

JOFFE, Mark S.
Russian/American 1864-1941
H,M

JOHANNOT, Tony
French 1803-52
B,CP,H,M,POS

JOHANNSEN, Theodor
German 1868-
B

JOHANSEN, Anders Daniel
Danish/American 20c.
F,H,M

JOHN
Polish early 20c.
POS

JOHN, Charles V.
American 20c.
M

JOHN, Grace Spaulding
American 1890-1972
F,H,M

JOHN, Werner
Swiss mid 20c.
GR60

JOHNE, Arnhild
German late 20c.
GR78-80-82

JOHNSON, Andrew
English early 20c.
POS

JOHNSON, Arne
Swedish 20c.
LEX

JOHNSON, Arthur Aloysius
American 1898-
F

JOHNSON, Bill
American 1929-
IL

JOHNSON, Bruce Henderson
Canadian 1926-
H

JOHNSON, (C.) Everett
American 1866-
F,H,M

JOHNSON, Carol
American 20c.?
H

JOHNSON, Charles Howard
American ac. late 19c.
PE

JOHNSON, Clifton
American 1865-
I,M,R

JOHNSON, Crockett
American 1906-76
CAV,H

CROCKETT
JOHNSON

JOHNSON, Douglas
Canadian/American 1940-
F,GR78,Y

JOHNSON, E. V.
American mid 20c.
ADV

JOHNSON, Edvard Arthur
American 1911-
H

JOHNSON, Frank Tenney
American 1874-1939
B,F,H,I,M,SO

JOHNSON, George H. Ben
American 1888-
H,M

JOHNSON, Gigi Shaule
American 20c.
M

JOHNSON, Harvey William
 American 1921–
 CON,H

hw johnson &

JOHNSON, Helen Lessing
 American 1865–1946
 F,H,M

JOHNSON, Helen Sewell
 American 1906–
 F,H,M

JOHNSON, Herbert
 American 1878–1946
 CC,EC,F,H,M

Herbert Johnson

JOHNSON, Howard E.
 American 20c.
 M

JOHNSON, James Ralph
 American 1922–
 CON,H

JAMES RALPH JOHNSON

JOHNSON, John E.
 American 1929–
 H

JOHNSON, Leonard Lucas
 American 1940–
 H

JOHNSON, Lonnie Sue
 American late 20c.
 GR81 thru 85

JOHNSON, M. Martin
 American 1904–
 GR53,H

JOHNSON, Margaret
 American 1860–
 I,M

JOHNSON, Merle De Vore
 American 1874–1935
 F,H,I,M

JOHNSON, Michael
 French late 20c.
 EI79

JOHNSON, Milton
 American 1932–
 H

JOHNSON, Neola
 American early 20c.
 F,M

JOHNSON, Raymond
 American 1927?–
 B,H?,M,PAP

JOHNSON, Robert Edwin
 Canadian 1885–1933
 H

JOHNSON, Robert Ward
 American –1953
 B,H,M

JOHNSON, Scole
 American early 20c.
 LEX

JOHNSON, Selina Tetzlaff
 American 1906–
 H

JOHNSON, Stanley Quentin
 American 1939–
 CON

Stan Johnson

JOHNSON, William Aloysius
 English 1892–
 M

JOHNSON, William Martin
 American 1862–
 M

JOHNSTON, David Claypoole
 American 1797/99–1865/67
 B,CC,D,EC,F,H,M

JOHNSTON, Edith
 American 20c.
 M

JOHNSTON, Robert E.
 Canadian/American 1885–1933
 B,F,H,M

JOHNSTON, Ruth
American 1864–
F,H,M

JOHNSTONE, Will
American 20c.
F,M

JOLIMEAU, Serge
American 20c.
P

SERGE JOLIMEAU

JOLLEY, Donal Clark
American 1933–
CON,H

DONAL C. JOLLEY

JOLY, Louis
French 1808/10–
B

JONAS, Ilse
Austrian 20c.
LEX

JONAS, Robert
American 1907–
PAP

jonas

JONES, Alfred
Anglo/Canadian/American 1819–1900
BSA,F,H,M

JONES, Alfred Garth
English 1872–1930
ADV,B,BK,PC

JONES, Allan Dudley, Jr.
American 1914/15–
H,M

JONES, Amy (Frisbie)
American 1899–
H,M

Amy Jones
1936

JONES, Annie Weaver
American ac. 1915
B,M

JONES, Barbara
English mid 20c.
GR52–54–55

Barbara Jones

JONES, Bayard
American 1869–
F,M

JONES, Casey
American 20c.
PAP

casey jones

JONES, David E.
American 20c.
C

DE Jones

JONES, David Michael
Welsh/English 1895–1974
B,BRP,M

JONES, Dick
see
JONES, Richard

JONES, Douglas
English mid 20c.
GR65–67

JONES, Edward Sprague
American 20c.
HA,LEX

EJS

JONES, Elizabeth Orton
American 1910–
H,M

JONES, Garth
see
JONES, Alfred Garth

JONES, Harold
American 1904–
H

JONES, John L.
 American early 20c.
 H

JONES, Keith
 Welsh/American 1950-
 F

JONES, Lois Mailou (Pierre-Noel)
 American 1905/06-
 F,H,M

JONES, Marguerite Mignon
 American 1898-
 F

JONES, Richard (Dick)
 American 20c.
 GR54-55-57-59-63-74,M

JONES, Robert Edmond
 American 1887-
 M

JONES, Robert (J.?)
 American 1926-
 ADV,F,GR65-83,IL,Y

JONES, Seth C.
 American 1853-1930
 F,I,M

JONES, Susan Alice
 American 1897-
 B,F,H,M

JONES, T.
 English mid 20c.
 GR52

JONES, Trefor
 English 20c.
 M

JONES, Wilfred J.
 American 20c.
 M,S

JONG, Ernest de
 South African mid 20c.
 GR61

JONSON, James
 American 1928-
 F,Y

JOPLING, Frederic Waistell
 Canadian 1859/60-1945
 H

JORDAN, Barbara Schwinn
 American 1907-
 H

JORDAN, Dora
 German early 20c.
 LEX

JORDAN, Fred
 Brazilian mid 20c.
 GR57-59-66-72-77-80

JORDAN, Helen Adelia
 American 1903-
 H,M

JORDAN, James Blount
 American 1904-
 H,M

JORDAN, Joan
 Swiss mid 20c.
 GR54-56-57-59-60

JORDAN, Ludwig Heinrich Ernst Erdmann von
 German 1810-87
 B

JORDAN, Paula
 German early 20c.
 LEX

JORDAN, Rudolf
 German 1810-87
 B,H,LEX,M,TB

JORDAN, Wilhelm
 German 1871-
 B,TB

JORES, Léontine
 see
 JORIS, Léontine

JORGE, Maria Alice da Silva
Portuguese 1924–
H

JORGULESCO, Jonel
American 1904–
H

JORIS, Léontine
Belgian 1870–1962
GMC,MM

[signature: Leo Jo]

JORN, Asger
Danish 1914–73
DRAW,H,POS

[signature: Jorn.]

JORNS, Byron Charles
American 1898–1958
H

JOSEPH, Adelyn L.
American 1895–
F,H

JOSEPH, Herbert
Canadian/American 1887–1965
WS

[signature: JH monogram]

JOSEPH, Sydney
American 20c.
GMC,M

JOSLYN, Florence Brown
American 20c.
F,H,M

JOSSELIN de JONG, Pieter de
Dutch 1861–1906
B,LEX,TB

[signature: P.d.J.]

JOSSO, Camile
French 1902–
B

JOSSOT, Henri Gustave
French 1866–
AN,B,CP,FS,LEX,MM,POS,POST,TB

[signature: jossot 1903]

JOU, Louis (Luis)
Spanish/French 1882/1968
B,H,M,S,TB,VO

[signature: LJ monogram in box]

JOURDAIN, Al (Aljourdain)
French 1920–
B

JOURDAIN, Pierre Gaston
French 19c.
B

JOUVE, Paul Pierre
French 1880–1973
AD,B,M

[signature: Paul Jouve]

JOY, Nancy Grahame
Canadian 1920–
H

JOYNAS (JONYNAS), Vytautus Kazys
Lithuanian/American 1907–
H

JU, Ix Hsiung
Chinese/American 1923–
AA,F,H

JUCH, Ernst
Austrian 1838–1909
B,EC,M,TB

[signature: EJ monogram]

JUCKER, Sita
Swiss 20c.
GR55,H

JUDD, David (Giad)
English mid 20c.
GR54

JUGUINE, Léon
 Russian 1891–
 B

JUHÁSZ, Árpád
 Hungarian 1863–1914
 B,LEX,TB

JULIAN-DAMAZY, William
 French 19/20c.
 LEX

JULIEN, Octave Henri
 Canadian 1852–1908
 H,M

JULIO
 Portuguese
 H

JÚLIO, Gil
 Portuguese
 H

JULIUS, Victor
 American 1882–1939?
 F,LHJ4/05,M

V. H. JULIUS

JUMP, E.
 Canadian ac. 1871–73
 H

JUMP, Edward
 American 1838–83
 CC,EC,H

E. Jump

JUNCO, Pio
 American 20c.
 H

JUNCZ (JURCZ)
 Hungarian 19/20c.
 GMC

JUNDT, Gustave Adolphe
 French 1830–84
 B,H

JUNG, Moritz
 Czechoslovakian/Austrian 1885–1915
 AN,B

JUNGE, Carl Stephen
 American 1880–
 APP,F,GMC,H,I,M

Carl S. Junge

JUNGHANS, Hans V.
 German early 20c.
 LIL1932

H. Junghans

JUNGHANS, Julius Paul
 German 1876–1953
 B,LEX,M,MM,TB

JUNGQUIST, Neva Gertrude
 American –1930
 M

JUNGSTEDT, Sigurd
 Swedish early 20c.
 LEX

JUNIPER, David
 English late 20c.
 E179

JUNKERS, Aleksandrs Mikela
 Latvian 1899–
 LATV

AJ

JUNOD, Ila M.
 American 20c.
 H

JUNOT, Jean Paul
 French early 20c.
 POS

JURGENS, Helmut
 German 20c.
 POS

JURGIELEWICZ, Mieczyslaw
 Polish 1900–
 LEX,VO

JUSP
 see
 SPAHR, Jürg

JUSTICE, Marion T.
 American 20c.
 CG10/34,*

MARION T.JUSTICE·

JUSTICE, Martin
 American early 20c.
 F,M,R,Y

MARTIN JUSTICE

JUSTIS, Lyle
 American 1892–1960
 F,IL,M,PE,S,Y

LYLE
JUSTIS
1930

JUSTUS, Roy Braxton
 American 1901–
 H,M

– K –

KAAE, Hans
 Danish mid 20c.
 GR64

Kaae

KAAN-ALBEST, Julius von
 German 1874–
 B

J.K.

KABELKA, Konrad
 Austrian 20c.
 LEX

KABOTIE, Fred
 American 1900–
 H,M

KÄCH, Walter
 Swiss 1901–70
 POS

KACZMARCZYK, Josef
 Polish 20c.
 LEX

KADLETZ, Willi
 Austrian 1895–
 B,LEX,TB

KAEMMERER, Frederik Henderik
 Flemish/French 1839–1902
 B,H,L,M

F.H KAEMMERER·

KAEPPELIN, Olivier
 French 20c.
 B

KAETSU, Utako
 Japanese mid 20c.
 GR64

KÄGE, Wilhelm
 Swedish 1889–
 POS,STU1919

WK

KAHLICH, Karl Hermann
 German/American 1890–
 H,M

KAHN, Joan
 American 20c.
 M

KAHN, Judith Pesmen
 American 1920–
 H

KAINER, Ludwig
 German 1885–
 AD,GR77,M,TB,VO

[signature]

KAINRADL, Leo
 German/Austrian early 20c.
 POS

[monogram]

KAISER, August
 American 1889–
 F

KAISER, Charles James
 American 1893–
 F,GMC,H,M

KAISER, Johann Wilhelm
 Dutch 1813–1900
 B,LEX,TB

[signature]

KAISER, Josef Maria
 Austrian 1824–
 LEX,TB

KAISER, Ri
 West German late 20c.
 EI79,GR85

KAISER, Richard
 German 1868–1941
 B,LEX,TB,VO

KAJA
 see
 ZBIGNIEW, Kaja

KAJLICH, Aurel
 Yugoslavian 1901–
 H

KALAB, Frantisek
 Czechoslovakian 1908–50
 B,H

KALAK, Theresa
 American 20c.
 M

KALAS, Ernest
 French 1861–
 B,LEX,TB

[signature]

KALCKREUTH, Gräfin Christine Sophie Gertrud
 German 1898–
 B,LEX

KALCKREUTH, Jo von
 German 1912–
 LEX,VO

KALCKREUTH, (Count) Karl Walter Leopold de
 German 1885–1928
 AN,B,H,M,TB

[signature: LK]

KALCKREUTH, Leopold Karl Walter Graf von
 see
 KALCKREUTH, (Count) Karl Walter Leopold de

KALDERON, A.
 Israeli mid 20c.
 GR65–66

KALIN, Victor
 American 1919–
 IL,PAP

[signature: Victor Kalin]

KĀLIS, Ernests
 Latvian 20c.
 LATV

KALLIS, Al
 American mid 20c.
 GR56

KALLMORGEN, Friedrich
 German 1856–1924
 B,LEX,M,TB

KALLOCH, Robert
American early 20c
VC

Kalloch

KALMENOFF, Matthew
American 1905–
H

KALNINS, Eduards
Latvian 1904–
B,LATV

*Ed, Kalnins
–46–*

KALOUSEK, Jiri
Czechoslovakian mid 20c.
GR65–66

KALTENBACH, Lucille
South African/American 20c.
B,F,M

KALVODA, Alois
Czechoslovakian 1875–1934
B,LEX,TB,VO

KAMATA, Teruho
Japanese mid 20c.
GR61

KAMATA, Zao
Japanese mid 20c.
GR59–60

KAMA

KAMEKURA, Yusaka
Japanese 1915–
CP,GR53–54–56–57–58–60–62 thru
66–68–74–75–77–78–79,H,LEX,POS

Kame.

KAMEN, Gloria
American 1923–
H

KAMENY, Aaron
Polish/American 1908–
H,M

KAMINSKY, Dora Deborah
American 1909–
H

KAMMULLER, Paul
Swiss 1885–
B,LEX,TB,VO

PK

KAMPEN, Michael Edwin
American 1939–
H

KAMPEN, Owen
American mid 20c.
PAP

KAMPMANN, Walter
German early 20c.
CP,POS

KAMPMANN

KAMPS, Jupp
German 1911–
LEX

KANDAUROV, Otarri Zakharovich
Russian 1937–
RS

KANDINSKY, Wassily
Russian 1866–1944
AN,APP,B,CP,DA,DES,DRA,H,M,MM,PC

Kandinsky

KANDO, Jules
Hungarian early 20c.
POS

KANE, Morgan
American 1916–
IL

MORGAN KANE

KANE, Theodorea
American 1906–
H,M

KANEDA, Koichi
 Japanese mid 20c.
 GR 64

KANEVSKII, Aminadav Moiseevich
 Russian 1898-
 EC

KANNENBERG, Richard
 German 1888-
 LEX,TB

KANOLDT, Edmund Friedrich
 German 1839-1907
 B,LEX,M,TB

KANTOR, Leonard
 American 20c.
 H

KAPEO, Jack
 American mid 20c.
 ADV

KAPITZKI, Herbert W.
 German 20c.
 GR 64-65,POS

Herbert W. Kapitzki

KAPPEL, Philip
 American 1901-
 B,F,H,M

KAPPEL, R. Rose (Gould)
 American 1910-
 F,H,M

KAPPES, Werner
 American late 20c.
 GR 82

GW.Kappes

KARÁCZONY, Ferencz
 Hungarian 20c.
 LEX

KARAKASHEV, V.
 Russian 20c.
 PG

KARASIN, Nikolaj Nikolajewisch
 Russian 1842-1908
 B,LEX,TB

KARASZ, Ilonka
 Hungarian/American 1896-
 F,H,M

KARCHER, Wilson
 American? early 20c.
 VC

WILSON KARCHER

KARCHIN, Steve
 American 1953-
 F,Y

KARGER, Carl
 Austrian 1848/49-1913
 B,H,LEX,TB

CK

KARI
 see
 SUOMALAINEN, Kari Yrjana

KARL, J.
 American 20c.
 M

KARL, Jules
 American mid 20c.
 PAP

KARLIN, Eugene
 American 1918-
 F,GR 66-67-69-72-73-75-77-83,H,M,Y

E Karlin

KARO
 see
 DUNIN-BRZEZINSKI, Jerzy

KAROLIS, Adolfo de
 Italian 1874-1928
 AN,B,H,M,S

A·D·K

KAROLSKA, Jerzego
 Polish 20c.
 LEX

KARPELÈS, Andree
 French 1885-
 B

KARPELLUS, Adolf
 Austrian 1869-1919
 B,CP,POS

KARPENKO, Mihails Mihaila
 Latvian 1915-
 LATV

MK.

KARSCH, Rudolf
 Austrian 1902-
 LEX

KASHIWAGI, Isami
 American 1925-
 H

KASIMIR, Alois
 Austrian late 19c.
 LEX,TB

AK

KAŠPAR, Adolf
 German 1877-1934
 LEX,TB

KAŠPAR, Ladislav
 Czechoslovakian 20c.
 LEX

KASS, János
 Hungarian 1927-
 B,H,POST

KASSER, Helen
 Swiss mid 20c.
 GR61

KASTEL, Roger K.
 American 1931-
 F,Y

KATAYAMA, Toshihiro
 Japanese/American 1928-
 GR60-61-62-66-68,H

KATES, Herbert S.
 American 1894-
 F,H

KATO, Kay
 Hungarian/American 20c.
 H

KATSU
 see
 YOSHIDA, Katsu

KATSUI, Mitsuo
 Japanese mid 20c.
 GR61-63-81

KATZ, Ethel
 American 1900-
 H,M

KATZ, Joel
 American late 20c.
 GR71-73-75-82

KATZ, Les
 American 20c.
 GR79,NV

LES KATZ 810

KATZLER, Vincenz
 Austrian 1823-82
 B,LEX,TB

KATZOURAKI, Agni Eleni
 Greek mid 20c.
 GR64-67-68-69

KATZOURAKIS, Michael
 Greek mid 20c.
 GR63-64-67-68,POST

KAUFFER, Edward McKnight
 American/English 1890-1954
 AD,ADV,BRP,CP,H,LEX,M,MM,PAP,POS,POST,
 STU1924

EMcKnight Kauffer.

KAUFFMANN, Hugo Wilhelm
 German 1844-1915
 B,H,LEX,M,TB

Hugo Kauffmann

KAUFFMANN, Paul Adolphe
French 1849–
B,TB

P.K.

KAUFFMANN, Robert C.
American 1893–
F,H,M

KAUFMAN, Ithac
Israeli mid 20c.
GR58

KAUFMAN, Joe
American 1911–
H

KAUFMAN, Stuart
American 1926–
H

KAUFMAN, Van
American mid 20c.
PAP

van

KAUFMANN, Hans
German 1862–
LEX,TB

KAUFMANN, John
American 1931–
H

KAUFMANN, Joseph Clemens
Swiss 1867–
B,LEX,TB

KAULBACH, Friedrich August von
German 1850–1920
B,BAA,H,LEX,M,TB

FAKaulbach

KAULBACH, Wilhelm von
German 1805–74
B,EC,H

W.K.

KAUS, Max
German 1891–
B,H,M,TB,VO

MK

KAUSCHE, Eva
German mid 20c.
GR53

KAUSCHE, Martin
German mid 20c.
GR52–53

KAUSCHE-KONGSBAK, Eva
German 1918–
LEX

KAUTEN, Mat
American 20c.
GMC

Mat
Kauten

KAWALEROWICZ, Marzena
American 20c.
GMC,P

KAWAMURA, Yunosuke
Japanese 20c.
POS

KAY
see
KRASNITZKY, Otto

KAY, Gertrude Alice
American 1884–
F,GMC,H,I,M,WW2/34

KAYAMA, Shirô
Japanese 1900–
H

KAYE, J. Graham
American 20c.
H,M

KAYSER, Louise Darmstaedter
American 1899–
H

KAZAR, Vasile
 Romanian 20c.
 LEX

KAZUMASA, Nagai
 Japanese mid 20c.
 B,GR58

KEANE, Lucina Mabel
 American 1904–
 H

KEARFOTT, Robert Ryland
 American 1890–
 H,M

KEATS, Ezra Jack
 American 1916–
 F,H

KEEFE, Dan
 American mid 20c.
 GR54,H

KEEL, Daniel
 Swiss mid 20c.
 GR57

KEELER, Katherine Southwick
 see
 KELLER, Katherine Southwick

KEELING, Cecil Frank
 English 1912–
 GR52 thru 55-57-59,H

Cecil Keeling

KEELY, Patrick
 English early 20c.
 GR54-61,POS,POST

Pat Keely 42

KEENE, Charles Samuel
 English 1823/29-91
 B,CAV,EC,GMC,H,M,PC

[monogram in box]

KEEP, Helen Elizabeth
 American 1868–
 F,H,M

KEEP, Virginia
 American 20c.
 M

KEEPING, Charles
 English 1924–
 H

KEES VAN DONGEN, Cornelius
 see
 DONGEN, Kees van

KEETMAN, Peter
 Swiss mid 20c.
 GR61

KEGG, George W.
 American 1884–
 H,M

KEHRER, F. A.
 American early 20c.
 F

KEICH, Gideon (Gidi?)
 Israeli 1923–
 GR56-74,H,POS,POST

KEIICHI, Tanaami
 Japanese 20c.
 CP

KEIL, Alfredo
 Portuguese 1850-1907
 B,H

KEIL, August
 Austrian 20c.
 LEX

KE(I)LFKENS, C. J.
 Dutch mid 20c.
 GR52-53-56-57-61-63

Kelfkens

KEIMEL, Hermann
 German early 20c.
 B,POS

keimel

KEISER, César
 Swiss mid 20c.
 GR58-59

KEISTER, Roy Chester
 American 1886-
 F,H,M

KEITH, Dora (Wheeler)
 American 1856-1940
 B,F,H,I,M

KEITH, Eros
 American 1942-
 H

KEITH, Lawrence Augustus Holton
 American 1892-
 H,M

KEITH, William
 American 1839-1911
 B,DA,F,H,I,M

KELLEN, David van der
 Dutch 1843-
 LEX,TB

KELLER, Arthur Ignatius
 American 1866-1924/25
 B,F,H,IL,M,Y

KELLER, Ernst
 Swiss 1891-
 GR53-57-69,H,LEX,POS,POST

KELLER, Ferdinand
 German 1842-1922
 B,H,M,LEX,TB

KELLER, Karl E.
 Swiss mid 20c.
 GR61

KELLER (KEELER), Katherine Southwick
 American 20c.
 H,M

KELLER, Lew
 American mid 20c.
 PAP

KELLER, Roswell
 American mid 20c.
 PAP

KELLER-LEUZINGER, Franz
 German 1835-90
 B,LEX,TB

KELLERER, Max
 German 1905-
 GR61

KELLEY, Eldon
 American 20c.
 CAV,M

KELLEY, Gary R.
 American 1945-
 F,GR85,Y

KELLOGG, Edmond Philo
 American 1879-
 F,H,M

KELLOGG, Janet Reid
 American 1894-
 F,H,M

KELLY, Alton
 American 20c.
 POS

KELLY, Grace Veronica
American 1884–
F,H,M

KELLY, James Anthony
American 20c.
H

KELLY, James Edward
American 1855–1933
B,F,H,I,M

KELLY, John David
Canadian 1862–1958
H

J.D.KELLY.98

KELLY, Paul Gregory
American 1908–
H,M

KELLY, Richard Barret Talbat
English 1896–1971
B,H,M

R. Talbat Kelly.

KELLY, Walt
American 1913–
H

KELMAN, Benjamin
Romanian/American 1887/90–
F,H,M

KELTING, Marie
Dutch 1886–
LEX,VO

MK·

KELTON, P. S.
Canadian ac. 19c.
H

KELWIG-STRELL, Reinhard
German 20c.
LEX

KEMBLE, Edward Windsor
American 1861–1933
B,CAV,CC,EC,F,GMC,H,I,IL,M,PE,R,Y

Kembll

KEMP, Oliver
American 1887–1934
B,CO7/04,F,H,M,SCR12/11

Oliver Kemp.

KEMPE, Roland
Swedish 1907–
B

KEMPER, Ruby Webb
American 1883–
F,H,M

KEMPERS, Mart
Dutch 1924–
GR52–54–55–58–60–62–64–76,H

Mart Kempers

KEMPF-HARTENKAMPF, Gottlieb Theodor
Austrian 1871–
B,LEX,TB,VO

GK.

KEMPSTER, William
English mid 20c.
GR56–62

KEN
see
ITOH, Kenji

KENDAL(L), Elizabeth
American 1896–
F,H

KENDERDINE, Augustus Frederick
Canadian 1870–1947
H,M

KENDRICK, C.
Canadian ac. 1872–73
H

KENDRICK(S), Charles
American 1841–1914
CWA,EC,I,M

KENLY, Henry Parson
American 20c.
M

KENNEDY, Joseph
 Canadian 1945–
 H

KENNER, Anton Ritter von
 Czechoslovakian 1871–1951
 B,TB

KENNY, John A.
 American 20c.
 H

KENNY, Patrick Gerald
 American 1912–
 H

KENT, Frank Ward
 American 1912–77
 H

KENT, Jack
 American 1920–
 H

KENT, Norman
 American 1903–72
 H,M,VO

KENT, Rockwell
 American 1882–1971
 APP,B,F,GMC,H,I,IL,LEX,M,PAP,PC,PE,Y

Rockwell Kent

KENTARO
 see
 IWATA, Kentaro

KENYON, Ley
 English 20c.
 LEX

KENYON, Norman
 American 1901–
 H

KENZLER, C.
 German 20c.
 M

KEOGH, Brian
 English mid 20c.
 GR57–64

Keogh

KEPLINGER, Hans
 Austrian mid 20c.
 GR56–59–60

KEPPLER, Joseph
 Austrian/American 1838–90/94
 CC,EC,F,GMC,M,PG,TB,Y

J. KEPPLER

KEPPLER, Richard Ernest
 German 1851–
 B,TB

R.E.K.

KER, William Balfour
 American ac. 1904
 M

KERIGAN, Mildred Anderson Post
 American 1892–1921
 I,M

KERNAN, Joseph F.
 American 1878–
 F,H,M

KERNS, Fannie M.
 American early 20c.
 F,H,M

KERR, Estelle Muriel
 Canadian 1879–
 H,M

KERR, George F.
 American 19/20c.
 CO8/05,F,H,M

KERR

KERR, Illingworth Holey
 Canadian 1905–
 H

KERSWILL, J. W. Roy
Anglo/American 1925–
CON,F,H

KESLER, Clara Elise
American 1910–
H,M

KESSELL, Mary
English mid 20c.
GR65

KESSLER, Franz
Austrian 20c.
LEX

KESSLER, Leonard H.
American 1921–
H

KESZTHFLYI, Alexander Samuel
Hungarian/American 1874–
B,H,M

KETTEN, Maurice Prosper Fiorino
American 1875–
B,F,H,M

KEULEMANS, J. G.
Dutch late 20c.
LEX

KEULEN, Jan van
Dutch mid 20c.
GR54–55,LEX

∨k

KEUNE, Heinz
German? early 20c.
LEX,TB

⊘

KEUPING, Victor L.
American 1903–
H,M

KEY, Alexander
American 20c.
M

AK_

KEY, John Ross
American 1832–1920
B,DA,F,H,I,M,SO

John Ross Key

KEY, Julian
see
KEYMOLEN, Julian

KEY, Theodore
American 1912–
EC,H,M

Ted Key

KEY SATO (SATO, Key)
Japanese 20c.
H,LEX

KEYMOLEN (KEY), Julian
Belgian 1930–
GR57–65 thru 68–70,H,POS

Julian Key

KEYS, Harry J.
American early 20c.
F

KEZER, Karel
German/American mid 20c.
GR52–53–57

KHAMBATTA, N. K.
Indian mid 20c.
GR60

KHIZHINSKY, Leonid Semyonovich
Russian 1896–
B,H,S

KHNOPFF, Fernand
Belgian 1858–1921
AN,B,CP,GMC,H

·FERNAND KHNOPFF·

KHO LIANG IE
Dutch mid 20c.
GR59

KIDD, Steven R.
American 1911–
F,H,IL,Y

KIDD

KIDDELL-MONROE, Jaon
English 1908–
H

K.M.

KIDDER, Harvey W.
American 1918–
F,PAP,Y

Kidder

KIDDER, Jack
Canadian 20c.
H

KIECKENS, Fritz
Belgian early 20c.
POS

KIENER, Josef
Austrian 1856–1918
B,LEX

JK.

KIESER, Gunther
German 1930–
GR54 thru 62-65 thru 72-75,POS

kieser

KIESLING, Ernst
German 1851–1929
B,LEX,TB,VO

KIESSLING, Heinz
German mid 20c.
GR55-56

KIESSLING

KIFFER, Charles
French 1902–
B,POS

chKiffer

KIHN, William (or Wilfred) Langdon
American 1898–1957
B,F,H,M

KIHO
Japanese 1778–1852
H

KIKUTI, Akira
Japanese mid 20c.
GR53

KILBURN
Canadian ac. 1855–60
H

KILLAM, (Walt) Walter Milton
American 1907–79
B,H,M,PAP

KILM, Wilfred
see
KIHN, William Langdon

KILMER, David L.
American 1950–
F,Y

KILVERT, Benjamin Sayre Cory
American 1881–1946
CEN10/05,EC,F,H,M,Y

–B–CORY KILVERT–
–1 9 0 5–

KIMBALL, Alonzo Myron
American 1874–1923
B,F,I,M,SCR5/08

ALONZO · KIMBALL

KIMBALL, Katherine
American 19?/20c.
B,F,H,I,M

KIMBROUGH, Frank Richmond
American –1902
B,I,M

KIMMEL, Lou
 American 1905/08-73
 F,H,M,PAP,Y

Kimmel

KIMURA, Masahiko
 Japanese late 20c.
 GR85

KIMURA, Sueko M.
 American 1912-
 F,H

KIMURA, Tomoyoshi
 Japanese mid 20c.
 GR57

KINDBORG, Johann Ludwig
 Swedish 1861-1907
 B,LEX,TB

iK

KINDEREN, Antoon Johan der
 Dutch 1859-1925
 AN

KINERT, Reed C.
 American 1912-
 H,M

KING, Alexander
 American 20c.
 M,S

KING, Francis Scott
 American 1850-1913
 B,CEN3/99,F,M

F.S. KING

KING, Frederic Leonard
 American 1879-
 B,F,H,M

KING, George A.
 American 20c.
 M

Geo.A.King 08

KING, George B.
 American ac. early 19c.
 F

KING, Gunning
 English 19c.
 B

KING, Hamilton
 American 1871-1952
 B,F,GMC,H,M,MUN6/03

Hamilton King

KING, Henri Umbaji
 American 1923-
 H

KING, Henrietta M.
 American 20c.
 B,M

KING, (Mrs.) Jessie Marion (Taylor)
 English 1875-1949
 AN,B,H,M,MM,STU1922,TB

JESSIE·M·KING

KING, Joe
 American 20c.
 M

KING, Mary Louise
 American 1907-39
 H,M

KING, Ruth
 American 19/20c.
 H,M

KING, Sydney
 English mid 20c.
 GR59-61-62-66

Sydney King

KING, Warren Thomas
 American 1916-
 H,PAP

KING, William J., Jr.
 American 1909-
 H,M

KING, William Ross
Canadian ac. 1822-66
H

KING, Wyncie
American 1884-
B,F,H,I,N

KINGHAN, Charles Ross
American 1895-
H,M

KINGMAN, Dong M.
American 1911-
F,H,M

KINGSLEY, Rose
English 1845-1925
H

KINNEY, Margaret West
American 1872-
F,H,I,M

KINNEY, Troy
American 1871-1938
B,F,H,I,M

KINNINGER, Edith
German 20c.
LEX

KINRINSHI
see
TAIZAN

KĪNS, Jānis Jura
Latvian 1909-
LATV

KINSELLA, E. P.
English -1936
ADV,M

KINSER, Bill
American mid 20c.
GR64-68-72-80-83

KINSEY, Helen Fairchild
American 1877-
B,F,H,M

KINSTLER, Everett Raymond
American 1926-
H

KIRBY, J.
Canadian 20c.
M

KIRBY, Rollin
American 1875-1952
CAV,CC,EC,H,LEX,M,PE

KIRCHBACH, Fritz Gottfried
German 1888-1942
POS

KIRCHNER, Albert Emil
German 1813-85
B,H,LEX,M,TB

KIRCHNER, Ernst Ludwig
German 1880-1938
AN,B,CP,DA,DES,DRA,H,M,PC,POS

KIRCHNER, Johann Josef
Austrian ac. late 19c.
LEX

KIRCHNER, Raphael
Austrian/French/American 1876-1919
B,FS,LEX,M,TB

KIRK, Maria Louise
American 19/20c.
F,H,I,M

KIRKBRIDE, Earle Rosslyn
American 1891-1968
F,H,M

KIRKPATRICK, Marion Powers
American 20c.
B,F,M?

KIRKPATRICK, William Arber-Brown
Anglo/American 1880-
B,F,H,M,VO

K

KIRMSE, Marguerite
Anglo/American 1885-1954
F,H,M

KIRSCH, Agatha Beatrice
American 1879-
F,H,M

KIRSCH, Dietrich
Austrian mid 20c.
LEX

KIRSCH, Frederick Dwight, Jr.
American 1899-
H,M

KIRSCHKE, Helene
German 1892-
LEX,VO

KISCKA, Isis
French 1908-74
B

KISER, Walter H.
American 20c.
M

KISSIG, Georg
German 1893-
LEX

KISSNER, John
German 20c.
LEX

KISTLER, H.
German 20c.
LEX

KITT, Katherine Florence
American 1876-
F,H,M

KITTELSEN, Theodor
Norwegian 1857-1913/14
B,EC,H,LEX,M,SC,SI,TB

KITTON, Frederick George
English 1856-1904
B,BK,H,M

KITTSTEINER, Theo
German 20c.
LEX

KIWITZ, Heinz
German 1910-
LEX,VO

HK

KIYOOKA, Roy Kenzie
Canadian 1926-
H

KLAGES, Frank H.
American 1892-
F

KLAPKA, Jerome J.
American 1888-
H

KLAPPROTH, Werner
Swiss mid 20c.
GR54

KLAPSCHI, Lizzi
Austrian 20c.
LEX

KLÄR, Maria
German 20c.
LEX,VO

KLAUBER, George
American mid 20c.
GR65

KLAUCK, Ed
American 20c.
M

KLEBE, Charles Eugene (Gene?)
American 1907–
H,M

KLEBER, Bartl
Austrian early 20c.
LEX

KLEIBER, Hans
German/American 1887–1967
H,M

KLEIN, Benjamin
Hungarian/American 1898–
F,H,M

KLEIN, Eitel
German 1906–
LEX,VO

EK

KLEIN, Isadore
russian/American 1897–
EC,F,H,M

I. KLEIN

KLEIN, Johann Josef Friedrich
French 1803–55
B

KLEIN, Paul
French 1909–
B

KLEIN, William
Italian mid 20c.
GR57

KLEINMICHEL, Julius
German 1846–92
B,LEX,TB

J.K.

KLEINOW, Ernst
German early 20c.
LEX

KLEINTJES, P.
Dutch 20c.
LEX

KLEMKE, (Prof.) Werner
German 1917–
G,GR59 thru 62-67-68

WK

KLEMM, Eleanor M.
American 20c.
M

KLEMM, Lance G.
American late 20c.
GR82-83

KLEMPNER, Ernest S.
Austrian/American 1867–
B,F,H,M

KLEP, Rolf
American 1904–
H,M

KLEPPER, Erhard
German 1906–
G

Erhard Klepper

KLEPPER, Max Francis
German/American 1861–1907
B,CO7/05,F,I

Max F Klepper

KLEPSER, Harold
American –1933
H,M

KLETT, Walter Charles
American 1897–1966
FOR,H,IL,M,SO

πशπ

KLEUKENS, Friedrich Wilhelm
German 1887–
AN,B

KLEY, Heinrich
German 1863–1945
B,EC,M,SI

Kley, Ky

KLIC, Karl
Austrian 1841–1926
B,LEX,TB

KLIMÁCEK, Fedor
Yugoslavian 1913–
H

KLIMANEK, Wilhelm
Czechoslovakian early 20c.
LEX

KLIMASCHIN, W.
Russian mid 20c.
LEX

KLIMEK, Lothar
German mid 20c.
GR61

KLIMSCH, Eugen John George
German 1839–96
B,LEX,M,TB

KLIMSCH, Hans Paul
German 1868–1917
B

KLIMT, Gustav
Austrian 1862–1918
AN,B,CP,DA,DRA,GMC,H,M,MM,POS

GUSTAV. KLIMT.

KLINE, George T.
American 1874–1956
F,H

KLINE, Hibberd van Buren
American 1885–
B,F,H,M

KLINE, Wendell
American 20c.
H

KLINE, William Fair
American 1870–1931
B,F,I,M,SN8/94

WILLIAM R. KLINE

KLING, Anton
Austrian 1890–
B,LEX,TB

KLINGELHOFER, Sascha
German 20c.
LEX

KLINGER, Julius
Austrian 1876–
AD,B,CP,LEX,MM,POS,POST,TB

JULIUS KLINGER

KLINK, Wilhelm
German 1874–
B

KLINKER, Orpha
American 1895–1964
H

KLINZ, Anita
Italian mid 20c.
GR65

KLIROS, Thea (Ted?)
American 1935–
AA,F,GR73?,Y

KLITGARD, J.
Danish mid 20c.
GR57

KLÖCKER
Swiss 20c.
BI

Klöcker

KLOEZEMAN, Bert
Canadian 1921–
H

KLONIS, K.
Greek mid 20c.
GR55

KLOPPER, Zanwill David
Russian/American 1870–
F,M

KLUGER, Erica
Israeli mid 20c.
GR64

KLUNDER, Barbara
Canadian late 20c.
GR85

B:K^LUN^HR

KLUSÁCEK, Karl L.
Czechoslovakian 1865–
LEX,TB

KLUTSIS, Gustav
Russian early 20c.
CP,POS

KLYNN, Herbert David
American 1917–
H

KNAB, Albert
German 1870–
B,LEX,TB

KNACKFUSS, Hermann Joseph Wilhelm
German 1848–1915
B,H,LEX,TB

KNAP, Joseph Day
American 1875–
F,M

KNAPP, Grace Le Duc
American 1874–
F,M

KNAPP, Walter Howard
American 1907–
H

KNAUBER, Alma Jordan
American 1893–
F,H,M

KNEBEL, Erwin
Swiss mid 20c.
GR57

KNECHT, Karl Kae
American 1883–
F,H,M

KNIGHT, Charles
English 1743–1826
B,H,M

KNIGHT, Charles K.
American 20c.
M

KNIGHT, Charles Robert
American 1874–1353
B,CEN1/05 & 10/07,F,H,I,M,Y

CHAS. R. KNIGHT

KNIGHT, Clayton
American 1891–
F,H,IL,M

CLAYTON
KNIGHT

KNIGHT, Clinton
American 20c.
M

KNIGHT, H. H.
American 20c.
M

KNIGHT, Hilary
American 20c.
ADV,H

KNIGHT, Jacob Jaskoviak
American 1938–
GR81,H

KNIGHT, Katherine Sturges
American early 20c.
F,M

KNIGHT, (Dame) Laura
English 1877–1970
B,BRP,H,M

LK

KNIGHT, Robert
American 1944–
H

KNILLE, Otto
German 1832–98
B,H,LEX,M,TB

[signature: OK 82]

KNITTEL, Willy
German 1884–
LEX,TB

KNOPFF, K.
Belgian 19/20c.
POS

KNORR, A. J.
American? early 20c.
ADV

A.J.Knorr

KNORR (KNÖRR), Charles Emile
German/French 1890–
B,M

CK

KNÖTEL, Richard
German 1857–1914
B,TB

[signature: R.K.]

KNOTH, Jan
Polish 20c.
LEX

KNOWLES, Farquhar McGillvray
American 1860–1932
B,F,H,M

KNOWLES, Horace J.
English early 20c.
LEX,STU1928

[signature: -HK-]

KNOWLES, Reginald L.
English ac. early 20c.
AN,MM,STU1914

[signature: RLK]

KNOWLTON, Reynold
Canadian late 20c.
GR82

KNUTSON, Johan
Finnish 1816–99
B

KOBELT, Willy
Swiss mid 20c.
GR63–65

KOBER, Nándor
Austrian –1951
LEX

KOBZAN, Jan
Czechoslovakian 20c.
LEX

KOBZDEJ, Aleksandea
Polish 1920–
B,GR59,H

[signature: Kobzdej]

KOCH, Franz
German 20c.
LEX

KOCH, Georg
German? 1857–
LEX,TB

[signature: G.K.]

KOCH, Lizette J.
American 1909–
H

KOCH, Lizette R.
American 1899–
H,M

KOCH, Ludwig
Austrian 1866–1934
B,LEX,M,TB

KOCH, Otto Adolf
German early 20c.
LEX

KOCH, Peter
American 1900–
F

[signature: P.K]

KOCH-GOTHA, Fritz
German 1877–
B

KOCH-HANAU
German 1882–
B

KOCHANOWSKI, Roman
Polish 1856/57–1945
LEX,TB,VO

RK

KOCHER, Hugo
German 20c.
LEX

KOCHERGHIN, Nikolai
Russian early 20c.
PG,POS

KOCI, Josef
Czechoslovakian 1880–
LEX,VO

KOCINOVÁ, Dagmar
Yugoslavian 1932–
H

KOCKOEK, H. W.
Dutch ac. early 20c.
LEX

KOCSIS, James C. (James Paul)
American 1936–
H

KODA-CALLAN, Elizabeth
American 1944–
F,GR83,Y

KOECHLIN, Lionel
French late 20c.
EI79

KOECHLIN

KOEHLER, Karl
American 20c.
PG

KOEHLER

KOEHLER, Marie
Canadian 1939–
H

KOENIG, John
French mid 20c.
GR59

KOENIG (KONIG), Paul
German mid 20c.
GR59-63-66-69-71

Paul König

KOERING, Ursula
American 1921–
H

KOERNER, H. T.
German 1855–1927
H

KOERNER, William Henry Dethlef
German/American 1878–1938
GMC,GR60,H,HA,IL,LEX,M

W. H. D.
Koerner

KOFLER, Oswald
Austrian 1923–
LEX

KOGAN, Jewgeni
Russian early 20c.
LEX

KOGAN, Moissej
Russian/French 1879–1943
H,LEX,TB,VO

MK

KOGLER, Gertrud Du Brau
German/American 1889–
H

KÖGLER, Karl
German 1838–1923
B

KOGLIN, Ulrich
German mid 20c.,
LEX

KÖGLSPERGER, Adolf
German 1891–
LEX,TB,VO

ΛK

KOGUT
Russian early 20c.
POS

KÖHLER, Karl
Austrian 20c.
LEX

K:

KÖHLER, Mela
Austrian early 20c.
LEX

KOHLHOFF, Alan (or Alma) Reed
American 1905–
M

KOHLMEIER, Albert
German late 20c.
GR76?–82

KOHN, Misch
American 1916–
APP,H,P,PC

KOHRT, Bertrand Pfieffer
German ac. early 20c.
GMC

KOHRT, Gertrude
German 19/20c.
LEX

KOHS, Lester
American mid 20c.
PAP

Kohs

KOI
see
UNSHO, Ikeda

KOISTER, Georges
Belgian 1879–
B,POS

KOIZUMI, Jun
Japanese mid 20c.
GR61

KOKINOS, Tony
American mid 20c.
PAP

KOKOSCHKA, Oskar
Austrian 1886–1980
AN,B,CP,DA,DES,DRA,H,M,PC,POS,TB

OK

KOLACZ, Jerzy
Canadian late 20c.
GR82 thru 85

JKoſacz 81

KOLAR, Miloslav
Czechoslovakian late 20c.
GR82

MKOLAR '81

KOLIBAL, Stanislav
Czechoslovakian 1925–
B,H

KOLIND, Povl
Danish mid 20c.
GR52–54

KOLL, Magdalena
German 1879–
LEX,VO

mKOII

KOLLER, E. Leonard
American 1877–
B,F,H,M

KOLLIKER, William Augustin
Swiss/American 1905–
CON,H,M

Kolliker

KOLLWITZ, Kathe
 German 1867-1945
 AN,APP,B,CP,DA,DES,DRA,H,LEX,M,
 PC,PG,POS,S,SI

Kollwitz

KOLOS-VARY, Sigismond
 Hungarian/French 1899-
 B,H

KOLSKI, Gan
 Polish/American 1899-1932
 F,M

KOMISAROW, Don
 American 20c.
 H

KONATSCHEWITSCH, Wladimir Michailowitsch
 Russian 1888-
 B,LEX,TB

KONDOR, Béla
 Hungarian 1931-
 B

KONECSNI, György
 Hungarian 1908-
 B,H,POST

KONGSTAD, Rasmussen Kristian
 Danish 1867-1929
 LEX,TB,VO

KÖNIG, Friedrich
 Austrian 1857-1941
 AN

FK

KÖNIGS, Edgar
 German 1908-
 LEX

KÖNIGSBRUNN, Hermann
 Austrian 1823-1907
 LEX

KONNO, Hiroshi
 Japanese 1915?-
 GR53-55-56-61,H

KONO, Takashi
 Japanese 1906-
 GR55-57-58-59-61,H,POS

KONSTANTINOFF, Fjodor Dessinowitsch
 Russian 1910-
 H,LEX,PC,VO

KONWICKA, Danuta
 Polish mid 20c.
 GR61-66

KOONS, Irv
 American mid 20c.
 GR58 thru 61-75

irv Koons

KOPALLIK, Franz
 Austrian 1860-
 B,LEX

KOPCAK, Adolph J.
 Italian/American 1895-
 H,M

KÖPECZY-BOCZ, Istvan
 Hungarian 20c.
 LEX

KOPEL, Ben
 see
 KOPLOWITZ, Benjamin

KOPLOWITZ, Benjamin
 American 1893-1950
 H,M

KOPMAN, Benjamin D.
 American 1887-1965
 B,F,H,M

KOPPEL, Charles
 American ac. 1853-65
 H

KOPY, Adolph J.
 Italian/American 1895-
 H

KOR, Paul
 Israeli mid 20c.
 GR63-65-66-71,POST

Kor 62

KÓRA
 see
 KOBER, Nándor

KOREN, Edward B.
American 1935–
CC,EC,GMC,GR82-83-85,H

KOREN

KORETSKY, Victor
Russian 20c.
B,PG

В.КОРЕЦКИЙ

KÖRNER, Magnus Peter
Swedish 1808–64
B

KÖRNER, Max
German 1887–
POS,VO

K

KORNERUP, Andreas Nicolaus
Danish 1857–81
LEX,TB

KORTEN, C. F.
American 20c.
LEX

KORUNKA, Karl
Austrian mid 20c.
GR61

KORUNKA, Rudolf
Austrian mid 20c.
GR61

KORYBUT, Wanda
Russian/American 1907–
H,M

KOSCH, Karl
Hungarian 1883–
LEX,TB,VO

KOSEL, Hermann
Austrian 1896–
H,POS,POST

KOSEL

KOSEL-GIBSON
Austrian early 20c.
CP

KOSEL-GIBSON

KOSKA
German 1808–82
B

KOSLOW, Ed
American 20c.
P

KOSLOW, Howard
American 1924–
CON,F,GR55,Y

HOWARD KOSLOW

KOSLOWSKY, Nota
American 1906–
H

KOSSIN, Sanford
American 1926–
F,GR65,IL,PAP,Y

Kossin

KOSTER, A. S.
Dutch 1863–
M

KOSTRZEWSKI, Franz
Polish 1826–1911
LEX,TB

F.K.

KOSZLER, Hugo
Austrian 1900–
BI

KOTIK, Jan
Czechoslovakian 1916–
B,GR61,H

jk

KOTSCHENREITER, C. Hugo
German 1854-1908
B,M,LEX,TB

KOUKRYNISKY
see
KRYLOV, P. N.

KOULL, Gilbert
Swiss mid 20c.
B,GR58

KOUPER, Léo
French mid 20c.
GR55-56

LÉO KOUPER

KOURDOFF, Valentin
Russian 1906-
B

KOVAČEVIC, Fredo
Yugoslavian 1870-
B,LEX,TB

KOVAČIK, Andrej
Yugoslavian 1889-1953
H

KOVALEVS, Vasilijs Petera
Latvian 1917-
LATV

KOVAR, Stanislav
Czechoslovakian mid 20c.
GR53

KOVEC, Charles
American 20c.
ADV

KOW, Alexis
French 20c.
POS

A. KOW

KOWALSKI, Léopold Franz (Francois)
French 1856-
B,BAA,LEX,M,TB

KOWALSKI-WIERUSZ, Alfred von
see
WIERUSZ-KOWALSKI, Alfred von

KOZEL, Hans Eduard
Austrian/German 1875-
B,LEX,TB

KOZICS, Ferencz
Hungarian/German 1864-1900
B,LEX,TB

KOZICZ, Sandor
German 1864-1900
B

KOZINS, Vladimirs Ivana
Latvian 1922-
LATV

KOZISEK, Franz
Czechoslovakian 1856-
LEX

KOZLINSKY, Vladimir
Russian early 20c.
POS

KOZMA, Ludwig (Lajos)
Hungarian 1884-
LEX,TB,VO

KRACHE, F.
German early? 20c.
LEX,TB,VO

KRAEMER, Benno
German mid 20c.
GR54

KRAFT, Helmut
German late 20c.
GR71-76-77-82

KRAIN, Willibald
German 1886-
B,LEX,TB,VO

KRAJEWSKI, Andrzej
Polish mid 20c.
GR61-65-68 thru 71-73-75-76-77-79

ANDRZEJ KRAJEWSKI

KRÁL, Jaroslav
Czechoslovakian 1883-1942
B,H,LEX,VO

KRALIK
 Czechoslovakian mid 20c.
 GR61

KRAMER, Carveth Hilton
 American 1943-
 GR79,H

KRAMER, Florian G.
 Austrian/American 1908-
 H

KRAMER, Peter
 German late 20c.
 GR80-82-83-85-86

KRAMER, William
 American ac. 1851
 M

KRAMM, Willibald
 German 1891-
 LEX,VO

KRANER, Florian
 see
 KRAMER, Florian G.

KRANNHALS, Hedda von
 German 1930-
 LEX

KRANNICH, Hans
 Austrian 20c.
 LEX

KRANZ, Kurt Peter
 German 1910-
 B,GR55,GWA

KRANZ, Wilhelm
 German 1853-
 B,TB

KRASNITZKY, Otto
 Austrian 1914-
 LEX

KRASZEWSKA, Olga Gräfin
 Polish/German 1859-
 LEX,TB

KRATOCHVIL, Zdenko
 Czechoslovakian 1883-
 LEX

KRAUS, Hans Felix
 American 1916-
 M

KRAUS, Robert
 American 1925-
 F,H

KRAUSE, Lisbeth B.
 German/American 1880-
 H,M

KRAUSE-CARUS, Arthur
 German 1883-
 B

KRAUSKOPF, Wilhelm
 German 1847-
 B,LEX

KRAUSS, Friedrich
 Austrian 1871-
 LEX

KRAUSS, Oscar
 American 20c.
 H

KRAUZE, Andrzej
 Polish 1947-
 POS

KRAVCHENKO, Alexis
 Russian 1889-
 B,S

KRAWCZYK, Sabine
 French late 20c.
 EI79

KRAWIEC, Walter
 Polish/American 1889-
 H,M

KREBS, Columba
 American 1902-
 H

KREDEL, Fritz
German/American 1900–
G,H,M

KREGERE, Vera Andreja
Latvian 1909–
LATV

KREHBIEL, Dulah Evans
American early 20c.
F,H,M

KREIDOLF, Ernst
Swiss 1863–1956
AN,B,LEX,M,TB

[signature: EK.]

KRE(I)LING, August von
German 1819–76
B,LEX,TB

KREISCHE, Gerhard
German 20c.
LEX

KREMP, Marie Miller
American early 20c.
H,M

KREPCIK, Karl Adolf
Austrian 1907–
LEX

KRESEK, Larry
American 20c.
NV

[signature: KRESEK]

KRESSE, Paul
American mid 20c.
PAP

KREUGER, Nils Edvard
Swedish 1858–1930
B,LEX,M,SC,TB,VO

[signature: N. Kreuger]

KREUTZBERGER, Charles
Alsace 1829–
B,LEX,TB

KREWITT, Marie E.
American 1902–
H,M

KRICHELDORF, Wilhelm
German 1865–
B,LEX,TB

[signature: WK]

KRIENSKY, Morris E.
Scots/American 1917–
H

KRIEVER, Josef
Polish 1871–
B

KRIGSTEIN, Bernard
American 1919–
H

KRIJGER, Henk
Dutch mid 20c.
GR54

KRIKORIAN, George
American mid 20c.
ADV,GR54

KRISČ, Bogdan
Yugoslavian 1932–
H

KRISTIN, Vladimir
Czechoslovakian 1894–
LEX

KRITCHER, Larry B.
American 1900–
IL

[signature: Kritcher]

KRIZANIČ, Pjer
Yugoslavian mid 20c.
LEX

KRIZE, Emilie Mary
American 1918–
F,H

KROHG (KRÖGH), Christian
Norwegian 1852–1925
B,H,LEX,M,SC

[signature: C Krohg]

KROHG, Per (Halfdan) Lasson
Norwegian 1889–1965
B,H,M,POS

Per Krohg. 1920

KROHN, Olaf
Norwegian early 20c.
POS

KROHN, Pietro Köbke
Danish 1840–1905
B

KROLL, Maria
English mid 20c.
GR52

KROMBACH, Max
German 1867–
LEX,TB

KRONENBERGS, Alberts Jēkaba
Latvian 1887–1958
LATV

A. K.

KRONENGOLD, Adolph
American 1900–
H,M

KROPP, Ernst
German 1880–
LEX,TB

KROTOWSKI, Stefan
German? early 20c.
LEX

KROUPA, Bohuslav
Canadian ac. 1872–73
H

KROYER, Peter Severin
Danish 1851–1909
B,GMC,H,M

KRUETZFELDT, Pauline Wulf
German/American 20c.
H,M

KRUGLIKOFF, E.
Russian early 20c.
LEX

KRUIS, Ferdinand
Austrian 1869–
B,TB

F.K.

KRUSE, Albert
American 20c.
M

KRUSH, Beth
American 1918–
H

KRUSH, Beth & Joe
Americans 1918 (both)–
H

Beth and Joe Krush

KRUSH, Joe (Joseph)
American 1918–
H,M

KRYLOV, Porfiry Nikitovich (pseudonym KOUKRYNISKY)
Russian 1902–
B,CP,H

KUBIN, Alfred
Bohemian/Austrian 1877–1959
B,DRAW,EC,H,M,PC,S,SI

KUBIN, Jaroslav Kristian
Czechoslovakian 1886–
LEX

KUBINYL, Kálmán Matyas Bela
American 1906–
H,M

KUBINYL, Laszlo
American 20c.
GR68–79,H

L. Kubinyl

KUCHARSKI, Zig
Canadian 1932?-
H

KUCHARSKY, Norman
Canadian 1915?-
H

KUCHARYSON, Paul
American 1914-
H,M

KUECHLER, Carl Hermann
German 1866-1903
B

C·H·K·

KUEHL, Jerome
American mid 20c.
GR59

KUH, Wilhelm
German early 20c.
LEX

KUHL, Jerome
American mid 20c.
GR53-55-56-57-63

KUHLMAN, Roy
American mid 20c.
GR59-60-61-63

KÜHN, Bernard
German 1850-1902
B

KUHN, Charles
Swiss 20c.
GR53-54,POS

CK

KUHN, Felicitas
Austrian 20c.
LEX

KÜHN, Gottfried
German? 1898-
LEX,TB

-GK-

KUHN, Robert (Bob) F.
American 1920-
H,IL

KUHN

KUHN, Walt
American 1877/80-1949
APP,B,CAV,EC,F,H,M,PC,Y

WALT
KUHN

KUHNERT, Richard
German 19?/20c.
LEX

KUHNERT, Wilhelm
Swiss 1865-1926
B,LEX,TB

W.K.

KUHN-REGNIER, Josef
French 1873-
B,LEX,TB

KÜHNT, G.
Prussian ac. early 20c.
LEX

KUICH, Karl Ludwig
Austrian 20c.
LEX

KUITHAN, Erich
Prussian 1875-1917
B,LEX,TB

KULISIEWICZ, Tadeusz
Polish 1899-
B,H,M,S

KÜLLING, Ruedi
Swiss 20c.
GR59 thru 68-70,POS

KÜLLING, Yvonne
Swiss mid 20c.
LEX

KUMAGAI, Akihiro
Japanese mid 20c.
GR60

KUMPEL
Swiss early 20c.
POS

KÜMPEL, Heinrich
Swiss mid 20c.
GR61

KÜNG, Edgar
Swiss mid 20c.
GR59-61-62

KUNHARDT, Dorothy
American 20c.
M

KUNINAO
Japanese 1793-1854
H

KUNIO
Japanese ac. 1752-85
H

KUNITAKE, Hisami
Japanese mid 20c.
GR60-69-70

KUNST, Adolf
German 1882-
LEX,TB

FK

KUNST, Carl
German 1884-1912
B,LEX,TB

KUNSTLER, Morton
American 1931-
F,H,Y

KUNZ, Anita
Canadian/American? late 20c.
GR82 thru 85,P

K U N Z

KUPKA, (Frank) Frantisek (Francois)
Czechoslovakian 1871-1957
AN,B,DA,DES,EC,FS,H,LEX,M,TB,VO

KUPREINANOV
Russian early 20c.
POS

KUPREJANOFF, Nikolai Nikolajewitsch
Polish/Russian 1894-1933
B,LEX,VO

HK

KUPRIANOV, Mikhail Vasilievich
Russian 1903-
CP,H

KURABE, Hiroshi
Japanese mid 20c.
GR64

KURI, Yoji
Japanese 1928-
EC,GR66-76-77-78-80 thru 83

KURIYAGAWA, Kenichi
japanese mid 20c.
GR59 thru 62

KURPERSHOEK, Theo
Dutch mid 20c.
GR59

KURTZ, Helmuth
Swiss 1877-1959
GR53-57-58-60,POS

KURTZ, John
American 20c.
P

KURTZ, Wilbur G.
American 1882-
F,H,M

KURTZKE, Rose
German 20c.
LEX

KURVERS, A.
Dutch early 20c.
GMC

KURZ, Albrecht
German 1858-
B

KURZ ZUM THURN UND GOLDSTEIN,
Ludwig Viktor Chevalier van
Austrian 1850-
B

KURZWEIL, Fritz
Austrian 1900-
POS

F.K.

KURZWEIL, Maximilian
Austrian 1867-1916
AN,B

Max Kurzweil

KUSAKA, Hiroshi
Japanese mid 20c.
GR60

KUSAKARI, Jun
Japanese mid 20c.
GR61-67

J. KUSAKARI

KUSTODIEV, Boris Mikhailovich
Russian 1878-1927
B,POS,RS,TB

B.K.

KUTCHER, Ben
Russian/American 1895-
H,M

KUTHAN, George
Canadian 1916-
H

KUTSCHER, Otto Franz
German 1890-
LEX,VO

KUTSCHERA, Franz
Bohemian 1807-
LEX,TB

FKy

KUTSCHERA, Harald
Austrian 20c.
LEX

KUSCHMANN, Theodor
German 1843-1901
B

Th.K.

KUTZER, Ernst
American 20c.
M

KUTZER, Erwin
Austrian early 20c.
LEX

KUWAHARA, Robert
American 20c.
M

KUYCK, Frans Pieter Lodewyk van
Belgian 1852-1915
B,H,M

KUZKOVSKIS, Josifs Benjāmina
Latvian 1902-
LATV

KYOSIA (KYOSAI or GYOSIA), Kawanabé (To-iku)
Japanese 1831-89
B,H

KYOSUI
Japanese 1816-67
H

KYSAR, Ed
American mid 20c.
GR53-57-59-61-65 thru 68-70-71-78-79-81

kysar

KYSELA, Frantisek (Franz)
Bohemian 1881-1941
B,LEX,TB,VO

K

- L -

L. E., (anonymous)
Italian ac. 1899
AN

LABAN, Maurice
English mid 20c.
GR57-58

LABBÉ, Werner
German 1909-
G,GR59

Werner Labbé

LA BELLA, Vincenzo
Italian 1872-
B,H

LABELLE, J. A. P.
Canadian 1857-1903
H

LABISSE, Félix
French 1903/05-
B,GR52,H

LABORDE, Charles (Chas)
Argentinean/French 1886-1941
B,FS,H,L,M,S

Chas. Laborde

LABOUREUR, Jean Emile
French 1877-1943
AD,B,H,L,LEX,M,S,TB,VO

LABOUREUR

LA CAFF, Elmore
American 20c.
M

LA CHARLERIE, Hippolyte de
Belgian 1827-67
B

LACHMANN, Anna
Austrian 1887-
LEX,VO

LACKER, René
French late 19c.
LEX

LACKMAN, Marc
French mid 20c.
GR60

LACOSTE, G.
English 20c.
PG

G Lacoste

LADA, Josef
Czechoslovakian 1887-1957
B,H,LEX,M,VO

LADD, Peter
American 1897-
H

LADREYT, Eugène
French 1832-
B

LAERUM, Gustav
Norwegian 1870-
B

LAESSIG, Robert
American 1920-
H

LA FARGE, Christopher
American 20c.
M

LA FARGE, John
American 1835-1910
B,BAA,F,H,LEX,M,PC,TB

LAFÈRE, E.
French ac. late 19c.
LEX

LAFNET, Luc
French early 20c.
B

LAFON, Albert Jean
French 1860-
LEX,TB

LAFORGE, Lucien
French early 20c.
B

LAFORTEZZA, Michael
American late 20c.
GR82

LA FRESNAYE, Roger Noël Francois de
French 1885-1925
B,DES,DRA,H,M

LAGANÀ, Guiseppe
Italian 1944-
EC

LA GATTA, John
Italian/American 1894-1977
EC,F,GMC,H,IL,M,PE,Y

LAGERSON, Rolf H.
Swedish 1925-
GR54-56-58 thru 65-67-68,H

LA GRANGE, Jacques
Franco/American 1917-
B,H,M

LA GUILLERMIE, Frédéric Auguste
French 1841-1934
B,LEX,M,TB,VO

LAGUT, Irène
French 1893-
B,M

LAGYE, Victor
Flemish 1825/29-96
B,BAA,H,M

LAHMER, Alfred
German early 20c.
LEX

LAHNER, Karl (Carl)
Austrian 1842-
B,TB

LAICHTER, Prokop
Czechoslovakian 1898-
LEX

LAIDLAW, Ken
English late 20c.
GR78-79-82

LAIRD, Mary (Hamady)
American 1948-
H

LAISNÉ
French 19c.
B

LAITE, Gordon
American 1925-
F,H,Y

LAKATOS, Artur
Austrian 1880-
B,LEX,TB,VO

LAKOS, Alfred
Hungarian 1870-
B,LEX,TB

LALIBERTE, Norman
American 1925-
F,GR60-71,H,Y

L'ALLEMAND, Gordon Lynn
American 1903-
H,M

LALLEMAND, Martin Jacques Charles
French 1826-1904
B

L'AMARRE, Pierre
Canadian 1915-
H

LAMB, Ella Condie
American 19/20c.
B,F,H,I,M

LAMB, Katherine Stymets (Tait)
American 1895-
F,H,M

LAMB, Lynton
English 1907-
GR52-53-54-56,H,LEX

Lynton Lamb

LAMB, Tom (Thomas B.)
American 1896-
H,M

LAMBDIN, Robert Lynn
American 1886-
H,IL,M,Y

R.L.LAMBDIN

LAMBERT, André
French early 20c.
B

LAMBERT, George E., Jr.
American 1889-
H,M

LAMBERT, Jack Lincoln
American 1892-
H

LAMBERT, Maurice de (Maurice Walter
Edmund de)
French 1873-
B,LEX,M,TB,VO

LAMBERT, Saul
American 1928-
F,GR61-65-73,P,Y

Lambert

LAMI, Eugène Louis
French 1800-90
B,H,LEX,M,PC,TB

LAMKEY, Rosemary
American 20c.
M

LAMM, Lora
Italian 1928-
GR58 thru 63,H

Lora Lamm

LÄMMLE, Hans
German mid 20c.
GR52-53-54-56-57-59-65

LÄMMLE, Sigrid
German mid 20c.
GR52-53-54-56-57-59-65-67

LÄMMLE, Sigrid & Hans
German mid 20c.
GR57

S. R. Lämmle

LAMON, A.
French late 19c.
LEX

LA MOND, Stella Lodge
American 1893-
H,M

LAMONT, Jean (Dill)
American 20c.
M

LAMOT, Jean
Argentinean mid 20c.
GR52

LAMOTTE, Bernard
Franco/American 1903-
ADV,H,M

LAMPE, Ferdinand von
German 1888-
LEX

LAMPELMAYER, Lisa
 Austrian 20c.
 LEX

LAMY, Pierre (called LAMBERT)
 French 1921-
 B

LAMY, Pierre Francois (Pierre Désiré Eugène
 Franc or Franc-Lamy)
 French 1855-1919
 B,LEX,M,TB

P.F.L.

LANCASTER, Elizabeth Greig
 American 1889-
 H,M

LANCASTER, Eric
 English 1911-
 GR55-56-58
 H

E.LANCASTER

LANCASTER, (Sir) Osbert
 English 1908-
 B,EC,H

LANCE, Janet
 French 19c.
 LEX

LANCERAY, Yevgeny Yevgenevich
 Russian 1875-1964
 AN

И. БИЛИБИНЪ.1905

LANÇON, Auguste André
 French 1836-85/87
 B,H,LEX,M

LAND, Clyde Osmer de
 American 1872-
 B

LANDACRE, Paul Hambleton
 American 1893-1963
 APP,H,M,PC,S

PL

LANDAU, Jacob
 American 1917-
 APP,F,GR57 thru 63-70,H,LEX,M,Y

Jacob Landau

LANDELLS, Ebenezer
 English 1808-60
 B,H,LEX,M,TB

E Landells

LANDELLS, Robert Thomas
 English 1833-77
 B,H,M

LANDER, E.
 American 20c.
 M

LANDER, R. M.
 English mid 20c.
 GR56

LANDGREBE, Erich
 Austrian 1908-
 LEX

LANDI, Juan
 Brazilian mid 20c.
 GR55

LANDIS, Thomas J. S.
 American 1861-1939
 M

LANDORI, Eva (Hoffmann)
 Hungarian/Canadian 1912-
 H

LANDROVEC, Divici
 Czechoslovakian 20c.
 LEX

LANE, (Lieut.) G. H.
 Canadian ac. 1881
 H

LANE, Marian V. M.
 Anglo/American 20c.
 F,H,M

LANE, Remington W.
 American ac. 1893
 H

LANE, Tony (Anthony S.)
American late 20c.
GR70-71-76-77-81-82

LANFAIR, Harold Edward
American 1898-
H,M

LANG, Charles Michael Angelo
American 1860-1934
B,F,H,I,M

LANG, Christian
Swiss late 20c.
GR66-68-69-70-79 thru 85

LANG, Dieter
German 20c.
LEX

LANG, Fritz
German 1877-
AD,B

FL

LANG, Hans
Austrian 1898-
B,LEX,VO

(HL)

LANG, Heinrich
German 1838-91
B,H

LANG, Josef Adolf
Austrian 1873-1936
B,LEX,TB

LANG, Otto U.
American -1940
M

LANG, Tony
American mid 20c.
GR65

LANG, William Anton
American 20c.
M

LANGDALE, Stella
Canadian
H

LANGE, Charles Michael Angelo
see
LANG, Charles Michael Angelo

LANGE, Herbert
German mid 20c.
GR52-53-54

LANGE, Otto
German 1879-1944
AMA6/31,B,LEX,M,POS

Offlunge

LANGE, Theobold Fritz
German 1894-
LEX,VO

LANGENBERG, Gustave C.
German/American -1915
I,M

LANGHAMMER, Arthur
German 1854-1901
AN,B,M

LANGKJAER, Jens
Danish mid 20c.
GR57-58-59-63

LANGL, Josef
Austrian 1920-
LEX,TB

Lg

LANGL(E)Y, Sarah
American 1885-
F,H,M

LANGNER, Nola
American 1930-
H

LANGTON, W. N.
Canadian ac. 1881
H

LANKES, Julius J.
American 1884-1960
APP,B,F,H,M,PC,S,VO

LANKES

LANNON, Norbert J.
American mid 20c.
PAP

LANOS, Henri
French 19/20c.
B,LEX

LANYI, Deszo?
Hungarian 1879–
B,POS

Lannyi

LAPA, Manuel Francisco Almeida e Vasconcelos
Portuguese 1914–
GR62,H,M

LAPORTE, Georges
French 1926–
B

LAPRADE, Pierre (Coffinhal-Laprade)
French 1875–1932
B,H,LEX,M,TB,VO

Laprade

LAPSLEY, Robert Ernest
American 1942–
F,Y

LARIANOV, Mikhail (Michael) F.
Russian/American 1881–1964
DRA,GMC,H,M,PC

M.L

LARSEN, Carl Christian
Austrian 1853–1910
B

LARSEN, Kaldron
Danish mid 20c.
GR55

LARSEN, Ole
American 1898–
H

LARSEN, Poul Eric
Danish mid 20c.
GR65

P.E. LARSEN

LARSON, Frank E.
American 20c.
H,M

LARSON, Sidney
American 1923–
H

LARSSON, Carl Olof
Swedish 1853/55–1919
AN,B,H,M,SC,TB

C.L 1903

LARSSON, Karl
Swedish/American 1893–
H,M

LARTER, Josenia Elizabeth
American 1898–
F

LA SALLE, Charles Louis
American 1894–1958
H,IL,M

CHARLES LASALLE

LASCARI, Salvatore
Italian/American 1884–
H,M

LASKER, Albert
American early 20c.
POS

LASKER, Joseph Leon
American 1919–
H,M

LASKOFF, Franz
Italian early 20c.
ADV,AN,LEX,POS

L.F.

LASSELL, Charles
see
LA SALLE, Charles

LÁSZLO, (George?)
American mid 20c.
M?,PAP

LÁSZLO (signature)

LATENAY, Gaston de
French 1851/59-1913
AN,B,LEX,M,TB

(monogram signature)

LATHAM, Barbara (Cook)
American 1896-
H,M

LATHROP, Dorothy Pulis
American 1891-
F,H,M,VO

D.P.L. (signature)

LATHROP, Francis Augustus
Anglo/American 1848-1909
B,F,H,M

LATOUR, Alfred
French 1888-1964
B,GR53,M,S

LAU, Olga Andrea Mathilde
Danish 1875-
B,LEX,TB

(signature)

LAU, Otto Emil
German late 29c.
LEX

LAUBI, Carl
Swiss early 20c.
LEX

LAUBI, Hugo
Swiss early 20c.
POS

LAUBY (LAUBI), Fritz
Swiss 1863-
M

LAUESEN, Laus
Danish 20c.
GR52-56

laus lauesen (signature)

LAUFBERGER, Ferdinand Julius Wilhelm
Austrian 1829-81
B,H,LEX,M,TB

LAUGHLIN, Alice Denniston
American 1895-1952
B,F,H,M

LAUGHLIN, J. E.
Canadian ac. 1895-1900
H

LAUNE, Paul Sidney
American 1899-
F,H,M

LAURENCE, Henry Buckton
Canadian ac. 1800
H

LAURENCIN, Marie
French 1885-1956
AD,B,DES,GMC,H,M,POS,VC

Marie Laurencin (signature)

LAURENS, Henri
French 1885-1954
B,DES,H,LEX,M,PC,TB,VO

HL , I (signature)

LAURENS, Jean Paul
French 1838-1921
B,BAA,H,L,M,TB

Jean Paul Laurens (signature)

LAURENT-DESROUSSEAUX, Henri Alphonse Louis
French 1862/65-1906
B,L,TB

H Laurent Desrousseaux (signature)

LAURIE-WALLACE, John
irish/American 1864-
F,M

LAUTENSCHLAGER, Doris
German 19?/20c.
LEX

LAUXMANN, Theodor
German 1865–1920
B

LAVADO, Joaquin (pseudonym QUINO)
Argentinean 1932–
PG

LAVAGNINI, Primo
Italian 1889–
H

LAVERDIÈRE, (Rev.) Aug.
Canadian ac. 1870
H

LAVERERGNE, Alfred
French 1892–
B

LAVERIE, R. de
French early 20c.
LEX

LAVES-GOLDHANN, Elsie
Austrian 1896–
B

LAVEY, Stan
American mid 20c.
GR59

LAVILLE, Maurice
French mid 20c.
GR57-58-65

MlAVILLE

LAVIN, Robert
American 1919–
IL

Bob Lavin

LAVINSKY, Anton Mikhailovich
Russian 1893–1968
POS

ЛАВИНСКИИ

LAWGOW, Rose
American 1901–
F

LAWRENCE, H. M.
American early 20c.?
R

LAWRENCE, Jacob
American 1917–
GR71,H,M

LAWRENCE, T. Cromwell
Anglo/American 1865/67–1905
I,M

LAWRENCE, William Hurd
American 1866–1938
H,HA6/04 & 10/04,M

WILLIAM HURD LAWRENCE.

LAWSON, Francis Wilfried
English 19/20c.
B,H,STU1899,TB

FWL

LAWSON, Grace
Canadian 1891–
H

LAWSON, Marie
American 20c.
M

LAWSON, Ralph L.
Canadian 20c.
M

LAWSON, Robert
American 1892–1957
FOR,H,M,PE,VO

Robert Lawson.

LAWSON, Wendell
Canadian 1898–1952
H,M

LAWSON, William Rawson
English 1900–
LEX,VO

LWR

LAYCOX, William Jack
American 1921–
H

LAZARE, Gerald John
Canadian 1927–
H

LAZARUS, Sidney
American 20c.
M

LAZEAR, Ann Tarantour
Canadian 1927–
H

LAZZARI, Pietro
Italian/American 1898–1979
B,H,M

LAZZARINI, Aldo
Italian/American 1898–
H,M

LEA, Frank
American 1904–
M

LEA, Tom
American 1907–
F,H,M

LEACH, Ethel Pennewill Brown
American 19/20c.
B,F,H,M

LEAF, Reuben
American 20c.
M

LEAF, Wilbur Munroe
American 1905–
H,M

LEAL, Paulo Guilherme d'Eça
Portuguese 1932–
H,Y

LEAMING, Charlotte
American 1878–1972?
F,H,M

LÉANDRE, Charles Lucien
French 1862–1934
B,EC,FO,FS,GMC,H,M,PC,POS

C. Léandre

LEAR, Edward
English 1812–88
B,BA,EC,H,M

LEARMONTH, Larry
English late 20c.
EI79

LEARNED, Arthur Garfield
American 1872–
B,F,GMC,H,I,M

LEASON, Percy Alexander
American 1889–1959
EC,H

Leason

LEAVITT, David Franklin
American 1897–
F,M

LEAVITT, Robert
American 20c.
H,M

LEBEAU, J. J. Christian
Dutch early 20c.
POS

LEBEDA, A.
Austrian early 20c.
LEX

LEBEDEV, Aleksandr Ignatevich
Russian 1830–98
EC

LEBEDEV, Vladimir Vasilievich
Russian 1891–
B,H,M,PC,POS,VO

JL

LEBÈQUE
French 19/20c.
POS

LEBIE, Maurice
French 19/20c.
LEX

LEBIS, Ján
Yugoslavian 1931–
H

LE BLANC, Emilie de Hoa
 American 1870-
 H,M

LE BLANC, Marie de Hoa
 American 1874-
 F,H,M

LE BLANT, Julien
 French 1851-
 B,H,L,M

J. Le Blant

LE BOUTEUX, Joseph Barthelemy
 French 1744-
 B

LE BRETON, Constant
 French 1895-
 B,H,LEX,VO

CLB

LE BROCQUY, Louis
 irish 1916-
 B,H,Contemporary Irish Art--Roderic
 Knowles--Wolfhound Press--Ireland 1982

LEBRUN, Rico (Federico)
 Italian/American 1900-64
 ADV,APP,DRAW,F,H,M,PC

lebrun

LECHTER, Melchior
 German 1865-1937
 AN,B,LEX,M,TB

LECOULTRE, M.
 French 20c.
 LEX

LEDELI, Moritz
 Austrian 1856-1920
 B,LEX,TB

mL

LEDERER, Wolfgang
 American 1912-
 H

LEDERER ROTTER, Suse
 Czechoslovakian early 20c.
 LEX

LEDGER, Mildred Mai
 English ac. 1901-14
 H,M

LE DIEU
 Canadian ac. 1888
 H

LE DOUX, Jean Picart
 French 1902-
 H,POS

P

LE DUC, Alice Sumner
 American early 20c.
 F

LEE, Alan
 English late 20c.
 EI79,GR85

LEE, C. Brinckerhoff
 American 1908-
 H,M

LEE, Charlie
 American 1926-
 H

LEE, Doris (Emrick)
 American 1905-
 B,F,GR53-54,H,LEX,VO

Doris Lee

LEE, Ed
 American mid 20c.
 GR65-74-77-78

LEE, Henry Jay
 American 20c.
 H,M,PG

LEE, Leslie W.
 American 1871-
 CO6/04,H,M

L.W. LEE.

LEE, Manning de Villeneuve
American 1894-
B,F,H,IL,M

M. de V. Lee

LEE, Robert J.
American 1921-
F,H,Y

LEE, Roland L.
American 1949-
CON

Roland Lee

LEE-SMITH, Hughes
American 1914-
H,M

LEECH, John
English 1817-64
B,CAV,EC,GMC,H,LEX,M,S,TB

J Leech

LEEKE, Ferdinand
German 1859-
B,LEX,M,TB

F.L.

LEEPA, Harvey
Russian/American 1890-
H,M

LEES, Harry Hanson
American -1959
F,H,M

LEETE, Alfred
English 1882-1933
ADV,CP,POS,POST

ALFRED LEETE

LEEUW, Cateau de
American 1903-
B,M

LEFCOURTE, Albert A.
American 20c.
M

LEFÈVRE, Lucien
French 19/20c.
CP

LEFFEL, David A.
American 1931-
H,record cover: 'Sound of a Drum'--Ralph
Macdonald--Rosebud recording 1976

Dal 76

LEFFERTS, Winifred Earl
American 1903-
F,H,M

LEFKOWITZ, Jack
American late 20c.
GR76 thru 80-82-84-85

LEFKOWITZ, Pam (Pamela)
American late 20c.
GR76-77-78-82-83-84

LEFLER, Heinrich
Austrian 1863-1919
B,POS,TB

Hb

LE FOLL, Alain
French mid 20c.
B,GR63-65-66-67-69-71-74-80

alain Le Foll

LEFORT, Henri Emile
French 1852-
B,LEX,M,TB

h.L.

LEFORT, Jean Louis
French 1875-
B,M

JEAN LEFORT.

LEFRANC, Margaret (Schoonover)
American 1907–
H,M

LEFT(O)WICH, Bill
American 1923–
CON,H

LEFTWICH-DODGE
see
DODGE, William De Leftwich

LÉGER, Fernand
French 1881–1955
APP,B,DES,DRA,DRAW,EC,GMC,GR54,H,
M,PC,POST,TB

LE GRAND (LEGRAND), Louis Auguste Mathieu
French 1863–1951
B,H,L,LEX,M,TB,VO

LEGUEY, Luc
French 1876–
B

LEHMANN, Felix
German early 20c.
LEX

LEHMANN, Herbert
German 1890–
B,TB

LEHMANN, Paul
German 1854–
B

LEHMANN, Wilhelm
German 1893–
LEX,VO

LEHR, Wilhelm L.
German early 20c.
LEX

LEIBOWITZ, Matthew
American 1918–
ADV,GR52–54–55–58–59–60–63

LEIDL, Anton
German 1900–
LEX,TB,VO

LEIGH, William Robinson
American 1866–1955
B,F,H,I,M,PE

LEIGHT, Edward
American 20c.
H

LEIGHTON, Alfred Crocker
Anglo/Canadian 1901–65
H,M

LEIGHTON, (Sir) Frederick
English 1830–96
B,H,M,POS,STU1894,TB

LEIGHTON, John
English 1822–1912
B,LEX,TB

LEIJENAAR, P. J.
Dutch mid 20c.
GR54

LEINWEBER, Anton Robert
German 1845–1921
B,LEX,M,TB

LEISSER, Theodor
Austrian 20c.
LEX

LEISTIKOW, Walter
Polish/German 1865–1908
AN,M

LEITCH, R. P.
Canadian ac. 1862–66
H

LEITCH, Richard Principal
English ac. 1840–75
B,H

LEITE, José de
Portuguese 1873–1939
H

LEITNER, Leander
American 1873–
B,F,H,M

LEJEUNE, Francois (Jean EFFEL)
French 1908–
EC,GR54,H

LEJEUNE, Philippe
French 1924–
B

LELAND, Charles G.
English 19/20c.
LEX

LELOIR, Alexander Louis
French 1853–84
B,H,LEX,M,TB

LELOIR, Maurice
French 1853–1940
ADV,B,FO,H,L,LEX,M,TB,VO

Maurice Leloir

LELONG, René
French ac. early 20c.
B,LEX

LE LOUARN, Yvan (Chaval)
French 1915–68
EC,H

ChGVGL

LE MAIR, H. Willebeck
Dutch 20c.
M

LEMARIE, Henry
French 1911–
B

LEMAY, Arthur
French/Canadian 1900–44
EC

Arthur LeMay

LEMBERT, M.
French 19/20c.
GMC

LEMBKE, Rolf
Swedish mid 20c.
GR61

LEMEILLEUR, Georges
French 1861–1945
B,LEX,M,TB

Æ.

LEMEUNIER, Claude
French 20c.
POS

L

LEMKE, Horst
German 1922–
GR62,H

Le·

LEMKE-PRICKEN, Marie Luise
German mid 20c.
GR65–66

LEMKES, Herbert
German 1909–
GR57

LEMMEL, M.
German late 19c.
LEX

LEMMEN, Georges
Belgian 1865–1916
AN,B,LEX,MM,POS

LEMMI, Lemmo
Brazilian 1884–1926
EC

LEMOINE, Georges
French late 20c.
EI79,GR68 thru 73–75 thru 78–85

LEMON, Arthur
English 1850–1912
B,EN

LEMON, C.
Canadian ac. 1871
H

LEMOS, Fernando de
Portuguese 1926–
B,H

LEMOS, Frank B. (Austin?)
American 1877–
I,M

LEMOS, José Fernandes de
Portuguese 1910–
H

LEMOS, Pedro J.
American 1882–1945
APP,B,F,H

LE MOUEL, Eugène
French 1859–
B,LEX

LENDECKE, Otto Friedrich Carl
Austrian 1886–1918
B,LEX,TB

LENGO, Francisco Sancha
Spanish ac. early 20c.
GMC

LENGSFELD, Julius
Austrian 1872–
LEX,TB

LENI, Paul
German 1885–
GMC,LEX,POS,TB

LENICA, Jan
Polish 1928–
CP,EC,GR52–53–54–56 thru 63–65 thru
68–70–71–74–78,H,POS,POST,VO

LENK, Koloman
Austrian 20c.
LEX

LENNIE, Beatrice
Canadian 1906–
H

LENNOX, S. Erma
Canadian 20c.
M

LENOIR, Marcel (MARCEL-LENOIR)
French 1872–1931
B,CP,M,POS

LENSKI, Lois
American 1893–
F,H,M

LENSSEN, Heidi Ruth
German/American 1909–
H,M

LENSVELT, Fritz
Dutch 1886–
B,GMC

LENT, Blair
American 1930–
H

LENTNER, Josef Friedrich
German 1814–52
B

LENTZ, Stanislaus
Polish 1863–1920
B,H,LEX

L

LENZ, Eugen
Swiss mid 20c.
GR52-53-60

LENZ, M.
Austrian early 20c.
PG

·M·LENZ·

LENZ, Max
Swiss mid 20c.
GR52-53-60

LENZ, Willard A.
American 20c.
M

LENZEN, Hans Georg
German 20c.
LEX

LEO
see
HIRSCHFELD, Leo

LEON, Ralph Bernard
American 1932–
H

LEONARD, Helen
American 1885–1908
I,M

LEONARD, Jack de Coudres
American 1903–
H,M

LEONARD, Lank
American 20c.
H

LEONARD, Robert
German early 20c.
POS

LEONARD, Robert L.
American 20c.
M

LEONARDI BUSI, Lilla
Italian 1900–
H

LEONESSA, Enrico della
see
LIONNE (DELLA LEONESSA), Enrico

LEONHARD, Walter
German 1912–
GR57

LEONHARDT, Olive
American 1894–
H,M

LEONNEC, G.
French early 20c.
GMC

LEONNEL
French early 20c.
ST

LEOPOLD, William
American –1911
I

LEPAPE, Georges
French 1887-1971
AD,B,GMC,M,POS,ST,VC

LEPÈRE, Alexandre
French 19c.
L

LEPÈRE, Auguste Louis
French 1849-1918
AN,B,H,LEX,M,PC,S

LE PETIT BERNARD (called)
see
SALOMON, Bernard

LE POIT(T)EVIN, Eugène (Edmond Modeste)
French 1806-70
B,EC,H,M

LEPORCHER, Soizick
French late 20c.
GR82

LEPPERT, Rudolph E.
American 1872-
B,F,H,M

LE QUERNEC, Alain
French 1944-
GR77-78,PG,POS

LEROUX, A.
Canadian ac. 1858-70
H

LEROUX, Auguste
French 1871-
LEX,VO

LE ROUX, Gaston Louis
see
ROUX, Gaston Louis

LEROY
French ac. 1930s
POS

LE ROY, Anita
American 19/20c.
F,H,I

LESLIE
Canadian ac. 1877
H

LESPINASSE, Herbert
American 1884-1972
B,M,STU1929,TB

LESSER, Gilbert
American mid 20c.
GR62-65-67-79 thru 77-80-81

LESSI, Giovanni
Italian 1852-1922
H

LESTER, Charles F.
American 1868-1938
M

LESTER, William H.
American 1885-
F

LESZCYNSKI, Michal
English 1906-
LEX,VO

LE-TAN, Pierre
French late 20c.
EI79,GR74-76-82

LETHERBROW, Thomas
English 1925-
H

LE TOURNIER, J.
French 20c.
B,LEX

LETTICK, Birney
American mid 20c.
ADV,GR76-80-84

LETTNER, Franz
Austrian 1909-
LEX,VO

LEUPIN, Herbert
Swiss 1916-
CP,GR55 thru 69-71-76-81,H,POS,POST

HEBERT.
LEUPIN

LEUTEMANN, Heinrich
German 1824-1905
B,LEX,TB

LEUTERITZ, Paul
German 1867-1919
LEX,TB

LEVEN, Hugo
German 1874-
B,LEX,TB

LEVERING, Albert
American 1869-1929
EC,I,M

ALBERT LEVERING

LEVERING, Robert K.
American 1919-
H

LEVETUS, Celia (Moss)
English 19/20c.
BK

LEVIGNE, Hubert
Dutch 1905-
LEX,VO

LEVIN, Alexander B.
Russian/American 1906-
F,H,M

LEVIN, Murray
American 20c.
M

LEVINE, Gilbert
American 1915-
H,record cover'My Lord What A Morning'--
Harry Belafonte--R C A Victor 1976

LEVIT, Herschel
American 1912-
GR53,H,M

Herschel Levit

LEVONE, Albert Jean
Russian/American 1895-
F,M

Levone

LEVY, Alexander Oscar
German/American 1881-
B,F,H,M

LÉVY, Alphonse Jacques
French 1843-1918
B,LEX

LÉVY, Charles
French late 19c.
FO

LÉVY, Léopold
French 1882-
LEX,TB,VO

.LL.

LEWANDOWSKI, Edmund D.
American 1914-
B,GMC,H,M

LEWANDOWSKI

LEWICKI, James
American 1917-
F,H,IL,M,Y

Lewicki

LEWIN, Arthur
German 1860-1923
B

AL

LEWIN, Leopold
Polish 1860–
B

LEWIS, Arthur Allen
American 1873–1957
B,F,H,I,M,PC

LEWIS, David
English mid 20c.
GR54

LEWIS, Fred
English 19/20c.
LEX

LEWIS, Harry Emerson
American 1892–
H,M

LEWIS, James
American early 20c.
M

LEWIS, James E.
American 1923–
H

LEWIS, Jane M. Dealy
English –1939
H

LEWIS, Jennie
American 20c.
M

LEWIS, Lalla Walker
American 1912–
H,M

LEWIS, Mary
American 1926–
H

LEWIS, Percy Wyndham
English 1884–1957
B,BRP,DA,GMC,H,M,POST

Wyndham Lewis

LEWIS, Richard
American 20c.
H

LEWIS, Tim
American 20c.
GR67 thru 71–73 thru 79,POS

LEWIS, Wayne
American 1947–
CON

Wayne Lewis

LEWITT, Jan
Polish/English 1907–
GR52–56,H,POS

Lewitt. 55

LEWITT, Jan & HIM, George
CP,GR52 thru 56,H,POS

Lewitt–Him

LEWY, Fritz
German 1893–
B,POS

LEY, Mary Helen
American 1886/88–
H,M

LEY, Willy
English? ac. early 20c.
LEX

LEYENDECKER, Frank X.
German/American 1877–1924
ADV,F,GMC,I,IL,M,POS,VC,Y

F.X.Leyendecker

LEYENDECKER, Josephine Christian
German/American 1874–1951
ADV,B,F,GMC,H,I,IL,M,POS,POST,R,Y

J.C.Leyendecker.

LHOTAK, Kamic
Czechoslovakian 1912–
B,H

KL

LHOTE, Andre
 French 1885–1962
 B,DES,H,M,POS

A.LHOTE.

LIBERI, Dante
 American 1919–
 H

LIBISZENSKI, H. B.
 Swiss early 20c.
 GR53-54,VC

LJB

LIBISZEWSKI, Serge
 Italian mid 20c.
 GR61-62-66

LICHTEN, Frances M.
 American 1889–1961
 F,H,M

LICHTENHELD, Wilhelm
 German 1817–91
 B,LEX,TB

WL

LICHTENSTEIN, Roy
 American 1923–
 APP,B,F,GR66-71,H,POS,POST

LICHTHARDT, Ulrich
 West German late 20c.
 EI79

LICHTIE, Justin
 American 20c.
 M

LICHTNER, F. Schomer
 American 1905–
 F,H,M

LICHTWITZ, Friedemann
 German mid 20c.
 GR52-61

Lichtwitz

LIDOV, Arthur Herschel
 American 1917–
 GR63,H,IL,M

Arthur Lidov

LIEBENAUER, E.
 Austrian 20c.
 LEX

LIEBENWEIN, Maximilian
 Austrian 1869–1926
 B,LEX,TB

LIEBER, Hugh Gray
 American 1896–
 H

LIEBERMAN, Frank Joseph
 American 1910–
 H,PAP

LIEBERMANN, Ern(e)st
 German 1869–
 AN,B,M,ME12/23,TB

EL

LIEBICH, Curt
 German 1868–
 B,TB

CL

LIEBLEIN, Muni
 American mid 20c.
 GR58

muni

LIEBSCHER, Adolf
 Czechoslovakian 1857–
 B,LEX

LIEBSCHER, Karl
 Czechoslovakian 1851–1906
 B,LEX

LIEDLOFF, James E.
 American 1905–
 H,M

LIENEMAYER, Gerhard
 German 1936–
 POS

LIEPINŠ, Janis Kārla
Latvian 1894–
B,LATV

LIGASACCHI, Natale
Italian mid 20c.
GR52

LIGHTFOOT, Peter
English 1805–85
M

LILIE, Georg
German 1873–
LEX,TB

G·L·

LILIEN, Ephraim Moses
German 1874–1925
AN,B

LILLEY, Vern
Canadian mid 20c.
GR55–56–57–65

LILOTTE, Friedrich
German 1818–
B

LIMA, Antonio
Portuguese 1891–1958
H

LIMA, Joāo Barbosa
Portuguese 19c.
H

LIMBACH, Russell T.
American 1904–
F,H,M

LIMBERG, Ferdinand
German 20c.
LEX

LIMMER, Emil
German 1854–1931
B,LEX,M,TB

E L

LINCOLN, A. W. B.
American 19?/20c.
R

–Lincoln–

LINCOLN, F. Foster
American ac. 1920s
F,PE

F·FOSTER
LINCOLN

LINCOLN, Philip
English late 20c.
E179

LINDBERG, Arthur H.
American 1895–
F,H,M

LINDBERG, Stig
Swedish 1916–
GR53–55–59–60–61,H

Stig L.

LINDBERG, Thorsten Harold Frederick
Swedish/American 1878–
B,F,H,M

LINDE-WALTHER, Heinrich Edouard
German 1868–
B,TB

L.V.

LINDEGGER, Albert
Swiss 1904–
H

LINDEMANN, Kat
German 20c.
LEX

LINDENBURG, Hans Peter
Danish 1854–
B

LINDENSCHMIT, Wilhelm von (the younger)
German 1829–95
B,H,LEX,M,TB

LINDENSTAEDT, Hans
German early 20c.
POS

LINDER, Sophie
Swiss 1838–71
B

LINDHARDT, Knud Hee
Danish mid 20c.
GR61

LINDHOLM, Peter
Finnish 20c.
POS

LINDLEY, Katrin
West German late 20c.
EI79,GR76 thru 80-83-84

LINDLOF(F), Edward Axel, Jr.
American 1943–
GR79-82-83,H

lindlof

LINDLOFF, Hans
German 1878–
LEX,TB

LINDNER, Ernest
Austrian/Canadian 1877?–
H

LINDNER, Ferdinand
German 1847–1906
B,LEX,TB

LINDNER, Richard
American 1901–
ADV,APP,B,DRAW,F,GR54-57,H,POS

Richard Lindner

LINDROTH, Per
Swedish early 20c.
LEX

LINDSAY, Norman Alfred Williams
Australian 1879–1969
AD,B,EC,M,S

NoRMAN LINDSAY

LINDSAY, S. A.
English 19/20c.
LEX

LINDSAY, Thomas M.
Scots 1882–
LEX,VO

LINDSAY, Vachel
American 1879–1931
M

LINDSLEY, Emily Earle
American 1858–1944
BAA,F,H,M

LINE, Clifton
American 20c.
M

LINEK, Lajos
Hungarian/American 1859–1941
B

LRM

LINER, Carl
Swiss 1871–
B,TB

LC

LING, Jui Tang
Chinese/American 20c.
LEX

LINK, Carl
German/American 1887–1968
H,M

LINN, Warren
American 1946–
F,Y

LINNEKOGEL, Otto
German early 20c.
LEX

LINNEL, Harry
American ac. early 20c.
CEN8/07,*

LINNELL, John
English 1792-1882
B,DA,H,M

LINNEMANN, Otto
German 1876-
B

LINSENMAIER, Walter
German/Swiss? 1917-
GR78

LINSON, Corwin Knapp
American 1864-1934
B,CEN2/05,F,H,I,M,TB

CORWIN KNAPP LINSON

LINTON, (Sir) James Dromgole
English 1840-1916
B,H,M,POS

LION, Charles
French 19/20c.
LEX

LION CACHET, C. A.
Dutch 1864-1945
POS

LIONNE (DELLA LEONESSA), Enrico
Italian 1865-1921
B,H,POS,TB

LIONNI, Leo
American 1910-
GR53-56 thru 61-70-78-80,H,POS

LIOZU, Jacques
French 20c.
B

LIPARI, Frank A.
Canadian
H

LIPINSKI, Eryk
Polish mid 20c.
GR54-56-57-61-62-64-66-69,LEX,POS

ERYK LIPINSKI

LIPINSKY DE ORLOV, Lino S.
Italian/American 1908-
H,M

LIPPENCOTT, Robert Taylor
American 1915-
M

LIPPINCOTT, William Henry
American 1849-1920
B,BAA,F,H,I,M

LIPPMAN, Peter J.
American 1936-
GR70,H

LIPS, F.
German 19/20c.
LEX

LIPUS, Rudolf
German 1893-
ADV,GWA,VO

R.LÍPUS

LISMER, Arthur
Canadian 1885-1969
B,H,M

LISSIM, Simon
Russian/American 1900-
B,H,M

LISSITZKY, El (pseudonym)
see
MARKOVICH, Eleazar

LISZT, Wilhelm
German 19/20c.
CP

LITCHFIELD, Donald
Anglo/American 1897–
H,M

LITLE, Arthur
American early 20c.
F,M

LITTLE, Alice
American early 20c.
VC

LITTLE, Edith Tadd
American 1882–
F,H,M

LITTLE, Joe
American 20c.
H

LITTLE, Nathaniel Stanton
American 1893–
F,H,I,M

LITTLEFIELD, William Horace
American 1902–
B,H,M

LITWAK, Israel
Russian/American 1867/68–
B,H,M

LIVACHE, Victor
French 1831–
B,LEX,TB

LIVEMONT, Privat A. Th.
Belgian 1861–1936
B,CP,GMC,MM,POS,POST

LIVERSEDGE, Audrey
Canadian 20c.
M

LIVERSEEGE, Henry
English 1803–32
B,H,M

LIVINGSTON, Robert Crawford
American 1910–
H,M

LIVINGSTON, Virginia
American 1898–
H

LIX, F.
American ac. 1890–1910
PE

LLAVERIAS, Joan
Spanish 19/20c.
POS

LLERENA(-AGUIRRE), Carlos Antonio
Peruvian/American 1952–
F,GR80,Y

LLEWELLYN, Sue
American late 20c.
EI79,GR81

LLIMONA, Joan
Spanish 19/20c.
POS

LOBBAN, John
English mid 20c.
GR57

LOBEL, Anita
Polish/American 1934–
H

LOBEL RICHE, Alméry
Swiss/French 1880–
B,LEX,M,VO

LOBICHOU, C.
French late 19c.
LEX

LOBO, Oskar Pinto
Portuguese
H

LOCHRIE, Elizabeth Davey
American 1890/91–
H,M

LOCK, Charles L.
Anglo/American 1919–
H

LOCKE, Charles Wheeler
American 1899–
F,B,H,M

LOCKERBIE, Alison Houston
see
NEWTON, Alison Houston Lockerbie

LOCKETT, Elizabeth
American 20c.
M

LOCKHART, James Leland
American 1912–
H

j lockhart

LOCKWOOD, Charlotte
American 20c.
M

LOCKWOOD, Gaye
English late 20c.
EI79

Gaye Lockwood

LOCKWOOD, James Booth
Canadian ac. 1885
H

LOCKWOOD, John Ward
American 1894–1963
H,M

LOCKWOOD

LODICO, S.
American mid 20c.
GR55

LODIGENSKY, Theodore
American 1930–
F,Y

LOEB, Louis
American 1866–1909
B,CEN2/99,F,H,HA6/07,I,M,Y

·LOUIS·LUEB·98

LOEDERER, Richard A.
Austrian/American 1894–
H,M

LOEFFLER, Gisella (Lacher)
Austrian/American 1900–
F,H,M

LOESTI, Georg
German ac. late 19c.
LEX

LOEVY, Edward (Edouard)
Polish 1857–1910/11
B,M

LOEW, Michael
American 1907–
H,M,PAP

Loew

LOEWENHEIM, S. Frederick
German/American 1870–1929
F,M

LOEWER, Henry Peter
American 1934–
H

LÖFFELHOLZ, Emil Freiherr von
German? 1884–
LEX

LÖFFLER, Berthold
Bohemian 1874–1960
AN,B,LEX,POS,POST,TB

BERTOLD LÖFFLER

LÖFFLER, Ludwig
German 1819–76
B,H,LEX,TB

·L.

LOFGREN, Charles
American 20c.
H,M

LOFTING, Hugh
Anglo/American 1886–
I,M

LOGAN, Clarice George
American 1909–
F,H,M

LOGAN, Elizabeth Dulaney
American 1914–
H,M

LOGAN, Herschel C.
American 1901–
F,H,M

LOGAN, Maurice
American 1886–1977
H,M

LOGAN, Velma Kidd
American 1912–
H,M

LOGVINOFF, Phyllis
Canadian 20c.
M

LOHDE, Max
German 1845–68
B,H,LEX,TB

M

LOHRER, Hanns
German 1912–
GR56–59,H

Lohrer

LOHSE, Richard P.
Swiss 1902–
B,GR52–53–56,H,POS

LOHSE, Willis
German/American 1890–
H,M

LOMBARD, Alfred
French 19/20c.
B

LOMBERS, Eric
English early 20c.
POS

Lombers.38

LANDINSKY, Bernard
French mid 20c.
GR60–74

LONDON, Alexander
Franco/American 20c.
H

LONDON, Leonard
American 1902–
H,M

LONG, Birch Burdette
American 1878–1927
CEN1/05,I,M

LONG, Charles Raymond
American 1909–
H,M

LONG, Daniel A.
American 1946–
F,Y

LONG, Robert Dickson
American 1884–
H,M

LONG, Stanley M.
American 1892–1972
H,M

LONGANESI, Leo
Italian mid 20c.
B,GR54–57–59

Longanesi e C.

LONGAY, Daniel
American mid 20c.
GR60

LONGOBARDI, Xavier
French 1921–
B,GR55–56–58–61–67,H

LONGONI, Alberto
 Italian 1921–
 B,H

A. Longoni

LONGYEAR, William Llonyn
 American 1899–
 F,H

LOO, Jack
 English late 20c.
 PG

J Loo 1915

LOOMIS, C. Ainslie
 Canadian 1917–
 H,M

LOOMIS, Chester
 American 1852–1924
 B,F,H,I,M

18 ₵ 79

LOOMIS, Richard N.
 American 20c.
 H

LOOMIS, (William) Andrew
 American 1892–1959
 ADV,F,H,IL,M,Y

ANDREW LOOMIS

LOOS, Lisl von
 Austrian 20c.
 LEX

LOOSCHEN, Hans
 German 1859–1923
 AN,B

HL

LOOSER, Hans
 Swiss mid 20c.
 GR59–60–62–63–64–68–70

LOOSER

LOOSER-BRENNER, Heinz
 Swiss mid 20c.
 GR60 thru 63–66–67–72–78

LOPES, Domingos Vasconcelos Marques
 Portuguese 1929–
 H

LÓPEZ, Juan Luis
 Spanish 20c.
 B

LOPEZ, Ruoda Le Blaance
 American 1912–
 H

LÓPEZ NAGUIL, Gregorio
 Argentinean 1894–1953
 H

LOPINA, Louise Carol
 American 1936–
 H

LOREDANO SILVA
 Swiss late 20c.
 GR85

loredano

LORENTZEN, Mogens
 Danish 1892–1953
 H,M

ml

LORENZ, Richard
 German/American 1858–1915
 F,H,M

LORENZINI, Eldora Pauline
 American 1910–
 H

LORIN, Philippe
 French 1933–
 B

LORING, Paul Stetson
 American 1899–
 H

LORME-CYR, Yolande de
 Canadian mid 20c.
 GR52

LORRAINE, Helen Louise
 American 1892–
 F,H,M

LORRAINE, Walter Henry
 American 1929–
 H

LORTZ, Helmuth
 German mid 20c.
 GR53 thru 56-59-62-69

LOSQUES, Daniel Thouroude de
 French 1880-1915
 B,LEX,TB

LOSSING, Benson John
 American 1813-91
 D,F,I,M

LOSSOW, Heinrich
 German 1843-97
 B,BAA,H,LEX,M,TB

17. *Lossow.*

LOSSY, Josef
 Hungarian ac. early 20c.
 LEX

LOSTUTTER, Robert
 American 20c.
 P

LOTT, Kip
 American late 20c.
 GR79-80-82

LOTTER, Richard
 German 1856–
 LEX,TB

LOTTON, Iwan Leroy
 American 1913–
 H

LOTZ, Helmuth
 German 20c.
 LEX

LOUDEN, Adelaide Bolton
 American 20c.
 H,M

LOUDEN, Norman P.
 American 1895–
 H,M

LOUDERBACK, Walt S.
 American 1887-1941
 B,F,H,IL,M

Walt Louderback

LOUGEE, Arthur
 American 20c.
 M

LOUGHEED, Robert Elmer
 American 1910–
 H,IL

R.E. Lougheed

LOUKOTA, Josef
 Czechoslovakian 1879–
 LEX,TB,VO

LOUKOTKA, F. K.
 Czechoslovakian 1883–
 LEX

LOUPOT, Charles Henri Honoré
 French 1892-1971
 AD,CP,GR56-58,H,POS,POST

LOVE, George Paterson
 American 1887–
 B,F,H,M

LOVE, Ralph
 American 1907–
 CON

Love

LOVEDAY, J.
 American 19/20c.
 GMC

LOVEGROVE, Stanley D.
American 1881–
F,M

LOVEJOY, Margot (MacDonald)
Canadian 1930–
H

LOVELL, Tom
American 1909–
CON,F,H,IL,M,PAP,Y

Tom LOVELL

LOVEN, Frank W.
American 1868/69–
F,H,M

LOVER, Samuel
Irish/English? 1797–1868
B,H,M

LOVIE, Henri
American ac. mid 19c.
D

LOW, (Sir) David
New Zealander/English 1891–1963
CAV,EC,H,M

low

LOW, Joseph
American 1911–
GR52 thru 55-57 thru 60-68,H

JL, Joseph Low

LOW, Laurence Gordon
American 1912–
H,M

LOW, Sanford Ballad Dole
American 1905-64
H,M

LOW, Will Hicok (Hicox)
American 1853-1932
B,BAA,F,H,I,M,R,Y

Will H. ow

LOWE, J. M.
Canadian 20c.
M

LOWE, Peter
American 1913–
H,M

LOWE, Thomas
Canadian 20c.
M

LOWELL, Orson Byron
American 1871-1956
CAV,EC,H,I,LEX,M,PE,Y

ORSON LOWELL

LOWENHEIM, Frederick
German/American 20c.
F,M

LOWENHEIM, Viola P.
American 1914–
H

LOWENSTEIN, Bernice
American 20c.
H

LOWERY, Robert S.
American 1950–
F,Y

LOWINSKY, Thomas Esmond
English 1892-1947
M,STU1930

LOWITZ, Anson Crawford
American 1901–
M

LOWREY, Rosalie
American 1893–
F,M

LOWRY, Strickland
English ac. 1779
B,H,M

LOYGORRI PIMENTEL, José
Spanish 20c.
B

LOZANO SIDRO, Adolfo
Spanish 1874–
B

LOZOWICK, Louis
Russian/American 1892–1973
APP,F,H,M,PC

LOUIS LOZOWICK

LUBALIN, Herbert
American 1918–
GR54–56 thru 59–61–62–66 thru 77–79–80–81,
H,POS,POST

LUBANSKA
see
STRYJENSKI, Zofia

LUCE, Leonard E.
American 1893–
F,M

LUCE, Lois
American 1906–
H,M

LUCHTEMEYER, Edward A.
American 1887–
F,H,M

LUCINI, Ennio
Italian mid 20c.
GR61–70

LUCKNER, Graf Heinrich von
German 1891–
LEX,TB,VO

HL

LUDBY, Max
English 1858–1943
B,H,LEX,M,TB

LUDEKENS, Fred
American 1900–
ADV,F,H,IL,M,Y

Fred Ludekens

LÜDERS, Hermann
German 1836–1908
B,LEX,TB

HL

LUDINS, Ryah
American 20c.
H,M

LUDKE, Alfred?
German? 1874?–
M,POS

LODLOW, Hal
English 1861–
M

LUDLOW, Mike
American mid 20c.
PAP

LUDWIG, Alois
German 19/20c.
MM,LEX

LUDWIG, Helen
American 20c.
H,M

LUDWIG, Hugo
Polish 20c.
LEX

LUFKIN, Raymond
American 20c.
M

LUFT, Werner
German 1902–
LEX,M,VO

LUKAVSKY, Jaroslaw
Czechoslovakian early 20c.?
LEX

LUKE, Keye
Chinese/American 20c.
M

LUKER, William, Jr.
English 1867/68-
B,H,LEX,M,TB

LUKS, Jacques
Swiss mid 20c.
GR57

LULEVITCH, Tom
American late 20c.
GR79-82-84-85

LUMLEY, Arthur
Irish/American 1837-1912
B,BAA,D,I,M

A. LUMLEY.

LUMLEY, Saville
English early 20c.
M,POS,POST

LUNDBORG, Florence
American 1880-1949
F,H,I,LEX,M,MM,POS,R

FL

LUNDEAN, Louis J.
American 1896-
H,M

LUNDGREN, Egron Sellif
Swedish 1815-75
B,BAA,H,LEX,M,TB

LUNDGREN, Eric
Swedish/American 1906-
H

LUN(D)GREN, Fer(di)nand Harvey
American 1859-1932
B,BAA,H,I,M,PE

Lungren-

LUNDQUIST, Einar
Swedish/American 1901-
F,H,M

LUNEL, Ferdinand
French 1857-
B,BI,CP

F. Lunel

LUNTZ, Victor
Austrian 1840-1903
LEX,TB

V. L.

LUP(P)RIAN, Hildegard
American 1897-
H,M

LUPUS
Dutch? early 20c.
CP

LVPVS 1924

LUQUE, Manuel
Spanish 1854-
B,LEX,TB

LURIE, Ronan
Israeli 1932-
EC

LUSTIG, Alvin
American mid 20c.
GR52-55-56

lustig

LUTTICH von LUTTICHHEIM, Eduard
Czechoslovakian/Austrian 1844-1920
B,LEX,TB

LUTZ, Edwid George
American 1868-
H,M

LUZA, Reinaldo
 Peruvian 1893-
 B,LEX,VC

—Reinaldo Luza—

LUZAK, Dennis
 American 1939-
 F,Y

LUZZATI, Emanuele
 Italian 1921-
 EC,GR57 thru 60-64-65-67 thru 71-76

EMANUELE LUZZATI

LYFORD, Philip
 American 1887-1950
 H,IL,M

LYFORD

LYLE, Justis
 American 20c.
 M

LYNCH, Albert
 Peruvian/French 1851-
 B,GMC,L,M

A. Lynch

LYNCH, Donald Cornelius
 American 1913-
 H

LYNCH, John
 American 20c.
 H,M

LYND, J. Norman
 American 1878-1943
 CAV,EC,F,M

J. NORMAN LYND.

LYNEN, Amédée
 see
 LYSSEN, Amédée Ernest

LYNNE, Michael
 American 20c.
 POS

LYON, Harold Lloyd
 Canadian 1930-
 CON,H

Harold L Lyon

LYON, Richard
 American 1913-
 H,M

LYONNET, Jean Pierre
 French late 20c.
 EI79

LYSER, Johann Peter
 German 1803-70
 B

LYSSEN (LYNEN), Amédée Ernest
 French 1852-
 B,H,LEX,TB

A.L.

– M –

M. H. W.
 American? early 20c.
 VC

M. S.
 French early 20c.
 AD

MAAS, Julie
 American 20c.
 H

MAASS, Harro
 German late 20c.
 EI79,GR82-85

H.Maass

MABIE, George Harold
 American 1892-
 H,M

MABY, Michael
 American late 20c.
 GR80-81-83-85

MAC ALLUM (MAC CALLUM), Hamilton
 see
 MACALLUM, Hamilton

MAC CAULAY, David Alexander
 American 1946-
 F,GR78,H,Y

MAC CAULEY, Charles Raymond
 American 1871-1934
 EC,F,H,I

C. R. macauley

MAC CONNEL, W.
 English -1867
 B,H

MAC DONALD, Frank E.
 American 1896-
 F,M

MAC DONALD, Grant Kenneth
 Canadian 1909-
 H

MAC DONALD, James
 Scots/American 20c.
 H,M

MAC DONALD, John Blake
 English 1829-1901
 B,H,LEX,TB

J.MacD.

MAC DONALD, Robert H.
 American 1903-
 H

MAC DONALD, Thoreau
 Canadian 1901-
 H

MAC DONALL, Angus Peter
 American 1876-1927
 EC,F,I,IL

ANGUS MAC DONALL

MAC DONNELL, (Miss) A.
 American 20c.
 M

MAC DOUGALL, Ken
 Canadian 1933-
 H

MAC FARLANE, J.
 American 19/20c.
 HA,*

JM

MAC FARLANE, (Mrs.) Scott B.
 American 1895-
 F

MAC GILLIS, Robert Donald
 American 1936-
 H

MAC GREGOR, Archie
 see
 MACGREGOR, Archie

MAC GREGOR, Sara Newlin
 American 19/20c.
 F,M

MAC HARSBERGER, Frank
 American 20c.
 M

MAC INTOSH, Frank
 American 1901-
 GMC,M

FM

MAC KAY, William Andrew
American 1878-1939
B,F,H,M

MAC KENZIE, Garry
Canadian/American 1921-
H

MAC KENZIE, Lurene
American 20c.
M

MAC KENZIE, Roderick D.
Anglo/American 1865-
B,CEN5/99,F,H

R.D.Mackenzie

MAC KINNON, Archibald Angus
American 1891-1918
I,M

MAC KINNON, Mary
American 1890-
ADV,F,M

Mary MacKinnon

MAC KINSTRY, Elizabeth
American 20c.
M

MAC KNIGHT, Ninon
Australian/American 1908-
H,M

MAC LELLAN, Charles Archibald
American 1885/87-
F,H,M

MAC MACKEN
see
MC MACKEN, David B.

MAC MORRIS, Leroy Daniel
American 1893-
B,F,H

MAC NAB, Peter
English -1900
B,EN

p.Macnab

MAC NUTT, Glen Gordon
Canadian/American 1906-
H,M

MAC PHERSON, Orison
American 1898-1966
H,IL,M

ORISON MacPHERSON——

MAC VEAGH, Louise Thoron
American 20c.
H,M

MACALLUM, Hamilton
English 1841-96
B,EN,H,LEX

H.Macallum

MACAULAY, David Alexander
see
MAC CAULAY, David Alexander

MACAULEY, Charles Raymond
see
MAC CAULEY, Charles Raymond

MACBETH, Robert Walker
English 1848-1910
B,EN,H,M

MACCHIATI, Serafino
Italian 1860/61-1916
B,H,TB

S.M.

MACCIÓ, Rómulo
Argentinean 1931-
B,H,LEX

maccio

MACDONALD, A. K.
English early 20c.
LEX

MACDONALD, Frances
Scots ac. 1890s
GA,POS

F
R
A
N
C
J
M
A
C
D
O
N
A
L
D

MACDONALD, L. W.
American ac. 1881
H

MACDONALD, Margaret
Scots ac. 1890s
AN,BAA,GA,POS

M
A
R
G
J
M
A
C
D
O
N
A
L
D

MACDONALD, Margaret Ellis
Canadian 1919–
H

MACDOUGALL, W. Brown
English –1936
BK

MACGREGOR, Archie
English –1910
BK,H?

A.G.M.

MACHADO, João Saavedra
Portuguese 1887–1950
GR81,H

MACHEFERT, Adrien Claude
American 1881–
H,M

MACHEK, Helmut
Austrian 20c.
LEX

MACHETANZ, Fred (Frederick)
American 1908–
F,H,M

F.M.

MACHETANZ, Sara
American 20c.
H

MACHIDA, Ryuyo
Japanese early 20c.
POS

MAC(H)IUNAS, George
American 20c.
GR65,POS

MACHNO, Marghera
Italian 20c.
POS

MAC(H)TEY, Nathan
American 20c.
M

MACIEL, Mary Oliveira
American 20c.
H

MACK, Stanley
American 1936–
F,GR71-72-74-76,Y

MACKENZIE, Roderick D.
see
MAC KENZIE, Roderick D.

MACKEY, William Erno
American 1919–
M

William E. Mackey

MACKINTOSH, Charles Rennie
 English 1868-1928
 AD,B,CP,GMC,H,LEX,MM

C R M

MACKINTOSH, Margaret Macdonald
 English 1865-1933
 AN,LEX,MM

MARGARET MACDONALD MACKINTOSH

MACKMURDO, Arthur Heygate
 English 1851-1942
 AN

A·H·MACKMURDO

MACNAB, Peter
 see
 MAC NAB, Peter

MACPHERSON, Douglas
 English 1871-
 M

MACQUOID, Thomas Robert
 English 1820-1912
 B,LEX

MACY, William Starbuck
 Canadian/American 1853-1916
 B,BAA,F,H,I

MADAN, Frederic C.
 American 1885-
 H,M

MADELAINE, Francis
 French 19/20c.
 LEX

MADELINE, Paul
 French 1863-1920
 B,LEX,TB,M

PM

MADER, Gerlinde
 West German late 20c.
 EI79,GR81-82-84

MADOU, Jean Baptiste
 Flemish 1796-1877
 BAA,H,M

MADRASSI, Ludovic Lucien
 French 1881-1956
 B,M

MADSEN, Otto
 German/American 1882-
 F,I,M

MADSON, Eleanor
 American 20c.
 M

MAEKAWA SEMPAN
 Japanese 1888-1960
 H,PC

MAES, Karel
 Belgian 1900-
 H,POS

Karel maes./22

MAESTRO, Giulio Marcello
 American 1942-
 H

MAF(F)IA, Daniel J.
 American 1937-
 F,GR81-82-83,H

Maffia

MAGA (Maga Agency)
 Italian 20c.
 POS

MAGAGNA, Anna Marie
 American 1938-
 F,Y

MAGALHAES FILHO, Marcel Maria Calvet de
 Portuguese 1913-74
 GR61,H

MAGEE, Alan Arthur
 American 1947–
 F,GR75-78,H,P,Y

ALAN MAGEE

MAGER, (Gus) Charles A.
 American 1878–
 F,H,M

MAGER, Frederick
 English 1882–
 LEX

MAGGI
 see
 BAARING, Maggi

MAGGIE
 French early 20c.
 ST

MAGGIE 12

MAGGS, Arnaud B.
 Canadian mid 20c.
 GR52-56-58-66

MAGNIE, Bernice
 American 20c.
 M

MAGNUS, Günther
 German mid 20c.
 GR61-64

MAGNUSSON, Gustaf?
 Swedish early 20c.
 POS

MAGONI, S.
 Swiss mid 20c.
 GR53-54

MAGRINI, Adolfo
 Italian 1874/76–
 B,H,LEX,VO

MAGRITTE, René
 Belgian 1898-1967
 APP,B,DA,GMC,GR70-72-80,H,PG,POS

Magritte

MAGUIRE, Robert
 American mid 20c.
 PAP,M

MAHAFFIE, Isabel Cooper
 American 1892–
 H,M

MAHIAS, Robert
 French 1890–
 B

MAHLAU, Alfred
 German 1894–
 LEX,POS

A.MAHLAU–

MAHLER, H.
 Swiss early 20c.
 POS

MAHOLY-NAGY, Laszlo
 Hungarian/American 1895-1946
 CP,H

MAHONEY, James
 English 1810/16-79
 B,H,TB

MAHONY, Felix
 American –1939
 B,F,H

MAHOOD
 English 19/20c.
 GMC

MAHURIN, Matt
 American late 20c.
 GR85,P

MAI-SCHLEGEL, J.
Austrian? 20c.
LEX

MAIER, Harry
German 20c.
LEX

MAIER, Johann Baptist
German early 20c.
POS

JBM

MAIGNAN, Albert
French 1845-95
B,FO,H

ALBERT MAIGNAN

MAILLART, Diogène Ulysse Napoléon
French 1840-
B,H,LEX

MAILLAUD, Fernand
French 1863-1948
B,STU1912

f.m

MAILLOL, Aristide
French 1861-1944
AN,APP,B,DA,DES,DRA,GMC,H,L,PC,S,TB

M

MAILS, (Rev.) Thomas E.
American 1920?-
H

MAINELLA, Raffaele
Italian 1856/58-
B,H,LEX,TB

RM

MAINSSIEUX, Lucien
French 1885-
B,H,LEX,VO

Lucien Mainssieux

MAIORANA
Italian mid 20c.
GR52

MAITIN, Samuel Calman
American 1928-
GR60-61-62-64-65-66-70,H

Maitin

MAITZ, Don
American 20c.
NV

Maitz

MAJA EVANS, G.
English 20c.
LEX

MAJERS, Hélène
French late 20c.
EI79,GR70-76

MAJEWSKI, G.
Polish mid 20c.
GR57

MAJEWSKI, Lech
Polish 20c.
POS

MAJO, W. M. de
English mid 20c.
GR54-56-62-63

MAKI, Gunji
Japanese mid 20c.
GR65

MALAVIELLE, Louis
see
DIL, S. M.

MALCLÈS, Jean Denis
French 1912-
B,GR52 thru 56-58,LEX,POS

Jean Denis Malclès

MALCOLM, James Peller
Anglo/American 1767-1815
B,D,F,H

MALCOLM, O. C.
American 19/20c.
R

[signature: O.C. Malcolm]

MALCOURONNE, Kathleen Delacour
Canadian 1885–
H

MALCYNSKI, Elizabeth P.
American 1955–
Y

MALECKI, A. W.
Austrian 20c.
LEX

MALEVICH, Kasimir
Russian 1878–1935
B,DA,H,POS

[signature: KM.]

MALFONEV, J.
American late 10c.
LEX

MALISH, Miro
Canadian late 20c.
GR81-82-85

MALLARD, Louis(e)
American 1900–
H,M

MALLEK, Waldemar
German mid 20c.
GWA,LEX

[signature: symbol]

MALLET, Beatrice
English 20c.
M

MALLON, Grace Elizabeth
American 1911–
H,M

MALLY, Anton
Austrian early 20c.
LEX

MALM, Gustav N.
Swedish/American 1869–
F

MALMAN, Christina
American 20c.
M

MALOY, Lois
American 20c.
M

MALTESTE, Louis
French 19/20c.
FS

[signature: LouisMalteste]

MALVERN, Corinne
American –1956
H,M

MALYUTIN
Russian early 20c.
POS(pg.139)

MAMBOUR, Auguste
Belgian 1896–1968
B,H,POS

[signature: Mambour]

MAN RAY
See
RAY, Man

MANCEAU, Patrick de
French 1901–
B

MANCEAU(X), Hughes
French 1895–
B,M

MANCHE
German? 20c.
CP

MANCINI, John
American 1925–
H

MANDEL, Saul
American late 20c.
GR54-55-58-60 thru 67-70-71-72-75-82

[signature: MANDEL]

MANDIN, Richard
French 1909–
B

MANDLICK, Auguste
Austrian 1860–
B

A. M.

MANDZJUK, Peter
Swiss late 20c.
GR77–85

MÁNES, Josef
Czechoslovakian 1820–71
B,H,LEX,TB

JM

MANESSIER, Alfred
French 1911–
B,DA,DES,H

Manessier

MANET, Edouard
French 1832–83
APP,B,CP,DA,H,LEX,M,PC,POS,R

Manet

MANFREDINI, Enzo
Italian 1889–1922
B,H

MANGOLD, Anton
Austrian 1863–1907
B,LEX,TB

am

MANGOLD, Burkard
Swiss 1873–1951
B,LEX,POS,POST

MANIATTY, Stephen George
American 1910–
F,H,M

S.G.MANIATTY

MANKES, Jan
Dutch 1889–
B

MANLEY, Elizabeth A.
Canadian 1938–
H

MANLEY, George P.
English 19/20c.
LEX,TB

MANLY, Charles MacDonald
Canadian 1855–1924
H,M

MANNSTEIN, Coordt von
German mid 20c.
GR64–65

v *Mannstein*

MANOIR, Irving K.
American 1891–
B,F,H,M

MANSFIELD, Blanche McManus
see
MC MANUS, Mansfield Blanche

MANSFIELD, James Carroll
American 1896–
H

MANSFIELD, Louise Buckingham
American 1876–
B,H,I,M

MANSO, Leo
American 1914–
F,H,PAP

MANSO

MANTA, Abel
Portuguese 1888–
H

MANTA, João Abel Carneiro de Moura
Portuguese 1928–
GR83,H

MANTA, Maria Clementina Vlas-Boas Carneiro
de Moura
Portuguese 1898-
H

MANTEGAZZA, Giacomo
Italian 1853-1920
B,H,LEX,TB

MANTELET, Albert Goguet
French 1858-
B,LEX,TB

MANTELET-MARTEL, André
French 1876-
B

MANTELL, Charlotte
American 20c.
M

MANTELLI, Emilio
Italian 1884-1918
H

EM

MANTEUFFEL
Polish early 20c.
POS

MANTON, G. Greenville
English 1855-1932
M

GREENVILLEMANTON
1910

MANUEL, Emmanuel Adsuara
Spanish 1918-
B

MANWARING, Michael
American late 20c.
GR77-82

MANZEL, Ludwig
Prussian 1858-1936
AN,B,LEX,TB,VO

L.M.

MANZI, Riccardo
Italian 1913-
GR52-54- thru 58-60 thru 69-71,H

MAPLESDEN, Gwendoline Elva
American 1890-
F,H,M

MAQUEDA, António Martin
Portuguese 1900-
H

MARAIS, Adolphe Charles
French 1856-
B,H,LEX,TB

MARANDAT, Henri de
French -1914
B

MARANOVA, Jarmila
Czechoslovakian mid 20c.
GR56

MARBER, Romek
English mid 20c.
GR63-64-65-67

MARCELIN, (Emile)
see
PLANAT, Emile

MARCH, Herrat
Canadian 19?/20c.
H

MARCH, Phillip
American mid 20c.
GR55-58

MARCHAND, André
French 1905/10-
B,DES,H,LEX,POS

andremarchand

MARCHAND, John Norval
American 1875-1921
H,MUN6/03

JNMARCHAND

MARCHETTI, Lou
 Italian/American mid 20c.
 PAP

[signature: Marchetti]

MARCHETTI, Ludovico
 Italian/French 1853-1909
 B,H,L,LEX,TB

[signature: Marchetti]

MARCHIORI, Carlos
 Canadian 1937-
 H

MARKS, (Prof.) Gerhard
 German 1889-
 G,H,PC

[signature: monogram]

MARCO, Phil
 American late 20c.
 GR64-82-85

MARCOUSSIS (MARKUS or MARKOUS), Louis
 Polish/French 1878-1941
 B,BI,DRA,FS,H,PC

MARKOUS

MARCUS, Nathan
 American 1914-
 H,M

MARCUS, Otto
 German 1863-1902
 B,VO,M

[signature: OM]

MARCZYNSKI, Adam
 Polish 1908-
 B,H

MARDON, Allan
 Canadian 1931-
 F,GR57-58,H,Y

[signature: MARDON]

MARDON, John
 Canadian 20c.
 H

MARE, André
 French 1885-
 B,LEX,TB,VO

[signature: AM.]

MARE, Tiburce de
 French 1840-1900
 B,LEX,TB

MAREK, Josef Richard
 Czechoslovakian 1883-1951
 LEX,VO

MAREK, Hans
 Austrian 20c.
 LEX

MARFURT, Léo
 Swiss/Belgian 1894-1977
 POS

[signature: marfurt]

MARGARITIS, Florent
 American 20c.
 M

MARGETSON, William Henry
 English 1861-1940
 B,EN,H,LEX

[signature: W.H.MARGETSON.]

MARGGRAFF, Gerhard
 German 1892-
 LEX,VO

MARGOLIS, Michael
 English mid 20c.
 GR60-61-62-66

[signature: margolis]

MARI, Enzo
 Italian 1932-
 GR64-69 thru 74

MARIANI
 see
 MOOSBRUGGER, Joseph

MARIE, Adrien Emmanuel
 French 1848-91
 B,BAA,H,LEX,TB

MARIN, Augusto
 Puerto Rican 1921-
 H

MARINI, Phil
 American mid 20c.
 PAP

MARINSKY, Harry
 Anglo/American 1909-
 H,M

MARKEN, Joslin
 Canadian 20c.
 H

MARKEVICH, Boris Anisimovich
 Russian 1925-
 H

MARKEY, Warren
 American 20c.
 C

MARKHAM, Kyra
 American 1891-
 H,M

MARKL, Paul
 Austrian 20c.
 LEX

MARKOUS
 see
 MARKUS, L. C. or MARCOUSSIS, Louis

MARKOVICH, Eleazar (Lazar)
 Russian 1890-1941
 CP,GMC,H,LEX,PC,PG,POS,TB,VO

MARKOW, Jack
 Anglo/American 1905-
 CAV,H,M

MARKS, Henry Stacy
 English 1829-98
 B,H,POS,POST,TB

MARKS, William
 American -1906
 F,I,M

MARKUS, Géza
 Hungarian 1872-1912
 LEX,TB

MARKUS, Ludwig Casimir
 see
 MARKOUS or MARCOUSSIS, Louis

MARLATT, H. Irving
 American 1867?-1929
 H,M

MARLETTO, Carlos Joseph
 Italian/American 1909-
 H,M

MARLIAVE, François Marie Leon de
 French 1874-
 B

MARLIN, Hilda Gerarda van Stockum
 Dutch/American 1908-
 H,M

MAROKVIA, Artur
 German/American 1909-
 H

MAROLD, Louis (Ludwig?)
 French -1899
 H

MAROLD, Ludwig (Ludek)
 Czechoslovakian/French 1865-98
 B,H,L,TB

MARONIEZ, Georges
 French 1865-
 B,LEX,TB

MAROTO, Esteban
Spanish 20c.
NV

ESTEBAN MAROTO.

MARQUES, Benjamin Goncalves
Portuguese 1938–
H

MARQUES, Bernardo Loureiro
Portuguese 1889–1962
H,M

MARQUES (MARQUES-BACH), Joan
Spanish late 20c.
GR83-84-85

Marquès

MARQUES, Ofélia
Portuguese 1906–52?
H

MARQUET, Pierre Albert
French 1875–1947
AN,B,DES,DRA,H,LEX,M,PC,VO

marquet

MARR, Carl
American 1858–
B,F,H,I,M

CM

MARRIOTT, Pat
English mid 20c.
GR57

MARRYAT, Francis Samuel
English 1826–55
H

MARS, Ethel
American/French 20c.
B,F,H,M

MARS, Irma Bratton
American 1901–
H,M

MARS, Reginald Degge
American 1901–
H,M

MARS, Witold T.
Polish/American 1908–
H

MARSCHNER, Arthur A.
American 1884–
F,H,M

MARSH, James
English late 20c.
EI79,GMC,GR70-78-79-80-82 thru 84

James Marsh

MARSH, Lucile Patterson
American 1890–
F,H,M

MARSH, Norman
American 20c.
H,M

MARSH, Reginald
American 1898–1954
APP,B,CAV,CC,F,H,HA,LEX,PC,SO,Y

Reginald Marsh

MARSH, Sam
American 20c.
H

MARSHALL, Benjamin
English 1767–1835
B,DA,H,M

MARSHALL, Bruce
American 1929–
H

MARSHALL, Francis
English 20c.
ADV,GR52 thru 55

F M

MARSHALL, Frank Howard
American 1866–1930
B,BAA,F,H,M

MARSHALL, Margaret Jane
 American 1895-
 F,H,M

MARSHALL, Robert
 Australian late 20c.
 GR79-81-82

RM

MARSTRAND, Vilhelm Nikolaj
 Danish 1810-73
 B,H,SC,M

MARTEN, Thomas Henry Oake
 Canadian 1880-1950
 H

MARTENSEN, Olle
 Danish mid 20c.
 GR53

MARTI, Bas
 see
 BAS, Marti

MARTI, Walter
 Swiss mid 20c.
 GR60-64

MARTIN, Alfred
 Belgian 1888-
 B

MARTIN, André
 French mid 20c.
 GR64

MARTIN, Charles
 French -1934
 AD,B,LEX,M,ST,VO

MARTIN, Charles Edward
 American 1910/11-
 EC,GMC,H,PLC

MARTIN, David Stone
 American 1913-
 GR52-54 thru 58,H,IL,LEX,M,PAP

MARTIN, Fletcher
 American 1904-79
 APP,H,M

MARTIN, Georg
 German 1875-
 B

MARTIN, H. B.
 American 20c.
 M

MARTIN, Homer Dodge
 American 1836-97
 B,BAA,D,F,H

MARTIN, Jerome
 American 1926-
 F,GR60-61-62-64 thru 69-71,Y

MARTIN, John
 Canadian late 20c.
 GR79 thru 83,H

MARTIN, John
 American 1946-
 F,Y

MARTIN, John
 English 1789-1854
 BA,DA,H

MARTIN, Nancy Yarnall
 American 1949-
 F,Y

MARTIN, Philip Lincoln
 American 1893-
 H,M

MARTIN, Rene
 Franco/American 20c.
 H

MARTIN, Roger H., Jr.
American 1925–
H

MARTIN, Stefan (Steven?)
American 1936–
F,GR79,H,Y

MARTIN, Thomas Mowrer
Canadian 1838–1934
BAA,H

MARTIN, Tom
American 1943–
H,M

MARTINDALE, Francis
English late 10c.
LEX

MARTINEAU, (Lieut.)
Canadian ac. 1876
H

MARTINET, Milo
Belgian early 20c.
POS

MARTINEZ, John
American 20c.
GR85,H

MARTINEZ, Olivio
Cuban 20c.
POS

MARTINEZ, Raul
Cuban 1927–
B,CP,POS

MARTINEZ, Xavier
Mexican/American 1874–
B,F,H

MARTINEZ, Xavier (Orozco)
American 1869–1943
H,M

MARTINEZ DEL BARRANCO, Bernardo
Spanish 1738–91
B,H

MARTINEZ ECHEVERRIA, Enrique
Spanish 1884–
B

MARTINI, Herbert E.
American 1888–
F,H,M

MARTINOT, Pierre
American mid 20c.
PAP

MARTINS, Alfredo Carvalho
Portuguese 1939–
H

MARTINS, Armando Tavares Alves
Portuguese 1922–
H

MARTINS, Humberto
Portuguese 1896–
H

MARTINS, João
Portuguese 1932–
H

MARTUCCI, Stan
American late 20c.
GR81–85

MARTY, (probably André Edouard)
French early 20c.
ADV,M

MARTY

MARTY, André Edouard
French 1882–1974
B,POS,ST,VC

A.E.MARTY - 1913

MARTYN, Ferenc
Hungarian 1899–
B

MARTYN, John
English –1828
B,H

MARTZ, Lukas
Swiss mid 20c.
GR54

MARVILLE, Charles
French 19c.
B,LEX,TB

MARVY, Louis
French 1815–50
B,H,LEX,TB

ML

MARX, Enid
English mid 20c.
GR52

MARX, Marcia
American late 20c.
GR82

MAS, Emile
French late 19c.
B,LEX

MASAFUSA
Japanese ac. mid 18c.
B,H

MASEK, Vaclav
Czechoslovakian 1893-
LEX,VO

MASEREEL, Frans Lauret
Belgian 1889-1971
AD,B,H,LEX,PC,S

MASLINE, Camille
American 1906-
M

MASON, Eleanor Iselin
American ac. 1925
H,M

MASON, Frank Henry
English 1876-1965
B,H,M,POST

MASON, Frederick
English 19/20c.
BK

MASON, George F.
American 20c.
M

MASON, Gibbs
American early 20c.
GMC

MASON, Robert
English 1946-
EI79,H

MASON, Robert Lindsay
American 1874-
B,F,M

MASON-GROSSE, Helene
American 1880-
LEX

MASSACRIER, Jacques
French mid 20c.
GR61-62-67-68

MASSAQUER, Edmond Joseph
Canadian 1875-1929
H

MASSÉ, Bob
Canadian 20c.
CP

MASSEY, John
American mid 20c.
GR60-61-62-64 thru 71-73-74-78,POS

MASSIAS, Georges
French late 19c.
ADV,B,TB

MASSIOT, George (BROWN, George Massiot)
American early 20c.
ADV

MASSON, André
French 1896–
APP,B,DES,DRA,DRAW,GMC,H,PC,POS

MASSON, Margaret
Canadian/American 20c.
H,M

MASSONET, Armand
Belgian 1892–
B,POS

MASTERS, Frank B.
American 1873–
B,F,M

MASTERSON, James W.
American 1894–1970
H

MASUDA, Tadashi
Japanese mid 20c.
GR57–60 thru 63–65–66–67

MASUTTI, Antonio
Italian 1810/13–95
B,H

MASUYUKI
Japanese ac. 1810
H

MATALONI, Giovanni M.
Italian 19/20c.
AN,CP,LEX,POS

MATANIA, Eduardo
Italian 1847–1929
B,H

MATANIA, Fortunio
Italian 1881–
B,H,LEX,TB,VO

MATANIA, Ugo
Italian 1888–
B,H

MATÉ, Andras
Hungarian 1921–
GR65–66–68,H,POST

MATEJKO, Theodor
German early 20c.
POS

MATELDI, Brunetta
Italian mid 20c.
GR53–60–66–71

MATELKA, Jindrich
Czechoslovakian 20c.
LEX

MATHER, Rudolf
Austrian 1891–
LEX,VO

MATHES, Harry
American ac. early 20c.
HA,LEX

MATHESON, Audrey
Canadian 19/20c.?
H

MATHESON, Frederik
Norwegian mid 20c.
GR55

MATHEWS, Ferdinand Schuyler
American 1854–1938
B,F,H,I

MATHEWS, Lucia Kleinhaus
American 1882–
F,H,M

MATHEWS, Tom
Canadian 20c.
H

MATHIESEN, Egon
Danish mid 20c.
GR 56-62

Egon Mathiesen

MATHIEU, Dora
see
DORA

MATHIEU, Georges
French 1921-
CP,DRAW,H,POS

MATHIEU, Hubert Jean
American 1897-
B,F,H,M

MATHIS, F.
French 19c.
B

MATISSE, Henri Emile Benoit
French 1869-1954
ADV,AN,APP,B,DA,DES,DRA,DRAW,GMC,
H,LEX,PC,POS,POST,VO

matisse

MATORA, Ôishi
Japanese 1794-1833
B,H

MATOS, Roland H.
Portuguese mid 20c.
GR 60

MATSUMOTO, Ukichi
Japanese mid 20c.
GR 65-67-74

MATSUYA HEISABURÔ
see
JICHOSAI

MATTA, Roberto S. A. M. Echaurren
Chilean 1912-
B,DA,DRA,DRAW,GMC(p1.204),H

MATTEI, Clarence R.
American 20c.
M

MATTEI, Virgilio P.
American 1898-
F,H,M

MATTELSON, Marvin
American late 20c.
GR 74-75-76-79 thru 82-84

MATTELSON

MATTER, Herbert
Swiss/American 1907-84
ADV,CP,GR 52-53-55-56-57,H,M,POS,POST

herbert matter

MATTERNES, Jay Howard
American 1933-
H

MATTESON, Bartow van Voorhis
American 1894-
F,M

MATTHAEI, Erwin
German 20c.
LEX

MATTHES, Ernest
German 1878-1918
B,LEX,TB

MATTHEWS, Anna Lou
American 19/20c.
B,F,H

MATTOCKS, Muriel
American -1947
F,M

MATULAY, Laszlo
Austrian/American 1912-
H

Laszlo Matulay

MATUSM, Don
American mid 20c.
ADV

MATYAS, Gaal
 Hungarian mid 20c.
 GR61

MATYSIAK, Walter
 Austrian 20c.
 LEX

MATZKE, Albert
 American 1882–
 B,F,M

MAUCH, Carl
 German/American 1854–1913
 I,M

MAUCH, Richard
 German/Austrian? 1874–1921
 B,LEX,TB

R.M.

MAUD, W. T.
 English 1865–1903
 B,H

MAUGHAN, William
 American 1946–
 CON

MAUGHAN

MAULL, Margaret Howell
 American 1897–
 F,M

MAURER, Sascha A.
 German/American 1897–1961
 GMC,H,M,POS

SASCIIA
MAURER

MAURER, Willibald
 German late 19c.
 LEX

MAURUS, Edmond
 French early 20c.
 POS

MAURZEY, Merritt
 American 1897/98–1975
 H

MAUTNER, Stefan
 Austrian 1877–
 LEX,VO

MAUVAIS, A.
 American ac. late 18c.
 B,F,H,I

MAUZAN, L. Achille
 Italian early 20c.
 AD,CP,PG,POS

MAUZAN

MAVERICK, Peter Rushton
 American 1755–1811
 B,D,F,M

MAVIGNIER, Almir da Silva
 Brazilian 1925–
 B,H,POS,POST

MAVRINA, Tatjana Alexeyevna
 Russian 1902–
 B,H

MAWICKE, Tran J.
 American 1911–
 F,H,Y

MAWICKE

MAX, Gabriel Cornelius Ritter von
 Czechoslovakian 1840–1915
 BA,BAA,H,LEX,TB

G. Max

MAX, Peter
 German/American 1937–
 ADV,CP,F,GR64-65-70-71,74,H,POS,POST

MAx

MAXEY, Betty
 American 20c.
 H

MAXWELL, Donald
 English 1877–1936
 M,VO

DM

MAXWELL, John Alan
American 1904–
F,H,M,PAP

John Alan Maxwell

MAXWELL, Perriton
American 20c.
M

MAY, Betty
Canadian 20c.
M

MAY, Elizabeth M. (Messiter)
American 1913–
H

MAY, F. S.
English early 20c.
ADV

MAY, Philip William (Phil May)
English 1864–1903
B,CAV,EC,F,GMC,H,POS,TB

MAY-HÜLSMANN, Valerie
German 1883–
B,LEX,TB,VO

MAYAKOVSKY, Vladimir
russiam 1893/94–1930
CP,PG,POS

MAYAN, Earl
American mid 20c.
PAP,M

MAYER, Fred A.
German/American 1904–
H,M

MAYER, Hansjörg
German early 20c.
POS

MAYER, Heinrich
German 20c.
LEX

MAYER, Heinz
German 19c.
LEX

MAYER, Henri
French 1844–99
B,H

MAYER, Henry (Hy)
German/American 1868–1954
B,CAV,EC,F,HA,M,R

MAYER, Lukas
German early 20c.
POS

MAYER, Mercer
American 1943–
F,GR76,H,Y

MAYER, Roger
Swiss mid 20c.
GR53–56–57–60–61–72

Roger Mayer

MAYER, Rudolf
Austrian 1854–
B

MAYER MARTON, Georg
Austrian 1897–
B,POS,M

MAYERHOFER, Johannes
Austrian 1859–1925
B

MAYERHOFER, Theodor
Austrian 1855–1941
B,H,TB

MAYERS, George
American mid 20c.
PAP

MAY(E)S, Paul Kirkland
American 1887/88–1961
H,M

MAYHEW, George
English mid 20c.
GR 52–53–63

MAYHEW, Richard
American 1924–
H

MAYNARD, George Willoughby
American 1843–1923
B,BAA,F,H,I,M

[signature: Geo W Maynard 74, Maynard]

MAYNARD, Richard Field
American 1875–
F,H,S,M

MAYO, Reba Harkey
American 1895–
H,M

MAYR, Heinrich
German 19/20c.?
LEX,M?

MAYRL, Willy
Austrian 19c.
LEX

MAYRS, Bill
Canadian mid 20c.
GR 64

MAYS, Maxwell
American 1918–
H

MAYS, Victor
American 1927–
H

MAZKER, Fred
German 20c.
LEX

MAZZA, Aldo
Italian 1880–
B,H,POS,VO

[signature]

MAZZOLARI, Ugo
Italian 1873–
H

MC AFEE, Ila Mae (Turner)
American 1897/1900–
H,M

MC ARDLE, Jay
American 19/20c.
H,PC

MC ARDLE, Jim
American 1899–
H

MC BRIDE, Henry
American 20c.
H

MC BRIDE, James Joseph
American 1923–
F,H

MC BURNEY, James Edwin
American 1868–1955
F,H

MC CAFFERY, Janet
American 20c.
H

MC CALEB, Fred F.
American 20c.
M

[signature: F. McCaleb]

MC CALL, Robert Theodor
American 1919–
F,H,IL,Y

[signature: McCall]

MC CALLUM, Corrie
American 1914–
H

MC CALLUM, Robert Heather
American 1902–
F

MC CANN, Gerald Patrick
 American 1916–
 CON

MC CANNA, Clare
 American 20c.
 H

MC CARTER, Henry Bainbridge
 American 1866–1942
 B,F,H,HA,I,LEX,M,VO,Y

MC CARTHY
 American ac. 1920–40
 PE

MC CARTHY, Clarence J.
 American 1887–1953
 F,H,M

MC CARTHY, Frank C.
 American 1924–
 AA,CON,H,IL,PAP

MC CARTHY, Jane
 American 20c.
 M

MC CAY, Winsor Zenic (Silas)
 American 1871–1934
 ADV,B,CAV,CC,EC,H,LEX,PE

MC CHRISTY, Quentin C.
 American 1921–
 H

MC CLAY, Robert
 American 20c.
 CP

MC CLEARY, Nelson
 American 1888–
 B,H,M

MC CLELLAND, John
 American 1919–
 IL

MC CLOSKEY, (John) Robert
 American 1914–
 H,M

MC CLURE, Henrietta Adams
 American –1946
 H,M

MC COLLUM, James Herman
 American 1904–
 H,M

MC COMB, Marie Louise
 American 20c.
 F,H,M

MC COMBS, Solomon
 American 1913–
 H

MC CONNELL, Gerald
 American 1931–
 F,PAP,Y

MC CONNELL, Jean
 American 20c.
 M

MC CONNELL, W.
 English –1867
 H

MC CORD, Peter B.
 American –1908
 I

MC CORD, William A.
 American –1918
 I

MC CORMICK, A. D.
 Canadian ac. 1897
 H

MC CORMICK, Arthur David
English 1860–1943
B,EN,H,M

MC CORMICK, Howard
American 1875–1943
B,F,H,I,M

MC CORMICK, Jo Mary
American 1918–
H

MC CORMICK, Katherine Hood
American 1882–1960
F,H,M

MC COSH, David John
American 1903–
F,H

MC COUCH, Gordon Mallett
American 1885–1962
F,H,M

MC COUN, Alice Louise Troxell
American 1888–
H,M

MC CRAY, Francis
American 20c.
M

MC CREA, Harold Wellington
Canadian 1887–1969
H

MC CREERY, Frank Root
American –1957
F,H

MC CULLOUGH, Lucerne
American 1915–
H,M

MC CULLOUGH, Suzanne
American 1915–
H,M

MC CULLY, Emily Arnold
American 1939–
H

MC CURRY, Charles Ray
American 1924–
H

MC CUTCHEON, John Tinney
American 1870–
CAV,CC,EC,F,GMC,H,I,LEX

MC CUTCHEON, S. G.
American ac. 1878–83
BAA,M

MC DANIEL, Jerry W.
American 1935–
GR66–67,IL

MC DERMOTT, Gerald
American 1941–
H

MC DERMOTT, Jessie
American ac. late 19c.
PE

MC DERMOTT, John R.
American 1919–
H,IL,LEX,PAP

MC DONALD, G. L.
American 1896–
H,M

MC DONALD, James
Canadian ac. 1876
H

MC DONALD, Mary
American 19?/20c.
I

MC EWAN, Keith
Dutch late 20c.
EI79,GR83

MC EWEN, Rory
English 1932–
H

MC FADDEN, James L.
American 20c.
M

MC FALL, Jay Vaughn
American 1878-1912
I,M

MC GEE, Olivia Jackson
American 1915-
H

MC GILL, Leona Leti
American 1892-
H

MC GINNIS, Robert E.
American 1926-
F,IL,PAP,Y

Robert McGinnis (signature)

MC GONEGAL, Maurice
Irish 20c.
M

MC GOVERN, John T.
American 20c.
M

MC GRATH, Anthony A.
American 1888-
H,M

MC GRATH, Joe
English mid 20c.
GR61

MC GRAW, Edgar
American 20c.
M

MC GREGOR, Hone
Canadian 1920-
H

MC HUGH, Arline B.
American 1891-
F,H,M

MC ILHENNY, Charles Morgan
American 1858-1904
BAA,F,I,M

MC ILVAIN, Duff
American 1918-
H,M

MC ILWRAITH, William Firsyth
American 1867-1940
H,M

MC INTOSH, Frank
see
MAC INTOSH, Frank

MC INTYRE, Kevin
American 20c.
H

MC KAY, Barry Kent
Canadian 1943-
H

MC KAY, Donald A.
American 20c.
H,M

MC KAY, Dorothy
American 1904-74
EC

Dorothy McKay (signature)

MC KAY, Edward R.
American 20c.?
H

MC KAY, James G.
Canadian ac. 1873-85
H

MC KAY, R. H.
Canadian ac. 1858
H

MC KEE, David
English late 20c.
GR67-68-69-77-80-82

MC KEE, Donald
American 1883-
CAV,F,H,LEX,M

DONALD McKEE (signature)

MC KEE, John Dukes
American 1899-
F,M

MC KELLER, Duncan A.
Canadian -1903?
H

MC KENZIE, Keith
English mid 20c.
GR54

MC KEOWN, Wesley Barclay
American 1927–75
F,Y

MC KERNAN, Frank
American 1861–1934
F,H,M

MC KIE, Roy
American 1921–
GR53-55-61,H

RM

MC KIM, William Wind
American 1916–
H,M

MC KINNEY, Gerald T.
American 1900–
F

MC KINNON, Archibald Angus
see
MAC KINNON, Archibald Angus

MC KNIGHT, Ninon
see
MAC KNIGHT, Ninon

MC KNIGHT KAUFFER, Edward
see
KAUFFER, Edward McKnight

MC LACHLIN, Steve
American 20c.
H

MC LANE, Myrtle Jean
American 1878–
CEN5/12,H,I,M

M·JEAN McLANE

MC LAREN, Alex
Canadian 1892–
H

MC LAREN, J. W.
Canadian 1896–
H,M

MC LAREN, Norman
Anglo/Canadian 1914–
EC,H

MC LEAN, Olive Gale
American 20c.
M

MC LEAN, Thomas W.
Canadian 1881–1951
H,M

MC LEAN, Wilson (L.)
Scots/American 1937–
F,GR70-72-74-75-77-78-80-81-82-85,P,Y

WILSON McLEAN

MC LENAN, John
American 1827–66
D

MC LEOD, Ronald Norman
American 1897–
H,IL,M

RONALD McLEOD

MC MACKEN, David B.
American 20c.
GMC,GR78,H,IL,M

McMacken

MC MAHON, Franklin
American 1921–
F,GR58-60-61-63-77-82,IL,Y

McMahon

MC MAHON, Mark Andrew
American 1950–
F,Y

MC MANUS, George
American 1884–
CAV,F,M

GEO McMANUS

MC MANUS, Mansfield Blanche
American 1870-
F,H,I,M,POS,R

MC MASTER-CHRISTIE
English mid 20c.
GR61

MC MEIN, Neysa Moran (Baragwanath)
American 1890-1949
ADV,F,GMC,H,I,IL

MC MILLAN, Constance
American 1924-
H

MC MILLEN, Jack
American 1910-
H,M

MC MORRIS, Le Roy Daniel
American 1893-
B,H,I,M

MC MULLAN, James
American 1934-
GR66 thru 77-79-82 thru 85,H

MC MULLEN, Jim
American mid 20c.
GR61-65-80

MC NAIR, Herbert J.
Scots ac. 1890s
GA,LEX,POS

HERBERT McNAIR

MC NALLY, Edwin Dean
Canadian 1916-71
H

MC NAMARA, Lena Brooke
American 1891-
H,M

MC NAUGHT, Harry
Scots/American 20c.
H

MC NAUGHTON, Colin
English late 20c.
EI79

MC NETT, Elizabeth Vardell
American 1896-
H

MC NETT, William Brown
American 1896-1968
H,M

MC NEVIN, John
American ac. mid 19c.
D

MC PHARLIN, Paul
American 1903-48
H,M

MC SWEENEY, Tony
English late 20c.
EI79

MC VICKAR, Harry Whitney
American -1905
I

MC VICKAR, Henry
American 19/20c.
CE12/97,R

MC VICKER, Charles Taggart
American 1930–
F,H,Y

MEAD, Ben Carlton
American 1902–
H,M

MEAD, Paul Edward
American 1910–
H,M

MEADE, John M.
English mid 20c.
GR52

MEADOWS, Joseph Kenny
English 1790–1874
B,H,M

MEANS, Elliott Anderson
American 1905–62
H,M

MEARS, W. E.
American early 20c.
HA10/03,*

MECACHIS (called)
see
SAENZ HERMUA, Eduardo

MECINA-KRZESZ, Jozef de
Polish/French 1860–
LEX,TB

MEDDLEY, Thomas W.
Canadian ac. 1832
H

MEDGES (MEDGYÈS), Ladislaw (László)
Hungarian/American 1892–
B,GMC,LEX,M

M·

MEDINA VERA, Inocencio
Spanish 1876–1917
B

MEDLEY, Robert
English 1905–
B,G54,H,M

MEDNIS, Otto Eduarda
Latvian 1925–
LATV

MEDOVIĆ, Celestin
Austrian 1859–1920
B,LEX,TB

MEDVEY, Lajos (Ludwig)
Hungarian 1882–
B,VO

MEEK, John
Anglo?/Venezuelan mid 20c.
GR56–57–71

MEEKER, Edwin J.
American 19c.
CWA

MEESE, James
American mid 20c.
PAP

MEGARGEE, Alonzo (Lon)
American 1883/91–1960?
H

MEGARGEE, Lawrence Anthony
American 1900–
H

MEGGENDORFER, Lothar
German 1847-1925
B,EC

MEGONI, S.
Italian 20c.
LEX

MÉHEUT, Mathurin
French 1882-1959
B,LEX,M

MEHRLE, Else
German 1867-
B,LEX,TB

MEID, Hans
German 1883-1957
LEX,PC,TB,VO

MEIERHOFER, Erwin
Swiss mid 20c.
GR60-61-63-64-65

MEIER-NIEDERMEIN, Ernst
German 1869-
B

MEINARDUS, D.
German ac. early 20c.
LEX

MEINEL, Harold
American 20c.
M

MEINSHAUSEN, George F. E.
German/American 1855-
B,F,H,I,M

MEISEL, Paul
American late 20c.
GR82

MEISERT, Hermann
German 20c.
LEX

MEISSL, August Ritter von
German 1867-
LEX,TB

MEISSNER, Alfred
American 1877-
F

MELCARTH, Edward
American 1914-
B,H,M

MELCHER, Bertha Corbett
American 1872-
B,F,H

MELIDA Y ALINARI, Don Enrique
Spanish 1834/37-92
B,H,TB

MELIKIAN, Mary
American 1927-
H

MELIN, John
Swedish 1921-
GR55-56-57-60-65,H

MELKA, Vince (Vincenz)
Bohemian 1834-1911
B,LEX,TB

MELKUS, Dragan
Yugoslavian 1864-1917
B

MELLO, Thomaz, José de (Tom)
Portuguese 1906-
GR58,H

MELTZOFF, Stanley
American 1917-
F,IL,M,PAP,Y

MELUZZO
Italian mid 20c.
GR58

MELVIN, Grace Wilson
 Scots/Canadian -1977
 H

MENABONI, Athos Rodolfo
 Italian/American 1895-
 H,M

MENDES, A. Lopes
 Portuguese 19c.
 H

MENDEZ, Leopoldo
 Mexican 1902/03-
 H,M

MENDEZ BRINGA, Narciso
 Spanish 1868-
 B

MENESES, Manuel de Macedo
 Portuguese 1839-1915
 H

MENGIN, Auguste Charles
 French 1853-1933
 B,M

MENSCHENDÖRFER, Wolfgang
 Romanian 20c.
 LEX

MENTE, Charles
 American 1857-1933
 BAA,F

MENTEL, Lillian A.
 American 1882-
 F,H,M

MENUSSI, Zila
 Israeli mid 20c.
 GR65

MENUSY, Cyla
 Israeli mid 20c.
 GR66-71

MENZ, Willy
 Guatemalan/German 1890-
 B,LEX,VO

W.M.

MENZEL, Adolf Friedrich Erdmann
 German 1815-1905
 B,DA,EC,H,LEX,PC,S

Ad. Menzel [signature]

MENZIES, Sheena Lilian
 Canadian 1921-
 H

MERCER, Barbara
 Canadian 20c.
 H

MERCIER, A. (Jean A.)
 French early 20c.
 CP,PCS

MERCK, H.
 German 19/20c.
 LEX

MEREDITH, Alice Adkins
 American 1905-
 H

MÉRIDA, Carlos
 Guatemalan/Mexican 1891/93-
 B,H,M

CARLOS
MERIDA
1965

MERKEL, Carl Gottlieb
 German 1817-97
 B,LEX,TB

MERKEL, Georg
 Austrian 1881-
 B,H,M

MERKEL, Paul
 Swiss mid 20c.
 GR60

MERKEL, Walter M.
 American 1886-
 H

MERKLING, Erica
 Austrian/American 20c.
 GR56-58,H

MERNSKIOLD, Erik
 Norwegian early 20c.
 POS

MERO, Lee
 American 1885–
 F

MERRICK, James Kirk
 American 1905–
 H,M

MERRICK, William Marshall
 American 1833–
 H

MERRILL, Frank Thayer
 American 1848–
 B,F,I,M

MERRILL, Marion
 American 20c.
 M

MERSON, Luc Olivier
 French 1846–1920
 B,H,TB

MERTÉ, Heinrich
 German 1838–
 B,LEX,TB

MERTENS, Charles
 Belgian 1865–1919
 B,H

MERVELDT, Hans Hubertus Graf von
 German? 20c.
 LEX,M

MERWART, Paul
 Polish/French 1855/62–1902
 B,H,TB

MERWIN, Decie
 American 1894–
 H,M

MESECK, Felix
 Polish 1883–1955
 B,LEX,TB,VO

MESEROLE, Harriet
 American early 20c.
 VC

MESNEL, A.
 French 19c.
 LEX

MESQUITA, Victor
 Portuguese 1939–
 H

MESSMER, Charles
 Swiss 1893–
 B

MESTRES, (I. Ono) Apeles
 Spanish 1854–1936
 B,EC,VO

MESUL, V. K.
 French 19/20c.
 LEX

METCALF, Willard Leroy
 American 1858–1925
 B,F,H,I,M

METCALFE, Howard Arlington
 American 1893–
 H,LEX,M

METEYARD, Thomas Breford
 American 1865–1928
 B,F,I,M,R

METH, Harry
 American 1916–
 M

METHER-BORGSTRÖM, Helge
 Finnish 20c.
 LEX

METHFOSSEL, Herman
 American 1873-1912
 I,M

MÉTIVET, Lucien Marie François
 French 1863-1930
 B,CP,GMC,L,LEX,POS,POST,R

LucienMÉTIVET.

METLICOVITZ, Leopold
 Italian 1868-1944
 AD,CP,H,LEX,MM,PG,POS

METTAIS, Charles Joseph
 French 19c.
 B

METTENLEITER, Johann Michel
 German 1765-1853
 B,H,LEX,TB

METTES, Frans
 Dutch mid 20c.
 GR52-53-54-60-68

METZ, Gustav
 German 1817-53
 B,H

METZL, Ervine
 American 1899-
 FOR,H,M

MEULEN, Edmond van der
 Flemish 1841-1905
 B,H

MEUNIER, Georges
 French 1869-
 B,CP,GMC

MEUNIER, Henri Georges Jean Isidore
 Belgian 1873-1922
 AN,B,CP,GA,MM,POS,POST

MEUNIER, Villes Alexis
 French 1863-
 LEX

MEURER, Albert John Theodore
 American 1887-
 H,M

MEXIAC, Adolfo (Alfonso)
 Mexican 1927-
 LEX,VO

MEYER, Charles
 Brazilian 20c.
 LEX

MEYER, Enno
 American 1874-
 F,M

MEYER, Friedrich (Friz)
 Swiss -1837
 B

MEYER, Fritz
 Swiss mid 20c.
 GR52

MEYER, Henry
 Canadian 1948-
 H

MEYER, Herbert
 American 1882-1960
 B,F,H,M

MEYER MENGEDE, Heinrich
 German 19?/20c.
 LEX

MEYER RUFF, Fritz
 Swiss 20c.
 GR65

MEYER SPEER, Walter
 German early 20c.
 LEX

MEYER WALDECK, Kunz
 Latvian 1859–1953
 LEX

KUNZ·MEYER-WALDECK·

MEYER WEGNER, O.
 German ac. early 20c.
 LEX

MEYERHEIM, Paul Friedrich
 German 1842–1915
 B,H,LEX,TB

MEYERS, Harry Morse
 American 1886–1961
 IL,M,VC

HARRY
MORSE
MEYERS

MEYERS, Herb
 American mid 20c.
 GR54-56

MEYERS, Robert William
 American 1919–70
 H,PAP

MEYLAN, Paul Julien
 Swiss/American 1882–
 CEN12/06 & 7/07 & 8/07,F,H,M

PAUL JULIEN MEYLAN

MEYNELL, Louis
 American early 20c.
 M

MEYNER, Walter
 American 1867–
 F,M

MEZEY, Gustav
 Hungarian/Austrian 1889–
 LEX

MICALE, Albert
 American 20c.
 H

MICH
 French early 20c.
 BI,LEX

MICHAEL, Grete
 Austrian 1888–
 LEX,VO

MICHAEL, Harry
 American 20c.
 M

MICHAEL-MOINDL, Grete
 see
 MICHAEL, Grete

MICHAELER, Chr.
 Austrian 20c.
 LEX

MICHAELS, Glen
 American 1927–
 H

MICHAELSEN, Ottar M.
 Norwegian mid 20c.
 GR52

MICHAELSON, Dorothy
 American mid 20c.
 ADV,GR69-70-76

MICHALSKI, Alice
 American 20c.
 M

MICHALSKI, Tilman
 German late 20c.
 GR79-82

MICHÈL, Hans
 German 1920–
 GR54 thru 58-60-61-62-68-69,H,POS,POST

michel

MICHEL, Karl H. M.
German 1885–
AD,B,LEX,POS,TB

MICHEL

MICHEL, Philippe
French 20c.
POS

MICHEL, Sally
American 20c.
M

MICHENEER, Edward C.
American 1913–
H,M

MICHENER, Pat
Canadian 1946–
H

MICHIE
American mid 20c.
ADV

MICHL, Frantisek
Czechoslovakian 1901–
LEX,VO

MICKELAIT, Karl (Carl)
German 1870–
B,TB

MICKS, Jay Rumsey
American 1886–
F,H,M

MICOLEAU, Tyler
American 20c.
H

MIDDA, Sara
English late 20c.
EI79

MIDDLETON, Michael J.
Canadian
H

MIEDINGER, Gerard
Swiss mid 20c.
GR52–53–54–57–60–64–69–70

MIELICH, Alfons Leopold
Austrian 1863–1929
B,LEX,TB

AM

MIELZINER, Jo
Franco/American 1901–76
B,F,H,M

MIELZINER, Leo
American 1869–1935
B,F,H,I

MIERTUSOVÁ, Anastázian
Yugoslavian 1927–
H

MIETHKE-GUTENEGG, Otto Maria
Austrian 1881–1922
B,LEX,TB

MIFLIEZ, Fernand
see
MISTI

MIGLIORATI, Adalberto
Italian 20c.
LEX

MIGNERY, Herb
American 1937–
CON

HERB MIGNERY

MIGNOT, Victor
Belgian 1873–
B,CP,LEX,MM,POS,TB

V. Mignot

MIHAESCO, Eugène
American 1937–
AA,GR69–72 thru 85

Eugène Mihaesco.

MIHÁLY, E. Kádár
Hungarian 1894–
B,LEX,TB,VO

MIKIELS, Roger
Belgian mid 20c.
GR58

Mikiels

MIKULSKI, Kazimierz
Polish 1918–
B,H

MILANOVIC, Djordje
Yugoslavian 1922–
H,POST

MILAS, Pino
Italian mid 20c.
GR64–76

MILASCHEWSKIJ, W.
Russian 1893–
B,LEX

MILE
see
BRUMSTEEDE, Emile

MILES, Reid
American mid 20c.
GR57–58

MILEY, Douglas
American 1941–
CON

Miley

MILHOUS, Katherine
American 1894–1977
H,M

MILL, Eleanor
American 1927–
H

MILLAIS, (Sir) John Everett
English 1829–96
B,BA,BAA,H,LEX,M,POS,POST

18⚭86

MILLAIS, John Guille
English 1865–1931
B,BK,H,TB

JGM

MILLAR, H. R.
English 19/20c.
BK,M

MILLARD, C. E.
American early 20c.
F,H,M

MILLARD, H. C.
American 20c.
M

MILLER
Canadian ac. 1870
H

MILLER, Charles F.
American 20c.
M

MILLER, Eleazar Hutchinson
American 1831–1921
B,D,F,I,M

MILLER, F. D.
Canadian ac. 1883
H,HA

F.D.M.

MILLER, Jack
English early 20c.
POS

JACK MILLER

MILLER, Jane Bealhy
American 1906–
H,M

MILLER, Jean
English mid 20c.
ADV

MILLER, Juliet Scott
American 1898–
F

MILLER, Kenneth Neils
American 1911–
H

MILLER, Marie Clark
American 1894–
H

MILLER, Marshall Dawson
American 1919–
H

MILLER, Martha E.
American 20c.
M

MILLER, Richard Emil
American 1875–1943
B,F,H,I,M

MILLER, Ron
American late 20c.
GR81–82

MILLER, William Rickary
Anglo/American 1818–93
BAA,D,H,Y

MILLET, Francis David
American 1846–1912
B,BAA,F,H,I,LEX,SCR9/88,TB

MILLICHIP, Paul
English mid 20c.
GR58

MILLIÈRE, Maurice
French 1871–
AD,B,GMC,M

MILLS, Bryan
Canadian mid 20c.
GR64–66–69

MILLS, D. Dewar
English mid 20c.
GR53

MILLS, Hugh Lauren
American 20c.
H,M

MILLS, Russell
Anglo/Canadian late 20c.
EI79,GR79

MILLS, Thomas Henry
American early 20c.
B,F,H

MILLSAPS, Daniel Webster III
American 1919/29–
H

MILNE, David Brown
Canadian/American 1882–1953
B,F,H

MILOSAVLIEVIC, Stevan
Hungarian 1881–1926
B

MILSK, (Miss) Mark
American 1899–
H,M

MILSOP, Don
American mid 20c.
PAP

MILTON, William
English –1790
B,H

MINA-MORA, Paul Jose
El Salvadoran/American 1915–
H

MINALE, Marcello
Italian 1938-
GR68-72-76,H

MINELLI LANZI, Lidia
Italian 1907-
H

MINER, Edward Herbert
American 1882-
B,F,H,M

MINGO, Norman Theodore
American 1896-
EC,F,H

MINK, David D. C.
American 1913-
H,M

MINOR, Wendell Gordon
American 1944-
CON,F,GR75-76-79 thru 83-85,Y

MINORU KAWABATA (KAWABATA, Minoru)
Japanese 1911-
B,LEX

MINTON, John
English 1917-57
B,BA,BRP,GR52-53-54,H

MINTROP, Theodor
German 1814/18-70
B,BAA,H,LEX,TB

MION, Pierre Riccardo
American 1931-
H

MIRACLE, R. Giralt
Spanish mid 20c.
GR55-61-63

MIRANDA (MIRAN), Oswaldo
Brazilian late 20c.
GR78 thru 85

MIRANDA, Santiago
Italian late 20c.
EI79

MIRANDE, Henry
French 1877-
B,FS,M

MIRANDE, L.
French 19/20c.
LEX

MIRET, Gill
American 20c.
HA,LEX

MIRÓ, Joan
Spanish 1893-1983
ADV,AN,APP,B,DA,DES,DRA,DRAW,GMC,
GR54-56-73-76-80,H,M,PC,POS,POST

MIRONESCO, Tudor
French late 20c.
GR74-77-82

MISEK, Darel
Czechoslovakian mid 20c.
GR54

MISH, Charlotte Roberta
American 1903-
F,H,M

MISTI (MIFLIEZ, Fernand)
French 19/20c.
B,BI,CP,M,MM,POS

MISZFELDT, Friedrich
German 1874–
B

MITCHELL, Alfred
American ac. 1887–89
H

MITCHELL, Arthur R.
American 1889–1977
H,M?

MITCHELL, Baresford Strickland
Canadian 1921–
H

MITCHELL, Charles Davis
American 1885/87–1940
F,H,IL,M,Y

CHARLES D. MITCHELL

MITCHELL, Dick
American late 20c.
GR78–81–82–83

MITCHELL, George Bertrand
American 1872/74–1966
B,F,H,M

G.B.MITCHELL—

MITCHELL, Glen
American 1894–
F,H,M

MITCHELL, I. E.
English 19/20c.
LEX

MITCHELL, James E.
American 1926–
H

MITCHELL, James Murray
American 1892–
F

MITCHELL, John Ames
American 1845–1918
B,CAV,EC,I,M

M

MITCHELL, Thomas Wilberforce
Canadian 1879–1958
H,M

MITELBERG, Louis (Tim)
French 1919–
EC,GR64–82,H

TIM

MITROCHIN, Dimitrij Isidorowitsch
Russian 1883–
B,LEX,VO

DM

MITSCHEK, A.
Austrian 20c.
LEX

MITSUHASHI, Yoko
Japanese 20c.
H

MITSUI, Eiichi
Japanese 20c.
H

MITSUI, Joshinosuka
Japanese mid 20c.
GR53

MITSUTOMO, Ishikawa
see
ISHIKAWA, Mitsutomo

MITTL, M. W.
German mid 20c.
GR64

MITU
see
ISHAKAWA, Mitsutomo

MITZKAT, Paul
Swiss mid 20c.
GR58–61

MIYANAGA, Takehiko
Japanese mid 20c.
GR53–54–57–58–63

T.miya—

MIZEN, Frederic Kimball
American 1888-1965
H,IL,M

Frederic Mizen

MIZRAKJIAN, Artin
Armenian/American 1891-
H,M

MIZUMURA, Kazue
Japanese/American 20c.
H

MIZUNO TOSHIKATA
Japanese 1866-1908
B,H

MJÖLNIR
German early 20c.
POS

MLEC(K)ZKO, Andrej
Polish late 20c.
EI79,GR77

MLODOZENIEC, Jan Lukasz
Polish 1929-
GR56-58-62-63-67-68-70-72-73,H,POS

J.MŁODOŽENIEC.

MOCHI, Ugo
Italian/American 1889/90-
H,M

MOCINE, Ralph Fullerton
American ac. 1900
MM

MOCK LA VERNE, F.
American 1913-
H

MOCKNIAK, George
American 20c.
H

MODERSOHN, Christian
German 20c.
LEX

MODIANI, Guido
Italian 20c.
POS

MÖE, Louis
Norwegian/Danish 1859-
M

MOEHSNANG, Egbert
German 1927-
B

MOEST, Hermann
German 1868-
B,TB

H.M.

MÖGLE, Fritz
German 20c.
LEX

MOHN, Viktor Paul
German 1842-1911
B,H,LEX,TB

V.P.M.

MOHOLY NAGY, Laszlo
Hungarian 1895-1946
B,H,PC,POS,POST,TB

MOHR, Martina
Austrian 20c.
LEX

MOHR, Paul
French early 20c.
POS

MOIR, Robert B.
American 1917-
H,M

MOIR, Vivian
American 20c.
M

MOISEIWITSCH, Carel
Canadian
H

MOJEN, Ingo
Italian mid 20c.
GR65-66-67

MOLARSKY, Sarah Shreve
American 1879–
H

MOLDENHAUER, Julius
German 20c.
LEX

NCLINA
Spanish early 20c.
CP

MOLINA

MOLINARD, P.
French mid 20c.
GR57

MOLKENBOER, Antoon (Theodorus M. A. A.)
Dutch 1872–
B,POS

Tm

MOLL, Carl
Austrian 1861–1945
B,GMC,H

CM

MÖLLER, Adolf
German 1866–
B

MOLLER, Bjarne
Norwegian 1923–
GR52–54,H,POST

moller

MOLNÁR, C. Pál
Hungarian 1894–
B,LEX

MOLNÉ, Luis Vidal
Spanish 1907–70
B

MOLTKE, Adam
Danish mid 20c.
GR52–55–57–58–63–65

MOLYNEUX, Edward Frank
Anglo/American 1896–
F

MOLZAHN, Johannes
German 1892–1965
B,H,POS(pg.176)

MOLZAHN

MOMBERGER, William
German/American 1829–
B,D,F,I

MONDAINI, Giacinto (Giaci)
Italian 1903–
H

MONDIER
French 19/20c.
POS

MONET, Jason
English mid 20c.
GR60

MONKS
Canadian ac. 1882
H

MONKS, Edward E.
American 1890–
F,H,M,PE

EDwARD
MONKS
'23

MONLEON Y TORRES, Raphael
Spanish 1847–1900
B,H

MONNERAT, Pierre
Swiss 1917–
ADV,GR52 thru 58–60–61–62,H,LEX,POS,VO

P. monnerat

MONNICKENHAM, Martin
Dutch 1874–
B,LEX,M

MONNIER, Henri Bonaventure
French 1799/1805-77
B,EC,H,POS,M

[signature: HM]

MONNOT, Cécile
French 1885-
B

MONRO, Clarence J.
American -1934
H

MONSIAUX (MONSIAU), Nicolas André
French 1754/55-1837
B,H,M

[signature: Monsiau.]

MONTALD, Constant
Belgian 1862-1944
B,POS

MONTASSIER, Henri
French 1880-
B,CP

[signature: Henri Montassier]

MONTAUT, E.
French 19/20c.
BI

[signature: E Montaut]

MONTAUT, Henri de (de Hem or Monta or Hy)
French 1825-90
B,H

MONTEANU, Valeriu
Romanian mid 20c.
LEX

MONTEGUT, Louis
French 1855-
B,TB

[signature: M]

MONTEIRO, Vincente do Rêgo
Brazilian 1899-1970
B,H,LEX

MONTENARD, Frédéric
French 1849-1926
B,H,M

[signature: Montenard]

MONTENEGRO, Roberto
Mexican 1881-1968
B,H,TB,M

[signature: Montenegro 68.]

MONTFORT, Charles Edwin
English 1891-
LEX

MONTIEL, David
American late 20c.
GR82-83-85

[signature: MONTIEL]

MONTPETIT, André
Canadian 1943-
H

MONTRESOR, Beni
Italian/American 1926-
H

MONVEL, Louis Maurice Boutet de
see
BOUTET de MONVEL, Louis Maurice

MOON, Carl
American 1879-1948
H,M

MOON, Sarah
French 20c.
GMC

MOOP, D.
see
ORLOV, Dimitri Stakeheyevich

MOOR, Dimitri Stakheyevic
Russian early 20c.
PG,POS

MOORE, Albert Joseph
English 1840-92
B,H,M

MOORE, Arthur W.
 Canadian ac. 1872-77
 H,M?

MOORE, Benson Bond
 American 1882-
 B,F,H,I,M

MOORE, Cecil Gresham
 Canadian/American 1880-
 F,M

MOORE, Chris
 English late 20c.
 EI79,GR77-80

MOORE, George
 English 19/20c.
 BI

MOORE, Guernsey
 American 1874-1925
 ADV,M

MOORE, Harry Humphrey
 American 1844-1926
 B,BAA,F,H,I,LEX,M,TB

MOORE, Henry Wadsworth
 American 1879-
 H,M

MOORE, James Gaylord
 American mid 20c.
 GR61-64,H

MOORE, Martha Elizabeth Burnett
 American 1913-
 H,M

MOORE, Phoebe
 American mid 20c.
 GR52-54-55-61

MOORE, Thomas Sturge
 English 1870-1944
 BK,M

MOORE, Tom James
 American 1892-
 H,M

MOORE-PARK, Carton
 American 1877-1956
 B,BK,CEN2/12,LEX,M,TB

MOORES, (Mabel?)
 American 19/20c.
 M?,R

MOOS, Carl
 German 1878-
 B,BI,CP,LEX,MM,POS

MOOS, Franz (K. John F.)
 Swiss 1854-
 B

MOOS, (Johann Jacob) Paul
 Swiss 1882-
 B

MOOSBRUGGER, Joseph (called MARIANI)
 Swiss 1829-69
 B

MOPP, Maximilian
 Austrian/American 1885-
 H,M

MOPPÈS, Maurice van
 French 1904-57
 B

MOR, Rode
 Danish 20c.
 POS

MORA, Francis Luis
 Uruguayan/American 1874-1940
 B,F,H,I,M,Y

MORA, Joseph Jacinto
Uruguayan/American 1876-1947
B,F,H,M

MORACH, Otto
Swiss 1887-1973
B,POS

MORACH

MORAIS, Alfredo Januário de
Portuguese 1872-1971
H

MORALIS, T.
Greek? 20c.
CP

MORALIS, Yannis
Greek 1916-
B,H

MORAN, Connie
American 20c.
H

MORAN, Earl Steffa
American 1893-
H

MORAN, Peter
Anglo/American 1841/42-1914
B,BAA,F,H,M

MORAN, Thomas
American 1837-1926
APP,B,BAA,D,F,H,I,LEX,TB

MORANG, Alfred Gwynne
American 1901-58
H

MORANTE
Cuban 20c.
POS

MORAVEC, Alois
Czechoslovakian 1899-
LEX,VO

MORAX, Jean
Swiss 1869-1939
B,LEX,TB,VO

MORBIDUCCI, Publio
Italian 1889-1937
B,H,LEX,VO

MORCHOISNE, Jean Claude
French late 20c.
GR76-82

MORCOS, Maher Naguib
Egyptian/American 1946-
CON

MORD(I)VINOFF, Nicols
Russian/American 1911-73
B,H

MOREAU, Adrien
French 1843-1906
B,BAA,H,L,M

A.M.

MOREAU, Jean Marie
see
CASSANDRE, A. M. (pseudonym)

MOREAU, Luc Albert
Franco/American 1882-1948
B,H,L,M,STU1930,TB,VO

M

MOREAU DE TOURS, Georges
French 1848-1901
B,H,M

MOREAU-NÉLATON, Etienne
French 1859–1927
B,H?,LEX,TB

MOREHEN, Horace
English ac. late 19c.
LEX

MOREL-RITZ, Louis Pierre (Stop)
French 1825–99
B,EC,FO,LEX,TB

MORELL, José
Spanish early 20c.
POS

MORELLI, Vincenzo (Enzo)
Italian 1896–
H

MORENO, Alvarez
Spanish 20c.
PG

MORETTI, Raymond
French 1931–
B,GMC

MOREU, René
French 1920–
B

MOREY, Bertha Graves
American 1881–
F,H,M

MOREY, Norman
American 1901–
H,M

MOREZ, Mary
American 20c.
H

MORFIERT, L.
Belgian mid 20c.
GR53

MORGAGNI, Claudio
Italian mid 20c.
GR57

MORGAN, Ava
American mid 20c.
PAP

MORGAN, Franklin Townsend
American 1883–
B,F,H,M

MORGAN, Frederick
English 1856–1927
B,H,LEX,TB

MORGAN, Jacqui
Swiss/American 20c.
ADV,CP,GMC,GR67-68-70-77-80-81

MORGAN, Jim
American 1947–
CON

MORGAN, Joseph
American 20c.
M

MORGAN, Lynn Thomas
American 1889–
F,H,M

MORGAN, Maritza Leskovar
Yugoslavian/American 1921–
H

MORGAN, Mary de Neale
American 1868–1948
F,H,M,Y

MORGAN, Matthew (Matt) Somerville
Anglo/American 1839–90
B,BAA,EC,F,I,LEX,R,TB

Matt Morgan

MORGAN, Roy
English mid 20c.
GR56–66

ROY MORGAN

MORGAN, Wallace
American 1873–1948
CAV,EC,F,FOR,H,IL,M,PE,Y

W. MORGAN

MORGENTHALER, Charles Albert
American 1893–
H

MORIMOTO, Shosuke
Japanese mid 20c.
GR60

MORIN, Edmond
French 1824–82
B,L

MORIN, H.
French 19/20c.
LEX

MORIN, Louis
French 1855–1938
B,M,TB

f m.

MORIN, Pierre Louis
Canadian 1811–86
H

MORINI, Daniele
Italian late 20c.
GR82

Morini

MORTIZ, Raymond
French 1891–
B

MORLAND, Norris
Canadian 20c.
M

MORLEY, Helen Sewell Johnson
American 20c.
H,M

MORNINGSTERN, Harry V.
American 1899–
H

MORONI, Antonello
Italian 1889–1929
B,H

MORRIS, Beth K.
American 20c.
M

MORRIS, Cedric
English 1895–
B,M

MORRIS, Edward A.
American 1917–
H

MORRIS, William
English 1834–96
APP,B,DA,H,POS,POST,S,STU1914,TB

WM

MORRISON, G. W. B.
Canadian ac. 1880
H

MORROW, Albert George
English 1863–1927
B,EN,GA,H,LEX,POS,TB

A. Morrow

MORROW, Anne
English late 20c.
EI79

MORROW, Barbara
American 20c.
H

MORROW, George
English 1869–
B,M

MORSE, Anne Goddard
American 1855–
B,F,H,M

MORSE, Lucy Gibbons
American 1856–1936
M

MORSE-MEYERS, Harry
English
LEX

MORTEN, Thomas
English 1836–66
B,H,M

MORTIMER, Francis
English
LEX

MORTON, Herbert
American early 20c.
POS

MORTON, John Ludlow
American 1792–1871
F,I,M

MORTON, Marian
American 20c.
H

MORVAN, Hervé
French 20c.
GR52-54-55-61,LEX,POS

HERVÉ
MORVAN

MOSBACH, Käthe
German 20c.
LEX

MOSBY, William Harry
American 1898–1964
H,M

MOSCOSO, Victor
American 1936–
CP,POS

Moroso

MOSCOTTI, Frank
American late 20c.
GR82

MOSÉ, David
Austrian 1870–1902
LEX,TB

M

MOSÉE, Karl
Austrian 1860–
B

MOSER, Barry
American 1940–
H

MOSER, Frank H.
American 1886–1964
EC,H,M

MOSER, James Henry
Canadian 1854–1913
B,BAA,F,H,M

MOSER, Kolomon
Austrian 1868–1918
AN,B,CP,GMC,H,LEX,TB,POS

KOLOMAN·MOSER·

MOSES, (called FORMSTECHER)
German 1760–1836
B

MOSHER, Christopher Terry
Canadian 1942–
EC

MOSKOWITZ, Shirley Edith (Gruber)
American 1920–
H,M

MOSLEY, Zack T.
American 1906–
H

MOSNAR, Yendis (pseudonym)
see
RANSOM, Sidney

MOSONYI-PFEIFFER, Hellmann
 Hungarian 1863-1905
 B,LEX,TB

MOSS, Donald
 American 1920-
 F,GR76,Y

MOSS, Geoffrey
 American late 20c.
 GR75 thru 85

MOSSA, Gustave Adolphe
 French 1883-1971
 B,LEX,TB

MOTTE, Henri Paul
 French 1846-1922
 B,H,M

MOTTER, Dean Roger
 American 1953-
 H

MOULD, Vernon
 Canadian 1927-
 H

MOUM, Gunnar
 Norwegian mid 20c.
 GR55,POST

MOUNTAIN, M. K.
 English 20c.
 M

MOUNTFORT, Irene
 English 20c.
 M

MOUNTFORT, Julia Ann
 Canadian/American 1892-
 F,H,M

MOURGUE, Pierre
 French 20c.
 GMC,LEX,VC

MOURON, Adolphe Jean Marie
 see
 CASSANDRE, A. M.

MOUSE, Stanley
 American 20c.
 GR68,POS

MOUSSEAU, Jean Paul
 Canadian 1927-
 B,H

MOWAT, Harold James
 American 1879-1949
 B,F,IL,M

MOYERS, William
 American 1916-
 CON,H,LEX

MOYNAHAN, John J.
 American 1877-1939
 M

MOZART, William
 American 1855-
 M

MOZLEY, Charles
 English 1915-
 H

MROSZCZAK, Martin (Jozef?)
 Polish 1910-75
 GR54-56-57-60-67-68,H,POS

MRÓZ, Daniel
 Polish 1917-
 EC,H

MROZEWSKI, Stefan
 French 19/20c.
 B,L

MUCENIEKS, Arturs Jāņa
 Latvian 1912–
 LATV

MUCHA, Alphonse (Alfonso Maria)
 Czechoslovakian 1860–1939
 ADV,AN,B,BI,CP,GA,GMC,H,LEX,MM,POS,
 POST,TB,VO

MUCHARSKI, Jan
 Czechoslovakian? early 20c.
 'Art Deco Style' by Th. Menten--Dover
 1972

MUCKLEY, Louis Fairfax
 English 19/20c.
 AN,B,BK,STU1904

MUELLER, Carl
 American early 20c.
 F,H,M

MUELLER (MÜLLER), (Prof.) Hans Alexander
 German/American 1888–
 H,LEX,M,TB,VO

MUELLER, John Charles
 American 1889–
 F,H,M

MUELLER, Lola Pace
 American 1889–
 H,M

MUENCH, Agnes Lilienberg
 American 1897–
 H,M

MUENCHEN, Al
 American 1917–
 IL

MUGGIANI, Giorgio
 Italian 1887–1938
 H,POS

MUHITS, Sandor Alexander
 Hungarian 1882–
 B,LEX,TB,VO

MÜHLBECK, Karoly (Karl)
 Hungarian 1869–1943
 B

MÜHLBERG, Georg
 German 1863–1925
 B,TB

MÜHLMEISTER, Karl
 German 20c.
 LEX

MUHRIEN, Achille
 American early 20c.
 GMC

MUHRMAN, Henry
 American 1854?–1916
 B,BAA,H,I

MUIR, Donna
 English late 20c.
 EI79,GR84

Donna Muir (signature)

MUIRHEAD, John
 English 1863-1927
 B,H

MUKAI, H.
 Japanese mid 20c.
 GR60

MUKAROWSKY, Josef
 Austrian 1851-
 B

MULAZZANI, Giovanni
 Italian late 20c.
 EI79,GR64-78-82-84-85

G. Mulazzani (signature)

MULFORD, Stockton
 American ac. 1923-34
 H,M

MULHAUPT, Frederick John
 American 1871-1938
 B,F,H,HA10/03,M

FREDK J. MULHAUPT (signature)

MULHOLLAND, Charles
 American 20c.
 M

MULLEN, F. E. (E. F. or E. J.)
 American ac. 1860s
 D,H

MULLEN, Richard
 American 1849-1915
 B,F

MÜLLER, Armin
 Swiss mid 20c.
 GR53-54-55-57-58-63-65-69-70

MÜLLER, C. O.
 German early 20c.
 POS

C.O.MÜLLER

MÜLLER, Curt
 German early 20c.
 LEX

MULLER, Dan
 American 1888-1977
 H,M

MÜLLER, E.
 German 20c.
 LEX

MÜLLER, Felix
 German mid 20c.
 GR61-62-63-75

MÜLLER, Fridolin
 Swiss mid 20c.
 GR56-58-60 thru 64-66-69

MÜLLER, Gerhart Kurt
 German 1926-
 LEX,VO

G.K.M. (signature)

MULLER, J. C.
 French mid 20c.
 GR61

MÜLLER, Karel
 Czechoslovakian 1899-
 GR56

Karel Müller (signature)

MÜLLER, Karl
 German 1865-
 B

MÜLLER, Karl Hermann
 German 1869-
 LEX,TB

MÜLLER, Lothar
 German 20c.
 LEX

MÜLLER, Otto M.
 Swiss mid 20c.
 GR60

O.M.M.

MÜLLER, Walter
 German 1919-
 LEX, VO

MÜLLER-BLASE
 German mid 20c.
 GR54 thru 58

Müller-Blase

MÜLLER-BRAUNSCHWEIG, Ernst
 German 1860-
 B, LEX, TB

E.M.

MÜLLER-BROCKMANN, Josef
 Swiss 1914-
 CP, GR52 thru 58-60-61, H, LEX, VO

Müller-Brockmann

MÜLLER-HAMBURG, Karl
 German 1865-
 LEX, TB

MÜLLER-HOFMANN, Rudi
 Swedish mid 20c.
 GR58

MÜLLER-HOFMANN, Wilhelm
 Austrian 1885-1948
 B, LEX, TB, VO

MÜLLER-KEMPTEN, Hildegard
 German 19/20?c.
 LEX

MÜLLER-KRAUS, Erich
 German 1911-
 LEX, VO

MÜLLER-LINGKE, Albert
 German 1844-
 B, TB

M·L

MÜLLER-MÜNSTER, Franz
 German 1867-
 B, LEX

MÜLLER-SAMERBERG, Karl Hermann
 German 1869-
 B

K-H.M.

MULLET, Suzanne M. (Smith)
 American 1913-
 H, M

MULLINS, Frank
 American 1924-
 F, IL, Y

Frank Mullins

MULLIS, Phyllis Haas
 American 1900-
 H, M

MULOCK, Cawthra
 Canadian 20c.
 M

MULOT, Willy
 German 1889-
 B, TB

M-

MULRONEY, Regina Winifred
 American 1895-
 F, H

MULVANY, May
 American early 19c.
 LEX

MUMMERT, Karl
 German 1879-
 B

MUNARI, Bruno
 Italian 1907-
 B, CP, GR56-58-62-68, H, POS

MUNARI

MUNCE, Howard
 American 1915-
 C

MUNCH, Edvard
　　Norwegian 1863-1944
　　AN,APP,B,DA,DES,DRA,H,M,PC,POS,SC

E w Mvnd

MÜNGER, Rudolf Alfred
　　Swiss 1882-
　　LEX,TB

MUNI
　　See
　　LIEBLEIN, Muni

MUÑOZ Y CUESTA, Domingo
　　Spanish 1850-1912
　　B,TB

DM

MUNRO, Roxie Jean
　　American 1945-
　　H

MUNSON, Floyd R.
　　American 20c.
　　M

MUNTHE, (Peter Franz Wilhelm) Gerhard
　　Norwegian 1849-1929
　　AN,B,H,POS,SC,TB

Gerh. Munthe

MÜNZER, Adolf
　　Polish?/German 1870-1952
　　AN

MURAD-MICHALKOWSKI, Gabriele
　　Austrian 1877-
　　B,LEX,TB,VO

MURAKAMI, Akira
　　Japanese mid 20c.
　　GR64

MURATORE, Rem
　　Italian mid 20c.
　　GR55,POS

MURAWSKI, Darlyne
　　American 20c.
　　P

MURAWSKI, Alex
　　American late 20c.
　　EI79,GR78-80-83

MURCH, Walter Tandy
　　American 1907-67
　　B,F,H

MURDFIELD, Carl
　　German 1868-
　　B

MURDOCH, Rowland R.
　　American 　　　-1917
　　B,M

MURELLO, John
　　American mid 20c.
　　GR65-72

MURER, Fred
　　Swiss mid 20c.
　　GR57-61

MURNAU
　　German early 20c.
　　AD

MURPHY, Ada Clifford
　　American 19/20c.
　　B,F,H

MURPHY, Al
　　American mid 20c.
　　GR65

MURPHY, Diana
　　English 20c.
　　M

Dm

MURPHY, Henry Cruse, Jr.
　　American 1886-1931
　　F,M

MURPHY, Hermann Dudley
　　American 1867-1945
　　B,F,H,I

MURPHY, John Cullen
　　American mid 20c.
　　ADV

MURPHY, John Francis
American 1853–1921
B,BAA,F,H,I,LEX,M,TB

J.F.Murphy

MURPHY, Mildred V.
American 1907–
H

MURPHY, Minnie Lois
American 1901–
H

MURPHY, Nellie L. (Littlehale)
American 1867–
B,F,H

MURPHY, Rowley Walter
Canadian 1891–1975
H,M

MURRAY, Alexander
American 1888–
H

MURRAY, Charles Oliver
English 1842–
B,H,LEX,TB

C.O.M.

MURRAY, Feg
American 20c.
H,M

MURRAY, Jack
American 20c.
M

MURRAY, James
Irish 1810–68?
H

MURRAY, Ronald
American 20c.
M

MURREY, Richard F.
American 1950–
H

MURRY, Jerre
American 1904–
H,M

MURTON, Clarence C.
American 1901–
H

MUSICK, William Earl
American 1896–
H

MUSSER, Byron J.
American 1885–
B

MUSSER, Josef
Austrian 1864–
B

MUSSINO, Attilio
Italian 1878–1954
EC,H

MUSSO, Sirio
Italian 1906–
H

MUTH, John Haverstick
American 1907–
H,M

MUTH, Richard
German 1868–
B,LEX,TB

MR

MUTTICH, Kamil Vladislav
Czechoslovakian 1873–1924
B

MUTZEL, Gustav
German 1839–93
B,H

MUYDEN, Ewert Louis van
Swiss 1853–1922
B

MUYDEN, Henri van
Swiss 1860–1936
B

ΛЛΛ

MYERS, Lloyd Burton
American 1892–1954?
B,H

MYERS, Louis
 American 1915-
 F,GR60-61-63-65-73-74-77,Y

MYERS, O. Irwin
 American 1888-
 F

MYERS, Willard
 American 1887-
 H

MYKKÄNEN, Martti August
 Finnish/Israeli 1926-
 GR54-55-56-58-60-61-63 thru 70,H,POS,
 POST

MYKKÄNEN

MYRAH, Newman
 Canadian/American 1921-
 CON

N-MYRAH

MYRBACH-RHEINFELD, Felicien Freiherr
 Baron de
 Austrian 1853-1943
 B

M

MYRHA, René
 Swiss 1939-
 B

- N -

NACCACHE, Edgard
 Tunisian 1917-
 B

NADAMOTO, Tadashi
 Japanese mid 20c.
 GR60-63-64-65,POS

NADEJEN, Theodore
 American 20c.
 M

NADLER, Ellis
 English late 20c.
 EI79,GR82

ELLIS NADLER

NADLER, Robert
 Hungarian 1858-1938
 B,LEX,VO

NADLER, Robert
 American 20c.
 H

NAGAI, Kazumasa
 Japanese 1929-
 B,GR60 thru 63-65-67 thru 71-80 thru 85,
 POS

KAZUMASA NAGAI

NAGANO, Yasuo
 Japanese mid 20c.
 GR64

NAGAO, Isojiro
 Japanese mid 20c.
 GR60

NAGAOKA, Shusei S.
 Japanese/American 1936-
 GR77,Y

NAGASAKI, Kumiko
 Japanese late 20c.
 GR79 thru 84

NAGEL, Dieter
 German late 20c.
 GR82

NAGEL, Hanna
 German 1907-
 LEX,VO

NAGEL, Patrick
 American 20c.
 GR81-83,P,POS

NÄGELE, Otto Ludwig
 German 1880-
 LEX,VO

NAGLER, Edith Kroger
American 1890/95–
B,F,H

NAGWEKAR, A. W.
Indian mid 20c.
GR65

NAGY, AI
American 20c.
H

NAGY, Sandor
Hungarian 1869–1951
B,LEX,VO

NAHL, Charles Christian
German/American 1818–78
B,BAA,D,H,M

NAHL, Hugo Wilhelm Arthur
German/American 1820?–81/89
D,H

NAHL, Karl
see
NAHL, Charles Christian

NAIKI, Koichi
Japanese mid 20c.
GR53

NAIKSATAM, Shri Avinash
Indian mid 20c.
GR65

NAILOR, Gerald Lloyde
American 1917–52
H

NAKAHARA, Fumito
Japanese mid 20c.
GR54

fumito

NAKAJIMA, Yasuo
Japanese mid 20c.
GR54

Naka

NAKAMURA, Akemi
Japanese mid 20c.
GR64–66

NAKAMURA, Makato
Japanese 1926–
GR64,POS

NAKANISHI, Kiyoto
Japanese/American 20c.
M

NAKATANI, Chiyoko
Japanese 20c.
H

NAM, Jacques Lehmann
French 1881–1974
B

NAMIR, Boris
Russian early 20c.
LEX

NANKIVEL, Claudine
American 20c.
H

NANKIVEL, Fred
American early 20c.
B,HA10/03 & 8/04 & 10/04

Fred Nankivel

NANKIVELL, Frank Arthur
Australian/American 1869–1959
APP,B,CAV,CC,EC,F,H,I,LEX,R

FRANK A NANKIVELL

NANNAN, Jacques
Belgian mid 20c.
GR54

JAC NANNAN

NANTEUIL, Celestin Leboeuf
French 1813–73
B,H,PC,POS

NAOMOV
Russian early 20c.
POS

NAPOLI, James
American 1907–
M

NAPOLI, Vincent
American 20c.
M

NAPPENBACH, Henry (Nap)
German/American 1862/1931
H,M

NAPPI, Rudolph
American mid 20c.
PAP

NARBONA, Josef Pla
Spanish 19c.
POS

NARBUT, Georgij Iwanowitsch
Russian 1886–1920
B,LEX,VO

ΓN

NARENDA, Srivastava
Indian 1931–
B

NARIYUKI
see
TAIZAN

NASH, Flora
American early 20c.
F

NASH, John Northcote
English 1893–
B,BRP,H,PC

JN

NASH, Joseph
English 1808–78
B,BAA,H,TB

JN

NASH, Joseph Pfanner
American 1900–54?
H,M

NASH, Paul
English 1889–1946
B,BRP,DA,H,PC,POS,POST

Paul Nash , Paul Nash

NASON, Thomas Willoughby
American 1889–1971
APP,F,H,PC

NAST, Thomas
German/American 1840–1902
B,BAA,CAV,CC,D,EC,F,GMC,H,I,PC,Y

Th: Nast.

NATHAN, Jacques
French 1910–
GR52 thru 58–60–61–63 thru 68,H,POS,POST

NATHAN

NATHAN, Janice (Jan?)
American 20c.
GR79,M

NATHAN GAROMOND, Jacques
see
NATHAN, Jacques

NATHORST-WESTERDAL, Putti
Swedish mid 20c.
GR52–56

putti

NATORI SHINSEN
Japanese 1886–1960
H

NATTEN, Adolf
German 19?/20c.?
LEX

NAU, August
German early 20c.
LEX

NAUDIN, Bernard
French 1876–1946
B,EC,FS,LEX,S,TB,VO

BN

NAUMANN, Max
German 1889–
B,LEX,VO

NAVARRO
Cuban 20c.
POS

navarro 73

NAVARRO Y GARCIA DE VINUESA, (Roman)
Spanish 1854–1928
B

NAVOSOV, V. I.
Russian 1870–1917
B,M

NEAGLE, C. F.
American early 20c.
ADV

NEAGLE

NEALE, George Hall
English 19/20c.
LEX,M,VO

GHN

NEALE, Russell
American 20c.
H

NEBEL, Gustave Mimouca
French 20c.
H

NEDO, Mion Ferrario
Italian/Venezuelan 1926–
GR60-61-62-70-72,H

NEEDHAM, Charles Austin
American 1844–1923
B,BAA,F,I

NEERTOFT, Werner
Danish mid 20c.
GR52 thru 55-62-72

NEFF, Earl J.
American 1902–
H,M

NEFF, Sid
American mid 20c.
GR65

NEFF, Wesley
American 20c.
GMC

NEGREIROS, José Sobral de Almada
Portuguese 1893–1970
H,M

NEGREIROS, Sarah Alfonso de Almada
Portuguese 1899–
H

NEGRI, Ilio
Italian mid 20c.
GR61-69-70-71

NEGRI, Rocco Antonio
American 1932–
H

NEGRON, William
American 1925–
F,Y

NEGUS, Richard
English mid 20c.
GR54-58-60-63-68

Negus

NEIBART, Wally
American 1925–
F,GR74-78-82

Wally Neibart

NEILL, John R.
American early 20c.
B,F,M,PE

NEILSON, Harry B.
English 20c.
M

NEILSON, Samuel
Canadian ac. 1790-1827
H

NEIMAN, Le Roy
American 1926-
F,H,P

NEISER, Donald
American mid 20c.
PAP

NEITZSCH, Walter
German early 20c.
LEX

NELL, (Miss) Tony
American 19/20c.
F,H,M

NELLES, Arthur Douglas
Canadian 1917-
H

NELSON, D. Earle
American 1902-
H

NELSON, Everett
American 20c.
M

NELSON, Faith
American 20c.
M

NELSON, G. Patrick
American early 20c.
HA6/07,M,Y

NELSON, H. B.
English 19/20c.
LEX

NELSON, Howard Edward Hughes
English 1871-
B,LEX,TB,VO

NELSON, Ralph Lewis
American 1885-
H,M

NELSON, Robert Clark
American 1925?-
GR58-60-66-74,H

NEMES, Mihaly (Michael)
Hungarian 1866-1930
B,TB

NENCIK, L.
Austrian 19/20c.
LEX

NEOGRADY, Laszlo (Antal) (Anton)
Hungarian 1861-1942
B,LEX,TB,VO

NERMAN, Einar
Swedish 1888-
AN,LEX,M,POS,SC,VO

NERUD, Josef Karl
German 1900-
G

NESBITT, Jackson Lee
American 1913-
H,M

NESS, Evaline (Bayard)
American 1911-
H

NESSIM, Barbara
　　American 1939–
　　F,GR70–75–76–77–81 thru 85,H,Y

Barbara NESSIM

NESTEL, Hermann
　　German 1858–
　　B

NETTER, Frank H.
　　American 1906–
　　H

NETZLER
　　Swedish mid 20c.
　　GR54

NEU, Ludwig
　　German 1897–
　　B

NEUBAUER, Frederick August
　　American 1855–
　　B,F

NEUBAUER, Leo
　　Austrian 20c.
　　LEX

NEUBURG, Hans
　　Swiss 1904–83
　　GR55,POS

NEUENSCHWANDNER, E.
　　Swiss early 20c.
　　LEX

NEUFELD, Wilhelm
　　German 1908–
　　G,GR60–64–67–72,LEX

Neufeld

NEUFELD, Woldemar
　　Russian/American 1909–
　　H,M

NEUGEBAUER, Peter
　　German mid 20c.
　　GR64

NEUHEISEL, Cecilia
　　American 1915–
　　H,M

NEUMANN, Ernst
　　German 1871–1954
　　B,MM,POS,TB

Ernst neumann

NEUMANN, Erwin
　　American 20c.
　　M

NEUMANN, Fred
　　German early 20c.
　　POS

NEUMANN·FRED

NEUMANN, Hans (D.?)
　　German 1902–
　　GR71

[HN monogram]

NEUMANN, Otto
　　German 1895–
　　LEX,VO

[signature]

NEUMANN, Paul
　　German early 19c.
　　LEX

NEUMANN-KARLSBERG, Paul
　　German 1868–
　　B,TB

P.N.

NEUMANN-SPALAT, Gottfried
　　Austrian 1915–
　　LEX

NEUMONT, Maurice
　　French 1868–1930
　　B,LEX,VO

NEUNZIG, K.
　　German early 20c.
　　LEX

NEUREUTHER, Eugen Napoleon
　　German 1806–82
　　B,H,M

[monogram]

NEUSTADT, Barbara
American 1920/22-
H

NEUSTÄDTL, Otto
Austrian 20c.
LEX

NEUVILLE, Alphonse Marie de
French 1835-85
B,BAA,H,M

A de Neuville

NEUWIRTH, Arnulf
Austrian 1912-
H,LEX,VO

N

NEVILLE, Vera
American 20c.
M

NEVITT, Richard Barrington
American 1936/37-
H

NEW, Edmund Hart
English 1871-1931
B,BK,H,M,STU1914,TB

EHNEW

NEWBERRY, Clare Turlay
American 1903-
H,M

NEWBOULD, Frank
English 1887-
CP,M,POS,POST

FRANK NEWBOULD

NEWELL, Peter Shead Hersey
American 1862-1924
B,CAV,EC,F,GMC,HA12/01 & 12/07,
LEX,M,R

Peter Newell

NEWFELD, Frank
Canadian 1928-
H

NEWHALL, Donald V.
American 1890-
F,M

NEWHALL, Elizabeth
American 1909-
H,M

NEWMAN, Anna Mary
American 19/20c.
F,H

NEWMAN, Henry Roderick
Anglo/American 1833-1917
B,F,H,I

NEWMAN, Isadora
American 1878-
F

NEWMAN, Ralph Albert
American 1914-
H

NEWTON, Alison Houston Lockerbie
Scots/Canadian 1890-1967
H,WS

NEWTON, Marion Cleever Whiteside
American 1902-
F,H

NEYDHART, Francis
Austrian 1860-
B

NEYMARK (NEYMARCK), Gustave Mardoché
French 1850-
B,TB

SN

NEZIERE, R. de la
French 19/20c.
LEX

NICHI
see
TAIZAN

NICHOLL, Andrew
Irish 1804-86
B,H,M

NICHOLLS, Denys
English mid 20c.
GR54

NICHOLLS, Rhoda Holmes
Anglo/American 1854-1930
B,H,I,M

NICHOLS, Dale William
American 1904-
B,H,M

NICHOLS, Harley De Will
American 1859-
B,H,HA,M

H·D·N·

NICHOLS, Henry Hobart
American 1869-1962
B,H,M

NICHOLS, Spencer Baird
American 1875-
B,F,H,I,M

Spencer Nichols

NICHOLSON, Ben
English 1894-
B,BRP,DA,H,POS

NICHOLSON, Delos Charles
American 1885-
H,M

NICHOLSON, Edith Reynaud
American 1896-
H

NICHOLSON, Isaac
English 1789-1848
B,H,M,TB

NICHOLSON, Roger
English mid 20c.
GR52

NICHOLSON, T. H. (probably Thomas Henry)
English -1870
B,H

NICHOLSON, (Sir) William Newzam Prior
English 1872-1949
AN,B,BRP,CP,DA,GA,GMC,H,PC,POS,POST,
TB,VO

William Nicholson.

NICHOSAI
see
JICHOSAI

NICKIG, Marion
German late 20c.
GR85

NICKOLDS, Roy
English 20c.
PG

NICOLAI, Maximilian Alexander
German 1876-
B,LEX,TB

M·A·N

NICOLAS, E.
German ac. early 20c.
LEX

NICOLET, Gabriel Emile Edouard
French 1856-1921
B,LEX,TB

Gabriel Nicolet

NICOLS, Audley Dean
American ac. 1919-35
H

NICOLSON, Robert
English mid 20c.
LEX

RTN

NICZKY, Rolf
German 1881-
B

NIEDERHAUSER, Paul
Swiss mid 20c.
GR58-65

NIELSEN, Jon
American mid 20c.
PAP

NIELSEN, Kai
 Danish 1882-1924
 H,M,TB

KN·

NIELSEN, Kay
 Danish 1886-1957
 B,GMC,TB,VO

KN

NIELSEN, Otto
 Danish 1916-
 GR54-56-57-58

ON

NIELSON, Kjeld
 Danish mid 20c.
 GR57

NIEMEYER, Adelbert
 German 1867-1932
 AN,B,LEX,TB

NIESS, Rudolf
 German 1903-
 GR55

R.N.

NIETSCHE, Erik
 Swiss/American 1908-
 LEX,VO

NIEUWENHUIS, Douwe (Dow)
 Canadian
 H

NIEUWENHUIS, Theodor Willem
 Dutch 1866-1951
 MM,POS

TN

NIEUWENKAMP, Wynand Otto Jan
 Dutch 1874-
 B,LEX,TB

W. O. J. N.

NIGG, Ferdinand
 German ac. early 20c.
 MM

NIGH, H.
 Dutch early 20c.
 POS

NIGHTINGALE, C. T.
 English 1878-
 M

NIKO
 Cuban 20c.
 POS

ñiko 74

NIKOLAIEV
 Russian early 20c.
 POS

NILSON, Friedrich Christoph (F. Christian)
 German 1811-79
 B,H,M

NILSON, Gösta Adrian
 Swedish 1884-
 LEX,VO

NIMAS, Paul
 American 1903-
 M

NISBET, Mary Jacquetta
 American 1928-
 H

NISENSON, Samuel
 American 20c.
 H

NISHI, Naoki
 Japanese late 20c.
 GR82

NISHIJIMA, Isao
 Japanese mid 20c.
 GR57-61-65 thru 69

N.Jima

NISHIMOTO, Shigeru
Japanese mid 20c.
GR57

NISHINO, Takahiko
Japanese late 20c.
GR82

NISHWAKI, Marjorie
Japanese/English 20c.
M

NISLE, Julius
German 1812-
B

NISS, Robert Sharples
American 1949-
H

NISSEN, Mary
American 20c.
M

NITSCHE, Erik (Eric)
Swiss/American 1908-
GR52-53-54-56-60-61-63,H,M,POS

ERIK NITSCHE

NITZSCHE, Elsa Koenig
American 1880-1952
B,F,H,M

NITZKY, Rolf
German
LEX

NIVEN, Frank R.
American 1888-
F

NIVERVILLE, Louis de
Canadian 1933-
GR62,H

NIVINSKIJ, Ignatij Ignatiewitsch
Russian 1888-1933
B,LEX,TB,VO

ИГН.Н.

NIX, Robert
Dutch late 20c.
EI79

NIZZOLI, Marcello
Italian 1895-
CP,GR55,H,POS

Nizzoli

NOAILLES
French mid 20c.
GR61

NOBLE, Carl E.
American 20c.
H,M

NOBRE, José Roberto Dias
Portuguese 1903-69
H

NOCI, Arturo
Italian/American 1874-
B,F,H

NOCKUR
German early 20c.
CP

NOËL, Jacques
French mid 20c.
GR57

J.Noël

NOËL, Pierre
French 20c.
B

NOFZIGER, Edward C.
American 1913-
CAV,H,M

Ed Nofziger

NOGUCHI, Hisamitsu
Japanese early 20c.
POS

NOGUEIRA, Rolando de Sa
Portuguese 1921-
H

NOGUÉS I CASES, Xavier
Spanish 1873-1941
B,EC

NOLF, John Thomas
 American 1871/74-1954
 F,H,M

NOLPA, Hans
 German 1878-1930
 B,LEX,TB

NONNACH, Marie
 American 20c.
 LEX

NONNAST, Paul E.
 American 1918-
 H,IL

nonnast

NONNI, Francesco
 Italian 1885-
 B,H

NORBONA, Pla
 Spanish 20c.
 POS

NORCROSS, Grace
 American 1899-
 H,M

NORDELL, Emma Parker
 American 20c.
 F,H

NORDMARK, Olof E.
 Swedish/American 1890-
 H

NORFIELD, Edgar
 English 20c.
 LEX,M

NORJOU, Félix
 French late 19c.
 LEX

NORLING, Ernest Ralph
 American 1892-
 F,H,M

NORLING, Ulf Ake
 Swedish mid 20c.
 GR61-63

NORLING

NORMAN, Geoffrey Rich
 Anglo/American 1899-
 F,H,M

NORMAND, A.
 French late 19c.
 LEX

NORRINGTON, Bob
 English late 20c.
 EI79,GR81

NORRIS, W. J.
 American 1869-
 B,F,M

NORTH, John William
 English 1842-1924
 B,H,LEX,TB

NW.

NORTHERNER, Will
 American 20c.
 P

NORTON, John Warner
 American 1876-1934
 F,H,POS

John Norton

NORTON, M. E.
 American 19/20c.
 R

M.E.Norton.

NORWAISH, Casimer (Cass)
 American mid 20c.
 PAP

NORWELL, Graham Noble
 Anglo/Canadian 1901-
 H,M,STU1925

GN

NOSWORTHY, Florence Englang
 American
 H,M

NOTLEY, Cecil D.
 English mid 20c.
 GR52-53

NOTMAN, James
 Canadian ac. 1871
 H

NOURY, Gaston
 French 1866-
 B,LEX,TB

NOVÁK, Jan
 Yugoslavian 1921-44
 H

NOVAKOVA, Vera
 Czechoslovakian mid 20c.
 GR61

NOVELLI, Enrico (Yambo)
 Italian 1876-1943
 EC

NOVEMBER, David
 American mid 20c.
 GR65-67-73-74

NOVINSKA, Nina
 American 20c.
 M

NOVOTNY, J. B.
 Czechoslovakian mid 20c.
 GR60

NOWAK, Leo
 American 1907-
 H,M

NOWICKI
 Polish early 20c.
 POS

NOWIK, Evelyn
 English mid 20c.
 GR54

NOYER, P. H.
 French 1917-
 B,PG

NUBIOLI, Danilo
 Italian mid 20c.
 GR61-66-73-81

NUDERSCHER, Frank Bernard
 American 1880-1959
 B,F,GMC,H,M

NUGENT, Arthur William
 American 1891-1975
 H,M

NUGENT, Meredith
 Anglo/American 1860-1937
 H,M,SN8/94

NUGENT, Richard Bruce
 American
 H

NUHFER, Olive Harriett
 American 1907-
 H,M

NUKI
 see
 MILLSAPS, Daniel Webster

NUMADA (NUMATA) KASHŪ
 Japanese 1838-1901
 H,J

NUÑES, Emerico Hartwicht Jacinto
 Portuguese 1888-1968
 B,H

NUNG, Chen Chi
 Chinese mid 20c.
 LEX

NURA
 American 20c.
 H,M

NURICK, Irving
 American 1894-1963
 F,H,IL,M,Y

NUSBAUM, Aileen
American 20c.
M

NUTZLE, Futzie
American 1942–
AA

NUYTTENS, Josef Pierre
American 1885–
B,F,H,M

NVUMALO, Caiphas
South African late 20c.
GR82

NYGAARD, Axel
Danish 1877–
LEX,VO

N:

NYMAN, Hilding Elof
Swedish 1870–
B

NYS
Belgian 19/20c.
POS,M?

NYSTAD, Gerda
Danish 1926–
EC,LEX

gerda Nystad.

NYSTRÖM, Jenny
Swedish 1857–
B

NYSTRÖM, P. O.
Finnish 20c.
GR60–63–66–67–69–71

(PON)

– O –

OAKES, William Larry
American 1944–
H

OAKLEY, Fred
Canadian
H

OAKLEY, Thornton
American 1881–1955
B,F,H,HA,I,IL,LEX,M,TB

T·Oakley–

OAKLEY, Violet
American 1874–1961
B,F,H,I,LEX,M,Y

VIOLET OAKLEY.

OAKMAN, John
English 1748?–1793
B,H,M

OBERGFELL, Richard
Canadian –1971
H

OBERHARDT, William
American 1882–1958
B,F,FOR,H,I,IL

Oberhardt

OBERLÄNDER, Gerhard
German 1907–
G

OBERLE, Jean
French 1900–61
B,GMC,H,M

OBERMAIER, Otto
German 1883–
B,LEX,TB,VO

OBIOLS PALAU, Josep
Spanish 1894–
B

OBLINSKI, Rafal
American 1943–
AA

O'BRIEN, Lucius Richard
Canadian 1832–99
B,H,M

OCHAGAVIA, Carlos
Argentinean/American 20c.
GR79–81–83,NV

ochagavia

OCHS, Jacques
Belgian early 20c.
M,POS

OCHS, Phil
American mid 20c.
PG

ODEN, Clytie
American 20c.
M

ODERMATT, Siegfried
Swiss mid 20c.
GR 57-60-61-63-67 thru 70-73

ODJIG, Daphne (Beavon)
Canadian
H

ODOM, Mel
American 20c.
GR 81-85,P

OECHSLI, Kelly
American 1918-
H

OEHLER, Bérénice Olivia
American 20c.
B,F,H

OELKE, Siegfried
German 1923-
G

OËR, Theobald Reinhold Freiherr baron von
German 1807-85
B,H,M,TB

OERTEL, Johannes Adam Simon
German/American 1823-1909
B,BAA,F,H,I

OESTERBERG, Roland
Swedish mid 20c.
GR 52

OESTERLIND, Allan
French 1855-1938
B,LEX,TB,VO

OFFEL, Edmond van
Belgian 1871-
B

OFFTERDINGER, Anni
German early 20c.
ST

OFFTERDINGER, Karl
German 1829-89
B,H,TB

O'GALOP (ROSSILLON, Marius)
French 1867-1946
B,BI,EC,POS

OGDEN, Henry Alexander (Harry)
American 1856-1936
BAA,CWA,F,H,PE,SN 7/94,Y

OGDEN, Henry P.
American 1856-1905
B,H

OGDEN, Lyman Garfield
American 1882-
F

OGÉ, Eugène
French 19/20c.
B,BI,POS

OGG, Oscar
 American 1908-71
 H,M

OGLE, Richard
 American 20c.
 M

OHARE, Joseph Francis
 American 1898-
 M

OHASHI, Tadashi
 Japanese 1916-
 GR54-56-57-61-67 thru 75-77 thru
 85,H,LEX,POS

Ō HA

OHAUS, Wilhelm Gottfried
 German 1828-84
 B

OHCHI, Hiroshi
 Japanese 1908-
 GR52 thru 58-60-61-63-65-66-70-71,H,POST

H.OHCHI

OHLENSCHÄGER, Fritz
 German early 20c.
 LEX

OHLSSON, Ib
 Danish/American 1935-
 H

OHNESORG, Karl (Carl)
 Austrian 1856-
 B,TB

C O

OHTA, Ken-ichi
 Japanese mid 20c.
 GR52

OHTA, Kenji
 Japanese mid 20c.
 GR55

K. Ohta

OILLE, Ethel Lucille (Wells)
 Canadian 1912-
 H

OKAMOTO, Shigeo
 Japanese late 20c.
 GR69-70-78-82

O'KANE, Helen Marguerite
 American ac. 1900
 M

OKAS, E.
 Romanian 1915-
 B,LEX

O'KEEFE, Neil
 American 1893-
 H,M

O'KEEFFE, Georgia
 American 1887-1986
 B,F,GMC,H,M

OKON, Mejo
 American 1953-
 F,Y

OKSEN, Jorgen
 Danish 1919-
 GR52-53-54-57,H

OKUMURA, Tamie
 Japanese late 20c.
 GR82

OKUN, Edward
 Polish 1872-1945
 AN,B

OKUNO, Hideo
 Japanese mid 20c.
 GR52-56-67

H.OKUNO

OKUYAMA, Gihacharo
 Japanese early 20c.
 POS

OLBINSKI, J. (Josef?) Rafal
 Polish?/American late 20c.
 GR75-81 thru 85

R.Olbinski

OLBRICH, Josef Maria
Austrian 1867-1908
B,CP,H,POS

OLDEN, George
American 1921-
GR55 thru 58-60,H

OLDENBURG WITTIG, Lotte
German 1869-
B,LEX,VO

L.O.W.

OLDMAN, Jean
American early 20c.
GMC

OLDS, Sara Whitney
American 1899-
H

O'LEARY, John
American 20c.
ADV,GR74 thru 80-82,H

O'LEARY, P. M.
Canadian ac. 1878-82
H

OLENCHAK, Thomas Richard
American 1907-
H,M

OLIVEIRA, Fernando de
Portuguese 1930-
H

OLIVER, Louise (Beebe)
American 1912-
H,M

OLIVIE-BON, Léon
French 1863-1901
B,M

OLIVY, Václav
Austrian?/Czechoslovakian early 20c.
POS

V·OLIVY

OLMOS, Fernando
Spanish mid 20c.
GR65

OLMOS.

OLRIK, Ole Henrik Benedkt
Danish 1830-90
B,LEX,TB

OLRIK, Sigurd
Danish 1874-1921
B

OLSEN, Harry Emil
American 1887-
B,F,H,M

OLSEN, Herbert Vincent
American 1905-73
H

OLSHAUSEN-SCHÖNBERGER, Käthe (Dombrovaki)
German 1881-
B,TB

K.O.S.

OLSON, Herbert Vincent
see
OLSEN, Herbert Vincent

OLSSON, Gunnar
Swedish mid 20c.
GR52-53-54

OLSTOWSKI, Franciszek
Polish/American 1901-
B,F,H,M

OLTAR-JEWSKY, W. K.
American 20c.
M

OLYFF, Michel
Belgian mid 20c.
GR52-58-60-62-70

O'LYNCH VON TOWN, Karl
Austrian 1869-
B,CEN6/09 & 9/09

O'Lynch

O'MALLEY, Power
Irish/American 1889?-1930
ABL8/05,EC,F,H,McC11/04,M

Power O'Malley or

OMAN, Edwin L.
American 1905-
H

O'MEILIA (O'MELIA), Philip Jay
American 1927-
H

O'Meilia

OMER, Rowland
Irish ac. 1755-67
B,H,M

OMS, Vicente (the Younger)
Spanish 1852-85
B

ONDREICKA, Karol
Yugoslavian 1898-1961
H,VO

KJ

O'NEAL, William Bainter
American 1907-
H,M

ONEGIN-DABROWSKI, Andrzej
Polish mid 20c.
GR65-71

ONEGIN DABROWSKI 64

O'NEILL, George (Bernard?)
English? early 20c.
AM4/25,B,M

GEORGE
O'NEILL

O'NEILL, John Patton
American 1942-
H

O'NEILL, Rose Cecil
American 1875-1944
CAV,EC,F,GMC,IL,LEX,M,PE,Y

oNei

O'NEILL-WILSON, Rose Cecil
see
O'NEILL, Rose Cecil

ONFROY DE BREVILLE, Jacques
French 1858-1931
EC

ONKELINK, Guy
Belgian 1879-
B

ONWHYN, Thomas
English 1820-86
B,M

OOSTEROM, Hans P. van
Dutch mid 20c.
GR61

OPERTI, Albert Jasper Ludwig Rouabigliera
Italian 1852-1927
B,F,H,M

OP GEN OORTH, Tessa
German mid 20c.
LEX

OPIE, John
English 1761-1807
B,DA,H,M

J. Opie

OPISSO SALA, Ricardo
Spanish 1880–1966
B,EC

OPPENHEIM, Louis
German early 20c.
B,POS

OPPENHEIM, Samuel Edmund
American 20c.
H

OPPENHEIMER, (Sir) Francis
English 1870–
B,TB

OPPENHEIMER, Johanna
German 1878–
B

OPPER, Frederick Burr
American 1857–
CAV,CC,EC,F,H,I,LEX

F. Opper

OPPER, John
American 1908–
H,M

ORAZI, Manuel
French 19/20c.
ADV,B,CP,FO,POS

ORBAAN, Albert F.
Italian/American 1913–
H

ORBY, Gunnar
Swedish mid 20c.
GR61

ORCHARDSON, (Sir) William Quiller
Scots 1832–1910
B,BAA,H,LEX,TB

WQO

ORCZYKOWSKI, Gregor
German 1926–
LEX,VO

ORDE, Gertrude Cederstrom
American 1901–
H

ORELL (ORELLI), Hans Heinrich
Swiss 1872–
B

ORIANI, Luigi
Italian 1919–
GR54–68,H

ORIZZO, José Clemente
Mexican 20c.
LEX

ORLIK, Emil
Austrian 1870–1932
AN,B,MM,PC,POS

ORLOFF, Gergory
Russian/American 1890–
F,H,M

ORLOV, Dimitri Stakeheyevich
Russian 1883–1946
B,EC

D. MOOP

ORLOWSKI, (Prof.) Hans Otto
German 1894–
B,G

ORR, Alfred Everitt
 American 1886–
 B,F

ORR, Forrest Walker
 American 1895/96–
 H,M

ORR, Martha
 American 20c.
 H

ORR, Richard
 English late 20c.
 EI79,GR85

ORRBY, Gunnar
 Swedish mid 20c.
 GR52

ORSELLINI, Glauco
 Italian mid 20c.
 GR52

ORSELTA-SCHMID, Ingeborg
 Austrian mid 20c.
 LEX

ORTEGA, José Garcia
 Spanish mid 20c.
 GR52-53-55-58

ORTEGA Y VEREDA, Francisco Javier
 Spanish –1881
 B

ORTEYS
 Spanish mid 20c.
 ADV

ORTMANN
 German early 20c.
 CP

ORTNER, Alfons
 Austrian 20c.
 LEX

ORWIG, Louise
 American early 20c.
 F,H,M

OSAWA, Kazuo
 Japanese mid 20c.
 GR64

OSBORN, Robert
 American 1904–
 CC,GR53-55-56-58-61-62-67-69-75,H,PG

OSBORNE, Addis
 American 20c.
 H,M

OSBORNE, Betty
 Canadian early 20c.
 WS

O'SHAUGHNESSY, Thomas A.
 American early 20c.
 B,H,M

OSIECKI
 Polish early 20c.
 POS

OSIS, Maigonis Jāņa
 Latvian 1929–
 LATV

OSKAR
 see
 PINTO LOBO, Oskar

OSNIS, Benedict A.
Russian/American 1872–
F,M,poster:'Help Fill The War Chest'––
"Humanity Calls" 1917,*

B.A.Osnis

OSPOVAT, Henry
English 1877–1909
B,BK,H,LEX,TB

OSSORIO, Alfonso Angel
Filipino/American 1916–
B,F,H

OSSWALD, Eugen
German 1879–
B,TB

Eug. O.

OSTBERG
Swedish 19/20c.
POS

OSTENDORF, Arthur Lloyd, Jr.
American 1921–
H

OSTERLIN, A.
Swedish mid 20c.
GR57–60

OSTERWALD, Rose d'
Swiss 1795–1831
B

OSTERWALDER, Hansuli
Swiss mid 20c.
GR60–72?

OSTERWALDER, Ute
German?/Swiss mid 20c.
GR69–72 thru 75–77–79–80–84–85

OSTOJA-CHROSTOVSKI, Stanislav
Polish 1897–1947
B,PEC,VO

SOC

OSTRENGA, Leo Raymond
American 1906–
H,M

OTERO, Aileen
American 20c.
M

OTIS, Samuel Davis
American 1889–
B,F,H,M

OTMAN, J.
American 20c.
M

OTNES, Fred
American 1925/26–
ADV,C,F,GR72–75 thru 80–82 thru 85,H,IL,Y

Fred Otnes

OTREY, Alexander
German 1877–
B

A.O.

OTSUKA, Tohru
japanese mid 20c.
GR57–60–70

OTT, Gunter
German mid 20c.
GR58–61–62–64

OTT, Henri
Swiss mid 20c.
GR52

ott

OTTENFELD, Rudolf Otto Ritter von
Austrian 1856–1913
B,LEX,TB

R v O

OTTEVAERE, Henri
Belgian 1870–1944
B,H,MM,POS

OTTH, J. P.
Swiss mid 20c.
GR54-63

OTTINGER, George Morton
American 1833-1917
H

OTTINGER, Kenneth
American 1945-
CON

Kenneth D. Ottinger

OTTLER, Otto
German early 20c.
POS

OTTMAN, Chic
American 19/20c.
R

OTTO, Lugwig
German 1850-1920
B,LEX,TB

OTTO, M. A.
German 20c.
LEX

OTTOLINI, Raquel Rogue Gomeiro
Portuguese 1889-1970
H

OURDAN, Joseph Prosper
American 1828-81
D,F,M

OURY, Louis
French 19/20c.
BI

Louis OURY

OUSHIN, N.
Russian 20c.
M

OUTCAULT, Richard Felton
American 1863-1923
B,CAV,F,I,LEX,R

RFOutcault

OUVRÉ, Achille
French 1872-1951
B,S

OVERBEEK, G. J. van
Dutch 1882-
B

OVEREND, William Heyshman
American 1851-98
B,H,TB

Who.

OVERLAND, Arne
Norwegian 20c.
LEX

OWEN, Bill
American 1942-
CP,H

OWEN, Frank Edward
American 1907-
CAV,M

OWEN, Michael G., Jr.
American 1915-
H,M?

OWEN, Will
English early 20c.
ADV,POS

OWENS, Charles
American 20c.
M

OWENS, John
Anglo/American 1892-1956
NG24

19 JOHN OWENS 05

OWENS, Maude Irwin
American 1900-
H

OWRY, Louis
 French 19/20c.
 BI

OXENBURY, Helen
 English late 20c.
 EI79,H

OXENHAM, Patrick
 English late 20c.
 EI79

OZOLIŠ, Martiņš Reiņa
 Latvian 1905-
 LATV

1945

OZOLIŠ, Valentins Antona
 Latvian 1927-
 LATV

– P –

P. B.
 German ac. late 19c.
 GMC

PAAP, Hans
 see
 PAPE, Hans

PAAR, Ernst
 Austrian mid 20c.
 GR54

PACCIONE, Onofrio
 Anglo/American mid 20c.
 ADV,GR63

PACH, Walter
 American 1883-1958
 B,F,H,M

PACHEKO, José
 Portuguese 1885-1934
 H

PACKARD, David
 American 1928-68
 H,P

PACKARD, Emmy Lou
 American 1914-
 H

PACKER, A. S.
 American 1907-
 H,M

PACKER, Clair Lange
 American 1901-
 H,M

PACKER, Fred Little
 American 1886-1956
 ADV,EC

PACKMAN, Frank G.
 American 1896-
 F,H,M

PACOLT, Ernst
 Austrian 20c.
 LEX

PADALKA, I.
 Russian early 20c.
 LEX

PADERLIK, Arnost
 Czechoslovakian 1919-
 B,GR54,H

PADRON
 Cuban? 20c.
 POS

PADUA, José
 Portuguese 1934-
 H

PAEDE, Paul
 German 1868-1929
 B

PAELTORRES, Armando
 Argentinean 20c.
 CP

PÁEZ, Torres Armando Pablo
 Argentinean 1918-
 GR66-69,H

PÁEZ, Vilar(i)ó, Carlos
 Uruguayan 1923–
 B,H

PAEZ VILARO 56

PAFLIN, Roberta
 American 20c.
 M

PAGE, Gilbert
 American 20c.
 M

PAGE, Grover
 American 1892–1958
 EC,F,H

[signature]

PAGE, H.
 American early 19c.
 D

PAGÉS, Jean
 American mid 20c.
 GR55,M,VC

J.PAGÉS

PAGÉS, Pierre
 French mid 20c.
 GR64,H

PAGET, Henry Marriott
 English 1857–1936
 B,BK,LEX,M,STU1899

HMP

PAGET, Sidney E.
 English 1860–1908
 B,BK,GMC,TB

SP

PAGET, Walter
 English 1863–1935
 B,BK

WP

PAGET-FREDERICKS, Joseph Rous-Marten
 American 1903–63
 F,H

PAGNATO, Frank
 American 20c.
 M

PAGNIEZ, Regis
 French mid 20c.
 GR64

PAHISSA Y LAPORTA, Jaime
 Spanish 1846–
 B

PAINE, Charles
 English ac. 1920's
 MM

CPAINE

PAJAK, Jacques
 French 1930–61
 B,H

PAKHOMOV, Alexei Fyodorovich
 Russian 1900–
 MM

АП::

PAKULA, Marvin
 American 1925–
 M

PAL (pseudonym)
 see
 PALEOLOGUE, Jean de

PALACIOS, Rafael
 Puerto Rican mid 20c.
 PAP

palacios

PALDI, Israel
 Russian/Israeli 1895–
 LEX,VO

'3ןנ

PALÉOLOGUE, Jean de
Hungarian/French 1855–
B,BI,CP,FO,GMC,LEX,MM,POS,POST,TB

PALETTE, Peter
see
ONWHYN, Thomas

PALEY, Robert L.
American ac. 1890–1906
H

PALITZSCH, Hanscheinrich
Austrian/German mid 20c.
GR54–56–57–58–60,H

PALKA, Julian
Czechoslovakian?/Polish 1923–
GR54–56–61–66,POS

J·PALKA

PALLA, Victor
Portuguese
H

PALLADINI, David
Italian/American 1946–
CP,F,GR71–73–74–75–78,Y

PALLADINO, Tony
American mid 20c.
GR56–61

Palladino

PALMEDO, Lillian Gaertner
American 1906–
B,H,M

PALMER, Allen Ingles
American 1910–50
H,M

PALMER, Bessie Laass
American 20c.
M

PALMER, Frances Flora Bond
Anglo/American 1812–76
D,F,H,M,Y

PALMER, Herman
American 1894–
B,F,H,M

PALMER, Hermione
American 20c.
H,M

PALMER, J.
American ac. early 19c.
F

PALMER, Lemuel
American 1893–
F,H,M

PALMER, W. J.
Canadian ac. 1873
H

PALOMAR, Francisco Alberto
Argentinian 1896–
H

PALULIAN, Dickran P.
American 1938–
F,GR75–76–79–80,Y

PALUMBO, Jacques Gaitan
Canadian 1939–
H

PANCHO
see
GRAELLS, Francisco

PANCOAST, Morris Hall
American 1877–
B,F,H,M

PANCOST, Morris Hall
see
PANCOAST, Morris Hall

PANIGL-SCHÖN, Hanna
Austrian 20c.
LEX

PANKOK, Bernhard
German 1872–1943
AN,B,H,M

PANN, Abel (Pfeffermann)
French? 1883–
B,LEX,VO

PANNAGGI, Ivo
 Italian 1901–
 B,LEX,VO

PANOFF, Ivan Stepanovitch
 Russian 1845–83
 B

PANQUEL
 French mid 19c.
 LEX

PANTLIN, John
 English mid 20c.
 GR53

PAOLETTI, Sylvius D., (D. Sylvius)
 Italian 1864–1921
 B,H,TB

PAOLI, Iris de
 see
 de PAOLI, Iris

PAOLOCCI, Dante
 Italian 1849–1926
 B,H

PAPE, Eric
 American 1870–1938
 B,F,H,I

PAPE, Ferdinand Charles François Joseph de
 Belgian 1810–85
 B,H

PAPE, Hans
 German/American 1894–1956
 B,G,H,TB

HP

PAPE, William
 German/Swedish 1859–1920
 B,M

W.P.

PAPIN, Joseph
 American 20c.
 H

PAPIOL
 Cuban 20c.
 POS

PARAY, Michael
 Canadian 1911–
 H

PARCELL, L. Evans
 American early 20c.
 F

PARES, Bip
 American 20c.
 M

PARHAM, Hilton L., Jr.
 American 1930–
 H

PARIN, (F) Gino
 Italian 1876–
 B,H,LEX

PARIS, Jean Marie Alfred
 French/Argentinian 1846/49–1908
 B,H

PARISH, Anne
 American 1888–
 LEX

PACK, Carton Moore
 see
 MOORE-PARK, Carton

PARK, James Kwan Kee
 Korean/American 1913–
 H

PARKE, Jessie Burns
 American 1889–
 B,F,H,M

PARKER, Alfred Charles
 American 1906–
 F,GMC,H,IL,M

PARKER, Arvilla
 American 20c.
 M

PARKER, Cora
American early 20c.
F,H

PARKER, Cushman
American 1881-
ADV,F,H,M

PARKER, Emma Alice
American 1876-
B,F,H,M

PARKER, Lewis
Canadian 1927-
H

PARKER, Nancy Wilson
American 1930-
H

PARKER, Robert Andrew
American 1927-
F,GR74-76-77-84-85,H,P,Y

PARKHOUSE, Stanley
American 20c.
H,M

PARKHURST, Anita (called Wilcox)
American 1892-
B,F,H,M

PARKHURST, Clifford Eugene
American 1888-
F,H,M

PARKHURST, Thomas Shrewsbury
American 1853-1923
B,F,M

PARKINSON, William Jensen
American 1899-1965
H,M

PARKS, Elise
American 20c.
M

PARKS, Gordon
American 1912-
H

PARKS, Gower
English mid 20c.
GR52

PARMALEE, Theodore D.
American 20c.
GR57,M

PARNALL, Peter
American 1936-
H

P.

PARRISH, Maxfield Frederick
American 1870-1966
ADV,B,CAV,EC,F,GA,GMC,H,I,IL,LEX,M,
MM,PE,POS,POST,TB,Y

Maxfield Parrish

PARRISH, Thomas
American 1837-99
H

PARRY, Marian (Feld)
American 1924-
H

PARSON, Leon
American 1951-
CON

Leon Parson

PARSONS, Alfred William
English 1847-1920
B,BK,H,I,SCR9/93

ALFRED PARSONS.

PARSONS, Charles H.
Anglo/American 1821-1910
B,BAA,F,H,I

PARTCH, Virgil Franklin II (Vip)
American 1916-
CAV,EC,GR55,H,LEX

Vip

PARTEE, McCullough
American 1900-
F,H,M

PARTINGTON, Gertrude
American ac. early 20c.
CEN3/04

PARTRIDGE, (Sir) John Bernard
English 1861-1945
B,BK,EC,H,POST

PARZINGER, Tommi
American early 20c.
M,POS

PASCAL, Theo
American 1915-
H

PASCALINI, Gabriel
French?/Canadian late 20c.
B,EI79,GR79

PASCHAL, Pierre
French 20c.
B

PASCHKE, Edward F.
American 1939-
F,H,P,Y

PASHCHENKO, Mstislav
Russian 1901-58
EC

PASQUIRE, Francis
French 1901-69
B

PASS, Herbert
Austrian mid 20c.
GR53

PASSOS, John Dos
Russian 20c.
M

PASSUTH, Ödön
Hungarian 1860-
B

PASTOR, José Miguel
Spanish 1857-1902
B,POS

PASTORIS, (Conte) Federico
Italian 1837-84
B,H,LEX

PATEK, August
Austrian 19/20c.
LEX

PATEL, Mickey
Indian late 20c.
GR82

PATER
see
SATO, Pater

PATERSON, D.
Venezuelan mid 20c.
GR57

PATERSON, George
Canadian early 20c.
GMC,WS?

PATHE, Moritz
German 1858-1907
B,TB

PATKA, Julian
Polish mid 20c.
GR55

PATON, F. Noel
English ac. late 19c.
EN

PATON, Frank
English 1856-1909
B,H,M

PATON, Jane Elizabeth
English 1934-
H

PATON, (Sir) Joseph Noel
　　Scottish 1821-1901
　　BA,H,TB

J.N.P.

PATOU
　　French early 20c.
　　ST

PATTEE, Elsie Dodge
　　American 1876-
　　B,F,H

PATTEN, Edmund
　　Canadian ac. 1852
　　H

PATTEN, William
　　American 1865-1936
　　M

PATTERSON, Andrew Dickson
　　Canadian 1854-1930
　　H,M

PATTERSON, Glen
　　Canadian 1952-
　　H

PATTERSON, Lawrence A.
　　American 20c.
　　M

PATTERSON, Margaret Jordan
　　American 19/20c.
　　B,F,H,I

PATTERSON, Robert
　　American 1895/98-
　　F,H,IL,M,Y

Robert Patterson

PATTERSON, Russell
　　American 1896-1977
　　F,GMC,H,IL,M,PE,Y

Russell PATTERSON

PATTISON, Albert Mead
　　Canadian 1877-
　　H

PATTON, Alan
　　American late 20c.
　　GR82

PAUL, Arthur
　　American 1925-
　　GR72,H,P

PAUL, Bruno
　　German 1874-1968
　　AN,B,CP,EC,GMC,H,LEX,MM,POS,SI

β

PAUL, Charles R.
　　American 1888-1942
　　B,F,H,M

PAUL, Gregory Wilmer
　　American 1950-
　　GR81,H

PAUL, Julian
　　American mid 20c.
　　PAP

PAUL

PAUL, Peter
　　American mid 20c.
　　PAP

PAUL, Rene Georges Hermann
　　French 1864/74-1940
　　B,FS,LEX,MM,TB,VO

hermann Paul

PAULELBAUER
　　see
　　ETBAUER, Theodor Paul

PAULÉMILE
　　see
　　PISSARO, Paul Émile

PAULETTO, Alfredo
　　Swiss mid 20c.
　　GR54-57-63

PAULEY, Floyd
 American 1909-35
 H,M

PAULI, Georg Vilhelm
 Swedish 1855-1935
 B,SC,TB,VO

G P

PAULL, Grace A.
 American 1898-
 H,M,S

PAULO
 see
 RODRIGUES-FERREIRA, Paulo

PAULSEN, Anna-Greta
 Swedish mid 20's
 GR52

PAULSEN, Ed
 American mid 20c.
 PAP

PAULSON, Carl
 American mid 20c.
 ADV

PAULTON, T. L.
 French early 20c.
 LEX

PAULUKA, Felicita Kárla
 Latvian 1925-
 LATV

PAULUS, Josep
 German 1877-
 B

PAUS, Herbert Andrew
 American 1880-1946
 F,GMC,IL,M,Y

P A U S

PAUSINGER, Franz von
 Austrian 1839-1915
 B,H,LEX,TB

F.vP.

PAVIA, Manuel Ribeiro de
 Portuguese 1910-57
 H

PAVIS, George Alfred
 French 1886-1951
 B

PAVLOFF, Szemion Andrejevitch
 Russian 1893-
 B

PAW, René de
 Belgian 1887-1946
 LEX,VO

PAXSON (PAXON), Edgar Samuel
 American 1852-1915/19
 B,H

E·S· Paxson

PAXSON, Ethel
 American 1885-
 B,F,H,M,SO

PAYNE, Albert Henry
 English 1812-1902
 B

PAYNE, Emma Lane
 American 1874-
 B,F,H,M

PAYNE, George
 American 20c.
 M

PAYNE, George Kimpton
 American 1911-
 H,M

PAYNE, Gordon
 American 20c.
 M

PAYNE, Henry A.
 English 1868-
 B,LEX,TB

H.P.

PAYNE, Joan Balfour
 American 1923-
 H

PAYNE, A. Wyndham
English 20c.
M

A.W.P

PAYOR, Eugene
American 1909–
H,M

Payor

PAYSON, Dale Constance
American 1943–
H

PAYTON, R. B. M.
English early 20c.
LEX

PAYZANT, Charles
American 20c.
H

PAZ PÉREZ, Gonzales de la
Mexican
LEX

PEACOCK, Claude
American 1912–
H

PEACOCK, Jon Edward
American 1908–
H,M

PEACOCK, Ralph
English early 20c.
B,LEX,TB

PEAK, Robert (Bob)
American 1928–
AA,F,IL,Y

B Peak

PEALE, Titian Ramsay
American 1799/1800–85
B,D,F,H

PÉAN, René
French 19/20c.
B,BI,FO

René Péan

PEAR, Jeannie
American 1922–
CON

Jeannie PEAR

PEARCE, Dennis J.
English 1926–
H

PEARCE, Helen Spang
American 1895–
H

PEARS, Charles
English 1873–
B,POST

CHAS PEARS

PEARSON, Charles
American 1907?–
LEX

PEARSON, Joseph
American mid 20c.
F?,GR58

PEARSON, Lawrence E.
American 1900–
H,M

PEASE, Nell Christmas McMullin
American 1883–
H,M

PEASE, Raymond S.
American 1908–
CON,PAP

Raymond S. Pease

PEAT, Fern Bisel
American 1893–
M

PEBAL, Kurt
 Austrian early 20c.
 POS

P.

PECHSTEIN, Max Hermann
 German 1881-1955
 AN,B,DRA,H,M,POS

HPechstein

PECK, Anna Merriman
 American 1884-
 B,BKM5/26 and 6/26,F,H,M

A.M.Peck

PECK, Clara Elsene
 American 1883-
 B,F,H,IL,M

Clara Elsene Peck

PECK, Graham
 American 1914-
 H,M

PECK, Henry Jarvis
 American 1880-
 F,H,HA,LEX,LHJ7/06

Henry J. Peck

PECK, James Edward
 American 1907-
 H,M

PECOUD, A.
 French early 20c.
 POS

APécoud

PEDERSÉN, Fritjof
 Swedish 1923-
 GR53-60,H,POST

Pedersén

PEDERSEN, Hugo Vilfred
 Danish 1870-
 B,TB

Hugo VP.

PEDERSEN, Sharleen
 see
 PEDERSON, Sharleen

PEDERSEN, Wilhelm Thomas
 Danish 1820-59
 B

PEDERSON, Sharleen
 American 20c.
 GR71-72-73-77,P

PEDUZZI, Karl
 Austrian 20c.
 LEX

PEERS, Frank W.
 American 1891-
 H,M

PEERS, Gordon Franklin
 American 1909-
 H,M

PEETERS, Joseph
 Dutch/Belgian 1895-1960
 B,H,POS

✶.

PEGRAM, Frederick
 English 1870-1937
 ADV,B,BK,H,LEX,M,TB

Fred Pegram

PEHAP, Erich Konstantin
 Estonian/Canadian 1912-
 H

PEIGNOT, Remy
 French mid 20c.
 GR52-54-61-66-67

PEIKLI, Dagfin
 Norwegian 20c.
 LEX

PEINER, Werner
German 1877–
B,GMC,M

W.PEINER

PEIRCE, Gerry
American 1900–
H,M

PEIRCE, H. Winthrop
American 1850–
B,F,H,I

PEIRCE, Thomas Mitchell
American 1864–
B,CEN10/09,F,I,M

THOMAS
MITCHELL
PEIRCE

PEIRCY, Frederick
see
PIERCY, Frederick

PEIXOTTO, Ernest Clifford
American 1869–1940
B,F,H,M,PE,R

E.C. Peixotto.

PELAYO, Orlando
Spanish 1920–
B,H

PELC, Antonin
Czechoslovakian 1895–1967
B,H

A.

PELCOQ, Jules
French 19c.
GMC

J.P

PELEGRI Y CLARIANA, José
Spanish 1838–80
B

PELL, Ella Ferris
American 1846–after 1935
B,BAA,F,H,M

PELLAR, Hans
German 1886–
B,TB,VO

P
H

PELLEGRINI, Riccardo
Swiss/Italian 1863–1934
B,H,POS,TB

P

PELLETIER, Narcisse
Canadian 20c.
M

PELLICER Y FEÑER, José Luis (Josep Lluis)
Spanish 1842–1901
B,EC,H,LEX,POS,TB

JL.

PELLON, Alfred
French 1874–
B,LEX,TB

PELS, Winslow-Pinney
American late 20c.
GR82

PEMMER, M.
German ac. late 19c.
LEX

PENA, Amado Maurelio Jr.
American 1943–
AA,H

PENAGOS Y TALABARDO, Rafael
Spanish 1889–
B

PENDERGAST, Molly
American 1908–
H,M?

PENDL, Erwin
 Austrian 1875–
 B,TB

PENFIELD, Edward
 American 1866–1925
 ADV,B,BI,CP,F,GA,GMC,H,I,IL,MM,POS,
 POST,R,TB

Ӻoward Ꝑenfield

PENGUILLY L'HARIDON, Octave
 French 1811–70
 B,H

O.P.L.

PENINGTON, Ruth Esther
 see
 PENNINGTON, Ruth Esther

PENKOFF, Ronald Peter
 American 1922–
 H

PENNELL, Joseph
 Anglo/American 1860–1926
 AN,APP,B,BK,F,H,I,IL,LEX,M,PC,PE,POS,
 POST,TB

Joseph Ꝑennell.

PENNES (SENNEP), Jean Jacques Charles
 French 1894–
 EC,H

J. Sennep

PENNINGTON, Harper
 American 1854–1920
 CWA,F,I,M

PENNINGTON, Ruth Esther
 American 1905–
 H,M

PENNINGTON, T. Maurice
 American 1923–
 H

PENNINGTON, W. V.
 American 20c.
 M

PENNY, Janice
 American 20c.
 M

PENTZ, Donald
 Canadian 1940–
 H

PEON, Ju
 Chinese ac. 1915
 M

PEPPER, George Douglas
 Canadian 1903–62
 H,M

PEPPER, Robert (Bob) Ronald
 American 1938–
 F,GR70-77-79

PERAHIM, Jules
 Rumanian 1914–
 B,H

PERARD, Victor Simon
 American 1870–1957
 B,CWA,F,H,I,SN8/94

V Ꝑerard.

PERCEVAL, Don Louis
 American 1908–
 H

PERCIVAL, Robert
 Canadian 1924–
 H

PERCY, Graham
 English late 20c.
 EI79,GR70

PERCY, Isabelle Clark
 American 1882–
 B,F,H,M

PERDRIZET, Auguste Adolphe
French 1855–
B

PEREA Y ROJAS, Alfredo
Spanish 1839–95
B

PEREA Y ROJAS, Daniel
Spanish 1834–1909
B

PEREIRA, Augusto Mota da Costa
Portuguese 1936–
H

PEREIRA, Júlio Maria dos Reis
Portuguese 1902–
H

PEREIRA, Margaret I. McConnell
American 20c.
M

PEREIRA, Roberto de
Portuguese 1908–69
H

PERELMAN, Sidney Joseph
American 1904–79
CAV,EC

PERICOLI, Tullio
Italian 1936–
EC,GR73–74–77–80–83–85

PERIZI, Nino
Italian 1917–
GR54,H

PERKES, Linnette Moeneh
American 20c.
F

PERKINS, Granville
American 1830–95
B,BAA,D,F,H,I

PERKINS, Jack
American 20c.
M

PERKINS, Lucy Fitch
American 1865–1937
F,H,I,M

PERKINS, Stella Mary
American 1891/96–
H,M

PERLEY, M. C.
American early 20c.
POS

PERLIN, Bernard
American 1918–
B,H,poster: 'Americans Will Always Fight
For Liberty––1778–1943'––1943,*

PERLMAN, Raymond
American 1923–
H

PERNITSCH, Leo
Austrian 1895–
LEX

PEROT, Edmond Maurice
French 1907–
B

PÉROT, Roger
French early 20c.
POS

PERRET, Paul André
Swiss mid 20c.
GR54–60–61–69–70–71–76–80

PERRETT, A. Louise
American early 20c.
F,H

PERRETT, Galen Joseph
American 1875–
B,F,H,M

PERRIN, Charles Robert
American 1915–
H

PERRIN, E. W.
American –1929
I

PERRIN, René
French mid 20c.
LEX

R.P.

PERRY, Alfred
American 20c.
C

PERRY, Emilie S.
American 1873–1929
B,F,H,M

PERRY, Kathryn Powers
American 1948–
H

PERRY, Raymond
American 1866–1960
B,F,H

PERTCHIK, Harriet
American mid 20c.
ADV,GR62

PESCHERET, Leon Rene
Anglo/American 1892–1961
F,H,M

PESCHKA, Anton
Austrian 1885–1940
LEX

PESKÉ, Jean Misceslas
French 1880–1949
B,LEX,POS,TB

PESSEL, Esther
American 1903–
H,M

PESSLER, Ernst
Austrian 1838–1900
B,LEX,TB

PETER, Rudolph
Swiss mid 20c.
GR61–62

PETERMAIR, Hans
Austrian early 20c.
LEX

PETERS, Charles Frederick
American 1882–1948
B,F,PE

PETERS, Dewitt Clinton
American 1865–
B,F,H,M

PETERS, Eric A.
American 1909–
H,M

PETERS, Lloyd A.
Canadian 20c.
M

PETERS, Ricarda
German mid 20c.
GR60

PETERS, W.
American ac. early 20c.
GMC

PETERS-MATISSE, Eric
French –1942
B

PETERSEN, Carl Olaf
Swedish/German 1881–1939
B,EC

PETERSEN, Friedrich
German 19/20c.
LEX

PETERSEN, Magnus Julius M.
　　Danish 1827–1917
　　B,TB

Magn. P.

PETERSHAM, Maud Fuller
　　American 1889/90–
　　H,M

PETERSHAM, Miska
　　Hungarian/American 1888–1959/60
　　H,M

PETERSON, Gunnar Biilmann
　　Danish early 20c.
　　POS

PETERSON, Margaret
　　Canadian/American 1902/03–
　　H,M

PETERSON, Perry
　　American 1908–58
　　F,IL

Peterson

PETERSON, Roger Tory
　　American 1908–
　　AA,H

PETERSON, Roy
　　Canadian 1936–
　　EC

PETERSSON, Björn
　　Swedish mid 20c.
　　GR52–72

PETETOT, Emile
　　see
　　PETITOT, Emile

PETIT, Léonel Justin Alexandre
　　French 1839–84
　　B,H

PETITOT, Emile
　　Canadian 1838–1927
　　H

PETLIN, Irving
　　American 1934–
　　B,H,P

PETREMONT, Clarice Marie
　　American 　　　–1949
　　B,F,H

PETRI (PETRIE), Frederick Richard
　　German/American 1824–57
　　B,H

PETRINA, Carlotta (Charlotte Kennedy)
　　American 1901–
　　H,M

PETRINA, John A.
　　Italian/American 1893–1935
　　H,M

PETRO, Joseph Victor Jr.
　　American 1932–
　　H

PETROVITS, Ladislaus Eugen
　　Austrian 1839–1907
　　B

L.E.P.

PETROVITS, Milan
　　Austrian 1893–
　　H

PETRUCCI, Carlo Alberto
　　Italian 1881–
　　B,H

PETRUCCELLI, Antonio
　　American 1907–
　　F,GMC,H,M,Y

A. Petruccelli

PETRY, Victor
　　American 1903–
　　F,H,M

PETTIER, Colette
　　French 1907–
　　B

PETTY, Bruce Leslie
　　Australian 1929–
　　EC,GR61–66,H

Petty

PETTY, George
American 20c.
ADV,GMC,H

PETTY

PETTY, Mary
American 1899–1976
EC,F,GMC,Y

Mary Petty—

PETUA, Jeanne
Swiss 1881–
B

PETULENGRO, Gipsy
American 20c.
M

PETZOLD, Willy
German early 20c.
POS

PEUGEOT, George Ira
American 1869–
B,F

PEYNET, Raymond
French 1908–
ADV,B,EC,GR54-58-61-62-63,H

Peynet

PEYRAUD, Elizabeth K.
American early 20c.
F,M

PEYROLLE(S), Pierre
French late 20c.
EI79,GR77-78,POS

PEYTON, Alfred Conway
American 1875–1936
B,F,H,M

PEYTON, Ann Moon
American 1891–
F,H,M

PFAFF, Hans
German 1875–
B

HP

PFAFF, Margarete
German 1863–
B

PFANNSCHMIDT, Carl (Karl) Gottfried
German 1819–87
B,H,LEX,TB

PFANNSCHMIDT, Ernest Christian
German 1868–1949
B,TB

E.P.

PFEFFER, Leopold
Austrian 20c.
LEX

PFEIFER, Hermann
American 1879–
CO6/05,F,H,M,Y

 HERMAN PFEIFER

PFEIFFER, Fritz Wilhelm
American 1889–1960
B,F,H,M

PFEIFFER, Isidore
Austrian 1866–
B

Þ.

PFEIFFER, Richard
German 1878–
B,TB

RP

PFEIFFER, Walter
Swiss late 20c.
B,EI79

PFEIFFER-KORTH, Gertrud
German 1875–
B

PFENDSACK, Hugo
Swiss 1871-1940
B,LEX,TB,VO

PFENNINGER, Heinrich
Swiss 20c.
LEX

PFLAUMER, Paul Gottlieb
American 1907-
F,H,M

PHARES, Frank
American 20c.
M,ME8/23

F.PHARES

PHARES, Margaret
American 20c.
M

PHIL MAY
see
MAY, Philip William

PHILIPP, Richard
Austrian early 20c.
LEX

PHILIPPOTEAUX, Henri Felix Emmanuel
French 1815-84
B,H,LEX,TB

F. Philippoteaux

PHILLIPS, Barye
American -1968/69
PAP

Barye

PHILLIPS, Bert Greer
American 1868-1956
BA,BAA,F,H,M

Bert Phillips.

PHILLIPS, (Clarence) Coles
American 1880-1927
ADV,EC,GMC,I,IL,M,Y

COLES PHILLIPS

PHILLIPS, Gordon Dale
American 1927-
CON,H

Gordon Phillips

PHILLIPS, Irving W.
American 1905-
H

PHILLIPS, John
English 19c.
B

PHILLIPS, John
Canadian early 20c.
M,WS

PHILLIPS, Theodore D. Jr.
American 1945-
H

PHILLIPS, Tom
American 1927-
CON

TOM PHILLIPS ∆

PHILLIPS, Walter Joseph
Canadian 1884-1963
B,F,H,M

PHILLIPS, Walter Shelley
American 1867-1940
H

PHILPOT, Glyn Warren
English 1884-1937
B,BRP,H,STU1924

G.P.

PHILPOT, Samuel H.
American 20c.
H,M

PHIZ
see
BROWNE, Hablot Knight

PHOENIX, George
English 1863–
B

PHYSIOC, Willis
American 20c.
M

PIATKOWSKI, Henryk
Polish 1853–1932
B,POS

PIATTI, Celestino
Swiss 1922–
GR53–58–60–73–75–77–82,H,POS,POST

PIATTI, Marianne
Swiss mid 20c.
GR60–61–62

PIAUBERT, Jean
French 1900–
B,H,M

PIAUBERT

PICABIA, Francis
French/Spanish? 1879–1953
B,DRA,GMC,H,PC,POS

F. Picabia

PICARD, Georges
French 1857–
B

G.P.

PICARD, Hughes
French 1841–1900
B,H,M

PICARD, (Miss) Maxime
American 20c.
M

PICARD LE DOUX, Charles Alexandre
French 1881–1959
B,GR58,H,M

PICART LE DOUX, Jean
French 1902–
B,GR52–53–54–60–61,H,POST

PICASSO, Pablo Ruiz Y
Spanish 1881–1973
ADV,AN,APP,B,CAV,CP,DA,DES,DRA,DRAW,
GMC,GR54–57–63–71,H,LEX,PC,POS,POST,S,
TB,VO

PICCOLI, Augusto
Italian mid 20c.
GR58

PICHARD, Jean Jacques
French 1905–49
B

PICHLER, Rudolf
German 1863–
B

PICHON, Marcelle
French early 20c.
ST

PICHOT GIRONÈS, Ramon Antonio
Spanish 1872–1925
B

PICK, Lilly
Austrian 20c.
LEX

PICKARD, Charles
English 20c.
H

PICKEN, George A.
American 1898–1971
B,H,LEX,M

PICKERING, George
English 1794–1857
B,H,M

PICKERSGILL, Frederick Richard
English 1820–1900
B,H,M

FRP, F

PICKHARDT, Carl Jr.
American 1908–
H,M

PICO
French early 20c.
The Decorative Twenties--M. Battersby--
Walker and Co.--New York 1969,*

Pico

PICOLO Y LOPEZ, Manuel
Spanish 1850–92
B

PICOUD, A.
French 20c.
LEX

PIDGEON, William Edwid
Australian 1909–
EC

PIECH, Paul Peter
English mid 20c.
GR53-55-58-80-83

PIECK, Anton F.
Dutch 1895–
B,LEX,VO

PIERCE, Anna Harriet
American 1880–
B,F,H,M

PIERCE, Diane (Huxtable)
American 1939–
H

PIERCE, Glenn M.
American 20c.
F,M

PIERCY, Frederick
English 1830–91
B,BAA,H

PIERSEN, Alden
see
PIERSON, Alden

PIERSON, Alden
American 1874–1921
B,I

PIETINEN
Swiss mid 20c.
GR61

PIETROVSKI, Antoni
see
PIOTROVSKI, Antoni

PIGLIA, Paola
American late 20c.
GR82-84-85

PIGLMAYER, Franz
Austrian 20c.
LEX

PIGNON, Edouard
French 1905–
B,DRAW,H

Pignon 60

PIJADE, Mosa
Yugoslavian 1889–
B

PIKE, John
American 1911–
H,IL,M

John Pike //

PIKE, S.
American ac. early 19c.
D

PILCH, Bertl (Adalbert)
 Austrian 20c.
 LEX

PILLARD (called)
 see
 VERNEUIL, Maurice

PILLATI, Henry (Heinrich)
 Polish 1832-94
 B,H

PILLATI, Ksavery
 Polish 1843-1902
 B

PILLE, Charles Henri
 French 1844-97
 B,H,L,TB

PILLE, Jean Baptiste Marcel
 French 19/20c.
 B,LEX

PILOT, Robert Wakeham
 Canadian 1898-1967
 H

PILOTY, Ferdinand
 German 1828-95
 H,LEX,TB

PILZ, Gottfried
 Austrian 20c.
 POS

PIMENOFF, Jurij Iwanowitsch
 Russian 1903-
 B,LEX,TB,VO

PIMSLER, Alvin J.
 American 1918-
 F,Y

PINA, Augusto
 Portuguese 1872-1938
 H

PINELES, (Miss) Cipé
 American 1908-
 F,GR68,M

PINHEIRO, Rafael Augusto Bordalo Prostes
 Portuguese 1846-1905
 H

PINKNEY, Jerry
 American 1939-
 F,GR72-76,H,Y

PINTER, Ferenc
 Italian late 20c.
 GR66-69-71-72-74-75-78-79-80-82-84

PINTO, Cândido da Costa
 Portuguese 1911-
 B,H

PINTO, Ralph
 American 20c.
 H

PINTO, Zélio Alves
 Brazilian late 20c.
 GR77-82

PINTO LOBO, Oskar
 Portuguese mid 20c.
 GR61

PINTORI, Giovanni
 Italian 1912-
 CP,GR52-58-60-68-70,H,POS,POST

PINWELL, George John
English 1842–75
B,BAA,H,STU1905,TB

GJP

PION, Jesin
Dutch 20c.
GMC

JEHV.y
PION

PIOTROVSKI, Antoni
Polish 1853–1924
B,POS

PIOTROWSKA, Irene Glebocka
Polish/American 1904–
H

PIPAL, Hans Robert
Austrian 1915–
LEX,VO

PIPER, Christian
German/American 20c.
GR72-74-75-76-80,P

PIPER, Denis
English mid 20c.
GR61

Denis Piper.

PIPER, John
English 1903–
B,BA,BRP,DRAW,GR54,H,M,POST

JohnPiper

PIPER, Roland
English? mid 20c.
GR60

PIRCHAN, Emil
German 1884–1957
B,POS

E.P.

PIRKHERT, Alfred
Austrian 1887–
LEX,VO

PIRNER, Maximilian
Czechoslovakian/Austrian 1852–1924/29
B,LEX,TB

PISIS, Filippo De
Italian 1896–1956
B,DA,H,M

risis

PISKORSKI, Tadeusz
Polish 20c.
POS

PISSARRO, Georges
French 1871–1961
B,GMC

PISSARRO, Lucien
French 1863–1944
AN,BRP,GMC,H

PISSARRO (PAULÉMILE), Paul Émile Benjamin
French 1884–
B,M,POS

PITMAN, Rosie M. M. (Macmillan)
English 19/20c.
B,BK,LEX,TB

ROSIE.M.M.PITMAN

PITMAN, Theodore B.
American 1892–1956
H

PITNEY, A. de Ford
American early 20c.
HA9/07

A. de Ford Pitney

PITT, Douglas Fox
English 1864–192
B,H

PITZ, Henry Clarence
American 1895-1976
B,F,FOR,H,IL,LEX,M,S,VO,Y

HENRY C.Pitz (signature)

PIUSSI-CAMPBELL, Judy
American 20c.
H

PIXIS, Theodor
German 1831-1907
B,H

PIZARRO, Cecillio
Spanish -1886
B,TB

C. P. (signature)

PLACE, Graham
American 20c.
H

PLACHY, Franz
Austrian early 20c.
LEX

PLAMKA, Faye
Austrian late 20c.
GR85

PLAMPER, Egon
German mid 20c.
GR53

PLANAS, Eusebio
Spanish 1833-97
B

PLANAT (pseudonym MARCELIN), Emile
French 1825-87
B

M. (signature)

PLANCK, Willy
German 1870-
B,LEX

PLANCKH, Viktor
Austrian 1904-41
LEX,VO

PLANK, George Wolfe
American 20c.
GMC,M,VC

G.P. (signature)

PLANS, S. A.
Belgian mid 20c.
GR60

PLANSON, André
Austrian/French 1898-1950
B,DES,H,LEX,VO

And. Planson (signature)

PLANTIKOW, Walter
German early 20c.
LEX

PLANTS, Duane
American mid 20c.
GR65-66

PLASCHKE, Paul A.
German/American 1880-1954
B,EC,F,H

Plaschke (signature)

PLASTOV, Arkadii Aleksandrovich
Russian 1893-1972
B,RS

АП. (signature)

PLATT, Joseph B.
American early 20c.
VC

JOSEPH B. PLATT (signature)

PLAUZEAU, Dimitri Petrovitch
Russian 1937-
B

PLEISSNER, Ogden Minton
American 1905-
B,F,H

PLETSCH, Oskar
German 1830-88
B,H,M,TB

PLEUKEBAUM, Meta
German 1876/83-
B,M

PLINZNER, M.
German 19/20c.
LEX

PLOCKHORST, Bernhard
German 1825-1907
B,H,LEX,TB

BP

PLOEGER, Ilse
German mid 20c.
GR60

PLOWMAN, George Taylor
American 1869-1932
B,F,I,LEX,TB,VO

George T.
Plowman

PLUDDEMANN, Hermann Freihold
German 1809-68
B,H,TB

PLUMERI, James
American 20c.
P

PLUMMER, Ethel McClellan
American 1888-1936
B,F,GMC,H

PLUMMER, W. Kirtman
American 20c.
H

PLUMP, Nikolaus
German 1923-
G

PLUNNECKE, Wilhelm
German 1894-
B,LEX,TB

POCCI, Graf Franz von
German 1803/07-76
B,EC,H,TB

F.P.

POCOCK, Julia
English ac. 1870-1903
B,H

PODBIELSKI, Bronislav
Polish 1839-90
B

PODWILL, Jerry (Jerome)
American 1938-
F,GR77,P,Y

POEGGE, Wilhelm
German early 20c.
LEX

POELL, Erwin
German 1930-
GR62-64-67-69-72

P.

POELZIG, Hans
German 1869-1936
B,H,POS

POETZELBERGER, Oswald
German 1893-
LEX,TB,VO

O.P.

POGACNIK, Marajan
Yugoslavian mid 20c.
GR58

POGANY, Willy (Vilmos Andras or William
 Andrew)
 Hungarian/American 1882–1955
 ADV,B,F,GMC,H,I,LEX,PE,TB,VO,Y

Willy Pogany

POGEDAIEFF, Georges A. de
 Russian/French 1897–
 B

G.P.

POGLIAGHI (POGLIACHI), Lodovico
 Italian 1857–1950
 B,H,TB

P

POHL, Dennis
 American 1941–
 F,Y

POHL, Hugo David
 American 1878–1960
 B,F,H

POINDEXTER, Vernon Stephensen
 American 1918–
 H

POINT, Armand
 French 1861–1932
 B,CP,M

A·Point

POIRÉ, Emmanuel
 see
 CARAN d'ARCHE

POIRIER, Jacques
 French 1928–
 B

POIRSON, V. A.
 French late 19c.
 LEX

POISSON, Ginny
 Canadian late 20c.
 GR78-81-82

POITEVIN, Pierre Jean
 French 1889–
 B,POST

POITTE, J.
 French late 19c.
 B

POL, C.
 Dutch early 20c.
 POS

POLÁK, Rudolf
 Czechoslovakian mid 20c.
 LEX

POLASZ, Monica W.
 German late 20c.
 EI79

POLE, Leon
 Canadian 20c.
 M

POLGAR, Marton (Martin)
 Hungarian 1879–
 B

POLGREEN, John
 American 20c.
 H,M

POLI
 Italian early 20c.
 POS

POLIFKA, Bernyce
 American 1913–
 M

POLITI, Leo
 American 1908–
 H,M

POLK, Mary Alys
 American 1902–
 F

POLLEY, Frederick
 American 1875–1958?
 B,F,H

POLLOCK, Courtenay E. M.
 English 1877–
 B,F,LEX,VO

POLLOCK, Ian
 English late 20c.
 EI79,GR78

POLLO(C)K, Merlin F.
American 1905–
H,M

POLONSKY, Arthur
American 1925–
H

POLSENO, Jo
American 20c.
H

POLTER, Heinz
German mid 20c.
GR61

POLYCHRONI, Celeste
French 20c.
M

POLZ, Edmund
Austrian 1864–
B

POMAR, Julio Artur da Silva
Portuguese 1926–
B,H

POMEROY, Elise Lower
American 1882–
H

POMMERHANZ, Karl
Austrian 1857–
B

K.P.

PONDEL, Friedrich
German 1830–
B

PONT, Charles Ernest
Franco/American 1898–
H,M

PONTI, Giovanni (Gio)
Italian 1891–
GMC,GR53-56,H

PONTY, Max
French early 20c.
POS

POOCK, Fritz
American 1877–1944?
H,M

POOK, Fritz
see
POOCK, Fritz

POOKE, Marion Louise
American 19/20c.
B,F,H

POOLE, Bert
American 1853–1939?
B,F,H,I

POOLE, Earl Lincoln
American 1891–
B,F,H,M

POOLE, Frederick Victor
Anglo/Canadian/American –1936
B,F,H

POOLE, Horatio Nelson
American 1885–
B,F,H,M

POOR, Henry Varnum
American 1888–1970
B,F,H,LEX

H.V.Poor

POORE, Henry Rankin
American 1859–1950
B,BAA,F,H,I,LEX,M,TB

H·R·P·

POORTEN, Karl August
German 1817–80
B

POPE, Allen Jr.
American 20c.
M,PAP

POPE, Kerig
American mid 20c.
GR72-73-75-81,P

POPESCU-GOPO, Ion
Romanian 1923–
EC

Gopo

POPINI, Alexander
 American ac. early 1900's
 PE

POPOVA, Ljubov Sergeievna
 Russian 1889-1924
 B,H,POS

POPPLETON, Craig
 American 1946-
 CON

PORCHEDDU, Beppe
 Italian 1898-
 H

PORENTA, Kaspar
 Yugoslavian 1870-1930
 B

PORSCHE, Otto Maria
 German 1858-1931
 B,TB

PORTER, Bruce
 American 1865-
 B,F,H,I,M,R

PORTER, George Edward
 American 1916-
 H,IL

PORTER, Jean Macdonald
 American 1906-
 H

PORZANO, Giacomo
 Italian mid 20c.
 GR60-61-66

POSADA, José Guadalupe
 Mexican 1851-1913
 APP,B,CP,H,PC,PG,S

POSCH, Rudolf
 Austrian 1890-
 B

POSCHENBURG-OKROTNY, Viktor
 Austrian 20c.
 LEX

POSSOZ, Mily
 Portuguese 1889-1967
 H

POST, Charles Johnson
 American 1873-
 CEN12/09,F,H,M

POST, Hermann
 American 20c.
 M

POST, May Audubon
 American 19/20c.
 B,F,H

POTERLET, L. Henri
 French ac. late 19c.
 LEX

POTTER, Beatrix (Heelis)
 English 1866-1943
 B,H

POTTER, Charles
 English 1878-
 LEX,TB,VO

POTTER, Edna
 American 20c.
 M

POTTER, Eleuthère de
 Belgian 1830-54
 B

POTTER, George Kenneth
American 1926–
H

POTTER, Harry Spafford
American 1870–
B,CEN10/06,F,H,M

—H.S.POTTER—

POTTER, Jack
American 1927–
IL

POTTER

POTTER, Muriel Melbourne
American 1903–
H,M

POTTER, Nathan Dumont
American 1893–1934
B,F,H,I

POTTER, Raymond
English ac. late 19c.
LEX

POTTHAST, Edward Henry
American 1857–1927
B,F,H,I,M,Y

E.Pollhasl

POUGET
French 19c.
H

POULBOT, Francisque
French 1879–1946
B,CP,EC,FS,H,POS,POST

poulbot

POWELL, Giorgiana J.
American 1936–
H

POWELL, Jerry
American mid 20c.
PAP

POWELL, H. M. T.
American ac. 1850
H·

POWERS, John M.
American 20c.
F,M

POWERS, Richard M. (Terry Gorman)
American 1921–
H,IL,NV,PAP

Powers

POWIS, William Henry
English 1808–36
B,H

POYNTER, (Sir) Edward John (James)
English 1836–1919
B,H,POS,POST

POZZATI, Severo
see
SEPO

POZZI, G. (Gino)
Italian 1900–
GR53,H

PRACA, Maria Leonor Guimarães
Portuguese 1936–71
H

PRADO, Vasco
Brazilian mid 20c.
LEX

PRANISHNIKOFF (PRIANICHNIKOFF), Ivan
Petrovitch
Russian 1841–1909/10
B

IP

PRANISHNIKOFF, J.
Canadian ac. 1870s
H

PRAQUIN, Pierre
French mid 20c.
GR56-60-61-62-66-67-68-70-84

P.PRAQUIN

PRASCHL, Stefan
Austrian 1910–
LEX

PRASSINOS, Mario
 Greek 1916-
 B,H

PRATES, Maria Emília
 Portuguese 1935-
 H

PRATHER, Ralph Carlyle
 American 1889-
 F,H,M

PRATT, Ethel Louise
 Canadian 1906-
 WS

PRATT, Harry Edward
 American 1885-
 F

PRATT, Inga
 American 1906-
 H

PRATT, Marcus
 American 20c.
 M

PRATT, Philip Henry
 American 1888-
 F,H

PRAY, Leon
 American 20c.
 LEX

PRAZSKY, Adolf
 Czechoslovakian mid 20c.
 GR52-57-58,POST

PRAŽSKÝ

PREBLE, Donna
 American 20c.
 M

PRECHTL, Michael Mathias
 German late 20c.
 GR73-77-78-81-82-83-84-85-86

PREETORIUS, C.
 German early 20c.
 LEX,STU1916

PREETORIUS, Emil
 German 1883-1973
 AN,B,CP,EC,H,POS,TB

PREGARTBAUER, Herrin Lois
 Austrian 1899-
 B,H,M

PREGELJ, Marij
 Yugoslavian 1913-67
 B,H

PREISER, C.
 German early 20c.
 LEX

PREISLER, Jan
 Czechoslovakian (Bohemian) 1872-1918
 AN,B

PREISS, Alexandru
 American 1952-
 AA

PREISSIG, Vojtĕch (Adalbert)
 Czechoslovakian 1873-1944
 B,H,TB

PRENDERGAST, Maurice Brazil
 American 1859-1924
 APP,B,F,H,I,M,R,SO

PRENTICE, Sydney
 American 1870-
 B

PRENTICE, Terence C.
 English early 20c.
 LEX

PRESSOIR, Esther (Estelle)
American 1905–
F,H

PRESTON, Alice Bolan
American 1888–1958
B,F,H,M

PRESTON, James Moore
American 1873–1962
B,F,IL,M

[signature: Jam. Preston.]

PRESTON, Mary Wilson
American 1873–1949
B,F,H,I,IL,M

[signature: Mary Wilson Preston]

PRETE, Danilo di
Brazilian mid 20c.
GR56

PRETSCH, John Edward
American 1925–
H

PREU, John D.
American 1913–
H

PREUSS, Friedrich Walter
German 1879–
B

PREUSS, Roger Emil
American 1922–
H

PREVIATI, Gaetano
Italian 1852–1920
B,H

PRIANICHNIKOFF, Ivan Petrovitch
see
PRIANISHNIKOFF, Ivan Petrovitch

PRICE, Chester B.
American 1885–1962
F,H,I,M

PRICE, Edith Ballinger
American 1897–
B,F,H

PRICE, Garrett
American 1896–1979
CAV,CC,EC,H,IL,Y

[signature: Garrett Price]

PRICE, George
American 1901–
EC,FOR,GR53,H,LEX

[signature: Geo. Price]

PRICE, Hattie Longstreet
American 20c.
M

PRICE, Hilda M.
English 20c.
M

PRICE, Julius Mendes
Anglo/Canadian? 1857–1924
H,TB

[signature: J.M.P.]

PRICE, Luxor
Welsh/American 20c.
M

PRICE, Margaret Evans
American 1888–
B,F,H,I

PRICE, Norman Mills
Canadian/American 1877–1951
ADV,F,GMC,H,IL,Y

[signature: Norman Price]

PRICE, William Mead
see
PRINCE, William Meade

PRIDOHL, Herbert
German 1907–
G

PRIETO, Julio
Mexican 20c.
LEX

PRIETO, Manolo
 Spanish 1912-
 H,POST

MANOLO prieto

PRIKKER (THORN-PRIKKER), Johan Thorn
 Dutch 1860-1932
 AN,CP,H,POS

J. THORN PRIKKER.

PRILIBERT, Gilbert
 French early 20c.
 ADV

Gilbert Prilibert

PRIMOSHIC, John F.
 American 20c.
 M

PRINCE, William Meade
 American 1893-1951
 B,F,H,IL,POS,Y

Wm MEADE PRINCE 1924

PRINCEHORN, Betz
 American 20c.
 M

PRINET, René François Xavier
 French 1861-1946
 ADV,B

PRINS, Benjamin Kimberley
 American 1904-
 H,IL

Prins

PRINS, J. Warner
 Dutch/American 1901-
 H

P.

PRIOR, Melton
 Anglo/Canadian 1845-1910
 B,H

M.P.

PRIOR, W. H.
 American ac. mid 19c.
 D

PRISCILLA, Louis
 American 20c.
 H

PRITCHETT, Robert Taylor
 English 1828-1907
 B,H,M

PRIVAT-LIVEMONT
 see
 LIVEMONT (PRIVAT)

PRJANISCHNIKOFF, Iwan Petrovitch
 see
 PRIANISCHNIKOFF, Ivan Petrovitch

PROBST, Thorwald A.
 American 1886-
 F

PROBST, Willi
 German 1915-
 LEX,VO

W-P-

PROBYN, Peter
 English? mid 20c.
 ADV

probyn

PROCHOVNIK, Leo
 German 1875-1940
 B

lp

PROCTOR, John
Scottish 1826–188?
EC

PROESSDORF, Alfred
German early 20c.
LEX

PROHASKA, Ray (Raymond)
Yugoslavian/American 1901–
F,FOR,GR58,H,IL,M,Y

Ray Prohaska

PROPER, J.
Dutch
LEX

PROPPER, Gerold
Swedish mid 20c.
GR65

PROSCHKO, Emilie Albertine
Austrian 1846–
B

PROTZEN, Otto
German 1868–1925
B,TB

PROUT, George Morton
American 1913–
H,M

PROUT, Victor
French 1842–1912
LEX

PROVENCIALI, Michele
Italian mid 20c.
GR57–60–71

PROVENSEN, Martin
American 1916–
H

PROWSE, Robert
American ac. 1910–20
H

PRUSAKOV, Boris (see BORISOV, Grigori
Ilych and PRUSAKOV, Boris)
Russian 1899–
CP,MM,POS

PRÜSSEN, Eduard
German late 20c.
GR67–68–72–75–77–85

PRUTSCHER, Otto
Austrian 1880–1949
LEX,MM

PRUTZ, Ludwig
German 1830–
B

PRYDE, James Ferrier
Scottish 1866–1941
AN,B,CP,GA,H,POS

PRYSE, Gerald Spencer (Spencer Pryse Gerald)
English 1881–
B,CP,POS,POST,TB

PRZYSTANSKI–ZDSISLAW, Wladislaw
Polish mid 20c.
GR65

PUB, C.
Belgian mid 20c.
GR52

C. Pub

PUCCI, Albert John
American 1920–
GR56,H

PUCCI

PUCHLEITNER, Karl
Austrian 20c.
LEX

PUDLICH, Robert
German 1905–
B,GR57–58,LEX,TB,VO

Pudlich

PUDNICKI, Marek
Polish mid 20c.
GR58

PUGH, Edward
English 1760?-1813
B,H

PUGH, Mabel
American 1891-
B,F,H

PUGLIESE, Carl J.
American 1918-
CON

Carl Pugliese

PUIFORCAT, Jean (Jep)
French 1897-1945
B,LEX

PUIG ROSADO, Fernando
French late 20c.
GR73-75-79-83-85

PULLINGER, Herbert
American 1878-
B,F,H,LEX,M,VO

Herbert Pullinger

PUMMILL, Robert
American 1936-
CON

pummill

PUNCHATZ, Don Ivan
American 1936-
F,GR65-67-69-70-72-80-82-83,P,Y

punchatz

PUPAZZI, Onorato
Italian early 20c.
POS

ONORATO

PURDY, Maude H.
American 1874-
F,H

PURKYNĚ, Karel
Polish/Czechoslovakian 1834-68
B,H,M,TB

K.P.

PURRMANN, Hans
German/French 1880-1966
B,DA,H

HP

PURRMANN, Karl
German 1877-
B

PURSELL, Weimer
American 20c.
H

PURVINŠ, Harijs Jāņa
Latvian 1920-
LATV

H.P.

PURVIS (PURVIG), Tom
English 1888-1959
ADV,CP,GMC,LEX,POS,POST

Tom Purvig

PUSEY, J. C.
American 20c.
M

PUTNAM, Frances M.
American 20c.
M

PUTNAM, Wallace Bradstreet
American 1899-
H

PUTTI
see
NATHOUT-WESTERDAL, Putti

PUTTNER, Joseph Carl Berthold
 Austrian 1821–81
 B,H

PÜTTNER, Walter
 German 1872–
 B

W·P.

PUTZ, Leo
 German 1869–1940
 AN,B,CP,LEX,VO

Leo Putz

PÜTZ, Ludwig
 Austrian/German 1866–
 LEX

PUVUS DE CHAVANNES, Pierre Paul
 French 1824–98
 AN,B,DA,H,M,POS

P Puvis de Chavannes.

PYE, Fred
 Anglo/American 1882–
 B,F,H

PYE, Thomas
 Canadian ac. 1866
 H

PYLE, Clifford Colton
 American 1894–
 F,H

PYLE, Gene J.
 American 20c.
 M

PYLE, Howard
 American 1853–1911
 B,F,GMC,H,I,IL,LEX,PAP,PE,S,TB,Y

P , H.P.

PYLE, Katherine
 American –1939?
 GMC,H,M

PYLE, Walter, Jr.
 American 1906–
 H,M

PYLES, Virgil E.
 American 1891–
 H,M

– Q –

QUACKENBUSH, Robert Mead
 American 1929–
 H

Robert Quackenbush

QUADRI, Giovanni
 Swiss 1866–92
 B

QUAGLIO, Eugen
 German 1857–
 LEX,TB

E.Q.

QUANT, Fritz
 German 1888–
 B

QUAT, Judith Gutman
 American 1903–
 H,M

QUAY, David
 English late 20c.
 GR82

QUÉMÉRÉ, Albert (Ru)
 French mid 20c.
 GR53

Ru

QUENTIN, Bernard Maurice
 French 1923–
 B,H

QUERFELD, Paul
 French? 20c.
 LEX

QUEST, Charles Francis
 American 1904–
 F,H,M

QUIDENUS, Fritz
German? 19/20c.
LEX

QUIGLEY, Edward B.
American 1895-1968
H

QUIGLEY, Jonathan L.
Anglo/American 1880-1954
ME23

Quigley

QUIGNON, Henri
American/French? early 20c.
POS

QUINAN, Henry R.
American 20c.
H,M

QUINN, Noel Joseph
American 1915-
H

QUINN, Paul
American 20c.
M

QUINN, Raymond John
American 1938-
H

QUINN, Robert Hayes
American 1902-62
H

QUIQUEREZ-BEAUJEU, Ferdinand von
Hungarian 1845-93
B,M

QUON, Mike
American late 20c.
GR85

- R -

RAABE, Alfred
American 1872-1913
I,M

RAATELAND, Ton
Dutch mid 20c.
GR56-57

RAB, Paul (Pol Rab)
French 1898-1933
B,EC

RABAS, Vaclay (Wenzel)
Czechoslovakian 1885-1954
B,H,M

RABES, Max Friedrich F.
German 1868-1944
B,TB

M.R.

RABIER, Benjamin Armand
French 1869-1939
B,EC,TB

BR

RABINO, Saul
Russian/American 1892-
M

RABUT, Paul
American 1914-
F,H,IL,Y

PAUL RABUT

RACKHAM, Arthur
English 1867-1939/40
ADV,AN,B,BK,H,M,S,TB,VO

Ac. es. —, Arthur Rackham

RÁCKI, Mirko
Yugoslavian 1879-
B,TB

M.R.

RACKOW, Leo
American 1901-
ADV,F,H,Y

RACKOW

RADA, Vlastimil
Czechoslovakian 1895-1962
B,H,M

RADAKOV
Russian early 20c.
POS

RADIGUET, Maximilian René
French 1816-99
B,H,LEX,TB

M.R.

RADLER, Max
German 20c.
LEX

RADO, Georges
Brazil mid 20c.
GR52

RAE, John
American 1882-
B,F,H,I,LEX,M,ME4/23,TB

JOHN RAE

RAEMAEKERS, Louis
Dutch 1869-1956
B,EC,POS,TB

Lgis Raemaekers—

RAEMDONCK, Georges van
Dutch 1888-
B,H

RAEMSEKER, Henri Francois
see
RAMAH, Henri Francois

RAFFET, Denis Auguste Marie
French 1804-60
B,CP,EC,H,PC,POS

RAFFLEWSKI, H. R.
German 1943-
B

RAG
see
GOLDBERG, Richard A.

RAGAN, Leslie Darrell
American 1897-
FOR,H,M

*LESLIE
RAGAN*

RAGNI, Hector
Uruguayan
LEX

RAGU, Edouard Auguste
French ac. late 19c.
B,LEX

RAIBLE, Alton Robert
American 1918-
H

RAICHILSON, Robert
American 20c.
M

RAILTON, Herbert
English 1857/58-1910
B,BK,H,M

RAIMELA, Raime
Finnish mid 20c.
GR56-57-58-60

RAIMELA

RAINNIE, Hedley Graham James
Anglo/Canadian 1914-
H

RAJ, Shree Des
Indian 20c.
BI

RAKEMANN, Carl
American 1878-
B,F,H,I

RAKYŌ
see
IMAO KEINEN

RALEIGH, Henry Patrick
American 1880-1944
B,F,H,IL,M,McC11/04,POST,Y

RALPH, Lester
 American 1877-1927
 CO10/04,I

RALSTON, James Kenneth
 American 1896-
 H,M

RALSTON, William
 English 1848-1911
 B

RAMAH, Henri François
 Belgian 1887-1947
 B,H

RAMBERG, Christina (Hanson)
 American 1946-
 H,P

RAMBERG, Johann Heinrich (John Henry)
 German/English 1763-1840
 B,EC,H

RAMBOUSEK, Jan
 Czechoslovakian 1895-
 B

RAMIREZ, Joel Tito
 American 1923-
 H

RAMMELT-BÜRGER, Käte
 German 1877-
 B,M

RAMOS, Júlio Gonzaga
 Portuguese 1868-1945
 B,H

RAMOS, Mel (Melvin John)
 American 1935-
 APP,B,CP,H

RAMSAYE, Fern Forester
 American 1889-1931
 M

RAMSDELL, Frederick Winthrop
 American 1865-1915
 B,BI,F

RAMSEY, Lewis A.
 American 1873-1941
 B,F,H

RAMUS, Charles Frederick
 American 1902-
 H

RAMUS, Michael
 American 1917-
 F,H,PLC,Y

RAND, Paul
 American 1914-
 ADV,CP,F,GR52-62-64-68,H,POS,POST

RANDALL, D. Ernest
 American early 20c.
 B,F

RANDALL, Theodore Amossa
 American 1914-
 H

RANDALL, Tony
 English late 20c.
 EI79

RANE, Walter
 American 1949-
 CON

RANFT
 French 19/20c.
 POS

RANFT, Richard
 Swiss 1862–1931
 B,LEX,TB,VO

R.R.

RANG, Ken
 American mid 20c.
 GR61–68

RANGHIERI, Walter
 Italian 1895–
 H

RANGHUSEN, Lennart
 Swedish mid 20c.
 GR52–54

RANIKE, Martin
 German 1863–
 B,TB

M.R.

RANKIN, Hugh
 American early 20c.
 NG3/21

RANKIN, Josephine
 English late 20c.
 EI79

RANKIN, Myra Warner
 American 1884–
 H

RANNELS (RANNELLS), Will
 American 1892–
 B,F,H

RANSAI
 Japanese late 19c.
 H

RANSOM, Fletcher C.
 American early 20c.
 CEN2/99,HA11/01 and 10/03,SCR4/06 and
 5/08

FLETCHER C RANSOM-

RANSOME, Arthur
 English 20c.
 M

RANSON, Sydney
 see
 YENDIS, Mosnar

RANSONNET, Eugen Baron von
 Austrian 1838–
 B,LEX,TB

E.R

RANZENHOFER, Emil
 Austrian 1864–
 B,POS,TB

ER

RAOUL, Margaret Lente
 American 1892–
 H,M

RAPER, F.
 American 20c.
 M

RAPOZA, Frank (Francisco)
 American 1911–
 H,M

RAPP, George
 American 20c.
 H,M

RAPP, Lois
 American 1907–
 H

RAPPARD, Clara de
 Swiss 1862–1912
 B

RASCHEN, Carl Martin
 American 1882–1962
 B,F,H

RASKIN, Saul
 Russian/American 1878–
 F,H

Saul Raskin

RASKIN(S), Ellen
 American 1928–
 GR57–62,H

RASKOB, Joseph
American 1905–
H

RASMUSSEN, Aage
Danish early 20c.
POS,POST

AAGE RASMUSSEN
1937

RASSANDRÉ, A. F.
French early 20c.
LEX

RASSENFOSSE, Armand
Flemish 1862–1934
AN,B,CP,GA,H,MM,POS,TB,VO

RASTORFER, Hermann
German mid 20c.
GR59-60-63-64-65

RATH, (Mrs.) T. Lindenberg
American 20c.
M

RATHBONE, Augusta Payne
American 1897–
H

RATHOUSKÝ, Jiri
Czechoslovakian 1924–
GR64-66-67,H

RATKAI, George
Hungarian/American 1907–
H

RATSUI, Mitsuo
Japanese 20c.
GMC

RATTNER, Abraham
American 1895–
F,GR57,H,M

1953

RATZKIN, Lawrence
American mid 20c.
GR64-67

RAU, Hans-Jürgen
German mid 20c.
GR62-65-67-68

RAU

RAU, William
American 1874–
B,F,H,M

RAUCH, Hans Georg
German late 20c.
B,GR82

RAUL, Minnie Louise Briggs
American –1955
H

RAUSCHENBERG, Robert
American 1925–
B,F,H,POST

RAUSCHER, Ludwig
German/Hungarian 1845–1914
B,LEX,TB

RAUSSER, F.
Swiss mid 20c.
GR60-64

RAVEL, Edouard
Swiss 1847–1920
B,LEX,TB

RAVEN-HILL, Leonar
English 1867–1942
B,BL1/05,EC,POS,POST,TB

RAVENEL, Pamela Vinton Brown
American 1888–
H,M

RAVN, Carsten Johan Nicolai
Danish 1859–1914
B,LEX,TB

C R

RAVESON, Sherman Harold
American 1907–
H,M

RAVO, René
French early 20c.
POS

RAWLINGS, John
American mid 20c.
ADV,GR55

RAWSON, Albert Leighton
American 1829–1902
B,BAA,I,M

RAWSON, Marion Nicholls
American 20c.
M

RAY, Deborah
American 1940–
H

RAY, Giovanni Battista
Italian 1881–
H

RAY, Joseph Johnson
American ac. 1906–08
H

RAY, Man
American 1890–1977
APP,B,EAM,GMC,H,PC,POS

RAY-BRET-KOCH
French early 20c.
LEX

RAYMOND, Alexander Gillespie
American 1909–56
H,M

RAYMOND, Charles
English mid 20c.
GR58

RAYNES, John
Australian 20c.
H

RAYNES, Sidney
American 1907–
H,M

RAYNESS, Gerard Mathiassen
American 1898–1946
H,M

RAYNOLT, Antoine Marie
French 1874–
B

RAYSSE, Martial
French 1936–
B,H,POS

REA, Gardner
American 1892–1966
EC,F,H,PE,PLC,Y

GARDNER
REA.

REA, Pauline DeVol
American 1893–
H

REACH, Max
German ac. early 20c.
LEX

READ, Elmer Joseph
American 1862–
B,F,H,PET1/97

E.J.READ

READ, Samuel
English 1816–83
B,H,LEX,TB

S.R.

REAL, James
American late 20c.
GR52

REALIER, Dumas Maurice
French 1860–1928
B,M,POS

REAM, Carducius Plantagenet
 American 1837–1917
 B,BAA,D,F,I,M

REAMS, Ronald D.
 American 1950–
 H

REARDON, Mary A.
 American 1912–
 F,H

REBHUHN, Werner
 German 1922–
 GR 59–63–64–66–68

REBOIRO
 Cuban 20c.
 POS

REBOLI, Joseph John
 American 1945–
 H

REBORA, Verbena
 Italian mid 20c.
 GR 61

REBOUSSIN, Roger André Fernand
 French 1881–
 B

RECHBERG, Arnold
 German 1879–
 B,LEX,TB

RECIPON, Georges
 French 1860–
 B

RECKELLUS, Lodewijk (Louis)
 Belgian 1864–
 B,H

RECORDON, Suzanne
 Swiss 1881–
 B

RED STAR, Kevin Francis
 American 1942/43–
 H

REDMAN, Joseph Hodgson
 American –1914
 B,I

REDON, Odilon
 French 1840–1916
 APP,B,DRA,EAM,H,PC,POS,TB

ODILON REDON

REDWOOD, Allen Carter
 American 1834–1922
 CWA,H,PE,Y

RÉE, Max Émil
 Danish/American 20c.
 H,M

REECE, Maynard
 American 1920–
 H

REED, Bryan
 English 1934–
 H

REED, Earl Meusel
 American 1894/5–
 H

REED, Ed
 American 20c.
 H,M

REED, Edith Meusel
 American 1894–
 M

REED, Ethel
 American 1876–
 ADV,B,CP,POS,POST,R,STU1913

REED, Florence Robie
 American 1915–
 GA,H,M

REED, James Reuben
American 1920–
GR54,H,M

REED, Marjorie
American 1915–
H

REED, Merle A.
American 20c.
M

REED, Philip G.
American 1908–
GR53-54-55,M

REED, Walter
American 20c.
IL

WALT REED

REEDER, Elsa
American 1883–1914
I

REES, Lonnie
American 1910–
H,M

The REESES
American early 20c.
ADV

REETH, Pierre Jean Baptist van
Flemish 1822–66
B

REEVA, H. S.
English early 20c.
LEX

REEVES, Betty-Joy
American 20c.
H

Betty Joy Reeves

REEVES, Norman
American 20c.
M

REFN, Helge
Danish early 20c.
POS

HELGE REFN 35

REGAMEY, Félix Élie
American 1844–1907
B,H,TB

Rx-

REGAMEY, Frédéric
French 1849–1925
B,FO,TB

Regamey

REGAMEY, Guillaume Urbain
French 1837–75
B,H,TB

GRegamey

REGELSKI, Arthur
German early 20c.
LEX

REGIS-MANSET
French mid 20c.
LEX

REGMIER, Ludovic
French 1851–1930
B

REGNAULT, Henri Alexandre Georges
French 1843–71
B,H,LEX,TB

HR

REGO, Paula Figueiroa
Portuguese 1935–
H

REHAG, Lawrence J.
American 1913–
GR56,H,M

REHBERGER, Gustav
Austrian/American 1910-
H,IL,Y

REHBOCK, Loren
American 20c.
CP

REHLENDER, Georg
German? 1845-
B,LEX,TB

REHLOCK, Gustav
Austrian 1851-
B

REHM, Fritz
German 1871-
B,BI,GA,POS,TB

REIBER, Richard Henry
American 1912-
H,M

REICH, Franz
Austrian 20c.
LEX

REICHENFELSER, Heinz
Austrian 1901-
B,LEX,TB,VO

REICHL, Alois
Austrian 1864-
B

REICHL, Ernest
American 20c.
M

REICHLEN, Eugène
Swiss 1855-
B

REICHMANN, Anneliese
German 20c.
LEX

REID, Albert Turner
American 1873-1955
CC,EC,F,H,M

REID, Andrew
English 1831-1902
B,H

REID, Bill
American 20c.
H

REID, (Sir) George
English 1841-1913
B,BK,TB

REID, James Colbert
American 1907-
H,M,S

REID, Robert O.
American early 20c.
M

REILLY, Frank Joseph
American 1906-
H,IL,M

REILLY, Gerald N.
Canadian mid 20c.
GR61-62

REIMANN, Carl
American 1873-
H,M

REIMERSCHMIDT, Richard
see also
RIEMERSCHMID, Richard

REIMESCH, Ragimund
Austrian 20c.
LEX,VO

REINBOLD, Anton
German 1881–
B

REINDORF, Samuel
Polish/American 1914–
H,M

REINECKE, A. W.
German 19/20c.
LEX

REINECKE, Emil
German 1859–
LEX,TB

REINECKE-ALTENAU, Karl
German 1885–
LEX,TB,VO

REINER, Imre
Hungarian/Swiss 1900–
B,G,GR53–54–58–59–61,H

REINGANUM, Victor
English early 20c.
ADV,GR52–53

REINHARD, Dietmar
Dutch late 20c.
EI79

REINHARD, Siegbert
German/American 1941–
F,Y

REINHARDT, Ad F.
American 1913–67
B,H

REINHARDT, Siegfried Gerhard
German/American 1925–
GR55,H

REINHART, Charles Stanley
American 1844–96
B,EC,F,H,I,PE,SCR9/93,Y

REINHART, Charles William
German/American 1858–
I

REINICKE, Emil
German 1859–
B

REINICKE, Paul René
German 1860–1926
B,M,TB

REINMAN, Paul
German/American 1910–
H

REISINGER, Dan
Israeli mid 20c.
GR64–65–66–68,POST

REISMAN, Philip
American 1904–
APP,GMC,H,M

REISS, Fritz
German 1857–1916
B,TB

REISS, (Fritz) Winold
German/American 1886/88–1953
F,H,M,Y

WINOLD
REISS

REISS, Lionel S.
Austrian/American 1894–
B,F,H,M

REISS, Lotte
Austrian 20c.
LEX

REISS, Manfred
English mid 20c.
GR 52-53-54-56

REISS

REITER, Freda Leibovitz
American 1919–
F,H

REITER, Laszlo (Ladislaus)
Hungarian 1894–
B

REITZEL, Marques E.
American 1896–
B,F,H,M

REIWALD, Jean
Swiss mid 20c.
GR 56

JEAN REIWALD

REJCHAN, Stanislaus
Polish/French 1858–1919
B,LEX,TB

S·R·

REKER, Günter
German 1921–
G

RELYEA, Charles M.
American 1863–1932
B,CO7/04,F,I,LHJ7/06,M,SCR9/02

C.M.RELYEA

REMINGTON, Frederic Sackrider
American 1861–1909
B,F,H,HA,I,IL,M,PE,TB,Y

FREDERIC REMINGTON

REMISOW, A. N.
Russian early 20c.
LEX

REMLINGER, Joseph J.
American 1909–
H,M

REMMEY, Paul Baker
American 1903–58?
H,M

REN, Chuck
American 1941–
CON

Chuck Ren

RENARD, Edouard Antoine
French 1802–57
B

RENARD, Marius
Belgian 1868–
B,POS

RENARD, Raymond
Belgian mid 20c.
GR 56-60

RENARD

RENAU
Spanish early 20c.
POS

Renau

RENAUCOURT, Henry de
 French early 20c.
 poster: 'L'Abbaye de Solesmes pres de
 Sable (Sarthe)', Lucien Serre Imp.,*

HENRY DE RENAVCOVRT-

RENAUD, Phil
 Canadian/American 1934-
 F,P,Y

RENDLE, John Morgan
 English 1889-
 M

RENEFER, Raymond
 French 1879-
 LEX,VO

R.

RENFRO, Edward R.
 American mid 20c.
 GR52-53-55-59-65

RENFRO

RENNER, Max
 German early 20c.
 LEX

RENNER, Paul Friedrich August
 German 1878-
 AN,B,POS,TB

R

RENNIE, Frank
 American 20c.
 M

RENNIE, Helen Sewell
 American 20c.
 H

RENNIE, Louise
 American 20c.
 M

RENNIE, W. F.
 Canadian ac. 1871
 H

RENOUARD, Charles Paul
 French 1845-1924
 B,L,M,TB

Paul Renouard

RENOUF, L.
 French 19/20c.
 LEX

RENSCH, Eberhard G.
 German mid 20c.
 GR57-58-60-63

RENTSCH, R.
 Swiss mid 20c.
 GR57

RENWICK, Howard
 American 20c.
 F,H

REPCZE, Johann
 Hungarian early 20c.
 POS

REPIN, Ilia Efimovich
 Russian 1844-1930
 M,P,S

RESCH, Alfred
 German mid 20c.
 GR65

Resch

RESCH NÄGELE, Lilo
 German 20c.
 LEX

RESEN-STEENSTRUP, Johannes
 Danish 1868-1921
 B

RESSEL, Maria
 Austrian 1877-
 B

RESSURREICÃO, Arsénio Bento da
 Portuguese 1901-
 H

RETHEL, Alfred
 German 1816-59
 B,H,M

RETHI, Lili Elizabeth
 Austrian/American 1894-
 B,H

RETHY, Lajos (Ludwig)
 Hungarian 1849-1931
 B

RETZSCH, Frederick August Moritz
 German 1779-1857
 B,BAA,D,H,M

REUSSING, William
 see
 REUSSWIG, William

REUSSWIG, William
 American 1902-
 H,IL,M

REUTERDAHL, Henry
 American 1871-1925
 B,F,H,HA,I,IL,TB

REVA, (REVA URBAN)
 American 1925-
 H

REVERE, Paul
 American 1735-1818
 B,CC,EC,F,H,PC,Y

REVESZ, Imre Emerich
 Hungarian 1859-
 B,TB,VO

REY, Hans Augusto
 German/American 1898-
 H

REY, J. L.
 Spanish early 20c.
 GMC

REYBURN, Samuel
 American 20c.
 M

REYNARD, Grant Tyson
 American 1887-1967
 B,F,H,IL,M

REYNAUD, Paul
 French 20c.
 POS

REYNOLDS, Clara W.
 American 1899-
 H,M

REYNOLDS, Frank
 English 1876-1953
 B,EN,GMC,H,M,PUN6/2/37

REYNOLDS, James
 American 1896-
 M,STU1929,VO

REYNOLDS, James Elwood
 American 1926-
 CON,H

REYNOLDS, John
 England early 20c.
 ADV,POST

REYNOLDS, Oakley
American 20c.
H

REYNOLDS, S. W.
American? early 20c.
VC

REYRE, Val
French early 20c.
B,LEX,VO

U.R.

REZABKOVA, E.
Czechoslovakian mid 20c.
GR52

REZNICEK, Ferdinand von
Austrian 1868–1909
B,EC

RHEAD (Brothers RHEAD), Louis, George
and Frederick
American and English 19/20c.
CEN11/98

RHEAD, George Wooliscroft
English 1855–1920
B,H,M

RHEAD, Louis John
Anglo/American 1857–1926
CP,F,I,M,MM,POS,POST,R,TB,Y

RHEINFELDEN, Friedrich G.
Austrian 1838–1903
LEX,TB

RHOADS, Harry Davis
American 1893–
H,M

RHODES, Helen N.
American –1938
F,H,M

RIABOUCHKINE, Andrei Petrovitch
Russian 1861–1904
B

RIBA, Paul F.
American 1912–77
H,M

RIBAS MONTENEGRO, Frederico
Spanish 1893–
B

RIBBONS, Jan
Anglo/American 1924–
GR53,H

RIBEIRO, Rogério, Fernando da Silva
Portuguese 1930–
H

RIBERA, Paco
Spanish early 20c.
POS

RIBOLDI, Gaetano
Italian 1790–1825
B,H

RICABONA
Austrian 20c.
LEX

RICART, Enric Cristofol
Spanish 1893–
B

RICAS
Italian early 20c.
POS

RICE, Anne Estelle
English early 20c.
LHJ7/06,M

RICE, Elizabeth
American 20c.
H

RICE, James William, Jr.
American 1934–
H

RICE, William Clarke
American 1875–1928
B,F,I,M

RICE, William Seltzer
American 1873–
B,F,H

RICE-MEYEROWITZ, Jenny Delony
American 1866-
F,H,M

RICHARD, J. M. L.
French mid 20c.
GR52

RICHARDS, Ceri
English 1903-71
B,BRP

RICHARDS, Frances
English 1903-
B

RICHARDS, Frederick Thompson
American 1864-1921
B,CO1/05 and 6/05,EC,F,I,LHJ7/06,M

RICHARDS, George Mather
American 1880-
B,F,M

RICHARDS, George W.
American 20c.
M

RICHARDS, Harriet Roosevelt
American -1932
CEN10/09,F,H,M

Harriet Roosevelt Richards

RICHARDS, Lee Green(e)
American 1878-1950
B,F,H,M

RICHARDS, Thomas Addison
Anglo/American 1820-1900
B,BAA,F,H,I,M

RICHARDS, Walter Du Bois
American 1907-
F,H,IL,M,Y

Walter Richards

RICHARDSON, Ed
American 1927-
H

RICHARDSON, Frederick W.
American 1862-1937
B,CEN3/04,F,H,I,M,R

FREDERICK RICHARDSON.

RICHARDSON, Harry C. (S?)
American 20c.
H,M

RICHARDSON, Herbert
American 20c.
M

RICHARDSON, Katherine N.
American early 20c.
LHJ4/05

RICHEMONT, Alfred Paul Marie Panom Desbassayns
French 1857-1911
B

RICHEZ, Jacques
Belgian 1913/18-
GR52-54-57-65-68,H,POS,POST

JACQUES RICHEZ

RICHMAN, Hilda
American 20c.
M

RICHTER, Adrian Ludwig
German 1803-84
B,H,LEX,S,TB

L·R.

RICHTER, Albert B.
German/American 1845-98
B,H,TB

A.R.

RICHTER, Aurel
Hungarian 1870-
B,TB

R.A.

RICHTER, Fritz
German 20c.
LEX

RICHTER, Gustav-Karl Ludwig
German 1803–84
B,H,TB

K.G.R.

RICHTER, (Prof.) Hans-Theo
German 1902–
G,H,M

RICHTER, Johann Salomo
German 1761–98
B

RICHTER, K. G.
German ac. early 20c.
LEX

RICHTER, Klaus
German 1887–
B

RICHTER, Ludwig Adrian
see
RICHTER, Adrian Ludwig

RICHTER, Mischa
Russian/American 1910–
EC,H,M

RICHTER, Robert
German 1860–
B,LEX,TB

RICHTER, Trude
Swiss 20c.
LEX

RICHTER, Wilmer Siegfried
American 1891–
F,H,M

RICKARD, Jack
American 1922–
EC

RICKELT, Karl
German late 19c.
GWA,LEX,M

K.R.

RICKETTS, Charles de Sousy
English 1866–1931
AN,BA,BK,H,PC,STU1930

RICO, Dan
American 1910–
H,M

RICORD, Patrice
French late 20c.
GR82

RICORD

RIDER, Arthur Grover
American 1886–
H,M

RIDGELY, Frances Summers
American 1892–
H

RIECK, Walter
German 1911–
LEX

RIEDTHALER, Willard A.
American 20c.
M

RIEGEN, William von
American 20c.
M

RIEMER, A.
German early 20c.
LEX

RIEMER, Walter
German early 20c.
LEX

RIEMERSCHMID, Richard
German 1868-1957
B,H,LEX,MM,TB,VO

RIENECKE, William
American 1892-1937
M

RIESEN, Eduard
French? early 20c.
LEX

RIESENBERG, Sidney H.
American 1885-
F,H,M,RC8/17

RIETH, Paul
German 1871-1925
B,LEX

RIGALT Y Blanch, Antonio
Spanish -1914
B

RIGALT Y FARRIOLS, Luis
Spanish 1814-94
B,H,TB

RIGALT Y TORTIELLA, Agustin
Spanish 1840-98
B

RIGBY, George
English 19/20c.
LEX

RIGER, Robert
American 1924-
H,IL

RIGGS, Robert
American 1896-1972
APP,F,FOR,H,IL,PC

RIGNEY, Francis Joseph
Irish/American 1882-
F,H,M

RIGO, Martin
Spanish 1949-
NV

RILEY, Arthur Irwin
American 1911-
H

RILEY, Bill
American 1921-
H

RILEY, Charles Reuben
see
RYLEY, Charles Reuben

RILEY, Kenneth Pauling
American 1919-
CON,F,H,IL,Y

RILEY, Maude Kemper
American 1902-
H

RILEY, Nicholas F.
American 1900-1944
F,H,IL,M

RIMMER, Alfred
English 1829-93
B,EN,H,M

RINALD, Helen
American 20c.
M

RINCIARI, Ken
Dutch late 20c.
EI79

RINGLER, Josef (Sepp)
Austrian 1887–
LEX

RIODAN, Roger
Irish/American 1848–1904
I,M

RIORDAN, Roger
see
RIODAN, Roger

RIOU, Edouard
French 1833–1900
B,H,M,TB

ER.

RIPLEY, Robert Leroy
American 1893–1949
EC,H,M

Rip.

RIPPL-RŌNAI, Jozef
Hungarian 1861–1927
AN,B,CP,H,TB

(R)

RIPPMANN, Lore
Swiss 1887–
B

RIQUER È INGLADA, Alejandro de
Spanish 1856–1920
B,POST

A ᴅᴇ RIQUER

–1900–

RISING, Dorothy Milne
American 1895–
H,M

RISKO, Robert
American 20c.
P

Risko 84

RISS, Karl
German 19/20c.
LEX

RISWOLD, Gilbert P.
American 1881–
B,F,H,M

RITTER, Lorenz
German 1832–1921
B,LEX,TB

L.R.

RITTER, Paul der ältere
German 1829–1907
B,H,LEX,M

RITTMEYER, Emil
Swiss 1820–1904
B,LEX

RIUDAVETS MONJO, José Maria
Spanish 1840–1902
B

RIVERA, Diego Maria
Mexican 1886–
APP,B,DES,EAM,GMC,H,M,PC

Diego Rivera

RIVERA, Rolando
American 20c.
H

RIVERS, Larry
American 1923–
APP,B,DRAW,EAM,F,GMC,H

Rivers

RIVOLI, Mario
American 1943–
H

RIVOLTA, Jack
 Anglo/American 1890–
 M

RIX, Julian Wellbridge
 American 1850–1903
 B,F,H,I,M

Julian RIX,
Julian Rix

RIZZARDI, Melchiorre
 Italian 1802–
 B,H

RJABUSCHKIN, Andrei Petrovitch
 see
 RIABOUCHKINE, Andrei Petrovitch

ROBAUDI, Alcide Théophile
 French 1850–1928
 B,M

A. R.

ROBBE, Manuel
 French 1872–1936
 B,M,POS

ROBBINS, Frank
 American 1917–
 H

ROBERT, Paul
 Swiss 1851–1923
 B,TB

P. R.

ROBERT, Philippe
 Swiss 1881–1930
 B

ROBERTS, Alan
 American 20c.
 M

ROBERTS, Bruce
 English 1918–
 LEX

ROBERTS, Dean
 American 1899–
 M

ROBERTS, Henry Benjamin
 English 1832–1915
 B,H,LEX,TB

ROBERTS, Jack
 American 1920–
 GR55–60

ROBERTS, Jack
 French 1894–
 B,M

ROBERTS, Louise Smith
 American 1887–1936
 M

ROBERTS, Morton
 American 1927–64
 F,H,IL,Y

Morton Roberts

ROBERTS, Raymond
 English mid 20c.
 GR61

ROBERTS, Sidney A.
 American 1900–
 H,M

ROBERTS, Violet Kent
 American 1880–1958
 F,H,M

ROBERTS, William
 English 1895–
 B,BRP,H,POST

William Roberts

ROBERTSON, Henry Robert
 English 1839–1921
 B,EN,H

ℛℛ

ROBERTSON, John Tazewell
 American 1905–
 H,M

ROBERTSON, Paul Chandler
 American 1902–61
 H

ROBERTSON, Walford Graham
English 1866/67–1948
ADV,B,GA,TB

ROBIDA, Albert
French 1848–1926
B,EC,FS,GMC,L,M

ROBINS, Seymour
American mid 20c.
GR 53–55–56–66–85,H

ROBINSON, Boardman
Canadian/American 1876–1952
APP,B,CC,D,EC,F,H,I,M,PC,Y

ROBINSON, Charles
English 1866–1931
BK

ROBINSON, Charles
English 1870–1937
B,BK,TB

ROBINSON, Charles Aral
American 1905–
H

ROBINSON, Clark
American late 20c.
GR 82

ROBINSON, David
American 1886–
AM5/25,B,F,H,SCR5/12

ROBINSON, Elton
America mid 20c.
GR 64

ROBINSON, Florence Vincent
American 1874–
B,F,H,I

ROBINSON, (Frederick) Cayley
English 1862–1927
B,H

ROBINSON, George Thomas
English 1828–97
LEX,TB

ROBINSON, Heath
see
ROBINSON, William Heath

ROBINSON, Hugh
English mid 20c.
GR 54–55–58

ROBINSON, Lincoln Fay
American 20c.
M

ROBINSON, Mark
American 20c.
M

ROBINSON, Robert Doke
American 1922–
H

ROBINSON, Ruth Mae
American 1910–
H

ROBINSON, Sheila
English mid 20c.
GR 52–54,H

ROBINSON, Theodore
American 1852–96
B,BAA,EAM,F,H,I,M

ROBINSON, Thomas Osborne
English 1904–
M

ROBINSON, Thomas P.
American 20c.
M

ROBINSON, William Heath
English 1872–1944
ADV,B,BK,EC,S,TB

W.H.ROBINSON

ROBIQUET, Pierre Victor
French 1879–
B,M

ROB-JON
see
JONAS, Robert

ROBSON, Albert H.
Canadian 1882–1939
M

ROCHE, Camille
French early 20c.
B

ROCHE, Marcel
French 1890–1959
B,H,TB,VO

M.R.

ROCHE, Pierre
French 19/20c.
B,POS

ROCHEFORT, John Young
French 20c.
LEX

ROCHEGROSSE, Georges Antoine
French 1859–1938
B,FO,H,L,POS,TB

G. Rochegrosse

ROCHELLE, Eugene
American 1876–1914
I,M

ROCHER, Edmond André
French 1873–
B,M

RÖCHLING, Carl
German 1855–1920
B,LEX,TB

C.R.

ROCKWELL, Grace Corson
American 20c.
M

ROCKWELL, Maxwell Warren
American 1876–1911
B,I,M

ROCKWELL, Norman Perceval
American 1894–1978
ADV,B,EC,F,FOR,GMC,GR62,H,IL,M,POS,VO,Y

Norman
Rockwell

RODCHENKO, Alexander Mikhailovich
Russian 1891–1956
B,H,MM,POS

RODELL, Don
American 1932–
CON

don rodell

RODEWALD, Fred C.
American ac. 1930–48
H,M

RODEWALD, Otto
German 1891–
B,LEX,TB,VO

RODEWIG, Doris
American 1927–
F

RODGERS, Richard H.
American 20c.
M

RODICQ, A. M.
French mid 20c.
GR52

RODIN, Auguste
French 1840–1917
AN,B,DES,GMC,H,PC

RODMELL, Harry Hudson
American 1896–
M

RODRIGUES, Glauco Octavio Castilhos
Brazilian 1929–
H

RODRIGUES, José
Portuguese 1904–
H

RODRIGUES, José Joaquin
Portuguese 1936–
B,H

RODRIGUES, Manuel
Portuguese 1924–
GR54–62,H,POST

RODRIGUES, Sebastião
Portuguese 1929–
GR58–60 thru 63,H,POST

S Rodrigues

RODRIGUES-FERREIRA, Paulo
Portuguese 1911–
GR65,H,POST

paulo.54

RODRIGUEZ, Guillermo C.
Uruguayan
LEX

ROE, Fred (Frederick)
English 1864–1947
H,LEX,TB

FR

ROEBER, Ernst
German 1849–1915
B,H

ROECK, Lucien de
Belgian mid 20c.
GR55

DEROECK

ROEDELINS, Hildegard
German 20c.
LEX

ROEDER, Elsa
American 1885–1914
I

ROEHL, Elizabeth von
German 20c.
LEX

ROEMBURG, Kees van
Dutch? mid 20c.
GR57

ROERTS, Wilhelm
German early 20c.
LEX

ROESCH, Carl
Swiss 1884–
LEX

ROESE, Herbert
American 20c.
M

ROESELER, August
German 1866–
B

ROESSEL, A. von
Dutch early 20c.
LEX

ROESSLER, Adalbert von
German 1853–1922
LEX,TB

ROEVER, Joan Marilyn
American 1935–
H

ROEY, Leon van
Danish 1921–
H

ROFFEY, Maureen
English mid 20c.
GR60–61–63–67

ROGERS, (Miss) Barksdale
American 20c.
F,H,M,SCR2/12

Barksdale Rogers –

ROGERS, Bruce
 American 1870-1957
 H,R

BRVCE ROGERS

ROGERS, Carol
 American 20c.
 H

ROGERS, Florence M.
 Canadian ac. 1877-97
 H

ROGERS, Frances
 American early 20c.
 F,H,M

ROGERS, Howard
 American 1932-
 F,Y

ROGERS, Hubert
 American 20c.
 M

ROGERS, James Edward
 Irish/English 1838-96
 B,H

ROGERS, John
 American 1906-
 H

ROGERS, Katherine M.
 American 1908-
 H,M

ROGERS, Leslie
 American 20c.?
 H

ROGERS, Mable
 American 20c.
 M

ROGERS, W. S.
 English 19/20c.
 BI,POS

W. S. Rogers.

ROGERS, William Allen
 American 1854-1931
 B,BAA,EC,F,GMC,H,HA,PE,PG,TB,Y

W. A. ROGERS

ROGERS, William Harry
 English 1825-73
 B

ROGERS, William J.
 American 1878-
 M

RÖGGE, Wilhelm
 German 1870-
 LEX,TB

RÖHLING, Carl
 German 1849-1922
 B

ROHMAN, Eric
 Swedish early 20c.
 POS

ROHN, Ray
 American 1888-1935
 F,H

ROHONYI, Charles
 Hungarian/Belgian 1906-
 GR53-54-58-59-61,H,POS

RO., ROHONYI-

ROHRER, Lothar
 German 20c.
 LEX

ROHSE, Otto Friedrich Gustav
 German 1925-
 G,GR58-60-62,H

ROICK, Oskar Julius
 German 1870-1926
 B

ROJAN
 French early 20c.
 ST

Rojan

ROJANKOVKSY, Feodor Stepanovich
 Russian/French/American 1891-
 H,M

ROJE, Arsen
 American 20c.
 P

ROLAND HOLST, Richard
Dutch 1868-1938
POS

ROLLER, Alfred
Austrian 1864-1935
AN,CP,H,POS,TB,VO

ROLLER, Janet Worsham
American 20c.
H

ROLLER, Samuel K.
American 20c.
H

ROLLET, Maurice Louis Etienne
French 1902-
B

ROLLI, Hanspeter
Swiss mid 20c.
GR57-59

ROLLINGSWORTH, Will
American 20c.
GMC

ROLLINS, Carl Purington
American 1880-
H,M

ROLLY
Swiss mid 20c.
GR54

ROMAN, Emanuel Glicen
Italian/American 1897/1901-
H,M

ROMAN, Max Wilhelm
German 1849-1910
LEX,TB

MR

ROMANELLI, Carol
American 20c.
M

ROMANELLI, Frank (Francesco)
Italian/American 1909-
H,M

ROMANELLI, Paolo
Italian mid 20c.
GR64

Romanelli '61

ROMANO, Emanuel Glicen
see
ROMAN, Emanuel Glicen

ROMANS, Aleksandre
Baltic 1878-1911
B

ROMBERG, Maurice
Belgian 19/20c.
STU1902

M.R.

ROMBOLA, John
American late 20c.
GR67-82

Rombola

ROME, Samuel
American 1914-
H,M

RÖMER, Edward Jean
Polish 1806-78
B

ROMERO, Carlos Orozco
Mexican 1898-
GMC,H

RÖMME, Martha
French early 20c.
ST

romme

ROMMEL, Li
Swiss/German 20c.
GR52-53

Li Rommel

RONAY, Stephen Robert
Rumanian/Hungarian/American 1900-
H

RONCE, J.
 French ac. late 19c.
 LEX

RONHONYI, Charles
 Hungarian/Belgian 1906–
 H

ROOD, Henry Jr.
 American 1902–
 H

ROOS, Birger
 American mid 20c.
 GR 54

ROOT, Barry
 American late 20c.
 GR 85

ROOT, Robert Marshall
 American 1863–1939?
 B,F,H

ROOWY, E.
 French early 20c.
 AD

ROPER, Edward
 English 1857–91
 H

ROPS, Felicien J. V.
 Belgian 1833–98
 B,CP,EC,H,M,MM,POS

ROSA, Guido
 American 1890–
 B,F,PE

ROSA, Guido and Lawrence
 Americans 1890– , and 1892–
 B,F,PE

ROSA, Lawrence
 American 1892–
 B,F,PE

ROSCH, Walter
 German 1900–
 B

ROSCOW, William
 American 1908–
 M

ROSE, Carl
 American 1903–71
 EC,H

ROSE, David
 American 1910–
 GR 56,H

ROSE, Gerald
 American 1935–
 H

ROSE, Guy
 American 1867–1925
 B,F,H,HA,I,TB

ROSE, Jack Manley
 American 20c.
 GMC,M,RC 8/17

ROSE, W. E.
 American 20c.
 M

ROSE, William F.
 American 1909–
 H

ROSENBAUM-SLADKY, Herta
 Austrian 20c.
 LEX

ROSENBERG, Henry M.
 American/Canadian 1858–1947
 B,F,H,M,R,SN 1/94,SO

ROSENBERG, Louis Conrad
American 1890–
B,F,H,I,M,W

Louis C Rosenberg

ROSENBERG, L. N.
see
BAKST, Leon N.

ROSENBERG, Manuel
American 1897–
F

ROSENBERG, Nelson Chidecker
American 1908–
H,M

ROSENFELD, Mort
American 1928–
F,Y

ROSENHOUSE, Irwin Jacob
American 1924–
H

ROSENMEYER, Bernard Jacob
American 1870–
F,H,HA,SCR1/04

Rosenmeyer

ROSENTHAL, David
American 1866/76–1949
F,H

ROSENTHAL, G. S.
American mid 20c.
GR54

ROSENTHAL, Jan
see
ROZENTĀLS, Janis

ROSENTHAL, Louis N.
American ac. 1859
M

ROSER, Robert
Danish mid 20c.
GR57–61

ROSER, Wiltrud
German mid 20c.
GR61

ROSIÉ, Paul
German 1910–
LEX,VO

RÖSLI, Enzo
Swiss mid 20c.
GR57–58–63

ROSOFSKY, Seymour
American 1924–
B,H,P

Rosofsky

ROSOL, Vladimir
Czechoslovakian mid 20c.
GR54–59

ROSOMAN, L. H.
American 20c.
M

ROSOMAN, Leonard
English 1913–
B,H

Leonard Rosoman

ROSS, Alex
Scottish/American 1908–
F,H,IL,Y

Alex Ross.

ROSS, Gordon
American early 20c.
CL11/10,M

Gordon Ross

ROSS, John
American 1921–
APP,H

ROSS, Stuart
American mid 20c.
GR64

ROSS, Tony
English late 20c.
EI79

ROSSE, Hermann
American 1887–
B,F,H

ROSSELET, André
Swiss 20c.
GR53-55

ROSSELLI, Colette
English mid 20c.
GR52

COLETTE
ROSSELLI

ROSSEN, Ru (Rud Herald) van
Dutch mid 20c.
LEX

ROSSER, Milburn
American 20c.
M

ROSSET-GRANGER, Edouard
French 1853-
B,H,LEX,TB

ROSSETT, Pierrette
Swiss mid 20c.
GR57

ROSSETTI, Dante Gabriele
English 1828-82
AN,B,BAA,H,M,PC,POS

ROSSETTI, Gian
Italian 1920-
GR52-56-57
H

ROSSI, Aldo
Italian mid 20c.
GR57

ROSSI, Attilio
Italian 1908-
GR55-60,H

ROSSI, Lucius (Lucio)
Italian/French 1846-1913
B,H,TB

ROSSI, Luigi
Swiss 1853-1923
B,LEX,TB

ROSSI, Paul A.
American 1929-
CON,H

ROSSILLON, Marius
see
O'GALOP

ROSSING, (Prof.) Karl
Austrian 1897-
B,M?

ROSSING, Willi
Czechoslovakian early 20c.
B,G,H,TB,VO

ROSSITER, A.
English mid 20c.
GR56

ROSSO, Gustavo
Italian 1881-1950
EC,H

ROSTGAARD, Alfredo
Cuban 20c.
B,POS

ROSTOCK, Edward
American late 20c.
GR52

ROSY, Maurice
French late 20c.
EI79

ROTH, Arnold
English 20c.
GMC,PLC

ROTH, Herbert
American 1887-1953
F,H,PE

ROTH, Ludwig M.
German 1858-
LEX

ROTH, Richard
German 1907-
GR52-58,H

ROTH, Wilhelm
German early 20c.
LEX

ROTHAUG, Alexander
Austrian 1870-1946
B

ROTHBART, Ferdinand
German 1823-99
B,H,LEX,TB

ROTHER, Rudi
German 1863-1909
B,TB

ROTHERMEL, Dorothy
American 20c.
M

ROTHHOLZ, H. A.
English mid 20c.
GR57-61

ROTHKO, Mark
American 1903-70
B,F,H,M,POS,SO

ROTT, Hans
German mid 20c.
GR61

ROTTEMBOURG, V.
French early 20c.
LEX

ROUBILLE, Auguste Jean Baptiste
French 1872-1955
B,FS,GMC,POS

ROUCHON, Jean Alexis
French 19c.
POS

ROUGE, Frédéric
Swiss 1867-
B

ROUNDS, Glen H.
American 1906-
H,M

ROUNTREE, Harry
New Zealander/English 1878-1950
EC,M

ROUQUET, Achille
French 1851-
LEX,VO

ROUSSEAU, Henri Emilien
French 1875-1933
AN,B

ROUSSEAU, Jean Charles
French mid 20c.
GR59-61-66

ROUSSEL, Ker-Xavier
French 1867-1944
AN,APP,B,H,POS

ROUVERET, René
French 20c.
B

ROUVEYRE, André
French 1879–
M

ROUX, Gaston Louis
French 1904–
B

ROUX, Gustave
French? 1828–85
B,LEX,TB

G·R·

ROUX, J.
French late 19c.
LEX

ROUX-BURGHARD, E. von
German 20c.
LEX

ROWE, Clarence Herbert
American 1878–1930
B,F,H,PE

*Clarence.
Rowe*

ROWE, Corinne
American 1894–1965
F,H

ROWE, Guy
American 1894–1969
H,M,SH6/23

ROWLAND, M. E.
American early 20c.
F

ROWNTREE, Kenneth
English mid 20c.
B,GR54

Kenneth Rowntree

ROX, Henry
German/American 1899–
GR53–57,H

ROY, Marius
French 1833–
B,H,LEX,TB

Marius.Roy.

ROY, Pierre
French 1880–1950
H,VC

Pierre Roy

ROZENTĀLS, Janis
Latvian 1866–1916
B,M

RU
see
QUÉMÉRÉ, Albert

RUANO LLOPIS, Carlos
Spanish 1879–
B

(Ruano Llopis)

RUBENSTEIN, Lewis W.
American 1908–
F,H,M

RUBIN, Hy
American 1905–60
H

RUBINO (RUBINI), Antonio
Italian 1880–1964
B,H,MM

A RUBINO

RUBIO Y VILLEGAS, José
Spanish –1861
B

RUBNER, Kurt
German 20c.
LEX

RUCKSTULL, Frederick Wellington
Alsace/American 1853–1942
B,F,H,I

RUDAUX, Henri Edmond
 French -1927
 B

RUDDER, Stephen Churchill Douglas
 American 1906-
 F

RUDEAUX, E.
 French ac. early 20c.
 LEX

RUDER, Emil
 Swiss mid 20c.
 GR58,POS

RUDIN, Nelly
 Swiss mid 20c.
 GR56-57-58-61

RUDNICKI, Marek
 Polish/French mid 20c.
 GR58

mR

RUDOLPH, Arthur
 German 1885-
 B,LEX,TB,VO

A.R.

RUDOLPH, John
 American 20c.
 M

RUDOLPH, Norman Guthrie
 American 1900-
 H,M

RUETER, George
 Dutch 19/20c.
 B,POS

RUFA
 see
 FÄCKE, Rudi

RUFFINS, Reynold
 American 1930-
 GR58-59-60-65-66-68,Y

Ruffins

RUFFOLO, Sergio
 Italian mid 20c.
 GR57-62

RUIZ, Frederico
 Spanish 1837-68
 B

RUIZ-NAVARRO, J.
 Spanish mid 20c.
 GR64

RUKLEVSKY
 Russian early 20c.
 POS

RUMMLER, Alexander J.
 American 1867-
 B,F,H

RUMOHR, Carl Friedrich
 German 1867-
 B

RUMPEL, Karl Ernst Friedrich
 German 1867-
 B

RUMPF, Emil (Paul Emil)
 German 1888-
 B

RUMPF, Fritz
 German 1856-1927
 B,LEX,TB

RUMPF, Fritz
 German 1888-
 LEX,TB

RUNDQUIST, Ethel
 American early 20c.
 GMC,VC

ETHEL Rundquist.

RUNGIUS, Carl Clemens Moritz
 German/American 1869-1959
 B,F,H

RUNQUIST, Arthur
 American 1891-
 H,M

RUPPRECHT, George
 American 1901-
 H

RUSE, Margaret
 American 20c.
 M

RUSH, Olive
 American 1873-1966
 B,F,H,I,SCR12/06

OLIVE RUSH

RUSHBURY, Henry
 English 1889-
 B

RUSINOL Y PRATS, Santiago
 Spanish 1861-1931
 B,GMC,H,POS

RÚSPOLI-RODRIGUEZ
 American mid 20c.
 ADV

RÚSPOLI-RODRÍGUEZ

RUSSEL, Alexander Jamieson
 Scottish 1807-80
 H

RUSSELL, Albert Cuyp
 American 1838-1917
 D

RUSSELL, C. D.
 American 20c.
 H,M

RUSSELL, Charles Marion
 American 1864-1926
 B,CC,F,H,I,IL,M,Y

CM Russell 1898

RUSSELL, Gyrth
 Canadian 1892-
 B,H

RUSSELL, Mark
 American 1880-
 GMC,H

MARK RUSSELL

RUSSELL, Walter
 American 1871-
 B,F,H,I

RUSSELL, Walter Westley
 English 1867-1949
 B

RUSSELL, Winifred Jonathan
 American 20c.
 H

RUSSI (ROSSI), Attilio
 Italian early 20c.
 POS

RUSSIAN, Gianni
 Italian 1922-
 GR54,H

RUSSO, Alexander Peter
 American 1922-
 H

RUSZCZYC, Ferdynand
 Polish 1880-1936
 B,LEX,VO

F.R.

RUTH, Asta
 German mid 20c.
 GR54-56-58

RUTH-SOFFNER, Asta
 German 1910-
 LEX

RUTHERSTEIN, Albert Daniel
 see
 RUTHERSTON, Albert Daniel

RUTHERSTON, Albert Daniel
 English 1881-1953
 B,BRP,M

RUTLAND, Emily Edith
 American 1894-
 H,M

RUTTAN, C. E.
 American early 20c.
 ADV

C.E. Ruttan

RUTY, P. M.
 French 1868–
 B,LEX,TB

RUUSKA, Pentti
 Finnish mid 20c.
 GR 65

RUYL, Louis H.
 American 1870–
 F,STU 1916

RUŽIČKA, Antonin Josef
 American 1883/91–1918
 B,M

RUZICKA, Rudolph
 Bohemian/American 1883–1978
 B,F,H,M,PC,TB,VO

R RUZICKA
1914

RYAN, Angela Svobodny
 American 1906–
 H,M

RYBKOVSKI, Thadeusz (Tadensz)
 Polish 1848–1926
 B,M

RYCHLICKI, Zbigniew
 Polish mid 20c.
 LEX

RYCHLICKI 28.

RYCKEBUSCH (RYCHEBUS)
 French 19c.
 B

RYDER, Mahler Bessinger
 American 1937–
 H

RYKR, Vaclav
 Czchoslovakian mid 20c.
 GR 65–66–67

RYLAND, Henry
 English 1856–1924
 B,H,M,POS,TB

HENRY RYLAND

RYLAND, Robert Knight
 American 1873–1951
 B,F,H,I,M,SO

R.K. RYLAND
1943

RYLEY, Charles Reuben
 English 1752–98
 B,H,M

RYŌJI
 see
 IMAO, Keiner

RYOSUI
 see
 RYUSI

RYŌSUKE
 see
 SHOTEI, Wanatabe

RYOTAI
 Japanese 1719–74
 B,H

RYUKOSAI
 Japanese ac. 1772–1816
 H,PC

RYUSI
 Japanese 1711–96
 H

RZAKOULIEV, Alikper
 Russian 1903–
 B

– S –

S. P. K.
 German mid 20c.
 POS

SAALBURG, Allen Russell
American 1899–
H,M,VC

Allen Saalburg

SAALBURG, Leslie L.
American 1902–75
F,M,VC,Y

Leslie Saalburg

SABER, Clifford
American 1914–
H

SABIA, William
American mid 20c.
GR65–66

SABIN, Joseph F.
French 1846–1927
B,BAA,F

SABLOW
see
SABURO, Yutensji

SABOGAL, José
Peruvian 1888–1956
B,H,LEX,M

J. Sabogal 1925

SABRAN, Guy
French early 20c.
AD

guy sabran

SABURO, Yutensji
Japanese late 20c.
GR82

Sablow

SACCARO, Giovanni (John)
American 1913–
H,M

SACCHETTI, Enrico
Italian 1874/77–
B,H,TB

SACCHETTI, Franco
Italian 1922–
H

SACHSTEN, Angel
German 20c.
GMC

ANGELSACHSEN

SACKER, Amy M.
American 1876–
B,F,H,M

SACKS, Cal O.
American 1914–
C,F,GR55–56,Y

SADATOSHI
Japanese ac. 1716–36
H

SADER, Lillian
American 20c.
H

SADIGHIAN, Parviz
American 20c.
P

SADLER, Walter Dendy
English 1854–1923
ADV,B,PC

W Dendy Sadler

SAEKI, Toshio
Japanese 1945–
EC

SAENZ HERMUA, Eduardo
Spanish 1859–98
B

SAETER, Georg
German mid 20c.
LEX

SAG
see
GARRARD, Sidney Arthur

SAGE, Jean (Jane?)
American 20c.
H?,M

SAHLIN, Carl Folke
American 1885–
H

SAHULA-DYCKE, Ignatz
Czechoslovakian/American 1900–
H

SAID, Claus Milton
American 1902–
H

SAILER, Josef Andreas
Austrian/German 1876–1958
LEX,VO

[S.]

SAINT, Lawrence
American 1885–1961
B,F,H,M

ℒℐ.

SAINT-AUBIN, Augustin de
French 1736–1807
B,H,PC

SAINT-GEORGE, Charles
French 1907–
B

SAINT-JOHN, J. Allen
American early 20c.
B,F,VC

J. Allen. St. John

SAINT-SAENS, Marc
French 1903–
B,GR55,H

SAINZ, Francisco
Spanish –1853
B

SAINZ Y OCEJO, Luis
Spanish –1920
B

SAITO, Hisashi
Japanese late 20c.
GR85

SAIVRE, Henri de
French 19/20c.
LEX

SAKRSHEWSKAJA, S.
Russian mid 20c.
LEX

SALA Y FRANCÈS, Emilio
Spanish 1850–1910
B,H,M

SALAMANDER
German 20c.
POS

SALDEN, Helmuth
Dutch 1910–
H,LEX

SALDUTTI, Denise
American 1953–
F,Y

SALERNO, Vincent
American 1893–
F

SALFORD, E. J.
American 20c.
M

SALG, Bert N.
American 20c.
M

SALINARO, Pietro Paolo
Italian 1901–
H

SALISBURY, Michael
American mid 20c.
GR65

S.

SALISBURY, Paul
American mid 20c.
GR65

SALLES, Robert
French 1871–1929
B,LEX,TB

SALLEY, Eleanor King (Hoskham)
American 1909–
H,M

SALMON, Donna Elaine
American 1935–
H

SALOMONI, Tito
American 20c.
P

Tito Salomoni

SALT, Henry
English 1780/1785–1827
B,H,M

SALTER, Geoffrey
English mid 20c.
GR56–60–61–63

SALTER, Georg(e)
German/American 1897–1967
GR52–58,H,POST

SALTZMANN, Carl
German 1847–1943
B,H,LEX,TB

C.Saltzmann

SALVADORI, Riccardo
Italian 1866–1927
B,H

SALVAT, François Martin
French 1892–
B

Salvat

SALVIONE, Giuseppe
Italian 1822–1907
B,H,LEX,TB

SALZEDO, Maggy
French early 20c.
POS

SAMBACH, (Johann) Christian
Austrian 1761–97
B

SAMBOURNE, Edward Linley
English 1845–1910
EC,LEX,TB

LINLEY·SAMBOURNE

SAMBROOK, Russell
American 20c.
GMC,M

*Russell
Sambrook*

SAMERJAN, George E.
American 1915–
H,M

SAMIRAILOW, Wiktor Dimitriewitsch
Russian? 1868–
B,LEX,TB

SAMIVEL
French 20c.
B

SAMOILVOS-BABINS, Levs Samuila
Latvian 1918–
LATV

Л.Самоилов-53

SAMOKICH, Nicolai Semionovich
Russian 1860–
B,M

SAMPLE, Paul Starrett
American 1896–1974
B,EI79,F,H,M,Y

PAUL SAMPLE

SAMUEL, Arthur
Swiss late 20c.
GR85

SAMWALD, Georg
Austrian 1891–
LEX,VO

G.S.

SANCHES, Daniel Ribiero
Portuguese 1921–
H

SANCHEZ, M. Carlos
Mexican 20c.
M

SANDBERG, Willem J. H. B.
Dutch mid 20c.
GR 52-55-58-59-64,POS

SANDECKA, Stanislava
Polish 1910–
POS

SANDECKA

SANDERSON, William
Latvian/American 1905–
H

SANDHAM, Alfred
Canadian 1838–1910
H

SANDHAM, (J.) Henry
Canadian 1842–1912
B,BAA,F,H,I,TB

SANDHORN, H.
American 19?/20c.
HA,LEX

H.S.

SANDIN, Joan
American 20c.
H

SANDOW, Franz
American 1910–
H,M

SANDOZ, Adolf Karol
Polish 1845/48–
B,M

SANDREUTER, Hans
Swiss 1850–1901
B,H,POS

SANDRI, Gino
Italian 1892–
H

SANDS, Gertrude Lois
American 1899–
H,M

SANDY, Percy Tsisete
American 1918–
H

SANDYS, Anthony Frederick Augustus
English 1829–1904
B,H,TB

SANDZEN, Sven Birger
American 1871–1954/64
APP,B,F,H

Birger Sandzén

SANFORD, John Williams Jr.
American 1917–
H,M

SANFORD, Lettice
English 20c.
M

SANFORD, Margaret
American 1847–1938
M

SANFORD, Roy
English mid 20c.
GR52

SÄNGER, Adolf
German early 20c.
LEX

SANGER, Grace H. H. Cochrane
American 1881–
F,H

SANGER, I. J.
American 1899–
F,H,M

SANHUDO, Sebastião de Sousa
Portuguese 1851–1901
H

SANNICOLO, G.
 Swedish late 20c.
 E179

SANSONI, Piero
 Italian mid 20c.
 GR65-68

Sansoni

SANTA-BARBARA, José Manuel Ludovice de
 Portuguese 1936-
 H

SANTACHIARA, Carlo
 Italian 1937-
 EC

Santachiara 1978

SANTEE, Ross
 American 1889-1965
 H,M

SANTOMASO, Giuseppe
 Italian 1907-
 B,H

[signature] '80

SANTORE, Charles Joseph
 American 1935-
 ADV,F,Y

Charles Santore

SANTOS, Abílio José Ferreira dos
 Portuguese 1926-
 H

SANTOS, Cipriano Dourado dos
 Portuguese 1921-
 H

SANYU YU
 Chinese/French 1900-
 B,LEX,VO

SANZ, Roman
 Spanish 1829-
 B

SAPHIEHA, Christine
 Polish/American 20c.
 H

SAPPER, Richard
 Guatemalan/German 1891-
 B,LEX,VO

R.S.

SARASIN, Hélène
 Swiss mid 20c.
 GR60-62

SARG, Tony
 Guatemalan/American 1880-1942
 ADV,B,F,H,IL,M,POST,TB,Y

TONI- SARG

SARGENT
 South African mid 20c.
 GR53

SARGENT, John Singer
 American 1856-1925
 B,BRP,EAM,F,GMC,H,I,M,PC

John S. Sargent

SARGENT, Natalie
 American 20c.
 M

SARGENT, Richard
 American 1911-
 H,IL,M

DICK SARGENT

SARIAN, Martiros Sergeevich
 Russian 1880-1972
 RS

SARIS, Anthony
 American 1924-
 IL

Saris

SARKA, Charles Nicolas
American 1879-1960
ABL8/05,B,EC,F,H,IL,Y

SARKA, Gerda Ploug
Danish 1881-
B

SARKADI, Emil
Austrian 1908-
LEX,TB

SARKADI, Leo (Schuller)
Hungarian/American 1879-
F,M

SARKOZY
French mid 20c.
GR60

SARKOZY

SARLUIS, Léonard
French 1874-1949
B,CP,M

.LEONARD. SARLUIS.

SARMA, P. N.
Indian mid 20c.
GR55

SARMENTO, Hugo Pinto de Morais
Portuguese 1885-
H

SARNOFF, Arthur Saron
American 1912-
AA,H

SARPANEVA, Timo
Finnish mid 20c.
GR53-55-59

SARRI, Corrado
Italian 1866-
B,H

SATO, Pater
Japanese/American late 20c.
GR82-85,P

SATOMI, Munetsugu
Japanese 1902-
B,POS

SATORSKY, Cyril
Anglo/American 20c.
H

SATTERLEE, Walter
American 1844-1908
B,BAA,F,H

SATTLER, Joseph
German 1867-1931
AN,B,CP,GA,MM,POS,TB

SATTY, Wilfried
German 1939-
H

SATYAJIT, Ray
Indian mid 20c.
LEX

SAUBER, Robert
English 1868-
B,LEX,TB

SAUBIDET, Tito Tomás N.
Argentinean 1891-
B,H

SAUGSTAD, Eugenie De Land
American 1872-
H,M

SAUL, Chief Terry
American 1921-
H

SAULNIER, James Phillippe
American 1899-
H,M

SAUNDERS, L. Pearl
American early 20c.
B,F,H,M

SAUNIER, Noël
French 1847-90
B,H,M

Noël Saunier

SAUTER, Rudolf Helmut
English 1895-
M,VO

W.S.

SAUVAGE, Sylvain
French 1888-1948
B

SAVAGE, Annie Douglas
Canadian 1896-1971
H,M

SAVAGE, Marguerite Downing
American 1879-
B,F,H,M

SAVAGE, Steele
American 1900-
H,M,PE

Steele Savage

SAVAS, Jo-Ann
American 1934-
H

SAVE, K. K.
Indian mid 20c.
GR60-62-63-64-67

SAVELLE, J. G.
American 20c.
M

SAVIGNAC, Raymond Pierre Guillaume
French 1907-
B,CP,GR52-62-64-68-82,H,POS,POST

savignac

SAVITT, Sam
American 20c.
CON,H

SAWKA, Jan
Polish/American
GR82,POS

SAWKA

SAWYER, Edmund Joseph
American 1880-
H,M

SAWYER, Ken
American late 20c.
GR52

SAWYER, Wells M.
American 1863-1960/61
B,F,H,M

SAWYERS, Martha
American 20c.
FOR,H,IL,M

MARTHA SAWYERS

SAXON, Charles David
American 1920-
EC,F,GMC,GR67,H

Saxon

SAY, Allen
American late 20c.
GR82

Allen Say

SAYER, Edmund Sears
American 1878-
H,M

SAYRE, Elizabeth Graves
American 20c.
H

SAYU, Katsura
Japanese ac. 1760
B

SBRAMA, Leone
Italian mid 20c.
GR 61-62-64-68

SCALÉ, Bernard
irish ac. 1756-80
B,H,M

SCANES, Ernest William
American 1909-
H,M

SCARABEO
Italian 20c.
POS

SCARFE, Gerald
English mid 20c.
GMC

Gerald Scarfe

SCARFE, Lawrence
English mid 20c.
GR 52-66-67

SCARPELLI, Filiberto
Italian 1870-1933
EC,H

SCARPELLI

SCELLIER, Madeleine
French 20c.
B

SCHA-TSCHUI-TSCHIIN
Chinese mid 20c.
LEX

SCHAAL, A.
German 19c.
LEX

SCHAAP, Ted
Dutch mid 20c.
GR 57-59-61-64

TEDSCHAAP

SCHAARE, Harry J.
American 1922-
CON,F,H,Y

Schaare

SCHABBEHAR, Ann Brannan
American 1916-
H

SCHABELITZ, Rudolph Frederic
American 1884-1959
B,EC,F,M,PE,SO

Schabelitz

SCHABERSCHUL, Max
German 1875-
B

SCHACHNER, Erwin
Austrian/American 20c.
H

SCHADE, Wilhelm
German 1859-
B,TB

W.Sch.

SCHAEFER-AST, Albert
German 1890-1951
EC

SCHAEFFER, Mead
American 1898-
B,F,H,I,IL,M,Y

Mead Schoeffer

SCHÄFER, Maximilian
German 1851-1916
B,TB

SCHÄFER, Rudolph Siegfried Otto
German 1878-
B,LEX,TB

SCHAFER, Wilhelm
German 1839–
B,LEX

SCHAFER-NATHAN, Steffie
German? mid 20c.
LEX

SCHAFFER, Myer
American 1912–
H,M

SCHALDACH, William Joseph
American 1896–
H

SCHALKWYK, Jan
Dutch mid 20c.
GR64

SCHANKER, Louis
American 1903–
APP,B,H,LEX,VO

SCHAPPLI, Sophie
Swiss 1852–1921
B

SCHARDT, (Prof.) Hermann
German 1912–
G,GWA,VO

SCHARF, (Sir) George, the younger
English 1820–95
B,H,M

SCHARF, Theo
Austrian/German 1899–
GWA,LEX

SCHARFF, Edwin
German 1887–1955
B,H,LEX,TB

SCHARL, Joseph
German/American 1896–1954
H

SCHARY, Saul
American 1904–78
H

SCHATT, Roy
American 1909–
H

SCHATZ, Felix
Austrian 1847–1905
B

SCHATZ, Otto Richard
Austrian 1900–
LEX

SCHAUM, Bernhard
German 1880–1916
B

SCHAUMANN, Ruth
German 1899–
B,LEX,TB,VO

SCHAUPP, Richard
German 1871–
B,TB

SCHAUROTH, Lina von
German 1875–
B,LEX,TB

SCHAWINSKY, Xanti
American 20c.
B,CP,M,POS

SCHEDLER, Jacques
Swiss 20c.
GR55–68,LEX

SCHEERBART, Paul
German, born Danzig 1863–1915
B,LEX,TB

SCHEFFEL, Herbert H.
American 1909–
H,M

SCHEIBENZUBER, R.
 German early 20c.
 LEX

SCHEIBER, Hugo
 Hungarian 1873-1950
 B

Scheiber

SCHEICHENBAUER, F.
 Italian mid 20c.
 GR60

SCHEIDEMANTEL, Walter
 German early 20c.
 LEX

SCHEIWL, Josef
 see
 SEIWL, Josef

SCHELL
 Belgian mid 20c.
 GR52-54

SCHELL 50

SCHELL, Francis (Frank) H.
 American 1834-1909
 B,CWA,D,H,I,SN7/94

FRANK H Schell

SCHELL, Frank Cresson
 American 1857-
 B,F,I,M,SN7/94 and 8/94,TB

-F. Cresson Schell.

SCHELL, Frank H. and HOGAN, Thomas
 H,CWA,M

S. & H.

SCHELL, Frederic B.
 American -1905
 CWA,H,M

Fred B. Schell-85

SCHELLING, George Luther
 American 1938-
 CON

George L. Schelling

SCHEMBERS, Josef
 see
 SEMBERS, Josef

SCHENK, Roland
 Swiss mid 20c.
 GR61

SCHENKEL, F.
 German 20c.
 LEX

SCHENKER, Ulrick
 Swiss mid 20c.
 GR60

SCHERENBERG, Hermann
 German 1826-97
 B,H,LEX,TB

H.S.

SCHERER, Paul L.
 American 20c.
 M

SCHERRER, Jean Jacques
 French 19c.
 B,M

SCHERRER, Joseph
 Canadian 1860-1936
 H

SCHERRES, Alfred
 German 1833-1923
 B,CEN10/09

Alfred Scherres.

SCHERRES, Carl (Karl)
 German 1833-
 B,H,LEX

SCHERZ, Fritz
 German early 20c.
 LEX

SCHERZER, Conrad
 German 1893–
 B,LEX,TB

C.S.

SCHEUCH, Harry William
 American 1907–
 H,M

SCHEUER, W.
 Canadian ac. 1873–83
 H

SCHEUERLE, Joe
 Austrian/American 1873–1948
 H,M

SCHEUFLER, Grete
 German early 20c.
 LEX

SCHEURICH, Paul
 American/German 1883–1945
 B,CP,MM,POS,TB,VO

Scheurich –

SCHIAVO, Elso
 Swiss mid 20c.
 GR 62–63–65–66–67–68

SCHICK, Carl
 French 1854–
 LEX

SCHICK, Fred G.
 American 1893–
 F

SCHICK, Laurens
 American 20c.
 LEX

SCHIEFER, Hella
 German mid 20c.
 LEX

SCHIELE, Egon
 Austrian 1890–1918
 AN,B,DRA,H,M,PC,POS

SCHIESTL, Rudolf
 German 1878–1931
 LEX,TB

RS

SCHIFFARTH, T.
 German early 20c.
 LEX

SCHIFFER, Ethel Bennett
 American 1879–
 B,F,H

SCHIFFERS, Franz O.
 German 20c.
 LEX

SCHILLING, Arthur Oscar
 German/American 1882–
 F,H,M

SCHILLINGER, Heinz
 German mid 20c.
 GR 60

SCHILLINGER, Hella
 German mid 20c.
 GR 60

SCHILLINGER, Julius (Gyula)
 Hungarian 1888–1930
 B

SCHINDELMAN(N), Joseph
 American 1923–
 GR 52–55–57–60–62–64–65–66,H

SCHINDLER, Emil Jacob
 Austrian 1842–92
 B,H,LEX,TB

SchL.

SCHINDLER, H. L.
 English 19/20c.
 LEX

SCHINDLER, Rudolf
 German mid 20c.
 GWA,LEX

SCHLAIKJER, Jesse William
American 1897–
B,F,H,M

SCHLECHT, Richard
American 1936–
H

SCHLEETER, Howard Behling
American 1903–
H,M

SCHLEGEL, Franz
Austrian 1851–1920
B

SCHLEGEL, Friedrich
Czechoslovakian 1865–
LEX,TB

SCHLEGER, Hans (Zero)
German mid 20c.
GR52–60–62–64–67,H,POS,POST

SCHLEIFER, Fritz
German early 20c.
POS

SCHLEINKOFER, David J.
American 1951–
F,Y

SCHLEMMER, Oskar
German 1888–1943
B,CP,DRA,H,POS,TB,VO

SCHLETTE, F. G.
Dutch early 20c.
BI

SCHLETTNER, Paul
German early 20c.
LEX

SCHLEY, Mathilde
American 1874–
F,H,M

SCHLICHTEGROLL, Carl Felix von
German 1862–
B

SCHLICHTER, Rudolf
German 1890–1955
B,H,LEX,VO

SCHLICHTING, Max
German 1866–
B

SCHLICK, Gustav Friedrich
German 1804–69
B

SCHLIE, Peter
German mid 20c.
GR65

SCHLIER, Hans
German early 20c.
LEX

SCHLIESSMANN, Hans
Austrian 1852–1920
B,POS,TB

SCHLITT, Heinrich
German 1849–
B,TB

SCHLITTGEN, Hermann
German 1859–1930
B,EC,TB

SCHLOEPKE, Theodor
German 1812–78
B,H,M

SCHLOSSER, Wolfgang
Czechoslovakian mid 20c.
GR56–65

SCHLOTTAN, Günter
German mid 20c.
GR52

SCHLUETER, Virginia Moberly
American 1900–
H

SCHLÜSSELBERGER, Epi
Austrian mid 20c.
GR55-57-59-67

SCHMAL-WILHAMS, Hans
German 20c.
LEX

SCHMALHAUSEN, Otto
Belgian/German 1890–
B,LEX,VO

S.

SCHMALZ, Max
German 1850–1930
B

SCHMARINOV
Russian mid 20c.
POS

SCHMAUK, Carl (Karl)
German 1868–
B

C·Sch.

SCHMEDES, Grete
German 1889–
LEX,VO

CSch.

SCHMEDTGEN, William Hermann
American 1862–1936
B,F

SCHMID, Eleonore
American?/Swiss late 20c.
GR67-85

SCHMID, Georg
Austrian mid 20c.
B,GR54-57-60-66-67

SCHMID, Julius
Austrian 1854–
B,LEX,TB

JS.

SCHMID, Matthias
Austrian 1835–1923
B,H,TB

MB

SCHMID, Max
Swiss mid 20c.
GR53-56-58-59-66

SCHMID, Peter
Austrian 20c.
LEX

SCHMIDHAMMER, Arpad
German 1857–1921
B

囲:

SCHMIDLIN, P. S.
Swiss mid 20c.
GR53-54-58

SCHMIDT, Alfred Michael Roedsted
Danish 1858–
B,POS,SC

SCHMIDT, Alwin E.
American 1900–
H

SCHMIDT, Carl Arthur
German/American 1890–
H,M

SCHMIDT, Carl Heinrich Wilhelm
German 1790–1865
B

SCHMIDT, Eugen Julius
German 1890–
LEX,TB

SCHMIDT, Felix
American 20c.
H

SCHMIDT, Fritz Philipp
German 1869–
B,TB

FS

SCHMIDT, Hans W.
German 1859–
B,TB

H.W.S.

SCHMIDT, Harold van
American 20c.
M

SCHMIDT, Harvey Lester
American 1929–
GR61-65,H,IL

Harvey Schmidt

SCHMIDT, Joost
German 1893–1948
B,CP,POS

SCHMIDT, Kurt
Austrian 20c.
LEX

SCHMIDT, Oscar Frederick
American 1892–1957
F,H,IL,M

O F. Schmidt

SCHMIDT, Otto
American –1940
F,H,M

SCHMIDT, Werner Paul
German 1888–
B,TB

W.P.S.

SCHMIDT-GOERTZ, Gustav
German 1889–
LEX,TB

SCHMIDT-HILL, Wilhelm
German 1880–
B

SCHMIDTHILD, Wilhelm
German 1876–
B,LEX,VO

W.S.

SCHMIED, François Louis
Swiss 1873–1941
AD,B,M,STU1913

F L.S.

SCHMITH, A.
American mid 20c.
GR54

SCHMITT, Carl
American 1889–
B,F,H,M

SCHMITTKE, Bernard
American 20c.
M

SCHMITZ, Adelheid
German early 20c.
LEX

SCHMITZ, Adolf Heinrich Gustav
German 1825–94
B,H?,TB

SCHMITZ-CROLENBURGH (called)
see
SCHMITZ, Adolf Heinrich Gustav

SCHMOHLE, Elisabeth
German ac. early 20c.
LEX

SCHMOLL von EISENWERGH, Karl
Austrian/German 1879–1947
AN,B,M

SCHMOLLER, Hans P.
German/English 1916–
GR52,H

SCHMOLZ, Richard
German early 20c.
LEX

SCHMOLZE, Karl Hermann
German 1823–61
B

SCHNACKENBERG, Roy
American 1934–
F,H,Y

SCHNACKENBERG, Walter
German 1880–
B,GMC,M,POS,TB,VO

Schnackenberg

SCHNARRENBERGER, Wilhelm
German 1892–
B,LEX,TB,VO

WILHELM SCHNARRENBERGER

SCHNEBEL, Karl
German 1874–
LEX,TB

Schn.

SCHNEBL(E)LIE, Robert Bremmel
English –1849
B,H,M

SCHNECK, Albert
Austrian? mid 20c.
ADV

SCHNEIDER, Arthur
American early 20c.
F,M

SCHNEIDER, August Gerhard
Norwegian 1842–72
B

SCHNEIDER, Ernst
German early 20c.
B,LEX

SCHNEIDER, Frederick
American 1946–
F,Y

SCHNEIDER, Hans
German early 20c.
LEX

SCHNEIDER, Marcus
Swiss mid 20c.
GR61–62

SCHNEIDER, Max
Swiss mid 20c.
GR57–58–59–63–65–68

SCHNEIDER, Otto J.
American 1875–1946
APP,B,F,H,I,M

SCHNEIDER, William
American 20c.
H

SCHNEIDLER, Ernst F. H. R.
German 1882–1956
LEX,VO

S.

SCHNEPF, Bob
English?, 20c.
CP

SCHNITZER, Theodor
Yugoslavian 1923–
H

SCHNORR, Peter
German 1862–1912
B,TB

P.S.

SCHNORR von CAROLSFELD, Julius
German 1794–1872
B,DA,H,M

SCHNUG, Leo
French 1878-1933
B,LEX,TB

SCHÖBEL, Georg
German 1860-
B

SCHOELLHORN, Hans Karl
Swiss 1892-
B

SCHOEN, Fritz
German 1871-
B,BI,K

SCHOENHAUS(-HALFLIGER), Coma
Swiss mid 20c.
GR57-61-63-64

SCHOEPS, M.
German early 20c.
LEX

SCHOFF, Otto
German 1888-
B,LEX,TB,VO

SCHOLLKOPF, Günter
German 1935-
G

SCHOLLY, Nora
German 20c.
LEX

SCHOLZ, Jürgen
German mid 20c.
GR58-59-60

SCHOLZ, Richard
German 1872-
B

SCHOMMER, François
French 1850-1935
B,TB,VO

SCHÖNBERG, Johann Nepomuk
Austrian 1844-
B,TB

SCHÖNER, Anton
German 1866-1930
B

SCHONER, Engelbert
German mid 20c.
LEX

SCHONGUT, Emanuel
American 1936-
F,H,Y

SCHÖNIAN, Alfred
German 1856-
B

SCHÖNPFLUG, Fritz
Austrian 1873-
B,LEX,TB

SCHÖNWALTER, Horst
German 20c.
LEX

SCHOOLCRAFT, Cornelia Cunningham
American 1903-
H

SCHOOLCRAFT, Henry Rowe
American 1793-1864
H

SCHOONMAKER, William Powell
American 1891-
F,H,M

SCHOONOVER, Frank Earle
American 1877-1972
CEN7/07,F,H,HA9/08 and 12/07,I,IL,LEX,M,Y

SCHÖPFLE, Alfred
German 1917-
LEX,VO

SCHOTT, Arthur
American 1813?-75
H

SCHOTTLAND, Miriam
American 1935-
F,H,Y

SCHRAG(G), Karl
German/American 1912-
APP,B,DRAW,H,PC,SO

Karl Schrag

SCHRAM, Alois Hans
Austrian 1864-1919
B,LEX,TB

A.H.S.

SCHRAMM, Ulrick
German 1912-
G

SCHRAMM, Viktor
Rumanian 1865-1929
B

SCHRAUDOLPH, Claudius von (the younger)
German 1843-91/1902
B,H,TB

C.S.

SCHRECKHASSE, Paul
German early 20c.
LEX

SCHREIBER, F.
German 19/20c.
LEX

SCHREIBER, Georges
Belgian/American 1904-77
H

SCHREIBER, Gladys
American 20c.
M

SCHREIBER, Guido
German -1886
B

SCHREIBER, Isabel
American 1902-
H

SCHREIBER-GAMELIN, Thea
German 20c.
LEX

SCHREINER, A.
German ac. late 19c.
LEX

SCHREYER, Oskar
German early 20c.
LEX

SCHREYVOGEL, Charles
American 1861-1912
B,BAA,F,H,I,M

Chas Schreyvogel 1885

SCHRIER, Jeffrey A.
American 1943-
F,Y

SCHRÖDER, Albert Friedrich
German 1854-
B

SCHRÖDTER, Adolf
Swedish/German 1805-75
B,EC,H,TB

Æ

SCHRÖDTER, Hans
German 1872-
B,LEX,TB

H.S.

SCHROEDER, William Howard
English -1892
B,H

SCHROM, Ernst
Austrian 1902-
LEX

SCHROTTER, Alfred von
Austrian 1856-1935
LEX,TB,VO

SD

SCHROYER, Robert McLelland
American 1907–
H

SCHUBEL
German early 20c.
B?,GMC

Schubel

SCHUBERT, August
Austrian 1844–
B,LEX,TB

SCHUBERT, Heinz
German 1913–
G

SCHUBERT, Johann David
German 1761–1822
B,H

SCHUBERT, Marie
American 20c.
M

SCHUCKER, James W.
American 1903–
H,IL,M

Schucker

SCHUFINSKY, Victor
Austrian 1876–
B,CP,MM,POS,TB

SCHUITEMA, G. Paul H.
Dutch 1897–
POS

SCHULER, (Jules) Théophile
French 1821–78
B,H,TB

Théophile Schuler.

SCHULLER, Jack Valentine
American 1912–
H

SCHULLERUS, Trude
Rumanian 1889–
LEX,VO

SCHULMEISTER, Willibald
German 1851–1909
B,LEX,TB

W.SCH.

SCHULPIG, Karl
German 1884–1948
POS,VO

S

SCHULT, Johann
German 1889–
B,TB

J.S.

SCHULTHEISS, Carl Max
German/American 1885–
B,H,TB

CM S

SCHULTHESS, Emil
Swiss mid 20c.
GR61/62

SCHULTZ, Albert B.
American –1913
M

SCHULTZ, Gerhard C.
German 1915–
LEX,VO

SCHULTZ, Harry
German 1874–
B,F,LEX,TB

h.G.

SCHULTZ, Monica
Swedish late 20c.
E179

Monica Schultz

SCHULT(Z)-WETTEL, Ferdinand
Alsace 1872–
B

Ferdinand Schultz-Wettel

SCHULTZE-BLANK, Fritz
German 1874–
B

SCHULZ, E.
Danish mid 20c.
GR54

SCHULZ, Fritz
German 19/20c.
LEX

SCHULZ, Günther Ferdinand Robert
German 1909–
LEX

SCHULZ, Wilhelm
German 1865–1952
B,TB,VO

S.

SCHULZ-NEUDAMM
German early 20c.
CP

SCHULZE-FORSTER, Hans
German mid 20c.
LEX

SCHUMACHER, Philipp
Austrian 1866–
B

SCHUMWAY, Henry C.
American 1807–84
B,H,M

SCHUPP
Swiss 19/20c.
POS

SCHURCH, Paul
Swiss 1886–
B

SCHURIG, Karl Wilhelm
German 1818–74
B,H

SCHURMANN, Maximilian
Yugoslavian 1890–1960
H

SCHURR, Claude
French 1921–
B,H'

SCHUSSELE-SOMMEVILLE, Christian
Alsace/American 1824–79
B,F,H,I

SCHUSTER, Karl
Austrian 1871–
B

SCHUSTER, Rudolf Heinrich
German 1848–1902
B,TB

RS

SCHUYLER, Remington
American 1884?–1955
CEN12/09,F,H

REMINGTON·SCHUYLER·

SCHWAB, Marcel
Swedish early 20c.
POS

SCHWABE, Carlos (Charles)
Swiss 1866-1926
B,CP,POS,TB

CARLOZ SCHWABE

SCHWABE, Randolph
English 1885-1948
B,M

SCHWAIGER, Hans
Bohemian 1854-1912
B,H,LEX,TB

H.S.

SCHWALLIE, Leonie Cushnie
American 20c.
M

SCHWARTKOFF, Earl C.
American 1888-
F

SCHWARTZ, Daniel
American 1929-
F,GR68,H,IL,Y

D Schwartz

SCHWARTZ, Hans
see
SCHWARZ, Hans

SCHWARTZ, Manfred
Polisah/American 1909-70
B,F,H,M

SCHWARTZMAN, Arnold
English mid 20c.
GR61-65

SCHWARZ, Felix Conrad
American 1906-
H,M

SCHWARZ, Hans
English mid 20c.
GR54-55-58

H.Schwarz

SCHWARZ, Helmut
German 1891-
LEX

SCHWARZ, Kurt
German/Austrian 1916-
GR54-56,H,POS

KURT SCHWARZ

SCWARZ, Walter
Austrian mid 20c.
LEX

SCHWARZ, William Tefft
American 1889-
F,H

SCHWARZBURG, Nathaniel
American 1896-
H,M

SCHWARZER, M.
German 19/20c.
POS

SCHWATZEK, Bruno Georg
Austrian 1908-
LEX

SCHWEGERLE, Hans
German 1882-
B,TB

SCHWEINFURTH, J. A.
American 19/20c.
R

J·A·SCHWEINFVRTH·

SCHWEINSBURG, Roland Arthur
American 1898-
H

SCHWEISS, Hans
German 1924-
GR54-59-61-63-64,H

Schweiss

SCHWEITZER, Iris
English mid 20c.
GR60

SCHWEITZER, J.
German late 19c.
LEX

SCHWEITZER, Wilfried
Austrian 1884-
B,LEX

SCHWEMMER, Fr. Rudolf
German early 20c.
LEX

SCHWIEDER, Arthur L.
American 1884-
F,H,M

SCHWIMMER, (Prof.) Eva
German 1901-
G

SCHWIMMER, (Prof.) Max
German 1895-
B,G

SCHWIND, Mortiz Ludwig von
Austrian 1804-71
B,DA,EC,H,TB

SCHWINN, Barbara E.
American 1907-
H,IL

SCHWITTERS, Kurt (Merz)
German 1887-1948
APP,B,CP,DA,DRA,H,PC,POS

SCHWÖRER (Schwoerer), Friedrich
German 1870-
B

SCHYE, Mildred Ruth
American 1901-
H,M

SCIAVARRELLO, Nunzio
Italian 1918-
H

SCIBETTA, Angelo Charles
Italian/American 1904-
H,M

SCIBILIA, Dominic
American late 20c.
GR82

SCIBOS, Charles
Swiss mid 20c.
GR61

SCLATER, G. T.
English 20c.
M

SCOLAMIERO, Peter
American 1916-
H

SCORDIA, Antonio (Francisco?)
Italian/Argentinian? 1918?-
B,GR53-58,H?

SCOTSON-CLARK, G. Frederick
English 19/20c.
CEN10/09,CP,R,SO

SCOTT, A. O.
American 20c.
M

SCOTT, Charles Hepburn
Canadian 1886-1964
H,M

SCOTT, Clyde Eugene
American 1884-1959
H

SCOTT, Georges
French 1873-1943
B,POST

SCOTT, H.
Canadian ac. 1880
H

SCOTT, Harold Winfield
American 1898–
H,M

SCOTT, Henri Louis
French 1846–84
B,LEX,TB

SCOTT, Howard
American 1902–
CP,FOR,H,IL

HOWARD
SCOTT

SCOTT, James Powell
American 1909–
H,M

SCOTT, John
American 1907–
AA,CON,H,IL

SCOTT, Julian
American 1846–1901
B,BAA,CWA,F,H,I,M

SCOTT, Lloyd Edward William
Canadian 1911–
H,M

SCOTT, Patrick
Irish mid 20c.
B,GR58–60

SCOTT, Ralph C.
Canadian/American 1896–
F,H,M

SCOTT, Sandra Lynn
American 1943–
CON

SCOTT, Septimus
English early 20c.
POST

SCOTT, William Edouard
American 1884–
B,F,H,M

SCOTT, William J.
Scottish/American 1879–1940
F,M

SCOTTI, Josef
German 19/20c.
LEX

SCOVEL-SHINN, Florence
see
SHINN, Florence Scovel

SCRANTON, H. H.
Canadian ac. 1872–
H

SCRUGGS, Margaret Ann
American 1892–
B,F,H,M

SCRUGGS-CARRUTH, Margaret Ann
see
SCRUGGS, Margaret Ann

SEABORN, Bert Dail
American 1931–
CON,H

SEAMES, Clarann
American 20c.
H

SEARLE, J. (Jan) L.
American 1938–
CON

SEARLE, Ronald
English 1920–
ADV,B,CC,GMC,GR52-68-82,H,PG,VO

SEATON, Walter Wallace
American 1895–
H,M

SEAVEY, Julien Ruggles
Canadian 1857–1940
H,M

SEAWELL, Henry Washington
American 20c.
B,F,M

SEBASTIANO, Roberto
Belgian? 20c.
GMC

SEBASTIAO, R.
Portuguese mid 20c.
GR57

SEBESTYEN, Josef
Austrian early 20c.
LEX

SEBILLE, Albert
French ac. early 20c.
B,POS

SEBOLDT, Otto Friedrich Wilhelm
German 1873–
B

SEBREE, Charles
American 1914–
H,M

SECANE, Luis
Argentinian 1915–
B

SECHE (SECHEHAYE), Joseph
German 1880–1948
POS

SECKAR, Alvena Vajda (Bunin)
American 1916–
H

SEDIVY, Franz Maria
Danish 1864–
B

SEDLACEK, Franz
Austrian 1891–
B,LEX,TB

SEDLACEK, Rudolf
Austrian ac. early 20c.
LEX

SEELAND, Marianne
Austrian early 20c.
LEX

SEELDRAYERS, Emile
Belgian 1847–1933
B

SEELEY, A. Duby
American 1950?–
C

SEELOS, Ignaz
Austrian 1827–1902
B,LEX,TB

SEEWALD, (Prof.) Richard
German 1889–
B,G,S

SEFTON, Anne H.
American early 20c.
ADV,GMC

SEGAN, Kenneth Akiba
American 1950–
AA

SEGAUD, Armand Jean Baptiste
French 1875–
B

SEGAWA, Yasuo
Japanese 1932–
GR62,H

SEGRELLES, José
Spanish 1885–
B,M

SEGUELA, Jacques
 French 20c.
 POS

SEGUIN, (Fortuné) Armand
 French 1869-1903
 AN,B,H

A ?eguin (handwritten signature)

SEGUIN, (Jean Alfred) Gerard
 French 1805-75
 B

SEGUSO, Armand
 American 20c.
 H,M

SEHRING, Harry
 American mid 20c.
 GR63-64-65

h. sehring (handwritten signature)

SEI
 see
 TAIZAN

SEIBERTZ, Engelbert
 German 1813-1905
 B,TB

SEIDAT, Irma
 German mid 20c.
 GR59-62-65

SEIDEN, Arthur (Art)
 American 1923-
 F,GR55-56,H,Y

SEIDL, Rudolfine
 Austrian mid 20c.
 LEX

SEIDMANN-FREUD, Tom
 German 20c.
 LEX

SEIELSTAD, Benjamin Goodwin
 American 1886-
 H

SEIEL STAD (boxed logo/mark)

SEIERS, Helmuts Jāṇa
 Latvian 1928-
 LATV

SEIGEN
 see
 TAIZAN

SEIGNER, Fritz
 Swiss mid 20c.
 GR52-55-59-62-64

SEIHŌ, Takeuchi Seiho
 Japanese 1864-1942
 B,H,J

SEIJU
 see
 HYAKUNEN, Suzuki

SEIKEI
 see
 UNSHO, Ikeda

SEILERN, Stephen (Stefan)
 Dutch mid 20c.
 GR65-66

SEIPP, Alice
 American 1889-
 B,H,I,M

SEITEI
 see
 SHOTEI, Wanatabe

SEITZ, Patricia
 American 20c.
 H

SEITZ, Rudolf von
 German 1842-1910
 B

SEIWL, Josef
 Austrian 1833-1912
 B

SEIPAS, Artur Manuel Rodrigues do Cruzeiro
Portuguese 1920–
H

SEKEY, Susanne
American mid 20c.
GR53

SELCUK
see
DEMIREL, Selcuk

SELDEN, Dixie
American –1936
F,H,M

SELIG, Sylvie
American 20c.
H

SELIGER, Hans Karl
German 1870–
B,LEX,TB

SELIGMANN, Adalbert Franz
Austrian 1862–
B

SELIGMANN, Kurt
Swiss/American 1900–61/62
APP,B,H,M

SELKIRK, Thomas Douglas
Scottish 1771–1820
H

SELKOVS, Vasilijs Jāņa
Latvian 1923–
LATV

SELL, Christian
German 1831–83
B,H,M

SELLARS, Joseph
American late 20c.
GR82

SELLBERG-WELAMSON, Greta
Swedish ac. early 20c.
LEX

SELLIER, P.
French ac. late 19c.
LEX

SELOFT, V.
Danish early 20c.
LEX

SELOUS, Henry C.
see
SLOUS, Henry C.

SELTZER, Isadore
American 1930–
F,GR59-61-63-67,POS,Y

SELWAY, Martina
English mid 20c.
GR64-66

SELWYN, Paul
American 1950–
C

SEM (GOURSAT, Georges)
French 1863–1934
B,POS,POST

SEMBERS, Josef
Austrian 1794–1866
B

SEMEGHINI, Defendi
Italian 1852–91
B,H

SEMIAN, Ervin
Yugoslavian/Czechoslovakian 1921–65
B,H

SEMMLER, Ernst
German 1888–
LEX

SEMPÉ, Jean Jacques
 French 1932–
 EC,GR85

[signature: Sempé]

SEMYOROV
 Russian early 20c.
 POS

SEN, Kalyan
 Indian mid 20c.
 POS

SENDAK, Maurice Bernard
 American 1928–
 H

SENDELL, Moyan
 English late 20c.
 EI79

SENECA, Frederico
 Italian 20c.
 AD,POS

[signature: Seneca]

SENECAL, Ralph L.
 Canadian/American 1883–
 F,M

SENGER, Rita
 American early 20c.
 VC

SENGER, Ruth
 American early 20c.
 GMC

SENN, Johannes
 Swiss 1780–1861
 B

SENNEP
 see
 PENNES, Jean Jacques Charles

SENNETT, William
 Canadian 20c.
 M

SENTARO, Iwata
 Japanese mid 20c.
 GMC

[signature: Sentaro]

SEOANE, Luis
 Argentinian 1910–
 GR55-56-59,H

SEON, Alexandre
 French 1855–1917
 B

SEPO (Pozzati Severo)
 Italian 1895–
 GR55-57,POS,POST

[signature: Sepo 53–]

SEPP, Frank
 German 1889–
 POST

SEREDY, Kate
 Hungarian/American 20c.
 H,M

SERNY
 see
 YSERN, R. S.

SEROV, Valentin Aleksandrovich
 Russian 1865–1911
 M,RS

SERRA (Y AUGUE), Enrique (Enrico)
 Spanish/Italian? 1859/60?–1918
 B,H,M

SERRES, Raoul Jean
 French ac. 1898–1906
 B,M

SERTIĆ, Zdenko
 Yugoslavian mid 20c.
 LEX

SÉRUSIER, Paul
 French 1864–1927
 AN,B,DA,H,M

[signature: P Sérusier]

SESSLER, Robert
Swiss mid 20c.
GR52-57

SETON, Ernest Thompson
Anglo/American 1860-1946
B,F,H,I,LHJ4/05,M,SCR2/02 and 4/06,TB

E. T. Seton

SETON-KARR, Keywood Walter
Canadian 1860-1938
H,M

SETTAN
Japanese 1778-1843
B,H

SETTANNI, Luigi
American 1908-
H

SETTEI
Japanese 1710-86
B,H

SETTEN
Japanese 1735-90
H

SETTERBERG, Carl George
American 20c.
H

SEVCIK, Karl
American 20c.
M

SEVE, Jacques de
French late 18c.
B,H

SEVERIN, Mark F.
Belgian 1906-
GR52-53-55,H,POS

SEVERIN

SEWELL, Amos
American 1901-
F,FOR,H,IL,Y

AMOS SEWELL

SEWELL, Edward
Canadian 1800-
H

SEWELL, Helen Moore (Marie?)
American 1896-1957
F,H,M

SEWELL, John
English 1926-
GR58-59-64-68,H

SEWELL, William S.
Canadian 1798-1866
H

SEXTON, Frederick Lester
American 1889-
B,F,H,M

SEYDL, Zdenek
Czechoslovakian 1916-
B,GR55-58-59-61-62,H

SEIDL

SEYFERT, Otto
Hungarian 1884-
B

SEYMOUR, Ralph Fletcher
American 1876-
B,H,I,M

SEYMOUR, Robert
English 1800?-36
B,H,M

SEYMOUR-HAYDEN, Francis
English 1818-
B,H,M

SEYMOUR-LUKAS, Marie
English 1921-
LEX,TB

SEZANNE, Augusto
Italian 1856-1935
B,H,LEX,TB

SGOUROS, Thomas
American 1927-
F,Y

SGRILLI, Roberto
Italian 1899?-
B,EC,H

Sgrilli

SHAFER, L. A.
American 1866-1940
B,F,H,HA,PE

L.A. SHAFER

SHAHN, Ben
Lithuanian/American 1898-1969
APP,B,CC,CE,CP,DA,DES,DRAW,EAM,F,
GMC,GR52-53-56-62-68,H,M,PC,PG,POS,
POST,Y

Ben Shahn

SHAMIR, G.
Israeli mid 20c.
GR54-58

SHAMIR, M.
Israeli mid 20c.
GR54-58

SHANAHAN, Ray P.
American 1892-1935
H,M

SHANK, Ilse
American 20c.
M

SHANKS, George
American 20c.
M

SHANKS, Hector
Canadian mid 20c.
GR52

SHANLEY, R. C.
Canadian ac. 1866
H

SHANNON, Charles Hazelwood
English 1863/65-1937
AN,B,H,M

CS

SHANNON, Howard Johnson
American 1876-
B,F,H,HA9/08,I,TB

Howard J. Shannon

SHAPERO, Don
American mid 20c.
GR64

SHAPI, Jack
American 1906-
M

SHAPIRO, Daniel
American 1920-
H

SHAPIRO, Irving
American 1927-
H

SHAPOUR, Parviz
Iranian late 20c.
GR85

SHARE, Henry Pruett
American 1853-1905
B,BAA,I,M

SHARLAND, Philip
English mid 20c.
GR54-56-58-60-61-62-63-64

SHARP, Adrian
Canadian ac. 1862
H

SHARP, Anne
English/American 1843-
EI79,H

SHARP, Everet Hill
American 1907-
F,H

SHARP, Harold
American 1919-
H

SHARP, Joseph Henry
American 1859-1934
B,F,H,I,M

J.H.SHARP, JH SHARP 89

SHARP, Martin
 Australian 20c.
 CP,POST

SHARPE, Christopher
 English mid 20c.
 GR 60-61

SHARPE, James C.
 American 1936-
 F,Y

SHARPE, Jim
 American 194?-
 C

SHARRER, Honoré
 American 1920-
 GR 82

SHAVER, James Robert
 American 1867-1949
 B,CO 6/05,H,M,PE,SCR 5/08

J-R-SHAVER

SHAW, Alan W.
 American 1894-
 H,M

SHAW, Byam John (John Byam Liston)
 English 1872-1919
 B,TB

SHAW, Charles Green
 American 1892-1974
 B,H,M

SHEAPHEARD, F. Newton
 English late 19c.
 LEX

SHEETS, Millard
 American 1907-
 B,F,H,M

SHEFFERS, Peter Winthrop
 American 1893-
 H,M

SHELDON, Charles
 American 20c.
 GMC

Charles Sheldon

SHELDON, Charles Mills
 American 1866-1928
 F,I,M

SHELDON, William Henry
 see
 SHELTON, William Henry

SHELDON-WILLIAMS, Inglis
 Canadian 1870-1940
 H,M

SHELTON, Gilbert Key
 American 1940-
 H

SHELTON, William Henry
 American 1840-1932
 B,BAA,CWA,D,I,M

W.H.SHELTON

SHENTON, Edward
 American 1895-
 H,IL,M

Edward Shenton

SHEP
 see
 SHEPARD, Otis

SHEPARD, Ernest Howard
 English 1879-
 H,M,PUN 6/2/37

E.H.Shepard

SHEPARD, Isabel Benson
 American 1908-
 H,M

SHEPARD, Mary
 American 20c.
 M

SHEPARD, Mary Eleanor
English 1909–
H

SHEPARD, Otis
American early 20c.
POS

SHEPHARD, Arthur
English late 19c.
LEX

SHEPHARD, Ernest H.
English 20c.
LEX

SHEPHERD, Caroline
American 20c.
M

SHEPHERD, Chester George
American 1894–
ADV,F

SHEPHERD, J. Clinton
American 1888–
B,F,H,M

SHEPHERD, James Affleck
English 1867–1900?
B,H,HA,TB

J.A.S.

SHEPHERD, William
Canadian ac. 1884
H

SHEPLER, Dwight Clark
American 1905–
H,M

SHEPPARD, J. Warren
American 1882–
H

SHEPPARD, Warren W.
American 1858–1937
B,BAA,F,H,I,M

WARREN SHEPPARD

SHEPPARD, William (Ludlow (Ludwell?))
American 1833–1912
B,CWA,D,H,I,TB

W. L. Sheppard

SHEPPARD-DALE, H.
English ac. late 19c.
LEX

SHEPPERSON, Claude Allin
English 1867–1921
B,BK,H,SCR5/01

Shepperson

SHERBOURNE, R.
English mid 20c.
GR54–56

SHERIDAN, Frank J., Jr.
American early 20c.
F,H,M

SHERIDAN, John E.
American 1880–1948
F,H,IL,M

Sheridan

SHERIDAN, Max
American 20c.
H

SHERINGHAM, George
English 1884–1937
ADV,B,H,M

SHERMAN, Irving Joseph
American 1917–
H,M

SHERMAN, James Russell
American 1907–
H,M

SHERMAN, Theresa (Veronica Reed)
American 1916–
H

SHERMUND, Barbara
American 1910?–78
EC,H,M

B. Shermund

SHERWOOD, G. S.
English 20c.
M,PUN6/2/37

G. S. SHERWOOD

SHERWOOD, Mary C.
American 1868–1943
B,F,H,M

SHERWOOD, Rosina Emmett
American 1854–1948
B,F,H,I,M

SHETYE, V. V.
Indian mid 20c.
GR63-64-65

SHIELDS, Charles
American 1944–
F,Y

SHIELDS, Francis Bernard
American 1908–
H,M

SHIELDS, Frederic James
English 1833–1911
B,H,M

SHIFFER, J. Bernard Van Rossum
American 20c.
M

SHIGENOBU
Japanese ac. 1770–80
H

SHIGENOBU II
Japanese ac. 1820
H

SHIGEO, Fukuda
Japanese mid 20c.
GR66,PG

SHIGERU, Miwa
Japanese 20c.
CP

SHIGERU, Nishimoto
Japanese 20c.
LEX

SHIGESADA
Japanese ac. 1830
B

SHIH-FA, Cheng
Chinese 1921–
H

SHIKO
see
HYAKUNEN, Suzuki

SHILLSTONE, Arthur
American late 20c.
GR52

SHIMIN, Symeon
Russian/American 1902–
H,M

SHIMIZU, Tadaschi
Japanese mid 20c.
GR52-57

SHIMON, Paul
American 20c.
H

SHINN, Everett
American 1876–1953
B,EAM,F,GMC,H,I,IL,M,Y

EVERETT SHINN
1916

SHINN, Florence Scovel
American 1869–1940
F,H,HA10/04,I,M,SCR11/02,Y

Florence Scovel Shinn —

SHIPMAN, A.
American mid 20c.
GR54

SHIPPEN, Green
see
Elliot, Elisabeth Shippen Green

SHIRK, Jeannette Campbell
American 1898–
B,H,M

SHIRLAW, Walter
Scottish/American 1838-1909
B,BAA,F,H,SCR9/88,TB

SHIVELY, Paul
American 1897-
H,M

SHLEEKT, G.
French/German early 20c.
GMC

SHMIT, E. Boyd
American 19/20c.
LEX

SHMITH, J. Frederick
American 20c.
LEX

SHŌ-IN
see
TESSAI, Tomioka

SHOEMAKER, Edna Cooke
American 1891-
F,H,M

SHOESMITH, Kenneth
English early 20c.
M,POS

SHOHO, Suga
Japanese ac. 1810
B

SHON, Alma
American mid 20c.
GR54

SHONEN
see
TAIZAN

SHOOFLY
see
SHUFELT, Robert

SHOPE, Irvin "Shortly"
American 1900-77
H,M

SHOPPE, Palmer
American 20c.
M

SHOR, Sara
Russian/English 20c.
M

SHORE, Robert
American 1924-
GR58,F,H,IL,Y

SHOREY, George H.
American 1870-1944
B,F,H,M

SHOTEI, Wanatabe
Japanese 1851-
J

SHOTWELL, Frederic Volpey
American 1907-29
F,M

SHOVER, Edna Mann
American 1855-
B,F,H,M

SHRADER, Edwin Roscoe
American 1879-1960
B,F,H,HA,I,SCR5/12,TB

SHRAMM, Paul H.
German/American 1867-
F

SHTERENBERG, David Petrovich
Russian 1881-1948
RS

SHUFELT, Robert
American 1935-
CON

SHULA-DYCKE, Ignatz
Bohemian/American 1900-
M

SHULEVITZ, Uri
Polish/American 1935–
H

SHULL, James Marion
American 1872–1950
F,H,M

SHUMBOKU (SHUNBOKU)
Japanese 1680–1763
H

SHUNGYOSAI
Japanese 1760?–1823
B,H

SHUNKYO
Japanese early 19c.
B,H

SHUNSEN
Japanese 1762–1830?
H

SHURTLEFF, Harold R.
American 20c.
LEX

SHURTLEFF, Roswell Morse
American 1838–1915
B,BAA,F,H,I,M

SHUSTER, William Howard
American 1893–1969
B,F,H

SHUTTS, Roland V.
American 20c.
M

SIBAL, Joseph
Austrian/American 20c.
H

SIBELLATO, Ercole (Eres)
Italian 1881–
B,H

SIBERELL, Anne Hicks
American 20c.
H

SIBLEY, Don
American 1922–
H

SIBRA, Paul Marie
French 1889–
B,LEX

SICHART, J. F.
German early 20c.
LEX

SICHEL, Harold M.
American 1881–
H,M

SICKELS, Noel Douglas
American 1911–
F,H,IL,Y

SIDJAKOV, Nicolas
Latvian/American 1924–
GR60–66–68–85,H

SIDNER, R.
Israeli mid 20c.
GR52

SIEBEL, Fred
American mid 20c.
ADV

SIEBEN, Gottfried
Austrian 1856–
B,TB

SIEBERATH, Alois
German ac. early 20c.
LEX

SIECK, Rudolf
German 1877–1957
B,LEX,TB,VO

SIEFFERT, Paul
French 1874–
B,M

SIEGEL, Anita
American late 20c.
GR82

SIEGEL, Dink
American 1915–
F,Y

SIEGEL, Leo Dink
 American 1910–
 H

SIEGEL, William
 Estonian/American 1905–
 M

SIEGERT, Eugen
 German 1856–1906
 B,LEX,TB

SIEGHART, Johann Simeon Benjamin
 German 18/19c.
 B

SIEGL, Karl Ritter von
 Austrian 1842–1900
 B,LEX,TB

SIEGMUND, Rudolph
 German 1881–
 B

SIEMASZKOWA, Olga
 Polish 1914–
 B,GR54–57,VO

SIEMASZKO–

SIESTRZENCEWICZ, Stanislav
 Polish 1869–1927
 B

SIEVERS, H. H.
 German 20c.
 LEX

SIGG, Alfred (Fredy)
 Swiss mid 20c.
 GR57–60–63–66–67–85

F.SIGG

SIGG, Walter
 Swiss mid 20c.
 GR54–56–57–60

SIGNAC, Paul
 French 1863–1934/35
 AN,B,DA,DES,DRA,EAM,GMC,H,M,PC

P. Signac
1930

SIGNORINI, Oscar
 Italian mid 20c.
 GR52

SIGNORINI, Telemaco
 Italian 1835–1901
 AN,B,H,LEX,TB

Signorini

SIGRIST, Karl
 German 1885–
 POS

K.S.

SILAS
 see
 McCAY, Winsor

SILBER, Esther (Reed)
 American 1900–
 H,M

SILBER, Maurice
 American 1922–
 H

SILVA, Abilio Leal de Matos e
 Portuguese 1908–
 H

SILVA, Antonio Santiago Goncalves Areal e
 Portuguese 1934–
 H

SILVA, Caetano Alberto da
 Portuguese 1843–1924
 H

SILVA, João Ribeiro Christino da
 Portuguese 1858–1947
 H

SILVA, José de Almeida e
 Portuguese 1864–1945
 H

SILVA, Mario de Campos Pimental da
 Portuguese 1929–
 H

SILVER, Michael
 American 20c.
 H

SILVER, Pat
American 1922–
H

SILVER, Rose
American 1902–
F,GMC,M

SILVER

SILVERMAN, Burton Philip
American 1928–
F,H,Y

Silverman

SILVERMAN, Melvin Frank
American 1931–66
F,H

SILVERSTONE, Marilyn
American mid 20c.
GR58

SIMAK, Lev
Czechoslovakian 1896–
B,H,LEX

lev

SIMARD, Jean
Canadian 1916–
H

SIMARD, Yves
Canadian late 20c.
EI79,H

SIMAS, F. M.
French 19/20c.
LEX

SIMBARI, Niccola
Italian 1927–
B,GR52–53–56,H

Simbari

SIMCOCK, A. M.
American 20c.
M

SIME, Sydney H.
English 20c.
B,M

SIMÉON, Fernand
French 1884–1928
AD,B,S

SIMEON

SIMIL, Alphonse Paul
French 1844–
B,LEX

SIMM, Franz Xavier
Austrian 1853–1918
B,TB

F.S.

SIMMLER, Wilhelm
German 1840–1914?
B

SIMMONDS, William George
English 1876–
B,M

SIMMONS, Albert Dixon
American 20c.
M

SIMOES de FONSECA, Gaston
French 1874–
B

SIMON, Ellen R.
American 1916–
H

SIMON, Erich M.
German 1892–
B

SIMON, Grant Miles
American 1887–
H,M

Grant Simon

SIMON, Howard
American 1902–79
F,H,M,S

SIMON, Jacques Roger
French 1875-1945
B,M

SIMON, Pavel
Czechoslovakian 1913-
LEX

SIMON, Pierre
French 20c.
LEX

SIMONEAU, Everett Hubert
American 1922-
H

SIMONET, Sebastian
American 1898-1948
F,H

SIMONETTI, Luigi
Italian 1893?-
H

SIMONS, Armory Coffin
American 1869-
B,F,H,M

SIMONT, J.
French early 20c.
LEX

SIMONT, Joseph
American 20c.
F,H,M

SIMONT, Marc
American 1915-
H,M

SIMPKIN, Alfred N.
American 20c.
M

SIMPKINS, Henry John
Canadian/American 1906-
H,M

H. Simpkins

SIMPSON, Charles Walter
English 1885-1971
B,H,TB

C.S.

SIMPSON, J. W.
English 19/20c.
POS

SIMPSON, Joseph
English 1879-
B,M

SIMPSON, William
English 1823-99
B,GMC,H,M

SIMS, Charles
English 1873-1928
B,H,M,POST

SimS

SINAIKO, Suzanne Fischer
Belgian/American 1918-
H

SINDELAR, Thomas A.
American 1867-
F,M

SINDING, Otto Ludvig
Norwegian 1842-1909
B,H,POS

SINÉ, Maurice
French 1928-
EC,GR54-59-61-62,H

siné

SINEL, Joseph
American 20c.
M

SINET, Maurice
see
SINÉ, Maurice

SINGER, Arthur B.
American 1917-
H

SINGER, Malvin
American 1911-
H

SINGLETON, Henry
English 1766-1839
B,H,M

SINKWITZ-EBERSBACH, Paul
 German 1899–
 LEX

SINNET, Stan D.
 American 1925–
 CON

SINOPICO, Primo
 Italiam 1889–1949
 B,H,POS

SINYUKAEVA, L.
 Russian 20c.
 PG

SIPORIN, Mitchell
 American 1910–76
 B,H,M

SIPOS, Béla
 Hungarian 1888–
 B

SIRATO, Francisco
 Rumanian 1877–
 B

SIRIO, Alejandro
 Spanish/Argentinian 1890–1953
 EC,H

SIRK, Albert
 Italian 1887–
 B

SIRONI, Mario
 Italian 1885–1961
 B,DES,H,POS,TB,VO

Sironi

SIS, Peter
 American late 20c.
 GR85

SISSA, Valeria
 Italian mid 20c.
 GR58

SIVKO, Vaclav
 Czechoslovakian mid 20c.
 LEX

SKAWONIUS
 Swedish 20c.
 CP

SKELLY, Jerr
 American 20c.
 H

SKELTON, Leslie James
 Canadian/American 1848–1929
 B,F,H,I,M

SKEMP, Robert Oliver
 American 1910–
 H,M

SKETCH, Jimmy
 see
 WATHEN, James

SKIDMORE, Lewis Palmer
 American 1877–1955
 B,F,H,M

SKIDMORE, Thornton D.
 American 1884–
 B,F,H,M

SKILES, Jacqueline
 American 1937–
 F,H

SKINNER, Elsa Kells
 American 20c.
 H

SKINNER, Thomas C.
 American 1888–1955
 H

SKOCZLAS, Wladyshaw
 Polish 1883–1934
 B,GMC,M,POS

SKOG, Nils
 Swedish mid 20c.
 GR52

SKOLLE, John
 German/American 1903–
 H,M

SKOOG, Nisse
 Swedish mid 20c.
 GR55

N. SKOOG

SKOOGAARD, Joachim Frederik
 Danish 1856–1933
 B,TB

J.S.

SKOTTSBERG, Lydia
 Swedish 1877–
 LEX,VO

L.S.

SKOVGAARD, Niels
 Danish 1853/58–1938
 H,LEX,TB,VO

SKRENDA, AI
 American 20c.
 M

SKRUBIS, Richards Rodolfa
 Latvian 1928–
 LATV

SKULME, Dzemma Otto
 Latvian 1925–
 LATV

SLABY, Frantisek (Franz)
 Austrian 1863–1919
 B,M

SLACK, Earle B.
 American 1892–
 H

SLACKMAN, Charles B.
 American 1934–
 F,GR65–67–82,P,Y

chas b slackman

SLADE, Adam (Frank)
 English 1875–
 B

SLADE, Anthony
 English 1908–
 B,M

SLAMA
 Austrian early 20c.
 PCS

SLATE, Joseph Frank
 American 1928–
 H

SLATER, Edwin Crowen
 American 1884–
 B,F,H,M

SLATTERY, W. G. (Bill)
 American 1929–
 GR56–57–59–60–62,H

Slattery

SLAVICEK, Antonin II
 Czechoslovakian 1895–
 B

SLAYTON, Ronald Alfred
 American 1910–
 H,M

SLEVOGT, Max Franz Theodor
 German 1868–1932
 AN,B,DA,EC,H,PC,SI,TB

M. Slevogt

SLIWKA
 Polish 20c.
 POS

SLOAN, (James) Blanding
 American 1886–
 F,H,SH6/23

Blanding Sloan

SLOAN, John
 American 1871–1951
 APP,B,DES,EAM,F,GMC,H,I,IL,M,MM,PC,PE,
 R,SO,TB

John Sloan sep. 1928 , JS , JS

–John Sloan–, John Sloan

SLOAN, Richard
 American 1935–
 H

SLOANE, Eric
 American 1910–
 AA,H,SO

SLOANE, Eunice
 American 20c.
 H

SLOANE, Mary Annie
 English late 19c.
 B,H,M

SLOBODKIN, Louis
 American 1903–75
 H

SLOBODKINA, Esphyr
 Russian/American 1914–
 H

SLOCUM, Joseph
 American 1883–
 B,H,I

SLOMAN, Joseph
 American 1883–
 B,F,H

SLOMCZYNSKI, J.
 Polish mid 20c.
 GR57

SLOTT-MÖLLER, Agnes
 Danish 1862–1937
 B,H,SC

SLOUS, Henry Courtney
 English 1811–90
 B,H,LEX,TB

SLUITER, Willy (Jan Willem)
 Dutch 1873–
 B,CP,M,MM,TB

SLUMSTTORMERNE
 Danish 20c.
 POS

SLUYTERS, Jan
 Dutch 1881–1957
 B,GMC,H,M

SMALL, David
 Scottish 1846–1927
 B,H

SMALL, Frank O.
 American 1860–
 LHJ6/94,M

SMALL, William
 English 1843–1929
 B,H,TB

SMALLEY, Janet Livingston
 American 1893–1965
 F,H,M

SMALLFIELD, Frederick
 English 1829–1915
 B,H,LEX,TB

SMARGIASSI, Mario
 Italian late 19c.
 LEX

SMEDLEY, Will Larrymore
 American 1871–1958
 F,H,I,M

SMEDLEY, William Thomas
 American 1858–1920
 B,BAA,F,H,HA,I,IL,PE,TB,Y

SMEERS, Frans?
Flemish 1873–
B,H,POS

SMEREKAR, Hinko (Heinrich)
Yugoslavian 1883–
B

SMETH, Hendrick (Rik de) (Henfi de)
Belgian 1865–1940
B,H

H. De Smeth

SMIDT, Sam
American mid 20c.
GR64–65–66

SMIDTH, Hans Ludvig
Danish 1839–1917
B,H

SMIES, Jakob
Dutch 1764/65–1823/33
B,EC,H

SMILLIE, James David
American 1833–1909
B,BAA,D,F,H,I,M

Smillie 1872

SMIRKE, Robert
English 1752–1845
B,H,M

SMIRKE, Sydney
English 1798–1877
B,H

SMITH, Albert E.
American early 20c.
F,H

SMITH, Albert Talbot
English 1877–
B

SMITH, Alice Ravenel Huger
American 1876–
B,F,H,I,M

Alice R Smith 1896

SMITH, Alvin
American 1933–
H

SMITH, Bissell Phelps
American 1892–
H

SMITH, Cecil Alden
American 1910–
H

SMITH, Charles William
American 1893–
APP,B,F,H,M

SMITH, Dan
American 1865–1934
F,H,IL,M

DAN·SMITH

SMITH, Dan Evans
American 1905–
GR54,H

SMITH, De Cost
American 1864–1939
B,F,H,M

SMITH, Donald
English mid 20c.
GR52–65

SMITH, Doug
American late 20c.
GR82–85

SMITH, Duncan
American 1877–1934
B,F,H,M

SMITH, E. Gordon
Canadian 20c.
H?,M,WS

SMITH, Elmer Boyd
Canadian/American 1860–1943
F,H,I,M,Y

SMITH, Ernest John
American 1919–
GR54,H

SMITH, Francis Berkeley
American 1868-
F,M

SMITH, Francis Hopkinson
American 1838-1915
B,BAA,D,F,H,HA,I,M

SMITH, G. Ralph
American 20c.
H?,M

SMITH, Gean
American 1851-1928
H,M

SMITH, Grace P.
American early 20c.
F

SMITH, Helen M.
American 1917-
H

SMITH, Howard Everett
American 1885-
AMA5/31,B,F,H,HA4/09 and 12/07,I,M

HOWARD SMITH

SMITH, Ismael Mari
see
SMITH-MARI, Ismael

SMITH, J. Cris
American mid 20c.
GR53-54

SMITH, James Calvert
American 20c.
B,F

SMITH, Jeffrey
American late 20c.
GR85

SMITH, Jerome H.
American 1861-1941
BAA,EC,H

SMITH, Jessie Willcox
American 1863-1935
B,F,FM3/25,GMC,H,HA,I,IL,LHJ4/05,M,
SCR12/11,TB,Y

JESSIE WILLCOX SMITH

SMITH, Joseph Anthony
American 1936-
H

SMITH, Laura
American late 20c.
GR85

LAURA SMITH

SMITH, Lawrence Beall
American 1909-
H,M

SMITH, Leland Croft
American 1910-
H,M

SMITH, Lillian Wilhelm
American 20c.
H,M

SMITH, Ludvig August
Danish 1820-1906
B

SMITH, Pamela Coleman
American 1877?-1950?
'American Woman Artist', Avon 1982

SMITH, Patrick Knox
Scottish/American 1907-
H

SMITH, Paul
American 1907–
GR52,H

SMITH, Robert Alan
American 20c.
GR59,H

SMITH, Sam
American 1918–
H

SMITH, Susan Carlton
American 1923–
H

SMITH, W. Harry
Anglo/American 1875–1951
F,H,M

SMITH, W. W.
Canadian ac. 1855
H

SMITH (GRANVILLE-SMITH), Walter Granville
American 1870–
B,F,H,I,MUN7/02,SN2/94

W. Granville-Smith

SMITH, William Arthur
American 1918–
F,H,IL,Y

William A. Smith 1958

SMITH, William Thompson Russell
Scottish/American 1812–96/97
H

SMITH, Winfrid
English early 20c.
LEX

SMITH, Wuanita
American 1886–
B,F,H,I,M

Wuanita Smith

SMITH-MARI, Ismael
Spanish 1886–
B,H

ISMAEL SMITH 1913

SMOCK, Nell S.
American 20c.
M

SMOKLER, Jerry
American mid 20c.
GR65–66–67

SMYTH, Ed
American 1916–
H

SMYTH, Samuel Gordon
American 1891–
H

SMYTHE, M.
English mid 20c.
GR61

SNEAD, Louise Willis
American 19/20c.
F,H

SNEATH, Allen
English mid 20c.
ADV

SNEDEKER, Virginia
American 1909–
H,M

SNELL, Carroll Clifford
American 1893–
H

SNOW, George
English late 20c.
EI79

GEORGE SNOW

SNOWDEN, Chester Dixon
American 1900–
H

SNOWDEN, William Estel Jr.
American 1904–
H,M

SNYDER, Coryden Granger
 American 1879–
 F,H

SNYDER, Harold E.
 American 20c.
 M

SNYDER, Jerome
 American 1916–76
 GR 52–53–55–56–57–63–67,H,Y

Jerome Snyder

SNYDER, Seymour
 American 1897–
 H

SNYDER, W. L. (W. P.)
 American ac. 1870–80
 H

SNYDER, Wesley P.
 American ac. mid 20c.
 Y

SNYDER, William Poinsette
 American 1853– , ac. 1884
 M

SOAVE, Carlo
 Italian 1844–81
 B,H

SOBCZYNSKI, Robert
 Polish mid 20c.
 GR 65

SOBRAL, José Maria Figueiredo
 Portuguese 1926–
 H

SOCCO, Carmen
 Peruvian 20c.
 LEX

SOCHA, John Martin
 American 1913–
 H,M

SODOMA, Frantisek
 Czechoslovakian mid 20c.
 GR 60–61

SÖEBORG, Knud Christian
 Danish 1861–1906
 B

SOERENSEN, Henrik
 Swedish 1882–
 LEX

SOHN, Hedda
 American 20c.
 M

SOIFERTIS, Leonid Vladimirovich
 Russian 1911–
 H

SOJO, Eduardo
 Spanish 1849–
 B

SOKAL, E.
 Austrian 20c.
 LEX

SOKOL, Bill
 Polish/American 1923–
 GR 53–68,H

bill sokol

SOKOLOFF, Pavel Petrovich
 Russian 1826–1905
 B

SOKOLOV, Nikolai Alexandrovich
 Russian/Canadian 1903–
 CP,H

SOLAR, Maria de
 French ac. late 19c.
 LEX

SOLBACH, Alberto
 Swiss mid 20c.
 GR 60–65–66–67

SOLBERT, Ronni G.
 American 1925–
 H

SOLLBERGER, Paul
 Swiss mid 20c.
 GR 55–56–57–59–61

PAUL SOLLBERGER

SOLLOTT, Lillian
 American 1909–
 H

SOLOMKO, Serge de
French early 20c.
B

SOLOMON, Maude Beatrice
American 1896–
F

SOMOMON, Merl
American 20c.
M

SOLON, Léon Victor
Anglo/American 1872–
B,F,H,I,POS,STU1904,TB

SOMM (François Clément Sommier) called Henry
French 1844–1907
B,L

SOMMER, (Miss) A. Evelyn
American 20c.
H,M

SOMMER, Edwin G.
American 1899–
F,H

SOMMER, Hanspeter
Swiss mid 20c.
GR57

SOMMER, Max
German 1902–
LEX,VO

SOMMER, Wilhelm
German 1877–
B

SOMMERSTED, Julie (Jane Nissen)
Danish 1883–1935
B

SOMMESE, Lanny
American late 20c.
GR85

SOMOFF, Constantin Andreievitch
see
SOMOV, Constantin Andreievitch

SOMOGYI, Gustav
Hungarian 1878–
B

SOMOROFF, Ben
American mid 20c.
GR56–59–65

SOMOS, Stefan Valentin (Istvan Balint)
Hungarian 1893–1931
B

SOMOV, Constantin Andreievitch
Russian 1869–1939
AN,B,RS,TB

SONDEREGGER, Jacques Ernest
Swiss 1882–
B,TB

SONDERLAND, Johann Baptist Wilhelm Adolf
German 1805–78
B,BAA,H,TB

SONN, Albert H.
American 1867–1936
B,F,H,M

SONNICHSEN, Yngvar
Norwegian/American 1875–1938
B,F,H,I,M

SONOFF, Constantin Andreievitch
see
SOMOV, Costantin Andreievitch

SONREL, Elisabeth
French 1874–
B,M

SOOY, Louise Pinkney
American 1889–
F,H,M

SOPER, Eileen Alice
English 1905–
H,M

ξaS

SOPHER, Aaron
American 1905–72
H,M

SOPOCKO, Konstanty
Polish 1903–
B

SORBIE, John J.
American mid 20c.
ADV68

SOREL, Edward
American 1929–
ADV,CC,EC,F,GR60–61–64–68–85,H,PG,Y

Edward Sorel

SORENSEN, Henrik Ingvar
Norwegian 1882–1962
B,H,M

SORIANO, Esteban
American 1900–
H

SORIANO-MURILLO, Benito
Spanish 1827–
B

SOTOMAYOR, Antonio
Bolivian/American 1904–
B,H,M

SOTTEK, Frank
American 1874–1939
B,F,H,M

SOTTLOG, F.
French 19/20c.
GMC

F. Sottlob

SOTTUNG, George K.
American 20c.
H

SOUCEK, Karel
Czechoslovakian 1915–
B,H

SOUDEIKINE, Sergéi
Russian/American 1886–1946
B,F,H,M

SOULAS, Louis Joseph
French 1905–1954
AD,B,H,STU1930,TB,VO

LJS LJS

SOULEN, Henry James
American 1888–1965
B,F,H,IL,M,Y

H.J. Soulen

SOURIAU, Jacques
French 20c.
LEX

SOUSA, João Manuel Rocha e
Portuguese 1938–
H

SOUSA, Pinto José Julio de
French 1855/56–1939
H,LEX,VO

SP

SOUTHALL, Joseph Edward
English 1861–1944
B,H,STU1926,TB

SOUTHCOTT, William Frederiks
English 1874–
B

SOUTHWICK, Katherine
American 1887–
B,F,H,M

SOUTHWICK, W. Hammersley
American 1894–
H,M

SOUZA, Alberto Augusto de
　　Portuguese 1880-1961
　　H

SOUZA, Maria Sophia Martins de
　　Portuguese 1870-1960
　　H

SOUZA-CARDOSO, Amadeu Ferreira de
　　Portuguese 1887-1918
　　B,H

SOWERS, Miriam R.
　　American 1922-
　　H

SOWERSBY, Amy Millicent
　　English 20c.
　　M

SOWINSKI, Stanislaus Joseph
　　American 1927-
　　H

SOYKA, Ed
　　American late 20c.
　　GR85

SPAAR, William Jr.
　　American 1896-
　　H,M

SPACAL, Luigi
　　Italian 1907-
　　GR53,H

SPACIL, Oskar
　　Czechoslovakian mid 20c.
　　GR52-54-55-56

SPADER, William Edgar
　　American 1875?-
　　F,H,M

SPAGNOLO, Kathleen Mary
　　American 1919-
　　H

SPAHR, (Jüsp) Jürg
　　Swiss 1925-
　　EC,GR56-57-61-63-65-66-68-71-72-76-78-81-85,
　　VO

SPALENKA, Greg
　　American 1958-
　　AA

SPANFELLER, James John
　　American 1930-
　　F,GR67-82,P,Y

SPANGENBERG, Gustav-Adolf
　　German 1828-91
　　B,H,LEX,TB

SPANIER, Käthe
　　German early 20c.
　　LEX

SPARE, Austin Osman
　　English 1888-
　　B

SPARK (SPARKS), Joseph
　　American 1896-
　　F,H,M

SPARKS, H. L.
　　American early 20c.
　　F

SPARKS, Richard
　　American 1945?-
　　C

SPARKS, Willi
　　American 1862-1937
　　B,F,H,M

SPARKS, William F.
　　American ac. 1881
　　H

SPARKES, Catherine Adelaide (Edwards)
　　English 1842-
　　B,H

SPARLING, John Edmond
　　Canadian/American 1916-
　　H

SPAULDING, Florence Louise
American 1899–
H,M

SPAULDING, Warren Dan
American 1916–
H,M

SPAVENTA, Filippi Leo
Italian 1912–
H

SPAZZAPAN, Lojze (Luigi)
Italian 1889/90–1958
B,DES,H

SPEAKMAN, Anna Weatherby Parry
American –1937
F,LHJ7/06,M

SPEAKMAN, Harold
American 1888–
I

SPEAR, Frank
American early 20c.
POS

SPEAR, Fred
American early 20c.
CP,POST

Fred Spear

SPEARS, Ethel
American 1903–
H

SPECHT, August
German 1849–
B

A.S.

SPECHT, Friedrich
German 1839–1909
B

SPECKTER, Hans
German 1848–88
B

SPECKTER, Otto
German 1807–71
B,H,M,TB

SPEED, Lancelot
English 1860–1931
EC,H

SPEENHOFF, J. H.
Dutch 1869–
B

SPEER, Terry
American late 20c.
GR85

SPENCE, Percy F. S.
Australian 1868–1933
B,M

SPENCER, Guy Raymond
American 1878–
B,M

SPENCER, Herbert
English 1924–
GR52–58,H

SPENCER, Hugh
American 1887–1975
B,F,H,M

SPENCER, Jim-Edd
American 1905–
H,M

SPENCER, Meade Ashley
American 1896–
H,M

SPENCER, W. Clyde
American 1864–1915
B,M

SPERRY, Armstrong
American 20c.
M

SPEYER, Christian
German 1855–1929
B,LEX,TB

SPICER-SIM(P)SON, Theodore
 Franco/American 1871–1959
 B,F,H,TB

T·S·S·

SPIEGEL, Doris
 American 1901/1907–
 H,M

SPIEGEL, Ferdinand
 German early 20c.
 B,GMC,GWA

FERDINAND SPIEGEL·07

SPIER, Peter Edward
 Dutch/American 1927–
 H

SPIERER, William McK.
 American 1913–
 H

SPIERINC, (SPIRINC), Clay Nicolas
 Flemish 15c.
 B,H

SPIESS, August
 German 1841–1923
 B,TB

af

SPIESS, Heinrich
 German 1831/32–75
 B,H

SPIGAI, Max
 Italian 1923–
 GR55–57–59–60–61–62,H

Spigai

SPIKIC, Tomaslav
 Italian late 20c.
 GR85

SPINDLER, Louis Pierre
 French 1800–89
 B

SPIRO, Eugene
 American 1874–1972
 B,H

SPITZER, Emmanuel
 German 1844/45–1919
 B,H

SPITZER, Grete
 Austrian 20c.
 LEX

SPITZER, Walter
 Polish 1927–
 B

SPITZMILLER, Walter
 American 1944–
 F,Y

SPITZWEG, Carl (Karl)
 German 1808–85
 B,BAA,EC,H,TB

Spitzweg

SPIVAK, H. David
 American 1893–1932
 H

SPOFFARD, Edward V.
 American 1895–1940
 M

SPOHN, Clay Edgar
 American 1898–1977
 H,M

SPOHN, Hans-Jürgen
 German mid 20c.
 GR65–66–68

SPOLLEN, Chris John
 American 1952–
 F,Y

SPORER, Eugen Otto
 German 1920–
 G,GR58–59–60

Es

SPORRER (SPORER), Philipp
 German 1829–99
 B

SPRADBER(R)Y, Walter Ernest
English 1899-
B,POST,M

SPRAGUE, Howard F.
American -1899
B,CEN12/98 and 1/99 and 5/99,TB

HFSPRAGUE.

SPRAGUE, Isaac
American 1811-95
H

SPRAGUE, Ken
English 20c.
PG

SPRAGUE, (Marjorie) Reynold
American 1914-
H,M

SPRATT, Alberti (Lamb)
American 1893-
H,M

SPRETER, Roy Frederic
American 1899-
H,IL,M

Spreter

SPRINGER, Charles Henry
American 1857-1920
B,I,M

SPRINGER, Ferdinand
German 1907/08-
B,H,M

SPULER, Erwin
German 1906-
B,GR55,TB

SPULER

SPURRIER, Steven
English 1878-1961
B,M,TB

S.S.

SQUIER, Donald Gordon
American 1895-
H,M

SQUIRE, Dorothea (Cram)
American 1901-
H

SQUIRE, Maud Hunt
American 1873-
APP,B,F,H,I,M

SQUIRES, C. Clyde
American 1883-1970
F,H,HA6/07 and 9/07,M,Y

C.ClydeSquires

STAAL, Pierre Gustav Eugene
French 1817-82
B,H,LEX,TB

G.ST.

STAB, Raymond
French 20c.
B

STABENAU, Friedrich
Polish/German 1900-
LEX,VO

STABIN, Howard
American late 20c.
GR52

STACEY, Lynn Nelson
American 1903-
H,M

STACEY, Walter S.
English 1846-1929
B,H,LEX,TB

W.S.S.

STACHIEWITCH, Pierre (Piotr)
Polish 1858-1938
B

STACHURSKI, J.
Polish mid 20c.
GR57

STACHURSKI, Marian
Polish 1931–
GR56-59-60-61-65,H

STADLER, Karl Maria
German early 20c.
PG

KARL·MARIA·STADLER

STAECK, Klaus
German 1938–
H,POS

STAEGER, Ferdinand
German/Czechoslovakian 1880–
AN,B,LEX,TB

STAEHLE, Albert
German/American 1899–
GMC,H,M

Albert
Staehle

STAËL, Hansi von Holstein
Portuguese 1913-66
H

STAFFORD, Albert
English 1903–
B

STAFFORD, Charles
American 20c.
M

STAEFL, Ottokar
Czechoslovakian early 20c.
CP

STAHL, Benjamin Albert
American 1910–
CON,H,IL,Y

Stahl

STAHL, Friedrich
German 1863–
B,M,TB

F. ST.

STAHL, Louise Zimmerman
American 1920–
H

STAHL-ARPKE, Otto
German early 20c.
CP

STAHL
ARPKE

STAHLEY, Joseph
American 1900?–
H,M

STAHR, Paul C.
American 1883–
F,H,M

STALL, J.
French ac. early 20c.
POS

STALOFF, Edward
American 1893–
H,M

STAMATY, Stanley
American 1916-79
EC,H

STAMM, Mart
Dutch early 20c.
POS

STAMPA, George Loraine
English 1875–
B,PUN6/2/37,TB

G. L. STAMPA

STAN, Walter P.
American 1917–
H,M

STAŃCZYK, Gryegorz
Polish 20c.
GMC

STANDON, Edward Cyril
American 1929–
H

STANEK, Muz
Austrian 20c.
LEX

STANFIELD, William Clarkson
English 1793–1867
B,H,M

STANIFORTH, Joseph Morewood
English 1863–1921
B,LEX,TB

[signature: JMS]

STANILAND, Charles Joseph
English 1838–1916
B,EN,H,TB

[signature: C]STANILAND]

STANISZEWSKI, Walter P.
American 1917–
H

STANKEVIČS, Aleksandrs Jāzepa
Latvian 1932–
LATV

STANKOWSKI, Anton
German 1906–
GR59–60–61–63–65–68,H

[signature/monogram: A over ST]

STANLAWS, Penrhyn
see
ADAMSON, Penrhyn Stanley

STANLEY, Dorothy (TENNANT, Dorothy)
English 1855–1926
B,EN

[monogram]

STANLEY, Frederick
American 20c.
M

STANLEY, Harold John
English 1817–67
B,H

STANLEY, Sidney Walter
English 1890–
B

STANLEY-BROWN, Rudolph
American 1889–
F

STANNY, Jancisz
Polish mid 20c.
GR58–59–65–68

STANSBURY, Arthur J.
American 1781–1845
D,Y

STANTON, Harry Edgar
English 1888–
B

STANTON, Horace Hughes
Anglo/American 1843–1914
B,LEX,TB

[monogram]

STANZIG, Otto
German 1904–
LEX

STAPLEFELDT, Karsten
American 20c.
M

STAPLES, Owen
Canadian 1866–1949
H,M

STARASTE, Margarita Jāna
Latvian 1914–
LATV

STARCE, E.
French ac. early 20c.
LEX

STACKE, Richard
German 1864–
B,TB

[signature: ST]

STAREISHINSKY, A.
Bulgarian 1936–
POST

STARK, Otto
American 1859–1926
B,BAA,F,I,M

STARK, W. R.
Canadian 20c.
M

STARMER
American early 20c.
ADV(pg.54),song sheet cover artist

STARMER

STARONOSSOW, Pyotr
Russian early 20c.
LEX

STAROWIEYSKI, Franciszek
Polish 1930–
CP,GR64,H,POS

F.STAROWIEYSKI

STARR, Lorraine Webster
American 1887–
F,H

STARRETT, Henrietta McCraig
American 20c.
M

STARRETT, Virginia Frances
American 1901–31
M

STASSEN, Franz
German 1869–
AN,B,TB

F.ST.

STASYS
see
EIDRIGEVICIUS, Stasys

STATHIS, Anthony
American mid 20c.
GR54

STAUBER, Carl
German 1815–1902
B,TB

St.

STAUBER, Jules
Swiss/German 1920–
GR52–53

STAUDINGER, Karl
German 1905–
G,H

STAUFFER, Edna Pennypacker
American 1887–1956
F,H,M

STEADHAM, Terry Evan
American 1945–
F,Y

STEADMAN, Ralph
English 1936–
CC,EC,EI79,GR82

Ralph STEADman

STEAGENT, George H.
Canadian ac. 1878
H

STEARNS, Frederic Wainwright
American 1903–
H

STEARNS, Sharon
American 20c.
M

STEBBING, John Noel, Jr.
American 1906–
H,M

STEBBINS, Ronald Stewart
American 1883–
F,H

STECH, David
American 20c.
M

STECHER, William Frederick
American 1864–
H,M

STEDING, Heinrich
German 1910–
LEX

STEDMAN, Wilfred Henry
Anglo/American 1892–1950
H

STEELE, Frederic Dorr
American 1873–1944
CEN2/99 and 12/09,F,H,HA,IL,M,
McC11/04,SCR5/08

Steele

STEELE, Helen McKay
American 19/20c.
H,I,M

STEELE, Ivy Newman
American 1908–
H,M

STEELE, J. W.
American 20c.
M

STEELE, Sandra
American 1938–
H

STEELE, Thomas Sedgwick
American 1845–1903
B,I

STEEN, Katherine E.
American early 20c.
LHJ7/06

STEER, Henry Reynolds
English 1858–1928
B,H,M

STEFFEN, Randy
American 1915–
H

STEFFENSEN, Paul
Danish 1866–1923
B

STEFFERL, Otto
Austrian
LEX

STEGER, Hans Ulrich
Swiss 1923–
GR62,H

STEGLEHNER, Karoly (Karl)
Hungarian 1819–90
B

STEGLICH, Julius
German 1839–1913
B

STEIG, William
American 1907–
ADV,CC,EC,F,GMC,GR52–53,H,M

W. Steig

STEIGER, Harwood
American 1900–
F,H

STEIN, Enrique
Argentinian 1843–1919
EC,H

STEIN, Gerhard
Prussian (German) 1893–
LEX

STEIN, Harve Carl
American 1904–
H,M

H.S.

STEIN, Modest
American 20c.
M

STEIN, Ralph
English late 19c.
LEX

STEIN, Walter
American 1924–
H

STEINBERG, David Michael
American 20c.
M

STEINBERG, Isadore N.
Russian/American 1900–
H,M

STEINBERG, James
 American late 20c.
 GR 82

STEINBERG, Nathaniel P.
 American 1896–
 F,H,M

STEINBERG, Saul
 Rumanian/American 1914–
 ADV,APP,B,CC,GMC,GR52–54–59–61–64–67,
 H,POS,VO

STEINBERG

STEINBRECHT, Alexander
 German 1864–
 B

STEINDL, J.
 Austrian mid 20c.
 LEX

STEINECKE, Walter
 German 1888–
 B,TB

STEINEN, Wilhelm von den
 German 1859–
 B

STEINER, Albe (Alberto?)
 Italian 1913–
 GR55–56–57–65–67,H

STEINER, Bernard
 German ac. early 20c.
 POS,POST

STEINER, Charlotte
 American 20c.
 M

STEINER, Heinrich
 Swiss 1906–
 GR53–54–55–57,H

Steiner

STEINER, Heiri
 Swiss mid 20c.
 GR56–58–59–60–61–63–65–68

STEINER, Jo
 German ac. 1920s
 MM,POS

JOSTEINER

STEINER, Joseph (Josef)
 German/Austrian? 1899–
 B,CP

J.STEINER

STEINER-PRAG, Hugo
 Austrian 1880–
 B

HS

STEINFELS, Melville P.
 American 1910–
 H

STEINHARDT, Jakob
 German/Israeli 20c.
 B,M

STEINKE, Bettina Blair
 American 1913–
 CON,H

Bettina Steinke

STEINKE, William (Bill)
 American 1887–
 F

STEINKRAUSS, Eva
 Austrian early 20c.
 LEX

STEINLEN, Marius
 Swiss 1826–66
 B

STEINLEN, Théophile Alexandre
 Swiss/French 1859–1923
 ADV,AN,B,CP,DES,EC,FO,FS,GA,GMC,H,
 MM,PC,PG,POS,POST,S,SI,TB

Steinlen

STEINLEN, (Théophile) Christian Gottlieb
 Swiss 1779-1847
 B

STEINMETZ, E. M. A.
 American? early 20c.
 VC

STEINWEISS, Alex
 American mid 20c.
 GR55-56-57-66-67

Steinweiss

STELLA, Edward
 Austrian 1884-1955
 B,LEX,TB

STELLA, Frank
 American 1936-
 APP,B,EAM,F,H,POS

STELLA, Guglielmo
 Italian 1828-88
 B,H

STEMLER, Otto Adolph
 American 1872-
 F,I,M

STENBERG Brothers (Georgi and Vladimir)
 Russian early 20c.
 H,POS

STENBERG, Georgi Augustovich
 Russian 1900-33
 H,MM,POS

STENBERG, Vladimir Augustovich
 Russian 1899-1982
 H,MM,POS

STENGEL, Hans
 American 1894-1928
 M

STEPANOVA, Vavvara
 Russian 1894/1900-1958
 B,H,POS

STEPHAN, Elmer A.
 American 1892-1944
 F,H,M

STEPHANI, Gaston
 French 20c.
 B

STEPHANOFF, Francis Philip
 English 1788-1860
 B,H,M

STEPHANOFF, James
 English 1787/88-1874
 B,H,M

STEPHENS, Alice (Barber)
 American 1858-1932
 B,CO7/05,F,GMC,H,HA10/01 and 8/04,I,IL,
 LEX,LHJ4/05,M,PE,TB

STEPHENS, Charles H.
 American 1855-1931
 CWA,F,H,M

STEPHENS, Frank L.
 American 1932-
 H

STEPHENS, Henry Louis
 American 1824-82
 B,BAA,H,I,M,TB

STEPHENS, William D.
 American early 20c.
 HA,LEX

STEPTOE, John
 American 1950-
 H

STERL, Robert Hermann
 German 1867-1932
 B,LEX,TB

STERMER, Dugald Robert
American 1936–
GR66-67-85,H

Dugald Stermer

STERN, Ernst
German 1876–
B

STERN, Jonasz
Polish 1904–
B,H

STERN, S. Tilden
American 1909–
H,M

STERNER, Albert Edward
American 1863–1946
APP,B,CEN2/99,CWA,EC,H,I,IL,
PC,PE,SCR9/93,Y

Albert E. Sterner

STERNGLASS, Arno
German/American 1926–
F,GR60-61-65-66-67,Y

STERRETT, Virginia Frances
see
STARRETT, Virginia Frances

STEUERMANN, Rem
Dutch mid 20c.
LEX

STEVENS, Beatrice
American early 20c.
SCR4/06

STEVENS, Charles K.
American 1877–1934
H,M

STEVENS, Clara Hatch
American 1854–
F,H,M

STEVENS, Edward Dalton
American 1878–1939
F,H,M

STEVENS, Gordon
English mid 20c.
GR52

STEVENS, Gustave Max
Belgian 1871–1946
B,H,MM

G.M. STEVENS

STEVENS, Harry
English mid 20c.
GR56-57-61-66-67,PG,POST

Stevens

STEVENS, Léopold
Belgian 1866–1935
B,H,POS

STEVENS, Lucy Beatrice
American 1876–
M

STEVENS, Mary E.
American 1920–66
H

STEVENS, Richard Clive
American 1917–
H,M

STEVENS, William Ansel, Sr.
American 1919–
H

STEVENS, William Dodge
American 1870–
F,H,HA8/04 and 12/07,M

STEVENS, William Oliver
American 20c.
M

STEVENSON, William Grant
English 1849–1919
B

STEWARDSON, John
American 19/20c.
R

STEWART, Albert T.
American 1900–
F,H,M

STEWART, Allan
English 1865–
B

STEWART, Arvis L.
American 20c.
H

STEWART, Clair
Canadian mid 20c.
GR53

STEWART, Frank Algernon
English 1877–
B,M

STEWART, Le Conte
American 1891–
B,F,H,M

STEWART, William
English 1886–
M

STEWART, William Branks
Scottish/American 1898–
H

STIASSNY, Klothilde
Austrian 19/20c.
LEX

STICHART, Alexander Otto
German 1839–96
B

STICKLAND, Paul
English late 20c.
GR82

STIEFEL, Edvard
Swiss early 20c.
B,POS

STIEGER, Hans
Swiss late 20c.
GR55–61–82

H Stieger

STIEGER, Heinz
Swiss mid 20c.
GR60–62–64 thru 68

Heinz Stieger

STIFTER, Adalbert
Austrian 1805/06–68
B,H,LEX,TB

A.St.

STIG, L.
see
LINDBERG, Stig

ŠTIKA, Karel
Czechoslovakian mid 20c.
LEX

STILLER, Günther
German 1927–
G,GR58–67–68

Stiller

STILLER, Ludwig
German 1872–
B

STILLWELL, Wilber Moore
American 1908–
H,M

STILLWELL-WEBER, Sarah S.
see
WEBER, Sarah S. Stillwell

STIMSON, John Ward
American 1850–1930
B,F,I

J.W.S.

STINSON, Paul
American late 20c.
GR82

STIRNER, Karl
German 1882–
LEX,TB

STIRNWEISS, Shannon
American 1931–
C,CON,F,H,Y

Stirnweiss

STIVERS, Don
 American 1926–
 CON

(signature: Don Stivers)

STIVERS, Harley Ennis
 American 1891–
 F,H,M

STMAD, M. Y.
 American late 20c.
 GR85

STO (pseudonym)
 see
 TOFANO, Sergio

STOAKS, Caroline
 American 1892–
 H

STOBBS, William
 English 1914–
 H

STÖCKE, Alfred
 German 19/20c.
 LEX

STOCKMANN, Hermann
 German 1867–
 B,TB

(signature: H St)

STOCKMARR, Erik
 Danish 1905–63
 GR53,POS,POST,VO

(signature: Stoc)

STOCKTON, Francis Richard
 American 1834–1902
 D

STOCKUM, Hilda von
 American 20c.
 LEX

STODDARD, Frederick Lincoln
 American 1861–1940
 B,H

STOECKLIN, Niklaus
 Swiss 1896–
 B,GR62,H,POS,POST,TB,VO

NST

STOEL, John
 Dutch late 20c.
 GR85

STOISAVLJEVIC, Mileva
 Polish 19/20c.
 AN

STOKES, Frank Wilbert
 American 1858–
 B,F,H,I

STOLK, Anna Joanna van (Hoogewerff)
 Dutch 1853–
 B

STOLL, John Theodore Edward
 German/American 1889–
 F,H,M

STOLL, Rolf
 German/American 1892–
 F,H,M

STOLLER, Helen Rubin
 American 1915–
 H,M

STOLZ, Albert
 Austrian?/Italian 1875–
 LEX,TB

STOLZEN, Jupp
 German 1867–
 LEX

STONE, Alan Reynolds
 English 1909–
 H

STONE, Charlotte
 American 20c.
 M

STONE, David K.
 American 1922–
 F,NV

(signature: DKStone)

STONE, Gil (Gilbert) Leonard
American 1940–
F,GR82,P

STONE, Helen
American 1903/04–
H

STONE, John R.
American mid 20c.
GR54

STONE, Marcus C.
English 1840–1921
B,H,TB

MARCUS STONE.

STONE, Seymour Millais
Polish/American 1877–
B,CO8/05,F,H,M

SEYMOUR M STONE

STONE, Walter King
American 1875–1949
B,F,H,I,M,SCR12/11,TB

WALTER KING STONE

STONER, Harry
American 1880–
B,H,M

STOOPS, Herbert Morton
American 1888–1948
F,H,IL,M,Y

HERBERT MORTON STOOPS

STOP (pseudonym)
see
MOREL-RITZ, Louis Pietre

STOR
see
STOCKMARR, Erik

STORCH, Karl (the elder)
German 1864–1954
B,GWA,VO

K. St.

STOREY, Ross Barron
American 1940–
F,IL,Y

B. Storey

STORM, Mark Kennedy
American 1911–
CON,H

Mark Storm

STORY, Benjamin
American –1927
M

STOTHARD, Thomas
English 1755–1834
B,H,M

STOVER, Allan James
American 1887–
F,H

STOVER, JoAnn
American 20c.
H

STOVER, Wallace
American 1903–
F

STOWELL, M. Louise
American 19/20c.
F,GA,H

STÖWER, Willy
German 1864–1931
B,TB

STRADA
Italian early 20c.
POS

STRAHAN, Alfred Winifield
American 1886–
B,F,H

STRAHTMANN (STRATHMANN), Carl
German 1866–1939
AN,CP

STRAIN, John Paul
American 1955–
CON

STRALTON, S.
English mid 20c.
GR53

STRANG, Ray C.
American 1893–1954/57
H,M

STRANG, William (Will)
Scottish 1859–1921
BK,CEN10/05,GMC,H

STRASSBERGER, Bruno Heinrich
German 1832–1910
B,TB

STRATIL, Karl
German 1894–
B

STRATTO, Alza (Hentschel)
American 1911–
H

STRATTON, Helen
English 19/20c.
BK

STRATTON, Sheila
English mid 20c.
GR54

STRAUB, Irmgard
German early 20c.
LEX

STRAUB, Matt
American late 20c.
GR82

STRAUCHEN, Edmund R.
American 1910–
H

STRAUS, Mitteldorfer
American 1880–
B,F,H

STRAUSS, Carl Summer
American 1873–
B,H,M

STRAUSS, Ethel Wall
American 20c.
M

STRAYER, Paul
American 1885–
H,M

STREAT, Thelma Johnson
American 1912–
H,M

STREET, Betty Joy
see
REEVES, Betty-Joy

STREET, David
American late 20c.
GR85

STREET, Frank
American 1893-1944
B,F,H,IL,M,Y

FRANK
STREET

STREETER, Donald Davis
American 1905-
H,M

STREFFEL
Swiss 19/20c.
POS

STRENG, Karlin
American 20c.
M

STRIEBEL, John Henry
American 1892-
H

J.H.S.

STRIJBOSCH, Wim
Dutch mid 20c.
GR59-60-63

STRIMPL, Ludwik
Czechoslovakian 1880-1937
B,TB

L·S.

STRINGFIELD, Vivian F.
American 19/20c.
F,H,M

STRNADEL, Antonin
Czechoslovakian 1910-
B,H

STROBEL, Max
American ac. 1853
H

STROBEL, Oscar A.
American 1891-1967
H

STROBEL, Tom (Thomas) C.
American 1931-
H,P

STROEDEL, Georg A.
German 1870-
B,TB

STRÖHL, Hugo Gerard
Austrian 1851-1919
B,TB

St

STROHOFER, Hans
Austrian 1885-
B,LEX,TB

h.
S.

STROOBANT, François (Franz)
Belgian 1819-1916
B,H,M,TB

F.STROOBANT

STROTHER, David Hunter
American 1816-88
CC,D,F,M

STROTHER, Sanford
American 20c.
M

STROTHMAN(N), Fred
American 1878/79-1958
F,H,HA9/08,M,ME4/23

Strothmann.

STRUNKE, Niklāvs
Latvian 1894-
B

STRUTZEL, Leopold Otto
German 1855-1930
B,TB

O.Str.

STRYJENSKI, (Mme) Zofia (Sophie)
Polish 1894–
B,POS,TB

Z. S.

STUART, José Herculano Tovrie de
Almeida Carvalhais
Portuguese 1888–1961
EC,H

STVART
1921

STUART, Kenneth James
American 1905–
H,M

STUART, R. James
American 20c.
M

STUBBS, Jesse C.
American
H

STUBBS, Mary Helen
American 1867–
F,H

STUBENRAUCH, Hans
German 1875–
B,TB

Hanstubenrauch

STUBIS, Tālivaldis
Latvian/American 20c.
H

STUCHLIK, Camill
Czechoslovakian 1863–
B

STUCK, Franz
see
VON STUCK, Franz

STUCKART
German early 20c.
B

STUCKI, Alois
Swiss 1854–94
B

STUDYNKA, E.
Austrian early 20c.
LEX

STUFFERS, Anthony
American 1894–1920
I,M

STUIS, Pret
Irish mid 20c.
GR60

STULER-WALDE, Marie
German 1868–1904
B,TB

M. St. W.

STULL, Henry
Canadian/American 1851–1913
B,I,M

Henry Stull

STUMPF, Wilhelm Ludwig Ferdinand
German 1873–
B,LEX

STUMVOLL, Franz
Austrian 20c.
LEX

STURBING, Jennette
Canadian 20c.
M

STURDIK, Jozef
Yugoslavian 20c.
H

STURGE-MORE, Thomas
English 1870–
AN

STURGES, Dwight Case
American 1874–1940
B,F,H

D.C. Sturges

STURGES, Katherine
American 1904-
F,H

K.S.

STURGES, Lillian B.
American 20c.
F,H

STURM, Dorothy
American 20c.
M

STURM, Josef
Austrian 1858-
B,LEX,TB

STURM, Marie
German/Austrian 1854-
B,LEX,TB

M.ST.

STURTEVANT, Edith Louise
American 1888-
F,H

STURTEVANT, Erich
German 1869-
B,TB

E.STURTEVANT

STURTEVANT, Louisa Clark
American 1870-
B,F,H

STURTEVANT, Wallis Hall
American 1891-
H,M

STURTZKOPF, Carl (Charly)
German 1896-
B,LEX,TB

STUTHERS, Percival
American 20c.
M

STUTZ, Ludwig
German 1865-1917
B,CO7/04,TB

L.STUTZ

STUYVAERT, Victor
Belgian 1897-1974
B

STYKA, Adam
Polish/American 1890-1959
B,H

ADAM STYKA

SUARÈS, Jean Claude
Egyptian/American 1942-
CC,F,GR82-85,Y

Suarès

SUBA, Susanne (McCracken)
Hungarian/American 1913-
AA,H,M

SUCHODOLSKI, Sigmund von
German 1875-
LEX,TB

S.

SUGA
see
SHOHO

SUGAI, Kumi
Japanese 1919-
B,GR53-56,H

SUGAKUDO, Shujin
Japanese ac. 1850-60
H,J

SUGAR, Sam
American 20c.
M

SUGARMAN, Tracy
 American 1921–
 IL

[signature: Tracy Sugarman]

SUGAYA, Sadao
 Japanese mid 20c.
 GR62–65–67

SUGIMURA, Jihei
 see
 JIHEI

SUHR, Frederic J.
 American 1885–1941
 B,F,H,M

SUIRE, Louis
 French 1899–
 B

SULLIVAN, Alice Chase
 American 1887–
 H,M

SULLIVAN, Bob (Robert)
 American mid 20c.
 GR57–58–65

[signature: Sullivan]

SULLIVAN, Edmund Joseph
 English 1861–1933
 B,BK,H,M,S

[signature: EDMUND·J·SULLIVAN.]

SULLIVAN, Gene
 American 1900–
 H

SULLIVAN, (Josef) James Frank
 English 1853–1936
 M

[signature: J. F SULLIVAN]

SULLIVAN, Lillie
 American –1903
 I,M

SULLIVANT, Thomas S.
 American 1854–1926
 EC,F,IL,PE,Y

[signature: T-S-Sullivant]

SULPIZIO, George
 American late 20c.
 GR52

SUMICHRASST, Josef
 American 1948–
 F,GR85,Y

SUMM, Helmut
 German/American 1908–
 H,M

SUMMERS, Dudley Gloyne
 American 1892–1975
 F,H,IL,M,Y

[signature: DUDLEY GLOYNE·SUMMERS]

SUMNER, G. Heywood Maunior
 English 1853–1940
 B,H,MM

[signature: HS]

SUNDBLOM, Haddon Hubbard
 American 1899–
 H,IL,M

SUNDGAARD, Erik
 American 1949–
 F,Y

SUNDSTROM, Christine
 Swedish mid 20c.
 GR53

[signature: Sundstrom]

SŪNIŅŠ, Kārlis Hermaņa
 Latvian 1907–
 LATV

[signature: K S]

SUOMALAINEN, Kari Yrjana
 Finnish 1920-
 EC

SUPANCHICH, Konrad von
 German 1858-1935
 B

SURA, Jaroslav
 Czechoslovakian mid 20c.
 GR 64-65-66-68

SURALLO
 Polish early 20c.
 POS

SURREY, Philip
 Canadian 1910-
 WS

SURTI, S. N.
 Indian mid 20c.
 ADV, GR 62-65-67-68

SURVAGE, Léopold
 French 1879-1968
 B, EC, H, M, TB, VO

SUS, Gustav Konrad
 German 1823-81
 B

SUSEMIHL, Heinrich
 German 1862-
 B

SUSKIND, Henry
 American 20c.
 M

SUSSMAN, Arthur
 American 1927-
 CON, H

SUSSMANN, Anton
 Austrian early 20c.
 LEX

SUSSMANN, Heinrich
 Austrian mid 20c.
 LEX

SUSUMI EGUCHI
 Japanese 20c.
 CP

SUTCLIFFE, John E.
 English 1876-1922
 B

SUTHERLAND, Graham
 English 1903-1980
 B, BRP, DA, DRAW, EAM, GR 54, H, PC, POS, POST

SUTHERLAND, Yvonne
 Australian late 20c.
 GR 82

SUTNAR, Ladislav
 Czechoslovakian/American 1897-
 B, GR 52-53-58-59, H, POS

SUTTER, Albert
 Swiss 1862-1923
 B

SUTTER, Henry
 American early 20c.
 VC

SUTTERLIN, Charles H.
 American 20c.
 M

SÜTTERLIN, Ludwig
 German 1865-1917
 B, POS, POST

SUTTON, George Miksch
American 1898–1940
F,H

SUTZ, Robert
American 1929–
CON

ROBERT SUTZ

SUYDAM, Edward Howard
American 1885–1940
AMA4/30,F,FM9/26,H,I,M

E H Suydam

SUYLING, Karel
Dutch late 20c.
EI

SUZUKI, Takao
Japanese mid 20c.
GR62–64

SVANBERG, Max Walter
Swedish 1912–
B,H

SVENSSON, Kamma
Danish 1908–
LEX,VO

K Sv.

SVOBODA, Josef Cestmir
Czechoslovakian/American 1889–
B,F,H,M

SVOBODA, Karl
see
SWOBODA, Karl

SVOBODA, Vincent A.
American 1877–1961
ABL8/05,CO10/04 and 8/05,H,M

VA.SVOBODA

SVOLINSKY, Karel
Czechoslovakian 1896–
B,H,M

KS

SWAANSWIJK, Lubertus Jacobus
Dutch 20c.
GMC

SWABACK, Edwin R.
American 20c.
SH6/23

EDWIN R SWABACK

SWAFFORD, J. G.
American 20c.
M

SWAIN, Frank
American 20c.
F?,M

SWAINSON, William
English 1798–1855
H

SWAN, Peter
Canadian late 20c.
EI79

SWAN

SWANSON, George Alan
American 1908–
H,M

SWANSON, Jonathan M.
American 1888–
B,F,H

SWANWICK, Betty
English 1915–
GR54,POST

SWAY, Albert
American 1913–
H,M

SWEARINGER, Karen
American late 20c.
GR85

SWEAT, Lynn
 American 20c.
 C

SWEENEY, Dan
 American 1880–1958
 H,IL,M

SWEENEY, Margaret
 English mid 20c.
 GR54

SWEENEY, Nora
 American 1897–
 F,H,M

SWIERZY, Waldemar
 Polish 1931–
 CP,GR55-68,H,POS,POST

SWIERZY

SWIFT, Dick
 American 1918–
 H

SWIFT, Stephen Ted
 American early 20c.
 F

SWINNERTON, James Guilford
 American 1875–1974
 B,F,H,M,SO

J. SWINNERTON

SWOBODA, Josef Cestmir
 see
 SVOBODA, Josef Cestmir

SWOBODA (SVOBODA), Karl
 Austrian 1823–70
 B,H

SWOBODA, Rudolph
 Austrian 1859–1914
 B,LEX,TB

SWORDS, Betty
 American 1917–
 EC

SWYNCOP, Philippe
 Belgian 1878–
 B,H,TB

PH.S.

SYBERG, Fritz Christian Wilhelm Heinrich
 Danish 1862–1939
 B,H,TB,VO

SYMONS, William Christian
 English 1845–1911
 B,H,LEX,TB

W.C.S.

SZABO, L.
 Belgian mid 20c.
 GR61

SZABO, Stefan
 Hungarian ac. late 19c.
 LEX

SZABÓ VON GABÓRJÁN, Kálmán
 Hungarian 1897–
 B,LEX,TB

SZAFRAN, Gene
 American 1941–
 F,Y

SZAFRANSKI, Kurt
 German 1890–
 B,TB

SZALAY, Lajos
 Hungarian/Argentinian 1909–
 GR66,H

SZANCER, Jan Martin
 Polish 20c.
 B

jms

SZANTO, Louis P.
 Hungarian/American 1889–1965
 B,H

SZANTON, John J.
 Hungarian/American 1889–
 H

SZASZ, Paul
 Hungarian 1872–1969
 B

SZCUKA, Mieczyslav
 Polish 1898–1927
 B,H,POS

SZEKERES, Cyndy
 American 20c.
 H

SZENTIVANYI, Lajos
 Hungarian 1909–
 B,DES

SZENTKUTI, Paulo
 Brazilian mid 20c.
 GR55

P. S2

SZEP, Paul
 Canadian 1941–
 CC,EC

SZEP

SZESZTOKAT, Willy
 German early 20c.
 LEX

SZILLARD, Iván
 Hungarian 20c.
 LEX

SZINTE, Gabor (Gabriel)
 Hungarian 1855–1914
 B

SZOEKE, Andrew
 American 20c.
 M

SZOMANSKI, Jan
 Polish 20c.
 POS

S.

SZÖNYI, István
 Hungarian 1894–
 B,LEX,TB,VO

SZOPOS, Sandor (Alexandre)
 Hungarian 1881–
 B

SZÜCS, Pál (Paul)
 Hungarian 1906–
 LEX

SZYK, Arthur
 Polish/American 1894–1951
 EC,H,M

SZYPIER, Ksawery
 Polish 1860–95
 B

– T –

T. M. D.
 Swedish ac. 1930s
 ADV

T M D.

T. V. (possibly Tony Varady)
 American mid 20c.
 PAP

T.V.

TABACK, Sims
 American 1932–
 GR65–68,H

Taback

TABARY, Celine Marie
Franco/American 1908–
H

TABER, J. W.
American ac. early 20c.
LEX

TABER, W. (L. W.)
American ac. 19/20c.
CEN 2/99 and 3/13 and 5/99,H

I W Taber

TABER, Walton (same as J. W. and L. W.)
American 19/20c.
CWA

Taber 85–

TABET, Claude
French 1924–
B

TABOHASHI, June
Japanese mid 20c.
GR 59–60

TACHIKI, Y.
Japanese mid 20c.
GR 64

TAFELMAIER, Walter
German mid 20c.
GR 64–68

TAFFS, C. H.
American 20c.
F,M

TAGAWA, Bunji
Japanese/American 1904–
H,M

TAGGART, Edward Lynn
American 1905–
F

TAGGART, Mildred Hardy
American 1896–
H

TAGGART, Nick
American late 20c.
EI 79

TAGORRO, José
Portuguese 1902–31
H

TAGUE, Walter Dorwin
English 20c.
LEX

TAICHINRO
see
HYAKUNEN, Suzuki

TAIT, Agnes (McNulty)
American 1897–
H

TAITO II
Japanese ac. 1810–53
B,H

TAIZAN (HINE-NO-TAIZAN)
Japanese 1810–67
H,J

TAKAHASHI, Kinkichi
Japanese early 20c.
POS

TAKAI, Peter
Rumanian/American 1905–
H

TAKANASHI, Yukuta
Japanese mid 20c.
GR 65

TAKEDA, Reichi
Japanese mid 20c.
GR 61

TALBOT, Edwin
Canadian ac. 1884–
H

TALBURT, Harold M.
American 1895–1966
EC,H,M

TALCOTT, Dudley Vail
American 1899–
H

TALLANT, Richard H.
American 1853–1934
H

TALLON, William John
American 1917–
H,M

TAMAGNO
French 19/20c.
CP

TAMAGNO

TAMASSI, Zoltan
Hungarian mid 20c.
GR58-59

TAMASSI

TAMBURINE, Jean
American 1930–
H

TAMBUSCIO, Giuseppe
Italian 1848–
B,H

TANAAMI, I. Keiichi
Japanese mid 20c.
GR64-65-67

TANAKA, Hiroshi
Japanese mid 20c.
GR61-65-66-67

TANAKA, Ikko
Japanese 1930–
GR61-62-67-68,H,POS,POST

TANAKA, Takeshi
Japanese 1921–
GR64,H

TANDLER, Rudolph Frederick
American 1887–
B,F,GMC,H

R.TANDLER

TANDY, John
English mid 20c.
GR54

TANDY, Russell H.
American 20c.
M

TANENBAUM, Robert
American 1936–
CON

R.Tanenbaum

TANIUCHI, Rokuro
Japanese late 20c.
GR82

Rokuro Taniuchi

TANNAHILL, Sally B.
American 1881–1947
F,H

TANNER, Paul
Swiss 1882–1934
B,LEX,TB

P.T.

TANSKI, Czeslaw
Polish 1863–
B

TANTTU, Erkki Lauri
Finnish 1907–
EC,H

E.T.56

TARA, Bill
American late 20c.
GR52-53-54

TARANTAL, Stephen
American late 20c.
GR82

TARASIN, Jan
Polish mid 20c.
GR55

TARRASA, Rimera
Spanish mid 20c.
GR60

TARU, Eugen
Rumanian 1913–
H

TASCHNER, Ignatius
German 1874-1913
AN,B

JT

TASKEY, Harry LeRoy
American 1892-
H

TATE, James
English 1914-
B

TATE, Sally
American 1908-
H

TATEISHI, Tiger
Japanese 1941-
B,GR82

TATHAM, Agnès
English 1893-
B,M

TATIN, Emile
French 20c.
B

TATTERSALL, George
English 1817-1849
B,H,M

TAUSCHEK, Otto
Austrian/German 1881-
AN

TAUSS, Herbert
American 1929-
IL

TAWSE, Sybil
English 20c.
M

TAYER, Mary V.
American 19/20c.
HA,LEX

M.Y.T.

TAYLOR, Audrey A.
Canadian 20c.
M

TAYLOR, Barnard Cook
American 1914-
H

TAYLOR, Bayard
American 1825-78
H

TAYLOR, Charles Jay
American 1855-1929
B,BAA,CEN8/07,EC,F,GMC,HA10/01,I,M,PE

TAYLOR, Collington
English early 20c.
LEX

TAYLOR, Edgar J.
American 1862-
B,F

TAYLOR, Ethel C.
American 19/20c.
F,H,M

TAYLOR, Farwell M.
American 1905-
H,M

TAYLOR, Frank H.
Canadian 19c.
H

TAYLOR, Frank Walter
American 1874-1921
B,F,I,IL,M,SCR9/06,Y

TAYLOR, Fred (Frederick)
English 1875-1963
ADV,B,MM,POS,POST,TB

FRED
TAYLOR

TAYLOR, G. Ruth
American 20c.
M

TAYLOR, Henry Weston
is incorrect
Horace Weston is correct

TAYLOR, Henry White
American 1899-1943
F,H,M

TAYLOR, Herb
Canadian mid 20c.
GR65

TAYLOR, Horace
American 1864-1921
B,I,POS

TAYLOR, Horace C.
English 1881-
B,LEX,POST,TB

HT

TAYLOR, Horace Weston
American 1881-
F,H,M,Y

TAYLOR, Isaac
English 1730-1807
B,H,M

TAYLOR, Isaac III
English 1787-1865
B,H,M

TAYLOR, J. W.
English 20c.
LEX

TAYLOR, James
English 1745-97
B,H,M

TAYLOR, James Earl
American 1839-1901
B,BAA,CWA,H,I,M

J.E.Taylor

TAYLOR, John Austin
American 20c.
M

TAYLOR, John William
American 1897-
B,H,M

TAYLOR, Lawrence Newbold
American 1903-
H,M

TAYLOR, Madeline
American 20c.
M

TAYLOR, Richard Lippincott Denison
Canadian/American 1902-70
ADV,EC,H,PLC

R.TAYLOR

TAYLOR, William
English 1800-61
H

TAYLOR, William Francis
Canadian/American 1883-
B,F,H,M

TAYLOR, William Ladd
American 1854-1926
B,F,H,I,IL

W.L.TAYLOR-

TAZELAAR, Elizabeth C.
American 20c.
M

TCHEKHOMINE, Serge
Russian 1878-
B,M

TCHELITCHEW, Pavel
Russian/American 1898–1957
B,GMC,H,M

P Tchelltchew 33

TCHERKESSOF, Georges
Russian 1900–43
B,M

TCHORZEWSKI, Jerzy
Polish 1928–
B,H

TEAGUE, Donald
American 1897–
B,FOR,H,IL,M

DONALD TEAGUE

TEAGUE, Walter Dorwin
American 1883–1960
H,PE

TEALDI, M.
Italian mid 20c.
GR61

M.Tealdi

TEALE, Earle Grantham
American 1886–1924
IL

TEALE

TEE-VAN, Helen Damrosch
American 1893–1976
F,H,M

TEESDALE, Gladys Mary
English 1898–
B,M

TEGETMEIER, Denis
English 1896–
LEX,M

TEGNE, Donald
American 20c.
M

TEGNER, Hans Christian Harold
Danish 1853–1932
B,M,POS,SC,TB

H

TEICHERT, Minerva Kohlhepp
American 1889–
H,M

TEICHMUELLER, Minnette (Pohl)
American 1872–
H,M

TEISSIG
Czechoslovakian 20c.
CP

Teissig 66

TEJA, Ramon Gonzales
Spanish late 20c.
GR52–53

G.TEJA

TELINGATER
Russian early 20c.
POS

TELLIN
Australian late 20c.
GR52

TEMPLE, Ernest Paul
Venetian 1924–
GR55?,H

TEMPEST, Margaret
English 20c.
M

TENERELLI, Joseph Dominic
American 1950–
Philadelphia Sunday Inquirer Magazine cover
12/86,*

JOE TENERELLI

TEN(G)GREN, Gustav-Adolf
 Swedish/American 1896–
 H,M,PE

TEN HOMPEL, Ludwig
 German 1887–
 B,LEX,TB

TENNANT, Dorothy
 see
 STANLEY, Dorothy

TENNIEL, (Sir) John
 English 1820–1914
 B,EC,H,PG,S,TB

TENRÉ, Charles Henry
 French 1864–1926
 B

TEPPER, Saul
 American 1899–
 H,IL,M,NG3/25,Y

TERAJIMA, A.
 Japanese 1896?–
 GR64,H?

TERESCHENKO, N. I.
 Bulgarian mid 20c.
 POST

TERICH, Valentin
 Austrian 1844–76
 LEX,TB

TERPNING, Howard Averill
 American 1927–
 CON,IL,Y

TERSCHAK, Emil
 German 19/20c.
 LEX

TERZI, Aleardo
 Italian 1870–1943
 AN,B,H,POS

TERZI, Andrea
 Italian 1842–1918
 B,H,LEX,TB

TESCHE, Carl
 German early 20c.
 LEX

TESCHENMACHER, Maximilian
 German 20c.
 LEX

TESKE-HARRIS, Diane
 American late 20c.
 GR82

TESSAI, Tomioka
 Japanese 1836/37–1924
 B,H,J

TESSMANN, Kurt Wilhelm Emil
 Austrian 1909–
 LEX

TESTA, Armando
 Italian 1917–
 GR52–54–60–66–67–85,H,P,POST

TESTAS, Willem de Famars
Dutch 1834-96
B

TETSUO, Miyahara
Japanese 20c.
CP

TEUBEL, Friedrich
Austrian 1884-
B,M

TEUSCHER, Fritz
German 1895-
LEX

TEUTSCH, Walter
German 1883-
B,M

TEVIS, Edwin Enos
American 1897/98-
H,M

TEXCIER, Jean
French 20c.
B

TEYSSIE, Jacques
French mid 20c.
GR58

Teyssié

THACKERAY, Lance
English -1916
B

THACHERAY, William Makepeace
English 1811-63
B,H,M,TB

THAYAHT, Ernesto Michehelles
Italian 1893-
B,ST

THAYER, Emma Homan
American 1842-1908
H

THELANDER, Henry
Danish 20c.
POS,VO

THEMERSON, Franciszka
English mid 20c.
GR53-54-55

Themerson.

THERMES, Giovanni
Italian/English mid 20c.
GR65-66

C. Thermes
64

THERMOND, Emile
French 1821-
B,LEX,TB

E.T.

THEUER, Oskar
German early 20c.
LEX

THEVENAZ, Paul(et)
Swiss 1891-1921
B,CP,M

**PAULET
THEVENAZ**

THEVENET, Jacques
French 1891-
B,H,M

Thoy Dhoulmes

THEVENOT, (Arthur) Francois
French 1856-
B,H,M

THIEDE, Henry A.
German/American 1871-
F,I,M

THIEL, Ewald
German 1855-
B

*EWALD
THIEL*

THIEL, Franz
German 20c.
LEX

THIEL, Johannes
German 1889–
B,GWA,TB

Th

THIELE, Wilhelm
German 1872–
B,TB

W.T.

THIEM, Herman C.
American 1870–
F

THIESS, Axel
Danish 1860–1926
B,SC

THIJSSEN, André
Dutch late 20c.
EI79,GR82

THINET, H.
French ac. early 20c.
ADV

THIRIET, Henri
French 19/20c.
BI,POS

THIRION, Eugene Romain
French 1839–1910
B,H,LEX,TB

THIRIOT, J.
French 20c.
LEX

THISTLEWAITE, F. W.
American 20c.
M

THOELE, Lillian Caroline Anne
American 1894–
F,H

THOLLANDER, Earl
American 1922–
GR54,H

THOM, Robert Alan
American 1915–
H,IL

ROBERT THOM

THOMA, Hans
German 1839–1924
B,DA,GMC,H

HHOMA.

THOMAS, Allan A. F.
American 1902–
F,H,M

THOMAS, Bert
Welsh 1883–1966
EC,M,POS

THOMAS, Estelle L.
American 20c.
F,H,M

THOMAS, Florence Todd
American 1909–
H,M

THOMAS, George Housman
English 1824–68
B,H,M

THOMAS, Glenn
American 20c.
H

THOMAS, Hans
Austrian mid 20c.
GR55

T

THOMAS, Henri Joseph
Flemish 1878-1972
B,H

THOMAS, Jacques François
French 20c.
B

THOMAS, Marjorie Helen
American 1885-
F,H,M

THOMAS, René William
French 1910-
B

THOMAS, (Mrs.) Vernon
American 1894-
F,M

THOMAS, W. F.
English late 19c.
GMC

THOMASON, (Major) John William, Jr.
American 1893-1944
H,M

THOMASSEN, Kaj Otto
American? early 20c.
PG

THOMPSON, Alan
American 1908-
H,M

THOMPSON, Bradbury
American 1911-
GR52-53,H

THOMPSON, Charles Thurston
English 1816/18-68
B,H,M

THOMPSON, Ernest Thorne
Canadian/American 1897-
B,F,H,M

THOMPSON, F. Raymond
American 1905-
H,M

THOMPSON, Floyd Leslie
American 1889-
F,H

THOMPSON, George W.
American mid 20c.
GR53

THOMPSON, Harry E.
American 20c.
M

THOMPSON, John
American 1940-
AA

THOMPSON, Kenneth Webster
American 1907-
GR55-68,H,M

THOMPSON, Lorin Hartwell, Jr.
American 1911-
H,M

THOMPSON, Marvin Francis
American 1895-
F,H,M

THOMPSON, Mills
American 1875-
B,CEN5/04,F,I,M

THOMPSON, Mozelle
American -1970
GR64-65
H

THOMPSON, Patricia
English mid 20c.
GR56

THOMPSON, Philip
English mid 20c.
GR59-64

THOMPSON, Richard Earle, Sr.
American 1914–
CON,H

[signature: t. thompson]

THOMPSON-SETON, Ernest
see
SETON, Ernest Thompson

THOMPSON-STEINKRAUSS, John
English late 20c.
EI79

THOMSEN, Arnoff
Danish 1891–
B

THOMSEN, Carl Christian Frederick Jakob
Danish 1847–1912
H,LEX,TB

[signature: F]

THOMSON, Hugh
English 1860–1920
B,BK,H,M,TB

[signature: H.J.]

THOMSON, Rodnay
American 1878–
B,F,M

THOMSON, William T.
American 1858–
F,H

THONI, Hans
Swiss mid 20c.
GR52–53–55–56–59

[signature: Thöni]

THONY, Eduard
German 1866–1950
B,POS

[signature: ETh]

THORN-PRIKKER, Jan
see
PRIKKER, Jan Thorn

THORNDIKE, Charles Jessie
American 1897–
H

THORNE, Diana
American 1895–
H

[signature: DT]

THORNE, Thomas Elston
American 1909–
H

THORNTON, Anna Foster
American 1905–
H

THORNTON, Eugen van Note (Gene)
American 1898–
H,M

[signature: GENE THORNTON]

THORNTON, Margaret Jane
American 1913–
H,M

THORNYCROFT, Rosalind
American 20c.
M

THORPE, Everett Clark
American 1907–
H

THORPE, James
English 1876–
B,TB

[signature: T]

THORSTEINSSON, Gudmunder
Icelandic 1891–1924
B

THÓTH, István
Hungarian early 20c.
LEX

THRASHER, Leslie
American 1889–
B,F,GMC,H,MP6/18

-Leslie Thrasher-

THROLL, Richard
German 1913–
LEX

THROSBY, John
English 1740–1803
B,H

THULSTRUP, (Bror) Thure de
American 1848–1930
B,BAA,CEN2/05,CWA,F,HA10/03,IL,PE,TB

B / D Thulstrup

THUM, Patty Prather
American 1853–1926
B,F,H,I,M

THUMANN, (Friedrich) Paul
German 1834–1908
ADV,B,BAA,H,M

THURBER, James Grover
American 1894–1961
ADV,B,CC,EC,H,Y

James Thurber

THURBER, Rosemary
American 1898–
H,M

THURLOW, Helen
American 1889–
F,H,M

THURSTON, John
English 1774–1822
B,H,M

THWAITES, W. H.
English ac. 1880
M

THWAITS, William H.
American ac. 1854–80
BAA,H

THYLMANN, Karl
German 1888–1916
B,LEX,TB

THYS, Joseph
Belgian 1891–
B

TIBOR, Toncz
Hungarian mid 20c.
GR53

Toncz Tibor

TICHON
French early 20c.
POS

TICHY, Frantisek
Czechoslovakian 1896–1961
B,H,M

TICHY, Gyula (Julius)
Hungarian 1879–1920
B,LEX,TB

TG.

TIDBALL, John Caldwell
American 1825–1906
H

TEIMANN, Walter
German 1876–1951
B,TB,M

WT

TIEN
see
HO, Tien

TIFFANY, William Shaw
American 1824–1907
B,F,I,M

TILBERGS, Jānis Kristapa
Latvian 1880–
B,LATV

J.R.Silbergs 57

TILBERGS, Romans Jāna
 Latvian 1920–
 LATV

TILKE, Max (Karl Max)
 German 1869–1942
 B,TB,VO

TILL, Peter
 English late 20c.
 EI79

TILLEY, Patrick
 English mid 20c.
 GR59-61-67

TILLMAN, D. Norman
 American 1899–
 H

TILLY, Wilhelm Eyvind
 Danish 1860–1935
 B,TB

TILMANS, Emile Henry
 Belgian 1888–
 B

TILSON, Beryl
 American 1912–
 M

TIM
 see
 MITELBERG, Louis

TIMAR, Emeric (Imre)
 Hungarian 1898–1950
 B

TIMLER, Carl
 German 1836–1905
 LEX,TB

TIMM, Franz
 German 20c.
 LEX

TIMMERMANS, Félix
 Belgian 1886–
 B,TB,VO

TIMMINS, Harry Laverne
 American 1887–1963
 H,IL,M

TIMMINS, William Frederick
 American 1915–
 H

TINANT, Robert
 French 1863–82
 B

TINAYRE, Jean Paul Louis
 French 1861–
 B,H?

TINGUELY, Jean
 Swiss 1925–
 B,GMC,H,POS

TINKELMAN, Murray Herbert
 American 1933–
 AA,CON,GR60-62-82,H,Y

TINKER, Jack
 American 20c.
 M

TINTNER, Erwin
 German early 20c.
 LEX

TIPPMANN, Albin
 German 1871–
 B,GWA

TIPS, Carlos
American/German 1891–
B,LEX,TB

TIRCE
American mid 20c.
ADV

TIREN, Gerda (Rydberg)
Swedish 1858–1928
B

TIREN, Johan
Swedish 1853–1911
B

TIRET-BOGNET, Georges
French 1855–
B

TISCHLER, Hermann
German 1866–
LEX,TB

TISCHLER, Victor
Austrian/American 1890–
B,H,M

TISDALL, Hans
English mid 20c.
GR52

TISSIER, Jeanne
French 1888–
B,M

TISSOT, Jean (James) Joseph Jacques
French/English 1836–1902
B,BAA,CEN12/98,H,M

[signature: J.J. Tissot.]

TITCOMB, Mary Bradish
American –1927
F,M

TITELBACH, L.
Austrian late 19c.
LEX

TITO
French early 20c.
ST

[signature: Tito]

TITTELBACH, Vojtech
Czechoslovakian 1900–
B,H

TITTLE, Walter Ernest
American 1883–1966
B,EC,F,GMC,H,I,M

[signature: Walter Tittle 1939]

TITUS, Aime Baxter
American 1882–
F,M

TITZ, Louis
Belgian 1859–
B,H

TOASFERN, Otto
American 1863?–1925
EC,M

TOBARI, Kogan
Japanese 1882–1927
H

TOBEY, Alton S.
American 1914–
H,M

[signature: alton S. Tobey]

TOBEY, Mark
American 1890–1976
APP,B,DA,DRAW,F,H,VO

[signature: Tobey]

TOBIAS, Abraham Joel
American 1913/14–
H,M

TOBIAS, Beatrice
American 20c.
M

TOBIN, George Timothy
American 1864-1956
B,CEN5/04,CO6/05,F,M,MUN8/97

George T. Tobin

TOBLER, Gisela
Italian mid 20c.
GR65-66-67

TOBLER, Victor
Swiss?/German 1846-1915
B,H,TB

VT

TODHUNTER, Francis
American 1884-1962
F,H,M

TOELKE, Kathleen
American late 20c.
GR85

TOFANI, Oswaldo
Italian 1849-1915
B,H,TB

TOF.

TOFANO, Sergio (Sto)
Italian 1886-
AD,B,EC,H,MM

sto

TOFT (TOFFT, TOFFTS or TUFTS),
Peter Petersen
Danish/American 1825-1901
B,H,M

TOIDZE, Izakly
Russian mid 20c.
POS

TOJO, Shotaro
Japanese 1865-1929
H

TOLFORD, Joshua
American 1909-
H

TOLIANI, Emilio
Italian 20c.
LEX

TOLKIEN, J. R. R.
English 20c.
LEX

TOLMIE, Kenneth Donald
Canadian 1941-
H

TOLSON, Norman
American 1883-
B,F,H

TOM
see
MELLO, Thomaz Jose de

TOMASO, Rico
American 1898-
F,H,IL,M

TOMÁSSI, Zoltán
Hungarian 1912-
LEX,VO

TOMASZEWSKI, Henryk
Polish 1914-
B,EC,GR54-56-61-62-63-65-67-68,H,POS,POST

H.TOMASZEWSKi 55

TOMAZIU, Georges
Rumanian 1915-
B

TOMES, Jacqueline
American late 20c.
GR52-53

TOMES, Margot Ladd
American 1917-
H,M

TOMIOKA, Eisen
Japanese 1864-1905
H

TOMKIEWICZ, Mieczslaw
Polish 20c.
CP

TOMLIN, Bradley Walker
American 1899–1953
B,F,H,VC

BRADLEY WALKER TOMLIN

TOMLINSON, Florence Kidder
American 1896–
H

TOMLINSON, Richard
American 20c.
H

RICHARD TOMLINSON

TOMMEY, Bob
American 1928–
CON

TOMREN, Karsten
Norwegian 1922–
POST

TON vas TAST
see
VALK, Anton van der

TONEY, Lawrence
American 20c.
M

TONG PING, Chang
Chinese 20c.
POS

TONK, Ernest
American 1899–
H

TOOKER, George
American 1920–
B,GMC,H

TOOKER

TOOROP, Jan
Dutch 1858–1928
AN,B,CP,H,MM,PC,POS,TB

TOPOLSI, Feliks
Polish/English 1907–
B,GR54-58-68,H,TB

F.T.

TOPOLSKI, Feliks
see
TOPOLSI, Feliks

TOPOR, Roland
French 1938–
B,EC,EI79,GR67,POS

Topor 69

TORGESSEN, H. J.
American 1907–
M

TORNEMAN, Axel
Swedish 1880–1925
H,LEX

TOROPINS, Aleksandrs Alekseja
Latvian 1924–60
LATV

TORRANCE, James
Scottish/English 1859–1916
B,M

TORRES, Armando Paez
Brazilian 1918–
GR55,POST

TORREY, Helen
American 20c.
M

TORREY, Marjorie
American 20c.
M

TOSSEY, Vernon
American 1920–
CON

Verne Tossey

TOTAIN, Lucien Napoléon François
French 1838–
B

TOTTEN, Robert
 American 1920–
 CON

TOTTEN, Vicken von Post
 Swedish/American 1886–
 F,H,M

TOUCHAGUES, Louis
 French 1893–
 B,DES,H,LEX,VO

TOUCHEMOLIN, (Charly) Alfred E.
 French 1829–1907
 B,H

TOUCHET, Jacques
 French 20c.
 B,M

TOUDOUZE, T. Edouard
 French 1844/48–1907
 B,H,L,M

TOULMIN-ROTHE, Ann
 American 20c.
 C

TOULOUSE-LAUTREC-MONFA, Henri Marie
 Raymond
 French 1864–1901
 ADV,AN,APP,B,BI,CP,DA,EAM,GA,GMC,
 H,MM,PC,POS,POST

TOURAINE, Edouard
 French –1916
 B

TOURRIER (TOURNIER), Alfred Holst
 English 1836–92
 B,H

TOURY, Geoffrey
 see
 TORY, Geoffrey

TOUSEY, T. Sanford
 American ac. 1924–48
 H,M

TOUSSAINT, Fernand
 Belgian 1873–1956
 B,POS

TOUSSAINT, Maurice
 French 19/20c.
 POS

TOVAGLIA, Pino
 Italian 20c.
 GR56-58-65-67-68,POS

TOWER, F. B.
 American ac. 1840s
 D

TOWERS, Matthew C.
 Canadian 1890?–
 M,WS

TOWN, Harold Barling
 Canadian 1924–
 F,H

TOWNSEND, Ernest Nathaniel
 American 1893–1945
 B,F,H,M

TOWNSEND, Frederick Henry
English 1868–1920
B,CL7/10,H,TB

TOWNSEND, Harry Everett
American 1879–1941
B,F,H,HA9/08,I,IL,TB

TOWNSEND, Henry James
English 1810–66
B,H

TOWNSEND, Lee
American 1895–1965
F,H,M

TOWNSEND, Marvin J.
American 1915–
H

TOYOKUNI II, Utagawa
Japanese 1777–1835
B,H,PC,POS

TRABUCCHI, Alfredo
Italian 1876–1918
H

TRACHSEL, Albert
Swiss 1863–1929
B,M

TRACY, Glenn
American 1883–
B,F,H,M

TRAHER, William Henry
American 1908/11–
ADV,H,M

TRAIN, H. Scott
American early 20c.
F,M

TRANCHANT, Maurice Lucien Charles
French 1904–
B

TRAPHAGEN, Ethel
American 1882–1963
H,M

TRAPIER, Pierre Pinckney Alston
American 1897–1957
H

TRAPP, W.
Swiss early 20c.
LEX

TRASOLL, Victor
American 20c.
M

TRAUFFER, Paul
Swiss mid 20c.
GR56-57-58-62-63

TRAUT, Tessa
German 20c.
LEX

TRAVERS, Cyril J.
Canadian 20c.
M

TRAVIS, Stuart
American early 20c.
VC

TRAVIS, William D. T.
American 1839–1916
B,D,I,M

TREASE, Sherman
American 1889–
B,F,H,M

TREATNER, Meryl
American 1950–
AA

TRECCANI, Ernesto
Italian 1929–
GR61,H

TREFETHEN, Norman
American 20c.
M

TREIDLER, Adolph
American 1886–
H,IL,POS,SCR5/12

ADOLPH TREIDLER

TREMBATH, James
American 20c.
M

TRENGROVE, Barry
English late 20c.
EI79,GR62

TRENTHAM, Eugene
American 1912–
H,M

TRENTIN, Angelo
Austrian/Italian? 1850/56–1912
B,H,LEX,TB

TREPICCIONE, Joseph J.
American 1948–
C

J.Trepiccione

TREPKOWSKI, Tadeus
Polish 1914–54
PG,POS

TREPTE, Toni
German 1910–
LEX,VO

TRESILIAN, Stuart
Scottish 20c.
M

TREUMANN, Otto H.
Dutch 1919–
GR52–53–55–56–58–60–65–66,H,POS,POST,VO

O.T.

TREVILIAN, Stuart
English mid 20c.
LEX

TREW, Cecil G.
English 20c.
M

TRIADO, José Mayol
Spanish 1870–
B,LEX,TB

TRICLAIR
German 20c.
GMC

TRICLAIR

TRIER, Walter
German 1890–1951
EC

TRIGGS, Floyd William
American 1872–1919
CE11/10,I,M

TRIGGS

TRIKOVSKY, Gizi
Hungarian 20c.
LEX

TRILLEAU, Gaston
French 19/20c.
B,M

TRIMM, George Lee
American 1912–
H

TRIMM, H. Wayne
American 1922–
H

TRINGHAM, Holland
English –1909
B

TRINKA, Jiri
Czechoslovakian 1910/12–69
B,EC,H

TRIPP, Wallace Whitney
 American 1940–
 H

TRISSEL, Lawrence E.
 American 1917–
 H

TRIVAS, Irene
 American mid 20c.
 GR54

TROG
 see
 FAWKES, Wally

TROJAN, Alfonz
 Hungarian 1894–1931
 B

TROLLER, Fred
 Swiss mid 20c.
 GR54–55–56–58–62–68

fred troller

TROMP, Erno
 Dutch late 20c.
 EI79

TROOP, Jan
 Dutch early 20c.
 GMC

TROOST, Grete
 German mid 20c.
 GR53–60–64

TROOST, Herbert
 German mid 20c.
 GR53–60

TROST, Friedrich (the elder)
 German 1844–1922
 B

TROSTEL, Max
 Swiss mid 20c.
 GR61

TROTH, Celeste Heckscher
 American 1888–
 H

TROWBRIDGE, Vaughan
 American 1869–1945
 B,CO1/05,F,M

TROY, Adrian
 American 1901–
 H,M

TRUBY, Betsy Kirby
 American 1926–
 H

TRUCHET, Abel
 French 1857–1918
 B,BI

TRUE, Allen Tupper
 American 1881–1955
 B,F,H,I

TRUE, Will
 English 19/20c.
 POS

TRUFFAUT, Fernand
 French early 20c.
 B

TRUMP, Georg
 German 1896–
 GR53,H

TRUTMANN, Beni
 French mid 20c.
 GR64

TSAO, Alex
 American mid 20c.
 GR62–64

TSAO

TSAO, Wou Ki (called)
 see
 ZAO, Wou Ki

TSCHAGGENY, Edmond Jean Baptiste
 Flemish 1818–73
 B,BAA,H

TSCHECHONIN, Sergeij Wassiliewitsch
Russian 1878-
B,GR56

TSCHERNY, George
Hungarian/American 1924-
CP,GR53-55-56-58-59-60-62-63-85,H,POS,
POST

TSCHICHOLD, Jan
Swiss?/German 1902-
CP,GR52,H,POS

TSCHICHOLD

TSCHUDY, Herbert Bolivar
American 1874-1946
B,F,H

TSCHUMI, Otto
Swiss 1904-
B,H

TSCHUPPIK, Klothilde
German 1865-1926
LEX,TB

TSUNEJIRO
see
HOBUN, Kikuchi

TSUNETOMI, Kitano (Kitano Tsunetomi)
Japanese 1880-1947
CP,H

TUCH, Kurt
German 1877-
B

TUCKER, Peri
Hungarian/American 1911-
H

TUCKERMAN, Arthur
American 20c.
M

TUDOR, Tasha
American 1915-
H

TUFTS, Peter Petersen
see
TOFT, Peter Petersen

TUGHAN, James
Canadian late 20c.
GR82-85

TULLOCH, William Alexander
American 1887-
B,F,H

TUMIATI (HIGHT), Beryl
Italian 1890-
H,illustrated 'I Grandi Navigatori Italiani'
by Giuseppe Fancivilli

TUNIS, Edwin Burdett
American 1897-1973
F,H

TUNNICLIFFE, Charles Frederick
English 1901-
B,GMC,H

TURGEON, Jean
(French) Canadian 1952-
EC

TURKLE, Brinton Cassaday
American 1915-
H

TURNER, Benjamin
English 20c.
M

TURNER, Charles Yardley
American 1850-1918
B,BAA,F,H,PC

TURNER, Gordon Robert
English/Swedish 1910-
H

TURNER, Jean Leavitt
American 1895-
H

TURNER, Leslie
American 1900-
F,H,M

TURNER, Roland
American 1931-
H

TURNER, Ross Sterling
American 1847-1915
B,CEN1/99,F,H,I

Ross Turner

TURNER, Stanley Francis
Canadian 1883-1953
H

TURUNEN, Seppo
Finnish mid 20c.
GR64

turnen

TURY, Gyula (Jules)
Hungarian 1866-1932
B,LEX,TB

T.GY.

TURZAK, Charles
American 1899-
H

TUSZYNSKI, L.
Austrian early 20c.
LEX

TUTTLE, Jean
Canadian late 20c.
GR85

TUTTLE, Macowin
American 1861-1935
AMA5/31,B,F,H

Macowin Tuttle

TWACHTMAN, John Henry
American 1853-1902
B,BAA,EAM,F,H,I,M,PC,R,SCR9/93

J.H.Twachtman.

TWEEHUIZEN, Will H. van
Dutch 1921-
GR53-58

WILL H. TW.

TWELVETREE(S), C. R.
American 19/20c.
CEN12/97,GMC,M

R 12-Tree

TWEREK, Richard
German 19/20c.
LEX

TWIDLE, Arthur
English 1865-1936
M

TWIGGER, Steve
English late 20c.
GR85

TWIGG-SMITH, W.
American 1883-
F,H

TWOPENY, William
English 1797-1873
B,LEX,TB

W.T.

TYFA, Josef
Czechoslovakian mid 20c.
GR54-55

TYLER, Audubon
American 20c.
M

TYLER, George
English -1859
M

TYLER, James Gale
American 1855-1931
B,BAA,F,I

JAMES G. TYLER

TYNG, Griswold
American 1883-
F,H

TYNI, Tapio
Finnish 20c.
POS

TYSZKIEWICZ, Samuele Federico
Polish 1889–
H

TYTGAT, Edgard
Belgian 1879–1957
B,H

TYTGAT, Minard
Belgian early 20c.
B,POS

TYTUS, Robb De Peyster
American –1913
I

– U –

UBAC, Raoul
Belgian/French 1910–
B,H

R. Ubac.

UBAGHS
Belgian early 20c.
B?,POS

UBBELOHDE, Otto
German 1867–1922
B,LEX,TB

O. U.

UBSDELL, Richard Henry Clements
English ac. 1828–49
B,H

UDIHARA, Tadao
Japanese mid 20c.
GR57–59–60–63

UDVARDY, Imre Laszlo (Emerich Ladislas)
Hungarian 1855–
B,M

UENO, Shigeo
Japanese mid 20c.
GR64

UHL, S. Jerome Sr.
American 1842–1916
ABL8/05,B,CEN10/05,H,I,M

Jerome Uhl–

UHRHAN, Carl Hermann
German 1904–
LEX,VO

UJIHARA, Tadao
Japanese mid 20c.
GR53–55–56

UJTZ
Hungarian early 20c.
POS

ULBRICHT, Elsa Emile
American 1885–
F,H,M

ULLMAN, Alice Woods
American 20c.
B,F,H,M

ULLMANN, E.
German early 20c.
LEX

ULLMANN, Gad
Israeli mid 20c.
GR65

ULP, Clifford McCormick
American 1885–1957
B,F,H,I,M

ULREICH, Eduard Buk
American 1889–
B,F,H,VC

BUK

ULREICH, Nura Woodson
American –1950
H,M

ULRICH (Prof.) Gerhard
German 1903–
G,GR52

Ulrich

ULRICH, Gerti
 German 20c.
 LEX

ULRICH, Joseph
 Austrian/Bohemian 1857-1930
 B

UNCETA Y LOPEZ, Marcelino
 Spanish 1836-1905
 B,POS

UNDERSEN, Baldemar
 Danish 19/20c.
 POS

UNDERWOOD, Clarence F.
 American 1871-1929
 B,F,I,LHJ4/05,M,POS,POST,SCR9/02,TB,VO

CLARENCE F.
UNDERWOOD

UNDERWOOD, (George Claude) Leon
 English 1890-
 EI79,F,H,STU1930

George Underwood

UNGER, Friedrich (Johan Friedrich August)
 German 1811-58
 B

UNGER, Hans
 German/English 1915-
 AN,CP,GR57-60-64-67,H,POS

Hans Unger
'66

UNGERER, Tomi
 Irish?/American 1931-
 CC,GR58-68-82,H,P,PG,POS,Y

U, Tomi Ungerer

UNGERMANN, Arne
 Danish 1902-
 EC,GR52-53-54,H,POS,VO

Arne Ungermann

UNICHOWSKY, Anton
 Polish 20c.
 LEX

UNO, Akiro
 Japanese mid 20c.
 CP,GR61-62-64-66,POS

UNOLD, Max
 German 1885-1964
 H,LEX,TB,VO

M.U.

UNRUH, Jack Neal
 American 1935-
 Y

UNSHO, Ikeda
 Japanese 1824-86
 H,J

UNTERBERGER, Karl Severin
 Austrian 1893-
 B,GWA,LEX,TB

UNWIN, Nora Spicer
 Anglo/American 1907-
 H

UOTANI, Natsuo
 Japanese mid 20c.
 GR53

UPJOHN, Anna Milo
 American early 20c.
 American Junior Red Cross poster:
 Lighting the Way to Service and Good Will,
 *,F,H,M

A.M. UPJOHN

UPSHUR, Thomas
 American 1944-
 Y

UP(S)TON, Florence K.
 American -1922
 B,F,H,I,M

UPTEGROVE, (Sister) M. Irena
 American 1898-
 H

URBACH, Josef
 Prussian 1889–
 B,LEX,TB,VO

URBAN, Irene
 American mid 20c.
 GR54

URBAN, Joseph
 Austrian/American 1872–1933
 B,TB

URBAN, Paul
 German early 20c.
 LEX

URBANIEC, Maciej
 Polish 1925–
 BI,GR63–65,POS

URBANIEC

URIET, Albert
 French early 20c.
 LEX

URLAUB, Georg Johann Christian von
 Russian 1844/45?–1914
 B,H,LEX,TB

G.U.

URUGAWA, Yasuro (u. Yass)
 Japanese mid 20c.
 GR54–56–58–61–68

U. Yass

USHER, J.
 American 20c.
 M

USHER, Ruby Walker
 American 1889–1957
 H

USRY, Katherine Bartlett
 American 20c.
 H,M

USTER, Hans
 Swiss mid 20c.
 GR58–63–68

Uster

UTAGAWA, Toyokuni II
 see
 TOYOKUNI II

UTAKUNI
 Japanese 1777–1827
 B,H

UTAMARO, Kitagawa
 Japanese 1754–1806
 B,H,POST

UTPATEL, Frank Albert Bernhardt
 American 1905/06–
 H

UTRILLO, Antonio
 Spanish 19/20c.
 POS

A.Utrillo

UTRILLO, (Don) Miguel
 Spanish 1862–1934
 B,POS,POST

M

UTRILLO, Maurice
 French 1883–1955
 B,DA,DES,H,PC,POS

Maurice Utrillo. V.

UTTERBACK, William (Bill) Dean
 American 1931–
 P,Y

UTZ, Thornton
 American 1914/15–
 CON,IL

Thornton Utz

UZARSKI, Adolf
German 1885–
B,LEX,TB

UZELAĆ, Milivoy
Yugoslavian 1897–
B,VO

– V –

VACA, Karel
Czechoslovakian mid 20c.
GR63-64-66-67-68

VACCARI, Arturo
Italian early 20c.
LEX

VACHA, Rudolf
Czechoslovakian 1860–
B

VACHAL, Jaroslav
Czechoslovakian 1896–
LEX

VACHUDA, Jaroslav
Czechoslovakian mid 20c.
GR64

VACHUDA 63

VAGIRBY, Viggo
Danish early 20c.
GR53,POS

VAGNBY, Viggo
Danish mid 20c.
GR54

VAIKSNORAS, Anthony, Jr.
American 1918–
H

VAKIRTZIS, Georges
Greek mid 20c.
GR64

VAL
English late 19c.
GMC

VaL

VALADON, Suzanne
French 1865–1938
B,DES,H,POS

Suzanne Valadon

VALDAIRE, Vivien
American? early 20c.
VC

VALDAMIS, Voldemārs Jāna
Latvian 1905–
LATV

W – 56

VALENCA, Francisco
Portuguese 1882–1962
H

VALENTIEN, Anna Marie
American 1862–
F,H,M

VALENTIN, A. Henry
French 1820–55
B,H

VALENTIN, Henry Augustin
French 1822–82/86
B,LEX,TB

h.V.

VALENTINE, D'Alton
American 1889–1936
F,H,M,ME11/23

D'ALTON VALENTINE

VALENTINE, Jim
Dutch late 20c.
GR82

VALERI, Ugo
Italian 1874–1911
B,H

VALETTE, Paul Bernard Joseph Maurice
French 1852–
B,LEX

VALIGURSKY, Ed
American late 20c.
NV

VALK, Anton van der
Dutch 1884–
B

VALKUS, James
Canadian mid 20c.
GR61-64

VALLA, Victor
American late 20c.
NV

V./.I./

VALLE, Maude Richmond Florentino
American 19/20c.
F,H

VALLÉE, A.
French early 20c.
GMC

Vallée

VALLÉE, L.
French early 20c.
ADV

L Vallée

VALLÉE, William Oscar
American 1934–
H,ST

VALLEJO, Boris W.
Peruvian/American 1941–
NV,Y

BORiS

VALLEJO Y GABAZO, José
Spanish 1821-82
B,TB

J.V.

VALLET, Louis
French 1856–
B,GMC,L,TB

L Vallet

VALLOTON, Félix Edouard
Swiss 1865-1925
AN,B,DES,EC,FS,GA,GMC,H,M,MM,PC,POS,
POST,R

F. VALLOTTON

VAN
see
KAUFMAN, Van

van ALLSBURG, Chris
American 20c.
P

van AVERBEKE, Emil
see
AVERBEKE, Emil van

VAN BAERLE, E.
American mid 20c.
ADV

VAN BELLEN, Walter
American late 20c.
GR52-53

VAN BROCK, J.
French early 20c.
ST

J v B.

VAN BUREN, Raeburn
American 1891–
H,M,Y

VAN CASPEL, Johan G.
Dutch 1870–
CP,PG,POS,VO

v. Caspel

VAN COTT, Dewey
American 1898–
F

VAN DALEN, Anton
 Canadian/American late 20c.
 GR64-65-66-82

ANTON van DALEN 1980

VAN de BOVENCAMP, Valli
 Rumanian/American 20c.
 H

VAN de SAND, Michael
 Polish 20c.
 POS

VAN de VELDE, Henry (Clemens)
 Belgian 1863-1957
 AN,B,CP,H,POS,TB

VAN DEN BORN, Bob
 Dutch 1927-
 H

VAN der BEKEN, Lewis
 American mid 20c.
 GR63-64-65

van der BERGH, Vikke
 French early 20c.
 FO

Vikke V. D. Bergh

VAN der HEM
 Dutch early 20c.
 POS

VAN der LECK, Bart Anthony
 Belgian 1876-1958
 B,CP,H,POS

van der WAAY, Nicolaes
 Dutch 1855-1936
 B,POS

VAN DIEDENHOVEN
 Dutch early 20c.
 POS

van DOESBURG, Theo
 Dutch 1883-1931
 B,CP,H

VAN DOEGEN, Kees
 see
 DONGEN, Kees van

VAN DOREN, Margaret
 American 1917-
 M

VAN DRESSER, William
 American 1871-1950
 AM7/23,F,H

VAN EVEREN, Jan
 American 1875-1947
 F,H,M

VAN GORDER, Luther Emerson
 American 1861-
 B,BAA,F

van HOEYDONCK, Paul
 Belgian 1925-
 B,H,P

van IMMERSEEL, Franz
 Belgian early 20c.
 POS

VAN KEULEN, Jan
 Dutch mid 20c.
 GR60-63

vK

van KONIJNENBURG, Willem
 Dutch 19/20c.
 B,POS

VAN LENNEP, Clara Hart
 American 20c.
 M

VAN LEYDEN, Karin Elisabeth
 Dutch/American 1906-
 B,H

VAN LOON, Hendrick Willem
 Dutch/American 1882-
 M

van MANNEN (van MAANEN), Charles
 American mid 20c.
 ADV,GR62-67

van OFFEL, Edmond
 Belgian 1871-
 B,LEX,TB

E v O

VAN ORDER, Grace Howard
 American 1905-
 H,M

VAN ORMAN, John A.
 American 20c.
 H

VAN RAALTE, David
 American 1909-
 H,M

VAN RAVESTEYN
 Dutch early 20c.
 POS

VAN RYDER, Jack
 American 1898-1968
 H,M

VAN RYSSELBERGHE, Theodore
 Belgian 1862-1926
 AN,B,MM,POS

VR , VR

VAN SAMBEEK, Will
 Dutch mid 20c.
GR65-67

VAN SCHAICK, S. S.
 American ac. late 19c.
 PE

VAN SLUIJTERS, Georges
 see
 de FEURE, Georges

VAN STOCKUM, Hilda
 Dutch/American 1908-
 H,M

VAN VALKENBURGH, Peter
 American 1870-1955
 H,M

VAN VOORHEES, Linn
 American 20c.
 H

VAN WERVEKE, George
 American 20c.
 F,M

VANACORE, Frank
 American 1907-
 H,M

VANDEMEST, Sabine
 French 20c.
 B

VANDER, G. Eynde
 Belgian mid 20c.
 GR64

VANDERBYL, Michael
 American late 20c.
 GR85

VANDERHOOF (VANDERHOFF), Charles A.
 American -1918
 CWA,H,I,PE

VANDERNOOT, E.
 American late 20c.
 GR52

VANDERSYDE, Gerritt
 English 20c.
 PG

VANDERVEER, (Miss) M. H.
 American ac. 1850s
 H

VANEČEK, Frantisek
 Czechoslovakian late 19c.
 LEX

VANEIGEM, Raoul
 French 20c.
 POS

VANENTI, Angleo
 Italian/American 20c.
 H

VANSELOW, M.
 Austrian/German 1871–
 LEX,TB

VARADY, Frederic
 American 1908–
 H,IL

VARADY, Tony
 American mid 20c.
 PAP

VARDENEGA, Alessandro
 Italian 1896–
 B,H

VARELA, E.
 Spanish 19/20c.
 GMC

VARGA, Arnold
 American 1926–
 GR56–61–65–68,H

VARGAS, Alberto
 American 1926–
 GMC,P

VARGISH, Andrew
 Hungarian/American 1905–
 H,M

VARGO, John
 American 1929–
 H

VARIAN, George Edmund
 American 1865–1923
 B,CEN2/99 and 5/99 and 6/05,F,H,I,M,PE,TB

VARLAMOS, Georges
 Greek 1922–
 H

VARONI (VARRONE?), Giovanni
 Austrian (Italian/Brazilian?) 1832–1910
 H,LEX,TB

VASARELY, Victor
 Hungarian/French 1908–
 B,GR62,H,POS

VASCONCELOS, Maria de Noémia D'Almeida
 Portuguese 1916–
 H

VASGERDSIAN, Haroutin
 Armenian/American 1906–
 H,M

VASILIU, Mircea
 Rumanian/american 1920–
 H,HA

VASILS, Albert
 American 1915–
 H

VASNETSOV, Viktor Mikhailovich
 Russian 1848–1919/28
 B,RS

VASSILIEV, Marie
 Russian/French 1884–1957
 B,POS

VASSILIOU, Spyros
 Greek 1902–
 B,M

VASSOS, John
 Greek/American 1898–
 AD,H,M

VAUGHAN, Anne
 American 20c.
 M

VAUGHAN, Keith
English 1912–
B,BRP,GR52–58,H

Vaughan.

VAUGHAN, Malcolm
American 20c.
M

VAUGHAN-JACKSON, Genevieve
English 1913–
H

VAUTER (VAWTER), John William
American 1871–1941
H,I,M

VAUTIER, (Marc Louis) Benjamin, the elder
German 1829–98
B,H,M

VAUZELLE, Jean Lubin
French 1776–
B,H

VAVASSEUR (VAVALSEUR), Eugene Charles Paul
French 1863–
POS

E.Vavalseur

VAVPOTIC, Ivan
Yugoslavian 1877–
B,TB

V.J.

VAVRINA, Karl
Czechoslovakian
LEX

VAWTER, John William
see
VAUTER, John William

VAYANA, Nunzio
Italian/American 1887–
F,H,M

VAZARY, Gabor (Gabriel)
Hungarian 1897–
B

VEBELL, Edward T.
American 1921–
H,IL

Ed Vebell

VEDDER, Elihu
American 1836–1923
B,BAA,F,H,I,TB

Vedder

VEDDER, Simon Harmon
American 1866–
B,M

VEDER, Eugène Louis
French 1876–
B

Eug. Veder

VEEN, Stuyvesant van
American 1910–
B

VEENENBOS, Jean
Dutch 1932–
LEX

VEER, Elisabeth van der
Dutch 1887–
B

VÉGH, Gustav
Hungarian 1890–
B,LEX,TB

V.G.

VELA, Alberto
Mexican/American 1920–
CON,H

Alberto Vela

VELARDE, Pablita
American 1918–
H

VELASQUEZ, Oscar
 American 1945–
 H

VELEZ, Luis
 Mexican 20c.
 BI

VELTHUIJS, Max
 Dutch mid 20c.
 GR65–66

VÉLY, Anatole
 French 1832/38–82
 B,GMC,H

VENO, Joseph R.
 American 1939–
 Y

VENTURA, Piero
 Italian/American 1937–
 Y

VENTURELLI, Jose
 Chilean 1924–
 H

VERBAERE, Herman
 Belgian early 20c.
 POS

VERBECK, William Francis (Frank)
 American 1858–
 F,GMC,HA11/02 and 6/04,I

FRANK VERBECK

VER BECKE, W. Edwin
 American 20c.
 M

VERBEEK, Frans
 Dutch mid 20c.
 GR52

VERBEEK, Gustav
 American 1867–1937
 F,HA,LEX

G.V.

VERBERNE, Alexander
 Dutch mid 20c.
 GR56–57

VERBERNE, P.
 Dutch mid 20c.
 GR53

VERDINI, Raoul
 Italian 1899–
 EC

VERDU, Joaquin
 Spanish 19c.
 POS

VERHOEVEN, Aart
 Dutch mid 20c.
 GR65

VERNAY, François Joseph
 Swiss 1864–
 B

VERNAZZA, Edoardo
 Uruguayan 20c.
 LEX

VERNET, Emile Jean Horace
 French 1789–1863
 B,H,LEX,TB

VERNEUIL, Maurice Pillard
 French 1869–1942
 B,MM

MPJ.

VERNEY, John
 English mid 20c.
 GR53–54

J.V.

VERNICE, Dante
 Italian mid 20c.
 GR60

VERNIER, Charles
 French 1831–87
 B,POS

VERNIER, Edmond
 see
 DOLA, Georges

VERNIER, François
 French mid 20c.
 GR58–62

VERNIER

VERŐCZEI-BALÁZS, Wera
Hungarian 20c.
LEX

VERONESI, Luigi
Italian 1908–
B,H,POS

VERREES, J. Paul
Belgian/American 1889–
F

VERRILL, Alpheus Hyatt
American 1871–
M

VERTÈS, Marcel
Hungarian/French 1895–1961
AD,ADV,B,GR52-55-56-58,H,M,POS,TB

VERTOV, Dziga
Russian early 20c.
CP

VESPIGNANI, Renzo
Italian 1924–
B,GR64,H,PC

VESSY, M.
Irish 20c.
M

VETTER, Georg
Swiss mid 20c.
GR52-63

VETTINER, Jean Baptiste
French 1871–
B,LEX,TB

VIANA, Maria Emília de Barbosa
Portuguese 1912–
H

VIANI, Lorenzo
Italian 1882–1936
B,H

VICAIRE, Marcel
French 1893–
B

VICAR, H. M.
American ac. late 19c.
HA,LEX

VICÉ, Herman Stoddard
American 1884–
F,H

VICENTE, Arlindo Augusto Pires
Portuguese 1906–
H

VICKERY, John
Australian/American 1906–
H

VICTOR, Joan Berg
American 1937–
H

VICUS, Enea
see
VICO, Enea

VIDA, Géza
Rumanian
LEX

VIDAL, Eugène Vincent
French 19/20c.
B,LEX,TB

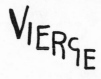

VIDAL, Pierre (Marie Louis Pierre)
French 1849–1929
B,LEX,TB

VIDIŅS, Kārlis Jāņa
Latvian 1905–
LATV

VIEIRA, Alfredo Carlos da Rocha
Portuguese 1883–1947
H

VIERGE, Daniel Urrabieta
Spanish/French 1851–1904
B,H,L,POS,S

VIGGO, Vagnby
Danish 1896–
H

VIGIL, Veloy Joseph
American 1931–
CON,H

VIGNA, Gloriano
American 1900–
F,M

VIGNELLI, Massimo
Italian 1931–
GR63-64-65-67,POS

VIGNOLA, Filipps Nero
Italian 1873–
B,H,LEX,TB

VIGNY, Benno
Dutch 20c.
LEX

VIKO
French 1915–
B

VIKSTEDT, Toivo Alarik
Finnish 1891–1930
EC

VILA, Francisco (Cesc)
Spanish mid 20c.
GR64-65-66

VILKS, Girts Andreja
Latvian 1909–
LATV

VILLA, Aleardo
Italian 1865–1906
B,H,POS,TB

VILLA, Georges
French 1883–
B,M

VILLA, Hernando Gonzallo
American 1881–1952
H,M

VILLEMOT, Bernard
French 1911–
B,GR52-59-61-63-65-68,H,POS,POST

VILLIERS, Frederick
English 1852–1922
H

VILLIERS-STUART, Constance Mary
English 20c.
B

VILLON, Jacques (Gaston Duchamp)
French 1875–1963
APP,B,DA,DRA,DRAW,DES,EAM,GMC,H,PC,
POS

VIMAR, Auguste
French 1851–1916
B,LEX

VINCENT, Benjamine
American late 20c.
GR85

VINCENT, René
French 1879–1936
AD,B,POS

VINCENTINI, Hilary
American 20c.
M

VINE, H. G. L.
English early 20c.
LEX

VINELLA, (Ray) Raimondo J.
American 1933–
AA,CON

R.Vinella

VINSON, Wilfrid L.
English 20c.
M

VIOLET, G.
French 20c.
LEX

VIOLLET le DUC, Eugène Emanuel
French 1814–79
AN,H,TB

VION, Raoul
French early 20c.
BI

Raoul. Vion

VIP
see
PARTCH, Virgil Franklin

VIRAC, Raymond Pierre
French 1892–
B

VIRGINIO
Italian 19/20c.
GMC

VIRIN, Carl Apel
Swedish mid 20c.
GR54

VISKUPIC, Gary
American 20c.
GR68–82,NV

Viskupic

VISSER, J.
Dutch, 1879–
B

VITACCO, Alice
American 1909–
H

VĪTCOLIŅŠ, Marģers Jāņa
Latvian 1912–
LATV

MV50

VITTINGHOFF, Karl Baron van (Fischbach)
German 1772–1826
B,H

VIVARELLI, Carlo L.
Swiss 1919–
GR56,H,POS

VIVASH, Ruth Athey
American 1892–
B,F,H

VIVIEN, Narcisse
Dutch/French 19/20c.
B,BI

VIZETELLY, Frank
English 1830–83
B,H,M

VIZETELLY, Henry
English 1820–94
B,H

VODRAZKA, Jaroslav
Yugoslavian 1894–
H

VOGEL, Christine
German 20c.
G

VOGEL, Heinrich Max
German 1871–1921
LEX,TB

VOGEL, Hermann
French 1856–1918
B,TB

VOGEL (VOGEL-PLAUEN), Hermann
German 1854–1921
B

VOGEL-PLAUEN, Hermann
see
VOGEL (VOGEL-PLAUEN), Hermann

VOGELER, Heinrich Johann
German 1872–1942
AN,MM

VOGELIUS, Paul August Giern
Danish 1862–94
B

VOGLER, Eleonore
German 20c.
LEX

VOGLER, Hermann
German 1859–
B,LEX,TB

H.V.

VOGT, Georg
German 1881–
B,LEX,TB

VOGUET, Leon
French 1879–
B

VOIGHT, Charles A.
American 19/20c.
F

VOIGT-CLAUDIUS, Meta
German 1866–
LEX,TB

VOLK, Stephen A. Douglas
American 1856–1935
CEN10/07,F,H

Douglas Volk

VOLKERS, Emil
German 1831–1905
B,H,LEX,TB

E.V.

VOLKERT, Hans
German 1878–
AN,LEX,TB

HV.

VOLKMANN, Hans Richard von
German (Prussian) 1860–1927
B,LEX,TB

VOLLAND, Ernst
German 20c.
POS

VOLTZ (VOLZ), Johann Michael
German 1784–1858
B,EC,H

VOLZ, Wilhelm
German 1855–1901
B,H,MM,TB

von BELFORT, Charles
American 1906–
H,M

VON DER LANCKEN, Frank
American 1872–1950
F,H

VON EISENBARTH, August
Hungarian/American 1897–
F,H

von FUEHRER, Ottmar F.
American 1900–67
H

VON HOFSTEN, Hugo Olof
Swedish/American 1865–
F

von KABISCH
German early 20c.
ST

VON LANGSDORFF, Georg Heinrich
German 1773–1812?
H

VON NEUMANN, Robert
German/American 1888–
F,H

von REZNICEK, Ferdinand Freiherr
 Austrian/German 1868-1909
 B,SI,TB

Reznicek [signature]

von REZNICEK, Franz
 German ac. early 20c.
 GMC,POS

VON RIEGEN, William
 American 1908-
 H

VON RIPPER, Rudolph Charles
 American 1905-
 H

von SCHMIDT, Harold
 American 1893-
 F,H,IL,M,Y

HAROLD VON SCHMIDT [signature]

VON SCHNEIDAU, Christian
 Swedish/American 1893-
 F,H

von STÜCK, Franz
 German 1863-1928
 AN,B,CP,EC,GMC,H,POS,POST,TB

FRANZ STVCK [signature]

VON WOERKOM, Funs
 American 20c.
 Y

VONDROUS, Dobroslav
 Czechoslovakian 1920-
 H

VONDROUS, John C., (Jan)
 American 1884-
 B,F,I

VONMETZ, Hans
 German 20c.
 LEX

VONNEGUT, Edith
 American 20c.
 P

VOORHIERS, Stephen J.
 American ac. 1940s
 LEX

VORST, Joseph Paul
 German/American 1897-
 H,M

VORWERK, E. Charlsie
 American 1934-
 H

VOSBERGH, Robert W.
 American 1872-1914
 B,I

VOSBURGH, Leonard
 American 20c.
 H

VOSKUIL
 German 20c.
 CP

VOSS, Karl Leopold
 German 1856-1921
 B

VOTAVOVÁ, Blanka
 Yugoslavian 1933-
 H

VOTRUBA, Jaroslav
 Czechoslovakian/Yugoslavian? mid 20c.
 GR61,H

VOUTE, Kathleen
 American 1892-
 H,M

VOZNIAK, Jaroslav
 Czechoslovakian 1933-
 B,H

VRIENDT, Juliaan de
 Belgian 1842-1935
 B,H,M

Juliaan De Vriendt. [signature]

VRUBEL, Mikail Alexandrovitch
 see
 WROUBE, Mikail Alexandrovitch

VUILLARD, Jean Edouard
French 1868-1940
AN,B,DA,DES,EAM,GMC,H,PC,POS,POST

Vuillard [signature]

VUILLEMENOT, Fred A.
American 1890-1952
F,H,M

VUILLEUMIER, Ida
Swiss 20c.
LEX

VUILLIER, Gaston Charles
French 1846/47-1915
B,M,TB

G.V., G.V [signature]

VUKOVIC, Marko
Austrian/American 1892-
M

VULLIAMY, Gerard (and not VUILLAMY)
Swiss/French 1909-
B,H

VULLIEMIN, Ernest John Alexis
Swiss 1862-1902
B

— W —

WACHSMANN, Julius
Austrian 1866-1936
B,TB

JW [signature]

WACHSTETER, George
American 1911-
H

WACHTEL, Elmer
American 1864?-1929
B,F,H,M

WACIK, Franz
Austrian 1883-1938
AN,B,M

[signature]

WACK, Henry Wellington
American 1875-1954
B,F,H,M

WACKERLE, Josef
German 1880-
B,LEX,TB

WADA, Makoto
Japanese 20c.
GR62-68,POS

WADDINGHAM, John Alfred
American 1915-
H

WADE, Jean Elisabeth
American 1910-
H

WADMAN, Lolita Katherine (Granahan)
American 1908-
H,M

WADOWSKI-BAK, Alice
American 20c.
H

WADSWORTH, Edward Alexander
English 1889-1949
B,BRP,CP,H,M

Edward Wadsworth [signature]

WADSWORTH, Wedworth
American 1846-1927
B,BAA,F,M

WAENTIG, Walter
German? 1881-
LEX,TB

WW [signature]

WAGENER, A.
German early 20c.
LEX

WAGER-SMITH, (Miss) Curtis
American 20c.
F,M

WAGNER, Adolf
German 1861-
LEX,TB

WAGNER, Alexander von
German?/Austrian 1838?/40–1919
B,H,LEX,TB

WAGNER, Alexander
German mid 20c.
GR58

WAGNER, Arnold Louis
American 1934–
H

WAGNER, Frank Hugh
American 1870–
B,F,H,M

WAGNER, Georg
German 1875–
LEX,TB

WAGNER, Mary North
American 1875–
B,F,H

WAGNER, Polly Kenyon
American 20c.
M

WAGNER, Richard Carl
Austrian? 1882–
LEX,TB

WAGNER, (Rob) Robert Leicester
American 1872–1942
B,F,H,I,M,R

WAGNER, Wolfgang
German 1884–1931
LEX,TB

W.W.

WAGREZ, Jacques Clément
French 1846/50–1908
B,GMC,H,M,TB

JACQVES WAGREZ

WAGULA, Hans
Austrian 1894–
B,POS,POST

WAGULA-GRAZ
Austrian mid 20c.
GR53

WAHL, Anna von
Russian 1861–
LEX,TB

A.W.

WAHLBERG, Sten
Swedish mid 20c.
GR56–59

S. Wahlberg

WAHLBOM, Johann Wilhelm Karl
Swedish 1810–58
B,H,M,SC

WAHLERT, Ernst Henry
American 1920–
H

WAIBLER, Friedrich
German late 19c.
LEX

WAIN, Louis
English 1860–1939
EC,M

L.W.

WAITE, Esther
American 20c.
M

WAJWOD
Polish early 20c.
POS

WALD, Adolf
German 19/20c.
LEX

WALD, Carol
American 1935–
GR82,Y

WALDECK, Nina V.
American 1868–1943
F,H,M

WALDHOF, E. M.
 German 20c.
 LEX

E.M.W.

WALE, Samuel
 English 1720?-86
 B,H,M

WALES, Arthur Douglas
 see
 WALES-SMITH, Arthur Douglas

WALES-SMITH, Anne Mary Dorothy
 English 1934-
 H

WALES-SMITH, Arthur Douglas
 English 1888-
 B,M

WALFINGER, Margit
 German 20c.
 LEX

WALKE, Nedda
 American 20c.
 LEX

WALKER, Alanson Burton
 American 1878-1947
 EC,F,H,HA9/08,M,SCR4/06

A·B·WALKER·

WALKER, Arthur George
 English 1861-1939
 B,BK,M

WALKER, Challis
 American 20c.
 M

WALKER, Charles W.
 American 20c.
 H

WALKER, Don
 American mid 20c.
 GR54

WALKER, D(o)ugald Stewart
 American 1865-1937
 F,H,I,M

WALKER, Francis S.
 Irish 1848-1916
 B,TB

F.S.W.

WALKER, Frederick
 English 1840-75
 AN,B,CP,GA,H,M,POS,POST

W-7

WALKER, Gilbert M.
 American 1927-
 H,IL

WALKER, John Crampton
 Irish 1890-
 B,M

WALKER, Mary Evangeline
 American 1894-
 H,M

WALKER, Nedda
 Canadian/American 20c.
 H

WALKER, T. Dart
 American 1869-1914
 B,I,LEX,M,TB

T.D.W.

WALKOWITZ, Abraham
 Russian/American 1878-1965
 APP,B,EAM,F,GMC,H,M,PC

WALL, Bernhardt T.
 American 1872-
 H,M

WALL, Bob
 American mid 20c.
 ADV

WALL, Hermann C.
 German/American 1875-
 CO2/05,HA,M

H · C · W A L L

WALL, Ralph Alan
 American 1932-
 CON,H

Ralph Wall Jr

WALL PERNÉ, Gustaaf Friedrik van de
 Dutch 1877-1911
 B

WALLACE, Frank (Harold Frank)
 English 1881-
 B,LEX,M

WALLACE, Lewis
 American 1827-1905
 H

WALLACE, William
 English 19c., (1801-66)?
 B?,H

WALLCONISMS
 Scottish early 20c.
 GMC

Wallcohins

WALLEEN, Hans Axel
 American 1902-
 H

WALLENBERG, Heinrich
 German 20c.
 LEX

WALLERSTEIN, Alan
 American late 20c.
 GR85

WALLING, Steve
 American mid 20c.
 GR64

WALLIS, Henry
 English 1804/05-90
 B,H,M

WALLIS, Mary Burton
 American 1916-
 H,M

WALSER, Karl
 German?/Swiss 1877-1943
 B,LEX,TB

KW

WALSH, John Stanley
 Anglo/Canadian 1907-
 H

John Walsh
1947

WALSTON, Jim
 American 1920-
 CON

Jim Walston

WALTEC, Harold
 American late 20c.
 GR52-53

WALTER, Johann Ernst Christian
 Danish 1799-1860
 B

WALTER, Karl
 Swiss 1877-1943
 B

WALTER, Karl H.
 German mid 20c.
 GR52-56

WALTER, Otto
 German -1914
 LEX,TB

WALTER, Solly
 American 1846-1900
 B,M

WALTER-ERNST, E.
 German ac. early 20c.
 LEX

WALTERS, Audrey
American 20c.
H

WALTON, Elyah
English 1832/33-80
B,H,M

WALTRAUD, Maria Magdelena
German 1938-
B

WALTRIP, Mildred
American 1911-
H,M

WANDERER, Friedrich Wilhelm
German 1840-1910
B,TB

F.W.

WANDS, Alfred James
American 1902/04-
F,H,M

WANGBOJE, Solomon Irein
American
H

WANSERSKI, Martin
American 20c.
P

WANSLEBEN, Arthur
German 1861-1917
B

A.W.

WARD, Dudley
Canadian 1879-1935
H

WARD, Edmund F.
American 1892-
F,H,IL,M,Y

EFWARD

WARD, Enoch
English 1859-1922
B

WARD, John Talbot, Jr.
American 1915-
H,M

WARD, Keith
American mid 20c.
ADV

WARD, Kitty Campbell
Canadian 20c.
M

WARD, Leroy P.
American 20c.
M

WARD, Lynd Kendall
American 1905-
H,IL,M,PC

LYND WARD

WARD, Mary Trenwith Duffy
American 1908-
H,M

WARD, Richard Jo
American 1896-
H

WARDELL, Dorothy W.
Canadian 20c.
M

WARDINSKY, E.
German 20c.
LEX

WARDMAN, John William
American 1901-
H

WARE, Florence Ellen
American 1891-1971
H

WARHOL, Andy (Andrew)
American 1930-87
ADV,APP,EAM,GMC,GR52-60-63-85,H,P,POS,
POST

andy warhol

WARING, Laura Wheeler
American 1887-1948/49
H

WARKANY, Josef
Austrian/American 1902–
H,M

WARNER, Earl A.
American 1883–1918
M

WARNER, Lily Gillett
American 19/20c.
F,H,M

WARNOD, Andre
French 1885–
B

WARRE, Edmund L.
English early 20c.
LEX

WARREN, Asa Coolidge
American 1819–1904
B,D,F,H,I

WARREN, Charles Turner
English 1762/67–1823
B,H,M

WARREN, Dorothea
American 20c.
M

WARREN, Elisabeth Boardman
American 1886–
F,H,M

WARREN, Garnet
Anglo/American 1873–1937
M,SCR5/01

*GARNET *WARREN*

WARREN, Harold Broadfield
Anglo/American 1859–1934
B,F,H,I,M

WARREN, Henry
Anglo/American 1794–1879
B,F,H,M

WARRICK, Meta Vaux
see
FULLER, Meta Vaux Warrick

WARSAGER, Hyman J.
American 1909–
APP,H,PC

WARSAW, Albert Taylor
American 1899–
F,H,M

WARWAS, Klaus
Polish 20c.
CP,GR66

WARZILEK, Rosa
Austrian mid 20c.
LEX

WASHBURN, Stan
American 1943–
H

WASNETZOW, Yury
Russian 1902–
B

WASZEWSKI, Zbigniew
Polish mid 20c.
GR61

WATERHOUSE, Charles Howard
American 1924–
H

WATERS, John
American 1883–
M

WATHEN, James (Jimmy Sketch)
English 1751?–1828
B,H,M

WATKINS, Bernard C.
American 20c.
M

WATKINS, Chris O.
English mid 20c.
ADV

WATKINS, Dudley Dexter
English 1907–69
EC

WATROUS, John B.
American 20c.
M

WATSON, Aldren Auld
American 1917–
FOR,H,M

A.W.

WATSON, Amelia Montague
American 1856-1934
B,F,H,I,M

WATSON, Emmett
American 20c.
GMC,M

WATSON, Ernest W.
American 1884-
B,F,H,M

WATSON, Eva Auld
American 1889-
B,F,H,M

WATSON, Hy S. (Henry Summer)
American 1868-1933
CEN5/99,F,HA10/03,I,LEX,M,R

HY.S.WATSON.

WATSON, James F.
American 20c.
M

WATSON, John Dawson
English 1832-92
B,GR61,H,M,TB

J.D.W.

WATSON, Karen
American late 20c.
GR82

Watson

WATSON, Wendy
American 1942-
H

WATT, Barbara Hunter
American 20c.
F,H,M

WATT, James Henry
English 1799-1867/76?
B,H,M

WATT, Richard H.
Canadian ac. 1884
H

WATTER, Joseph
German 1838-1913
B,TB

JW

WATTS, Arthur George
English 1883-1935
B,M

WATTS, Stan
American 1952-
GR82,Y

WAUD, Alfred R.
American 1829-91
CWA,D,H,M,Y

AR.Waud

WAUD, William
Anglo/American 1828?-78
CWA,D,H

WAUDBY, Roberta F. C.
American 20c.
M

WAUGH, Coulton
Anglo/American 1896-1973
B,F,H,M

coulton waugh

WAUGH, Dorothy
American 20c.
M

WAUGH, Frederick Judd
American 1861-1940
B,F,H,I,M

waugh

WCJCIECH, Fangor
Hungarian mid 20c.
GR54

WEAVER, Annie Vaughan
American 20c.
H,M

WEAVER, Norman
English mid 20c.
GR58-60

WEAVER, Robert Edward
American 1924-
GR64,H,IL,P,Y

W&aV&L

WEBB, A. C.
American 1888-
B,F,H,M

G.C.Webb

WEBB, Archibald Bertram
English 1887-
B,M

WEBB, Francis
Canadian ac. 1866
H

WEBB, James Elwood
American 20c.
H,M

WEBB, Margaret Ely
American 1877-
CEN6/09,F,H,M

Webb

WEBB, Paul
American 1902-
EC,EI79,H,M

T. WeBB

WEBB (Tom) Thomas
American 20c.
M

WEBBER, Franklin
Franco?/American mid 20c.
GR55-60-66

Webber

WEBBER, Wesley
American 1841-1914
B,BAA,F,H,M

Wesley Webber

WEBER, Emil H. F.
Austrian mid 20c.
LEX

WEBER, H. P.
Swiss mid 20c.
LEX

WEBER, Johann Jakob
Swiss 1803-80
B

WEBER, Johannes
Swiss 1846-1912
B

WEBER, Marie
German late 19c.
B,LEX,TB

M. Weber.

WEBER, Rudolph
Swiss/American 1858-1933
M

WEBER, Sarah S. Stil(l)well
American 1878-1939
H,HA6/04,I,IL,M,SCR11/02,Y

WEBER, Theodore Alexander
German 1838-1907
B,H,LEX,M,TB

Th Weber

WEBER, Walter Alois
American 1906-
M

WEBER, Willi
Swiss 1933-
GR60,H

WEBSTER, Harold Tucker
American 1885-1952
F,H,M

WEBSTER, Hutton, Jr.
1910-56
H,M

WEBSTER, Tom
American 20c.
M

WECHSLER (or WESCHLER), Max Josef
German 1884-
LEX,TB

M.W.

WECZERZIK, Alfred
born Silesia 1864-
LEX,TB

WEDDA, John A.
American 1911-
H

WEDEMEYER, A.
German early 20c.
LEX

WEECH, Sigmund von
German early 20c.
LEX

WEEGE, William
American 1935-
APP,CP,H

WEEKS, Edwin Lord
American 1849-1903
F,H,HA,M

E.L.Weeks, E.L.Week

E.L.Weeks

WEEKS, Leo Rusco
American 1803-77
H,M

WEERT, Jan Baptiste de
Flemish 1829-84
B

WEERTS, Jean Joseph
French 1847-1927
B,H,LEX,M,TB

J.J.WEERTS.

WEGMANN, Karl J.
Swiss mid 20c.
GR52

WEGNER, Fritz
Austrian/English 1924-
H

WEGUELIN, John Reinhard
English 1849-1927
B,BK,H,I,M,TB

JR Weguelin

WEHLE, Johannes Raphael
German 1848-1936
B,TB

J.R.W.

WEHNERT, Edward Henry
English 1813-68
B,H,M

WEHR, Julian
American 20c.
M

WEHR, Paul Adam
American 1914-73
H

WEIDENAAR, Reynold Henry
American 1915-
APP,H

WEIGAND, Konrad
German 1842-97
B,H,TB

WEIGHTMAN, Maurice
 English 20c.
 M

WEIGL, Franz
 Austrian 1810–
 B

WEIHS, Bertram A. Th.
 Dutch mid 20c.
 GR52-58

BERTRAM

WEIHS, Kurt
 American mid 20c.
 GR54

WEIL, Ernst
 German 1919–
 G

W.

WEIL, Lisl
 Austrian/American 20c.
 H

WEIL, Sylva
 American 20c.
 M

WEILUC
 French ac. early 20c.
 GMC

WEiLuc

WEIMAR, Wilhelm
 German 1859–1914
 B,TB

W. W.

WEIMER, Charles Perry
 American 1904–
 H,M

WEINDORF, Arthur
 American 1885–
 F,H,M

WEINER, Isadore
 American 1910–
 H,M

WEINHEIMER, George
 American 20c.
 H

WEINSTOCK, Carole
 American 1914–
 H,M

WEIR, Harrison William
 English 1824–1906
 B,H,M

Weir

WEIR, Robert Walter
 American 1803–89
 B,BAA,D,F,H,M

WEIR, Walter
 English –1816
 H

WEIR, William Joseph
 Irish/American 1884–
 F,H,M

WEISBACH, Georg
 German ac. early 20c.
 LEX

WEISBECKER, Phillipe
 American late 20c.
 GR82

WEISBECKER

WEISE, Oswald
 German 1880–
 LEX

WEISE, Robert
 German 1870–1923
 B,LEX,TB

R.W.

WEISGARD, Leonard Joseph
 American 1916–
 H,M

WEISGERBER, Albert
German 1878-1915
AD,AN,B,H,POS

WEISGERBER
11

WEISMANN, Jacques
French 1878-
B,M

WEISS, Antal
Hungarian early 20c.
LEX

WEISS, Emil
Austrian/American 1896-1965
H,POS

E
W

WEISS, Emil Rudolph
German 1857-1942
AN,B

WEISS, Ferdinand
German 1814-78
B,H,LEX,TB

WEISS, Helfried
German 20c.
LEX

WEISS, Julius
American 1912-
H,M

WEISS, Oskar
Swiss late 20c.
GR82

WEISS, Oskar Julius
German mid 20c.
GR59-61

WEISS, Wojciech Stanislav
Polish 1875-
B,CP

WEISSER, Ludwig
German 1823-79
B,H

WEISSHAPPEL, Leopold
Austrian
LEX

WEISZ, August
Austrian early 20c.
LEX

WEITZ, Allan
American 20c.
GMC

WEIXLER, Viktor
German/Austrian 1883-
LEX

WEIXLGÄRTNER, Johann Bpatist Vincenz
Austrian 1846/49-1912
B,TB

WELCH, Jack W.
American 1905-
ADV,CP,IL,M

Welch

WELD, Ski
American 20c.
M

WELDON, Charles Dater
American -1935
B,CEN8/96,F,H,HA,I,TB,Y

C.D.Weldon

WELFORD, A.
English 20c.
M

WELLEKENS, A.
Belgian mid 20c.
GR53-54-56

WELLER, Don M.
American 1937-
AA,GR68,Y

Weller.

WELLER, Paul
American 1912–
M

WELLER, Samuel
see
ONWHYN, Thomas

WELLING, Richard
American 1926–
C

WELLINGS, William
English ac. 1793–1801
B,H

WELLNER, W.
German late 19c.
LEX

WELLS, Betty Childs
American 1926–
H

WELLS, Dorothy B.
American 20c.
M

WELLS, E. B.
American late 19c.
R

WELLS, H. G.
Hungarian early 20c.
POS

WELLS, James Lesesne
American 1902/03–
H,M

WELLS, Josiah Robert
English ac. late 19c.
B,EN,LEX

J.R.Wells

WELLS, Newton Alonzo
American 1852–
B,F

WELLS, Rhea
American 1891–
M

WELLS, William L.
American ac. 1890s
H

WELSCH, Paul
French 1889–1954
B,F,M

WELSH, (Horace) Devitt
American 1888–1942
B,F,H,I,M

WELSH, William P.
American 1889–
B,F,GMC,H,IL,M

WELSH

WELTI, Fritz Urban
Swiss early 20c.
LEX

WELY, Jacques
French 1873–1910
B,FO,TB

J. Wely

WENCK, Paul
German/American 1892–
H,M

WENCKEBACH, Ludwig Willem Reymert
Dutch 1860–
B,LEX,TB

·L.W.R.

W.

WENDE, Phil
American late 20c.
GR82

WENDE

WENDEN, Nadine
American 20c.
M

WENDLING, Ernst
Austrian 20c.
LEX

WENDRICH, Max
 Russian 19/20c.
 LEX, TB

WENDT, Eigil
 Danish mid 20c.
 GR58

WENDT, Georg
 French 19/20c.
 LEX

WENIG, Bernhard
 German 1871–
 LEX

WENING, Regula
 Swiss mid 20c.
 GR61

WENNENBERG, Brynolf
 Swedish 1866–1950
 BI, TB

B.W.

WENNERSTROM, Genia Katherine
 American 1930–
 H

WENRICK, John
 American 1894–
 M

WENZ-VIÉTOR, Else
 German early 20c.
 LEX

WENZEL, William Michael
 American 1918–
 H

WENZELL, Albert Beck
 American 1864–1917
 B, EC, F, H, I, IL, LHJ6/94, TB

#Wenzell

WERDOWATZ, Willy
 Austrian 20c.
 LEX

WERENSKIOLD, Erik Theodor
 Norwegian 1855–1938
 B, H, SC, TB

Erik Werenskiold.

WERKMAN, Hendrik Nicolaas
 Dutch 1882–1945
 AN, B, CP, H, POS

H.N.W.

WERLEY, Beatrice B.
 American 1906–
 H

WERMELINGER, Willi
 Swiss mid 20c.
 GR61-63-64-68

WERNER
 French late 20c.
 GR85

WERNER '84

WERNER, Aleksander
 English mid 20c.
 GR52-53-57

WERNER, Anton Alexander von
 German 1843–1915/19
 B, H, LEX, M

WERNER, R.
 Swiss mid 20c.
 LEX

WERNER, Willibald
 German 1863–
 LEX, TB

W.W.

WERNTZ, Carl N.
 American 1874–1944
 B, F, H, M

WERTH, Kurt
 German/American 1896–
 H, TB

WESPI, Dora
 Swiss late 20c.
 GR82-85

WESSELHOEFT, Mary Fraser
 American 1873-
 B,F,H,M

WEST, Daniel T.
 American 20c.
 M

WEST, Harold Edward
 American 1902-
 H,M

WEST, Joseph Walter
 English 1860-1933
 B,LEX,POST,TB

WEST, Lowren
 American 1923-
 GR56-57-58,H

WESTALL, Richard
 English 1765-1836
 B,H,M

RW

WESTARP, W. V. von
 German mid 20c.
 GR65

WESTCOTT, George
 American 20c.
 H,M

WESTERLUND, Kjell
 Swedish mid 20c.
 GR54

WESTERLUND

WESTERMAN, Harry James
 American 1876-1945
 B,CO7/04,EC,H,M

Westerman

WESTERMAYER, Karl
 German 19/20c.
 LEX

WESTERMAYR, Konrad
 German 1883-1917
 LEX,TB

WESTFAHL, Conrad
 see
 WESTPHAL, Conrad

WESTMACOTT, Bernard
 Anglo/American 1887-
 M

WESTMAN, Edvard (Edouard)
 Swedish 1865-1917
 B,POS

WESTPHAL, Conrad
 German 1891-
 B,H,LEX

ω.

WESTPHALEN, August
 German 1864-
 B

WETHERALD, Harry H.
 American 1903-55
 F,H,M

WETHERBEE, H. D.
 American 20c.
 M

WETLESEN, Wilhelm Laurits
 Norwegian 1871-1925
 B,LEX,TB

WETLI (WETTL), Hugo
 Swiss 1916-
 GR56-58-61-63-65-68

Wetli 57

WETZELSBERGER, Fritz
 Austrian 20c.
 LEX

WEXLER, Jerome Leroy
 American 1923-
 H

WEZEL, Peter
 Swiss mid 20c.
 GR65

WHARTON, James Pearce
American 1893-1963
H,M

WHEAT, Corydon
American 20c.
M

WHEATLEY, F.
English early 20c.
POST

WHEELAN, Albertine Randall
American 1863-
F,SN7/94

Albertine · Randall · Wheelan.

WHEELER, Catherine Werneke
American 20c.
M

WHEELER, Cleora Clark
American 20c.
F,H,M

WHEELER, George Bernard
American 20c.
M

WHEELER, Laura B.
American early 20c.
F,H

WHEELER, Mark
American 1943-
H

WHEELHOUSE, M. V.
English 20c.
M

WHEELOCK
American 20c.
B,M?

WHEELWRIGHT, Elizabeth S.
American 1915-
H

WHEELWRIGHT, Rowland
Austrian 1870-
B

RWheelwright

WHELAN, Michael
American late 20c.
NV

WHISTLER, Rex John
English 1905-44
B,H,S,TB

Rex W.

WHITCOMB, Jon
American 1906-
ADV,GMC,H,IL,M,H

Jon Whitcomb

WHITE, Barbara
American mid 20c.
GR65

WHITE, Charles Edward III
American 1940-
GR66-68,Y

WHITE, Charles Henry
Canadian/American 1878-
B,HA8/04 and 4/09,I,M

White

WHITE, Ethelbert
English 1891-1972
B,BRP,H,MM,TB

Ethelbert White

WHITE, Ethyle Hermann
American 1904-
H

WHITE, Francis Robert
American 1907-
H,M

WHITE, George Gorgas
American 1835-98
B,D,H,I,M

WHITE, Gwendolen (Jones)
English 1903–
B

WHITE, Jacob Caupel
American 1895–
B,F,H

WHITE, Ralph Ernest, Jr.
American 1921–
H

WHITE, Theo
American 1902–
H,M

WHITE, William Davidson
American 1896–
H,M

WHITE, William Fletcher
American 1885–
F,M

WHITE, William Johnstone
English ac. 1804–10
B,H

WHITEFIELD, Edwin
Anglo/American 1816–92
D,H,M

WHITEHAM, Edna M.
American early 20c.
F,H

WHITEHEAD, Walter
American 1874–1956
F,H,M

WALTER
WHITEHEAD

WHITESIDES, Kim
American 1941–
Y

WHITFORD, William Garrison
American 1886–
H,M

WHITING, Frederic
English 1874–
B,M

FREDERIC WHITING

WHITING, John Downes
American 1884–
B,F,H,M

WHITING, Mildred Ruth
American 20c.
H,M

WHITMAN, Charles Thomas
American 1913–
H,M

WHITMAN, John Franklin, Jr.
American 1896–
H

WHITMAN, John Pratt
American 1871–
H,M

WHITMIRE, La Von
American 20c.
H,M

WHITMORE, M. Coburn
American 1913–
H,IL

coby whitmore

WHITNEY, Elwood
American 20c.
H

WHITNEY, Isabel L.
American –1962
B,F,H

WHITNEY, Marjorie Faye
American 1903–
H,M

WHITTEMORE, Constance
American 20c.
M

WHITTEMORE, Margaret Evelyn
American 20c.
H,M

WHITTINGHAM, William Henry
 American 1932–
 IL,Y

[signature: Whittingham]

WHYMPER, Charles
 English 1853–1941
 B,BK,H,M

WHYMPER, Edward
 English 1840–1911
 B,M

WHYMPER, Frederick
 Canadian ac. 1863–82
 H

WIBOLLT, (Jack) Aage Christian
 Danish/American 1894–
 H,M

WIBOPF
 French ac. late 19c.
 GMC

WIBORG, Koren
 Norwegian 19/20c.
 POS

WICHTENDAHL, Oskar
 German 1861–
 LEX,TB

[signature: OSKAR W.]

WIDER, Otto
 German early 20c.
 LEX

WIDMANN, Willy
 German 1908–
 LEX

WIDMER, Hansruedi
 Swiss mid 20c.
 G58–59–61–62–68

WIDMER, Heinrich
 German ac. early 20c.
 LEX

WIDMER, Jean
 French mid 20c.
 GR61

WIDNMANN, Julius
 German 1865–1930
 LEX,TB

[signature: IW]

WIECZOREK, Sylvester
 Polish mid 20c.
 GR65

WIEDEN-VEIT, Grete
 Austrian 1879–
 B,LEX,TB

WIEDENHOFER, Oskar
 Austrian 1889–
 B,LEX

WIEDERKEHR, Jürg
 Swiss mid 20c.
 GR58

WIEGER, Wilhelm
 German 1890–
 LEX,TB

WIEGHORST, Olaf
 Danish/American 1899–
 H

[signature: O. Wieghorst]

WIELAND, Hans Beatus
 Swiss 1867–
 B,LEX,TB

[signature: H.B.W.]

WIENER, Hilda
 German/Belgian 20c.
 M

WIER, Gordon Don
 American 1903–
 H

WIERTZ, Jupp
 German 1888-1939
 AD,ADV,CP,POS,TB

J P
J P
WIERTZ

WIERUSZ-KOWALSKI, Alfred van
 Polish 1849-1915

A. Wierusz-Kowalski

WIESE, Kurt
 German/American 1887-
 H,M,S

WIESEN, George William, Jr.
 American 1918-
 H,M

WIESENBERG, Louis
 American 20c.
 M

WIESMULLER, Dieter
 Swiss late 20c.
 EI79,GR85

D·W

WIESNER, William
 American 1899-
 H

WIGGINS, George E. C.
 American 20c.
 H,M

WIINBLAD, Bjorn
 Danish 20c.
 POS

Bjørn Wiinblad-54

WIJNBERG, Nicolaas
 Dutch 1918-
 GR68,H

WILBUR, Dorothy Thornton
 American early 20c.
 F,H

WILBUR, Ted
 American 20c.
 H

TED WILBUR

WILCOX, David
 American 20c.
 GR82,P

WILCOX

WILCOX, Frank Nelson
 American 1887-
 F,H

WILCOX, Michele
 American late 20c.
 GR82

WILD, Roger
 Swiss/French 1894-
 B,H,LEX,TB

RW

WILDA, Charles H.
 Austrian 1854-1907
 B,BAA,LEX

WILDBUR, Peter
 English mid 20c.
 GR60-63-64-67

WILDE, John
 American 1919-
 DRAW,H,M

WILDER, H. M.
 American ac. 1898
 M

WILDHACK, Robert J.
 American 1881-
 ADV,F,M,POST

'WILDHACK·

WILDRAKE
 Canadian ac. 1841
 H

WILDSMITH, Brian Lawrence
 English 1930–
 H

WILES, Frank
 American early 20c.
 CEN9/12

FRANK
WILES

WILES, Irving Ramsay
 American 1861–1948
 B,BAA,F,H,I,SN1/94,Y

J.R.Wiles

WILFORD, Loran Frederick
 American 1892–
 F,H,IL,PE

LORAN F. WILFORD

WILHELM, Hans
 German early 20c.
 LEX

WILHELM, Roy E.
 American 1895–1954
 H,M

WILKE, Erich
 German 1879–1936
 LEX

WILKE, Hermann
 German 1876–
 LEX

WILKE, Karl Alexander
 Austrian 1879–
 LEX,TB

WILKE, Rudolf
 German 1873–1908
 AN,EC,GMC

WILKE, William Hancock
 American 1880–
 B,F,H,M

WILKENS, Hugo
 American 20c.
 M

WILKIN, Eloise Burns
 American 1904–
 H,M

WILKINS, Elizabeth Walter
 American 1903–
 H,M

WILKINS, Gladys Marguerite
 American 1907–
 H,M

WILKINS, Ralph Brooks
 American 20c.
 H,M

WILKINSON, Edward
 Anglo/American 1889–
 B?,F,H,M

WILKINSON, Gilbert
 English 1891–195?
 EC

WILKINSON, J. Walter
 American 1892–
 M

WILKINSON, Norman
 English 1878–1934
 B,LEX,M,POST

Norman Wilkinson–

WILKINSON, Ronald
 English mid 20c.
 GR52–66–67–68

WILKON, Jozef
 Polish 1930–
 GR65,H

WILL, August
American 1834-1910
B,CEN11/98,I,M,TB

Aug. Will

WILL, Blanca
American 1881-
B,F,H,M

WILLARD, Howard W.
American 1894-1960
F,H,IL,M

Howard Willard

WILLARD, Rodlow
American 1906-
H

WILLAUME, Louis
French 1874-
B,M

WILLAUMEZ, René
French early 20c.
VC

RvBW

WILLCOX, Sandra
American 20c.
H

WILLE, August von
German 1829-87
B,H,LEX,M,TB

A v W

WILLEBEEK LE MAIR, Henirette
Dutch 1889-
B

WILLEM, Bernard Holtrop
Dutch 20c.
POS

WILLETTE, (Leon) Adolphe
French 1857-1926
B,EC,FS,GMC,H,M,POS,POST,SI,TB

A. Willette

WILLIAMS, Ann Mary
English 19c.
B,H

WILLIAMS, Charles D.
American 1880-1954
F,H,IL,M

C. D. Williams

WILLIAMS, Clara E.
American early 20c.
F,H,M

WILLIAMS, Eleanor Troy
American 20c.
M

WILLIAMS, Florence White
American -1953
B,F,H,M

WILLIAMS, Garth Montgomery
American 1912-
H

WILLIAMS, George Alfred
American 1875-1932
B,CEN2/99,F,I,M,SCR11/02

Geo A Williams

WILLIAMS, Gluyas
American 1888-1982
ADV,B,EC,F,H,M,PE

Gluyas Williams

WILLIAMS, Irving Stanley
American 1892-
H,M

WILLIAMS, Jennie
American 195?-
C

JENNIE WILLIAMS

WILLIAMS, John Alonzo
American 1869-
B,H,I,M

WILLIAMS, John Scott
 Anglo/American 1897-1976
 B,H,IL,M,PE,Y

·J·ScottWilliams·

WILLIAMS, Morris Meredith
 English 1881-
 B,M

WILLIAMS, Paul
 American 1934-
 Y

WILLIAMS, Pauline Bliss
 American 1888-
 B,F,H,M

WILLIAMS, Richard James
 English 1876-
 B

WILLIAMS, Samuel
 English 1788-1853
 B,H,M

WILLIAMS, Thomas H.
 English ac. 1801-30
 H

WILLIAMS, Walter J., Jr.
 American 1920/22-
 H

WILLIAMS, Warren
 English 1863-
 B

WILLIAMS, (Mrs.) Watson
 see
 VEZELAY, Paule

WILLIAMSON, Ada C.
 American 1882/83-1958
 B,F,H,M

WILLIAMSON, J. Maynard, Jr.
 American 1892-
 B,F,M

WILLIAMSON, James W.
 American 1899-
 H,IL,M,Y

WILLIMAN(N), Rolf
 Swiss mid 20c.
 GR62-67,POS

WILLING, John Thom(p)son
 Canadian/American 1860-after 1934
 B,BAA,F,M

WILLIS, Ian Robert
 English 1944-
 H

WILLIS, Ralph Troth
 American 1876-
 F,H,M

WILLMARTH, Kenneth L.
 American 20c.
 H,M

WILLOUGHBY, H.
 English early 20c.
 ADV

WILLOUGHBY, Vera
 English early 20c.
 AD,M

WILLOUGHBY, Walter L.
 American 20c.
 M

WILLRAB
 Austrian early 20c.
 POS

WILLRAB

WILLS, Franz Hermann
 German mid 20c.
 GR52-53-54-56-57-58-59

WILLSON, John
 Canadian 19/20c.
 H,M

WILLSON, Martha Butterick
American 1885–
B,F,H,M

WILLUMSEN, Boye W.
Danish mid 20c.
GR62–64–65

Boye Willumsen

WILLUMSEN, Jens Ferdinand
Danish 1863–1958
B,H,POST

WILLY
see
ERIKSSON, Willy

WILNER (WILMER), George
American 20c.
H,M

WILSON, Albert Leon
American 1920–
H

WILSON, Charles Heath
English 1809–82
B,H,M

WILSON, Donald Roler
American late 20c.
GR82

WILSON, Douglas
American 20c.
H,M

WILSON, (Rev.) E. F.
Canadian ac. 1876
H

WILSON, Edward Arthur
Scottish/American 1886–1970
ADV,B,F,H,IL,M,Y

WILSON, Edward N.
American 1925–
H

WILSON, Ellis
American 1899/1900–
H,M

WILSON, Elsie
Canadian 20c.
M

WILSON, Franklin
English 1940–
H

WILSON, Gilbert Brown
American 1907–
F,H,M

WILSON, Harriet
American 1886–
H,M

WILSON, J. Coggeshall
American early 20c.
LEX

WILSON, John
American 20c.
GR65,H

WILSON, John Francis
Canadian 1865–1941?
H

WILSON, Mortimer, Jr.
American 1906–
CON,H,IL,M

WILSON, Oscar
English 1867–1930
H

WILSON, Patten
English 1868–
B,BK,STU1901,TB

WILSON, Reagan
American 20c.
P

WILSON, Rose Cecil O'Neil
American 20c.
F,H,M

WILSON, Rowland Bragg
American 1930–
ADV,EC,H

Rowland B. Wilson

WILSON, Sophie
American 1887–
H,M

WILSON, Stanley Charles
American 1947–
H

WILSON, Thomas Walter
English 1851–1912
B,H

WILSON, Thomas William
American 1945–
Y

WILSON, W. O.
American 19/20c.
LEX

WILSON, Wes
American 1937–
POS

WILSON-WATKINS, May
English? early 20c.
SCR1/04

May Wilson-Watkins
M.W.W.

WILWERDING, Walter Joseph
American 1891–1966
H,M

WIMAN, Vera
American 20c.
H,M

WIMBUSH, J. L.
English ac. late 19c.
LEX

WIMMER, Albert
German 19/20c.
LEX

WIMMER, Eduard Josef
Austrian 1882–1961
B,POS

WIMPERIS, Edmund Monson
English 1835–1900
B,H,M

EMW

WINCHELL, Paul H.
American 20c.
H,M

WINDBERGER, Ferry
Hungarian/Austrian 1915–
LEX

WINDELL, Violet Brumner
American 20c.
H

Windell '75

WINDHAGER, Franz
Austrian 1879–1959
B

WINDROW, Patricia (Klein)
Anglo/American 1923–
H

WINDSCHEIF, Fritz
German 1905–
LEX

WINEBRENNER, Harry Fielding
American 1884–
B,F,H

WINGATE, Carl
American 1876–
F,H,M

WINGATE, Robert Bray
American 1925–
H

WINGERD, Loreen
American 1902–
F,H,M

WINKLER, A.
Swiss mid 20c.
GR61

WINKLER, Eduard
Russian/German 1884–
LEX

WINKLER, Franz
Polish early 20c.
LEX

WINKLER, Rolf
Austrian/German 1884–
M

RW

WINNER, Gerd
German 1936–
B,H

WINNER, Margaret F.
American 1866–1937
F,H,M

WINSEY, A. Reid
American 1905–
H

WINSHIP, Florence Sarah
American 20c.
H

WINSLOW, Earle Bartrum
American 1884–1969
B,F,H,M,Y

WINSLOW, Eleanor C. A.
American 1877–
B,F,H,M

WINSLOW, Morton G.
American 20c.
H,M

WINSLOW, Vernon
American
H

WINSTANLEY, John Breyfogle
American 1874–1947
F,H,M

WINTER, Alice Beach
American 1877–
B,F,H,M

WINTER, Charles Allan
American 1869–1942
B,CEN10/09,F,H,I,M

WINTER, Ezra Augustus
American 1886–1949
B,F,H,I,M

WINTER, Klaus
German 1928–
GR58-59-60-61-68?,H

WINTER, Lumen Martin
American 1908–
H,M

WINTER, Milo Kendall
American 1888–
B,F,M

WINTER, William Arthur
Canadian 1908/09–
B,H

WINTERBERG, Helmut
Swiss mid 20c.
GR53-54-56

WINTERHAGER, Klaus
German mid 20c.
GR62-64-68

WINZER, Charles Freegrove
English 1886–
B,M,TB

GW

WIPPERMANN, Wilhelm
German mid 20c.
GR54

WIRALT, Edouard
French 20c.
B

WIREMAN, Eugenie M.
American early 20c.
F,LHJ4/05,M

WIREMAN, Katherine Richardson
American 20c.
HA12/07,LHJ7/06,M

KATHARINE R WIREMAN

WIREN, Steffan
Swedish 1926–
GR52-53-55-56,POST

WIRKKALA, Tapio
Finnish mid 20c.
GR54

WIRSUM, Karl
American 20c.
P

WIRTH, Anna Maria Barbara
American 1868–1939
F,H,M

WIRTH, Kurt
Swiss 1917–
GR52-68,H

Wirth

WIRTH, Robert
American mid 20c.
GR53

wirth

WIRTH, Rudolf
German early 20c.
LEX

WISE, M.
American late 20c.
GR52

WISER, Guy Brown
American 1895–
F,H,M

WISMER, Francis Lee
American 1906–
H

WISNIEWISKI, Leszek
Austrian late 20c.
GR82

WISSING, B.
Belgian mid 20c.
GR60-61

WISTEHUFF, Revere F.
American 20c.
M

WITKAMP, Ernest Sigismund
Dutch 1854–97
B,H,POS

WITT, Johann
German 1834–86
B,M

WITTERS, Neil
American 19/20c.
F,H

WITTIG, Friedrich
German 1854–
LEX,TB

F. W.

WITTING, Walther Günther Julian
German 1864–1940
B,LEX,TB

WITTLINGER, Fritz
German early 20c.
LEX

WITTMACK, Edgar Franklin
American 1894–1956
H,M

WITZ, Ignacy
Polish 1919–71
EC,H

W.

WITZEL, Josef Rudolph
German 1867–
CP,GMC,MM

g. R. Wilzel

WIWEL, Niels
Danish 1855–1914
B

WIWIORSKY, R.
 German early 20c.
 LEX

WOBST, Friedrich
 German 1905–
 LEX

WOERKOM, Josef van
 Dutch 20c.
 LEX

WOGSTAD, James Everet
 American 1939–
 H

WOHLBER, Meg
 see
 WOLBER, Meg

WOHLBERG, Ben
 American 1927–
 IL,Y

Ben J Wohlberg (signature)

WOHLFARTH, Rudolf
 Austrian mid 20c.
 LEX

WOLBER, Meg
 American 20c.
 H

WOLBRAND, Peter
 German 1886–
 LEX

WOLCHONOK, Louis
 American 1898–
 F,FM3/25,H,M

Louis Wolchonok (signature)

WOLCOTT, Elizabeth Tyler
 American 1892–
 M

WOLD-TORNE, Oluf
 Norwegian 1867–1919
 B,SC

WOLF, Ben
 American 1914–
 H

WOLF, Hamilton Achille
 American 1883–
 F,H

WOLF, Henry
 American 1925–
 GMC,GR55-58-62-65-68,H

WOLF, Käthe
 German early 20c.
 LEX

WOLFE, Bruce
 American 20c.
 P

WOLFF, Otto
 German/American 1858–
 F

WOLFLI, Adolph
 Swiss 1864–1930
 B,GMC

WOLLE, Murie Sibell
 American 1898–1977
 H

WOLPE, Berthold
 German/English 1905–
 H

WOLS, (Alfred Otto Wolfgang Shultze)
 German 1913–1951
 B,DRAW,H

WOLS (signature)

WOLSEY, Tom (Thomas)
 English mid 20c.
 GR52-53-55-58-61

Wolsey (signature)

WOLSKY, Milton Laban
 American 1916–
 H

WOLSTENHOLME, Jonathan
 English late 20c.
 EI79

JONATHAN WOLSTENHOLME (signature)

WOLTERS, Georg
German 1861–
LEX,TB

G.W.

WOLTERS, Hilde
Dutch late 20c.
GR85

WOMRATH, Andrew Kay
American 1869–
B,F,M

A.K.W.

WONG, Jeanyee
American 1920–
H

WONG, Tyrus
Chinese/American 1910–
H

WOOD, Beatrice
American early 20c.
B,H

WOOD, Harry Emsley, Jr.
American 1910–
H,M

WOOD, Harry Morgan
American 1902–
F,H

WOOD, J. Crawford
American? early 20c.
SCR11/02

WOOD, Jessie Porter
American 1863–
B,F,H

WOOD, Ruth Mary
English 1899–
M

WOOD, Stanley
English 1860–
H,M

WOOD, Starr
English 1870–
B,M,STU1903

WOOD, Virginia Hargraves
American early 20c.
B,F,H

WOODBRIDGE, George Charles
American 1930–
EC

WOODBURY, Charles Herbert
American 1864–1940
APP,B,F,H,I,M,MM,POS,R

WOODBURY, Mabel J.
American 20c.
M

WOODCOCK, John
English mid 20c.
GR52

WOODROFFE, Paul Vincent
English 1875–1954
BK

WOODRUFF, Claude Wallace
American 1884–
F,H,M

WOODRUFF, Porter
American early 20c.
M,VC

WOODRUFF, Thomas
American late 20c.
GR82

WOODS, Henry
English 1846–1921
B,H

WOODS, Rex Norman
Anglo/Canadian 1903–
H,M

WOODVILLE, Richard Caton
 Canadian/American 1856–1937
 BAA,BL1/05,H,TB

R·Caton Woodville

WOODWARD, Alice Bolingbroke
 English 1862–1911
 B,BK,M,TB

AWB.

WOODWARD, Cleveland Landon
 American 1900–
 H

WOODWARD, Ellsworth
 American 1861–1939
 B,F,H,I

WOODWARD, John Douglas
 American 1846/48–1924
 B,BAA,CWA,H,I,TB

Woodward

WOODWARD, Stanley Wingate
 American 1890–
 B,F,H,I

WOOHHISER, Jack
 American 20c.
 NV

JW.

WOOLEY, C.
 English early 19c.
 B

WOOLF, Michael Angelo
 Anglo/American 1837–99
 B,CC,D,EC,H,I,TB,Y

Woolf

WOOLRYCH, Bertha Hewit
 American 1868–1937
 B,F,H

WOOLRYCH, Francis Humphrey W.
 Australian/American 1868–
 B,F,H,I

WOOLSCHLAGER, Laura
 American 1932–
 CON

Woolschlager *

WORCH, H. R.
 American 20c.
 M

WORDEN, Laicita Warburton
 American 1892–
 B,F

WORES, Theodore
 American 1860–1939
 B,F,H,I

Theodore Wores.

WORK, J. Clark
 American 20c.
 H

WORMS, Jules
 French 1832–1924
 B,BAA,H

JWorms

WORRALL, Henry
 American 1825–1902
 D,H

WORTH, Thomas
 American 1834/39–1917
 B,BAA,CC,D,EC,I,M,TB,Y

Thos. Worth

WORTMAN, Denys
 American 1887–1958
 EC,FOR,H,IL

Wortman

WORTSMAN, Wendy
 Canadian late 20c.
 GR85

WOSK, Miriam
 Canadian/American 1947-
 Y

WOTTAWA, Babette
 Austrian early 19c.
 B

WOWK, Jury
 Ukrainian early 20c.
 LEX

WOYTY-WIMMER, Hubert
 Rumanian/Austrian 1901-
 B,LEX,TB

WOZNIAK, Dorothy
 American late 20c.
 GR82

WOZNIAK, Elaine
 American late 20c.
 GR82

Wozniak

WRAGG, Arthur
 English 1903-
 M

WRANGEL, U. von
 German early 20c.
 LEX

WRENN, Charles Lewis
 American 1880-1952
 B,F

WRIGHT, Alan
 English 1900-
 B,BK,TB

WRIGHT, Alfred G.
 English 19/20c.
 LEX

WRIGHT, Alice Maud
 English 20c.
 M

WRIGHT, Barton Allen
 American 1920-
 H

WRIGHT, Cameron
 see
 WRIGHT, Philip Cameron

WRIGHT, Charles H.
 American 1870-1939
 B,F,H

WRIGHT, Charles Lennox
 American 1876-
 B,F,H

C LENNOX-WRIGHT

WRIGHT, Edgar
 English? early 20c.
 ADV

WRIGHT, George Hand
 American 1872-1951
 B,F,H,I,IL,M,SCR9/02,Y

WRIGHT, Grant
 American 1865-1935
 GR66,F,H

WRIGHT, John Massey
 English 1773/77-1858/66
 B,H

WRIGHT, Harold David
 American 1942-
 H

WRIGHT, Henry Charles Seppings
 English 1849-1937
 H

WRIGHT, M. S.
American early 20c.
LEX

WRIGHT, Marsham Elwin
Anglo/American 1891-
B,F,H

WRIGHT, Philip Cameron
American 1901-
F,H,M

WROUBEL (WRUBEL), Mikhail Alexandrovitch
Russian 1856-1910
B,H,RS

WRUBEL, Arno
German mid 20c.
GR58-60

WUERPEL, Edmund Henry
American 1866-1958
B,F,H,I

WULF, Lloyd William
American 1913-
H,M

WULFF, H. Wilhelm
German 1870-
LEX

WÜLLNER, Leopold
Austrian early 19c.
B

WÜRBEL, Franz Theodore
Austrian 1858-
B

WURMAN, Reven T. C.
American late 20c.
GR85

WURR, Matthew
English late 20c.
EI79

WÜRTEMBERGER, Ernst
Swiss 1868-1934
B

WÜRTZ, Adam
Hungarian 1927-
B

WÜST, Ferdinand
German? 1845-
LEX,TB

fW.

WUTHENAU, Alexander von
Brazilian 20c.
LEX

WUTTKE, Carl
German 1849-1927
B,LEX,TB

WYATT, Charles Oliver
Canadian ac. 1876-78
H

WYATT, William Stanley
American 1921-
H

WYDLER, Hans
Swiss mid 20c.
GR54-55

WYETH, Andrew Newell
American 1917-
B,F,FOR,GMC,H,I,IL,M,SCR12/06,Y

WYETH, Newell Convers
American 1882-1945
B,F,H,I,M

N.C.WYETH
·1905·

WYL(L)IE, William Lionel
English 1851-1931
B,H,POS,POST

WYMAN, F. E.
Canadian ac. 1865
H

WYNN, Dan
American mid 20c.
GR54-58-63,H

DAN WYNN

WYNNE, Leslie Bernard, Jr.
American 1920-
H

WYSPIANSKI, Stanislaw
Polish 1869–1907
AN,B,H

St. Wyspianski

WYSS, Alban
Swiss mid 20c.
GR60–62–63

WYSS, Marcel
Swiss mid 20c.
GR57–62–66

WYSS, Robert
Swiss 1925–
GR57–63–68,H

RW

- X -

XAM, (Fendt Max)
Swiss mid 20c.
GR54–56

X AM

XANTI
see
SCHAWINSKY, Xanti

XARA, Francesco
Portuguese 1882–1954
H

XAUDARO, Joaquin
Spanish 1872–1933
B,GMC,POS

1 Xaudaro

XENSKIS, Hector
Greek 1900–72
GR56–57

XENSKIS

XIMENÈS, Eduardo
Italian –1932
H

XIMENÈS, Ettore
Italian/Argentinian 1855–1926
B,H,M

- Y -

YAHN, Erle
American mid 20c.
GR54

YALOWITZ, Paul
American late 20c.
GR85

YAMA, Sudzuki Shinjiro
Japanese/American 1884–
H,M

YAMACHITA, T.
Japanese mid 20c.
GR64

YAMADA, Shinkichi
Japanese early 20c.
POS

YAMADA, Tadami
Japanese late 20c.
GR82

Tadami Yamada

YAMAGUCHI, Harumi
Japanese 1940–
POS

Harumi

YAMAMOTO, Shoun
Japanese 1870–1965
H

YAMANA, Ayao
Japanese early 20c.
GR53–59,POS

*AYAO
1953*

YAMAO, Susumu
Japanese mid 20c.
GR64

Yamao

YAMASHIRO, Ryuichi
Japanese 1920-
GR52-54-56-57-59-63-65

R. yamashiro

YAMASHITA, Yuzo
Japanese mid 20c.
GR64

YAMAZAKI, Renzo
Japanese mid 20c.
GR55-58

YAMAZAKI, Takao
Japanese 1905-
GR52,H

YAMBO
see
NOVELLI, Enrico

YANAGIHARA, Ryohei
Japanese mid 20c.
GR58-60

RYOHEI Y.

YANOW, Rhoda Mae
American 20c.
H

YAP, Weda (Louise Drew-Cook)
American 1894-
H,M

YARON, Alexander A.
American 1910-
H

YASS, U.
see
URUGAWA, Yasuro

YASUNAMI, Settai
Japanese 1887-1940
H

YATSUMURA, K.
Japanese mid 20c.
GR64

YEAGER, Walter Rush
American 1852-96
H

YEATS, Elizabeth C.
irish -1940
M

YEATS, Jack Butler
Irish/English 1871-1957
B,BRP,H

YEGLEY
English? mid 20c.
POS

YENA, Donald
American mid 20c.
H

YENDIS, Mosnar (RANSOM, Sidney)
English 19/20c.
CP,POS

MOSNAR YENDIS

YENS, Karl Julius Heinrich
German/American 1868-1945
B,H

YERKES, Lane Hamilton
American 1945-
F,Y

YLEN, Jean D'
French ac. 1920
CP,M,POS,POST

Jean J Ylen

YLINEN, Viktori Johann
Finnish 1879-
B

YNGLADA, Pedro
Spanish 1881-1958
B

YOEMAN, (Mrs.) Antonia
Australian 20c.
GMC

YOHN, Frederick Coffay
American 1875-1953?
B,F,H,I,IL,M,SCR1/04 and 3/12,Y

F. C. YOHN

YOKOO (YOKŌ), Tadanori
Japanese 1936–
CP,EC,GR 61–62–63–66–67–82–85,POS

Tadanori Yokoo

YOKOYAMA, Taizo
Japanese 1917–
H

YOSHIDA, Hambei
see
HAMBEI

YOSHIDA, Katsu
Japanese 20c.
P

Katsu '82

YOSHIHARU
Japanese 1828–88
H

YOSHIKIYO
Japanese ac. 1701–16
H

YOSHINOBU
Japanese ac. 1745–58
H

YOSHITARO, Isaka
Japanese 20c.
CP

YOSHITSUNA
Japanese ac. 1848–68
H

YOSHITSUYA
Japanese 1822–66
H

YOSHIUME
Japanese 1819–79
B,H

YOSŌSAI
see
IMAO, Keinen

YOST, James Z.
American late 20c.
NV

JZYost

YOUNG, (Capt.) Allen
Canadian ac. 1860
H

YOUNG, Arthur (Art)
American 1866–1943
B,EC,F,H

Young

YOUNG, Arthur Raymond
American 1895–1943
F,H

YOUNG, Chick
American 1901–
H,M

YOUNG, D. Malcolm
Canadian 20c.
M

YOUNG, Elmer E.
American 1897–
H,M

YOUNG, Esther Christensen
American 1895–
F,H,M

YOUNG, Henry Arthur
see
YOUNC, Arthur

YOUNG, John Chin
American 1909–
H,M

YOUNG, John J.
American 1830–79
H

YOUNG, Joseph Louis
American 1919–
GR54,H

YOUNG, Walter N.
American 1906–
H

YOUNG, Webb
　　American 1913-
　　CON,H

Webb Young

YOUNG, William Crawford
　　American 1886-
　　F,H,M

YOUNG-HUNTER, John
　　see
　　HUNTER, John Young

YOUNGERMAN, Jack
　　American 1926-
　　APP,B,F,H

YOUNGBLOOD, Nat
　　American 1916-
　　H

YPHANTIS, George Andrews
　　American 1899-
　　H,M

YRAN, Kurt
　　Norwegian mid 20c.
　　POST

YSERN, R. S.
　　Spanish 1908-
　　POST

YUKOV
　　Russian early 20c.
　　POS

YUMURA, Terhito
　　Japanese 1942-
　　POS

YUNKERS, Adja
　　Latvian/American 1900-
　　APP,B,DRAW,H,PC

YVE
　　Swiss mid 20c.
　　GR54

- Z -

ZABEL
　　German ac. early 20c.
　　POS

ZABOLY, Bela Pal
　　American 1910-
　　H,M

ZABOROWSKA, Suzanne Alice
　　French 1894-
　　B

ZABRANSKY, Adolf
　　Czechoslovakian 1909-
　　B,GR55,H

ZACCONE, Fabian F.
　　Italian/American 1910-
　　H,M

ZACHARIAS, Alfred
　　German 1901-
　　G

ZACHAROW, Christopher
　　American late 20c.
　　GR85

ZACK, Leon
　　Russian/French 1892-
　　B,H,M

ZADIG, Bertram
　　Hungarian/American 1904-
　　H,M

ZADNICK, Karl
　　Czechoslovakian 1847-1923
　　B

ZÁDOR, István
　　Hungarian 1882-
　　B,LEX,TB

ZAFAUREK, Gustav
Austrian 1841-
B

ZAGORSKI, Stanislaw
Polish/American mid 20c.
GR 62-64-68

ZAHARIEV, Vasil
Bulgarian 1895-
H

ZAHEL, Luzian
German 20c.
LEX

ZAID, Barry
American 20c.
POS

ZAIDENBERG, Arthur
American 20c.
H,M

ZAKARIAN, Aram
American mid 20c.
GR 64-65

ZALENKO, Harry
American mid 20c.
GR 54-60

ZALESKI, Antoni
Polish 1824-85
B

ZALLINGER, Jean Day
American 1918-
H

ZALOR, Alfred
American mid 20c.
GR 58-59

Alfred Zelor

ZAMCZNICK
Polish 20c.
POS

ZAMECZNIK, Stanislaw
Polish 1909-
GR 59,H

ZAMECZNIK, Worciech
Polish 1923-
GR 52-55-56-58-60-61-63-64-67,H

W.Zam.55

ZAMINSKI
Polish early 20c.
POS

ZAMPINI, Mario
Italian 1905-
LEX

ZANDER, Jack
American 20c.
GR 53,H

ZANGENBERG, Ingvar
Danish mid 20c.
GR 53

ZANOTTO, Francesco
Italian
H

ZAO, Wou Ki
Chinese/French 1920/21-
B,H,PC

ZAPATER, Juan José
Spanish 1866-1921
B

ZAPF, Hermann
German 1918-
H,LEX

hz.

ZARNOWEVOWORA
Polish early 20c.
POS

ZARRAGA, Angel
Mexican 1886-1946
B

Angel ZARRAGA 1926

ZARRINKELK, N.
Iranian late 20c.
GR 85

ZARUBA, Jerzy
Polish mid 20c.
LEX

ZASCHE, Theodor
Austrian 1862-1922
B,LEX,TB

ZAVAGLI, Renato de
see
GRUAU

ZAYAS, George de
Mexican/American 20c.
B,M

ZBIGNIEW, Kaja
Polish mid 20c.
GR55-56-58

Z·KAJA 51

ZBROZYNA, B.
Polish mid 20c.
GR56-57

ZEBERINŠ, Indrikis Andreja
Latvian 1882-
B,LATV

ZEBOT, George Jurij
American 1944-
AA

ZEH, Friedrich Albert
German 1834-65
B

ZEHME, Werner
German 1859-
LEX,TB

ZEHNDNER, Augustin
Swiss mid 20c.
LEX

ZEIDLER, Theodore E.
American 20c.
M

ZEIGLER, Lee Woodward
American 1868-1952
B,CEN12/97,H,I,MUN8/97

ZEILINGER
American? early 20c.
VC

ZELEK, Bronislaw
Polish mid 20c.
GR65-67-68

ZELENAK, Cresencia
Hungarian mid 20c.
GR61

ZELENKA, Frantisek
Czechoslovakian early 20c.
POS

FZ

ZELENKA, Jaroslav
Czechoslovakian mid 20c.
GR60-62

ZELENKA

ZELGER, Arthur
Austrian mid 20c.
GR52-55

ZELGER

ZELIBSKA-VANCIKOVA, Maria
Yugoslavian 1913-
H

ZELIO
see
PINTO, Zelio Alves

ZEMACH, Margot
 American 1931–
 GR65,H

ZENOBEL, Pierre
 French early 20c.
 POS

ZEPF, Toni
 German mid 20c.
 GR53,POST

ZERBONI, Fritz
 Austrian early 20c.
 LEX

ZÉRÓ
 see
 SCHLEGER, Hans

ZERGAVY, Jan
 see
 ZRZAVY, Jan

ZHUKOV, Nikolai
 Russian 1908–73
 EC

ZICK, Alexander
 German 1845–1907
 B,LEX,TB

ZIEFF, Howard
 American mid 20c.
 GR58-64

ZIEGENFEUTER, Dieter
 German late 20c.
 GR82

ZIEGLER, Eustace Paul
 American 1881–1941
 F,H,M

ZIELER, Mogens Holger
 Danish 1905–
 B,GR53-55-62-64,H,TB

ZIELINSKI, John
 American late 20c.
 GR82

ZIELKE, Julius
 German 1826–1907
 LEX,TB

ZIEMIENSKI, Dennis Theodore
 American 1947–
 Y

ZIEPF, Howard
 see
 ZIEFF, Howard

ZIER, Edouard Francis
 French 1856–1924
 B,LEX

ZIETARA, Walenty (Valentin)
 German 1883–1935
 POS,TB

ZIG (ZYG), (BRUNNER or BRUMMER, L.)
 see also
 ZYG

ZIK
 German early 20c.
 POS

ZIMMELE, Margaret Scully
 American 1872–
 B,F,H,I

ZIMMER, Ernst
 German 1864–1901
 LEX

ZIMMER, Fred
 American 1923–
 Y

ZIMMERMAN, Eugene
 Swiss/American 1862–1935
 F,H,I,M

ZIMMERMAN, Mac (Max)
 Polish/German 1912–
 B,GR61,H

ZIMMERMAN, Mason W.
 American 1860/61–
 H,I,M

ZIMMERMAN, William Harold
 American 1937–
 H

ZIMMERMANN, Bodo (Bozi)
 Polish 1902–
 GWA,LEX,TB

ZIMMERMANN, Ernst Karl Georg
 German 1852–1901
 B,H,LEX

EZ.

ZIMMERMANN, Frieder
 German late 20c.
 GR82

ZIMMERMANN, Oskar
 Austrian 1899–
 LEX

ZIMMERMANN, Wolf D.
 German 1925–
 GR53–60,H

ZIMNIK, Reiner
 German 1930–
 EC,G

ZIMPEL, Julius
 German?/Austrian 1896–1925
 LEX

ZINCKGRAF, Heiner
 German mid 20c.
 GR52–53

ZINDEL, Georg
 Austrian 19/20c.
 LEX

ZINGER, Oleg
 Russian/French 1909–
 B,GR53–54–55–59

O.Z.

ZINOVIEW
 French early 20c.
 ST

ZIPIN, Martin Jack
 American 1920–85?
 H,M

ZIRKEL, E. H.
 German ac. early 20c.
 LEX

ZISKA, Helene F. (Baroness)
 American 1893–
 H,M

ZISLIN, Henri
 French 1875–
 B,M

ZO, Henri Achille
 French 1873–1933
 B,TB

ZOELL, Robert
 Canadian/American 1940–
 GR66,Y

ZOGBAUM, Rufus Fairchild
 American 1849–1925
 B,BAA,CEN1/86 and 12/98,CO6/05,CWA,H,
 HA,I,IL,PE,Y

ZON, Jacques
 Dutch 1872–
 B,POS

ZORNES, James Milford
 American 1908–
 B

ZOUSMANN, Leonid
Russian 1906-
B

ZRYD, Werner
Swiss mid 20c.
GR58-59-63-64-66

ZRZAVY (ZRSAVY), Jan
Czechoslovakian 1890-
B,H

ZUBER, Julius
Polish/Austrian 1861-
B,TB

J.Z.

ZUCCARELLI, Frank Edward
American 1921-
H

ZUCHT, Monika
German late 20c.
GR85

ZUELCH, Clarence Edward
American 1904-
H

ZÜHLKE-ZOCK
German mid 20c.
LEX

ZULIK, Else
Austrian 20c.
LEX

ZUMBUSCH, Ludwig von
German 1861-1927
AN,B,CP,GMC,POS,TB

ZVMBVSCH

ZUMTOBEL, Hedwig
Austrian 20c.
LEX

ZUPANSKY, Wladimir
Czechoslovakian 1869-1928
B,LEX,TB

ZUR, S.
Israeli mid 20c.
GR56

ZÜRCHER, Hans
Swiss 1880-
B,LEX,TB

Hz

ZUREK, Nicolay
American late 20c.
GR85

ZURROZA, Jorge
Mexican late 20c.
GR85

ZVAGUZIS, Idulis Roberta
Latvian 1928-
LATV

ZVIRBULIS, Normunds Pētera
Latvian 1929-
LATV

ZWART, Piet
Dutch 1885-
B,CP,POS,POST

P.ZWART.

ZWEEKER (ZWECKER), Johann Baptist
German 1814-76
B,H

ZWEIGLE, Walter
German 1859-1904
LEX,TB

WZ

ZYG (ZIG), (ZYGISMUND, Leopold Brunner)
Polish 187?-1961
FS

ZYG

ABOUT THE AUTHOR

John Castagno has been an art researcher for the past twenty five years and is also a multimedia artist and sculptor. He received his art education at The Fleisher Memorial, The Philadelphia College of Art, The Pennsylvania Academy of The Fine Arts and the Barnes Foundation in Merion, Pennsylvania.

John Castagno's art is in more than forty museum and public collections in the United States, Israel, and Ireland, as well as in the private collections of Presidents Jimmy Carter and Gerald Ford.

John Castagno also lectures on art and art as an investment.